Henri Matisse: The Early Years in Nice

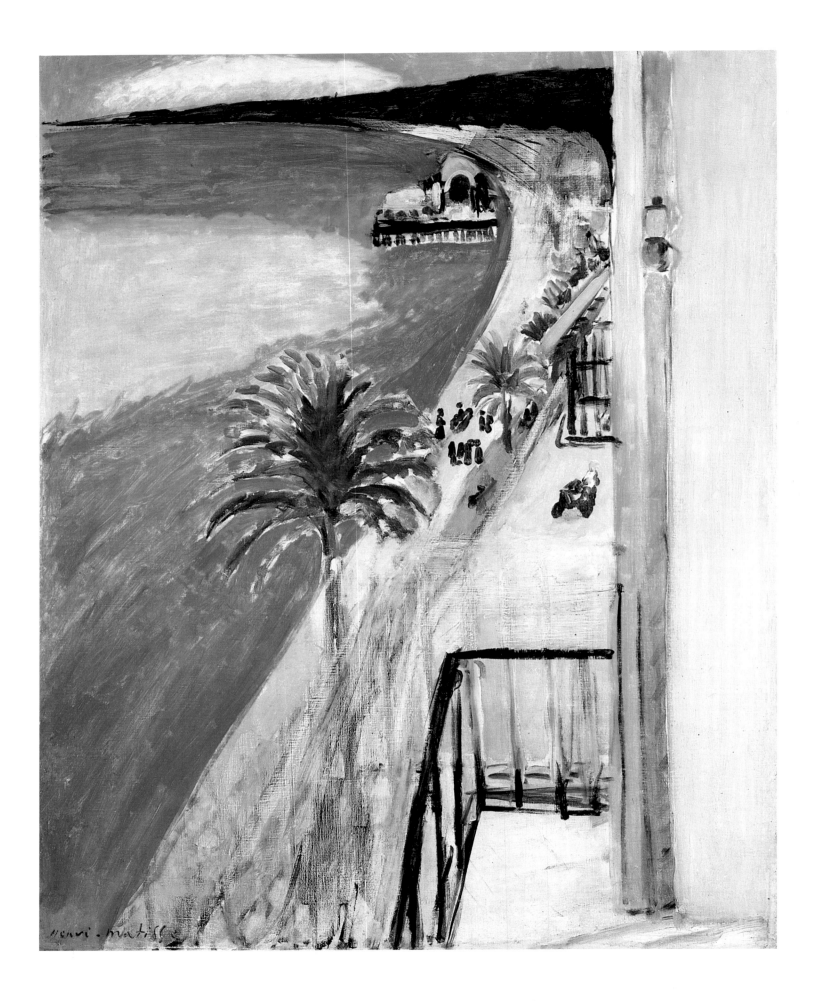

Jack Cowart
Dominique Fourcade

Henri Matisse
The Early Years in Nice
1916–1930

National Gallery of Art, Washington

Harry N. Abrams, Inc., New York

This exhibition is made possible by a grant from GTE Corporation

Exhibition dates at the National Gallery of Art: 2 November 1986 –29 March 1987

Designed by Melanie B. Ness and Marlise Mason
Edited by Jane Sweeney

The text type is Raleigh, set by Composition Systems Inc., Falls Church, Virginia
Printed on 135 gsm Gardamatt Brillante manufactured by Cartiere del Garda
Printed and bound in Italy by Amilcare Pizzi, S.p.A., Milan

The clothbound edition is published by Harry N. Abrams, Inc., New York

Library of Congress Cataloging-in-Publication Data
Cowart, Jack.
Henri Matisse: The early years in Nice, 1916–1930.
1. Matisse, Henri, 1869–1954—Exhibitions.
I. Fourcade, Dominique. II. National Gallery of Art (U.S.) III. Title.
ND553 .M37A4 1986 759.4 86-19967
ISBN 0-89468-097-8 (paper)
ISBN 0-8109-1442-5 (cloth)

Contents

Foreword

From the time Henri Matisse became the leader of the fauve movement in 1905, his expanding contributions to art have undergone continuous evaluation, and since midcentury there has been increasing sensitivity to his place in the history of western painting. The National Gallery's exhibition *Henri Matisse: The Early Years in Nice 1916–1930* is the latest chapter in the important and rewarding evolution of Matisse studies. We have a chance to see, here and for the first time, a coherent group of major paintings representing that period when Matisse gave up his primary artistic residence in Paris to settle in Nice. First as a temporary visitor and then as a permanent citizen, we watch him respond to the Mediterranean and the constancy of its light.

Matisse yielded also to the geographic and conceptual closeness to North Africa of his new home in Nice. There his interest in the exotic was combined with his deep-seated penchant for the intimate. One result was the compellingly powerful and well-known Odalisque series, a theme that his predecessors Ingres and Renoir had woven so tightly into French painting's fabric of images. At the same time Matisse was depicting the landscape around Nice, and these compositions, which have been too-long neglected, make a fascinating contrast to the more private and contained interiors with their dense patterns. Different though they are in subject, the canvases reveal Matisse's obsession with light and its ability to influence the composition of a painting.

Any large Matisse exhibition (this one has 171 paintings) is necessarily an international project. This show is no exception. Certain public collections are fortunate to be very rich in key Matisse pictures from this period. The directors and curators of these museums merit our most sincere gratitude, since without their loans our exhibition would have lacked the desired resonance. Our special thanks, therefore, go to Hubert Landais, directeur des Museés de France, and his colleagues, Dominique Bozo, conservateur-en-chef des Museés de France, and Michel Hoog, conservateur du Musée de l'Orangerie; Hans Christoph von Tavel, director of the Kunstmuseum Bern; Arnold Lehman, director of the Baltimore Museum of Art; Anne d'Harnoncourt, director of the Philadelphia Museum of Art; William S. Rubin, director of painting and sculpture, the Museum of Modern Art; Richard Madigan, director, Norton Gallery and School of Art, West Palm Beach; Budd Bishop, director, Columbus Museum of Art; Michael Kan, acting director, the Detroit Institute of Arts; and Evan Turner, director, Cleveland Museum of Art. Mr. and Mrs. Pierre Matisse provided essential support,

advice, and loans, and Claude Duthuit was invaluable in arranging certain loans and supplying crucial archival material. In addition, our deepest thanks go to all the private lenders to this exhibition. Because of their generosity, sixteen paintings are here shown publicly for the first time since they were created by the artist. A complete list of lenders is provided at the beginning of this catalogue.

The entire project has been realized by the National Gallery's curator of twentieth-century art, Jack Cowart, and by Dominique Fourcade, our guest co-curator for the show. Their enthusiasm, knowledge, and assiduousness have been extraordinary. Both were catalysts for our 1977 shared exhibition, *Henri Matisse: The Cut-Outs*, and it has been a pleasure to return with them to the inexhaustibly fascinating topic of Matisse's art. We are also grateful to E. A. Carmean, Jr., who, as curator of twentieth-century art here before moving to the directorship of the Fort Worth Art Museum, was involved with the exhibition at its earliest stage.

Just as the loans to this exhibition have come from both public and private sectors, so has the financial support that has made it possible. A United States government indemnity, granted through the Federal Council on the Arts and Humanities, has gone a long way toward making this exhibition a reality. In the realm of private funding the National Gallery has been privileged to work with the GTE Corporation for the fourth time. GTE's distinguished record as a patron of the arts is well known. Their support, coupled with the enthusiasm of GTE's chairman, Theodore F. Brophy, has made the preparation of this exhibition a particular joy.

J. Carter Brown
Director

Lenders to the Exhibition

Collection of the late Lucien Abrams

Mr. and Mrs. William R. Acquavella

Mr. and Mrs. James W. Alsdorf, Chicago

The Art Institute of Chicago

Martha Baer

The Baltimore Museum of Art

Annick and Pierre Berès, Paris

Mrs. Heinz Berggruen

Mr. and Mrs. Warren Brandt

Bridgestone Museum of Art, Tokyo

The Cleveland Museum of Art

Colin Collection

Henry Ford II

Collection S

Columbus Museum of Art, Ohio

Courtesy of Smith College Museum of Art, Northampton

Mrs. Joanne Toor Cummings

Courtesy of Davlyn Gallery

Lois and Georges de Menil, New York

The Denver Art Museum

The Detroit Institute of Arts

Alexina Duchamp

Everhart Museum

The Fine Arts Museums of San Francisco

Galerie Jan Krugier, Geneva

Glasgow Art Gallery and Museum

Stephen Hahn, New York

Courtesy of Stephen Hahn, Inc.

Dr. and Mrs. Paul Hahnloser

Mr. and Mrs. Nathan L. Halpern

Courtesy of Harmon Fine Arts, Inc.

Mr. and Mrs. Herbert J. Klapper, New York

Kunstmuseum Basel

Kunstmuseum Bern

Kunstmuseum Solothurn

Mr. and Mrs. Donald B. Marron

Mme Jean Matisse

M. Gérard Matisse

Mr. and Mrs. Peter D. Meltzer

The Metropolitan Museum of Art

The Minneapolis Institute of Arts

Moderna Museet, Stockholm

Montreal Museum of Fine Arts/Musée des Beaux-Arts de Montreal

Musée d'Art Moderne de la Ville de Paris

Musée de l'Orangerie, Paris

Musée des Beaux Arts de La Chaux-de-Fonds

Musée Matisse, Le Cateau-Cambrésis

Musée Matisse, Nice-Cimiez

Musée National d'Art Moderne/Centre Georges Pompidou

Musées Royaux des Beaux-Arts de Belgique, Brussels

Museu de Arte de São Paulo

Museum of Fine Arts, Boston

The Museum of Fine Arts, Houston

The Museum of Modern Art, New York

National Gallery of Art, Washington

Norton Gallery and School of Art, West Palm Beach

Ohara Museum of Art, Kurashiki, Japan

William S. Paley

Philadelphia Museum of Art

The Phillips Collection, Washington

Private Asset Management Group, Inc., New York

Fredrik Roos

The Mortimer D. Sackler Family Collection

Mr. and Mrs. Arnold Saltzman, New York City

San Diego Museum of Art

Scottish National Gallery of Modern Art

William Kelly Simpson

The Trustees of the Tate Gallery

Thyssen-Bornemisza Collection, Lugano

Mrs. Harold Uris

Mrs. W. Leicester Van Leer

Virginia Museum of Fine Arts

Wadsworth Atheneum, Hartford

Worcester Art Museum

Sam and Ayala Zacks Collection, Art Gallery of Ontario

Anonymous lenders

Acknowledgments

In a long, original, and widespread project like this, the organizers have asked many questions and hoped for many favors. During these last three years we have received remarkable generosity, offered on behalf of Henri Matisse as well as drawing upon personal friendships. Many have given selflessly of their energies and time, and this exhibition and publication could not have advanced without worldwide cooperation. It is with deepest appreciation that we acknowledge those who have been so helpful in our quest. We thank also the private lenders and professional staffs of each museum lending to this exhibition, without whom there could have been no *Henri Matisse: The Early Years in Nice 1916–1930.*

For substantial help in all areas of research documentation and loans

Mr. and Mrs. Pierre Matisse, New York
M. and Mme Claude Duthuit, Paris
Wanda de Guébriant, Archives Matisse, Paris
Dr. Margrit Hahnloser-Ingold, Fribourg
William Acquavella, New York
Eugene Thaw, New York
Giuseppe Eskenazi, London
Dominique Bozo, conservateur-en-chef, Musées de France, Paris
Isabelle Monod-Fontaine, conservateur-en-chef, Musée National d'Art Moderne, Paris
Dr. Hans Christoph von Tavel, director, Kunstmuseum Bern
Anne d'Harnoncourt, director, Philadelphia Museum of Art
James N. Wood, director, The Art Institute of Chicago
William Rubin, director of paintings and sculpture, The Museum of Modern Art, New York
Michel Hoog, conservateur-en-chef, Musée de l'Orangerie, Paris
Brenda Richardson, deputy director and chief curator, The Baltimore Museum of Art
Guy-Patrice Dauberville and Michel Dauberville, Galerie Bernheim-Jeune et Cie, Paris
Marie-Thérèse Pulvenis de Seligny, Villeneuve-Loubet

For assistance and research in Nice and its environs

M. Arderet, secrétaire, Club Nautique de Nice; Jean Arnaud, architecte, Nice; M. Bérard, Bérard Photographie, Saint-André-de-Nice; Mme George Besson, Paris; Madeline Cambuzat, conservateur directrice de la Bibliothèque Municipale, Nice; Maître Julien Carlo, notary, Nice; Mme Lydia Delecktorskaya, Paris; Mme de Galleani, archiviste, Archives Municipale, Nice; M. Deloze, Nice; Dr and Mme Patrick Desmoulin, Nice; Geneviève Etienne, conservateur adjoint, Archives Départementales des Alpes Maritimes, Nice; Emlen Etting and Gloria Braggiotti, Philadelphia; Mme Galy, Fontvielle; Mme Isabelle Gendre, Responsable du Centre Municipal de renovation de Vieux Nice; René Giraud, conservateur, Bibliothèque Municipale, Nice; M. Guillot, Bibliothèque Municipale, Nice; Mme Hernandez, Cagnes; M. and Mme Claude Houpert, Draguignan; M. Icard, président, Club Nautique de Nice; Mme Lisa Jaggli-Hahnloser, Winterthur; M. and Mme André Lafitte, Saint-Paul de Vence; Les Editions Giletta, Nice; Mme Masso, conservateur, Archives Municipales, Nice; Mme Melandri, Nice; M. and Mme Mongellaz, Nice; Gilbert Montessino, architecte, Nice; Michèle Rouland, Studios de la Victorine, Nice; Robert Sabatier-Vellerut, Nice; Mme Sauvaigo, conservateur, Musée Renoir; Ferdinand Veran, Nice; Mme Violette Veran, Nice

For assistance in locating paintings

Kenji Adachi, director, National Museum of Modern Art, Tokyo; Thomas Amann, Zurich; William Beadleston, New York; Heinz Berggruen, New York; Ernst Beyeler, Basel; Carlo Bilotti, New York; Susan Brody, New York; Princesse Jeanne-Marie de Broglie, Christie's, Paris; Harry Brooks, Wildenstein and Co., New York; Christopher Burge, Christie's, New York; Desmond Corcoran, Lefevre Gallery, London; François Daulte, Lausanne; David Ellis-Jones, Christie's, London; Michael Findlay, Christie's, New York; Mary Giffard, Marlborough Fine Art Ltd., London; Stephen Hahn, New York; Paul Haïm, Paris; Joan Q. Hazlitt, Pasadena; Morisada Hosokawa, Tokyo; James Jensen, curator, Honolulu Academy of Arts; Paul Kantor, Los Angeles; Antoinette Kraushaar, New York; Richard Larkin, Mystic, Connecticut; Steingrim Laursen, Louisiana Museum, Humlebaek, Denmark; Maître Guy Loudmer, Paris; James Mayor, London; Tokuzo Mizushima, Fujikawa Galleries, Inc., Tokyo; Charles Moffet, curator-in-charge, The Fine Arts Museums of San Francisco; David Nahmat, Davlyn Gallery, New York; David Nash, Sotheby's, New York; Lawrence Rubin, New York; Marc Scheps, director, The Tel Aviv Art Museum; Robert Schmit, Paris; Laura Sueoka, San Francisco; Nathan Smooke, Los Angeles; Alfred Stendahl, Hollywood; Toni Stooss, curator, Kunsthaus Zurich; Michel Strauss, Sotheby's, London; Martin Summers, Lefevre Gallery, London; John Tancock, Sotheby's, New York; Hideo Tomiyama, deputy director, National Museum of Modern Art, Tokyo; Daniel Varenne, Geneva; George Wachter, New York; Mr. and Mrs. John Warrington, Cincinnati

For assistance with research and archives

Michael Auping, chief curator, Albright-Knox Art Gallery, Buffalo; Sylvie Avizou, Sotheby's, Paris; Mme Monique Barbier-Müller, Geneva; Juliet Wilson Bareau, London; Mrs. Alfred Barr, New York; Marc Blondeau, Sotheby's, Paris; Catherine C. Bock, Chicago; Bernard Bohn, Detroit; Hélène Bokanowski, Paris; E. A. Carmean, Jr., Fort Worth; Esther M. Carpenter, photographic archives, The Museum of Modern Art, New York; Stephen C. Clark, Jr., New York; Susan Corn Conway, Washington; Judith Cousins, research curator, The Museum of Modern Art, New York; Joan Crowell, Quoque, Long Island, New York; Violette de Mazia, director of education and vice president, The Barnes Foundation; Marina Ducrey, Galerie Vallotton, Lausanne; Mr. and Mrs. Julian Eisenstein, Washington; John Elderfield, curator of drawings, The Museum of Modern Art, New York; Jack Flam, New York; Sidney Frick, president, The Barnes Foundation; Mrs. Robert O. Glasgow, Iowa City; John Golding, London; Dr. Lennart Gottlieb, curator, Aarhus Kunstmuseum; Sir Lawrence Gowing,

London; Philippe Grunchec, Paris; Douglas Hall, curator, Scottish National Gallery of Modern Art, Edinburgh; Mrs. Paul M. Hirschland, Great Neck, New York; John Klein, New York; Dr. Ubald Kottmann, Solothurn; M. and Mme Claude Laurens, Paris; Anne Lepage, Paris; Dr. Marjory Lewisohn, New York; Jean-Hubert Martin, Paris; Nicholas Martin, Washington; Mme Juliet Man Ray, Paris; Nathalie Menasseyre, bibliothécaire en chef, Musée National d'Art Moderne, Paris; Jean-Marie Menez, Paris; Olivia Motch, New York; John Hallmark Neff, Chicago; Michèle Paret, Fondation Wildenstein, Paris; Ronald Pickvance, London; Stephanie Rachum, curator, The Israel Museum, Jerusalem; John Rewald, New York; Sabine Rewald, The Metropolitan Museum of Art, New York; Antoinette Rezé, chef du services photographique, Musée National d'Art Moderne, Paris; Rona Roob, librarian, The Museum of Modern Art, New York; Antoine Salomon, Paris; Winifred Schiffman, Paris; Pierre Schneider, Paris; Joseph Simas, Paris; Sidney Simon, New York; Catherine Thieck, Paris; Lucien Trelliard, Paris; Christopher With, Washington

At the National Gallery of Art

Department of twentieth-century art, most especially Marla Price, assistant curator of twentieth-century art, and the research assistance of Barbara Meyer, Carma Fauntleroy, Laura Coyle, Sharon Wilinsky, Kathleen Howe, Elisabeth Fraser, Jonathan Bloom, with the support of Susan Pitler, Kate Allen, and Debra Easterly; department of installation and design, Gaillard F. Ravenel, Mark A. Leithauser, and Gordon Anson; editors office, Frances Smyth, Jane Sweeney, and Melanie B. Ness; office of the registrar; photographic services; library; photographic archives; and office of exhibition programs, D. Dodge Thompson, chief.

Finally, we are thankful for the patience and support of those close to us as what began a limited project became an all-consuming venture.

Jack Cowart
Dominique Fourcade

Fig. 1. Henri Matisse on fourth-floor balcony of his 1, place Charles-Félix studio, c. 1929

The Place of Silvered Light:
An Expanded, Illustrated Chronology of Matisse in the South of France, 1916–1932

Jack Cowart

Matisse's visits to Nice and the south of France and his artistic developments during the so-called *niçoise* period have been confused in sequence and consequence. The dates, sites, evolution of style, subjects, and motifs have been only superficially presented—almost every publication on the artist skips over this 1916–1932 era. Wedged between the heroic-abstracting commissions generated by the Russians before World War I and the great Barnes mural *La danse* of 1931–1933, this middle period has gained relatively little attention, exposure, or understanding since its fall from critical favor in the early 1950s.

This chronology is the first focused attempt to document the flow of places, events, and paintings of these years. It is necessary because at no previous time in his career would physical location or environment play so large and long a role in contributing to the appearance of the resulting art. During this period in Nice sets of particular and peculiar circumstances were influential for Matisse's art. The city: the hotel rooms, the studios, the apartments, everything that is the côte d'Azur conditioned Matisse's vision and personal spirit. To know more about these stimuli does not remove any of the mystery or power of his invention. Rather, it permits an approach to the work that is less factually erroneous.

Many of the artist's activities in the south can be reconstructed through archival sources in Nice and Paris and especially through the substantial visual information contained in his imagistic paintings. Even though he was not "copying" in the literal sense of the word, these works do preserve critical elements of particular settings and the time of their production. Other information about these years can be found in the archives of the Matisse family, Galerie Bernheim-Jeune, the Archives Municipales de Nice, and the Archives Départementales des Alpes-Maritimes, as well as private letters, photographs, and personal memoirs from a great variety of sources.[1]

It is impossible for any sensitive person to be in Nice, or elsewhere along this section of the French Mediterranean, and not be profoundly struck by the physical presence of the region. Nature is supremely evident in the clear zones of blue water, large sky, mountains, and sun. One cannot escape the dramatic arc of the baie des Anges, the broad spread of the city filled with palms, colorful flowers, red-tile-decorated buildings, and lively, expressive people. The steep hills and rugged, varied terrain are a prelude to the Alps and have inspired numerous authors and artists, major as well as minor. Affected by the light, scale,

and energies of this exotic region, Matisse's art appropriated topical details, colors, and a sense of period decoration that exude the delicate aroma of the Riviera during the 1920s.

Matisse was never a stay-at-home artist. He traveled constantly, searching experiences and following particular courses of study. As a Frenchman born in the north, near the border of Belgium, he enjoyed going to warmer, visually "hotter" places. In addition to his other trips throughout Europe, Matisse visited the south and Mediterranean areas more than a dozen times before 1916.[2] Thus his later stays in Marseilles and Nice fit within a personal and artistic pattern. Coming at a time when the artist was forty-eight years old, the first trip to Nice may have begun as a symbolic return to the adventures, challenges, and yearnings of his earlier years: those of the "hot" fauve period, for example, or the romantic allure of North Africa.

Between 1914 and 1918 France, and indeed most of the Continent, was immersed in the tragic battles of World War I. In 1915 the German line of trenches was along the Aisne River, about fifty miles from Paris; Matisse's boyhood home was in this territory occupied by the invading troops. It was also a time of ferment in the arts, with the nonobjective vanguard making its first manifestations and cubism continuing its historic evolution. Activities of futurists, orphists, the metaphysical artists, and the early dadaists were being seen. Matisse was acutely aware of these events in art, literature, music, fashion, and theater, yet he needed to find his own space, to produce new work that met his agenda, not someone else's.

By 1915 Matisse was famous in artistic circles. He had material comfort, exhibitions, steady sales, a family, and a long list of influential friends. It is noteworthy, therefore, that he would strike out on an uncharted path, living in cramped, inexpensive, and impersonal hotels in Nice, a city where he was a literal stranger, an outsider. We know that this break —and Matisse's great, mature artistic transition—began in Paris and Issy-les-Moulineaux; but history proves that it would blossom in the south.

Chronology

1915–1916

Matisse and his friend and companion, the artist Albert Marquet, visited Marseilles in December 1915[3] and worked from views in the old port and the neighboring coastal fishing village of L'Estaque.[4] Several small paintings of fishing boats or French navy sailing ships anchored in the port, as well as a drawing from L'Estaque, which he ostensibly wanted to go back to finish later, may date from this first visit to Marseilles.[5]

Matisse's home, immediately outside of Paris, was at 92, route de Clamart, Issy-les-Moulineaux. His wife of eighteen years, Amélie Matisse, and his family were in residence there and the artist could work in his tranquil garden and large, airy studio. In Paris he had kept his studio at 19, quai Saint-Michel, which had views of Nôtre Dame and the Seine.

He may well have returned to Marseilles in the summer of 1916,[6] but while Diehl proposes that the artist made a rapid trip to Nice at this time,[7] there is neither artistic nor documentary proof for this. Rather, the rest of the summer and fall were spent in his Issy and Paris studios. There he began a fateful series of paintings portraying the model as odalisque, as a draped seated figure with interior still-life elements and a view out the window to a landscape beyond, or as a single figure in close-up, intensely psychological portraits (see pls. 4 and 12).

For the first time Matisse pursued an intensive study of the particular features of a hired model, Lorette.[8] The results offer striking references, not only to this significantly new model, but also to the art of Gustave Courbet. For example, several of the Courbets owned by Matisse, as well as the *Spanish Woman* (1855, Johnson Collection, Philadelphia

Fig. 2. *The Music Lesson*, 1916/1917 (Jean, Amélie, Marguerite, and Pierre Matisse; Issy-les-Moulineaux), oil on canvas, 245 x 209.5 (96½ x 82½). The Barnes Foundation, Merion, Pennsylvania

Fig. 3. *Three Sisters Triptych*, 1916/1917 (Lorette, one of her sisters, and another model; Issy-les-Moulineaux), (left to right) *Three Sisters with Negro Sculpture, Three Sisters with Grey Background, Three Sisters and "The Rose Marble Table,"* oil on canvas, each panel 195 x 97 (76¾ x 38³⁄₁₆). The Barnes Foundation, Merion, Pennsylvania

Museum of Art), show a dark-skinned, dramatic female with flowing, tentaclelike, long black hair, and seem very much the prototype for Matisse's Lorette. Challenged by the potential of visual research of the model, Matisse composed paintings using not only Lorette, but also her sister and a woman named Aïcha.[9] By the end of 1917 this obsessive suite of Lorette-related paintings would number at least forty.

Lorette, a dark-haired, southern-European-looking model, posed for Matisse early in 1916, figuring in *The Italian Woman* (1916, The Museum of Modern Art), a monumental work in which the artist treated the portrait subject in his then-current Cézannesque, cubistic style. He soon shifted dramatically from the reductivist scheme of this painting and the equally abstracting *The Piano Lesson* (1916, The Museum of Modern Art) to a more ornate representational style. The Barnes Foundation *The Music Lesson* (fig. 2) and the great *Three Sisters Triptych* (fig. 3) of 1917 would be the result.[10] Lorette is the model who is present through this major shift, figuring in both cubistic paintings and these subsequent Courbet-related precursors of Matisse's first *niçoise*-period style.

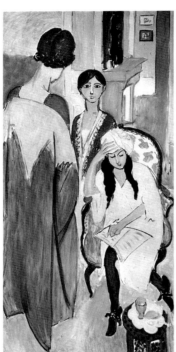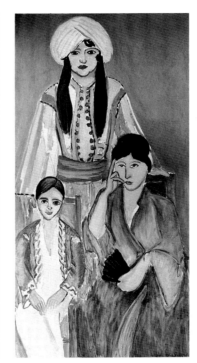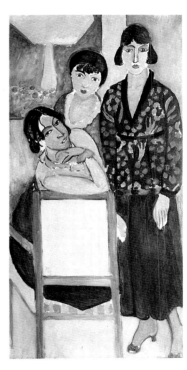

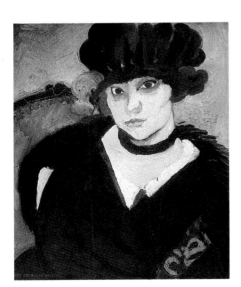

Fig. 4. *Marguerite, la toque de velours bleu*, 1915/1916, oil on canvas, 46 x 38 (18⅛ x 15). Present location unknown

Of all subjects, it was Marguerite Matisse (1894–1983), the artist's daughter, who would be the model of longest duration and most persuasive vitality. Matisse's portraits of her represent an astonishing chronicle, not only of the artist's creative invention and stylistic development, but also of Marguerite's evolution to an adult psychology. In every major period in the artist's work from 1897 to 1923 her portrayals are found. Nicknamed Margot, she grows up before our eyes in numerous paintings, drawings, and graphic works.[11] In *The Breton Serving Girl* of 1897 the two-year-old Marguerite is obliquely portrayed,[12] but by his fauve period we see her clearly, in a formal portrait. Then in the teens there is a particularly strong series, including the haunting *Marguerite, la toque de velours bleu* (fig. 4) and the large group of paintings in this current exhibition. Until she married Georges Duthuit in 1923 and spent most of her time in Paris, Marguerite was often the other figure in Matisse's 1921–1923 groupings, posing with the hired model Henriette Darricarrère.

Matisse was in Paris for the 31 December banquet at the Palais d'Orléans on avenue de Maine in honor of Guillaume Apollinaire and the publication of his book of various stories and prose works, *Le poète assassiné.*[13]

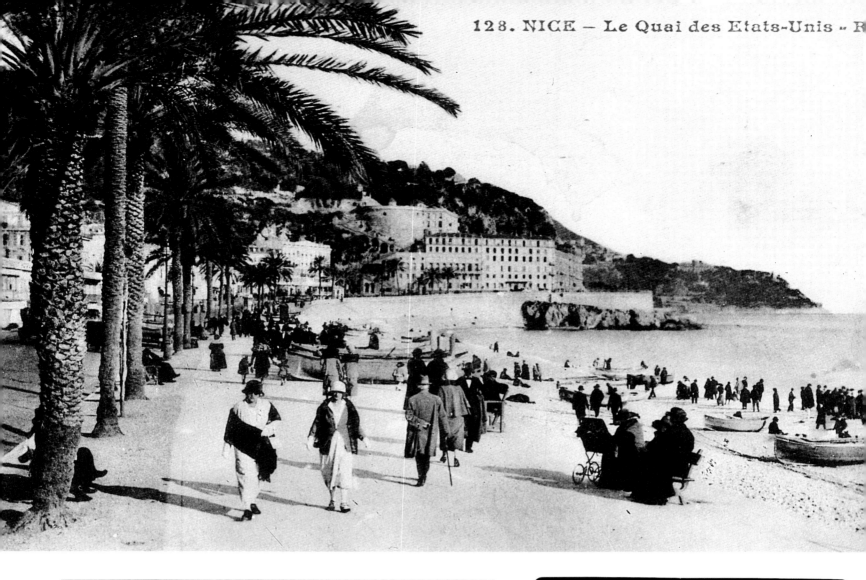

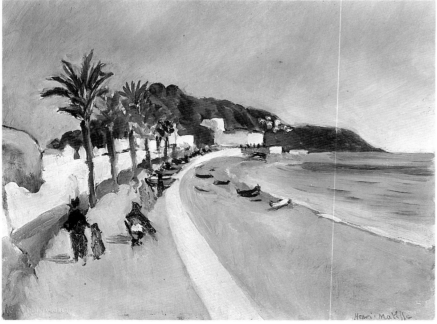

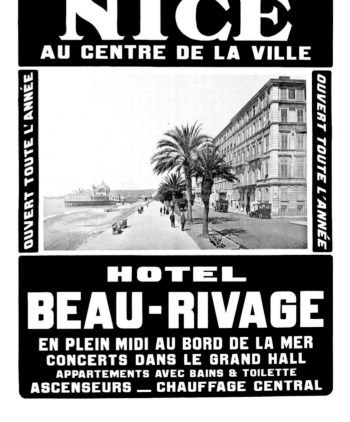

Fig. 5. (top) Postcard view, Nice, quai des
Etats-Unis, c. 1927

Fig. 6. (bottom left) *Côte d'Azur, Nice (?)*,
c. 1919, oil on canvas. Present location
unknown

Fig. 7. (bottom right) Poster showing Hôtel
Beau-Rivage, with the Jetée Promenade and
Casino, early 1900s

18

1917

Matisse and Monet were in communication from 1914 onward, especially between November 1916 and May 1917. Letters from Monet to the Bernheim-Jeune brothers mention the planning in response to Matisse's wish to visit Monet. It seems clear that the May 1917 rendezvous, which also included Albert Marquet, did take place.[14]

Leaving Issy in June or July, Matisse visited Chenonceaux with Marquet and another artist, Jacqueline Marval.[15] He returned to Marseilles with Marquet in December, staying at the Hôtel Beauvau.[16]

Matisse arrived by 20 December in Nice, and checked into the Hôtel Beau-Rivage, 107, quai des Etats-Unis.[17]

The Hôtel Beau-Rivage stands facing the Bay of Nice near the Opéra, the cours Saleya flower and vegetable markets, and close to the Vieille Ville, the oldest part of the city, which dates from the sixteenth and seventeenth centuries and has narrow, twisting streets and an everyday presence of traditional life.[18] There is an unobstructed view to the Mediterranean, the beach, and of the full trajectory of the sun. Several blocks to the west is the jardin Albert-1er. These formal gardens and the adjoining, so-called Jetée Promenade (a pier that contained restaurants and a casino, in an "oriental-style"), were a rendezvous for tourists and residents alike.[19] The headquarters of the Club Nautique de Nice was at 91, quai des Etats-Unis during this period.[20] Several of their boats were drawn up on the beach. Matisse later joined this club and was an active participant, owning two small boats.[21]

The average room at the front of the Hôtel Beau-Rivage was a curious affair. It was unusually long and narrow, dominated by a single large window overlooking the sea. The decor of the room was dreary, yet through the window a copious amount of direct sunlight could stream; at times it overwhelmed the single bed, the armoire, and the squat hotel chair, and bounced off the walls, the ceiling, and the mirror. We know of six scenes Matisse painted in this room: two from a bird's eye-view (Philadelphia and Zurich, pls. 47 and 48), a third (Rump Collection, Copenhagen, pl. 50), and two small but vibrant close-ups of the solitary window (pl. 49). Loneliness and a remote sadness is particularly evident in the sixth, the artist's self-portrait (pl. 46).

Matisse recounted:

> I left L'Estaque because of the wind, and I had caught bronchitis there. I came to Nice to cure it, and it rained for a month. Finally I decided to leave. The next day the mistral chased the clouds away and it was beautiful. I decided not to leave Nice, and have stayed there practically the rest of my life.[22]

Matisse wrote his wife (31 December 1917) that indeed it had been raining but had just cleared, and he hastened to make what is now his first Nice window painting. It was a "size 15" (66 x 55 cm) and he illustrated his letter with a sketch showing a composition similar to that of the work in the Philadelphia Museum of Art's Gallatin Collection (pl. 47).[23] The Zurich (pl. 48) and Copenhagen (pl. 50) paintings also contain new dynamism and the impact of the sun, sky, and sea.

> Most people came here for the light and the picturesque quality. As for me, I come from the north. What made me stay are the great colored reflections of January, the luminosity of day-light.[24]

Matisse visited Auguste Renoir in Cagnes on 31 December 1917. Matisse said of Renoir:

> His life was a long martyrdom: he suffered for twenty years from the worst form of rheumatism, the joints of his fingers were all immense, calloused, horribly distorted. . . . [And he still did] all his best work! . . . as his body dwindled, the soul in him seemed to grow stronger continually and to express itself with more radiant ease.[25]

Fig. 8. Henri Matisse, Hôtel Beau-Rivage, with early state of *Autoportrait*, 1918

1918

Matisse returned to Renoir's in early 1918 to solicit a response about his new Nice work. Matisse said:

> As I admired him greatly, I would go and see him in his house at Cagnes, Les Collettes. He received me cordially and I showed him several of my paintings, in order to find out his opinion. He looked at them in a rather disapproving manner. Then he said: "In all truthfulness, I don't like what you do. I'd almost like to say that you are not a good painter, or even that you are a very bad painter. But one thing prevents me from doing this: when you put black on the canvas it stays in its plane. All my life, I thought that one couldn't use it without breaking the chromatic unity of the surface. It is a tint that I have banished from my palette. As for you, using a colored vocabulary, you introduce black and it holds. So, in spite of my feeling, I think that you are most surely a painter."[26]

Matisse told the related story of Renoir's response to Matisse's painting of his hotel room, presumably the work now in Philadelphia: "How you have managed to express the atmosphere of a hotel room in Nice! But that blue of the sea should come to the front. . . . And that black line from which the white curtains fall. It's in its place. Everything is very accurate. It was difficult. . . . It makes me mad. . . ."[27]

While Pierre Schneider suggests that Renoir may have represented Matisse's last connection to Courbet and his generation,[28] it is certain that Matisse was interested in Renoir himself. He, as another of the French elder artists, impressed Matisse by his continued curiosity, even in old age.[29] Matisse acquired his works, as he did also those of Courbet, Degas, and Cézanne.[30]

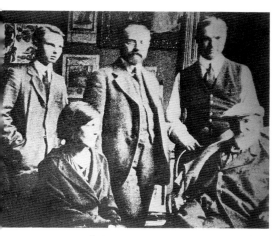

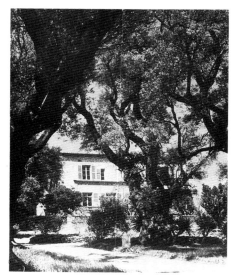

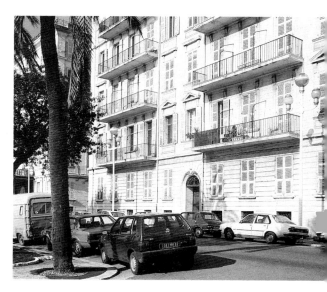

Fig. 9. (left) Henri Matisse, center, standing between Claude and Jean Renoir, with Auguste Renoir and Greta Prozor seated, c. 1919?

Fig. 10. (middle) Olive trees, Renoir's gardens, Villa Cannet, Cagnes

Fig. 11. (right) 105, quai des Etats-Unis

By February or March,[31] Matisse rented an empty apartment at 105, quai des Etats-Unis, next door to the Hôtel Beau-Rivage. The Paul Schmitz family owned 109, 107, and 103 on the quai at this time, and would eventually own no. 105. It is plausible that Matisse gained information from the hotel staff and the proprietors about available space nearby.

Matisse wrote to Camoin on 18 April 1918 from 105, quai du Midi:
As for me, I am held here by the landscapes at the pass of Villefranche, above the station at Riquier near the tunnel, and I don't intend to return until I have gotten something good out of it, I hope. . . . In the meantime, it has been raining for eight days and the sea is raging. Now, the trees are full of flowers, and they won't wait to fall until I can work on them after the rain. A burst of sunlight will knock them down. In

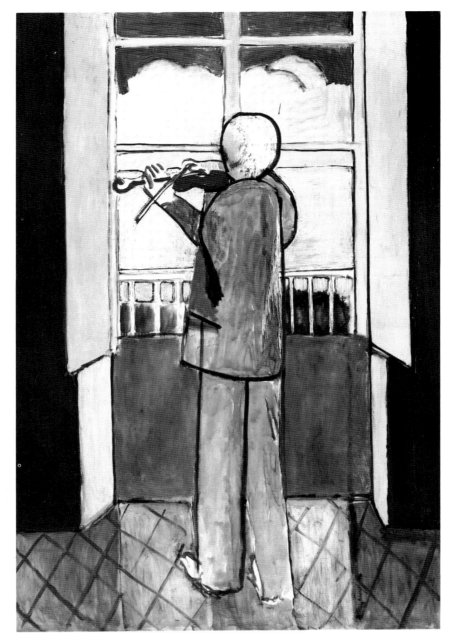

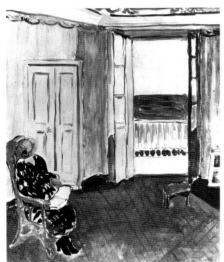

Fig. 12. (left) *Intérieur, femme lisant, manteau écossais*, 1918 (105, quai des Etats-Unis), oil on canvas. Present location unknown

Fig. 13. (right) *Le violiniste à la fenêtre*, 1918 (105, quai des Etats-Unis), oil on canvas, 149 x 97.5 (58⅝ x 38¾). Musée National d'Art Moderne, Paris

the meantime, I am painting flowers in my studio, an apartment that I have rented for three months, quai du Midi. I am also working at the Ecole des Arts Décoratifs led by Audra, formerly at Moreau's. I draw *The Night* and I model it ... I study with the Lorenzo de Medici by Michelangelo: I hope to instill in myself the clear and complex conception of Michelangelo's construction.[32]

It is not known which seafront apartment of this four-story building was taken, but the perspective seems proper from the second floor, right[33] when compared to *La baie de Nice* (pl. 55). *Intérieur, femme lisant, manteau écossais* (fig. 12) records details of this space, with its decorated ceiling, swag stucco or plaster crown molding, striped wallpaper, and diagonally laid red-tile floor. The rooms in no. 105 are ample and light-filled. At least nine paintings from this interim studio or from its balcony are known.

Pierre Matisse, who like his father played the violin, served as the model for *Le violoniste à la fenêtre* (fig. 13), a combination portrait and crypto self-portrait. During the Easter season the artist painted at least five portraits of his daughter, Marguerite, posed on the narrow balcony, several in the distinctive Bongard-designed black and white Scotch plaid coat (pls. 52 and 53).[34]

21

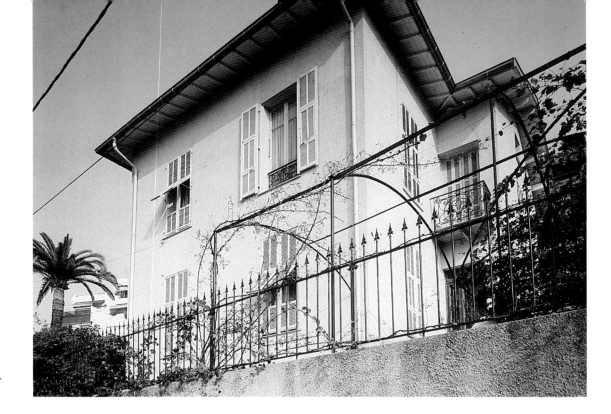

Fig. 14. Villa des Alliés, Nice (138, boulevard du Mont Boron)

Fig. 15. (left) *Villa bleue,* c. 1918/1919 (Nice), oil on board, 33 x 41 (13 x 16⅛). The Barnes Foundation, Merion, Pennsylvania

Fig. 16. (right) *Plage à Nice, vue du Château,* 1917/1918, oil on board, 33 x 41 (13 x 16⅛). Present location unknown

The Hôtel Beau-Rivage having been requisitioned for the housing of soldiers, Matisse and his son moved, c. 9 May 1918, to the Villa des Alliés, on an impasse called petite avenue du Mont Boron, near 136, boulevard du Mont Boron.[35] It is now numbered 138 (fig. 14). This small house is located on the hills rising steeply above and behind the port of Nice and the train station at Riquier. In 1918 the location was remote from the life of the city and direct views of the sea, but Matisse had convenient access to several sites on Mont Boron and its sister hill, Mont Alban. Of particular interest to him was a house called "la villa bleue," a large building that acquired this sobriquet from its blue-tiled roof, visible throughout the Paillon Valley (fig. 15).[36] Additional landscapes were painted among the eucalyptus groves or in the garden of the Château, the central hill overlooking the port and beaches of Nice (fig. 16).

Matisse wrote a letter to Camoin on 23 May 1918 from Villa des Alliés, petite avenue du Mont Boron:

I have worked all this time in full sunlight from ten o'clock to noon and I subsequently found myself exhausted for the rest of the day. I am going to change my hours. Tomorrow I'll start at six-thirty or seven—I think I can have one or maybe two hours of work. The olive trees are so beautiful at this hour. High noon is superb but frightening. I find that Cézanne conveyed it well in its relationships, fortunately not in its brilliance, which is unbearable. A little while ago, I took my nap underneath an olive tree and what I saw was of a color and a softness of relationships that was truly moving. It seems as though it is a paradise that one does not have the right to analyze, however one is a painter, God damn it. Ah! Nice is a beautiful place! What a gentle and soft light in spite of its brightness! I don't know why I often compare it to that of the Touraine. Touraine light is a little more golden. Here it is silvered. Even the objects that it touches are very colored, such as the greens for example. I have often fallen on my face. After having written this declaration, I am looking around the room where some of my daubs are hanging, and I think I've hit it sometimes—but it isn't certain.[37]

and:

What I see everyday, the sun rising, at five o'clock coloring Nice and its mountains (inversely). I am high above Nice, I am at the pass of Villefranche, the sun is rising behind me. I can see the mountains towards Cagnes becoming colored first, then the castle of Nice and finally the city, every day at five o'clock (you can see that I am serious).[38]

Matisse returned to Issy-les-Moulineaux in mid-June or July, pausing for a short visit to Maintenon, south of Paris.[39] After a late-summer trip north to Cherbourg and a presumed return stop in Issy, the artist went south in November, visiting with Bonnard in Antibes at the time of the armistice.[40] Installing himself in Nice, he took his first room at the Hôtel Méditerranée et de la Côte d'Azur, at 25, promenade des Anglais.[41] Thus Matisse began his pattern of work after summer travels, which he would continue at this hotel for the next three years.

The Hôtel Méditerranée et de la Côte d'Azur was a significant improvement upon the modest Hôtel Beau-Rivage, but it was clearly not one of the opulent Victorian fantasies that had sprung up in Nice during the city's heyday as an English resort. There were no grand restaurants, ballrooms, or winter gardens at the Méditerranée. Rather, the hotel sat

Fig. 17. (left) Map of Nice, promenade des Anglais, quai des Etats-Unis, and principal hotels, c. 1925

Fig. 18. (right) Postcard, Hôtel Méditerranée et de la Côte d'Azur, early 1900s

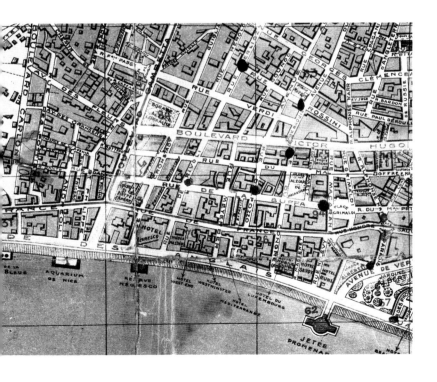

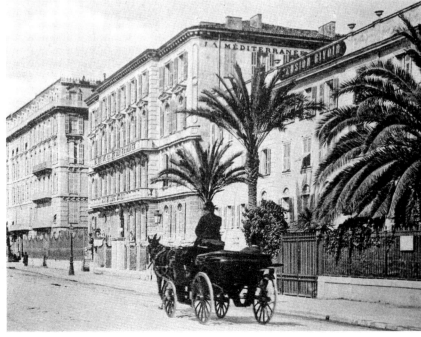

Fig. 19. *The French Window at Nice*, 1919/1920 (model: Antoinette; Hôtel Méditerranée et de la Côte d'Azur), oil on canvas, 130.2 x 88.9 (51¼ x 35). The Barnes Foundation, Merion, Pennsylvania

unobtrusively, as a small neighbor to the larger Hotel Westminster and the Hotel Royal on the promenade, several blocks to the west of the Jetée Promenade. Yet, this hotel would become for Matisse a most fertile, expansive environment. From the room, with its large windows looking out over the baie des Anges, he recorded the full sweep of the sun. The rooms were decorated in nineteenth-century Italianate styles. Matisse would artistically enlarge this hotel, its presence, its rooms, and the views well beyond their literal dimensions; he would push his art and the rhythms of its surfaces to record his new levels of excited observation. He would say later: "An old and good hotel, of course! And what pretty Italian-style ceilings! What tiling! It was wrong to demolish the building. I stayed there four years [*sic*] for the pleasure of painting nudes and figures in an old rococo sitting room. Do you remember the light we had through the shutters? It came from below as if from theater footlights. Everything was fake, absurd, amazing, delicious."[42]

Matisse stayed three winter/spring seasons at the Méditerranée, and after that took special rooms there as his vantage point for the Batailles de Fleurs parade of 1922, and probably 1923 as well.

His first room had shuttered, double French doors opening out onto a balcony with a carved or cast balustrade. Such rooms existed on the first and second floors, center, of the hotel. Ornate floral wallpaper, ceiling moldings, tiled floor, a decorative glass lunette surmounting the balcony doors, and large, slightly transparent curtains completed the decor (pl. 71). Models were chosen to pose on the balcony, holding brightly colored red, green, or orange umbrellas. These parasols not only shaded them from the sun but also provided a soft irradiation of colored light that Matisse would capture on canvas. The tall shutters provided another Mediterranean element, and their patterns would be exploited in numerous subsequent works.

Found in this room was a small, ordinary table for writing or makeup. The table, with its oval mirror and embroidered skirt, became an important compositional element for Matisse, and he began a faithful, almost poetic relationship with it. Portraying the glass often mysteriously black, sometimes crosshatched, or sometimes fully reflecting, the oval mirror opening the painting to the exterior[43] was contrasted to the black rectangle of a blotter or drawing portfolio, which reestablished a certain internal plane. This table became the room's inhabitant, with or without the model, artist, or family member. In a manner consistent with his lifelong furnishing of paintings with personal decorative articles, Matisse seized this mirror and table and included it in his repertory of forms from 1918 until he left the Hôtel Méditerranée et de la Côte d'Azur at the end of the spring in 1921.

1918–1919

The eighteen-year-old model Antoinette Arnoux[44] entered his work during winter 1918–1919, posing for the striking series of paintings and drawings dealing with the plumed hat motif.[45] Matisse fabricated this curious bit of millinery himself. "I worked a lot with the hat which I made myself out of an ostrich feather, Italian straw and a stream of black and blue ribbon which the milliners call Comet. This hat was made in order to be able to put it on two ways, backward and forward. The result is my painting with a red background which is part of the S. C. Clark collection."[46]

The works from his four-painting suite range from thinly brushed and intimate studies to the harder-edged, severely stylized canvas described above by the artist and now in the Minneapolis Institute of Arts (pl. 91). In this work Antoinette is not the soft, vulnerable young woman portrayed in the others (notably pls. 90, 92, 93, and fig. 20); she is metamorphosed into a sophisticated creature, whose Nefertiti-like eyes and thick hair hark back to Matisse's fascination with the physiognomy of Lorette.

A study piece (fig. 21) documents the setting of this first Hôtel Méditerranée room and Antoinette, with the versatile hat upon a bentwood chair.

Fig. 20. *Femme en blanche*, 1919 (model: Antoinette; Hôtel Méditerranée et de la Côte d'Azur), oil on canvas, 74 x 60.6 (29⅛ x 23⅞). Stolen, present location unknown

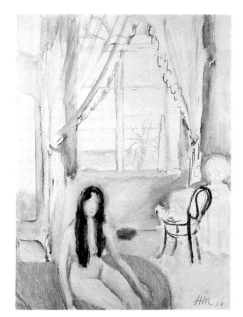

Fig. 21. *Antoinette, intérieur,* 1919/1920 (Hôtel Méditerranée et de la Côte d'Azur), oil on canvas. Present location unknown

Many of Matisse's earlier paintings depended on family members for subjects; but with hired models—the earlier Lorette and, now, Antoinette, complicated plays of imagery, subtle eroticism, and autobiographical content increased. For example, *La séance de peinture* (pl. 77) is a marvelous combination of the oval mirror (acting as a porthole through which we see the ocean, palm tree, and sky) with a still-life arrangement of flowers, vase, lemons, and painting implements. On one side of the canvas Matisse is shown painting and on the other the passive model Antoinette reads, against a mysteriously odd black ground. The static scene embodies a contemplative microcosm, replaying Matisse's experience of Nice at this time. Seemingly simple at first, this masterpiece of the early *niçoise* period is dramatic and tense, and not so simple after all.

1919

Leaving Nice in the late spring,[47] Matisse returned to Issy, spending the summer there[48] painting several large-scale still lifes and a dramatic group portrait of family members in his garden (pls. 31 and 32).[49] In other works Matisse expanded his use of ornamental backgrounds, devoting more of the composition to the decorative and planar play of patterns. He used his personal collection of wall hangings, folding screens, costumes, and carpets as found in *Les pavots—Feu d'artifice* and *La chaise aux pêches* (pls. 20 and 25). Antoinette also posed in the Issy landscapes and interiors, dressed in costumes vaguely reminiscent of the Middle East or North Africa (pls. 27 and 28).

In September or October Matisse went to London to work with the Ballets Russes de Monte Carlo on costumes and sets commissioned by Diaghilev for the Stravinsky and Massine production of *Le chant du rossignol.*[50]

The artist returned to Nice later in the fall, taking his second room at the Hôtel Méditerranée et de la Côte d'Azur. This room, on the front facing the sea, had no balcony. The windows, with decorative iron grilles, did not extend to the floor, though they had long draperies and short decorated sheer curtains.[51]

Deprived of the patterns offered by a balcony balustrade and its full view to the beach and sea, Matisse focused on the strong play of the window shutters. He accentuated the louvers and the movable sections, allowing vibrant slices of blue water and sky, the promenade, and foliage to enter (pl. 86). There was no geometrical tile floor but, rather, a floral rug that was portrayed differently from painting to painting. It is sometimes small-patterned and mute; in other works it assumes a larger decorative play ("growing" as the hanging textile does in *Figure décorative sur fond ornemental*, pl. 168). The artist hired a model, perhaps one of Antoinette's sisters, and posed this woman in various ways: with her hair held by a tall Spanish comb, wearing tasseled shawls, an ample striped robe (fig. 22), in a ruffled blouse, or nude, draped simply with a celery-colored cloth. These works mark Matisse's growing commitment to the theme of the model posed against a room interior or window-landscape view.

1920

Matisse left Nice for London in January 1920, again for work on *Le chant du rossignol* for the Ballets Russes de Monte Carlo.[52]

On his return the artist had a room without balcony, but the windows there may have had decorative grilles. He continued the series of models posed in armchairs against the windows and room furniture, setting soft forms against hard rectilinear ones (pl. 86) much in the same vein as the ballet decor and costumes, which themselves mixed floral chinoiserie and brusque geometric abstractions.[53]

By Bastille Day (14 July) Matisse and his daughter Marguerite were in Etretat on the Channel coast. Their hotel fronted on the beach, offering the opportunity for a portrait of

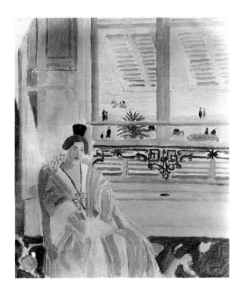

Fig. 22. *Femme assise, peigne espagnole, robe rayée,* 1919/1920 (Hôtel Méditerranée et de la Côte d'Azur), oil on canvas. Present location unknown

his room, the flags, and the boats drawn up on the sand, in a *niçoise* mode. The archetype for such work is his fauve-period *Fenêtre ouverte à Collioure* (1905, John Hay Whitney Collection, New York), but Matisse's Etretat visit also produced three grand cliff/beach paintings. One is tempted to say that they form a set, much as his Tangiers, Villa Bronx paintings of 1912 constitute a moment of creative tripling.[54] Before the porous clay cliffs of Etretat and its rock formations (so popular with the impressionists), Matisse established landscape settings for still lifes of an eel, two rays, and fish on beds of wet kelp. These were not portrayed as dead[55] but rather as glistening, squirming things, active in contrast to the more static geography; the movement of a sailboat is indicated in each of the three works, the boat itself diminishing as the compositional presence of the Falaise and the Porte d'Aval also diminish.[56] One can safely assume that Matisse spent the rest of the summer in Etretat, not only by the large number of works datable to this period, but also from a letter Matisse mailed from Etretat to Camoin, dated 18 September.[57]

The artist returned to Nice by the end of September,[58] again taking up residence at the Hôtel Méditerranée et de la Côte d'Azur. This room had a front terrace on the bay, with full French doors, decorative wallpaper, an oval-mirrored table, and other miscellaneous furniture. Matisse now began to personalize his decor, installing some of his own small paintings and perhaps a few of his decorative hangings, as well as a striped cloth which he placed over tables. As moving eyewitness testimony we have the words of Charles Vildrac in 1920–1921:

> I went to see Matisse once in that room in Nice which looks out on the promenade and on the sea and which he has left since. I knew most of the paintings that he painted there these last years. Therefore I found the high window and its curtains, the red rug and its decoration, the "toad" armchair in which Matisse often placed the nude model, or which he put, empty, close to the window, adorning this affable and plump chair with a lace antimacassar. I recognized the decorated porcelain vase and the lacquered dressing table with the oval mirror. Without a doubt, I found myself in the room "of the Matisse paintings". . . .
>
> First of all, this room wasn't as big as I had thought: I had gotten the impression from certain canvases that one could walk in it freely, with great strides, dance in it with ease; actually, it was all lengthwise, quite cluttered and the window took up the better part of its width. Besides, I had to realize that the painter had given it a fresh and entirely submissive soul, like flowers are to the variations of the sky, a soul which in reality it did not have: it was certainly a pleasant hotel room, but with the soul of a hotel room.
>
> Finally, and this really struck me, these objects that I was discovering one by one were singularly eclipsed by the pictorial memory that I had of them: it seemed to me that they had abdicated a magnificent personality. They weren't any longer these "solid appearances" of which Elie Faure speaks, "rising from the silence in the ardent solitude of their own reality."
>
> Didn't Matisse paint this window, these curtains saturated with light, this red rug, this furniture, the same day as when some magician had created this room with the stroke of a wand, while each object, occupying the only place that suited its shape, its volume, its color, had just ingeniously and for the first time, offered up its grace to the light?
>
> You understand, of course, that the magician had been Matisse himself, and that I was in a position to admire a little more still the creative power of the painter by looking at his motifs with my eyes of a nonpainter.[59]

Of the greatest consequence was the arrival of Henriette Darricarrère (fig. 23). She would serve as Matisse's primary model for the next seven years and, in effect, incarnate the artistic and psychological atmosphere of these *niçoises* years, 1920 to 1927.

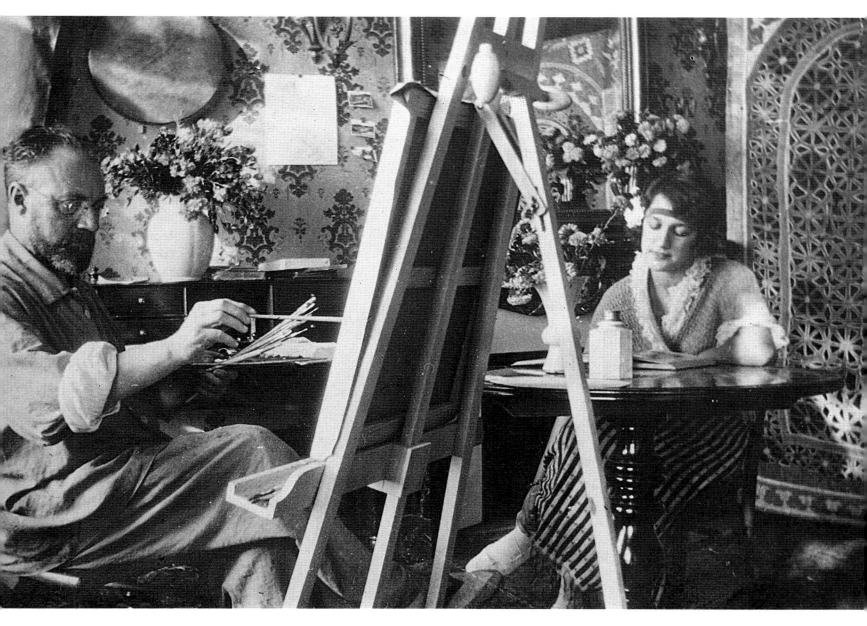

Fig. 23. Henri Matisse with model Henriette Darricarrère, in the pose of the Kunstmuseum Bern *Liseuse au guéridon*, 1921 (pl. 118). Photograph by Man Ray

Henriette was born in 1901 in Dunkirk. Her family moved to Nice, renting an apartment near place Charles-Félix. Older than her two brothers, she was, nonetheless, still a young woman when Matisse first saw her at the Studios de la Victorine performing as a ballerina before the camera. The artist arranged for her to begin modeling shortly thereafter; her family recounts that he encouraged her to continue her lessons in piano, violin, and ballet, also allowing her time to paint and attend musical and other social events in Nice.

During her seven years of modeling, Henriette excelled at role-playing and had a theatrical presence that fueled the evolution of Matisse's art. Earlier, Lorette and Antoinette had initiated the exotic odalisque fantasy, but it was Henriette whose personality seems to have been the most receptive. She adopted the subject roles more easily and could express the moods and the atmosphere of Matisse's settings without losing her own presence or her strong appearance. Her distinctive physical features—a sculpturesque body and a finely detailed face with a beautiful profile—are evident in many of the artist's paintings, sculptures, and works on paper.

Eventually Henriette would marry and leave, but her modeling established a remarkable impression on Matisse's art and on her own personal life. Henriette Darricarrère Plent still lives in the south of France.[60]

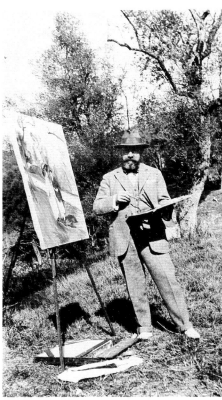

1921

From the room terraces of the Hôtel Méditerranée et de la Côte d'Azur, Matisse realized his next important series of paintings, five so-called *Fête des Fleurs* works: three from 1921, one from 1922, and the last probably from 1923. All represent the "Batailles de Fleurs," the competitive parade of flower-decorated floats and marching bands on the promenade des Anglais to the Jetée Promenade during the carnival celebrations near Mardi Gras. This procession, a kind of mini-Rose Bowl parade, was one of the great animations of Nice, marking the promise of a change in season from winter to spring. The floats were decked with those ubiquitous Provençal carnations, roses, and just-budding mimosas, making combinations of pink, red, white, and yellow against green leaves. The poles lining the promenade des Anglais were hung with blue, white, and red tricolors, and the inhabitants celebrated actively before the nominally penitential season of Lent. Matisse depicted Marguerite and Henriette on the balcony, creating an even more elevated perspective of them and the parade. These festival paintings are the grand *niçoise* counterpart to the Etretat cliff paintings; they make this 1920–1923 period one of heroic landscape work.

In the spring Matisse, Henriette, and eventually Marguerite went on painting picnics to the valley of the Loup, the river flowing into the Mediterranean at Villeneuve-Loubet, ten miles west of Nice. There were an auberge and a mill near the river's mouth, where jazz concerts, dances, and other festivities were held.[61] As one traces the river northward the terrain varies. The sparse coastal pines are replaced by stands of lush deciduous trees. The ever-steepening banks finally narrow into a true gorge, with great promontories flanking a village called Pont du Loup. Matisse's day trips were to sites along this river, and its various floodplains and hillsides, the artist traveling throughout the region in his automobile. He continued out-of-doors, painting Henriette alone or paired with Marguerite on the steep hill of La Mantega, just north of the Nice central station. He also posed his model in the gardens in Parc Liserb in Cimiez, as well as on the overlooks of the Château above the old port.

His second and last summer visit to Etretat, in 1921, resulted in Manet-like, dark-manner still lifes of exceptional quality and intensity; the previous summer's work has also been related to Chardin and Courbet.[62] The work of both summers, and the evolution of

Fig. 24. (left) Henri Matisse, near the Loup River, 1920s

Fig. 25. (right) Henri Matisse with his *Conversation sous les oliviers*, 1921 (pl. 129), in either Parc Liserb or on La Mantéga, Nice

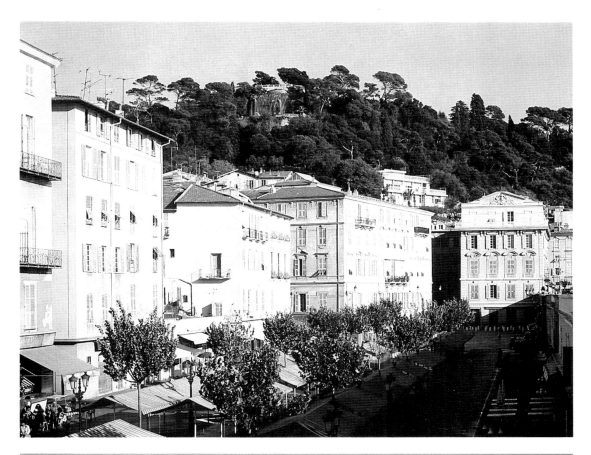

Fig. 26. Place Charles-Félix from Cours Saleya

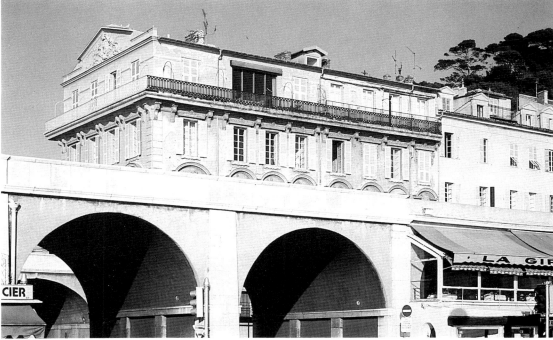

Fig. 27. No. 1, place Charles-Félix, south facade seen from the quai des Etats-Unis

Nice material, take part in the general 1920s art trend toward a new classicism. It existed not only for Matisse but also for others in the school of Paris.[63]

The return to Nice was probably in September and marked the next important phase. Matisse did not take a room at the Hôtel Méditerranée but, rather, rented an apartment at 1, place Charles-Félix.[64]

He had so far personalized his environments in the hotel, committed more attention to the modeling of the *niçoise* Henriette, and sought the special environment of the Midi. It seems clear now that Matisse's status was modifying itself to that of a resident. The

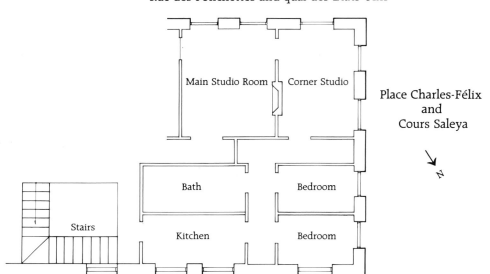

Baie des Anges and beach
Rue des Ponchettes and quai des Etats-Unis

Main Studio Room Corner Studio

Place Charles-Félix
and
Cours Saleya

N

Bath Bedroom

Stairs

Kitchen Bedroom

Fig. 28. Speculative diagram of Henri
Matisse's third-floor apartment and studio,
1, place Charles-Félix, established by Jack
Cowart

taking of the place Charles-Félix apartment was a major step in personal, physical, and creative attachment that would bind the artist to Nice and the côte d'Azur until his death thirty-three years later.

One, place Charles-Félix is an eighteenth-century building at the east end of the cours Saleya in the Ponchettes district of Nice. Built as the ornate meeting place for the Senat du Comte de Nice, it became the residence of the well-known historian of Nice, Comte Eugène Caïs de Pierlas (1842–1900).[65]

A fourth floor with balcony had been added to the original Italianate structure in the nineteenth century. The building offers unique views over the market, the city, and the promenade des Anglais to the west, La Tour Bellanda, with the Escalier Lesage mounting the hill of the Château, near the point Rauba Capeu and to the east. To the south is the quai des Ponchettes, the quai des Etats-Unis, and the baie des Anges, all within walking distance of Matisse's first Hôtel Beau-Rivage. Immediately behind the apartment building is La Chapelle des Penitents Rouges, the private chapel for the civic-oriented association of *niçois* fishermen. Facing both south and west, the place Charles-Félix building has unparalleled exposure to the entire atmosphere of Nice and the côte d'Azur, with sight lines all the way to Cap d'Antibes and Cannes beyond.[66]

Matisse's first rented apartment was on the third floor, west end. He rented this from the second half of 1921 until late 1926 or early 1927.[67] He then moved to a single apartment on the top, fourth, floor, west end, and within a year added the east-end apartment. He stayed there until fall 1938.[68]

The third-floor apartment had regular-size windows set at waist height. The windows on the west end were above encased heating units, taking advantage of the thick walls and the deep set-in of each window frame. There were two principal working rooms in the front, on the sea side. The larger of these, with two windows and a fireplace, served as the primary painting and drawing studio. A densely and strangely patterned wallpaper and frescoed ceiling decorated the room. Matisse further amplified this by installing his paintings and drawings as well as mirrors, reproductions of Michelangelo drawings, and items from his own collection of ethnic masks, fabric hangings, and paintings, notably works of Courbet.[69]

Matisse now had large demountable frames that would support the selected decorative fabrics he used as backdrops. In effect, the artist had a portable theater in these spaces. In the larger room, with his sets, models, and costumes, he could focus toward the interior of

30

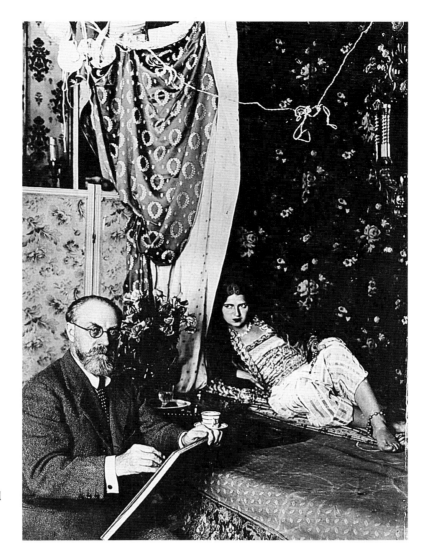

Fig. 29. (top) Henri Matisse drawing Henriette Darricarrère, mid-1920s, third-floor apartment and studio, 1, place Charles-Félix

Fig. 30. (bottom) The artist Pierre Bonnard striking a humorous pose as a "Matisse odalisque," mid-1920s, third-floor apartment and studio, 1, place Charles-Félix

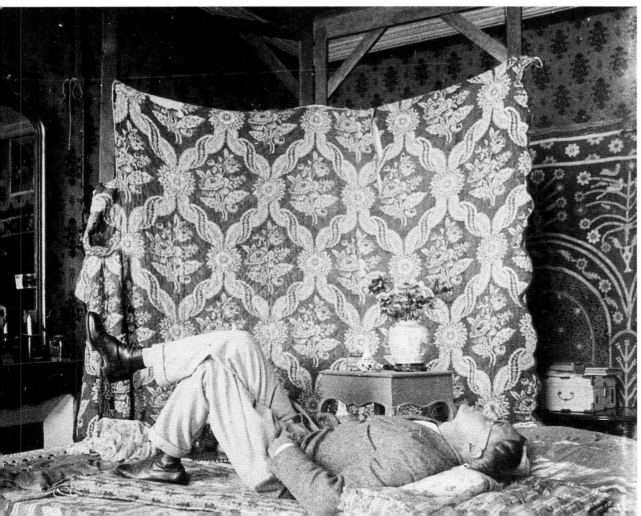

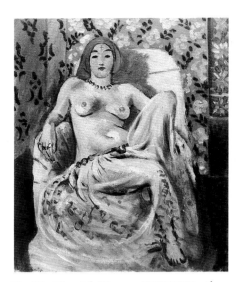

Fig. 31. *Moorish Woman*, 1922/1923, oil on canvas, 46 x 38 (18⅛ x 15). The Barnes Foundation, Merion, Pennsylvania

the room. Or he could look outward, posing his women or still lifes by the windows, to the cours Saleya market, the baie des Anges, or the low line of houses on the quai des Etats-Unis between his building and the beach. The other studio room on the corner seems to have been simpler, with a tight, striped wallpaper, and it was in this space that he worked on sculpture. He was thus equipped to have the best of both worlds: the interior studios and the exterior world framed by his window apertures. Furthermore, he was now a formal resident of Nice, the jewel of the Mediterranean.

The early suites of models posed at the window, seemingly lost in thought, often show a bright red, yellow, blue, black, and white paisley-patterned cloth applied to the wall area beneath the open volets. Later paintings show a red-and-white horizontally banded cloth, also presumably added by the artist, to make a planar pattern-against-pattern, weaving space and color.

Other works, like the great *Paravent mauresque* (pl. 117), continued to build colors, light, pattern, and the delicate drama of the models in an intimate domestic setting. Matisse's interiors were literal environments, large, complex, and passionate. The model Henriette is the focus of presentations that would soon portray her as odalisque, isolated in Matisse's artistic harem.[70]

To avoid the strong côte d'Azur light and heat, as well as to make a reunion with his family, Matisse followed his predictable pattern of going to Issy for the summer. He would return to Nice by 21 August.[71]

Fall 1922–Winter/Spring 1923

The season 1922–1923 is characterized by a series of single-figure frontal portraits. The model was Henriette, set—almost wedged—against decorative backgrounds. Their stylistic evolution toward dramatic abstraction can be seen in a group of four odalisques, the first two of which were painted before February 1923, the third before April, and the fourth before October. The early *Odalisque à mi-corps—le tatouage* is static in composition, thinly painted, and sparse in its pattern (pl. 160). The delicate nuances of the pigment and the open brushwork make an allusion to form rather than a full plastic realization of it. The second odalisque painting is the sumptuous *Moorish Woman* (fig. 31). A warm, pink-bodied model with a cross marked on her forehead, wearing a green-flecked gauze skirt and bright red, blue, and white rings, is set against a background of purple, brown, pink, green, and red. This work has an odd, dreamy feeling as if the artist were progressively moving from direct experience toward an exotic, imagined, more visionary world. The later *Odalisque assise aux bras levés, fauteuil rayé vert* is much more actively composed (pl. 161). The model is reminiscent of Matisse's intensive studies from the casts of Michelangelo's Medici Chapel sculptures at the Ecole des arts décoratifs in Nice. Draped in a gauzy skirt, the sculpturesque Henriette sits in a striped chair, her left leg drawn up, both hands joined over her head. This pose consolidates the process of numerous other paintings and drawings by Matisse during this period, in which he searched for his perfect union of body forms in physical and visual tension.[72]

The last of this painting group is *La pose hindoue*, a work intimate yet of monumental visual proportions (pl. 164). Here Henriette is shown cross-legged, static like an Eastern icon, hands above head; strong, flat patterns of the chair drapery, window shutters, wallpaper, and hangings tightly lock in the remaining canvas area. The contrasts of abstracted form and colors are clear. It is the rigorous simplifications of works like this that launch his highly stylized paintings of the 1930s. Matisse said late in that decade:

> My models, human figures, are never just 'extras' in an interior. They are the principal theme in my work. I depend entirely on my model, whom I observe at liberty, and then I decide on the pose which best suits *her nature*. When I take a new model I

intuit the pose that will best suit her from her un-self-conscious attitudes of repose, and then I become the slave of that pose. I often keep those girls several years, until my interest is exhausted. . . .

The emotional interest aroused in me by them does not appear particularly in the representation of their bodies, but often rather in the lines or the special values distributed over the whole canvas or paper, which form its complete orchestration, its architecture. But not everyone perceives this. It is perhaps sublimated sensual pleasure, which may not yet be perceived by everyone.[73]

Matisse took his last front balcony room at the Hôtel Méditerranée et de la Côte d'Azur for the carnival. In the result, the Cleveland painting (pl. 109), the perspective view has been flattened and the work evolves according to previous schemes. One gets the impression that the wonder and excitement of the artist for the subject has dissipated, that the phase of his most expansive landscapes is now over. From 1923 onward he will focus almost exclusively on the fantasies of the studio, where his manipulated compositions of textile patterns, still lifes, and human forms will raise to their highest level the issue of theatrical illusion versus abstraction.

His daughter, Marguerite, married the scholar of Byzantine and modern art, Georges Duthuit. Establishing residence in Paris, she will no longer figure as a model in Matisse's paintings.

Fall 1923–Summer 1925

A group of 1923–1924 works portrays Henriette making music and art, two activities central to Matisse's own personal life. Here the model, who trained as a ballet dancer and painted and played the violin and piano,[74] was not falsely staged but, rather, was involved

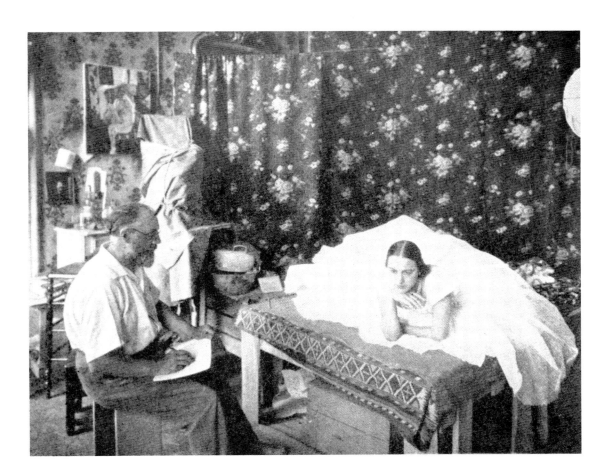

Fig. 32. Henri Matisse drawing Henriette Darricarrère, mid-1920s, third-floor apartment and studio, 1, place Charles-Félix

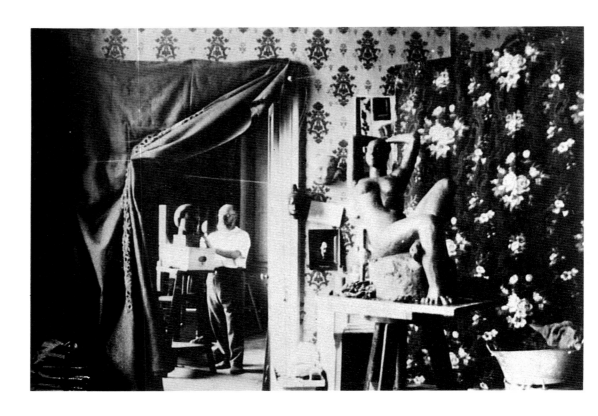

Fig. 33. Henri Matisse working on his sculpture *Henriette*, mid-1920s, third-floor apartment and studio, 1, place Charles-Félix

in pursuits legitimate to her interests. This undefined colloquy resulted in a group of biographical/autobiographical paintings, carrying forward classic themes found in the artist's work from his earliest days. Reminiscent of Matisse's *Painter's Family* (1912, now in the Hermitage), *Pianiste et joueurs de dames* (pl. 153) shows the new home of the artist with the "family" of Henriette and her two brothers (Paul and Jean). The Moorish screen, his recently acquired cast of Michelangelo's *Dying Slave*, violins hanging on the end of the armoire, the checker board, the upright piano, and the panoply of other patterns assault the eye with their relentless play and vibrant colors. It is a fully saturated and dynamic scene in contrast to the nostalgic subject. These works were the last explicit depictions of music making; however, paintings of painters, readers, and checker playing occurred at intervals into the 1940s.

The dense, lush atmosphere of the third-floor studio is also succinctly rendered in three of the strongest works of the winter and spring of 1924: *Odalisque aux magnolias* (pl. 162), *Anémones dans un vase de terre* (pl. 143), and *Intérieur au phonographe*. Each is a masterpiece of its subject, comprising significant scale, pattern against pattern, vivid palette, comprehensive modeling of forms, and dramatic luminosity. The *Intérieur au phonographe* depicts the two front studio rooms of the place Charles-Félix apartment (pl. 144). The still life is set on a draped table beside a window casting light on the fireplace, a record player, and the wall. The Moorish-design hanging, which Matisse habitually used to cover the doorway connecting to the corner studio room, is tied back to reveal the view through to the western rooftops and mountains behind Nice. Part of the facade of the chapel of the Misericordia in the cours Saleya is also visible in the window, above an empty chaise longue. Included in this painting are many of Matisse's constituent references to Nice: the city, the sunlight, air, landscape, interiors, patterns, "oriental-exotic" decoration, still lifes, the chaise longue where he would pose his grand odalisques, the record player (as music), and complex allusions provided by the mirror (incorporating the artist's image). All are neatly woven together in an unobtrusive way, deceptively presented to obscure his sense of passion, intense focus, and rigorous work: a distinctly Matissian job of camouflaging tension. As he later said:

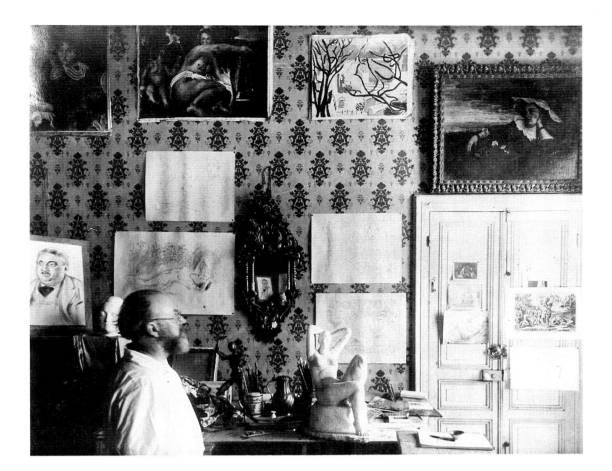

Fig. 34. Henri Matisse and north wall of his third-floor apartment and studio, mid-1920s, 1, place Charles-Félix

Fig. 35. Henri Matisse humorously "drinking," early 1920s, third-floor apartment and studio, 1, place Charles-Félix. The painting *Les Musiciennes*, 1922, is on easel

Look closely at the Odalisques: the sun floods them with its triumphant brightness, taking hold of colors and forms. Now the oriental decor of the interiors, the array of hangings and rugs, the rich costumes, the sensuality of heavy, drowsy bodies, the blissful torpor in the eyes lying in wait for pleasure, all this splendid display of a siesta elevated to the maximum intensity of arabesque and color should not delude us. In this atmosphere of languid relaxation, under the torpor of the sun washing over people and objects, there is a great tension brewing, a tension of a specifically pictorial order, a tension that comes from the interplay and interrelationship of elements.[75]

In the summer Matisse, his wife, his daughter, and her husband, Georges Duthuit, visited southern Italy and Sicily, looking at Byzantine art. Passing through Rome, Martorana, and Monreale, the artist later claimed no influence.[76] However, Italianate aspects, a sense of the decoration, the rich patterns of mosaics and marble, and a darker palette do seem to be in some contemporary works, notably the *Figure décorative sur fond ornemental*.

Fall 1925–Fall 1926

The last significant works painted on the third floor were with the model Henriette posed in *Odalisque with Tambourine, Sylphide* (pl. 158), and the masterpiece *Figure décorative sur fond ornemental*. The *Odalisque with Tambourine* is another explicit reinterpretation of Michelangelo's Medici tomb figure *Night*, but there is an even more Italianate atmosphere in the *Figure décorative*. The Venetian rococo mirror hanging behind the model has been greatly enlarged by the artist since the time he used it in his 1917 painting *Le peintre et son modèle* (pl. 4). Then it was a minor decorative item, but now, ten years later, this mirror occupied a compelling central portion of the composition; its forms are echoed in the

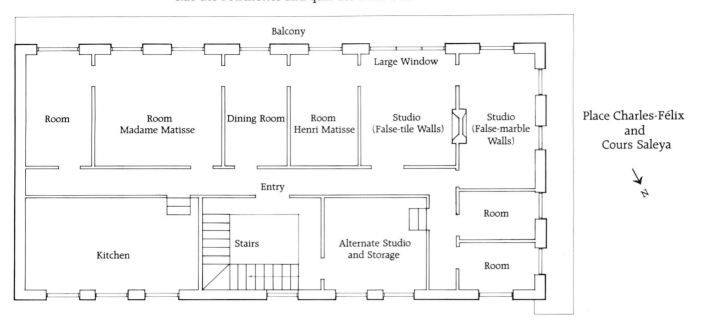

Baie des Anges and beach
Rue des Ponchettes and quai des Etats-Unis

Balcony

Large Window

| Room | Room Madame Matisse | Dining Room | Room Henri Matisse | Studio (False-tile Walls) | Studio (False-marble Walls) |

Place Charles-Félix
and
Cours Saleya

N

Entry

Kitchen | Stairs | Alternate Studio and Storage | Room

Room

Fig. 36. Speculative diagram of fourth-floor double apartment and studios, 1, place Charles-Félix, as used by the artist during the late 1920s and 1930s, established by Jack Cowart

gigantesque flowered pattern of the backdrop. Rarely in these early Nice paintings had the artist so relentlessly combined three carpet designs, a Chinese-style jardiniere, an odd marbleized or needlepoint section, and the peculiar brown, blue, and orange palette.

Fall 1926–March 1927

Matisse moved from the third floor to the top floor of 1, place Charles-Félix.[77] He may have begun first with the left section of the building and then acquired the use of the right section, thus making a double apartment. This change to the fourth floor was a most remarkable event, for he left rather snug and heavily decorated rooms below. The new apartment was larger, airier, and even more panoramic, with a balcony running around the south and west sides. The south wall of the center studio room was almost entirely glazed, and the large triple floor-length window opened out to the balcony. This apartment let in much more of the outside world. Matisse now had a dramatic light chamber with a grand view of the entire promenade des Anglais, the bay, and most of the city and the mountains behind. The walls of the center studio were white with an unusual painted false-tile squaring. The walls of the corner studio were false marble set in trompe l'oeil rectangles, and there were green baseboards in both rooms. The new pattern of the false tiling enters Matisse's repertoire at this time, as does his delight in reproducing the false marbleizing.[78] By contrast, the other rooms in the apartment seem to have been conventionally and simply decorated. There was a third interior studio, the *atelier-remise*, where Matisse worked on occasion.

Continuing across the seafront of the apartment from the two studios was Matisse's small bedroom, the dining room, a double room (which would be Amélie Matisse's when she moved to Nice from Issy in 1928), and another so-called *salle d'habitation*. A large kitchen and the bath were at the back, four steps down. On the west end were two other rooms for family living. This complex of rooms served Matisse well until his move to the Hôtel Régina in 1938.[79]

Clearly, the central feature of this apartment was the great window.[80] It remains today, and the effect is blinding (no surprise that Matisse wanted to put up an awning to soften the light).[81] He no longer needed the rigged-up lighting apparatus that can be seen in

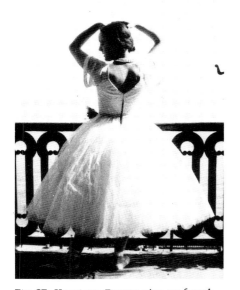

Fig. 37. Henriette Darricarrère on fourth-floor balcony, 1, place Charles-Félix, after 1927

photographs of the former studios on the third floor.[82] Now there was full sun or saturating light under almost any weather condition, further amplified by white walls. Of consequence also was the unusual railing running as a continuous frieze around the front two sides of the building. Their flat metal cutouts remain today; the artist often used their shapes as pure design elements in paintings and drawings.

Spring 1927–1931

The works of this period will be the high-contrast paintings of odalisques and decorative screens, with samovar, a rococo table, a Turkish chair, checker board, and some of the grand floral hangings seen earlier in the *Figure décorative sur fond ornemental* of 1925–1926. These striking paintings are the fullest realization of Matisse's thesis on pattern, decoration, and the odalisque placed in his "brewing tension." He surely enjoyed the deceptive game he played with this conflict between reality, appearance, and art, and dreaming and waking. These paintings are fantasies in the best sense of the word, but for the sake of denying such an accusation, he said: "I do odalisques in order to paint nudes. But how does one paint nudes without their being artificial? Because I know that odalisques exist. I was in Morocco. I have seen some."[83]

Amélie Matisse moved to the apartment in the spring of 1928 and was often seen thereafter in photographs with her husband.[84]

A new direction coinciding with his move to the new studio is signaled by *La femme à la voilette* (pl. 172). It is the last major picture for which Henriette modeled.[85] Matisse compressed his space and painted a cross-hatch on the clothes, denying folds or volume. Line becomes independent, as does the singing color.

There are several remarkable endings in this period. In the paintings of 1928–1931 of the new studio with the new hired models Lisette, Hélène, Lily, LouLou, Zita and her sister, or with still lifes against the false-tiled walls, the artist had found an intrinsic, graph-paper-like measuring device. Matisse conscientiously replicates the effect of this squaring,

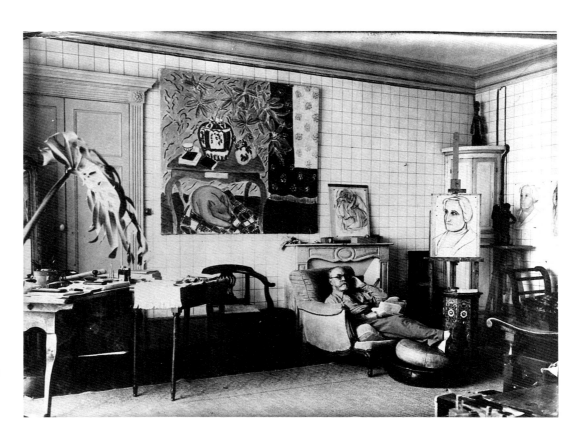

Fig. 38. Henri Matisse in his center studio, fourth floor, 1, place Charles-Félix. This studio has false-tile wall decoration. The photograph dates after 1934

37

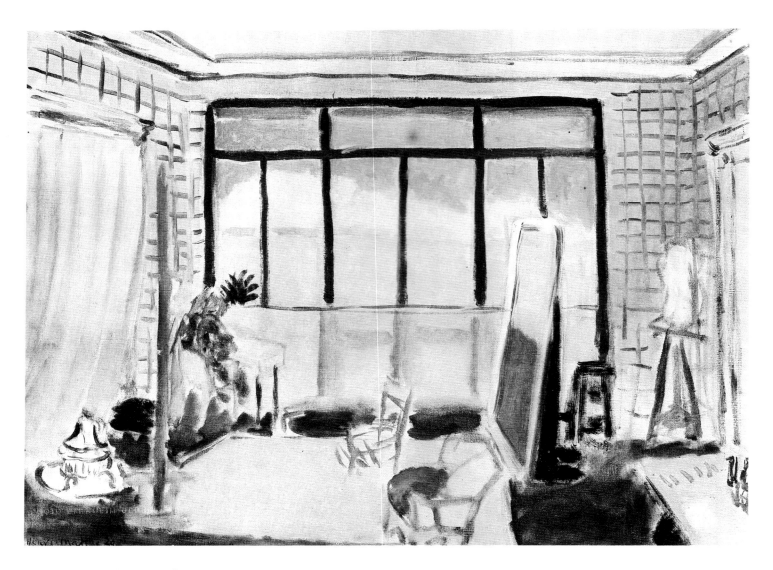

Fig. 39. (top) *L'atelier*, 1929, oil on canvas, 46 x 61 (18⅛ x 24) (1, place Charles-Félix, fourth floor, showing the large window facing the baie des Anges). Private collection

Fig. 40. (bottom) *Odalisque tatouée*, 1929, oil on canvas, 56 x 46 (22 x 18⅛). Present location unknown

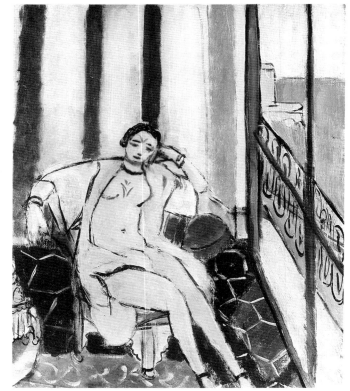

offsetting the rigid geometricity by delicate arabesques or volumetric modeling. He now sets architectural forms against curvilinear natural elements, much like his contrast of the geometric costumes of his 1920 *Le chant du rossignol* against the floral chinoiserie of the decor.

In these great and most fluid of all paintings by Matisse, each work appears soaked with light; the white beneath the increasingly thin pigment reflects even more of it. The works look as though a camera aperture has been opened, resolution of form washed over, softened, volume and weight dismissed. This literal and most astonishing *niçoise* light is, at last, captured.

The other final paintings are the three large-scale works; two of flowers (pls. 184 and 185) and the last, the scintillating *La robe tilleul* (pl. 187). The gladioli and dahlias of the still lifes sit on Matisse's Renaissance-motif stool against the *faux marbre* walls of the corner studio. They make an opulent pair, reminding us of the profusion of flowers and the Italianate/French elegance of Nice, put by Matisse into an unlikely but correctly handled juxtaposition.

1930–1932

La robe tilleul breathes a daytime heat. Begun before Matisse left on his 1930, yearlong, round-the-world trip to the United States and Tahiti, he worried for much of his voyage about how to conclude this work. Upon his return, solutions materialized, incorporating the full spirit of the Nice environment, perhaps with a final intense dose of the South Pacific.

In 1931 he accepted the commission from Dr. Albert Barnes to provide a mural decoration linking the three great lunettes above the outside-opening French doors of his Merion, Pennsylvania, gallery/museum. These decorative lunettes can only be seen in a kind of *contre-jour*; that is, we must look directly into this light when viewing the works above. The strong light of the doorways below tends to make the panels hover. This situation makes a curious and provocative relationship to the direction that Matisse's paintings had already been moving in since 1928, in his own studio chamber of strong light.

Fig. 41. No. 8, rue Désiré-Niel, Nice, the building used by Matisse as a temporary studio for the painting of the Barnes murals, *La danse*, 1931–1933

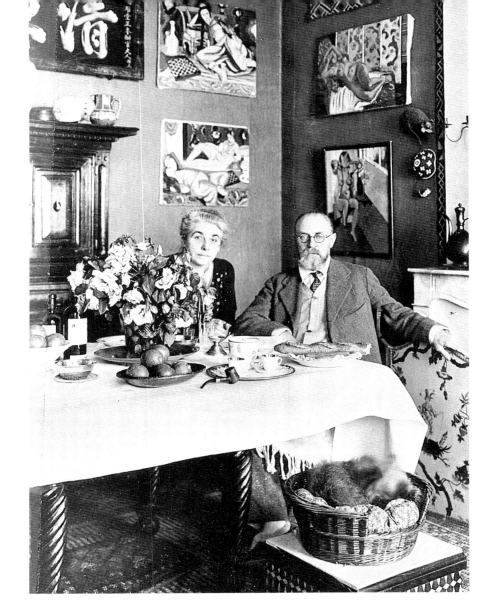

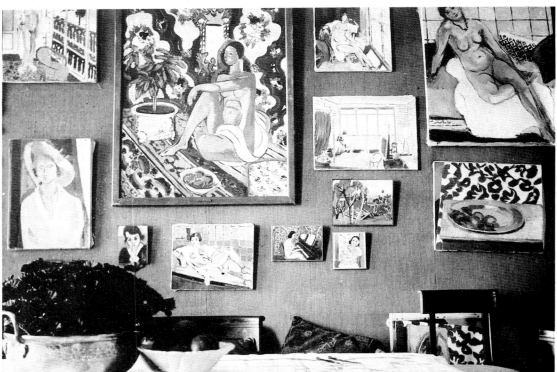

Fig. 42. (top) Henri Matisse and Amélie Matisse, c. 1929, dining room, fourth floor, 1, place Charles-Félix

Fig. 43. (bottom) Dining room wall, June 1929, fourth floor, 1, place Charles-Félix

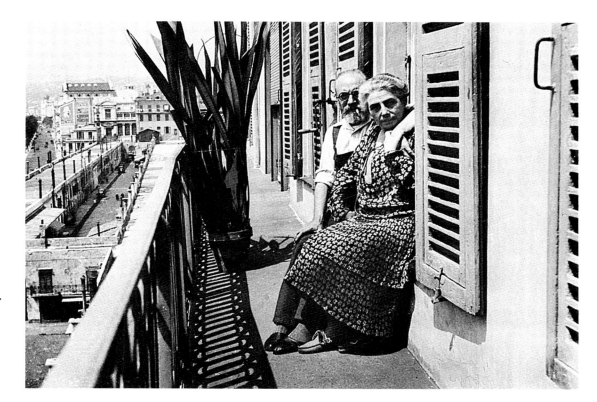

Fig. 44. (top) Henri Matisse and Amélie Matisse, c. 1929, fourth-floor balcony, 1, place Charles-Félix

Fig. 45. (bottom left) Henri Matisse on fourth-floor balcony, 1, place Charles-Félix, early 1930s. Photograph by Albert Eugene Gallatin

Fig. 46. (bottom right) View to the east from Matisse's large studio window, 1929, fourth-floor studio, 1, place Charles-Félix

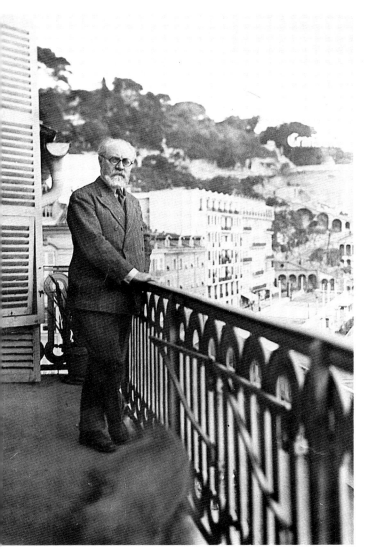

The murals are more than fourteen feet high by forty-six feet wide, and the monumental scale of the project obliged the artist to take a special studio in Nice. This was a vacant garage warehouse at 8, rue Désiré-Niel, two blocks from the Ecole des arts décoratifs, rue Tonduti de l'Escarène (fig. 41).[86] It is said to have belonged to the wine merchant whose shop on the cours Saleya was not far from 1, place Charles-Félix.

The emerging Barnes *La danse* is his great summation of the theme he had explored in the large 1905 *Joie de vivre* (already owned by Barnes) and two versions of *La danse* (Museum of Modern Art, New York, 1909 and the Hermitage, Leningrad, 1909–1910), in his experiences with *Le chant du rossignol* and, finally, in the Henriette-related odalisques and ballet-costume subjects of the 1920s. The later costumes and decor for the 1939 Ballet Russes de Monte Carlo *Rouge et noir,* as well as works using the same subject in the years 1937–1938, will be no more than a reprise of this grand 1931–1933 Barnes mural project.[87]

This chronology offers the first quantified formulation of Matisse in Nice, 1916–1932. These early years in Nice represent the artist's deeply personal time of severe and prolonged challenge to himself, to what he wanted his art to be, and how he must and would continue.

Notes

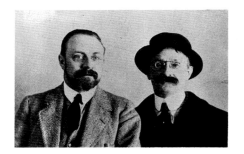

Fig. 47. Henri Matisse and Albert Marquet, Marseilles, 1916. Photo-Eclair, 18 Cannebière

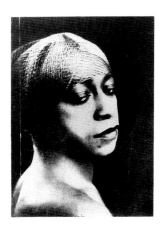

Fig. 48. Aïcha la noire, Paris, early 1900s

1. I am greatly indebted to Marie-Thérèse Pulvenis de Seligny for her two years of professional assistance and research support concerning many technical points of this chronology. Mlle Pulvenis volunteered considerable time and energy in establishing and then maintaining contact with archival sources and those people who remember Matisse's early years in Nice. She has acquired numerous documentary photographs for me and was an indispensable coordinator for the on-location camera work at 1, place Charles-Félix and 105, quai des Etats-Unis used in the National Gallery of Art film produced on the occasion of this exhibition.
2. In 1898 he was in Corsica; in 1899, Toulouse; in 1904, St. Tropez; in 1905 and 1906, Collioure; in 1906, Algeria; in 1908 and 1909, Cavalaire; in 1910, Seville; in 1911, Collioure; in 1912, Tangiers; in 1913, Morocco; and in 1914, Collioure.
3. Giraudy 1971, 19, indicates the visit took place from c. 1 December 1915 to c. 19 January 1916; Schneider, 1984, 735, refers to Matisse's 2 December 1915 postcard from the Hôtel Beauvau in Marseilles to his friend, the painter Chaurand-Naurac. A photograph taken at the portraitist Cannebière (fig. 47) would seem to date from this 1915/1916 visit.
4. Giraudy 1971, 6 December 1915, 19.
5. See Giraudy 1971, 19, for the letter of 19 January 1916; and Fourcade 1975, no. 48, 93, for the drawing that may relate to this remark. It seems that he may not have returned to L'Estaque as soon as he had planned, according to an interview with Wanda de Guébriant, Archives Matisse, 17 February 1986.
6. Confirmed, interview, Wanda de Guébriant, Archives Matisse, 20 November 1985.
7. Diehl 1954, 154.
8. Alternate spelling, Laurette.
9. I am grateful for the reference supplied me by John Klein in locating "Aïcha la noire," a celebrated and exotic Parisian model: Crespelle, 1962, 18–19. It is she who may also be the model used by Matisse. Mr. Klein's dissertation in progress, "Matisse's Portraits and Self-Portraits" (New York, Columbia University) will serve as a source for the planned exhibition on the same subject being organized by the Musée Matisse, Le Cateau, and by Dominique Szmyuziak and John Klein.
10. Lorette is known to have had one sister, portrayed in the Barnes triptych as the small girl. The title for this, as well as the Orangerie painting (pl. 19), may be technically incorrect. Interview, Wanda de Guébriant, Archives Matisse, 17 February 1986.
11. See Schneider 1984, "The Family Prerogative," chapter 12, 311–339.
12. Schneider 1984, 316–318, n. 14.
13. Shattuck 1968, 293.
14. Wildenstein 1985, 395 and 397. See letters no. 2205, 28 November 1916, 395; no. 2205a, 12 December 1916, and no. 2229, 1 May 1917, 397.
15. Interview, Wanda de Guébriant, Archives Matisse, 25 November 1985; Diehl 1954, 154.
16. Besson 1939, 135–140. This seems to be a most, though not absolutely, credible first-hand account of Matisse's earliest days in the south. The artist painted a miniature portrait of Besson in Marseilles, December 1917, and then one later in January 1918 during the stay at the Hôtel Beau-Rivage, Nice.
17. Escholier 1956, 115; and Besson 1939, 135–140. The Archives Municipales confirms that the historic name of this street was quai du Midi. Matisse used this street name in his return address despite the fact that, by the deliberation of the municipal council of 30 April 1917, upon the proposition of General Goiran, mayor of Nice, the name was changed to quai des Etats-Unis to salute the entry of America into World War I. Mathiot, 321–322.

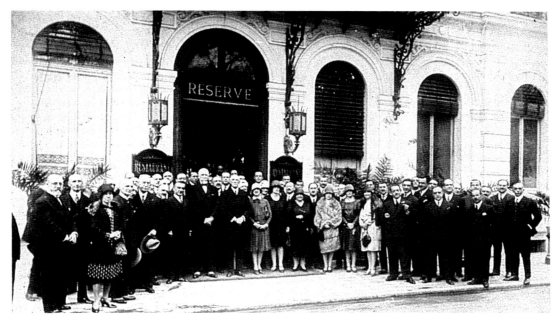

Fig. 49. Members of the Club Nautique de Nice, 1930s. Henri Matisse at extreme left

Fig. 50. *Paysage*, c. 1918, oil on board, 32.4 x 40.6 (12¾ x 16). Present location unknown

Fig. 51. *Paysage Rimiez*, c. 1923, oil on board, 22 x 28 (8⅝ x 11). Present location unknown

18. During 1985/1986 the Hôtel Beau-Rivage is under conversion from a hotel to luxury condominiums. In the process of the renovation and change of ownership, numerous crates of room registers, daily journals, and account books were found and have been deposited with the Archives Départementales. It will take some time before this mixed material is catalogued to permit finding a register that might document Matisse's visit and his room.

19. The Jetée Promenade was dismantled by the occupying Axis troops in 1943.

20. Annuaire 1926.

21. I appreciate the information provided by M. Icard, president of the Club Nautique and adjoint to the mayor of Nice, which indicates that Matisse formally entered the club in 1927 (Pierre Matisse also joined that year). By 1931 the artist had a *canoë avec barreur* and a *canoë course*. M. François Veran was also a member. *Annuaire* 1931, Club Nautique de Nice, 70, 99.

22. Fourcade 1972, 123; translation Flam 1973, 134.

23. Interview, Wanda de Guébriant, Archives Matisse, 17 February 1986.

24. Fourcade 1972, 123, n. 82. Translations of quotations in text, except where otherwise credited, are by Nicholas Martin.

25. Translation Harris 1923, 140.

26. Gilot 1965, as reprinted in Fourcade 1972, n. 64, 202.

27. Escholier 1956, reprinted Fourcade 1972, n. 64, 202, though this differs somewhat from Besson 1939, 41–44.

28. Schneider 1984, 503.

29. For more information, appraisals, and recountings of Matisse and Renoir, see Fourcade 1976, especially 96–106.

30. Matisse owned Courbet's *The Source of the Loue, Blond Woman Sleeping*, and a large sketch for *Young Ladies on the Banks of the Seine*, as well as various drawings; Cézanne's *Three Bathers*, 1879–1882, and a portrait.

31. Date estimated through information contained in letters: 18 April 1918, Matisse to Camoin letter, Giraudy 1971, n. 32; and 9 May 1918, Matisse to Henri Laurens (unpublished). I appreciate the generosity of M. and Mme Claude Laurens in making the 9 May 1918 letter available to me.

32. Giraudy 1971, 21.

33. References to building stories in this text are made in the European system, in which the floor above the entrance or ground level is numbered the first floor.

34. The fashion designer Germaine Bongard was a sister of Paul Poiret.

35. Annuaire 1926 lists the proprietor as a M. Ferroglio.

36. This building remained intact until at least 1976, as documented in the photographic archives of M. Berard. This section of Nice has changed radically, however, and the proposed location of 219, avenue du Mont Boron is somewhat speculative.

37. Paris 1970, 55.

38. Giraudy 1971, 22.

39. Interview, Wanda de Guébriant, Archives Matisse, 25 November 1985.

40. Cassarini 1984, n.p.

41. This full name and address are listed in the Annuaire 1918.

42. Carco 1953, 262–263, reprinted in Fourcade 1972, 123.

43. A sensitive analysis of mirrors and paintings within paintings from Matisse's *niçoise* period can be found in Clair 1970, 65–71.

44. Alternate spelling is Arnoud. Antoinette had two sisters, who may also have posed for Matisse.

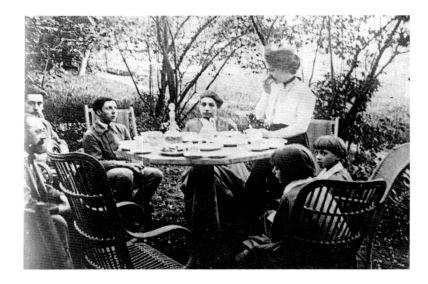

Fig. 52. The Matisse family in their Issy-les-Moulineaux garden, with Nicolas Bongard, before 1915

Fig. 53. *Le bord du Loup, l'allée du pins,* c. 1922, oil on canvas, 50.2 x 60.9 (19¾ x 24). National Gallery of Art, Washington, Chester Dale Collection 1963.10.166

45. Cinquante dessins 1920 contains a veritable anthology of her attributes and appearances; see Elderfield 1984, 74–100, 262–268, and ills. pages 171–175, for extended discussion of the Antoinette plumed hat drawings and Matisse's drawings of the 1920s. For other illustrations of the many "faces" of Antoinette, see also Schneider 1984, 498–499.

46. Matisse questionnaire, Barr Archives, Museum of Modern Art, New York.

47. An unpublished letter from Matisse to George Besson, 11 May 1919, addressed from Nice, indicates the artist was there at least to that date.

48. Interview, Wanda de Guébriant, Archives Matisse, 25 November 1985.

49. A family photograph, dated before 1915, records aspects of Matisse's Issy-les-Moulineaux garden and his unusual rose-marble table.

50. Interview, Wanda de Guébriant, Archives Matisse, 17 February 1986. *Le chant du rossignol* was a ballet in one act by Igor Stravinsky and Léonide Massine after a story by Hans Christian Andersen.

51. Only the center rooms on the first and second floors had balconies. Side rooms on those floors and all rooms on the third floor had none.

52. Interview, Wanda de Guébriant, Archives Matisse, 25 November 1985. The ballet was first produced at the Opéra in Paris, 2 February 1920. Matisse would follow the troupe to Covent Garden, London, in June for the opening of the English run.

53. Cowart 1977, 84–85.

54. See the related paintings in the Moderna Museet, Stockholm, National Gallery of Art, and private collection, New York; Schneider 1984, 462–463.

55. Matisse told the Cone sisters that he kept the animals alive, dumping water on them and, when finished, returned them to the ocean. (Conversation noted in the Cone Collection Archives, Baltimore Museum of Art.)

56. Also called La Roche Percée or L'Elephant, these rocks were subjects used by Monet and Courbet, as well as by Matisse in smaller paintings.

57. Giraudy 1971, 22.

58. Certainly by 29 October, the date of a letter from Matisse to Félix Fénéon apparently mailed from Nice, now in the Barr Archives, Museum of Modern Art, New York.

59. Vildrac 1922, n.p. Another recollection from the time of Matisse's stays at the Hôtel Méditerranée can be found in Romains 1970, 90–94. Romains n.d., 19–20, includes reminiscences of the artist's time at 1, place Charles-Félix.

60. I am greatly indebted to Mme Claude Houpert (née Claudie Plent), the daughter of Henriette Darricarrère Plent, for so generously supplying information concerning her mother and family as well as various photographic documents relating to the artist and model.

61. I appreciate the information concerning the Auberge du Loup furnished by Mme Mongallez, as well as her assistance, with M. Jean Arnaud, in our visits to 105, quai des Etats-Unis.

62. Schneider 1984, 502–504.

63. See Bock 1986, n. 20, for the post–World War I situation in France as it affected the arts; see also *Le retour à l'ordre*, C.I.E.R.E.C., Travaux VIII (Saint-Etienne, 1974); *Les Réalismes, 1919–1939* [exh. cat., Musée National de l'art moderne] (Paris, 1980); and Silver 1981.

64. Diehl 1954, 76, says 1 October 1921. The Hôtel Méditerranée et de la Côte d'Azur was demolished c. 1937, as indicated by the Annuaire 1938. This site is where the present L'immeuble de la mer, J. J. Mecatti now stands, 25 and 25 bis, promenade des Anglais.

It has been proposed that Matisse borrowed or rented Frank Harris' apartment in Nice during the late teens or early twenties (Watkins 1984, 161). But a survey of archival sources suggests that Matisse and Harris may not have known each other until later. It was a friend of Harris, however, Georges Maurvret, a writer for *L'Eclaireur de Nice*, who did live at 1, place Charles-Félix. Matisse rented one of the apartments in this building from him.

In a letter of 14 January 1926 Harris asked Maurvret if he could arrange a meeting with Matisse. I appreciate the generosity of Mme Malandri, Nice, in sharing this letter with me and the documentation supplied by M. Robert Vellerut-Sabatier, Nice, concerning rental information supplied him by Mme Duthuit in 1973.

65. In the 1920 Annuaire, the building was still registered as the Maison de Comte de Pierlas.

66. This view reminds one of the artist's panoramic painting of 1905, *Le Port d'Abaille, Collioure.*

67. The Signification & Sommation from J. Borra, huissier (summons server) for the lawyer of M. François Veran, Louis Carlo to Henri Matisse, dated 5 March 1927, indicates that Matisse was occupant of the top, fourth, floor of 1, place Charles-Félix. Previously, the second half of the fourth floor was occupied by a M. Malaussena. The proprietors of the building in the mid-1920s were, and remain today, the Veran family. The documents so generously supplied by M. Julian Carlo, Nice, who now directs the firm of Louis Carlo, established critical references for this chronology.

68. The Resiliation de Bail from Henri Matisse to the Veran family is dated 10 June 1938, after which time he moved to the Hôtel Régina in Cimiez.

69. See especially the book of photographs by Erich Hermann in the library of the Museum of Modern Art, New York, which offers various views of Matisse's third- and fourth-floor apartments and their interior decor. The Musée Matisse, Cimiez, is currently involved in cataloguing all known photographs of Matisse and his studios. Their summer 1986 exhibition of selected photographs inaugurated the museum's efforts to establish this complete reference and eventually to publish it.

70. See Bock 1986 for an interpretive study of certain aspects of the Nice period, Matisse, and his models. I appreciate Dr. Bock's communication of her manuscript to me before publication to allow for mutual checking of facts, the inclusion of some references, and the exchange of opinions.

71. Gowing 1966, 10.

72. His ultimate resolution of this Michelangelesque sculpture question would, however, be in a sculpture, the marvelous 1923–1925 *Large Seated Nude.*

73. Matisse 1939, 8–14, as translated in Flam 1973, 82.

74. See the curious article in *Paris Match*, No. 294 (13–20 November 1954), "Matisse—Le Maître avait une élève secrète, son modèle il y a 30 ans," 34.

75. Translation in Schneider 1984, 506, from Verdet 1952, 125.

76. Schneider 1984, 737.

77. We know that he was installed there 5 March 1927 by the date of a summons presented to Matisse, which gave the artist notice that he must stop the installation of an awning above the balcony facade. However, Matisse's wishes must have prevailed, as his 1929 drawing (Fourcade 1975, cat. no. 81) depicts an awning in place over the large window, and other documentary photographs show Henriette Darricarrère, in ballet costume with shawl, under the awning. He may have lived in the single apartment there from the end of 1926 until April 1928, but surely not any longer than that, since his lease, filed now with the firm of Julian Carlo in Nice, specifies that he was then obligated to pay rent for a double space.

78. Later this unusual marbleizing would figure in the background of the notable *Still Life with Magnolia Branch*, 1934, and the false *carrelage* became a central element of the great *Pink Nude*, 1935, among other works.

79. I appreciate the assistance of Mme Lydia Delectorskaya, Paris, in confirming the fourth-floor place Charles-Félix apartment spaces.

80. Legend has it that it was Matisse who had this double window installed. It is an anomaly, to be sure, considering the design of the building. But an early postcard view of Nice, bearing the postmark 21 November 1906, shows what appears to be an existing enlarged window already here (fig. 36). In truth, the hot light provided by this south-exposure window makes it a "view," or touristic, window rather than that source of neutral, north light so sought by artists. Therefore it seems likely that Matisse inherited the window, accepting it and using it positively, as he also accepted and used the unusual painted wall decorations in his two main studio rooms.

81. See n. 77.

82. *Cahiers d'Art* 1, no. 7 (September 1926), 153.

83. *Verve* 1, no. 3, 121. A broader view of Matisse's orientalism is found in Kenneth E. Silver, paper presented at the 73rd Annual Meeting, College Art Association of America, Los Angeles, February 1985, titled "From Cosmopolitan to Colonial: Henri Matisse's Esthetic of the Orient."

84. Interview, Wanda de Guébriant, Archives Matisse, 25 November 1985.

85. Schneider 1984, 528, sees this work as Matisse's homage to the pensive Lorenzo de Medici of Michelangelo's S. Lorenzo tomb.

86. M. Deloze, an artist in Nice, today distinctly remembers visiting Matisse in this temporary studio and watching Matisse work with students from the Ecole des arts décoratifs, pinning up the large sheets of colored papers used to establish the first designs. No. 8, rue Désiré-Niel is a surprising space, a very large double building on a narrow street. The facade is twenty-nine meters wide and seven meters high, with tall doors and fan windows. Twenty-three meters deep, the interior of the two was not subdivided until after the mid-1930s. Thus the space was more than adequate for the mural execution. More commonly it has been said that Matisse worked on *La danse* in a building built as a film studio, making one think of the studios de la Victorine, avenue Edouard Grinda, on the west side of Nice near Saint-Augustin. My survey of sources and records relating to the filming history and business of La Victorine, as well as of those persons close to Matisse at the time, casts serious doubt on this proposition. Published photographs (Schneider 1984, 737, and *Art News* 1951) seem to show the interior of 8, rue Désiré-Niel.

87. Cowart 1977, 86–96.

Fig. 54. Interior of 8, rue Désiré-Niel, Nice

Fig. 55. Interior of 8, rue Désiré-Niel, Nice

An Uninterrupted Story

Dominique Fourcade

The oeuvre of Henri Matisse must today be seen as an uninterrupted story. It is a tightly woven fabric of initiatives, a chain of events both improvised and necessary, unforeseen and logical. Not one link from this chain can be missing if we want to understand Matisse's project, the variety of its experimental directions, the multiplicity of its implications, as well as the scope of its perseverance. At least three reasons argue in favor of the organization of an exhibition specifically devoted to the 1916–1930 period of Matisse's oeuvre. In the first place, this exhibition has been necessary for a long time because these fifteen years include works of great beauty, which is reason enough to consider exhibiting them. Secondly, the years 1917 to 1930 constitute a unity distinct from the previous years (just as Matisse's painting takes another major turn in 1931 and 1932). Finally, the production of these first years in Nice has never been examined in depth; many critics have been content for a long time with hasty and stereotypical judgments deforming the meaning of this period, to the point that we can say it is today still very poorly known.

For complex ideological reasons, this period of Matisse's art has until now been considered a lazy and conservative interim, not to say a reactionary one; it has been looked at with commiseration by most commentators, classified as a moment of fatigue in his work, an unfortunate pose in the sacrosanct march forward—thus, a pose that there has been every interest in skimming over as quickly as possible. In short, there was satisfaction in letting the artist die in 1916 with *La leçon de piano* (The Museum of Modern Art), even if that meant letting him be reborn from nothingness in 1932 with *La danse* (The Barnes Foundation); then, from there, to let him leap via *Nu rose* (1935, The Baltimore Museum of Art), abstractly and without transition, to the cut-outs at the end of his life! Thus, in their modernist obsession, even the best writings on Matisse, aside from the few rare exceptions, and the best exhibitions of his paintings had come to a point of obscuring almost completely his first years in Nice.

We think it is absolutely necessary to restore the fullness to Matisse's development. And we would like to show that the paintings of the years 1917–1930 are not the dull reflection of a leave of happiness the artist would have passively accorded himself. Nor do they offer the image of a return to order, for there is neither return nor order here, as we shall see. Something else entirely is in question. These years are in fact an extremely active and a totally surprising moment in Matisse's journey. The object of this exhibition, then, is

Henri Matisse, by Man Ray, c. 1930.
Courtesy of Lucien Trelliard, Paris

simply to let this moment be seen, to show it for the first time, to illustrate the often dramatic and novel sequences composing it, in order to make available a more objective idea of what Matisse painted during those amazing first years in Nice.

Among all the mutations Matisse's art undergoes in the period concerning us, the most obvious is the reappearance of the figure, as such, in his painting: the human figure, the figure of objects, and the configuration of space, in depth and volume, in which these figures fit and take their meaning. The components of the universe become once again easily identifiable. Several observations are necessary here: this is the mutation that most struck and even disconcerted people and is by far the most obvious, but it is certainly not the most important pictorially among those mutations that then intervened in his art. Second observation: Matisse's painting never had been nonfigurative, it always represented something of the real. What one might say is that the figuration of the real was, depending upon different stages of his work, more or less direct, more or less immediate. Here, in the first stages of the period in Nice, Matisse carries out a deliberate shift, a difficult passage of trial and error toward a painting in which reference to the real is more directly readable. It is nevertheless essential to note that he is not painting the "real" as he might have done until 1904; in 1917, Matisse does not unaccountably regress to a prefauvist manner of painting; on the contrary, he instinctively and subtly displaces the given elements of his painting (without preconceived notions and without mixing them up). There is, then, mutation, but not return: Matisse explores a new mode of transfiguration because he feels the need, pushed by his anguish as creator, not because of a loss of creative energy. Last observation: the source of this mutation is not Nice—it takes form in Paris and in Issy-les-Moulineaux, before he settled in Nice during the working season 1916–1917.

The very example of this shift, of this "refiguration," is proposed in the two canvases *La leçon de piano* (The Museum of Modern Art) and *La leçon de musique* (The Barnes Foundation, fig. 2, p. 17), painted in Issy-les-Moulineaux. It has taken commentators a very long time to admit that *La leçon de musique*, the more figurative of the two, could be subsequent to *La leçon de piano*, in which the real is rendered much less literally—today, this has yet to be understood well. This incomprehension rests on the prejudice that only nonfigurative art merits the qualification of abstract art, followed by another prejudice, according to which abstract art (that which is not supposed to be figurative) represents the supreme achievement of twentieth-century art. Consequently, one cannot envisage an artist, namely Matisse, who, instead of going from the simplest (or rather that which was designated as such—the figurative) to the more complex (the nonfigurative, or the less figurative), does precisely the opposite. When, documents in hand, one had to face the facts, it became difficult to give up generally accepted ideas: the passage from nonfigurative to figurative—or, to be precise, in the case of Matisse, from less figurative to more figurative —was considered an unexpected shift back to naturalism, a renunciation of abstraction (which is to say the greatness of modern art), and thus, to a greater or lesser degree, a sign of decadence. The fact that this second composition, in which the real was clearly readable, demanded as much imagination and distancing on the part of Matisse was denied. The second also demanded a spatial and chromatic organization as complex as the first of these two paintings, in which the real was uneasily decipherable. The fact that the experimentation and effort required of both paintings was equal, and that the quality of abstraction was equivalent, was also denied.

Thanks to the publications and exhibitions of Matisse's oeuvre that have taken place since 1966, today we know enough paintings from the years 1916–1920 to give ourselves a less imprecise idea; now it remains to bring them together in a serious manner, and put them end-to-end in order to further our knowledge decisively. Everything points to these years 1916–1920, overlapping his move to Nice, as having been pivotal years for Matisse, years of experimentation and torment. Everything confirms that this was not a period of

ease, that things did not go in only one direction. The movement that swings between the more and the less figurative reverses itself several times. For example, Matisse would paint two portraits of Auguste Pellerin, and two of George Besson: here, in opposition to the succession of *Leçon de piano—Leçon de musique*, each time the second portrait is the less figurative, and the more stylized. Or, again, in the series of nearly forty canvases figuring the model Lorette, all very topical, very immediate, one emerges, *L'italienne* (The Museum of Modern Art), in which Matisse finds himself, as if unwillingly, dragged down by his former manner of painting and caught in his earlier, less direct mechanics. In the same line of thinking, *Le peintre et son modèle* (Musée National d'Art Moderne, pl. 4) is the work in which these two movements come together and confront each other, the one bringing him closer to the figurative, the other carrying him further away, nearly contradicting each other in the same painting.

Matisse has obviously reached the end of something. If it remains clear that his art undergoes a transformation, the precise reasons urging this transformation are much less obvious. As a hypothesis suggested by the paintings we have in front of us, one can imagine that he used up the language he elaborated between 1904 and 1915, and that he wanted to find a way out of it; he was looking for several ways out. Three paintings from 1919 offer a particularly explicit example of this quest and the resulting disjunction: *Le torse de plâtre, bouquet de fleurs* (pl. 26), *Bouquet de fleurs pour le 14 juillet 1919*, and *La chaise aux pêches* (pl. 25). In these three important paintings that we would so much have liked to bring together here, he takes up for the last time the motif of a wall hanging, with its forceful blue arabesques, already used in several earlier canvases, particularly in two chef d'oeuvres from 1909, *La desserte rouge* and *Nature morte camaieu bleu* (both in the Hermitage in Leningrad). But the manner in which he proceeds in 1919 is radically different from that of 1909. In *La desserte rouge* or *Nature morte camaieu bleu*, this hanging is a motif that is both the decorum and the unique space of the painting; it is projected to the foreground, and is practically the only plane of the painting into which all other elements must be integrated—it is, in and of itself, the whole world of the painting. Ten years later, this same motif is pushed to the background.

Matisse begins reinstituting a depth, a three-dimensional space in which he is going to situate objects that will be, for the first time in years, distinct from their background. And it is not by chance that Matisse uses this arabesque-covered fabric as a repoussoir. With this fabric he deliberately and progressively pushes his own recent past into the background in order to establish, by trial and error, a different painting. By using the same accessories but for different ends, he gives himself familiar points of departure and return; at the same time, he puts himself in a position to mark out his path and to assure himself of the well-founded nature of each stage. We have already said that nothing is easy for him. Thus the bouquet of flowers in the painting of 14 July 1919 is still poorly detached from its background, awkwardly inserted in space; thus the volume of the plaster torso in the São Paulo painting produces a violent contrast with the background of blue arabesques, revealing still unresolved contradictions; only in *La chaise aux pêches*, by far the most beautiful of the three paintings, is created a faultless whole in which the still life and its background dissolve together into a common, nearly velvet space.

The years 1916–1919 are when Matisse forcefully brings together all he knows about painting: his own work and that of his predecessors. He draws from himself in all manners possible, as we have seen, and will undergo several displacements in relation to himself. But he also calls upon himself the resources of great western painting: he will go resolutely back to and beyond Cézanne to the roots of his culture as it was realized by the French masters of the nineteenth century—Ingres and Courbet, and especially Manet (which leads to the masterpiece, *La table de marbre rose*, pl. 30). He introduces blacks and earthen colors to his palette that were not there before, and, simultaneously but in the opposite direction, colors that are faded and thinned out, pale greens and yellows, light purples to which he had not

accustomed us. Matisse's search for a new space, simultaneous with his search for a new chromatic definition, cannot be better summarized than in the 1917 triptych *Les trois soeurs* (fig. 3, p. 17), which is in the Barnes Foundation, as are so many other pre-*niçoise* and *niçoise* masterpieces. However figurative it may be, this composition, both novel and modern, concedes nothing to the production of the ten previous years. The swirling complexity of the organization of its spaces, the opposition between its flat surfaces and areas of depth, the extraordinarily inventive variety of the placement of characters on each of the three panels, the novelty of the color relationships (the unceasing play between light and dark, the opaque and filtering zones), all contribute to making this crucial work wonderfully captivating. Moreover, the principal pictorial contribution of the *niçoise* period is inaugurated magnificently by this canvas painted in Issy-les-Moulineaux; this new contribution is, again, not the reappearance of the figure, but, rather, the statement of a new unity and a new surface stability through the use of light.

In what manner did Nice have a decisive influence on Matisse's art? Could what happened to his art between 1917 and 1930—when he lived in this city, this site, its ambience, not to mention its light—have taken place elsewhere? Nice did nothing but propose a physical site for the series of mental operations that were started before Matisse settled there, and which would have happened anyway in his painting, wherever he might have been. But it is also clear that once the process began, his painting would be affected by Nice and the air he breathed there, just as the impressionist revolution, a mental operation if ever there was one, took for its object what the painters who accomplished it had in their eyes: the light of Ile-de-France. Great painting has never been a reproduction of the site in which it was painted, but it has always been impregnated with all the elements that compose this site. This was true before Matisse, and his art, more than many others, is confirmation of this principle. All the major pictorial decisions in his work have relied upon a real site, and these decisions work on a precise place in physical space, one in which he is momentarily settled, and one which is chosen or accepted only by virtue of the stimulation he instinctually expects from it. Thus Saint-Tropez, Collioure, Morocco, the Paris workshop, the house and workshop in Issy have had this quality for him. Nevertheless, the source of the painter's art does not reside in the site in which he paints; the source is the interior necessity of the artist, regardless of place. The site does nothing but offer its particular riches to the painter, to be used or not, depending on what he needs at the moment and how receptive he is.

It was the perfect time for Matisse to visit and, then, later, to settle in Nice. Three years earlier such a journey would have yielded nothing because Matisse was not yet questioning himself as he would in 1917—the painting then is flagrant proof of this. That Matisse, at a moment when he felt the need to reformulate his painting, started looking for new places and that Nice retained his interest should not be a surprise to us. Nevertheless, his stay in Nice is unlike earlier migrations. Let us say first that this migration will be his last—Matisse will not move elsewhere. All the same, in Nice itself, Matisse, forever dissatisfied and searching, will move several times again—Hôtel Beau Rivage, Hôtel Méditerranée, Villa des Alliés, the third and then the fourth floor of the place Charles-Félix (without forgetting diverse short-lived workshops, from a small room to a large garage). To this we must add, after the period that concerns us, the two grand residencies at the end of his life: the Hôtel Regina overlooking the town and the villa in Vence. The list is really impressive. One should also mention the summer visits to Paris, and several trips or longer stays in other places. Hence, in some respect, Matisse is more than ever flitting from branch to branch. Each one of these sites can be identified in his painting. Each new frame proposes a novel sum of sensory stimulants that he uses completely, with extraordinary voracity, and which he transposes to the surface of the canvas in a series of successive explorations that are so many spatio-luminous formulations.

Today we are in a position to look calmly at the entirety of Matisse's career. We still have a tendency to forget the sum of unceasing experiences and the self-interrogation upon which his career was built. Seeing nothing but the accomplishments of his oeuvre, we have a tendency to forget that each stage is tied to an implantation in a new site, itself consequent upon an uprooting from a previous site, and that this supposes great courage as it also implies much anguish. One should remember that Matisse, upon arriving in Nice at the end of 1917, was nearly fifty years old. He is then already considered by the cognoscenti as being one of the two great masters of the twentieth century. He has reached a state of material comfort, he has a family, and he has organized a whole life-style for himself around the workshop in Paris and his house and workshop in the suburbs. He occupies an important position in French and international intellectual life; nevertheless, he leaves all that behind and settles, *alone,* in a modest hotel room that one would imagine better suited for the beginnings of a young artist. In keeping with this are his first *niçoises* paintings, which are poignantly modest, though deceptive. The titles—*Ma chambre au Beau-Rivage* (pl. 47) and *Intérieur à Nice* (pl. 48)—name a modest empty space, a nearly total bareness, but these titles do not tell the essential: that this *chambre,* in the painting, is a box of light.

In 1919, although having stayed in Nice several times, he is still painting major works in Issy-les-Moulineaux: *La chaise aux pêches, Le thé dans le jardin* (pl. 31), and *La table noire* (pl. 29). *Le thé dans le jardin* is, in its own way, a recapitulation of the past, composed in the manner of Matisse's then-present mode of research. Recapitulation of the past because one finds the marble table put back on its horizontal plane and at its real depth in the space of the garden. This is the same table that, two years earlier, he had so inventively (and nonfiguratively) verticalized in the foreground of *La table de marbre rose,* before this painting became the background of the right panel for the triptych *Les trois soeurs* (pl. 19). *La table de marbre rose,* being, if you like, a Matisse within a Manet, a nonfigurative plane in a figurative universe, is the statement of a hesitation between two manners, a statement exquisitely integrated into the surface of the painting. This is Matisse's dilemma in 1916 and 1917, a dilemma that will open out into the paintings of the following years, the so-called *niçoises.* This dilemma will only be resolved through the act of painting. In 1919 he begins to find a way out: in *Le thé dans le jardin* the table is given back its status as figure, and the whole painting details for the first and last time the space of the Issy garden that Matisse had synthesized time and time again—a garden often extremely difficult to recognize and interpret in a number of paintings from the ten previous years. In 1919, there is a kind of intimate unveiling, an explication of things, a farewell that borrows from impressionism (but a contradictory impressionism, since it uses earth colors!) as much as from Bonnard. But Matisse composes this past—an old site in his life he delivers to us once and once only "as it is"—through the screen he has been attacking for nearly two years: the use of light. A light that replaces the architectonics of color, a light that is nonimpressionist and nonexpressionist and that becomes the major pictorial development as well as the very subject of the years 1917–1930.

It is undeniably in Nice that he progressively puts the finishing touches on this abstract pictorial light. It is even probable that the precise physical identity of the light in Nice—its nearly touchable reality, its omnipresence and permanence—furnished him not only with a decisive impulse but also with a point of reference, a stimulant for the mind, a unit of measure, as well as a challenge. But it is also equally clear that this light is the principal subject of works painted outside Nice, in Paris, in Issy, or in Etretat during these same years. Normandy's light would nourish his painting and be applied to the canvas in the same manner as that of Nice, but its tonality would be different simply because the natures of the two lights are not the same. The veil of light Matisse obtains in the three large canvases of the Etretat cliffs (pls. 110, 111, and 112) does not have the same texture as the light that pervades *Grand intérieur, Nice* (pl. 100) or *Anémones dans un vase de terre*

(pl. 143). But in each case it is the light, independent of the colors used, that makes these paintings hold together; it is the light that gives them their unity and is the object of Matisse's research, as well his means of liberating himself from the work of the years 1904–1916.

From 1904 to 1916 Matisse elaborated an architectonics of color, whereas from 1917 to 1930 he moves to an architectonics of light. In the 1904 to 1916 period Matisse paints with and through color. He gives forms body with touches of color, enlarges them into zones of color, and expresses relations between forms through flat color relationships. He expresses spaces through large areas of juxtaposed colors and goes so far as to express the world in a unique space, rendered by a single plane in a single color in which forms—scraped or in reserve—are (tolerantly) immersed. In this context lines no longer have the role of containing or delimiting forms, but, running across the color, indicate tensions that are precisely not contours. For twelve years, then, Matisse elaborated and perfected this new language, this new breath, with unequaled audacity, while retaining clarity and self-evidence. The architectonics of light that is going to replace this breathing with and through color is an attempt at abstraction no less grand, an effort no less concerted to reinterpret the world. His new, chromatic approach will consist of scattering a myriad of diverse colors on the canvas (it should be noted that only a colorist of the caliber of Matisse could produce these colors, let alone put them together on the same surface). In this first period in Nice, Matisse is still the greatest colorist of his time. The multitude of colored elements is held together and forms a coherent fabric through the grace of a unity of light. A kind of supreme plane of light pervades and unifies the otherwise implausible diversity of colors (diametrically opposed to the spectrums of realism or naturalism). This unique luminous plane, an architecture without pillars, is so strong that it achieves the annihilation of the third dimension of space—the depth of perspective that Matisse will nevertheless reinstate.

This light is not necessarily white, or golden, or silver. It is without color, the neuter, the one—it has something hard about it, because it proceeds from an intense mental asceticism. It also has something soft, because it expresses the unison in the world. It is even sometimes black, as in *Intérieur au violon* (pl. 50), in a prodigious inversion of itself that renders light even more abstract while strengthening its presence. This light is not imposed, but gives the various subjects a sense of relatedness by absorbing whatever figures enter Matisse's painting. This is as true of the odalisques as of the still lifes, of interiors as of landscapes. *Odalisque aux magnolias*, for example (pl. 162), perhaps the most beautiful odalisque Matisse ever painted, is a luminous transfiguration, a veritable upheaval, through the use of light, of a subject otherwise ridiculously banal, formless, and tired. *Anémones dans un vase de terre*, the incomparable still life, is a culmination of chromatic intensity that even Redon would not have attempted. Matisse advances an amazing stridency in this still life. The bouquet is a kind of delirium withheld and released by the light in which the elements of the painting float—creating, again, a kind of spatial light. The same goes for his landscapes. It is difficult to imagine a more chromatically scattered surface than that of *Fête des fleurs*, for example (pl. 107), and yet the myriad spots and gestures of color are resolved in creamy light that is the very type of invention Matisse accomplishes during this period.

During these years in Nice, Matisse applies light into the very hollows of bodies. But this allover light is extremely difficult to achieve: it implies a balance between extremes and calls for complete resourcefulness on the part of a colorist who must simultaneously invent innumerable color unities that will translate elements of the painting and watch over the luminous connections that will render these chromatic unities plausible. This process is necessarily simultaneous. He must paint this fragmented color and totalizing light in one and the same gesture, searching for the point of balance in a dramatic all-or-nothing effort. Matisse, for reasons we will come back to, paints many canvases during these years; he is painting continually, but the total resourcefulness his method requires then cannot be equally sustained. When it is not, surfaces lose their tension and the painting fails; subjects

reassume their heaviness and banality. These cases of failure are not infrequent during Matisse's first years in Nice. This pursuit of light is, at least until 1925, his most serious pursuit—his particular stubbornness in Nice—and it must pass through several itineraries. One itinerary is to push the color to extreme intensities. In the bouquets of anemones, a prime example, the flowers can be either densely concentrated into an area of the canvas, or separated from each other at the ends of long stems projecting intense firelike colors into space (as, for example, in *Anémones et vase chinois* in the Baltimore Museum of Art). In each case Matisse immerses this fire, dense or scattered, in a greater luminous space that commands and immobilizes the radiance. Another manner consists in uniformly flooding the surface with colored events, sufficiently large to be identifiable and to fit (unrealistically) an object, but also sufficiently limited in size so that one carries no more chromatic weight than another. When he proceeds in such a way, cushions, flowers, wall fabrics, women's bodies, bedspread, table, mirror, rugs are as much different chromatic events as they are different planes, unified by the equal light emanating from each of them. This relies upon Matisse's invention of a luminous conception of color. It also happens that the color on the canvas is diluted to an extreme, to the point that it is no more than a thin washed-out film (for example in *Nu au peigne espagnol, assis devant une fenêtre à voilages*, pl. 85). When color is no more than tinted air like this, one could say that Matisse is working with a chromatic conception of light.

Color, painted color, this shimmering from the years in Nice with hardly an equal in western painting, is not the only channel through which Matisse explores light. He advances on several fronts at once. It should not be forgotten that he is also drawing prolifically during these years, and that his engraved oeuvre is considerable in size. Matisse works light through black and white in his drawings and lithographs in the same way he reaches light through color in his painting. The lithographs are of two orders: some can be called linear and attain a calligraphic allover quality—in *Arabesque* for example, or *Odalisque voilée*, the inventiveness of the line weaves a very warm and gray network, a free network of light, that literally creates light on the page; others are constructed on a system of accentuated chiaroscuro, white bands/black bands, a system of luminous shadows—*Grande odalisque à la culotte bayadère* and *Le renard blanc* are the most beautiful examples and as strong as any of the paintings. A very intense light emanates that is unrelated to the subject represented, is without connection to any figure, detached like an independent entity. The striking charcoal drawings from this period correspond to the aesthetic of these lithographs—such as *Femme étendue, châle espagnol* in the Baltimore Museum of Art, or *Jeune femme à la guitare* in the Art Gallery of Ontario. These large imposing sheets of paper articulate an architecture of light—absolutely symmetrical with that of contemporaneous paintings—built upon a play between blacks, whites, and shading. To be complete, an appreciation of Matisse's work must include these drawings and lithographs.

Expression through light is not the only characteristic of Matisse's painting in this first period in Nice. Another original trait is his treatment of space. The actual space Matisse depicts is frequently one of the hotel rooms that were his studios, and, later, rooms of apartments in which he lived and painted. More often than not, Matisse includes a window in his view of the room, which might be open or closed—it might also have louvered shutters, drawn or half-drawn, filters of light with which he may or may not play. And then there can be, or not, the additional, and unmistakable, presence of the sea through the window or past the balcony. All resemblance to a known site stops there. In this framework, Matisse will invent all kinds of spatial schemes that the prosaic reality of the site could in no way portend.

For example, the rooms often have a piece of furniture—the dressing table/desk—equipped with an oval mirror. With the help of this precious yet very ordinary mirror, Matisse is able to transform a simple space into a complex one: he not only gives us the

normal view of the room (what we would see in the position of the painter), but also the added, unexpected, view of another part of the room, caught in the reflection of the mirror. Thus in *Vase de fleurs sur la coiffeuse* (pl. 78), the close-up of the flowers and the mirror would give us a closed-in space if the mirror's reflection of the bed in the distance did not add depth and volume to the scene. In *La séance de peinture* (pl. 77), the background we look at is a large black area, very subtly pierced by the sight, reflected by the mirror placed in the center, of the sea and a palm tree that are behind us. In *Anémones au miroir noir* (pl. 79) he does exactly the opposite: there where we expect the reflection of something outside the frame, the mirror's glass is a black oval reflecting nothing but its own abstract light. In other even more exciting and subtler cases, the space reflected by the mirror in a given painting—we could call it supplementary and indirect space—is not fully explicable except through space that is directly figured in another painting. Thus the red tiling reflected in the mirror of *Intérieur au cahier noir* (pl. 72), hardly actually visible in this painting, is, "in reality," the tiling explicitly depicted in another view of the same room, the painting *Intérieur à la boîte à violon* (pl. 71), in which the mirror, this time, is neutralized, black, and mute.

In another novelty from this period, Matisse's eye seems to proceed like a camera, engaging in a long traveling from canvas to canvas, going from a close-up to an increasingly distant view (or the inverse), showing a part of the scene and then the whole scene, varying the angles of the points of view. Since each different sequence consists of a single canvas, one would have to reunite all of them in order to complete the cinematography of his pictorial universe. This is precisely what his oeuvre has become to us as we have been preparing this exhibition of Matisse's early *niçoise* period: a tight and coherent cinematography, despite its inevitable ups and downs in quality. It has been a fascinating job to put the sequences of this film end-to-end, from dispersed parts of the globe, because we had the feeling we were following the same paths as the artist—as if penetrating his mind, behind his eye, able, finally, to understand his vision by reconstituting the continuity of his life's work. A cinematography and, hence, a rather dramatic genealogy: one painting being the child of another and the parent of a third, going from event to event—sometimes from event to failure, but a failure is still an event. The purpose of this exhibition, then, was the attempt to reassemble these pairs, these series and families, because it appeared fundamental to bring them back together: this alone would allow us to grasp the how and why of Matisse's painting in Nice. Only by taking away from each of these paintings the character of an accidental and isolated production are we able to restore the working of the artist's eye and the interior necessity of his art. Unfortunately, no exhibition with this purpose can be a total success; for countless respectable and justified reasons, permission to borrow certain paintings could not be obtained.

Les persiennes (*The French Window at Nice*, The Barnes Foundation, fig. 19, p. 24), for instance, is one of the unobtainable masterpieces. It encompasses the amplitude and near solemnity of the attempt, as well as the level of accomplishment Matisse reaches during his first years in Nice. In Matisse's circle this large painting (130 by 89 centimeters, 51 by 35 inches) was nicknamed "the cathedral." The model Antoinette is seated in the center of the space of the room. The window is open but the shutters are closed, or near closed, except for one half-open panel, through which some natural light passes. But the real light is not the natural light, it is a light that is entirely recomposed. Matisse's light is pictorial. Just as he "pretended" with the oval mirror, he "pretends" with these exquisite shutters whose thin adjustable slats filter the light and allow for unending modulations of it. To modulate light is to modulate space, for the space here is nothing but light. Once again Matisse would deceive us if we were not attentive: *Les persiennes* is not a realistic representation of a hotel room in Nice, but the symbolic representation of a mental light. This light is as much in the bedspread's blue and yellow stripes as in the floor's violet, the model's red panties, and the black chair; it pretends to filter (green) through the wooden

slats (gray-blue) of the shutters. In fact, in the only reality that counts here—which is pictorial—this light is a totally abstract whole that does not come from the outside. This whole is the product of the ensemble of colors brought into play on the canvas, a compelling kind of creamy and immaterial blue that is included nowhere in a realistic view of things. This spacious blue—which is not preconceived—is contained only in the result, which is to say at the extreme point of the attempt carried out in the eyes of Matisse.

If we go back to *Grand intérieur, Nice,* which may be considered a matching piece to *Les persiennes,* what difference do we see? The shutters are open this time; the model is outside the room, moved off onto the balcony; one can picture the sea, or rather the blue wall blocking off the horizon at the end of the painting's perspective. But what difference in terms of light is there between these two paintings? None. In the sense that, blinds open or closed, this light is always an immense mental space; it is not the light of the sun, but Matisse's elaboration of light. In the case of *Grand intérieur, Nice,* the light even becomes a kind of second space that embraces and, in a way, annuls the space of the first degree which itself is treated in a highly unusual manner. One begins with a view plunging down onto the foreground, the armchair, and the dresser (as if Matisse painted this part from the top of a ladder); then the eye looks up in an abrupt and contradictory manner toward the open window, the model seated on the balcony, and, instead of a beyond, one sees a wall: the sea.

In a number of other canvases, *Le paravent mauresque* (pl. 117) for example, Matisse treats space in a completely different manner. Here he abandons the window and the shutters, thereby abandoning the illusion that the light—his subject—could come from the outside. He reconstructs, inside the room in which he is painting, an entirely artificial space, excessively full. In a decor of wall fabrics, partitions, and rugs, Matisse abandons the everyday physical world, that of the ordinary hotel or apartment room, to isolate himself in his own world, a world entirely recomposed and, as it were, ready to paint. In sum, in this last category of paintings, the transfiguration begins even before the act of painting. In *Les persiennes* or *Grand intérieur, Nice* one can say that he was painting the room "as is," the luminous transfiguration intervening on the surface of the canvas only, and in the stages of painting, during the act; in *Le paravent mauresque,* on the contrary, Matisse transforms his workshop into a painting even before the act of painting it; thus, in this borderline case, his painting is no more than a "reproduction" of the already transformed. Each square centimeter here is an entangled density of color motifs without precedence. All is nothing but decor, there is no more air. A model, sometimes two, often an odalisque, is there more like a fish in a fishbowl than a human being in space. A bouquet often comes in to occupy the little volume left between the floor and walls, overloading even more the surface of the canvas. Here the linear apparatus is spineless, there is practically no line left. It is the painting's medley of colors that holds the ensemble together, and produces light: structure and meaning. A light without air.

In the end, all of Matisse's research during these first years in Nice arrives at a new unity of the surface: human beings and objects are not treated differently than floors or walls on the painting's surface. Matisse progressively abolishes all pictorial distinction between the apparent subject of his paintings (a woman reading, or a bouquet of anemones) and the background of these same paintings. He resolves this subject-background distinction in terms of space, as we have seen, and resolves the problem of space in terms of light. Each parcel of the painting's surface is a site of color, whether it represents lemons or a woman's body or part of the room's wall; and each site of color becomes a source of light that, combined with all the other sources of light on the canvas, create a wholeness of light and space. Nevertheless, one work from the winter of 1925–1926, *Figure décorative sur fond ornemental* (pl. 168), breaks with this method and brings the problem of the background into full question again. Schematically, this painting represents a highly sculptural, and even architectural, nude that Matisse intentionally detaches

from the background against which it is seated.

The title of this painting is itself an enigma in that it reverses the commonly held meaning of the word decorative, calling for a reconsideration of this category—a Matissian category par excellence. The decorative is not the decor! The figure holds itself against the decor, but it is the figure that is decorative, the decor is only ornamental. The decorative is a fundamental category in Matisse's work, it is and always has been for him the stage that determines whether or not a painting can be considered accomplished. But the path Matisse takes to arrive at the decorative varies according to different periods of his career, and the content itself of this notion varies according to these periods. In the course of the *niçoise* period Matisse reconsidered the terms of this category several times, and *Figure décorative sur fond ornemental* is obviously a new development in his thinking. Here, the decorative is a strongly accentuated volume. It is not an architectonics of light as before; it is an architecture of forms, supported by a system of very firm and structured lines. The decorative, in this painting, is a sculpture isolated from its environment, separate and distinct, a presence without ambiguity, distracted from a space that is more ambiguous than ever.

Once more, Matisse was still advancing simultaneously toward several points on the horizon. While he was elaborating his spatial light, the luminous flatness we have discussed at length here, he would continue to treat the question of volume and, toward this end, practiced sculpture. The major sculpture from these first years in Nice is *Grand nu assis, bras levés*, which evolved during two years (1923–1925). Relying on this sculpture, *Figure décorative sur fond ornemental* is the brutal reinsertion of volume into space, and, moreover, the most "*niçois*" space Matisse ever dared paint. Never before, in fact, during the years in Nice, had Matisse produced a space more compact, saturated, or complex. It is compact to the point of leaving almost no depth for the figure—which must, so to speak, force a place for itself in the ornamental overlapping. It is saturated in the sense that there is not so much as a millimeter on the canvas that is not covered with an ornamentation brought here to a kind of delirium. It is complex because at least six different ornamental motifs are put into play on the painting's field (the hanging in the background, with a baroque Venetian mirror in the middle; the flowerpot's blue porcelain; the floor, composed first of parallel lines, then the highly interlaced rug; and, finally, on the right, a vertical plane, the back of a chair perhaps, of yet another texture). The result is an ornamental whirlwind contrasting the rigidity of the decorative figure. The different motifs are constantly cut off, either one by another, or by the frame, or by the figure. The floor is not horizontal, and it is hardly distinct from the wall. *Figure décorative sur fond ornemental* is really an extreme—or rather two extremes in the same painting—and like a culmination of pictorial space proper to that moment in Matisse's art. Other paintings in the same vein would follow, though they are not nearly as farsearching.

The last years our exhibition covers will see Matisse evolve again. The chromatic elements distance themselves from each other, the fabric of colors loosens up, and the surface is cleared out—the move to the fourth floor of the place Charles-Félix, a space much more open than those Matisse lived in until then during his period in Nice, is certainly linked to this evolution. Parallel to his painting, Matisse undertakes an important series of etchings and drypoints devoted to the *niçois* themes again while inaugurating a new approach: the black line on the white of the page will alone create all nuances in color as well as the force of light. This is the meaning of the work of the following years, beyond the period we have been considering here—reaching the point at which it is light itself, mastered from 1917 to 1930, that engenders color—but this is the continuation and reversal of a story that will not be interrupted until the artist's death.

We hope to have given an image of Matisse in the years 1917 to 1930 that is truer to reality than the comfortable and deceptive cliché generally admitted. We hope to have

shown a Matisse at work, looking to renew his art, finding novel solutions—and sometimes failing in his quest. We think the true figure emerging from an attentive examination of his work is diametrically opposed to "le peintre du bonheur" that he in fact never was. He is a troubled artist and his painting is not quiet. He works with muted insistence, comes back to the same problem time and time again, gives way to the universe of his painting only, and isolates himself in it. Obsessions filter through and anguish emanates from the succession of images these fifteen years of painting offer us. The depicted world is one of waiting and sadness; a world of a heavy eroticism, almost a world of the voyeur. A distant world, in which communication seems impossible, or futile; besides, beings have become painted things in this world, color events in view of obtaining light on the painting's surface—they are dispossessed of all but their chromatic lives. The world of these first years in Nice is a world behind glass—the world in a fishbowl, the world indefinitely repeated in a kind of insistent existential loss. As if the light one had to obtain resulted in nothing but solitude, and demanded a fatal renunciation.

Translated by Joseph Simas

Il y a tant de choses que je voudrais comprendre, et surtout moi-même—*après un demi-siècle de dur travail et de réflexion ce mur est toujours là—la nature ou plutôt* ma nature *reste mystérieuse—cependant je crois avoir mis un peu d'ordre dans mon chaos, en gardant vive la petite lumière qui me guide et répond encore énergiquement aux S.O.S. assez fréquents. Je ne suis pas* intelligent.

There are so many things I would like to understand, and most of all *myself*—after a half century of hard work and reflection the wall is still there. Nature—or rather, *my nature*—remains mysterious. Meanwhile I believe I have put a little order in my chaos by keeping alive the tiny light that guides me and still energetically answers the frequent enough S.O.S. I am not *intelligent*.

Unpublished letter December 1938,
Henri Matisse to George Besson
Translated by Jane Sweeney

Album of Colorplates

This panoramic view of Matisse (1916–1930) contains 188 colorplates of which 171 are reproductions of the paintings in this exhibition. The Album, as a different way of looking at the artist, presents new painting images and, ultimately, a new image of Matisse. Many rarely seen or underappreciated paintings, as well as his most famous works from these years, are organized and presented here in color; fifty-three works are reproduced in color for the first time in Matisse literature.

In this Album the works are grouped by subjects and attitudes. We hope to recapture the vitality of the artist, his repertoire of forms, his creative dialogue. The Album plates are in a loose chronology; the Catalogue is more strict in chronological arrangement. Plate numbers and catalogue numbers are reconciled in the Concordance that follows the Select Bibliography. Any painting not in the exhibition is marked in its Album caption with an open square □

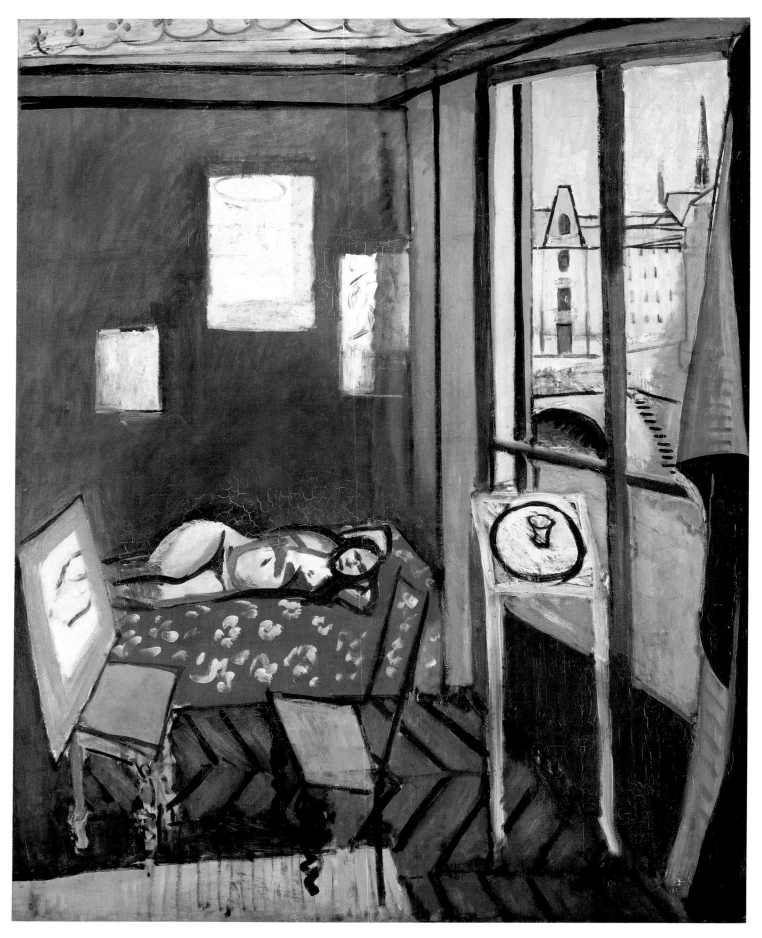

Pl. 1. *L'atelier du quai Saint-Michel*, 1916, 146 x 116 (57½ x 45¾). The Phillips Collection, Washington

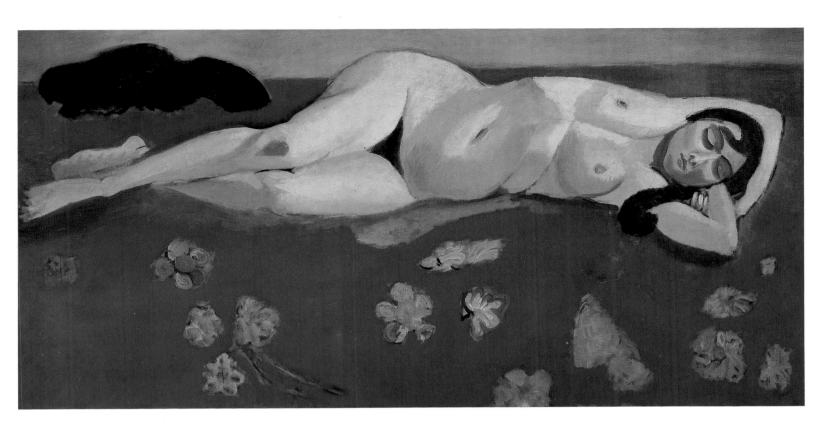

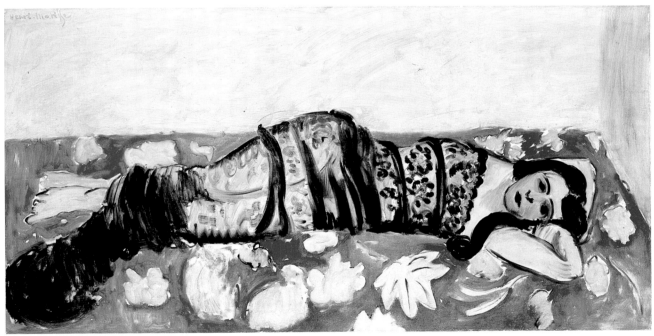

☐ Pl. 2. *Lorette allongée sur lit rose*, 1916, 95 x 196 (37⁷/₁₆ x 77³/₁₆). Collection Stavros S. Niarchos

☐ Pl. 3. *Lorette allongée enveloppée dans un châle*, 1918, 67.3 x 129.5 (26½ x 51). Norton Simon Art Foundation

61

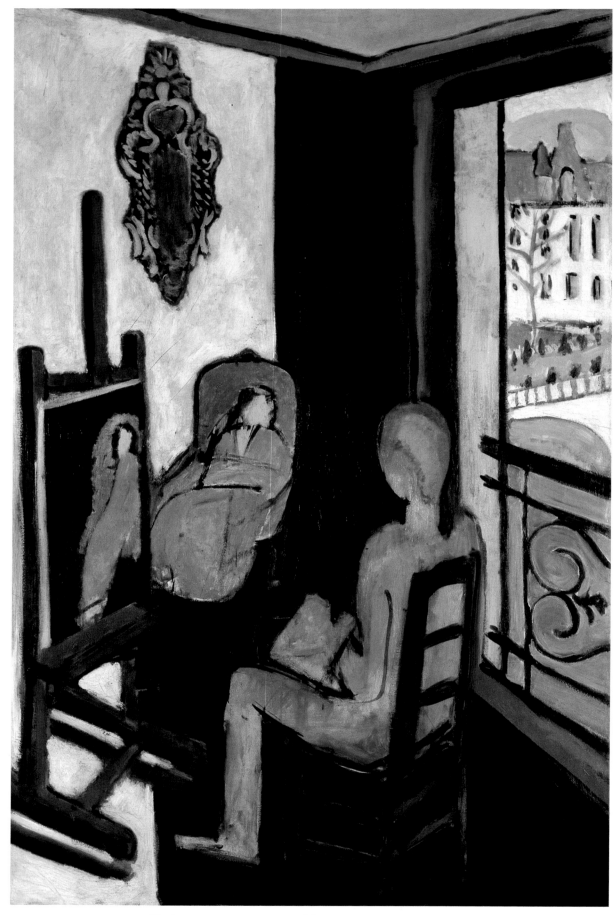

□ Pl. 4. *Le peintre et son modèle*, 1916, 146.5 x 97 (57⅝ x 38³/₁₆). Musée National d'Art Moderne / Centre Georges Pompidou

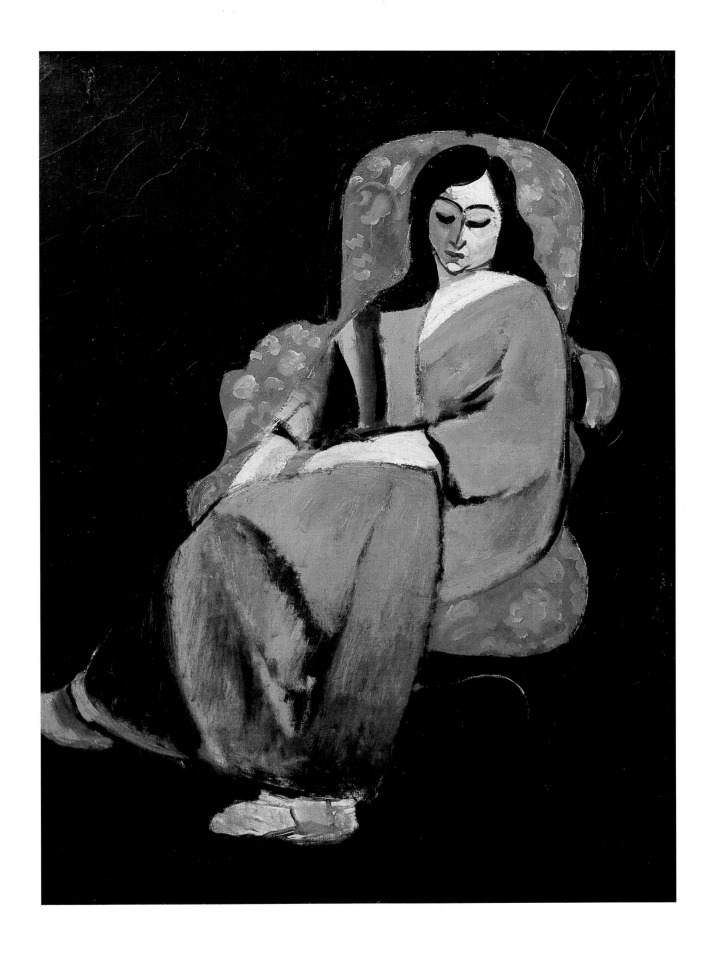

Pl. 5. *Lorette sur fond noir, robe verte*, season 1916–1917, 73 x 55 (28¾ x 21⅝). Private collection

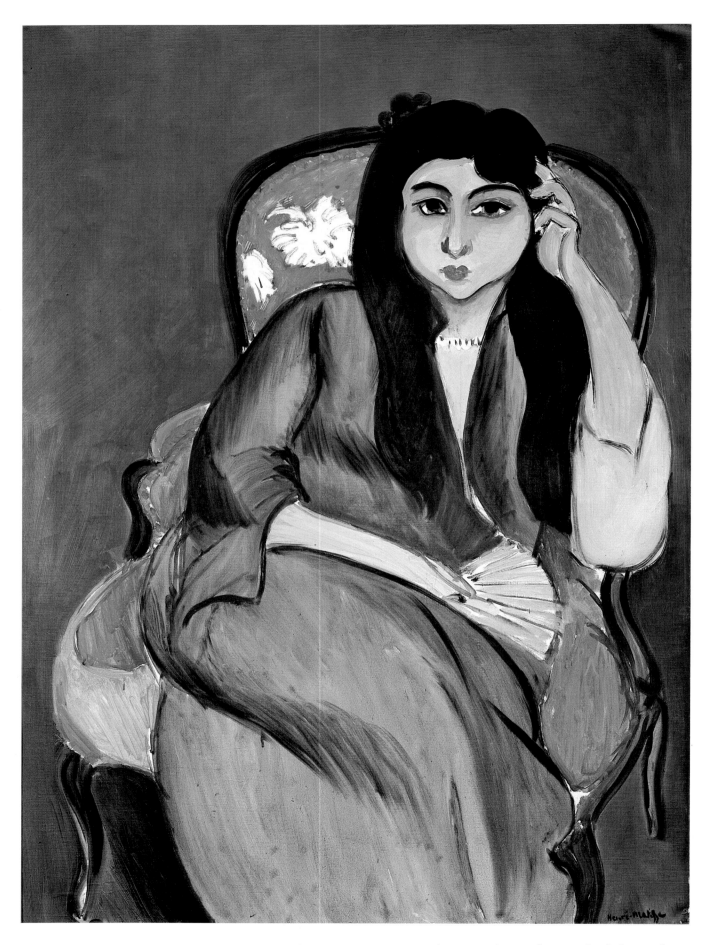

Pl. 6. *Lorette assise, bergère rose,* 1917, 100 x 73 (39⅜ x 28¾). Dr. and Mrs. Paul Hahnloser, Fribourg

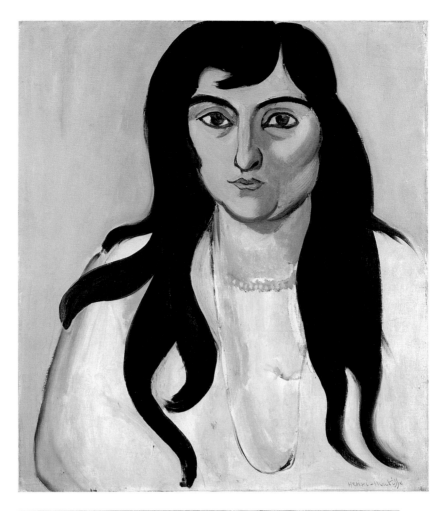

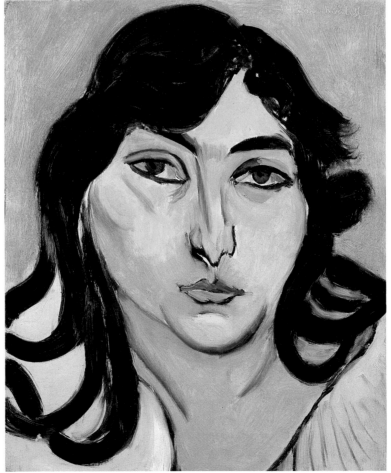

Pl. 7. *La femme au collier d'ambre,*
1917, 45.5 x 36.5 (17⅞ x 14⅜). Pri-
vate collection

Pl. 8. *Tête de Lorette aux longues
boucles,* 1916–1917, 35 x 27 (13¾ x
10⅝). Norton Gallery and School
of Art, West Palm Beach, Florida

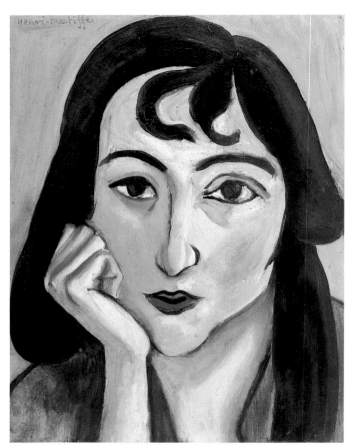 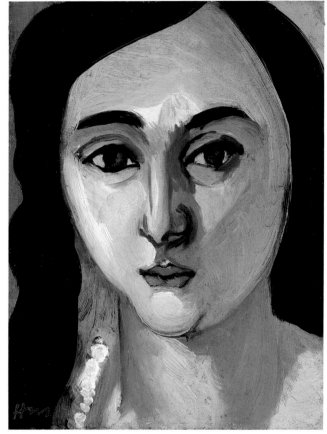

Pl. 9. *Tête de Lorette aux deux mèches*, 1917, 34.9 x 26.4 (13¾ x 10⅜). Mr. and Mrs. William R. Acquavella, New York

Pl. 10. *Tête de Lorette*, 1916–1917, oil on panel, 22 x 15 (8⅝ x 5⅞). Private collection

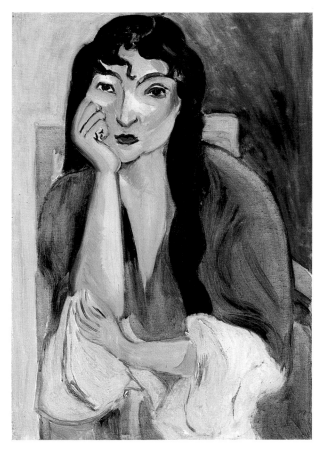

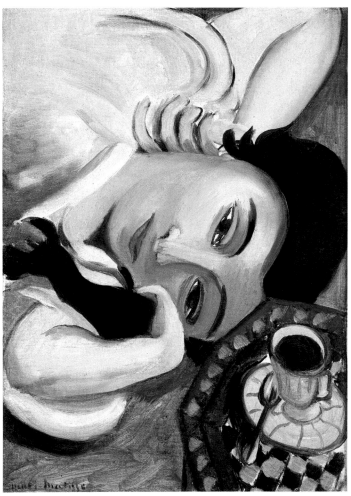

Pl. 11. *La méditation, Lorette,*
1916–1917, 49.5 x 34.3 (19½ x
13½). The Museum of Fine Arts,
Houston, Gift of Miss Ima Hogg

☐ Pl. 12. *Lorette à la tasse de
café,* season 1916–1917, 66 x 43 (26
x 16¹⁵⁄₁₆). Private collection, cour-
tesy Marlborough Fine Art Ltd.

67

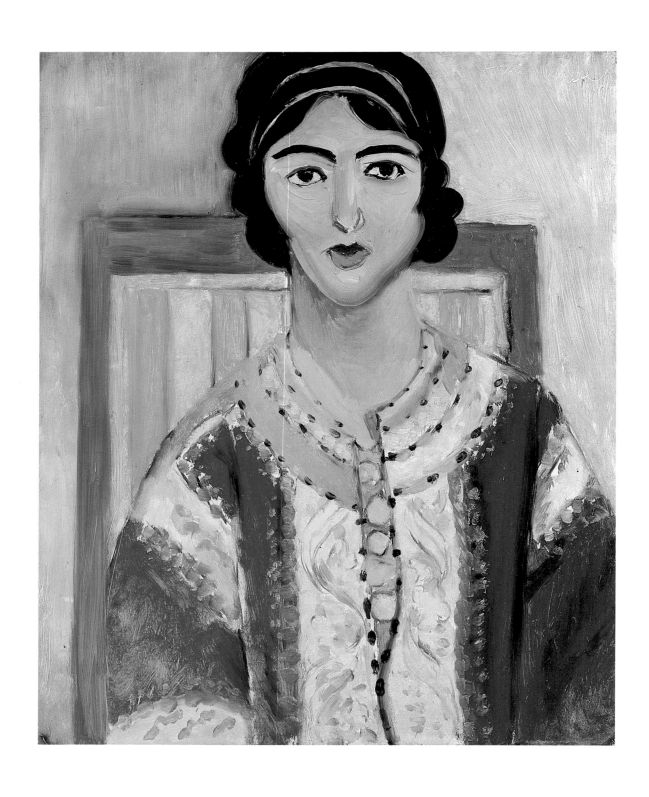

Pl. 13. *Lorette à la veste rouge*, season 1916–1917, oil on panel, 46.4 x 36.2 (18¼ x 14¼).
Columbus Museum of Art, Ohio: Gift of Ferdinand Howald

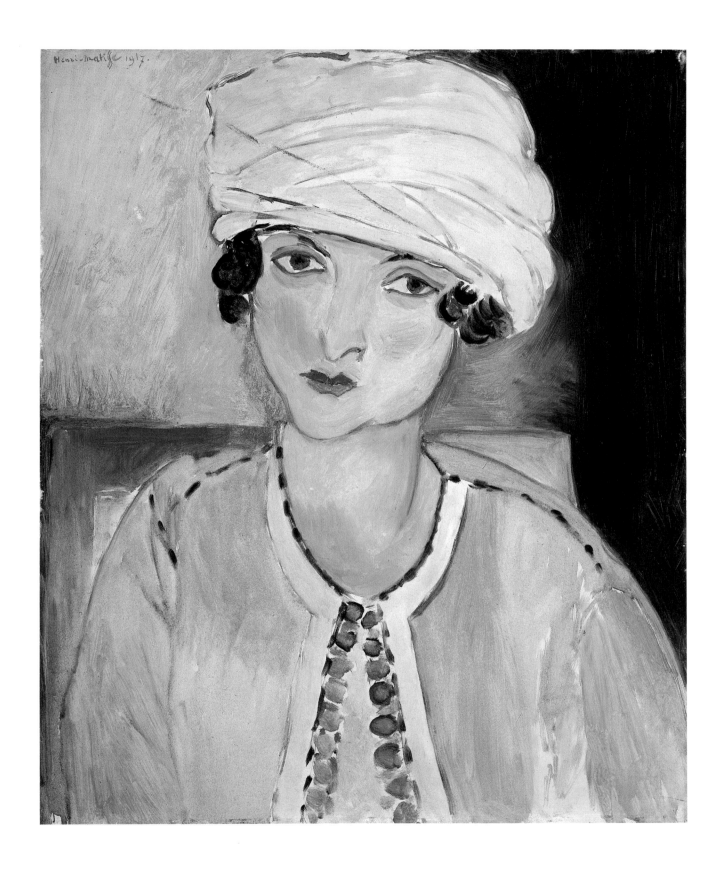

Pl. 14. *Lorette au turban, veste jaune,* 1917, oil on board, cradled, 61.3 x 49.5 (24⅛ x 19½). National Gallery of Art, Washington, Chester Dale Collection 1963.10.39

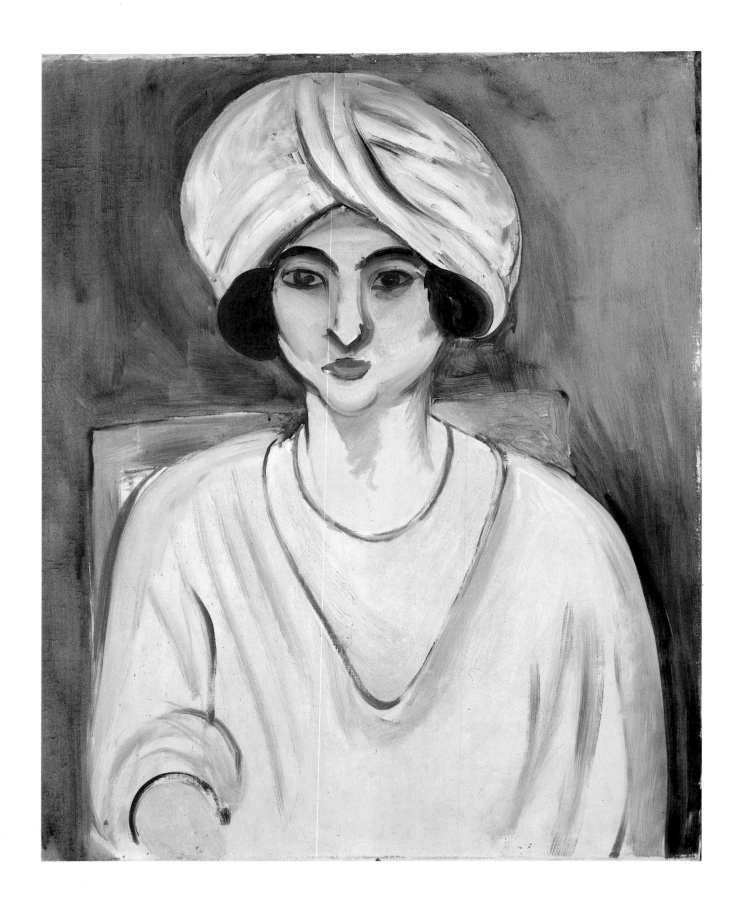

Pl. 15. *Femme au turban*, 1917, 81.3 x 65.4 (32 x 25¾). The Baltimore Museum of Art: The Cone Collection, formed by Dr. Claribel Cone and Miss Etta Cone of Baltimore, Maryland. BMA 1950.229

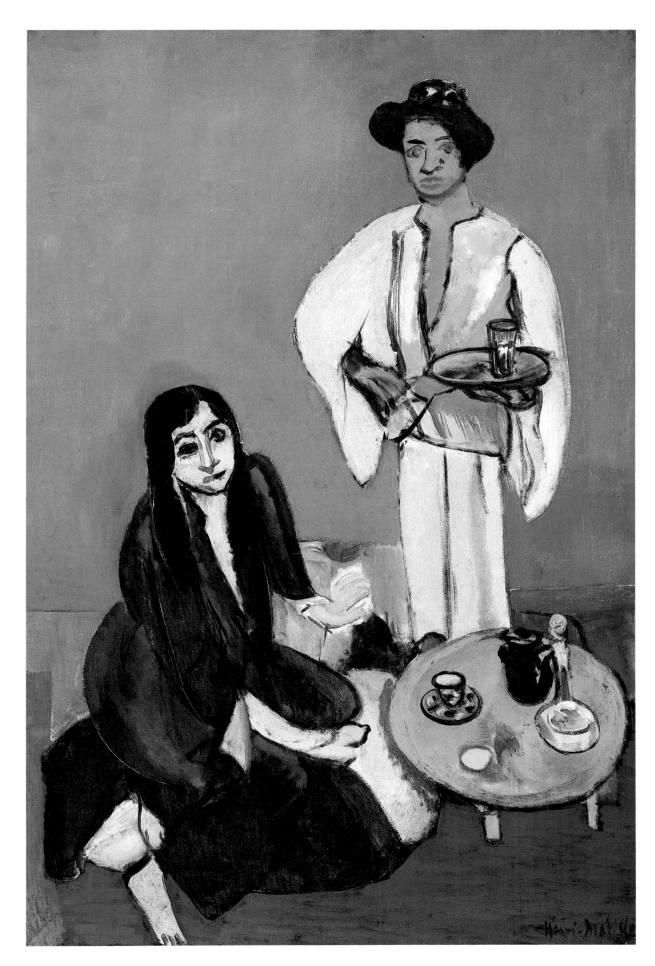

Pl. 16. *Déjeuner oriental*, 1917.
100.65 x 65.41 (39⅝ x 25¾).
Detroit Institute of Arts,
Bequest of Robert H. Tannahill

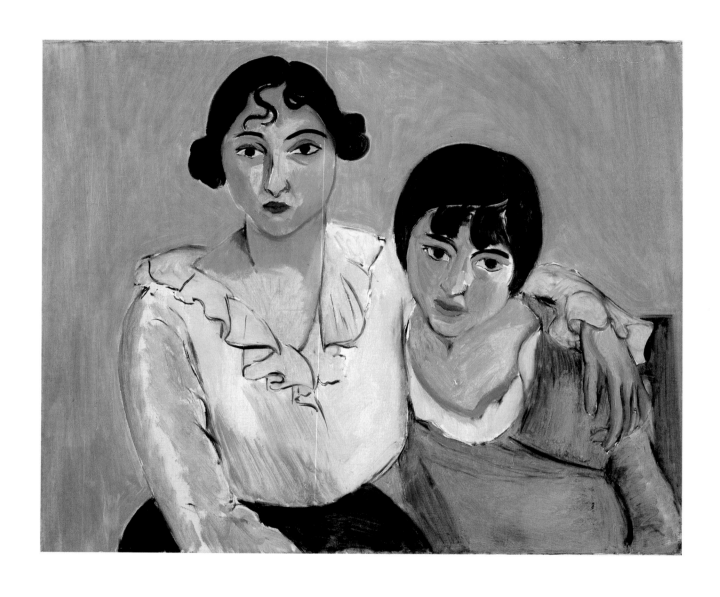

Pl. 17. *Les deux soeurs*, 1917, 61 x 74 (24 x 29⅛). The William D. Lippitt Memorial Collection, Denver Art Museum

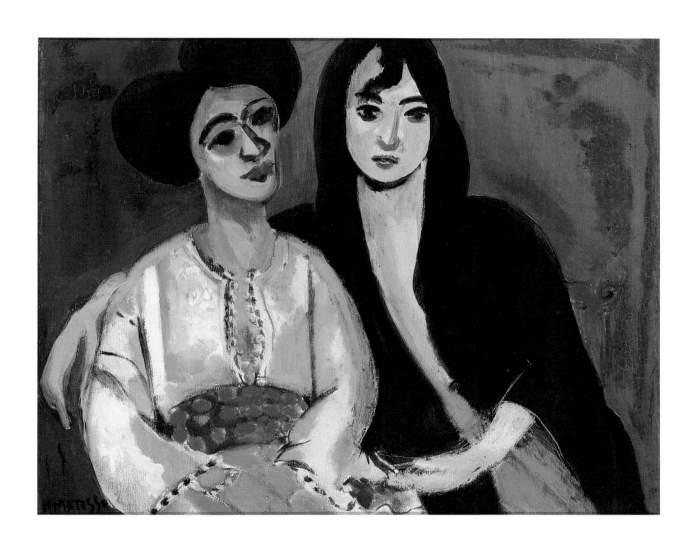

Pl. 18. *Aïcha et Lorette*, 1917, 38 x 46 (15 x 18⅛). Private collection

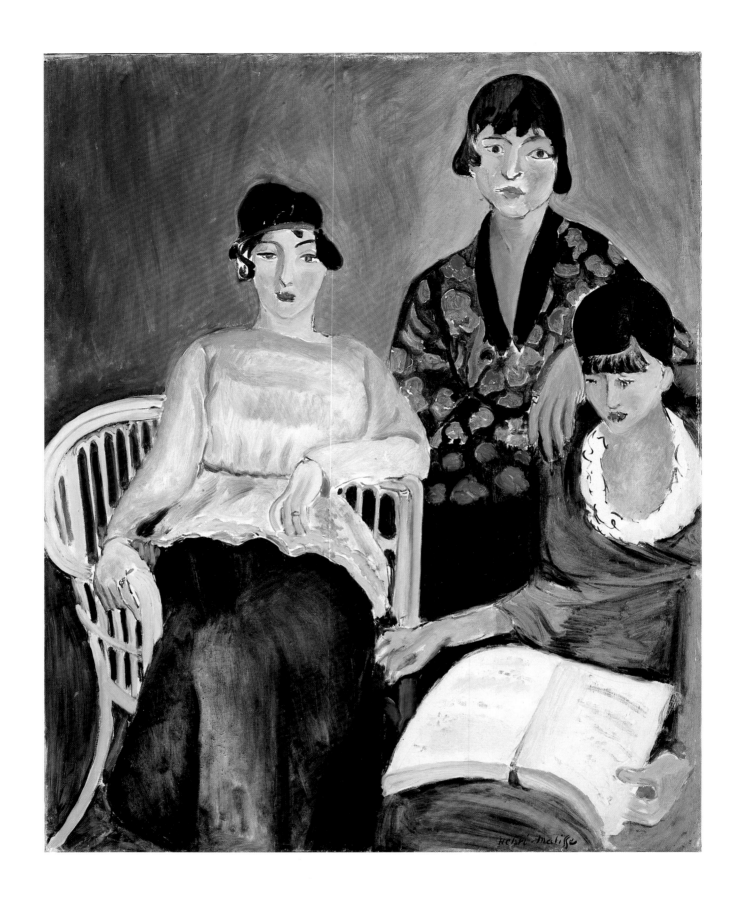

Pl. 19. *Les trois soeurs*, 1917, 92 x 73 (36¼ x 28¾). Paris, Musée de l'Orangerie, Collection Jean Walter et Paul Guillaume

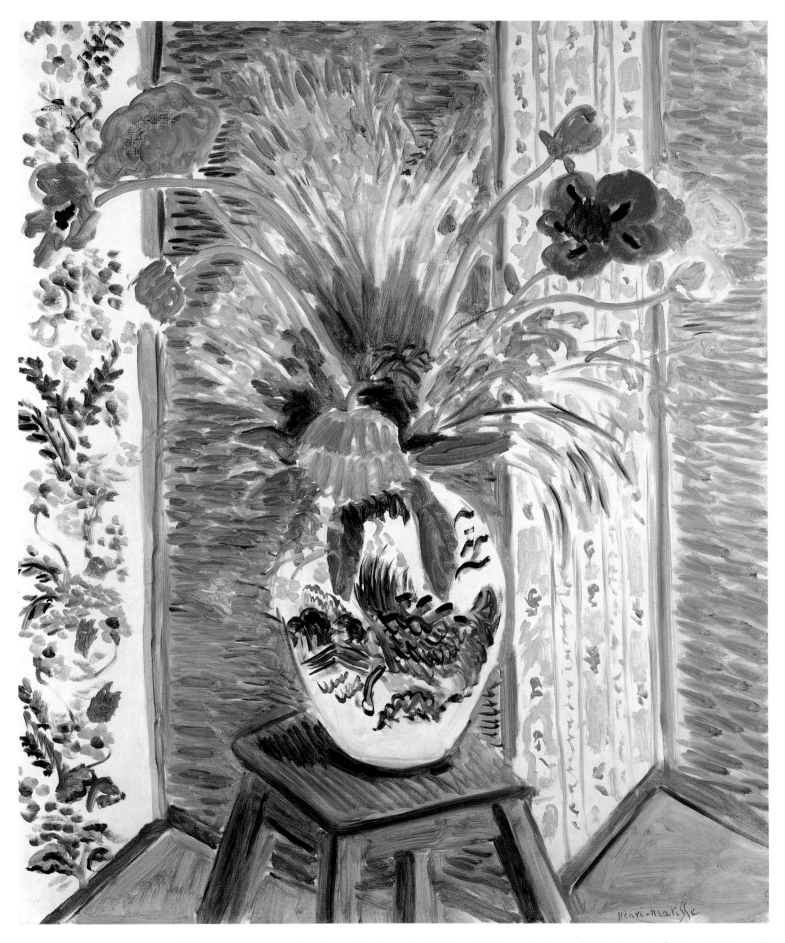

Pl. 20. *Les pavots—Feu d'artifice*, 1919, 100.6 x 81.3 (39⅝ x 32). Detroit Institute of Arts, Bequest of Robert H. Tannahill

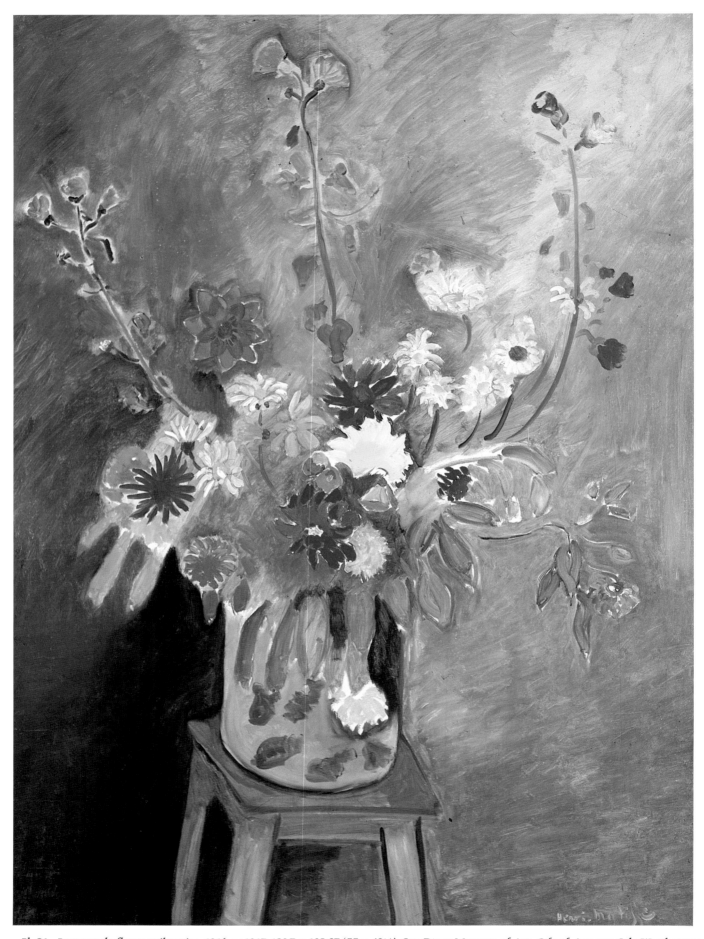

Pl. 21. *Bouquet de fleurs mélangées*, 1916 or 1917, 139.7 x 102.87 (55 x 40½). San Diego Museum of Art: Gift of Annetta Salz Wertheimer

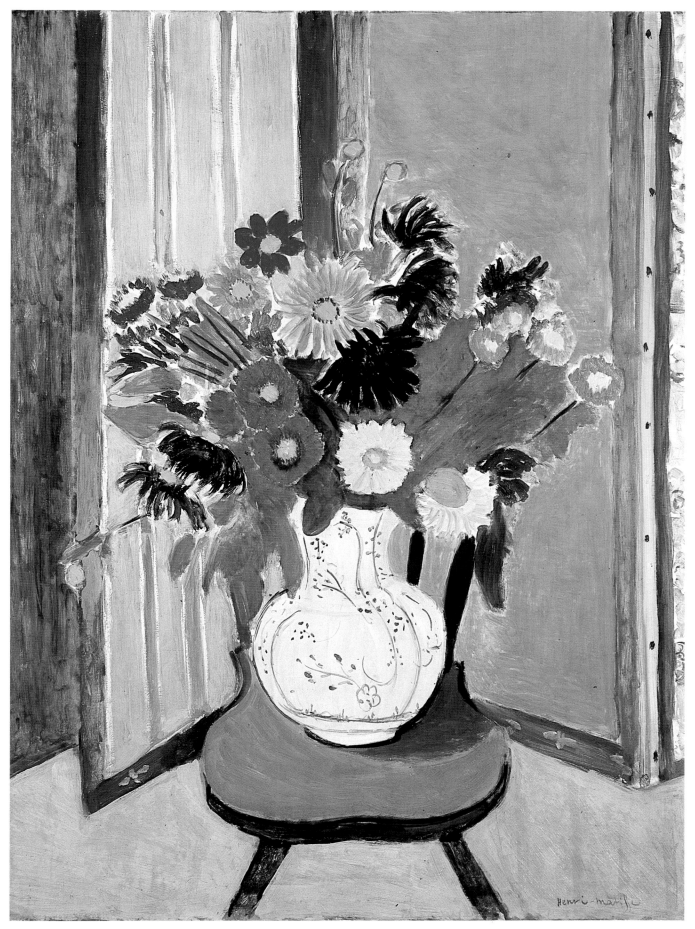

Pl. 22. *Bouquet de fleurs—Les marguerites,* 1919, 101.6 x 73.7 (40 x 29). Private collection, Chicago

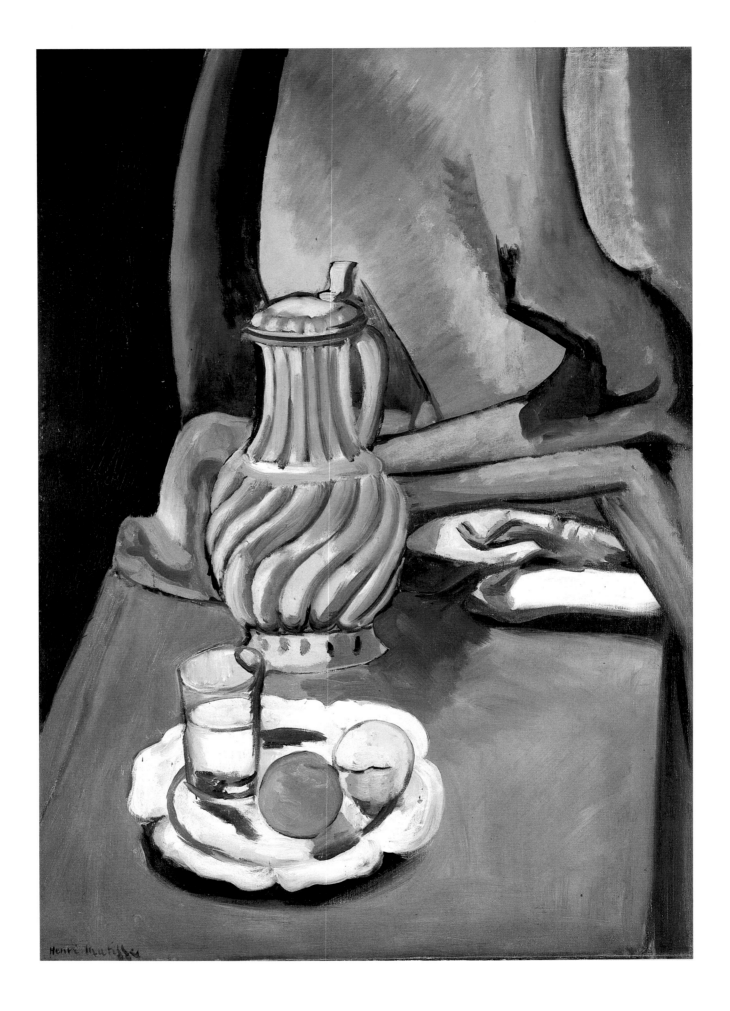

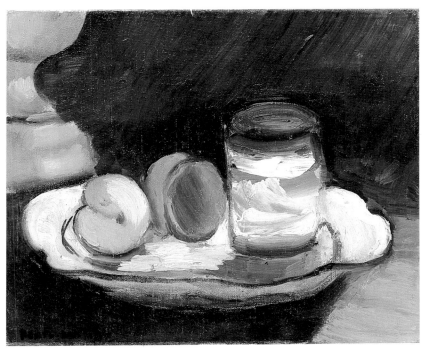

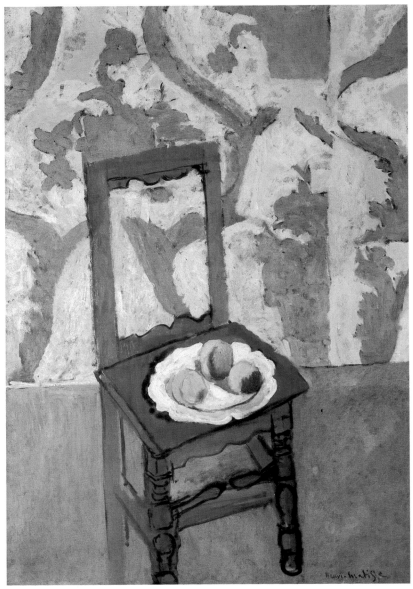

Pl. 23. (left) *Le pot d'etain*, 1917, 81.3 x 65.4 (32 x 25¾). The Baltimore Museum of Art: The Cone Collection, formed by Dr. Claribel Cone and Miss Etta Cone of Baltimore, Maryland. BMA 1950.230

Pl. 24. (top) *Nature morte, pêches et verre*, 1916 or 1918, 22.5 x 27.7 (8⅞ x 10⅞). Collection Martha Baer

☐ Pl. 25. (bottom) *La chaise aux pêches*, 1919, 130 x 89 (51⅝ x 35³/₁₆). Private collection

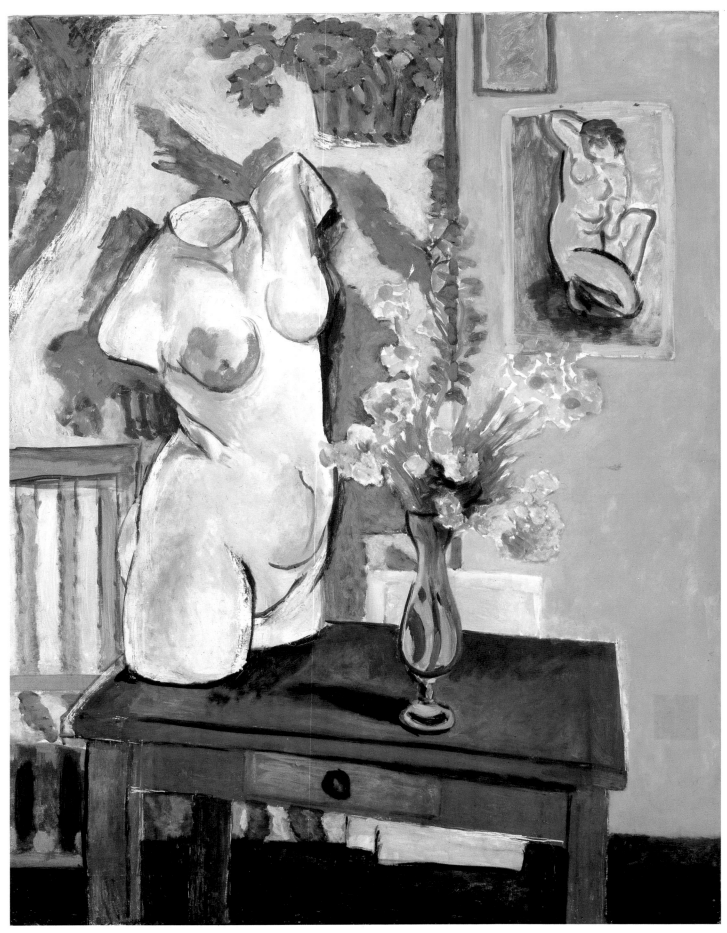

Pl. 26. *Le torse de plâtre, bouquet de fleurs*, 1919, 113 x 87 (44½ x 34¼). Museu de Arte de São Paulo

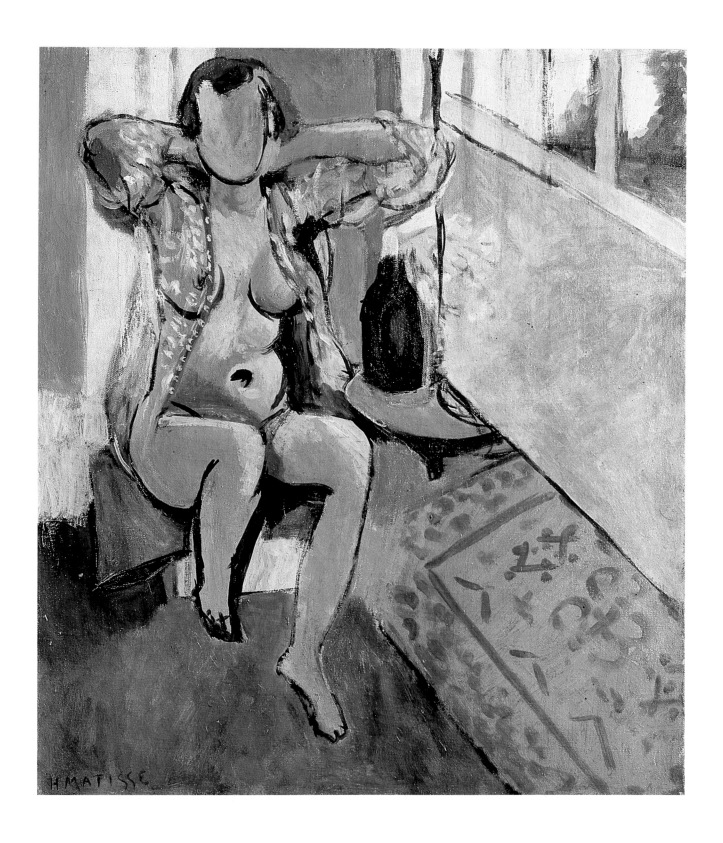

Pl. 27. *Nu au tapis espagnol,* summer 1919. 65 x 54 (25⅝ x 21¼). Private collection

81

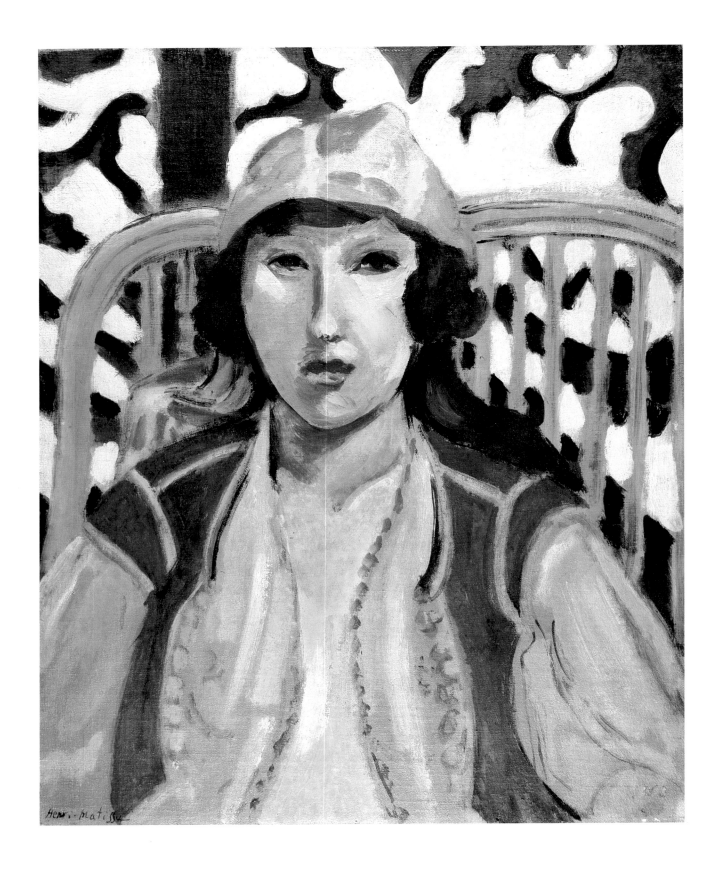

Pl. 28. *Femme vêtue à l'orientale,* July 1919, oil on canvas on cardboard, 40.8 x 32.7 (16¹/₁₆ x 12⁷/₈).
Glasgow Art Gallery and Museum

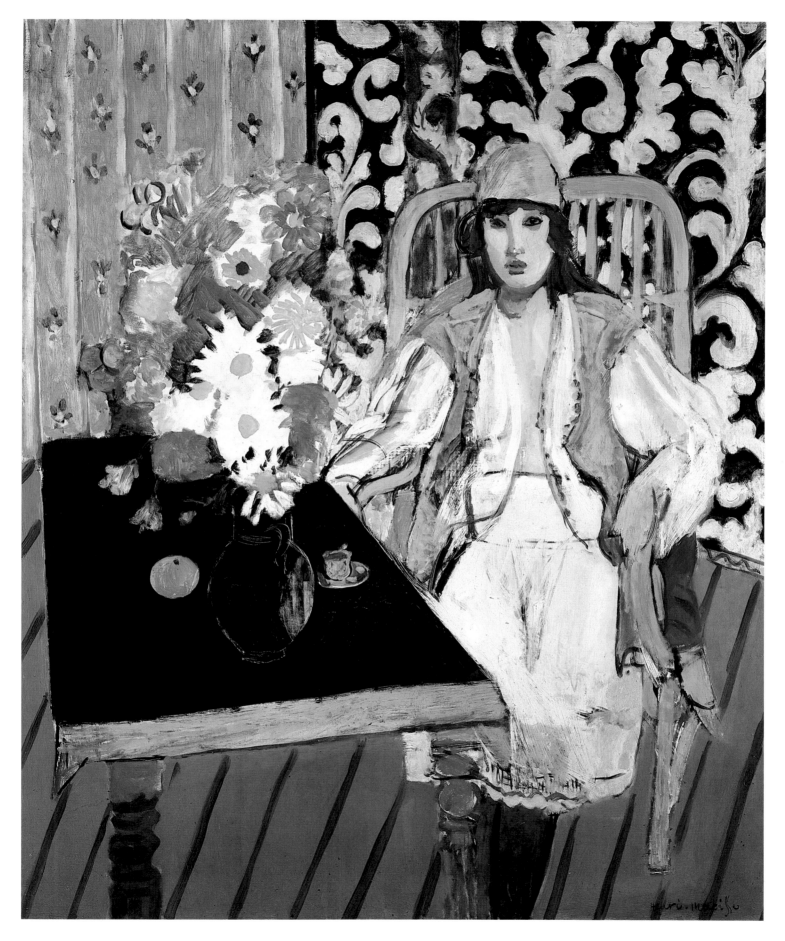

Pl. 29. *La table noire*, summer 1919, 102 x 80 (40¼ x 31½). Private collection, Switzerland

Pl. 30. *La table de marbre rose*, spring or autumn 1917, 146 x 97 (57½ x 38¼). Collection, The Museum of Modern Art, New York. Mrs. Simon Guggenheim Fund

84

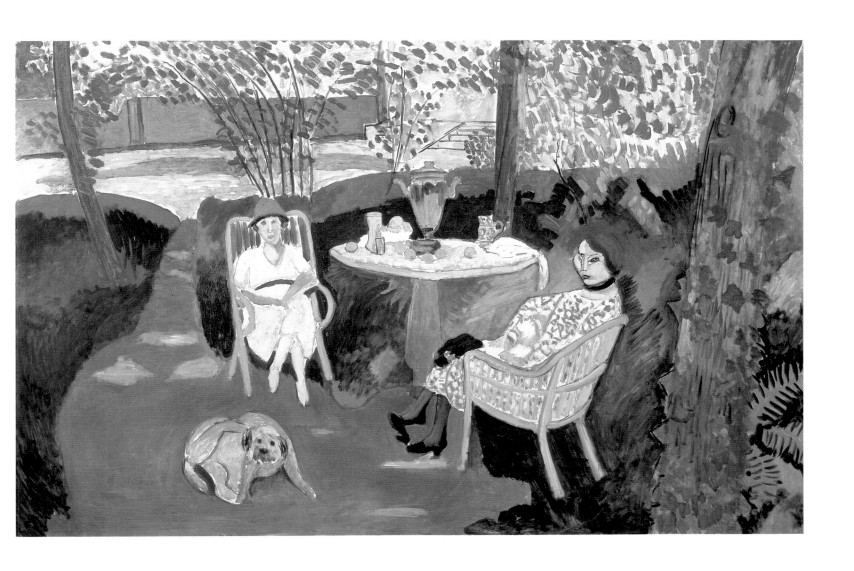

□ Pl. 31. *Le thé dans le jardin*, 1919, 140 x 212 (55⅛ x 83½). Los Angeles County Museum of Art, Bequest of David L. Loew in Memory of His Father, Marcus Loew

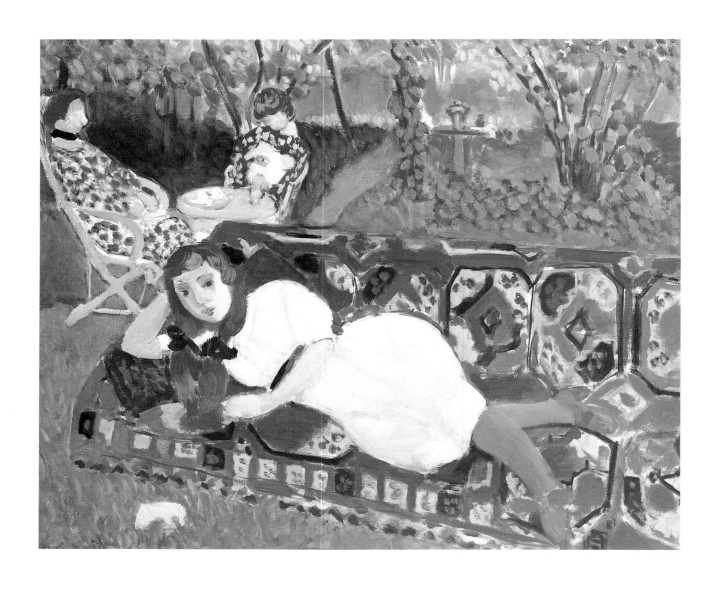

Pl. 32. *Jeunes filles au jardin*, summer 1919, 54.5 x 65 (21½ x 25⅝). Musée des Beaux Arts de La Chaux-de-Fonds, Collection René and Madeleine Junod

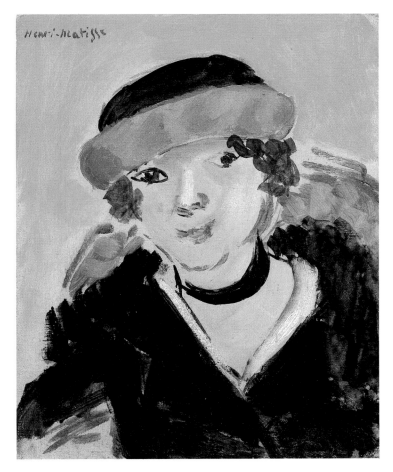

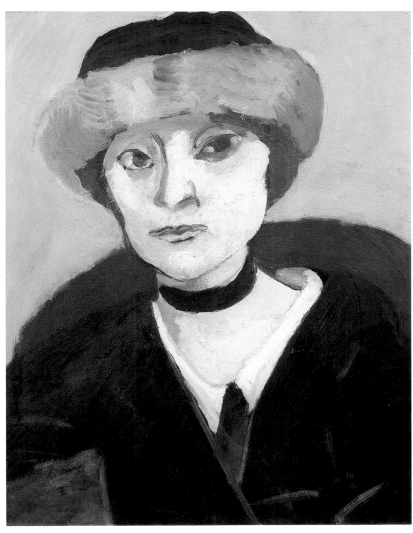

Pl. 33. *Petit portrait de Marguerite, toque de fourrure*, 1918, 23.8 x 18.8 (9⅜ x 7⅜). Private collection

Pl. 34. *Marguerite à la toque de fourrure*, late 1918, oil on panel, 41 x 33 (16⅛ x 13). Private collection

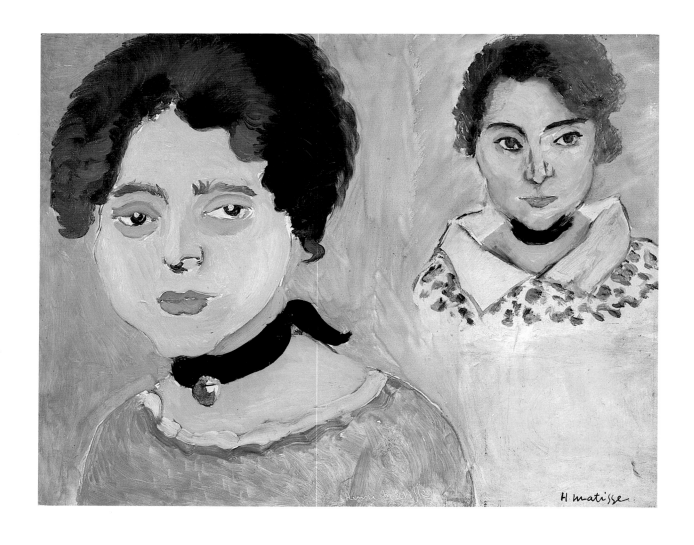

Pl. 35. *Double portrait de Marguerite sur fond vert*, c. 1919, 32.5 x 41.5 (12¹³⁄₁₆ x 16⅜).
Private collection

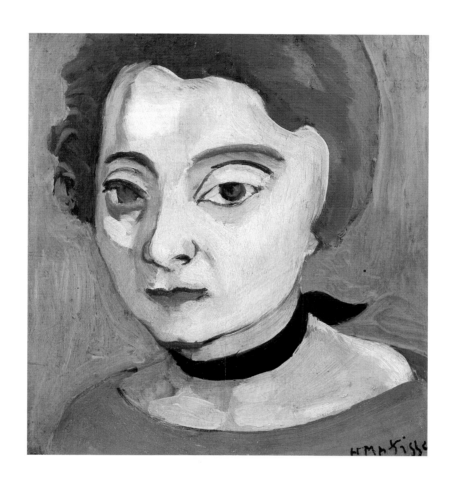

Pl. 36. *Marguerite au ruban de velours noir,* 1916, oil on panel,
18 x 17 (7⅛ x 6¾). Private collection

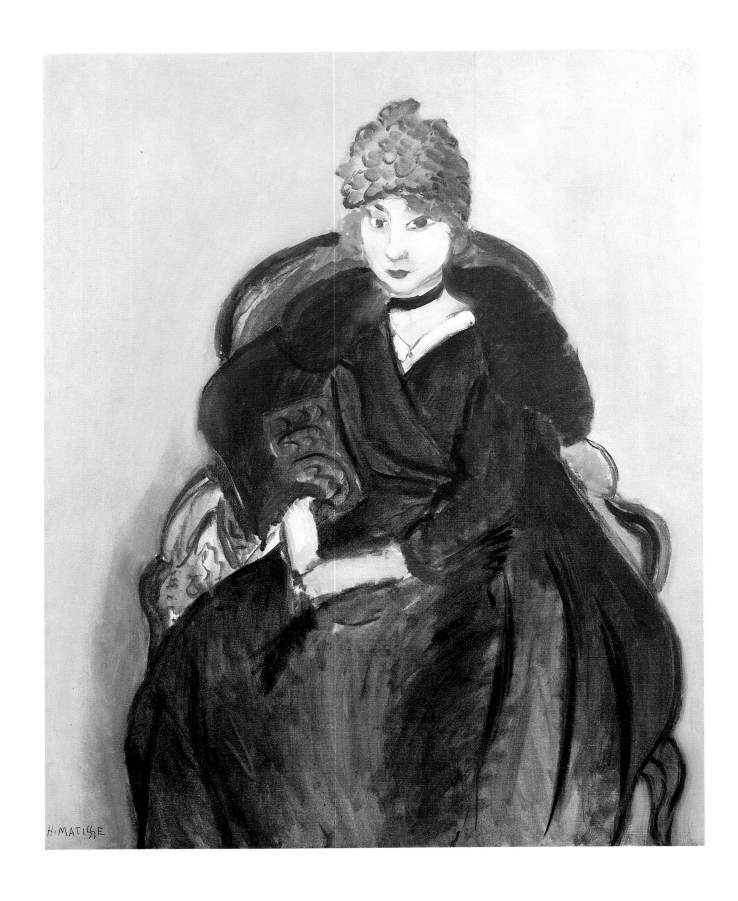

Pl. 37. *Marguerite à la toque bleue.* 1918. 81 x 75 (31⅞ x 29½). Private collection

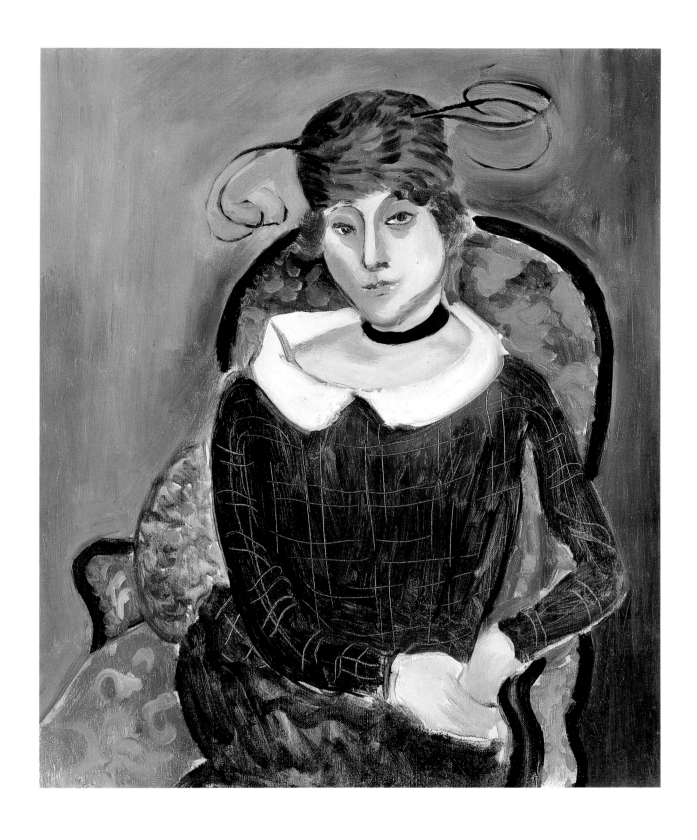

Pl. 38. *La toque de goura*, 1918, 46 x 38 (18⅛ x 15). Wadsworth Atheneum, Hartford, The Ella Gallup Sumner and Mary Catlin Sumner Collection

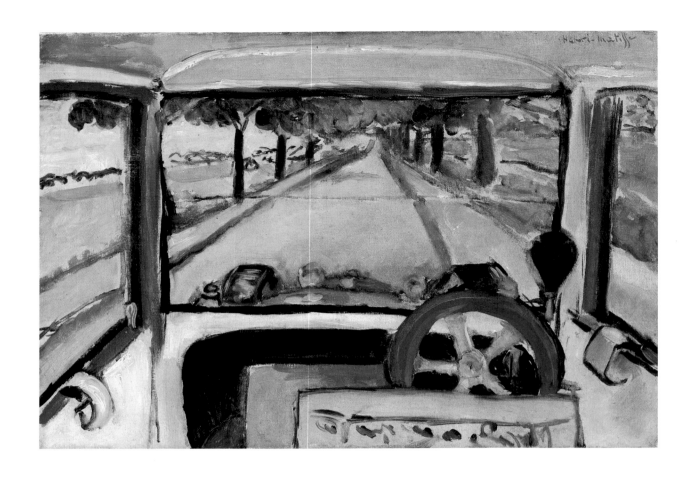

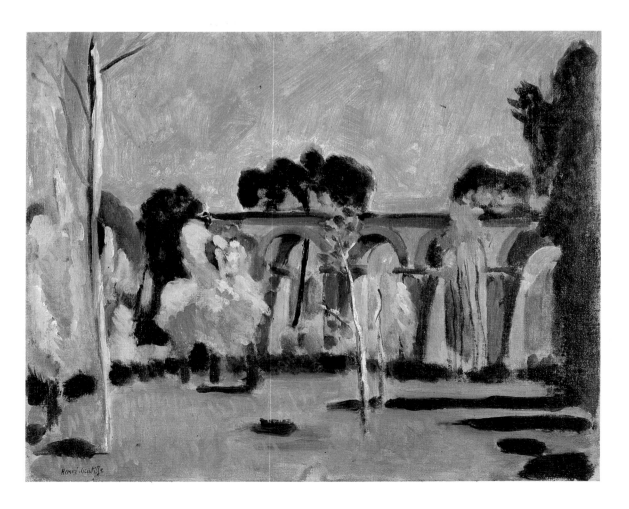

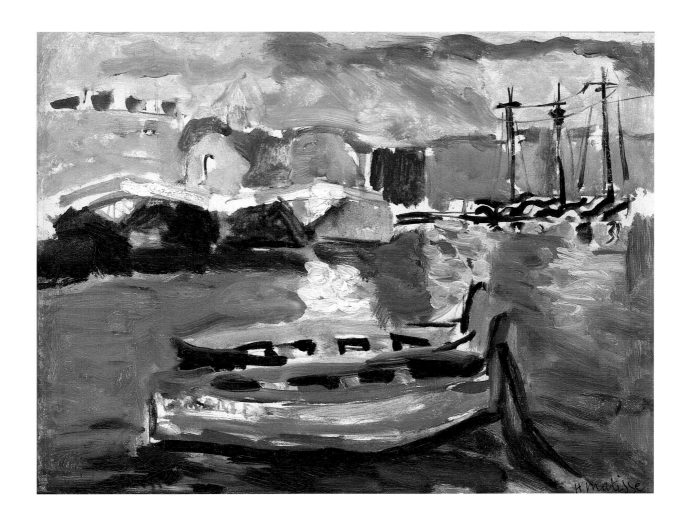

Pl. 39. (top left) *Route de Villacoublay,* 1917, 38 x 55 (15 x 21⅝). Cleveland Museum of Art, Bequest of Lucia McCurdy McBride, In memory of John Harris McBride II

☐ Pl. 40. (bottom left) *Le viaduc de Maintenon,* 16 July 1918, 35 x 42 (13¾ x 16½). The Baltimore Museum of Art: The Cone Collection, formed by Dr. Claribel Cone and Miss Etta Cone of Baltimore, Maryland. BMA 1950. 232

Pl. 41. *Deux barques dans le port de Marseilles,* 1917, oil on panel, 27 x 34.9 (10⅝ x 13¾). Private collection

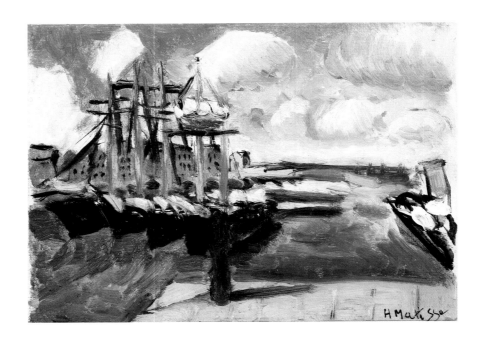

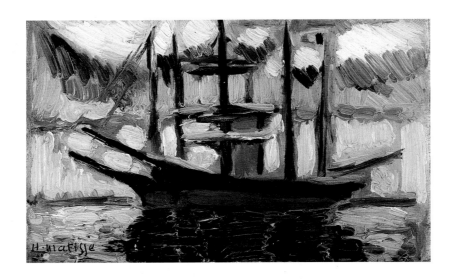

Pl. 42. *Quatre bateaux bord à bord dans le port de Marseilles*,
1915/1916, oil on panel, 15.9 x 21.6 (6¼ x 8½). Private collection

Pl. 43. *Deux bateaux bord à bord dans le port de Marseilles*, 1915/1916,
oil on panel, 8.9 x 14 (3½ x 5½). Private collection

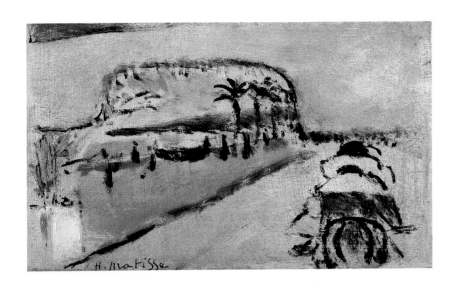

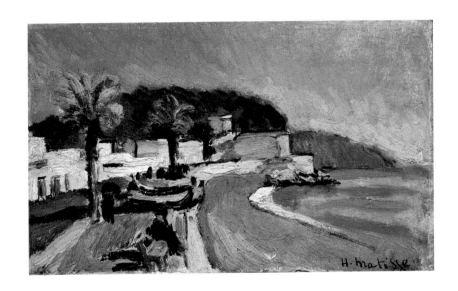

Pl. 44. *Café des Ponchettes, sous la tente,* 1916(?), oil on board, 9 x 14
(3½ x 5½). Private collection

Pl. 45. *Promenade des Anglais, Nice,* 1915/17, oil on board, 9 x 14 (3½ x 5½).
Mrs. Heinz Berggruen

95

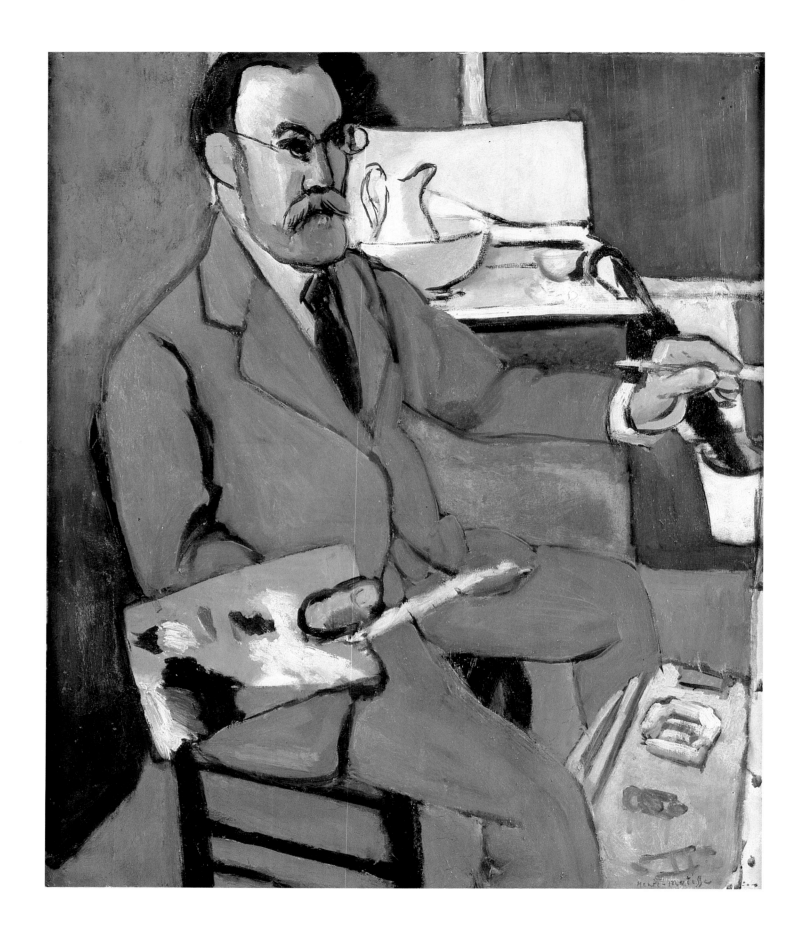

Pl. 46. *Autoportrait*, January 1918, 65 x 54 (25⅝ x 21¼). Musée Matisse, Le Cateau

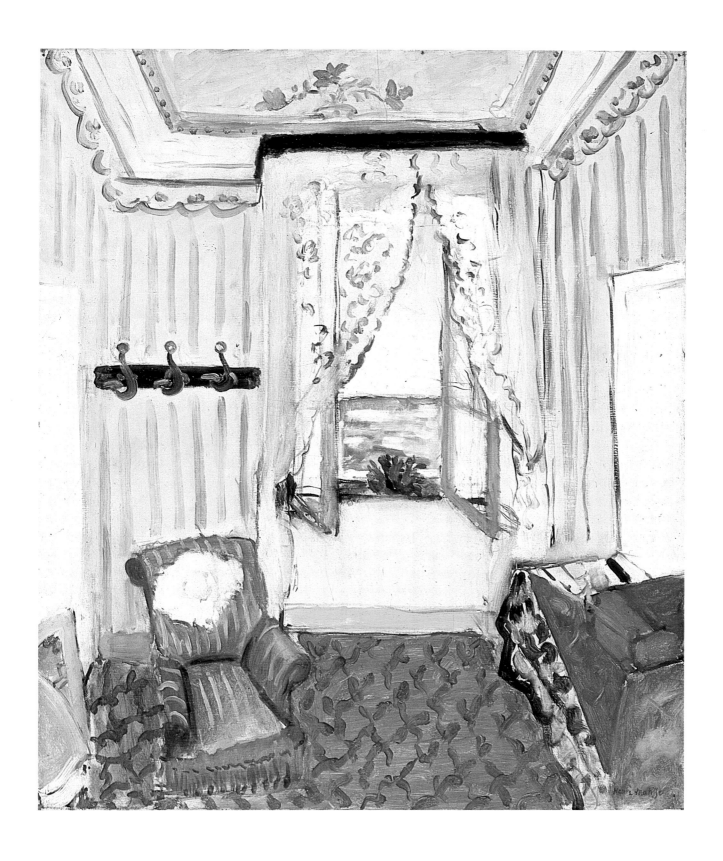

Pl. 47. *Ma chambre au Beau-Rivage*, late 1917–early 1918, 73.7 x 60.6 (29 x 23⅞). Philadelphia Museum of Art: The A. E. Gallatin Collection

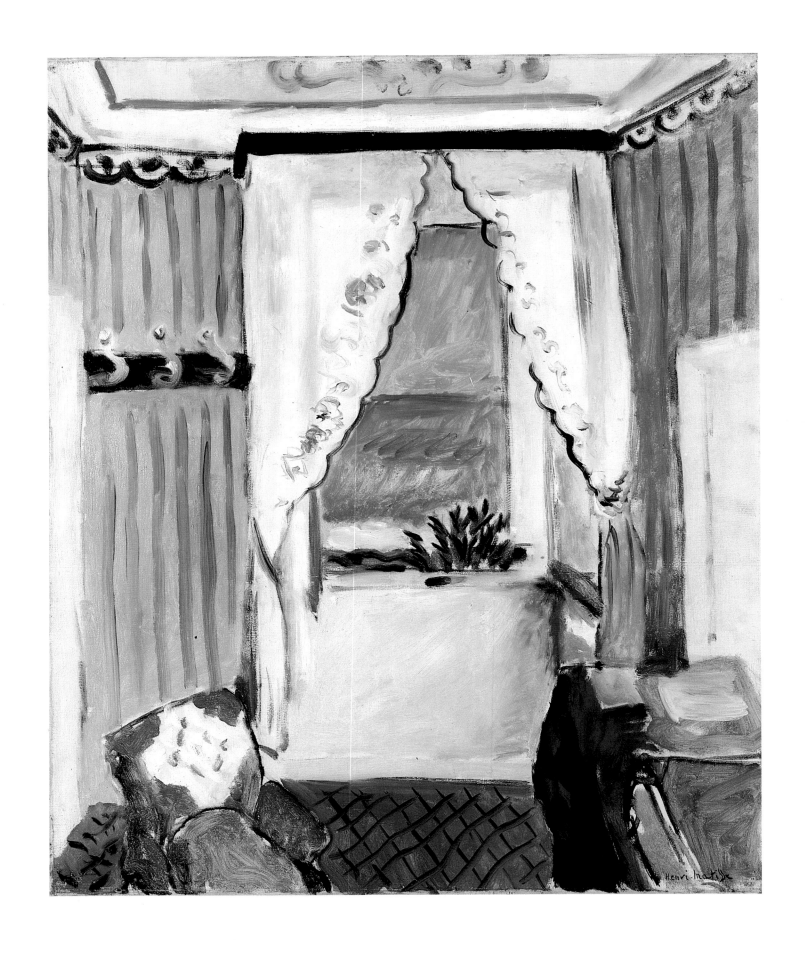

Pl. 48. *Intèrieur à Nice*. January 1918. 65.5 x 54.5 (25¾ x 21½). Private collection

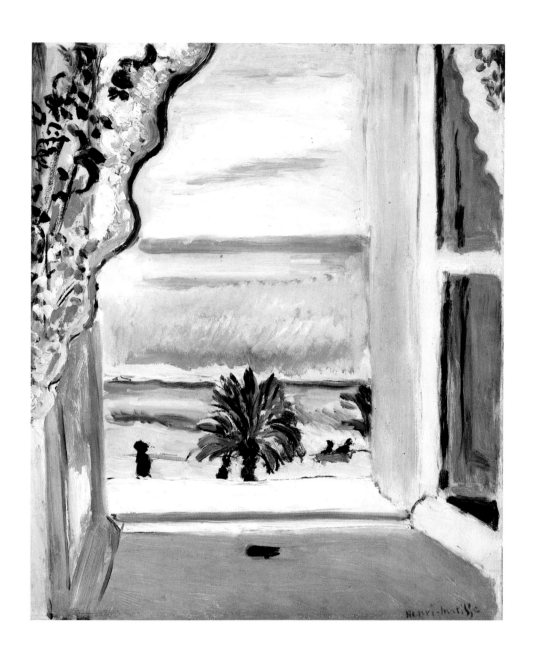

Pl. 49. *La fenêtre ouverte*, early 1918, 42 x 33 (16½ x 13). Private collection

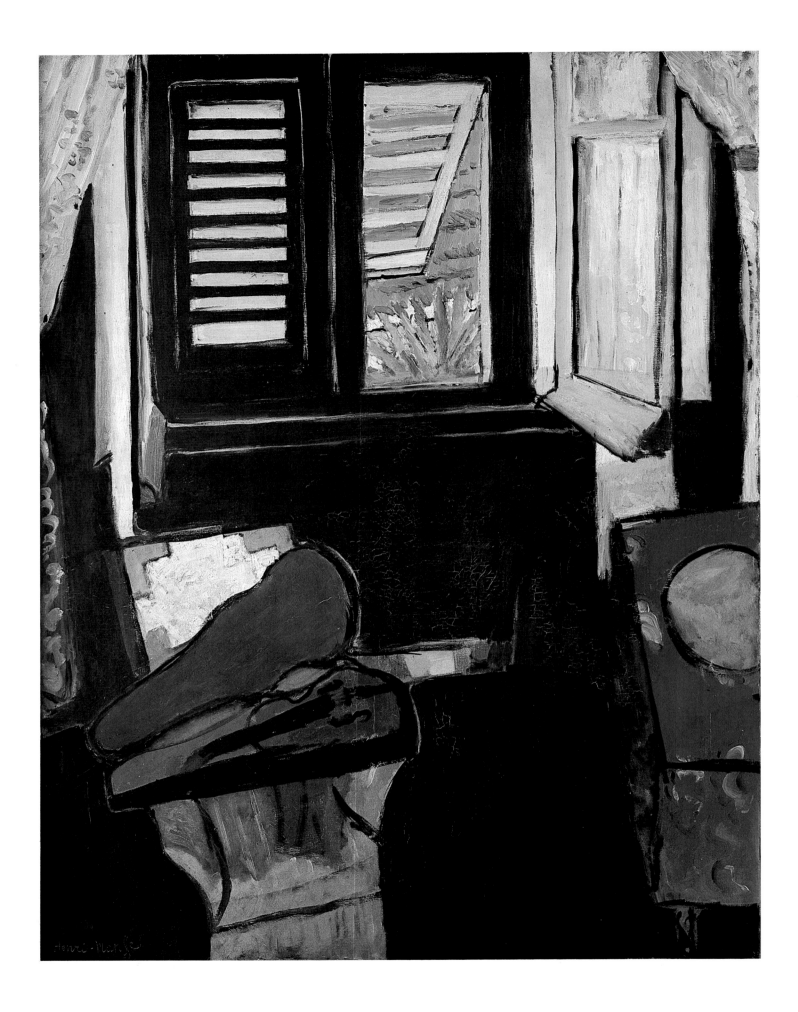

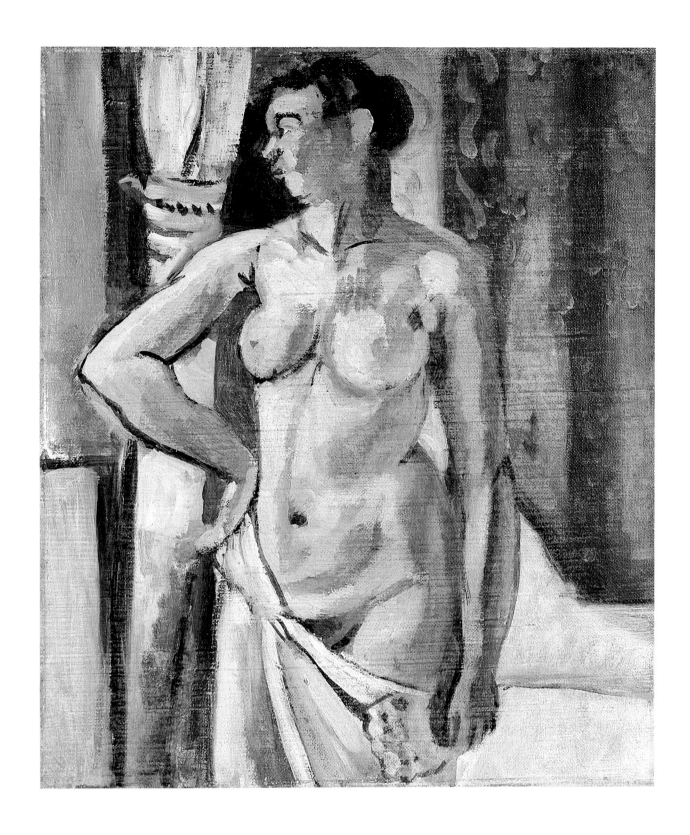

☐ Pl. 50. (left) *Intérieur au violon*, 1917 / 1918, 116 x 89 (45¹¹⁄₁₆ x 35³⁄₁₆). Statens Museum for Kunst, Copenhagen, J. Rump Collection

☐ Pl. 51. *Nu debout de face, devant une fenêtre, tête tournée vers la droite*, 1918, oil on cardboard, 41 x 33 (16⅛ x 13). Private collection, Paris

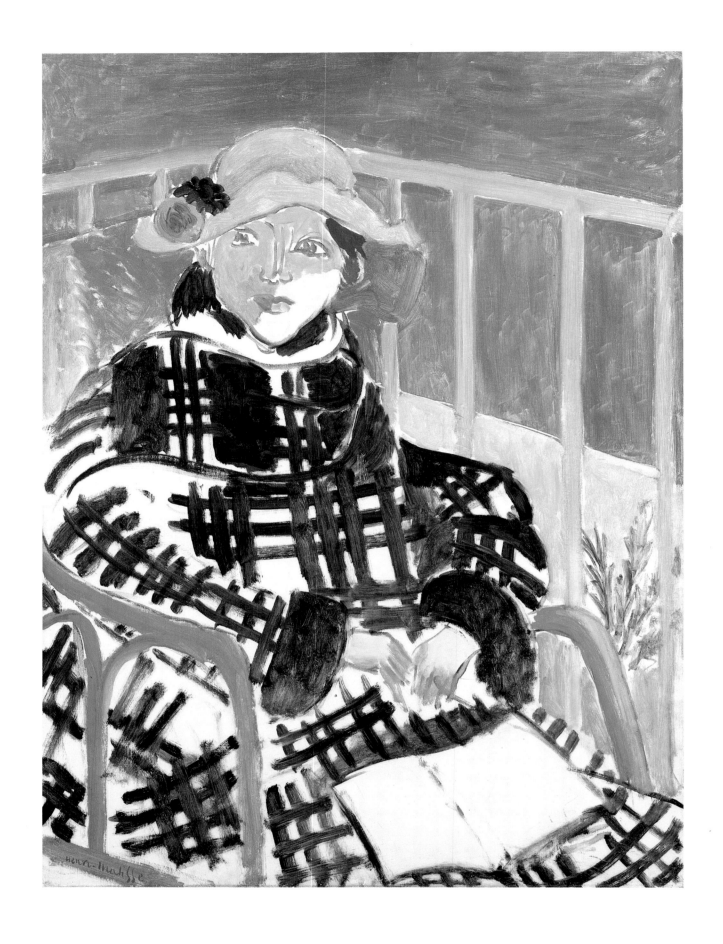

Pl. 52. *Mlle Matisse en manteau écossais*, Easter 1918, 95 x 75 (37⅜ x 29½). Collection of Henry Ford II

102

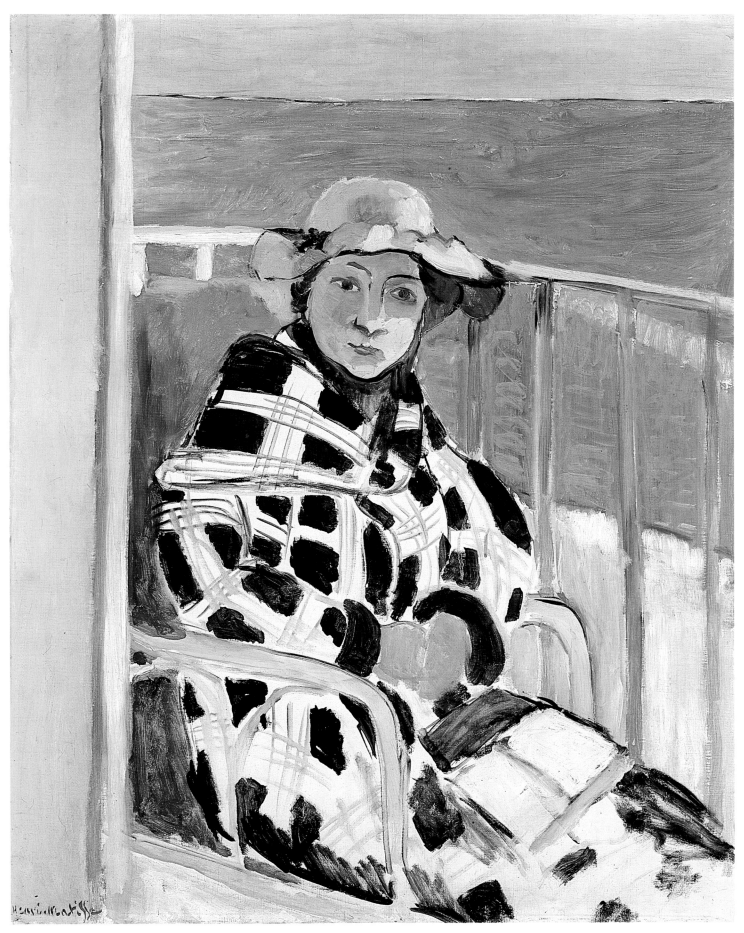

□ Pl. 53. *Mlle Matisse au manteau écossais*, Easter 1918, 95 x 75 (37⅜ x 29½). Private collection

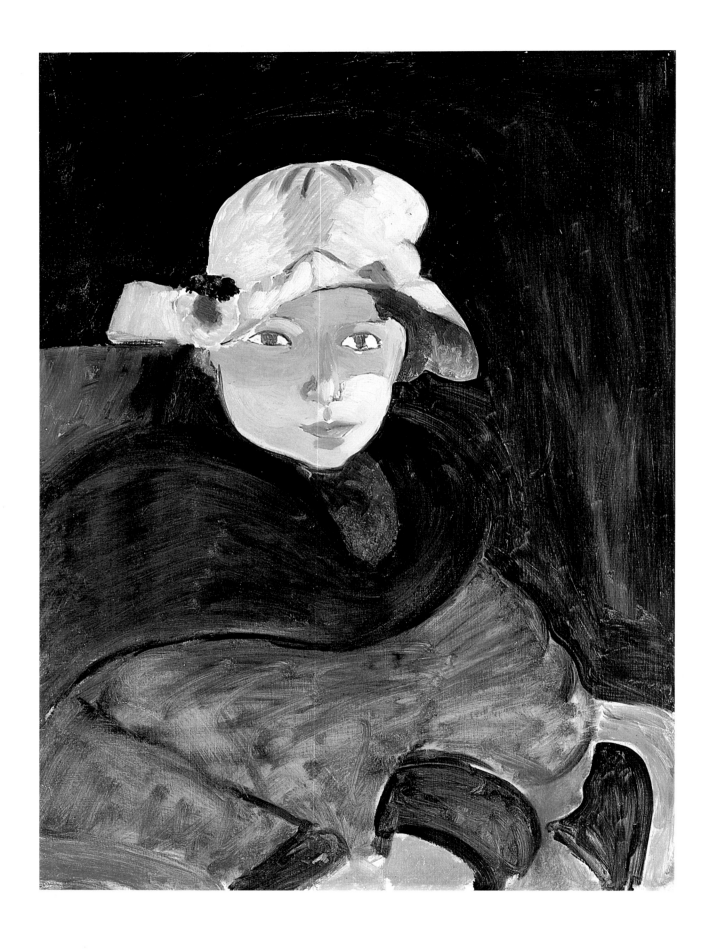

Pl. 54. *Portrait de Mlle Matisse*. Easter 1918. 72.5 x 52.5 (28½ x 20⅝). Ohara Museum of Art, Kurashiki, Japan

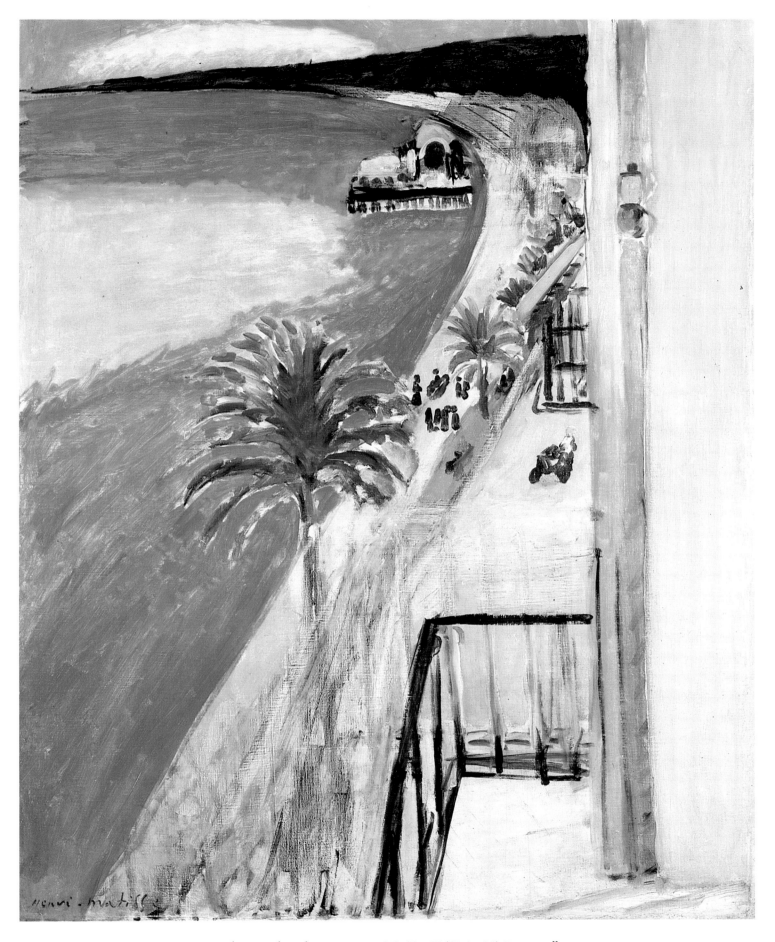

Pl. 55. *La baie de Nice*, Easter 1918, 90 x 71 (35⅜ x 28). Private collection

Pl. 56. *Oliviers, jardin de Renoir à Cagnes*, 1917, 38 x 46 (15 x 18⅛). Private collection

106

□ Pl. 57. *Maison entre les arbres*, 1919, 33 x 41 (13 x 16⅛). Private collection, Paris

107

Pl. 58. *Paysage du midi*, 1918, oil on board, 33 x 41 (13 x 16⅛). Columbus Museum of Art, Ohio: Gift of Ferdinand Howald

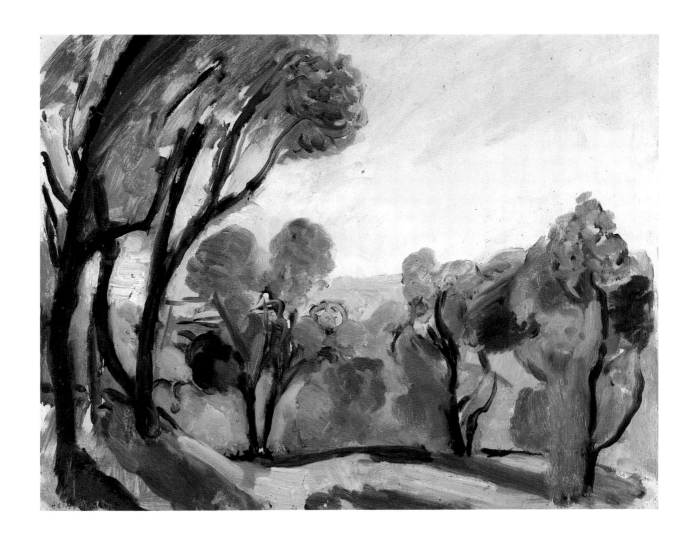

Pl. 59. *Paysage d'oliviers*, 1918, 33 x 41 (13 x 16⅛). Private collection

109

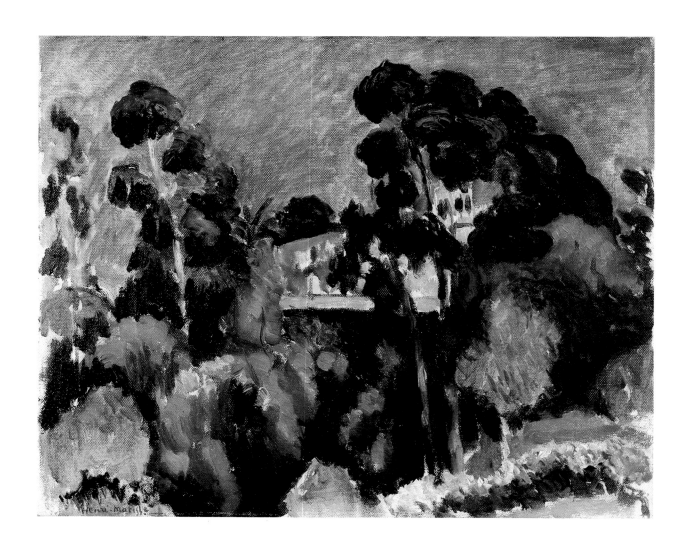

Pl. 60. *Les eucalyptus, Mont Alban*, spring 1918, 32.7 x 40.8 (12⅞ x 16¹/₁₆). The Baltimore Museum of Art: The Cone Collection, formed by Dr. Claribel Cone and Miss Etta Cone of Baltimore, Maryland. BMA 1950.231

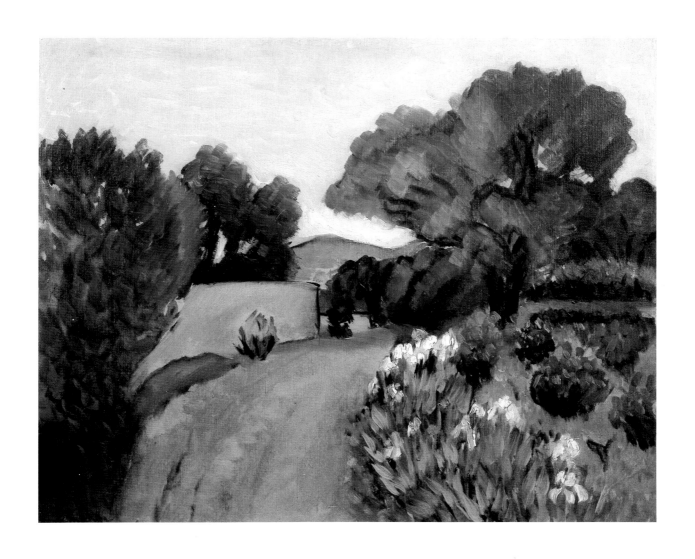

Pl. 61. *Dans la campagne de Nice, jardin aux iris*, 1919, 33 x 41 (13 x 16⅛). Collection Lois and Georges de Menil

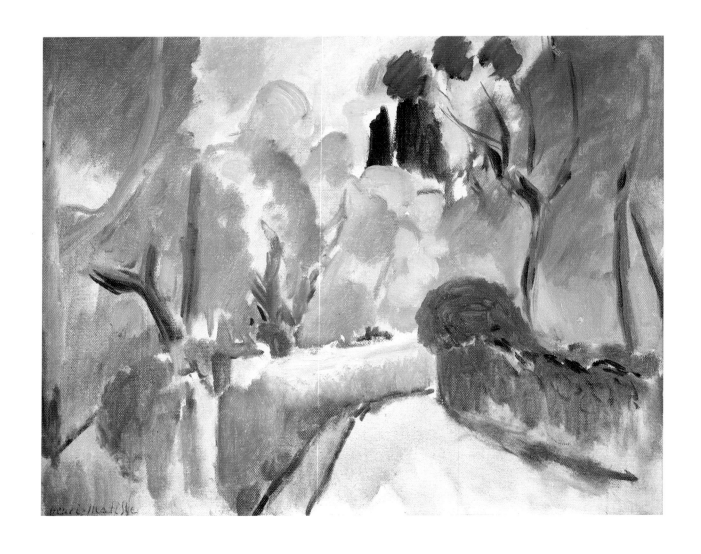

Pl. 62. *Chemin entre les murs*, 1918, 33 x 41 (13 x 16⅛). Private collection

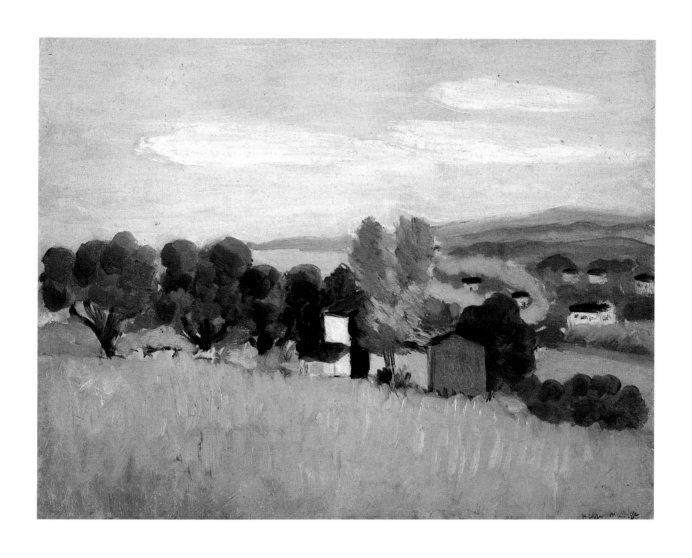

Pl. 63. *L'automne à Cagnes*, 1918, 33 x 41 (13 x 16⅛). Private collection

113

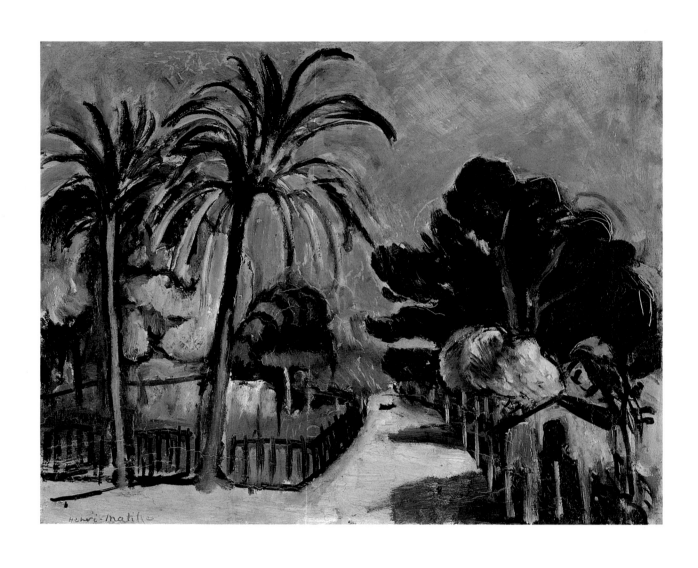

Pl. 64. *Le jardin du Château*, 1918, oil on cardboard, 33 x 41 (13 x 16⅛). Kunstmuseum Bern

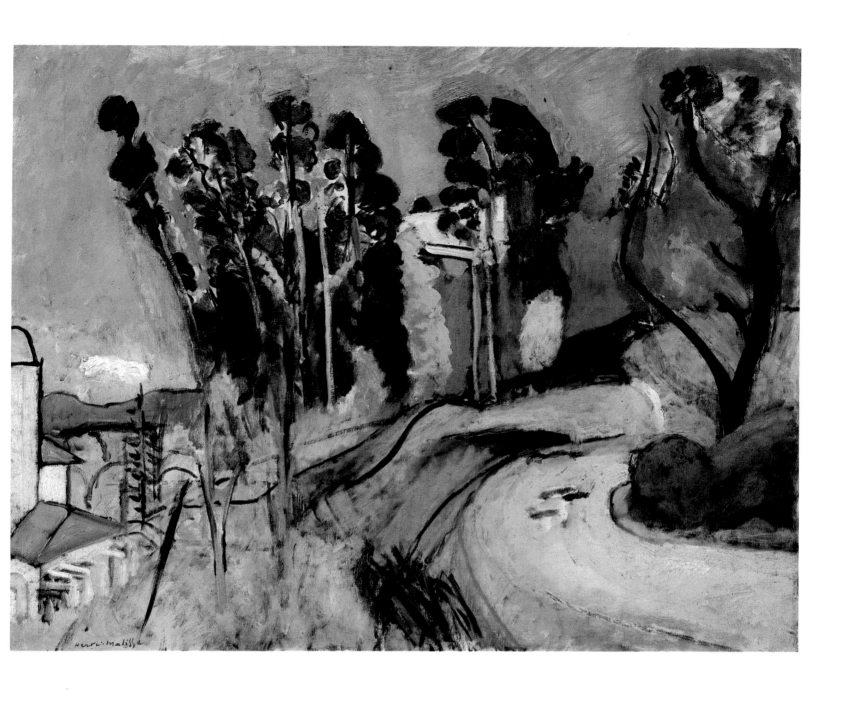

Pl. 65. *Grand paysage, Mont Alban.* 1918, 73 x 92 (28¾ x 36¼). Alexina Duchamp

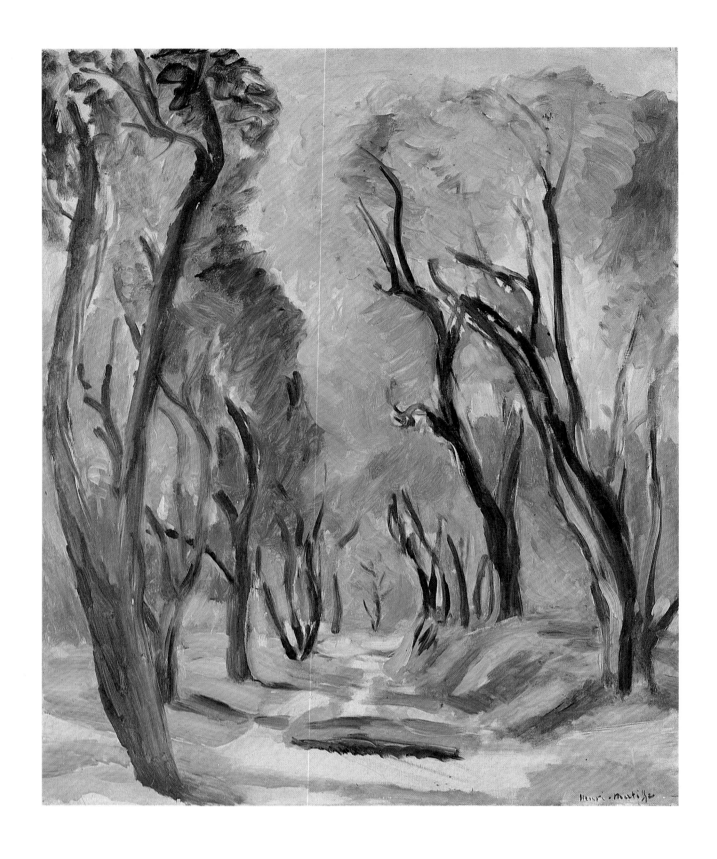

Pl. 66. *L'allée des oliviers*, 1920, 74 x 60 (29⅛ x 23⅝). Musée d'Art Moderne de la Ville de Paris, Paris

116

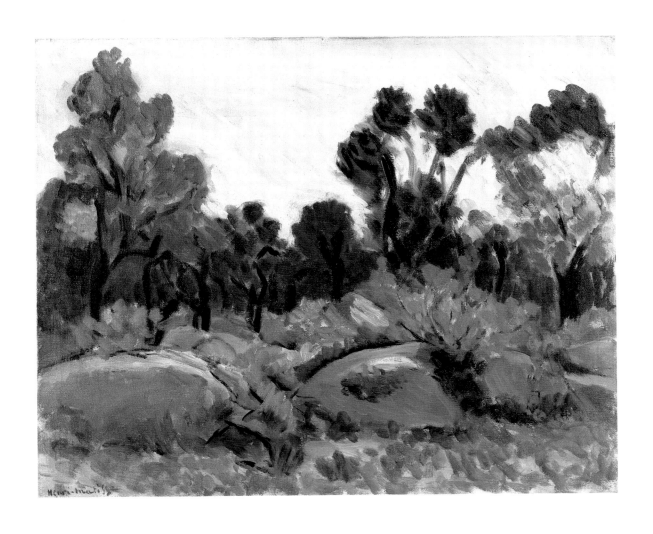

Pl. 67. *Rochers de la vallée du Loup*, 1925, 38.5 x 47 (15⅛ x 18½). Bridgestone Museum of Art, Tokyo

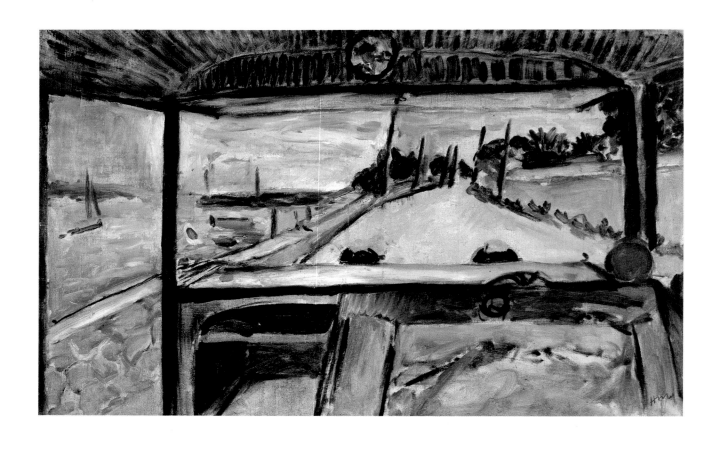

Pl. 68. *Antibes, paysage vu de l'intérieur d'une automobile,* 1925, 37 x 61 (14⅝ x 24). Mr. and Mrs. Warren Brandt

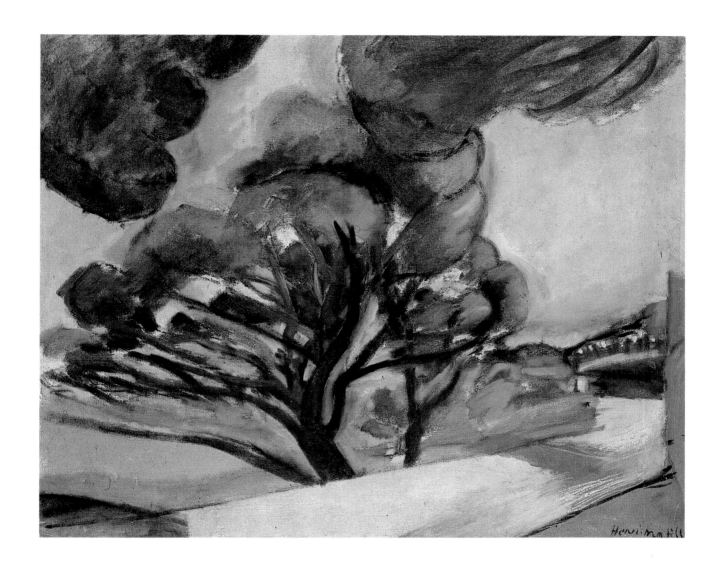

Pl. 69. *Route du Cap d'Antibes—Le grand pin*, 1926, 50 x 61 (19⅝ x 24). Mme Jean Matisse

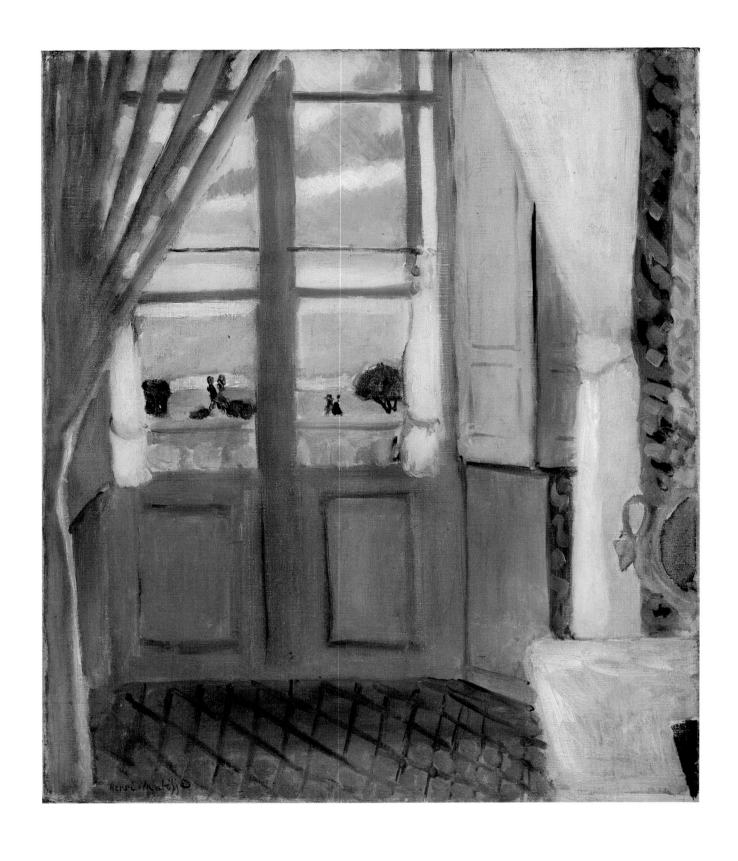

Pl. 70. *La fenêtre fermée*, season 1918–1919, 54 x 44.4 (21¼ x 17½). Virginia Museum of Fine Arts, Collection of Mr. and Mrs. Paul Mellon

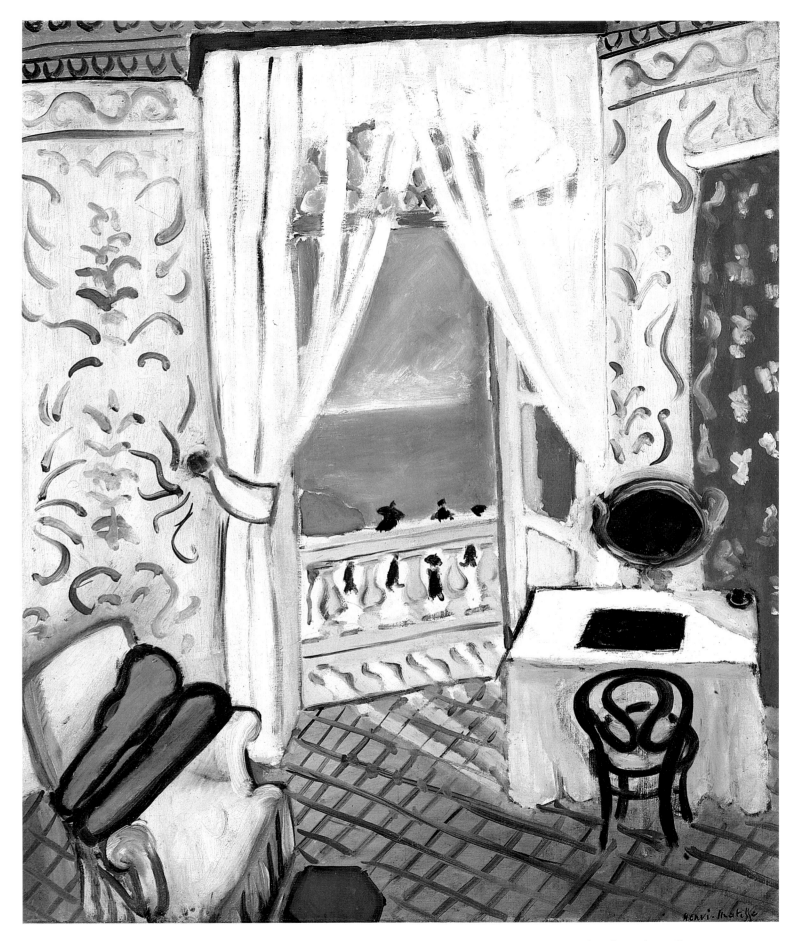

Pl. 71. *Intérieur à la boîte à violon*, winter 1918–1919, 73 x 60 (28¾ x 23⅝). The Museum of Modern Art, New York. Lillie P. Bliss Collection, 1934

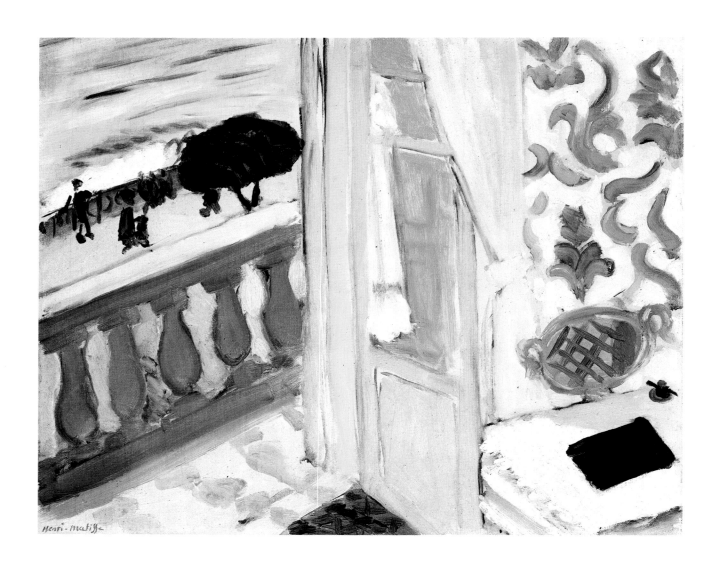

Pl. 72. *Intérieur au cahier noir,* December 1918, oil on cardboard, 23.5 x 42 (9¼ x 16½). Private collection, Switzerland

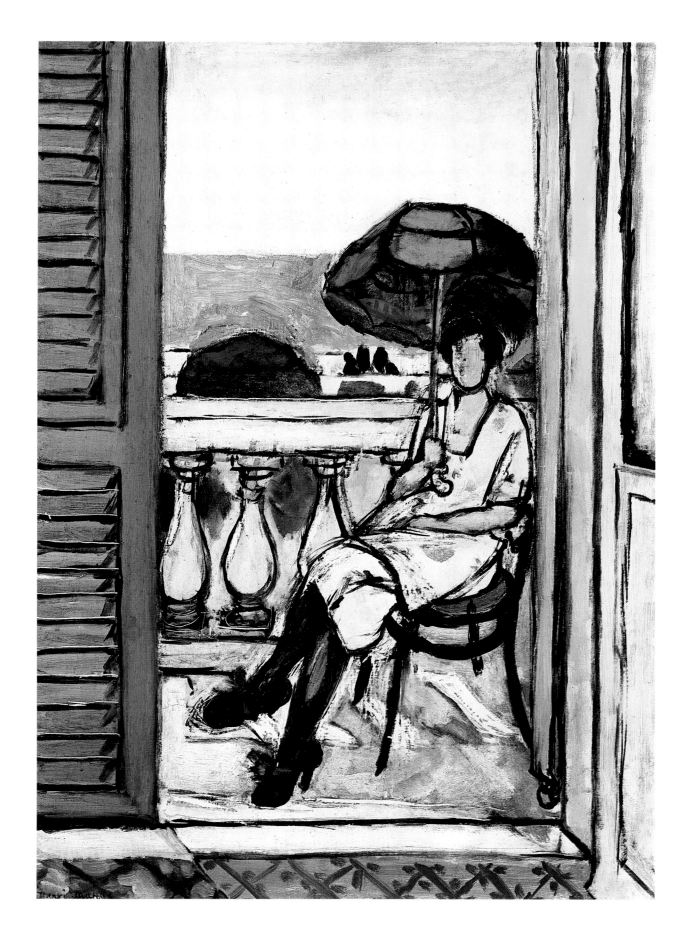

Pl. 73. *Femme au balcon à l'ombrelle verte, de face,* 1919, 66.5 x 47 (26⅛ x 18½). Private Asset Management Group, Inc., New York

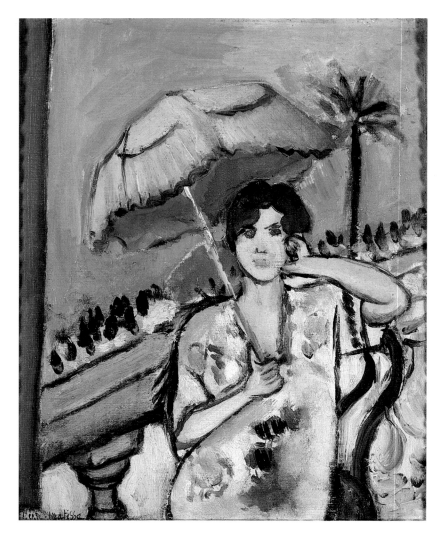

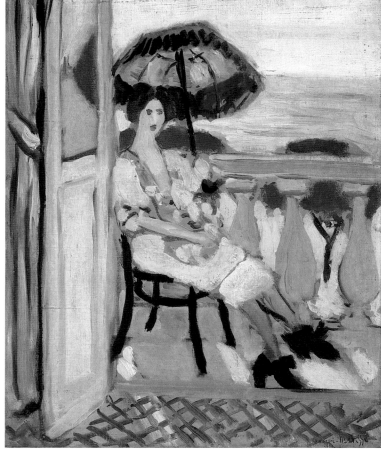

Pl. 74. *Femme au balcon à l'ombrelle rose, de face, mi-corps,* 1919,
23 x 19 (9¹/₁₆ x 7½). Annick and Pierre Berès, Paris

Pl. 75. *Femme assise au balcon, ombrelle verte, bas violets,* 1919,
42 x 33 (16½ x 13). Annick and Pierre Berès, Paris

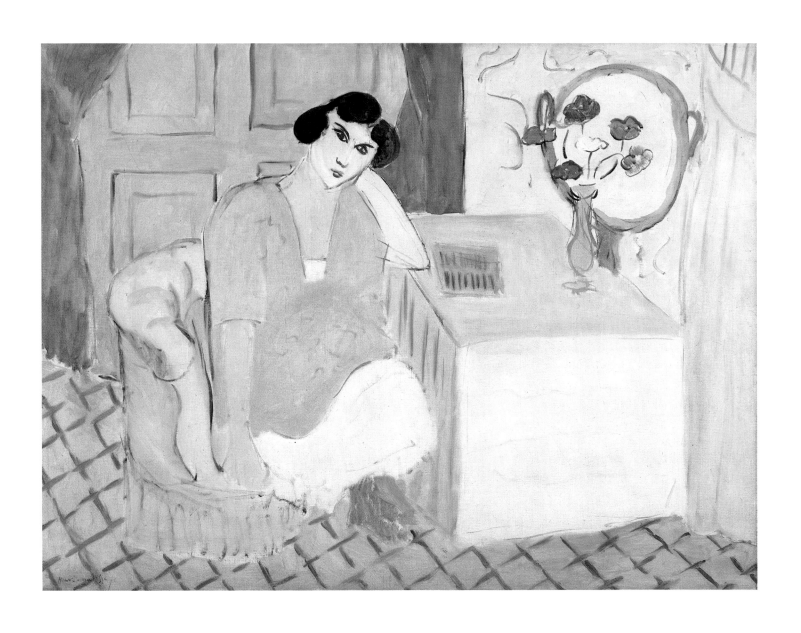

Pl. 76. *La liseuse distraite*, 1919, 73.7 x 91.4 (29 x 36). The Trustees of the Tate Gallery, London

125

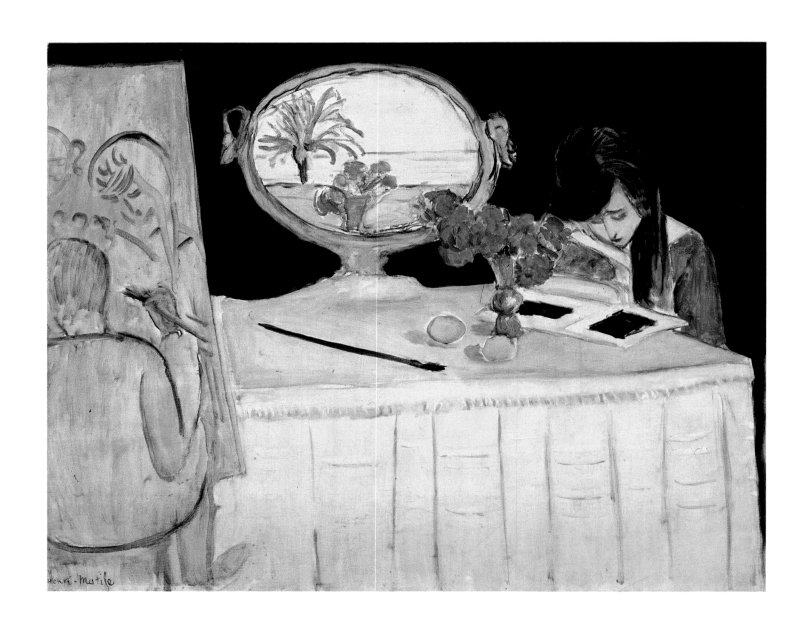

Pl. 77. *La séance de peinture,* 1919, 74 x 93 (29⅛ x 36⅝). Scottish National Gallery of Modern Art, Edinburgh

126

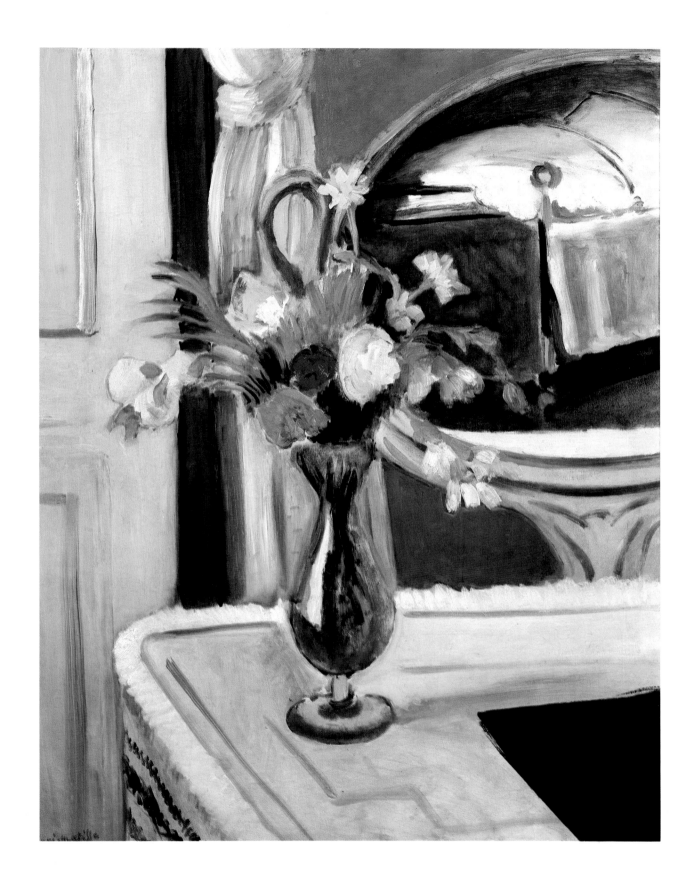

□ Pl. 78. *Vase de fleurs sur la coiffeuse, lit refletée dans le miroir,* 1919, 65.1 x 49.5 (25⅝ x 19½).
Private collection

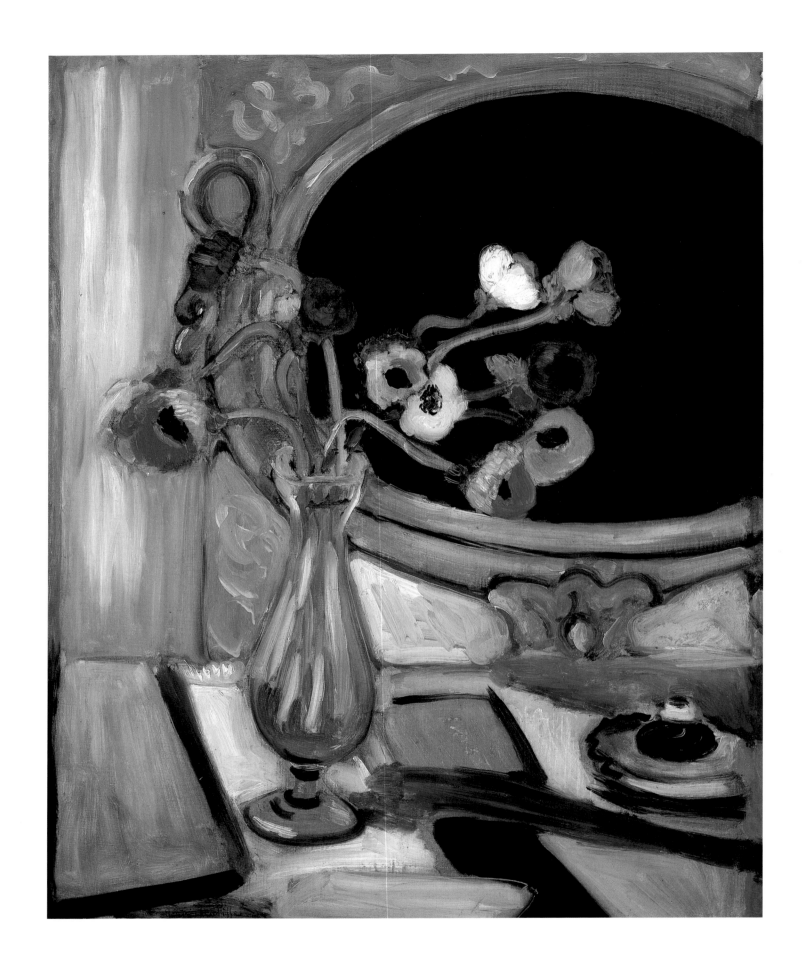

Pl. 79. *Anémones au miroir noir*, 1919, 68 x 52 (26¾ x 20½). Private collection

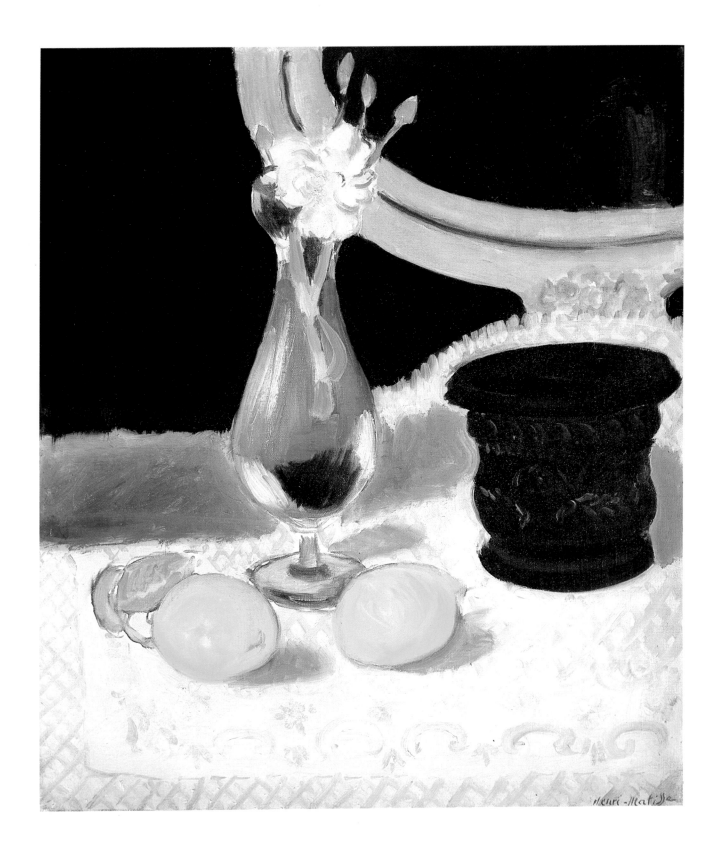

Pl. 80. *Nature morte, vase de fleurs, citrons, et mortier*, 1919, 46 x 38 (18⅛ x 15). Mr. and Mrs. James W. Alsdorf, Chicago

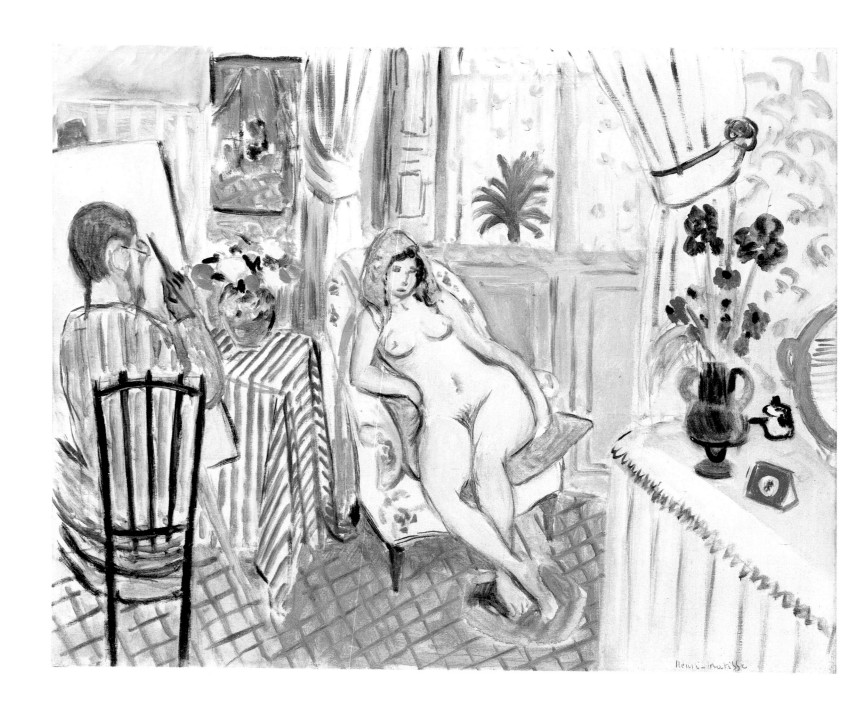

Pl. 81. *Le peintre et son modèle, intérieur d'atelier,* 1919, 60 x 73 (23⅝ x 28¾). Mr. and Mrs. Donald B. Marron, New York

130

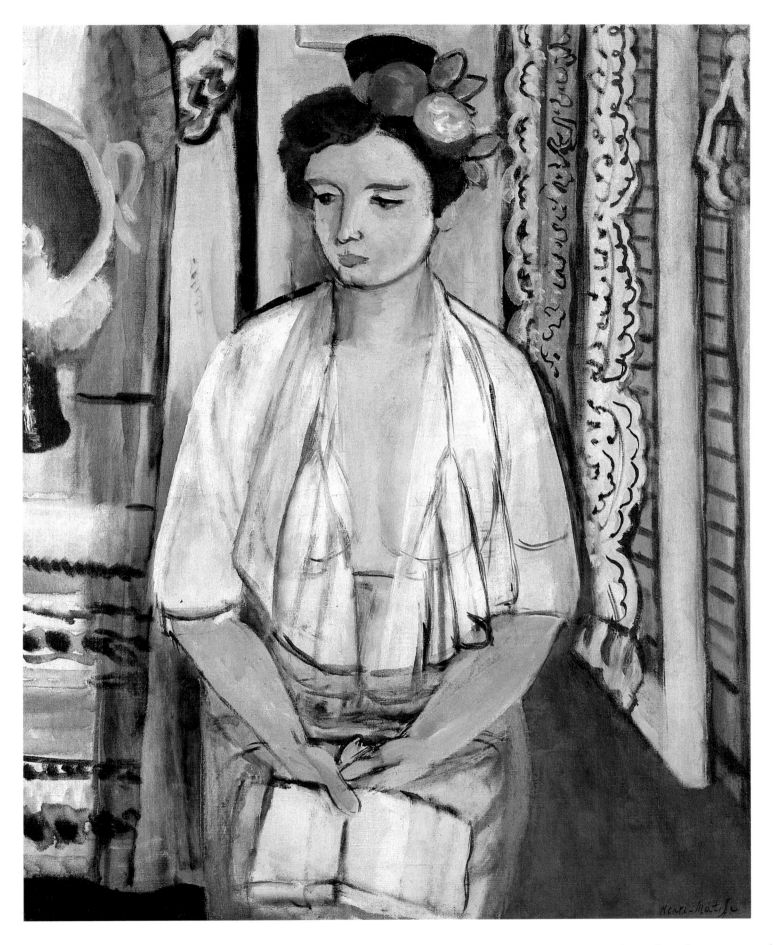

Pl. 82. *Liseuse, fleurs dans les cheveux,* 1918 or 1919, 79 x 64 (31⅛ x 25¼). Stephen Hahn Collection, New York

131

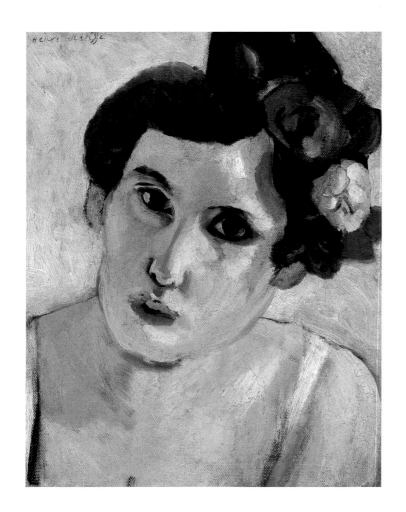

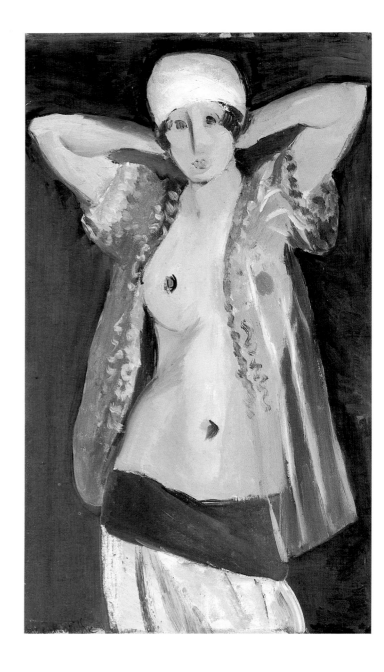

Pl. 83. *Tête de femme, fleurs dans les cheveux*, 1918 or 1919, oil on board, 35 x 27 (13¾ x 10⅝). Courtesy Galerie Jan Krugier, Geneva

Pl. 84. *La blouse transparente*, 1919, 43 x 25 (16⅞ x 9⅞). Private collection, Switzerland

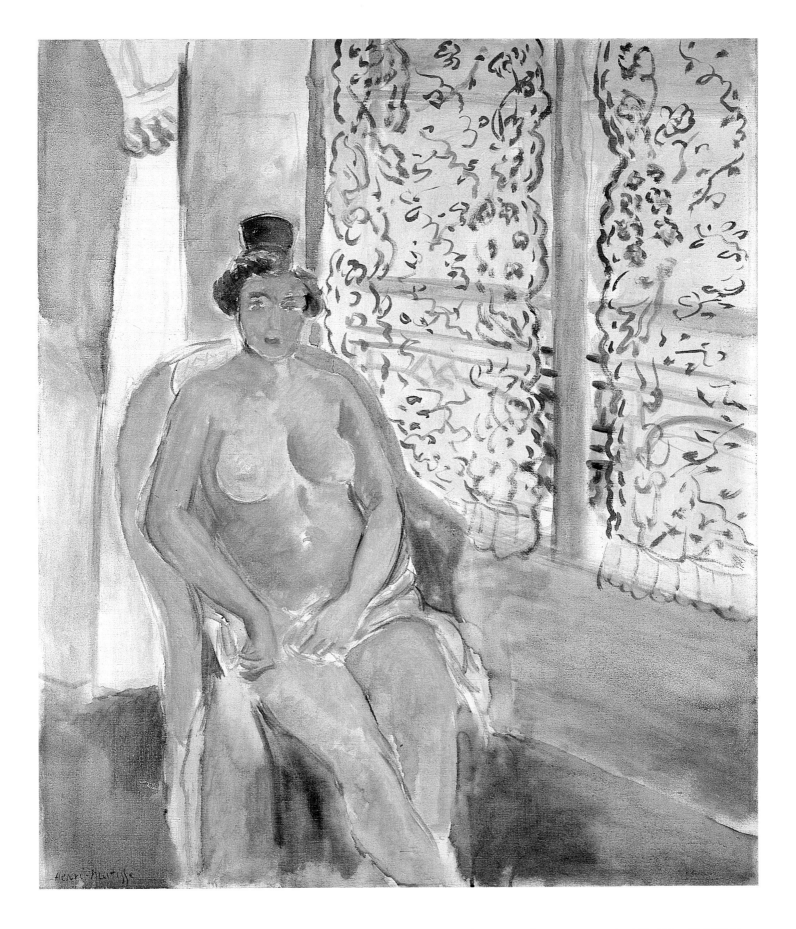

Pl. 85. *Nu au peigne espagnol, assis devant une fenêtre à voilages*, season 1919–1920, 73.2 x 60.4 (28¹³⁄₁₆ x 23¾). The Baltimore Museum of Art: The Cone Collection, formed by Dr. Claribel Cone and Miss Etta Cone of Baltimore, Maryland. BMA 1950.237

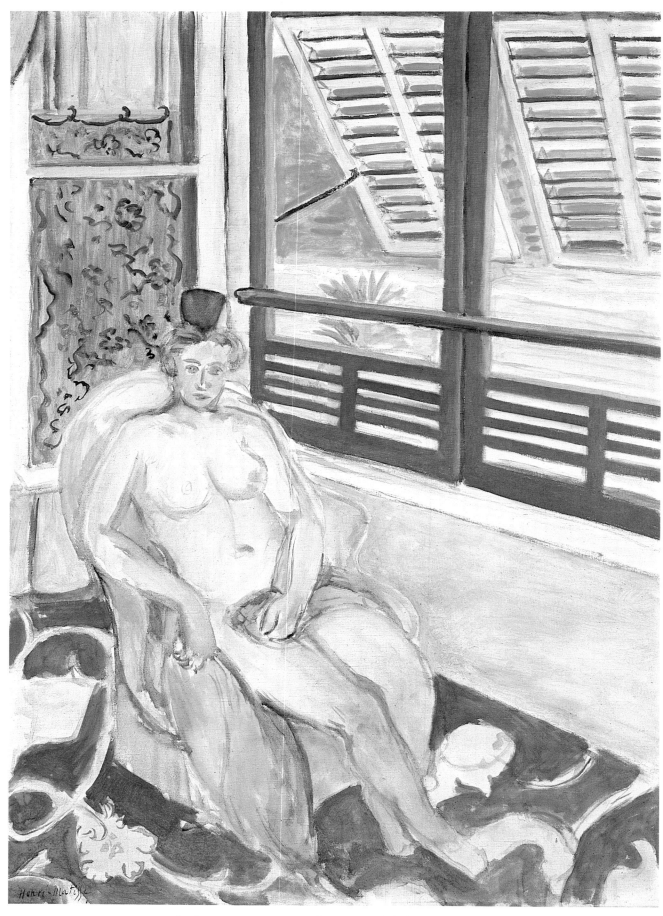

Pl. 86. *Nu au peigne espagnol, assis près de la fenêtre,* 1919, 92 x 64.5 (36¼ x 25⅜). Kunstmuseum Solothurn, Josef Müller-Stiftung

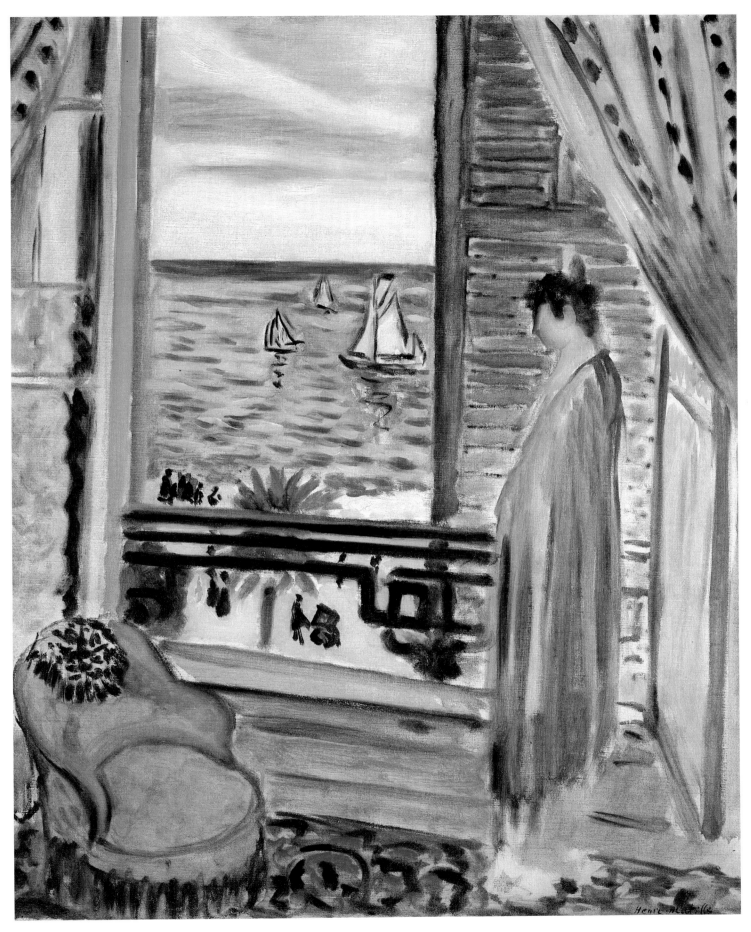

Pl. 87. *Femme au peigne espagnol, debout devant la fenêtre,* 1919, 73 x 60 (28¾ x 23⅝). Private collection

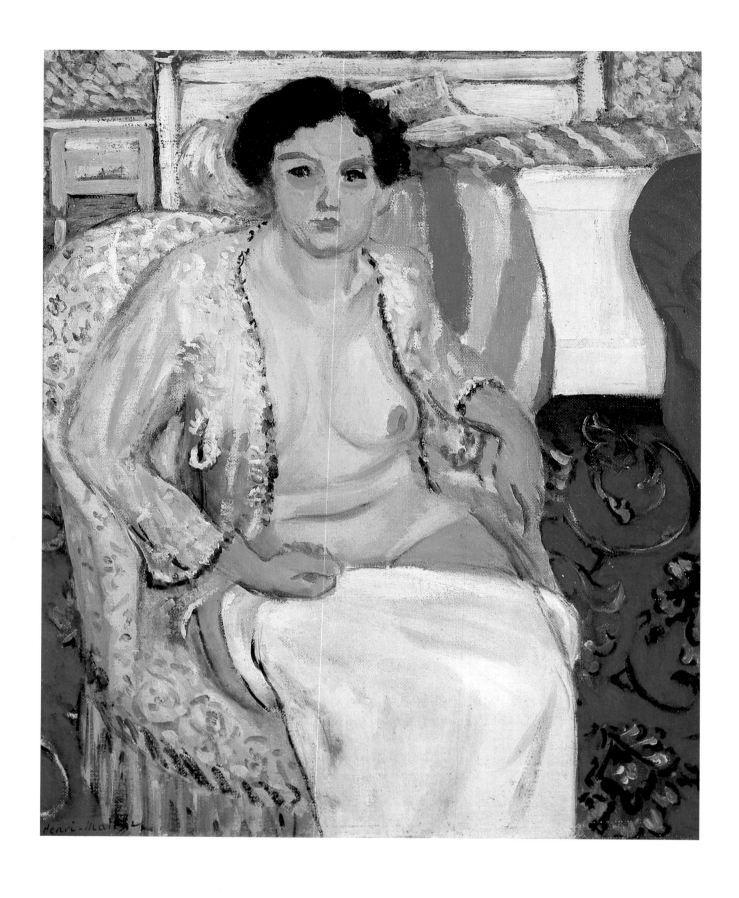

Pl. 88. *Femme assise dans un fauteuil, peignoir entrouvert,* 1920, 45.7 x 30.5 (18 x 12). Mr. and Mrs. Nathan L. Halpern

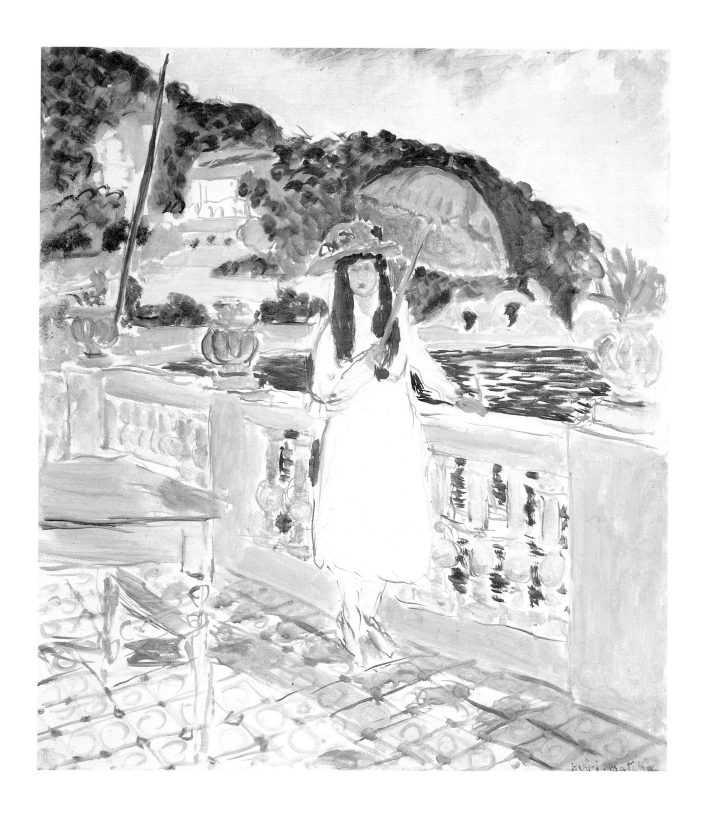

Pl. 89. *Sur la terrasse, jeune fille à l'ombrelle rose,* 1919, 55.7 x 47.7 (21⅞ x 18¾). Worcester Art Museum

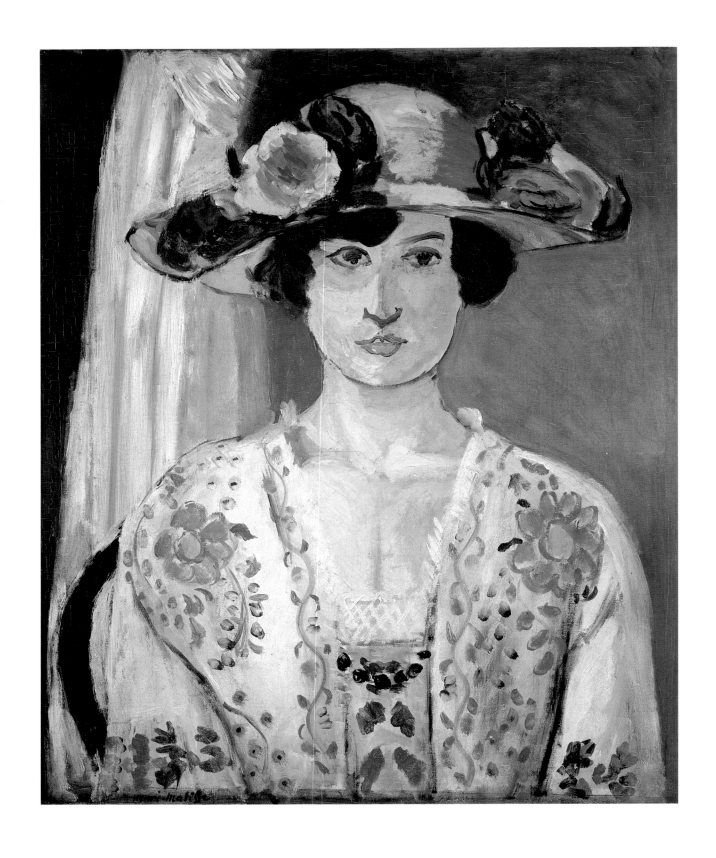

Pl. 90. *Femme au chapeau fleuri*, 1919, 58.9 x 49.9 (23⅛ x 19⅝). Mr. and Mrs. Herbert Klapper, New York

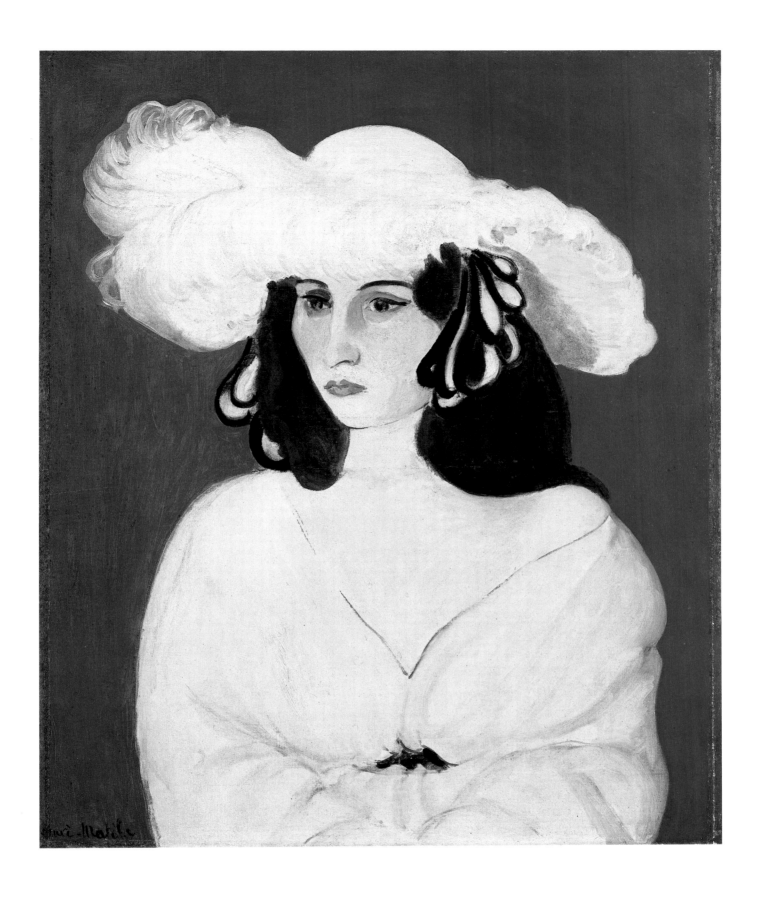

Pl. 91. *Les plumes blanches,* 1919, oil on linen, 73.03 x 60.33 (28¾ x 23¾). The Minneapolis Institute of Arts, The William Hood Dunwoody Fund

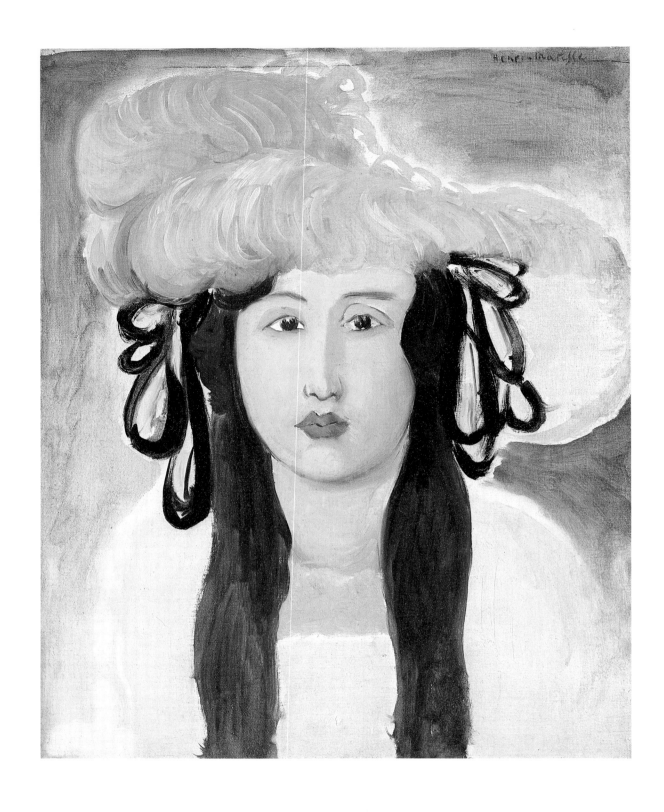

Pl. 92. *Le chapeau à plumes*, 1919, 48 x 39 (18⅞ x 15⅜). National Gallery of Art, Washington,
Chester Dale Collection 1963.10.168

140

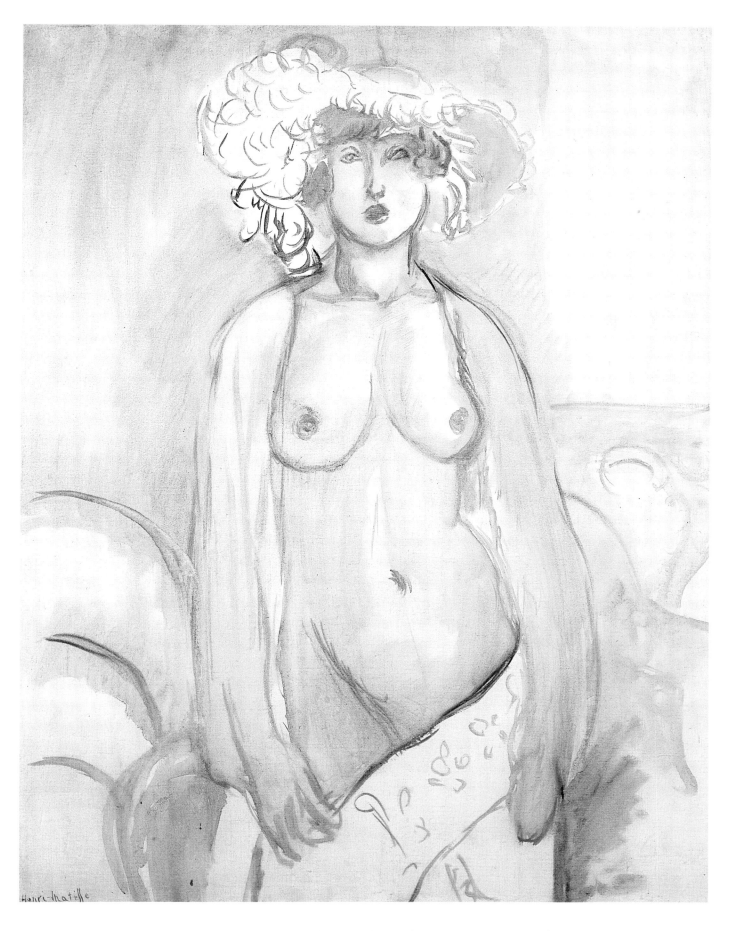

Pl. 93. *Antoinette au chapeau à plumes, debout torse nu,* early 1919, 66 x 50 (26 x 19⅝). Mrs. Harold Uris, New York

141

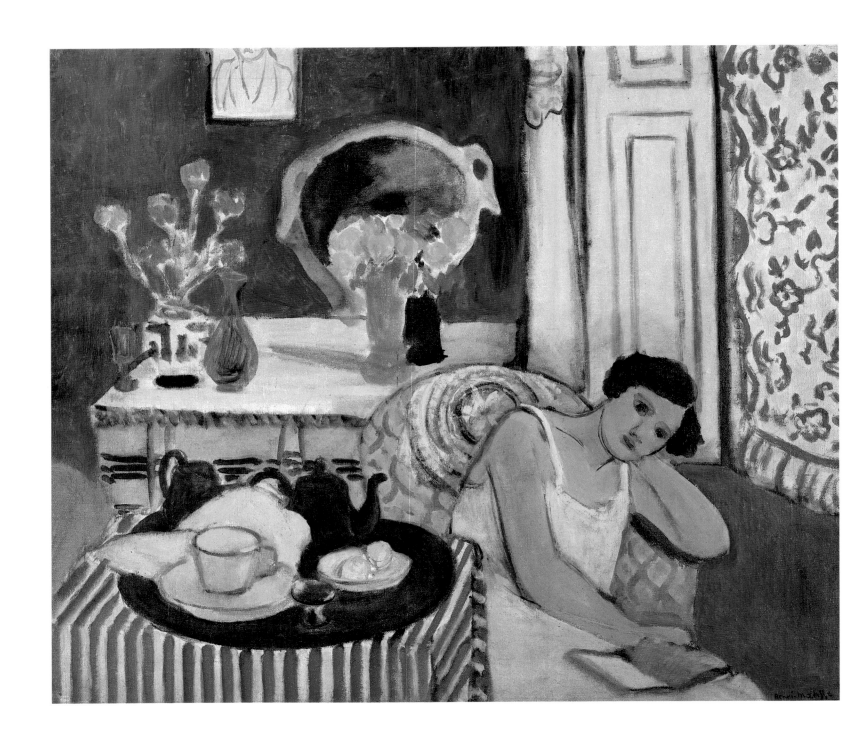

Pl. 94. *Le petit déjeuner,* 1920, 61 x 71 (24 x 28). Philadelphia Museum of Art: The Samuel S. White, 3rd, and Vera White Collection

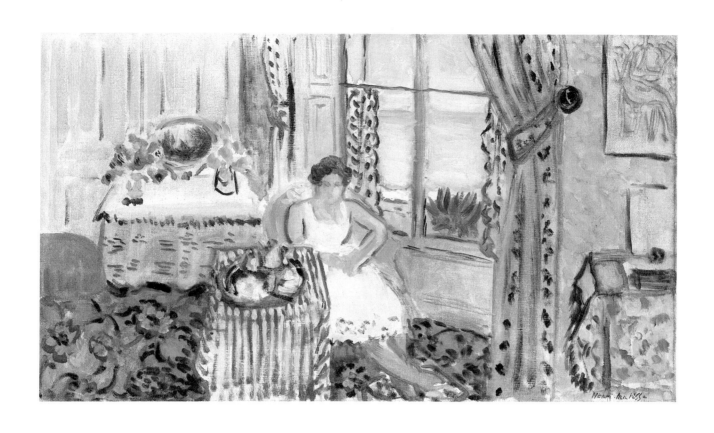

Pl. 95. *Le thé du matin*, 1920, 33 x 56 (13 x 22). Private collection, Tokyo

143

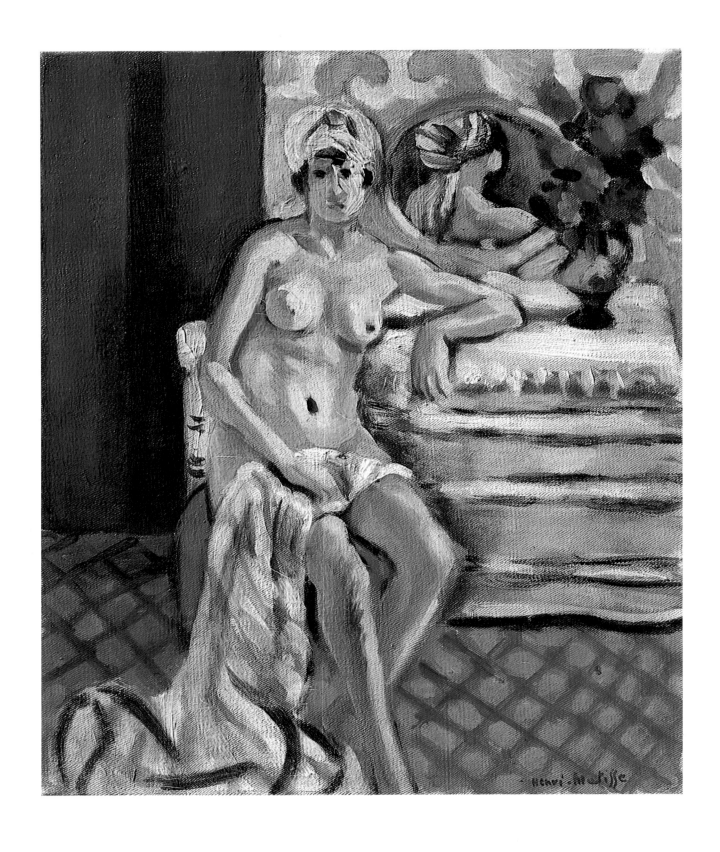

Pl. 96. *Nu assis au turban, reflété dans le miroir,* 1921, 38.4 x 34.9 (15⅛ x 13¾). Sam and Ayala Zacks Collection, Art Gallery of Ontario

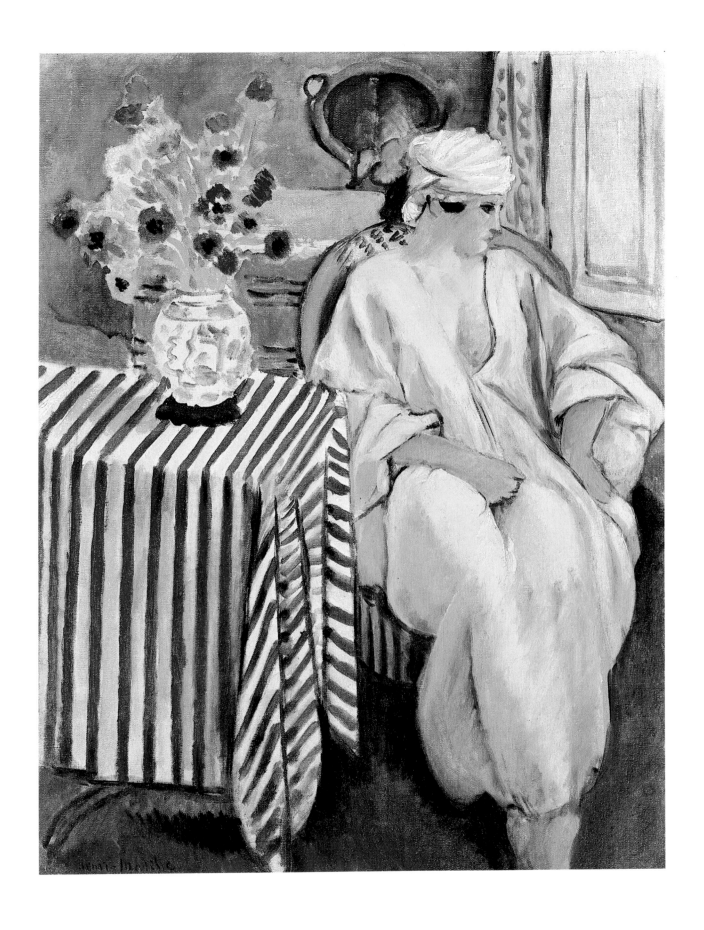

Pl. 97. *La méditation—Aprés le bain.* 1920. 73 x 54 (28¾ x 21¼). Private collection

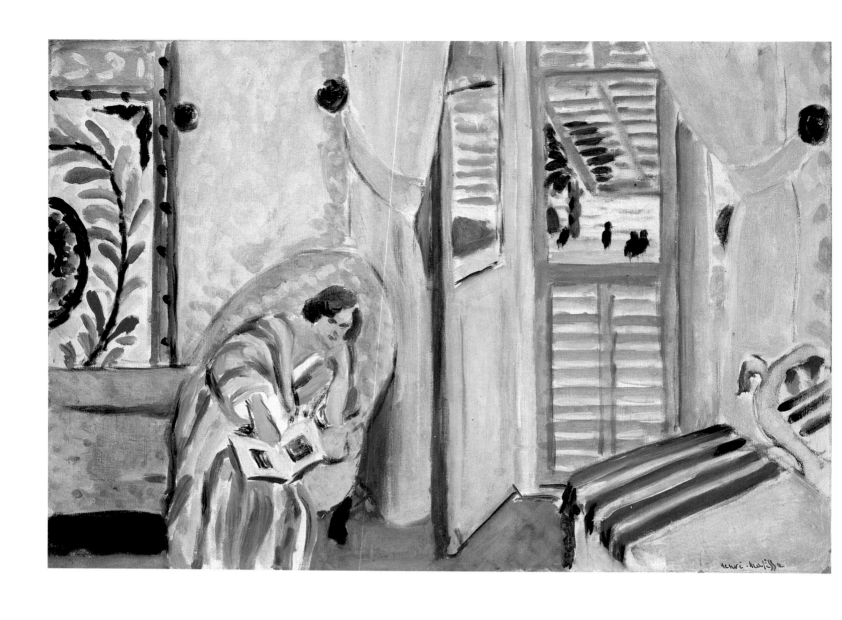

Pl. 98. *Intérieur à Nice, femme assise avec un livre*, 1920, 47 x 66 (18½ x 26). Philadelphia Museum of Art: Given by Mr. and Mrs. R. Sturgis Ingersoll

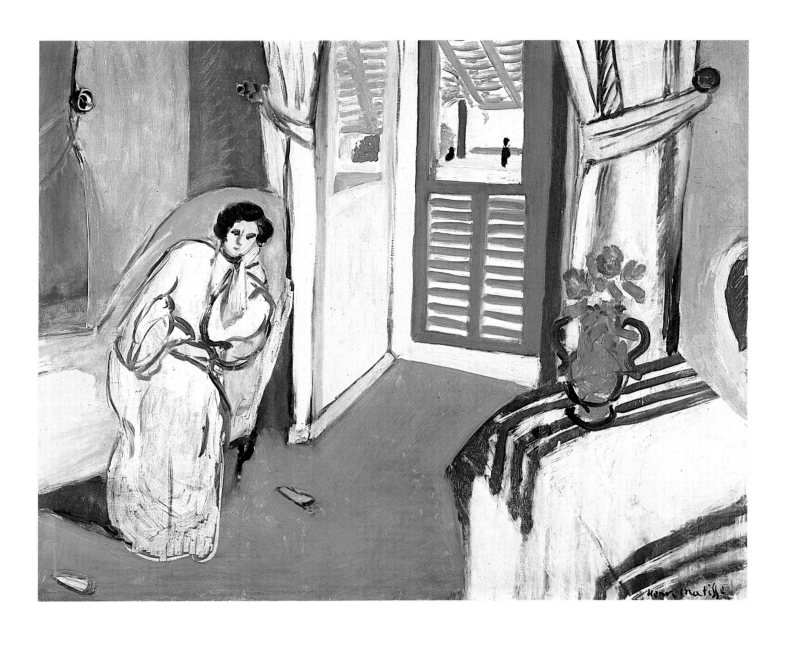

Pl. 99. *Femme au divan*, 1920, 60 x 73.5 (23⅝ x 29). Oeffentliche Kunstsammlung, Kunstmuseum Basel

147

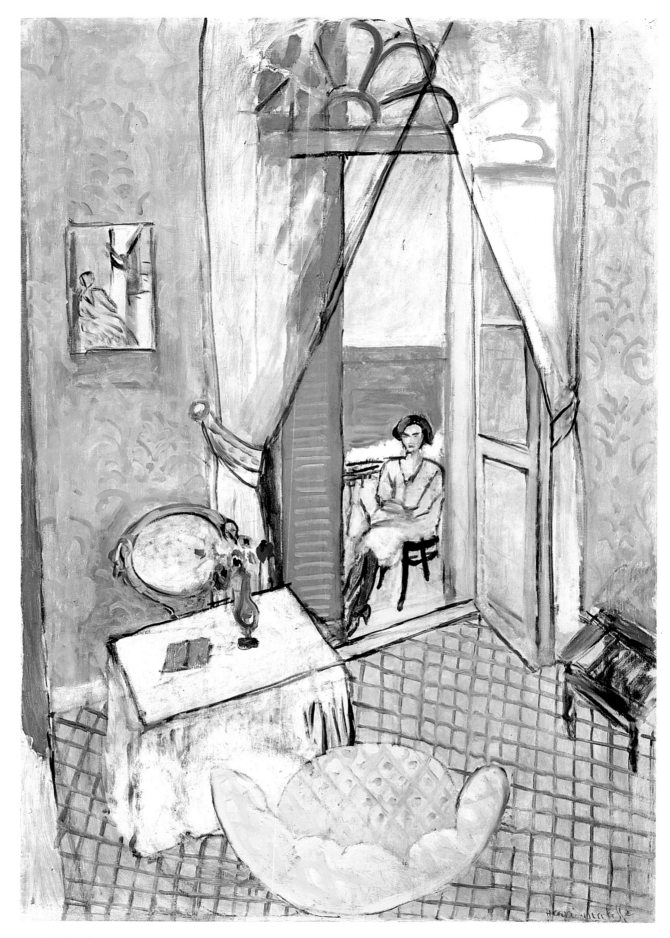

Pl. 100. *Grand intérieur, Nice*, 1919 or early 1920, 132.2 x 88.9 (52 x 35). The Art Institute of Chicago, Gift of Mrs. Gilbert W. Chapman

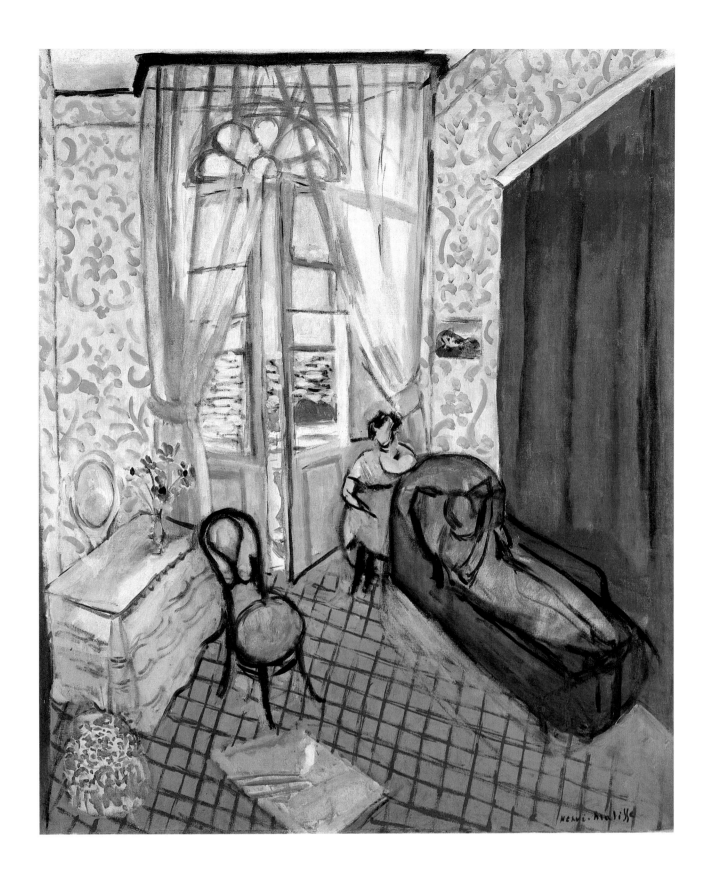

Pl. 101. *Deux femmes dans un intérieur,* February 1921, 92 x 73 (36¼ x 28¾). Paris, Musée de l'Orangerie, Collection Jean Walter et Paul Guillaume

149

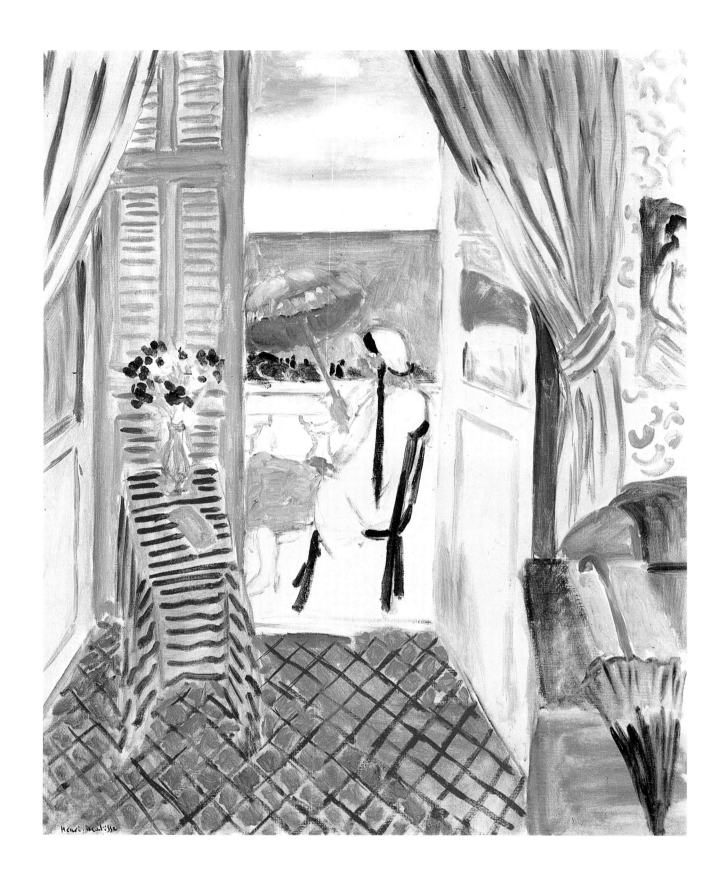

Pl. 102. *Femme à l'ombrelle rouge, assise de profil,* 1919 or 1921, 81 x 65 (31⅞ x 25⅝).
Private collection

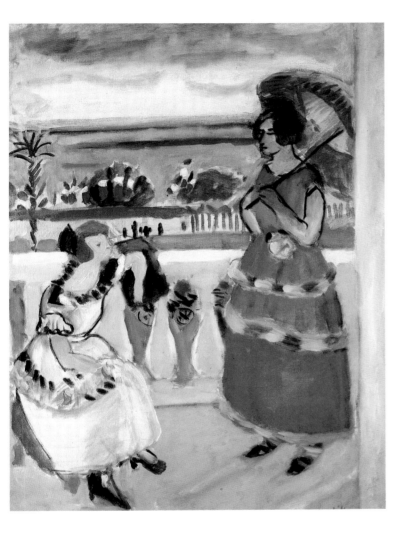

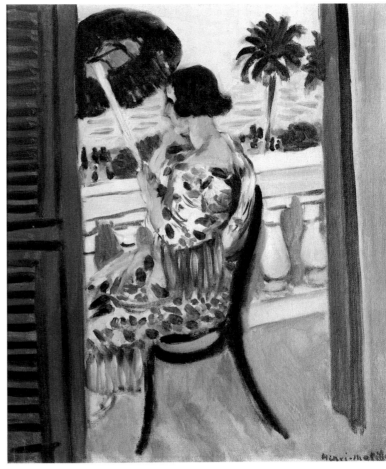

Pl. 103. *Deux femmes sur un balcon*, 1921. 69 x 54 (27⅛ x 21¼).
Simon and Marie Jaglom

☐ Pl. 104. *Femme au balcon, à l'ombrelle verte, de profil*, 1921, 46 x 37
(18⅛ x 14⅝). Private collection

151

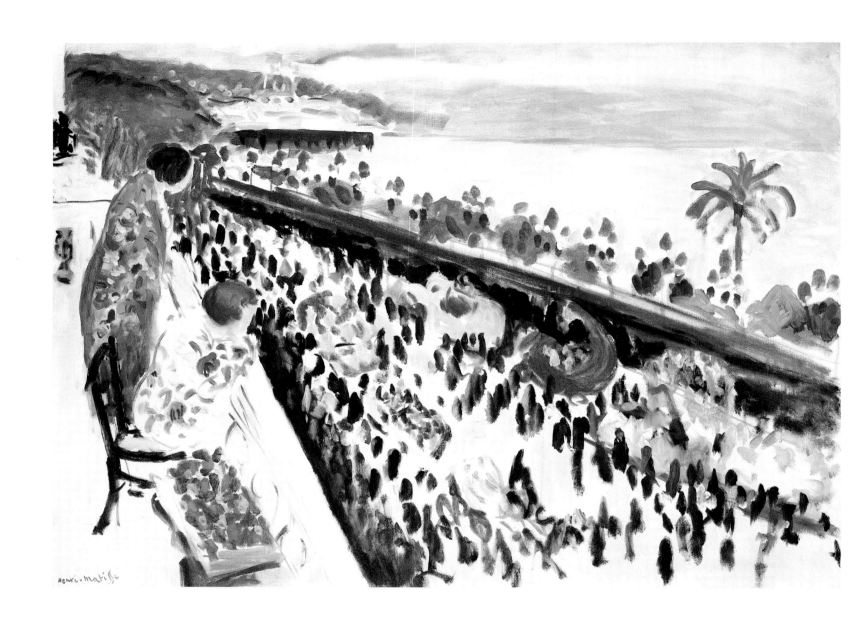

Pl. 105. *Fête des fleurs*, 1921, 72.5 x 99 (28½ x 39). Private collection, Switzerland

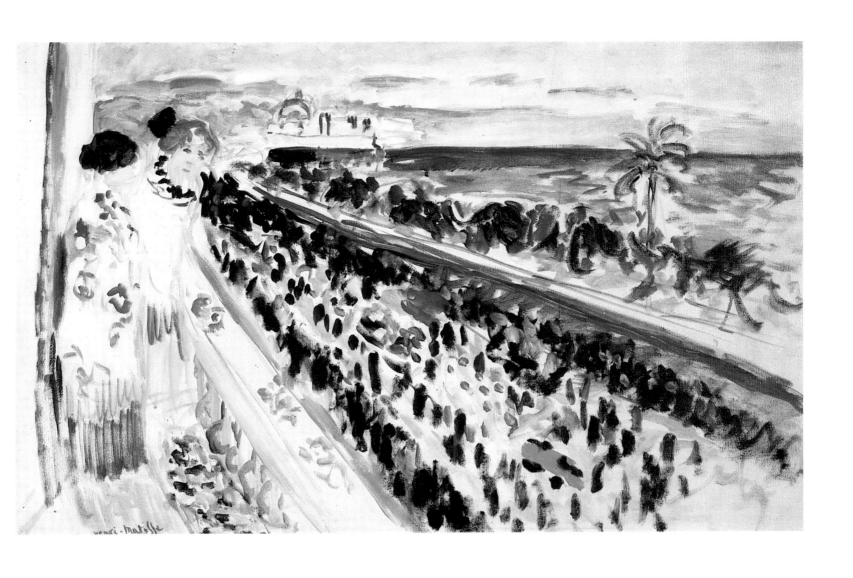

Pl. 106. *Fête des fleurs*, 1921, 65 x 101 (25⅝ x 39¾). Private collection, Zurich

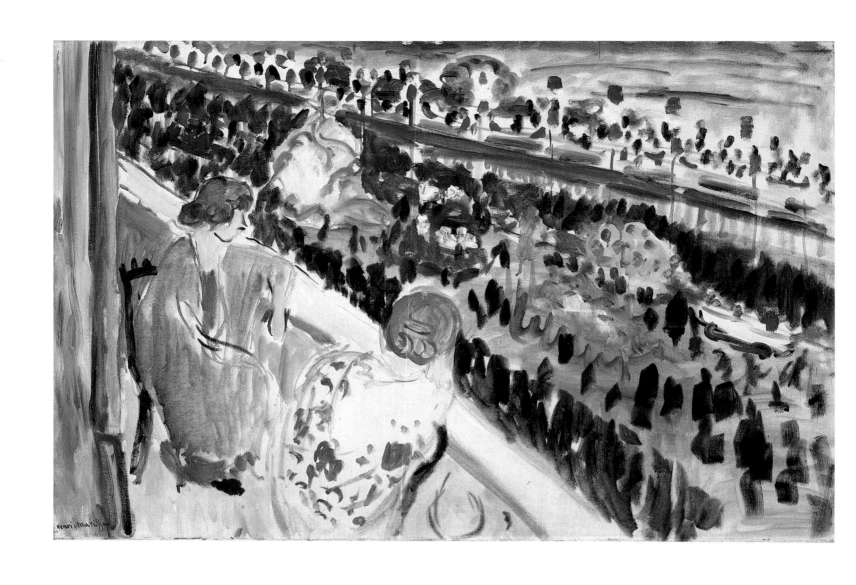

□ Pl. 107. *Fête des fleurs*, 1921, 65.5 x 99.5 (25⅞ x 39⅛). Kunstmuseum Bern

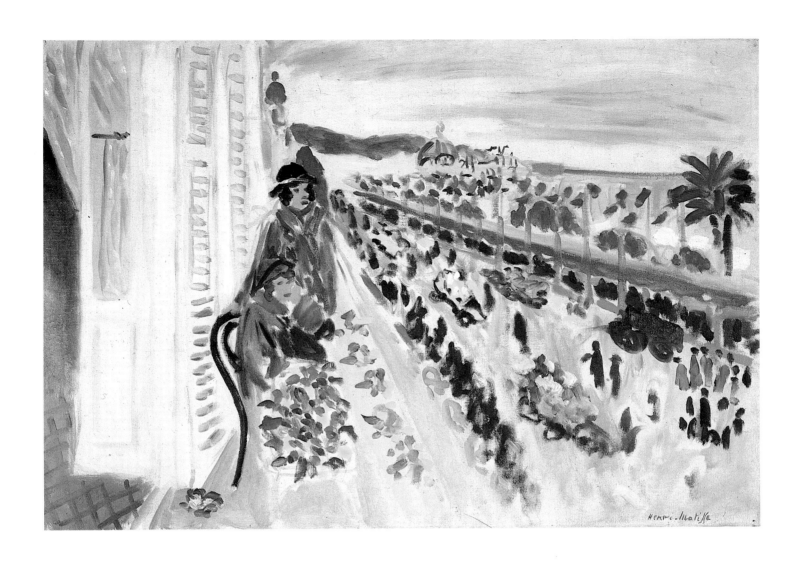

Pl. 108. *Fête des fleurs*, 24 February 1922, 65.8 x 93.1 (25⅞ x 36⅝). The Baltimore Museum of Art: The Cone Collection, formed by Dr. Claribel Cone and Miss Etta Cone of Baltimore, Maryland. BMA 1950.240

155

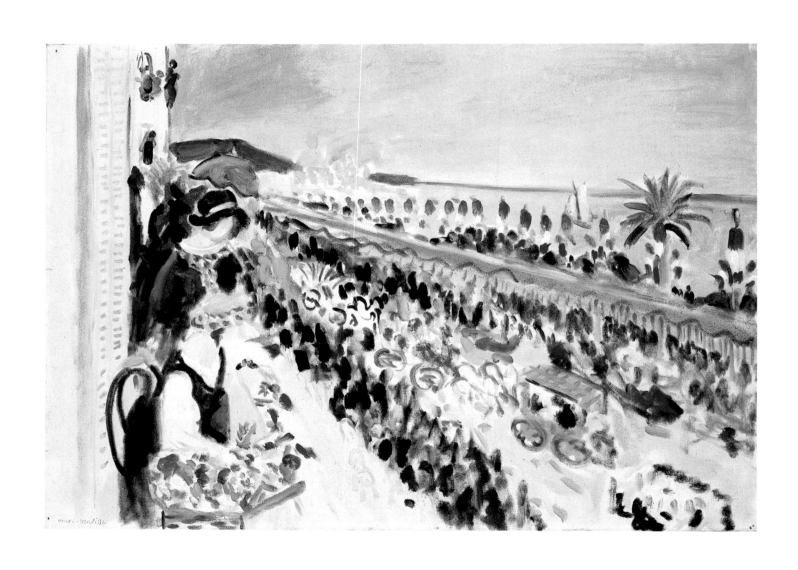

Pl. 109. *Fête des fleurs,* 1923, 67.3 x 95.2 (26½ x 37½). Cleveland Museum of Art, Mr. and Mrs. William H. Marlatt Fund

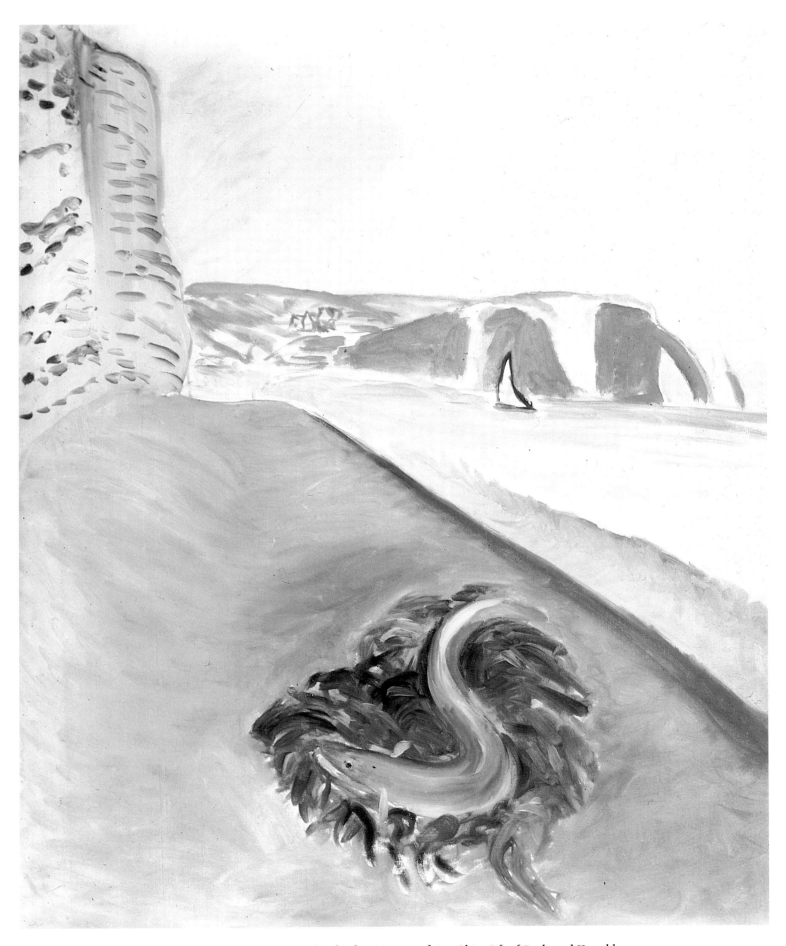

Pl. 110. *Grande falaise, le congre,* 1920, 91 x 72 (35⅞ x 28⅜). Columbus Museum of Art, Ohio: Gift of Ferdinand Howald

157

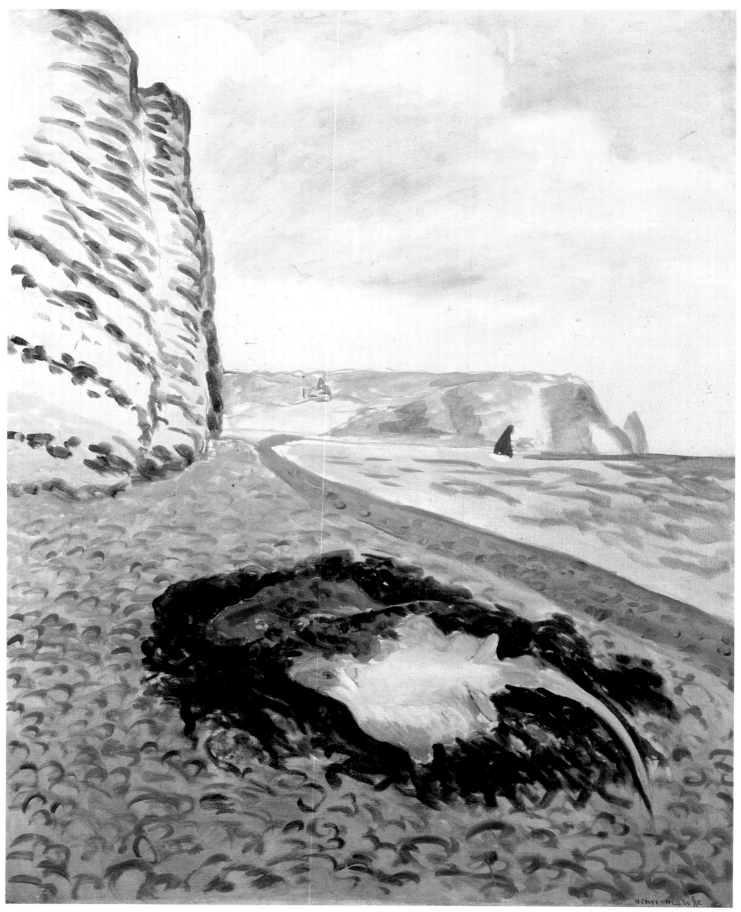

Pl. 111. *Grande falaise, les deux raies*, 1920, 93 x 73 (36⅝ x 28¾). Norton Gallery and School of Art, West Palm Beach, Florida

158

Pl. 112. *Grande falaise, les poissons*, 1920, 93.1 x 73.3 (36⅝ x 29). The Baltimore Museum of Art: The Cone Collection, formed by Dr. Claribel Cone and Miss Etta Cone of Baltimore, Maryland. BMA 1950.233

159

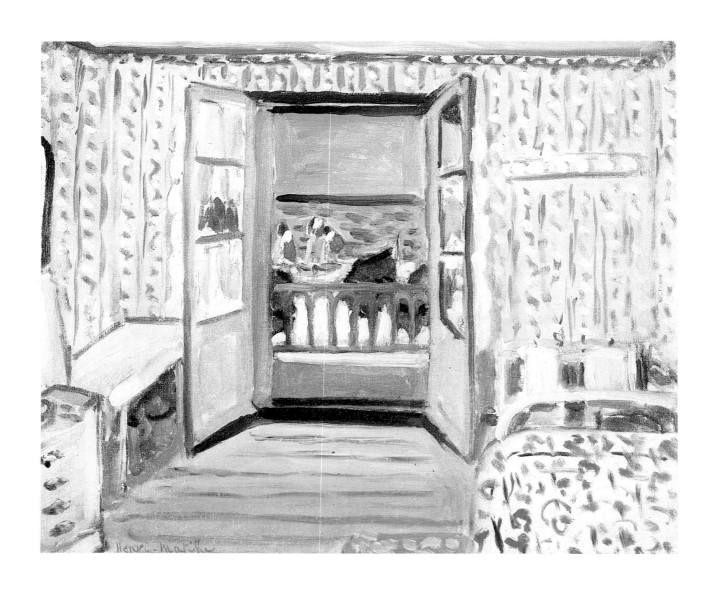

Pl. 113. *Intérieur à Etretat, le 14 Juillet,* 1920, 72.5 x 60 (28½ x 23⅝). Courtesy of Davlyn Gallery, New York

Pl. 114. *Portrait de Marguerite endormie*, 1920, 46 x 65 (18⅛ x 25⅝). Private collection

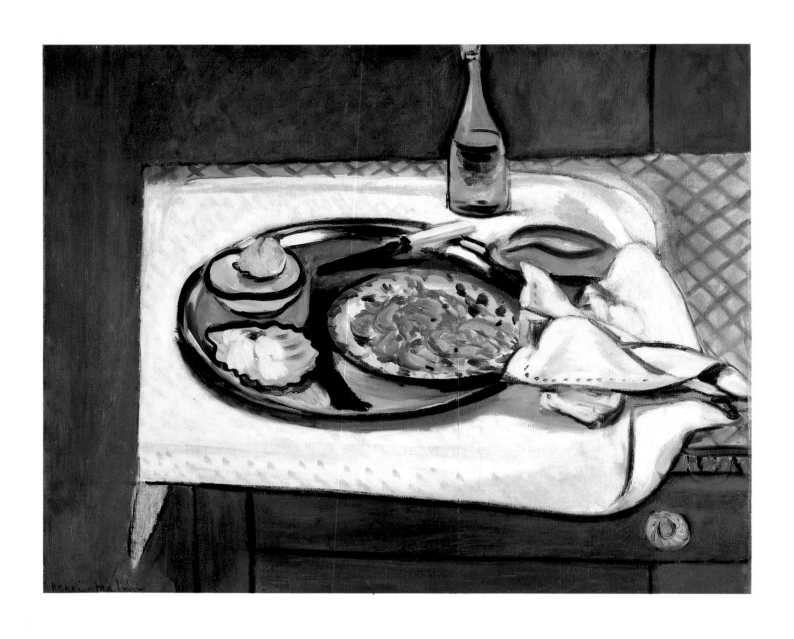

Pl. 115. *Les crevettes roses*, 1920, 54 x 73 (21¼ x 28¾). Everhart Museum, Scranton, Pennsylvania

162

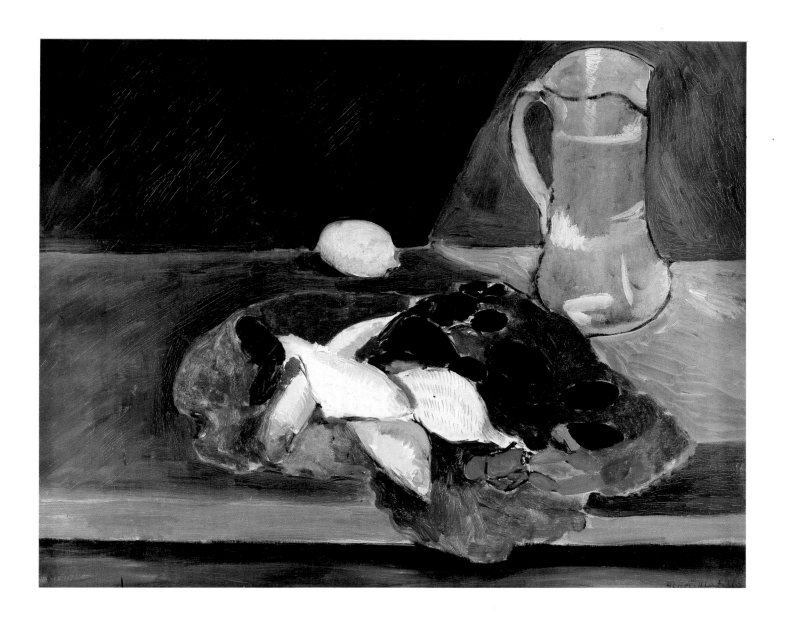

Pl. 116. *Nature morte, poissons et citrons,* 1921, 60 x 73 (23⅝ x 28¾). Private collection

163

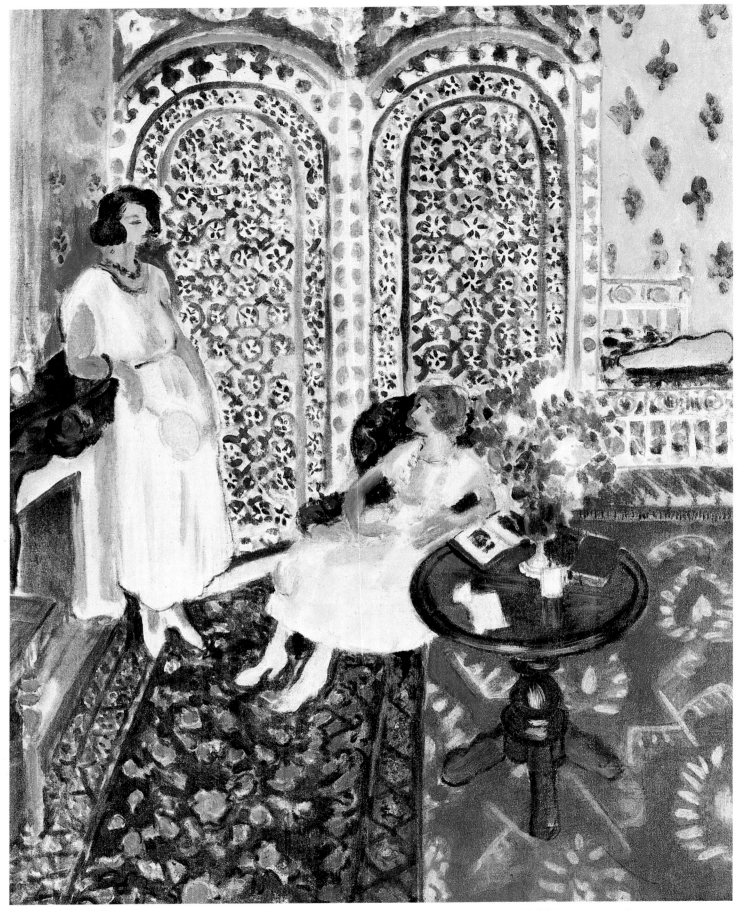

Pl. 117. *Le paravent mauresque*, 1921, 92 x 74 (36¼ x 29¼). Philadelphia Museum of Art: Bequest of Lisa Norris Elkins

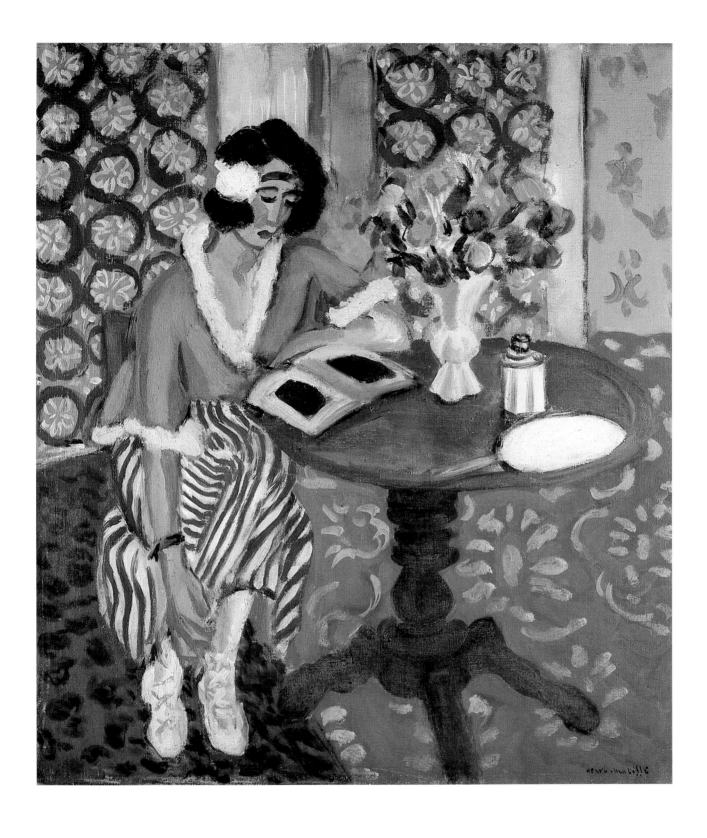

Pl. 118. *Liseuse au guéridon (en vert, robe rayée rouge)*, c. 1923, 55.5 x 46.5 (21⅞ x 18¼).
Kunstmuseum Bern

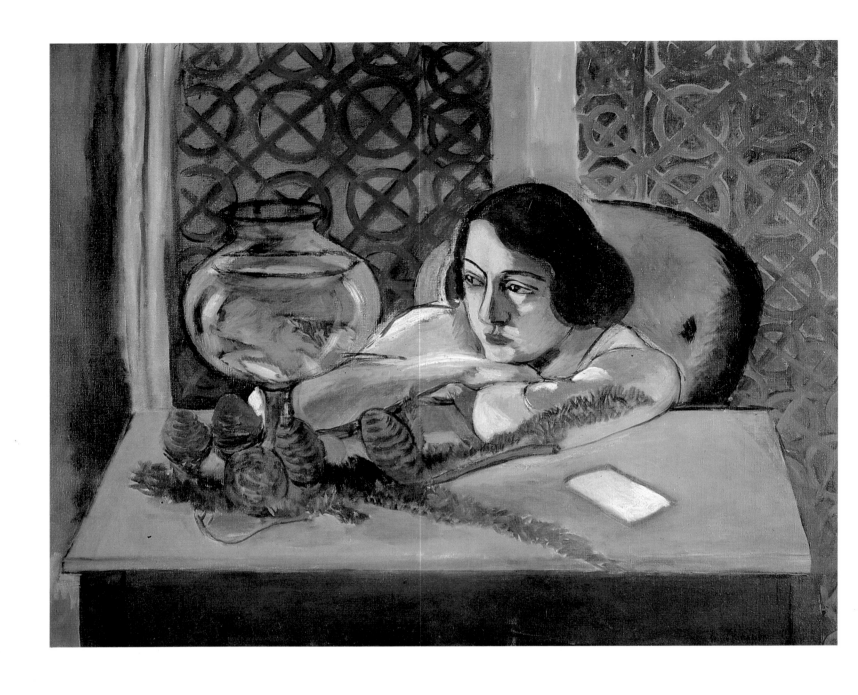

☐ Pl. 119. *Femme devant un aquarium*, 1923, 80 x 99.1 (31½ x 39). The Art Institute of Chicago, Helen Birch Bartlett Memorial

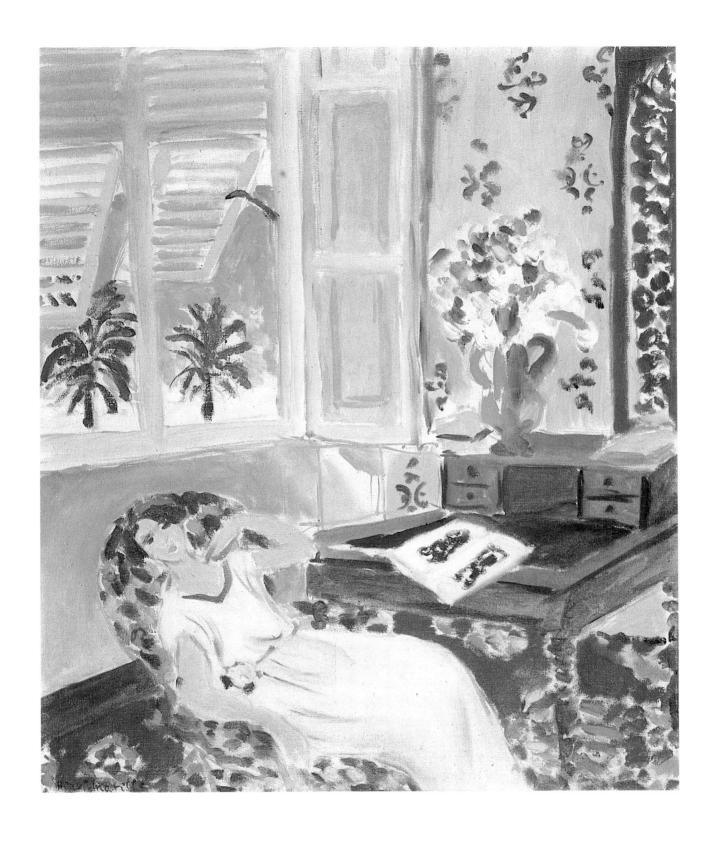

Pl. 120. *Intérieur à Nice, la sieste.* 1922, 66 x 54.5 (26 x 21½). Musée National d'Art Moderne/
Centre Georges Pompidou

167

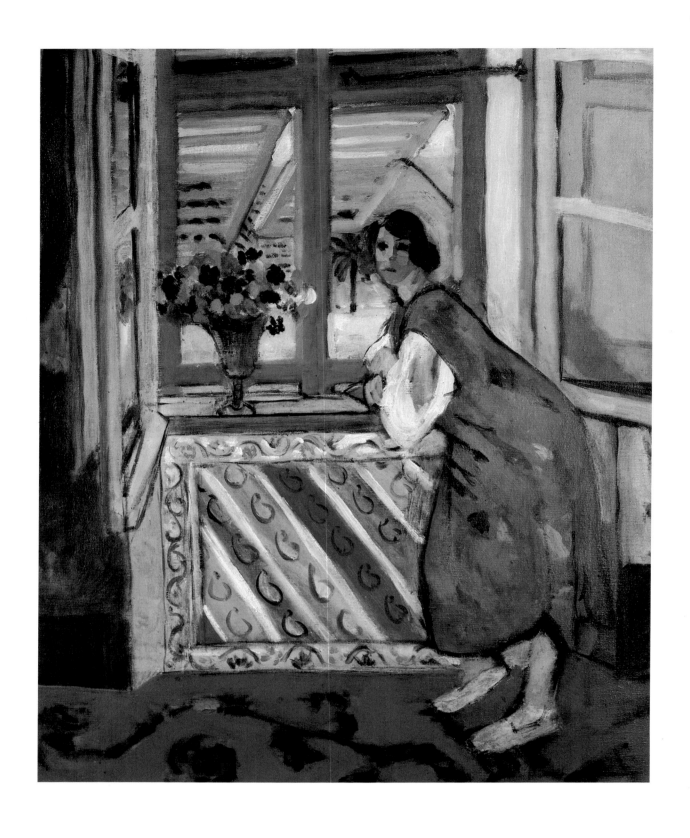

Pl. 121. *Intérieur à Nice, jeune femme en robe verte accoudée à la fenêtre*, 1921, 65 x 55 (25½ x 21⅝). Colin Collection

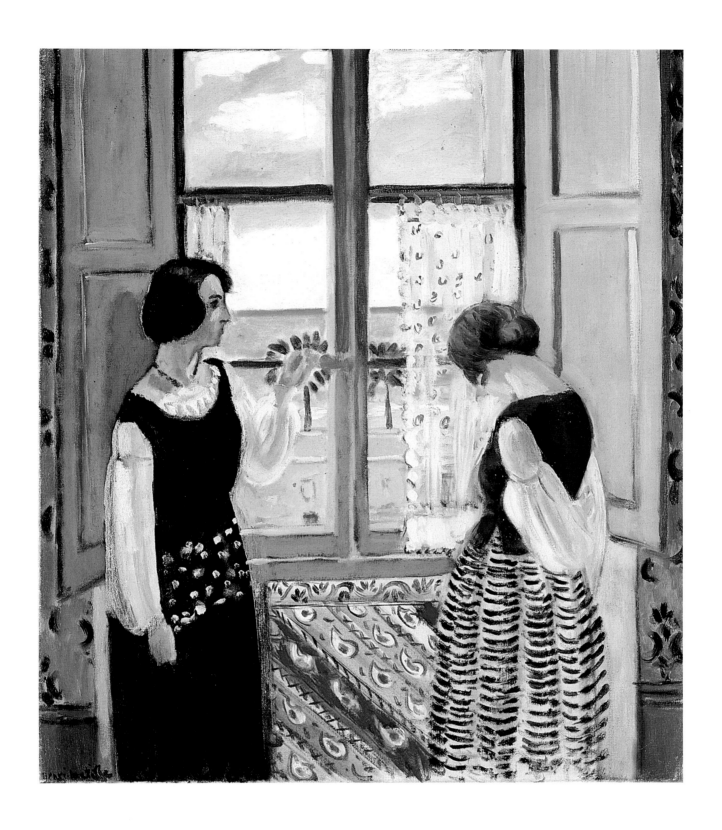

Pl. 122. *L'attente*, 1921–1922, 61 x 50 (24 x 19⅝). Collection of the late Lucien Abrams

169

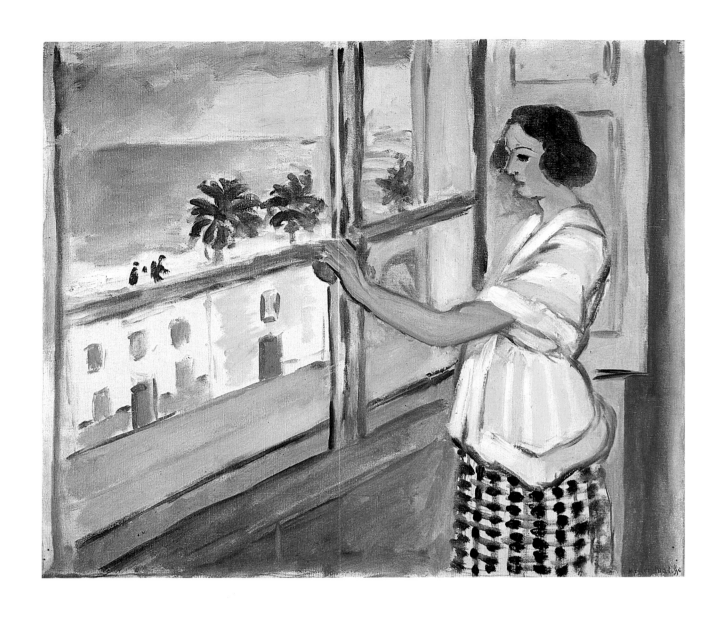

Pl. 123. *Jeune femme à la fenêtre, soleil couchant*, February 1921, 52.4 x 60.3 (20 x 25¾). The Baltimore Museum of Art: The Cone Collection, formed by Dr. Claribel Cone and Miss Etta Cone of Baltimore, Maryland. BMA 1950.245

170

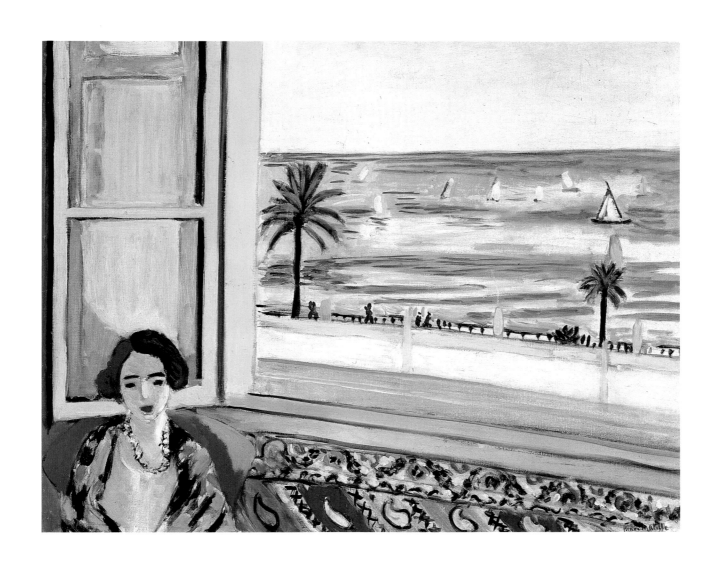

Pl. 124. *Femme assise, le dos tourné vers la fenêtre ouverte*, 1921–1923, 73 x 92.1 (28¾ x 36¼).
Montreal Museum of Fine Arts/Musée des Beaux-Arts de Montréal. Purchased 1949 with
Tempest Fund

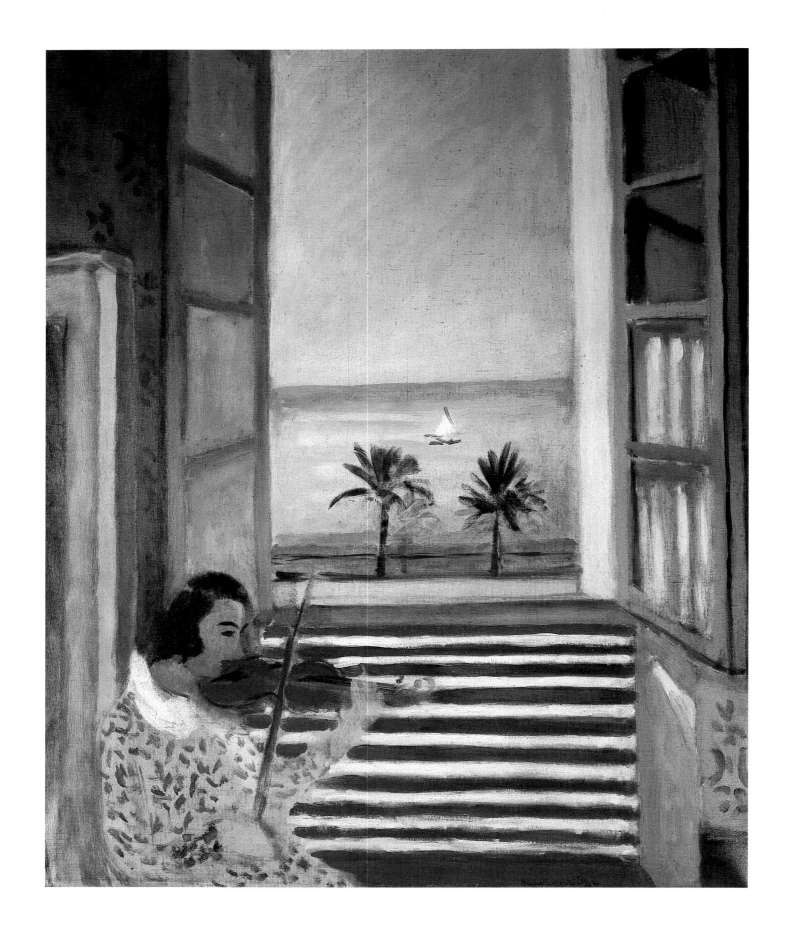

Pl. 125. *Jeune femme jouant du violon devant la fenêtre ouverte*, 1923, 73 x 60.3 (28¾ x 23¾).
Mrs. W. Leicester Van Leer, New York

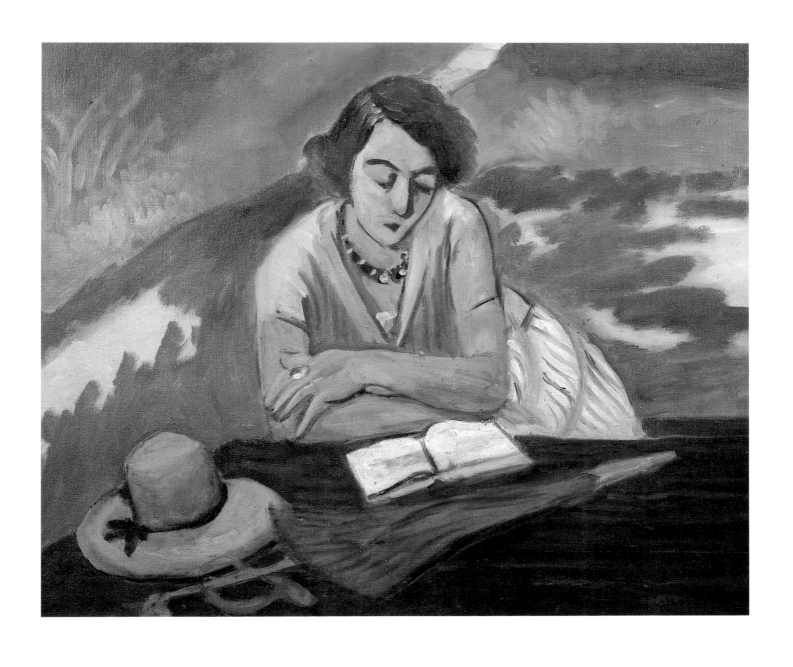

Pl. 126. *Liseuse en plein air, ombrelle sur la table,* October 1921, 50 x 61 (19⅝ x 24). The Trustees of
the Tate Gallery, London

173

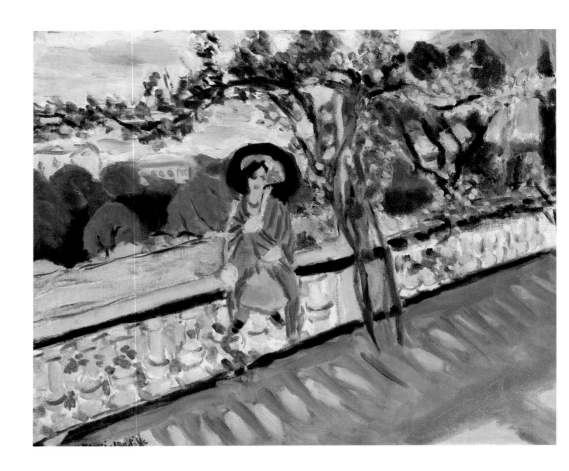

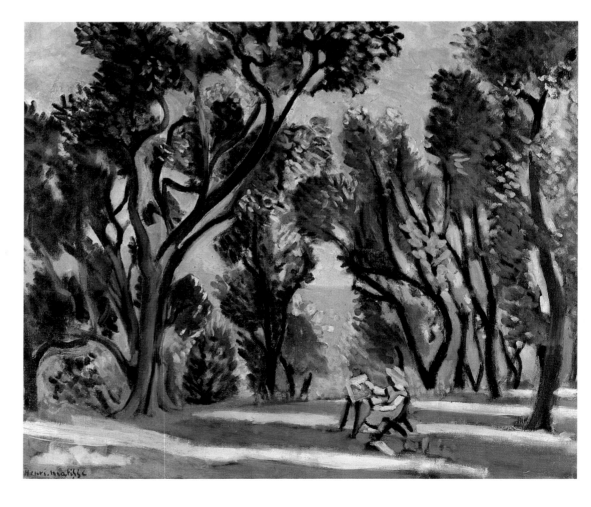

Pl. 127. (above) *Sur la terrasse, Parc Liserb*, 1921, oil on canvas on cardboard, 37.5 x 45.5 (14¾ x 18). Musées Royaux des Beaux-Arts de Belgique, Bruxelles/Koninklijke Musea voor Schone Kunsten van België, Brussel

Pl. 128. *Peintre dans les oliviers*, 1923–1924, 60.3 x 73.4 (23¾ x 28⅞). The Baltimore Museum of Art: The Cone Collection, formed by Dr. Claribel Cone and Miss Etta Cone of Baltimore, Maryland. BMA 1950.249

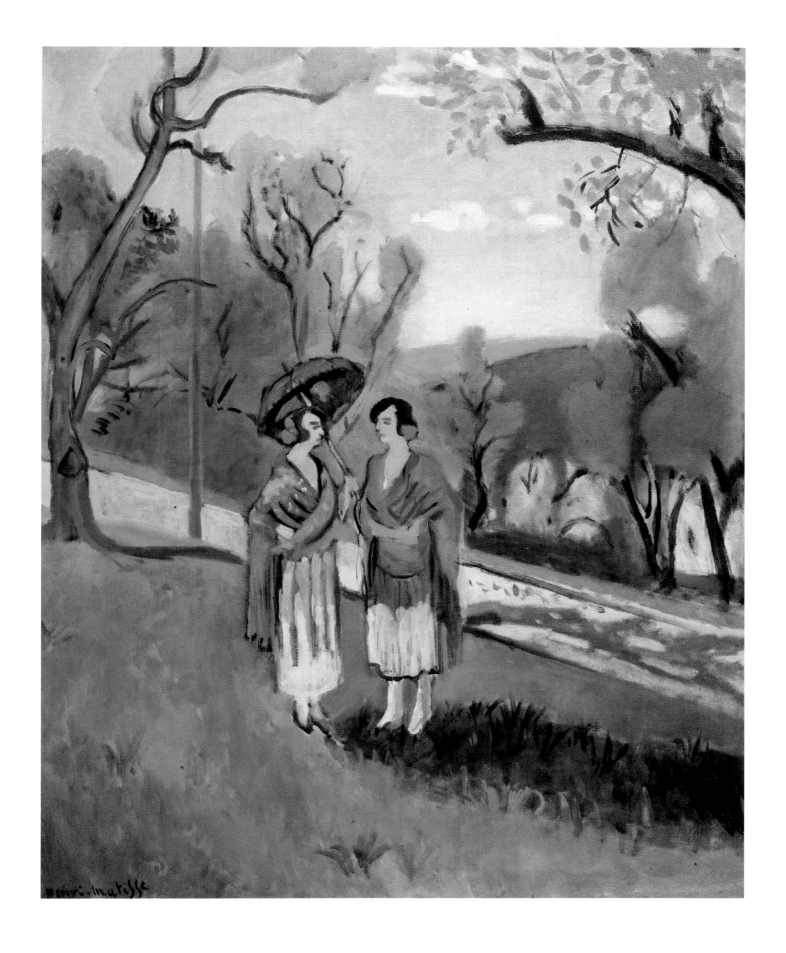

Pl. 129. *La conversation sous les oliviers*, 1921, 100 x 84 (39⅜ x 33). Thyssen-Bornemisza Collection, Lugano, Switzerland

175

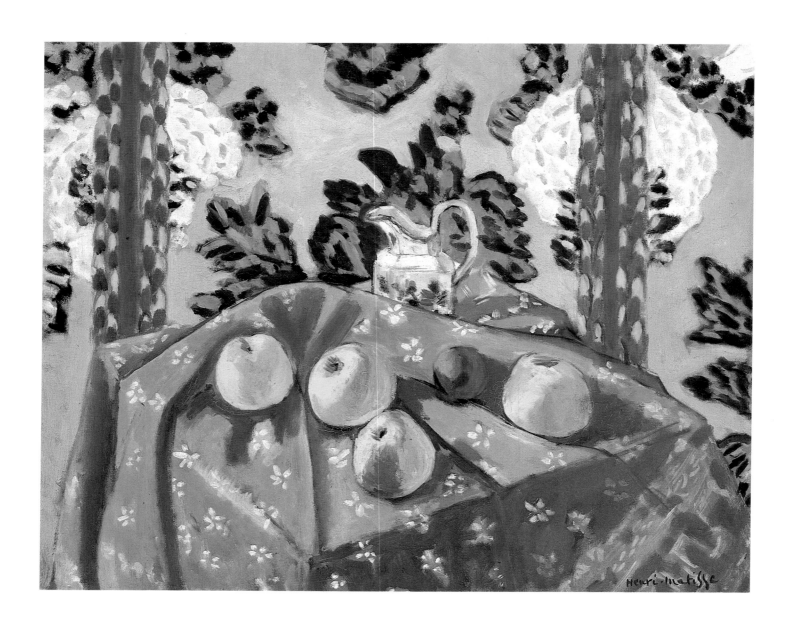

Pl. 130. *Nature morte aux pommes sur nappe rose*, 1924, 60.4 x 73 (23¾ x 28¾). National Gallery of Art, Washington, Chester Dale Collection 1963.10.169

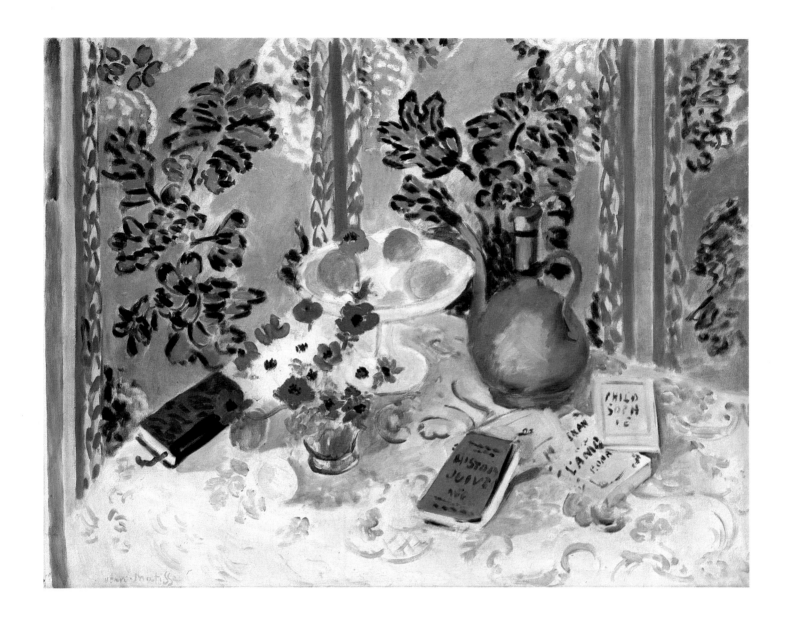

Pl. 131. *Nature morte, "Histoires Juives,"* 1924, 82 x 101 (32¼ x 39¾). Philadelphia Museum of Art:
The Samuel S. White, 3rd, and Vera White Collection

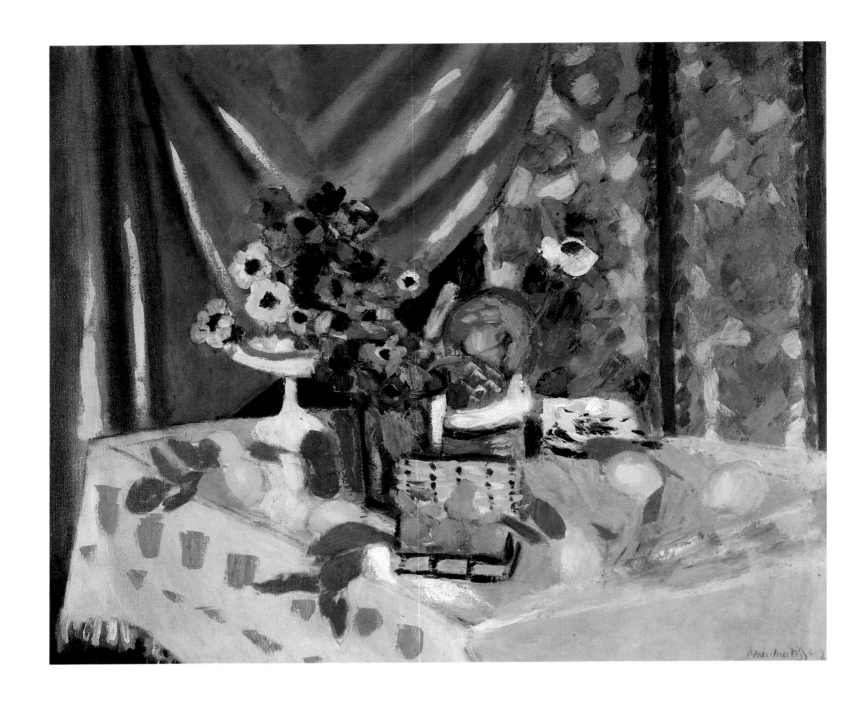

Pl. 132. *Nature morte, nappe rose, vase d'anémones, citrons, et ananas*, 1925, 80 x 100 (31½ x 39⅜). Private collection

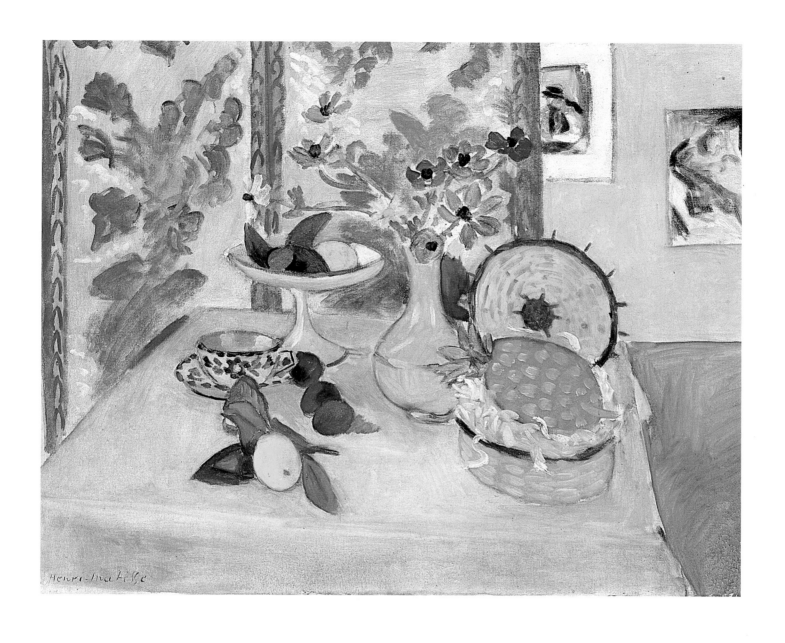

Pl. 133. *Nature morte (ananas, compotier, fruits, vase d'anémones)*, 1925, 81 x 100 (31⅞ x 39⅜).
Philadelphia Museum of Art, The Henry P. McIlhenny Collection In Memory of Frances P. McIlhenny

179

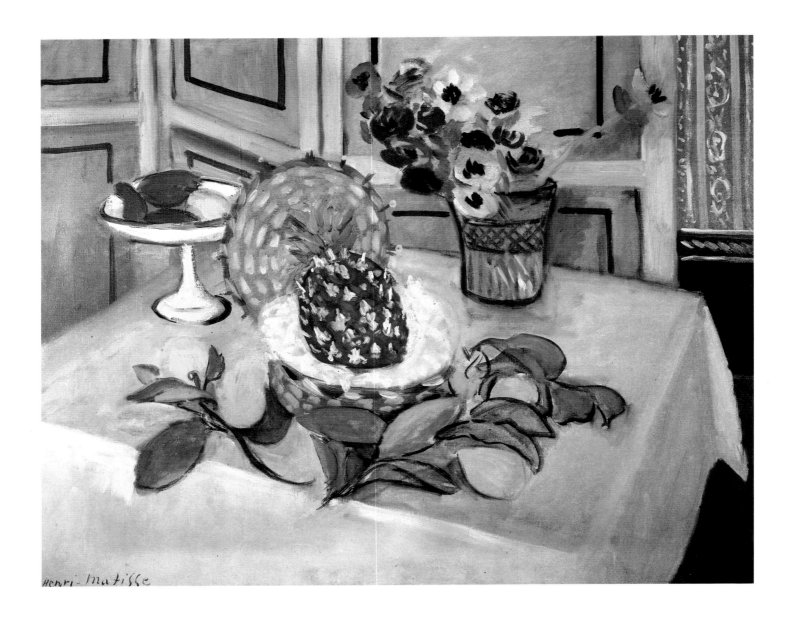

□ Pl. 134. *La nappe rose, citrons et anémones*, 1925, 61.5 x 81.0 (25⅝ x 31⅞). Private collection

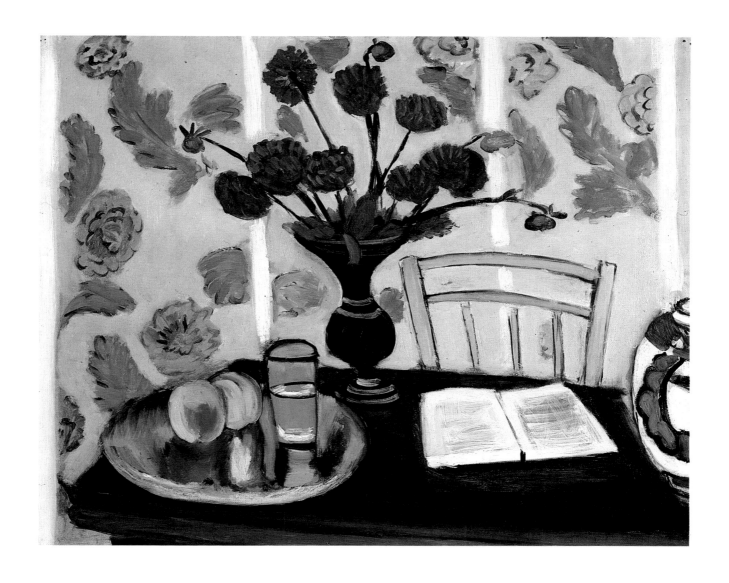

□ Pl. 135. *Nature morte, bouquet de dahlias et livre blanc,* 1923, 50.2 x 61 (19¾ x 24). The Baltimore Museum of Art: The Cone Collection, formed by Dr. Claribel Cone and Miss Etta Cone of Baltimore, Maryland. BMA 1950.249

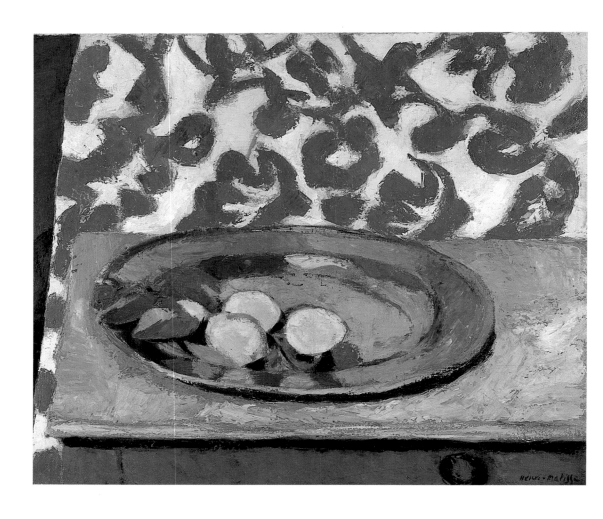

Pl. 136. (above) *Les citrons au plat d'étain,*
1926. 43 x 66 (16⅞ x 26). Mrs. Joanne
Toor Cummings

Pl. 137. (right) *Ananas dans un panier,*
1926. 47 x 38 (18½ x 15). Mme Jean Matisse

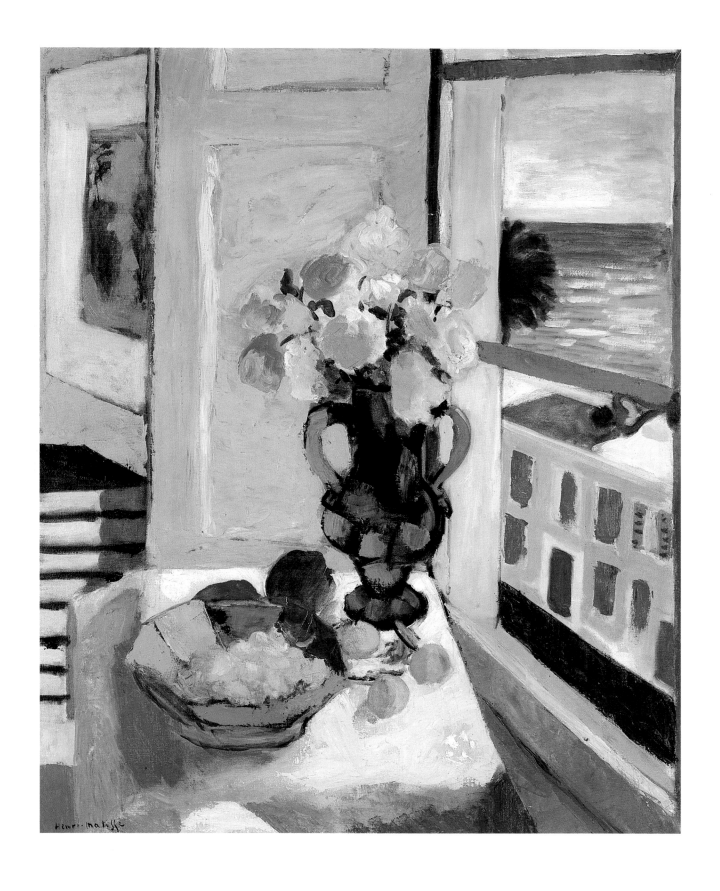

Pl. 138. *Les roses safrano devant la fenêtre*, 1925, 80 x 65 (31½ x 25⅝). Private collection, Switzerland

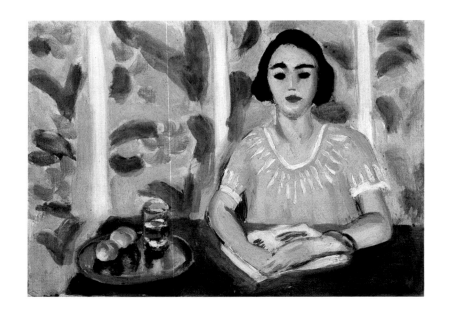

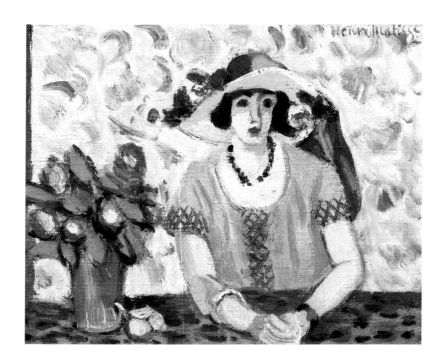

Pl. 139. *Liseuse aux pêches*, 1923, 12.7 x 17.2 (5 x 6¾). Stephen Hahn
Collection, New York

Pl. 140. *La capeline de paille d'Italie, vase de fleurs*, 1923, 13 x 17 (5⅛ x 6¾).
Private collection

184

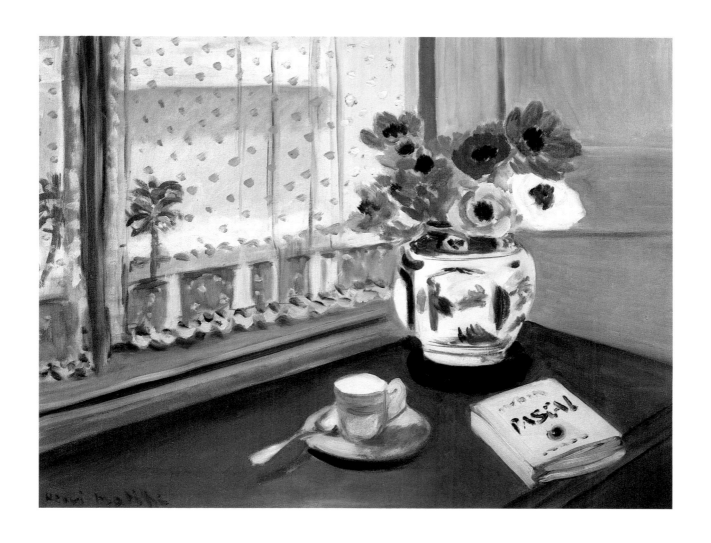

Pl. 141. *Nature morte, "Les pensées de Pascal,"* 1924. 50 x 65 (19⅝ x 25⅝). Private collection

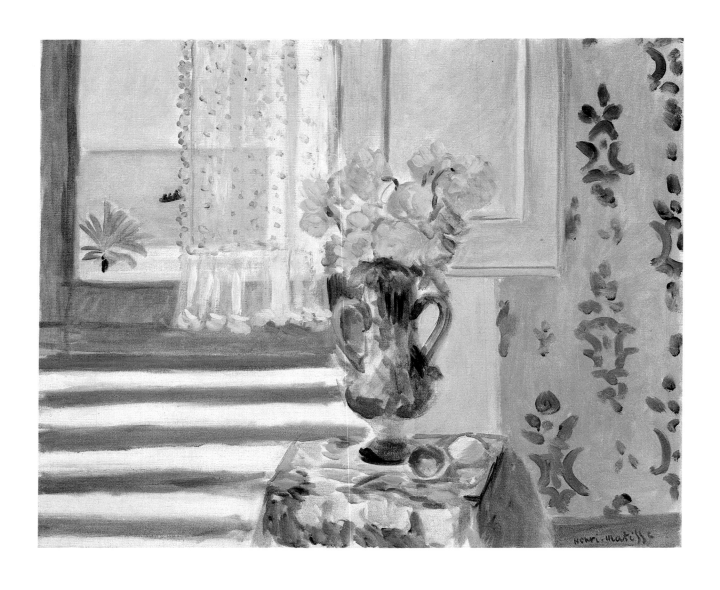

Pl. 142. *Vase de fleurs devant la fenêtre,* 1924, 60 x 73.5 (23⅝ x 29). Museum of Fine Arts, Boston, Bequest of John T. Spaulding

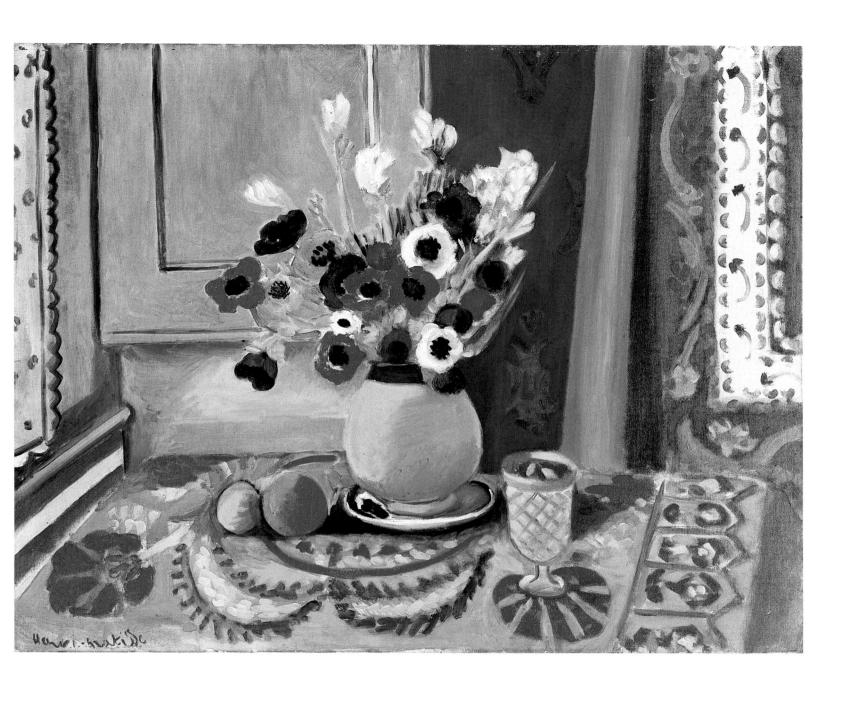

Pl. 143. *Anémones dans un vase de terre*, 1924. 73 x 92 (28¾ x 36¼). Kunstmuseum Bern

187

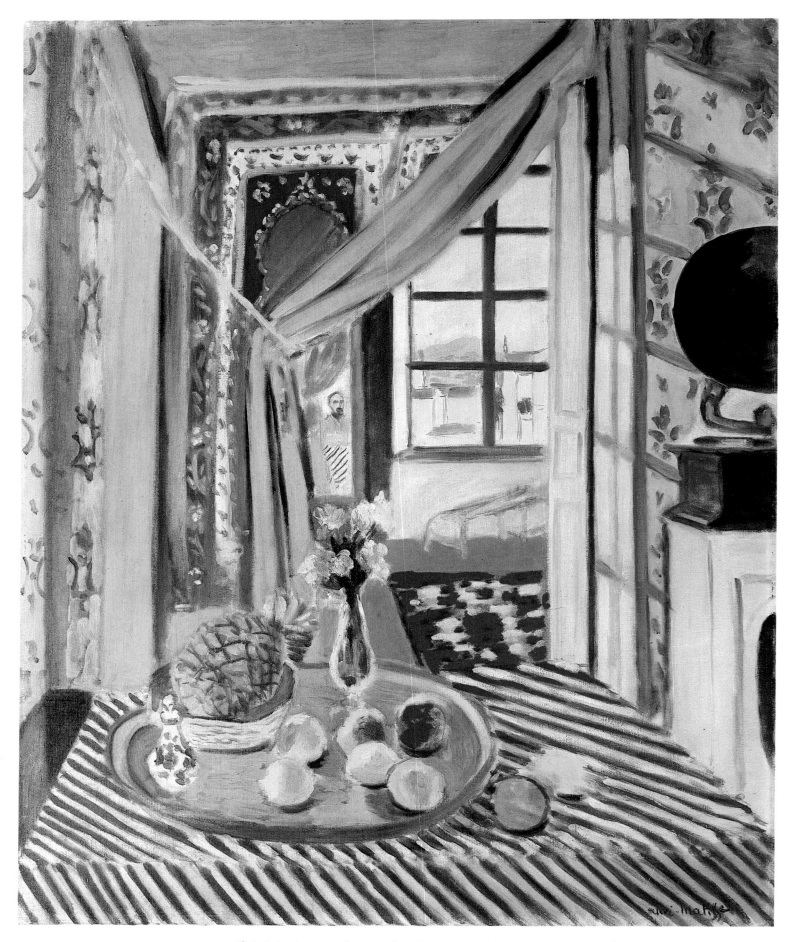

Pl. 144. *Intérieur au phonographe*, 1924, 100.5 x 80 (39⅝ x 31½). Private collection

188

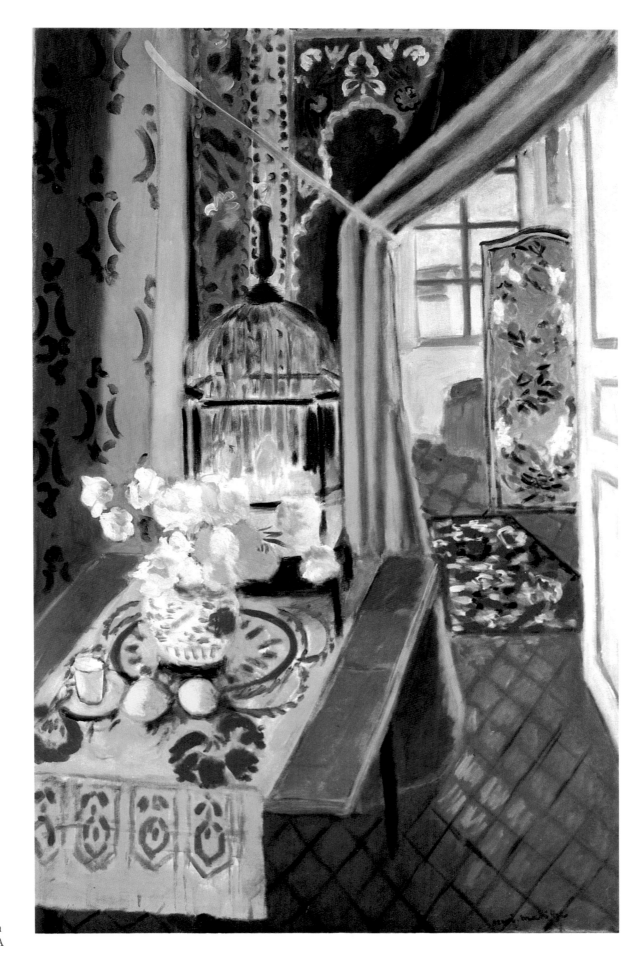

Pl. 145. *Intérieur, fleurs et perruches*, 1924, 117 x 74 (46⅛ x 29⅛). The Baltimore Museum of Art: The Cone Collection, formed by Dr. Claribel Cone and Miss Etta Cone of Baltimore, Maryland. BMA 1950.252

189

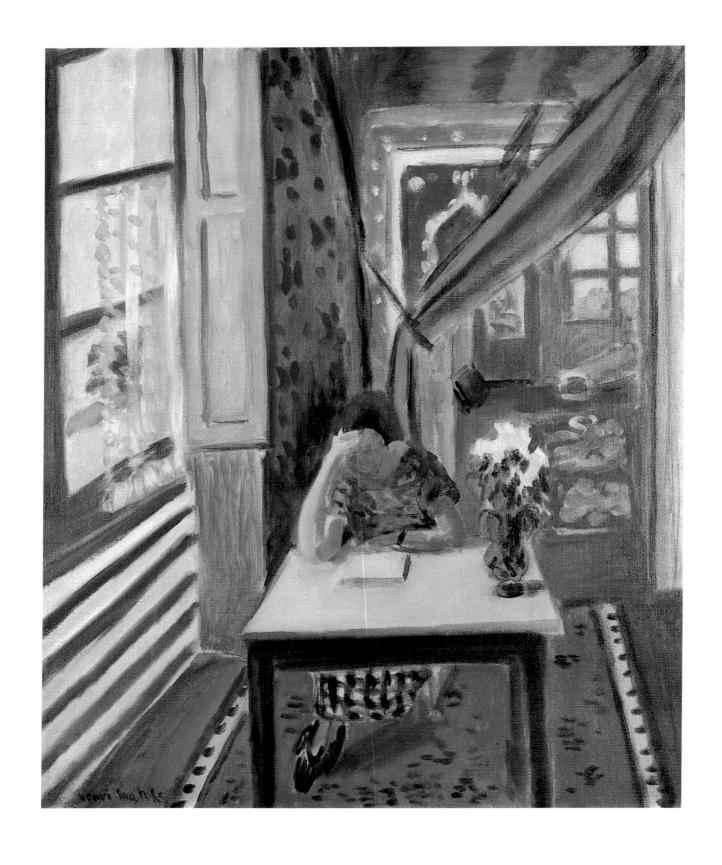

Pl. 146. *Liseuse accoudée à une table, devant une tenture relevée*, season 1923–1924, 60 x 49
(23⅝ x 19¼). Collection of Henry Ford II

190

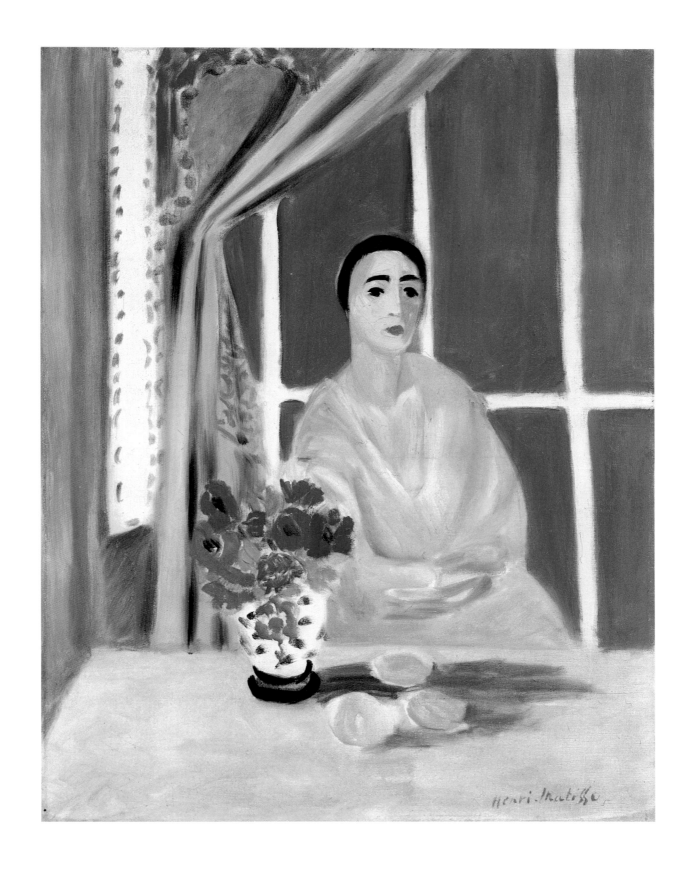

Pl. 147. *Femme assise, sur le fond rouge de l'envers d'un paravent*, 1923–1924, 66 x 50.5 (26 x 19⅞). Worcester Art Museum, Gift of Mrs. R. L. Riley

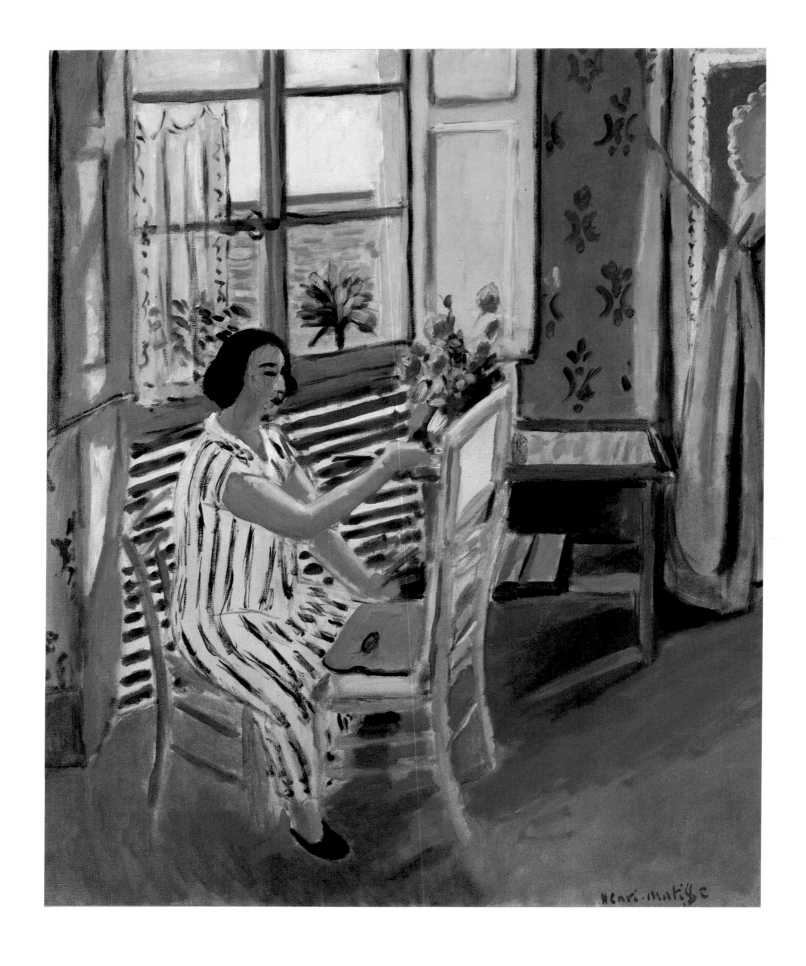

Pl. 148. *La séance du matin*, 1924, 74 x 61 (29⅛ x 24). Private collection

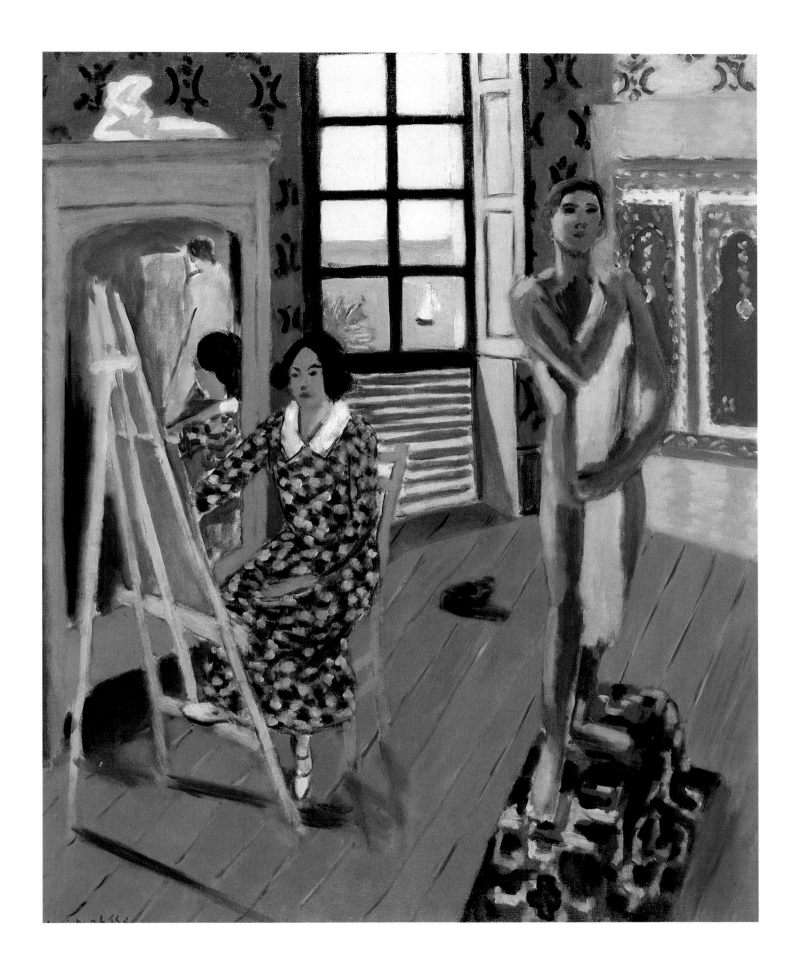

Pl. 149. *La séance de trois heures*, early 1924, 92 x 73 (36¼ x 28¾). Private collection

193

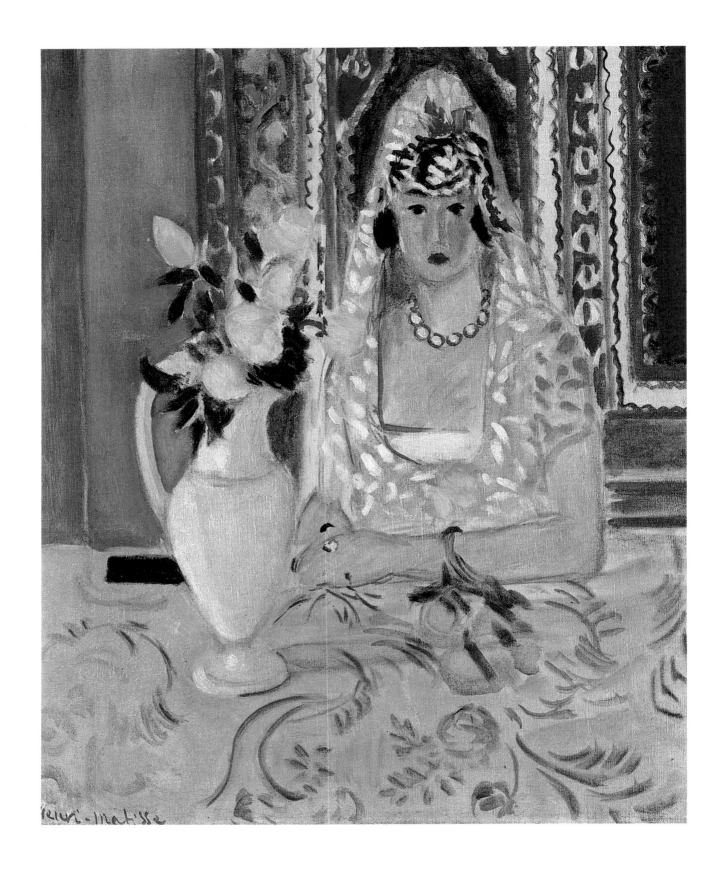

Pl. 150. *L'espagnole aux fleurs*, 1923, 61 x 51 (24 x 20⅛). Private owner represented by
Acquavella Galleries

194

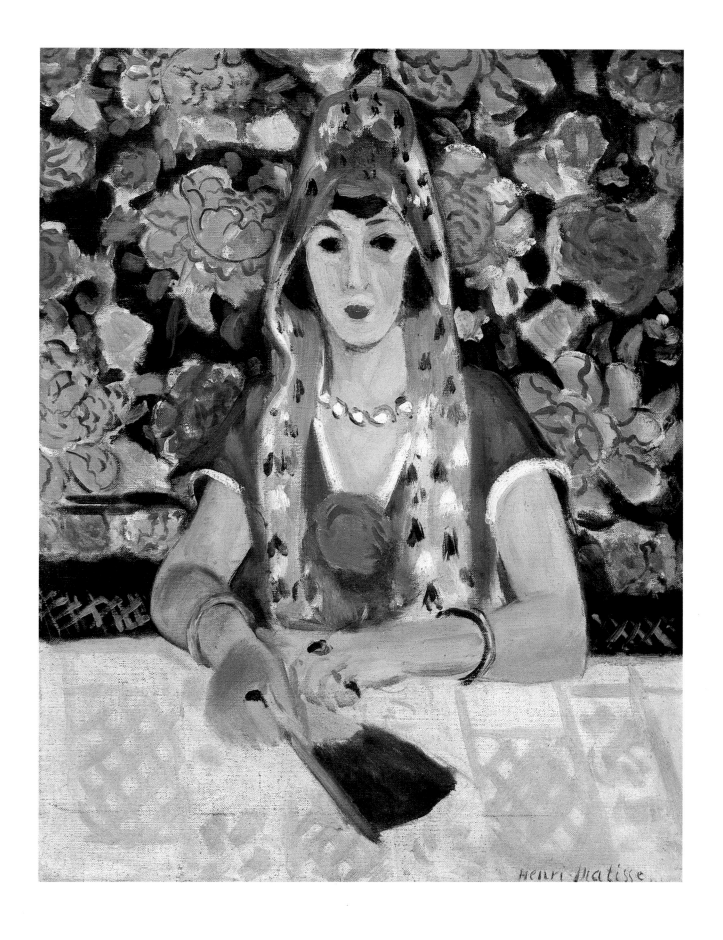

Pl. 151. *Espagnole, harmonie bleue*, 1923, 48 x 36 (18⅞ x 14⅛). The Metropolitan Museum of Art, Robert Lehman Collection 1975.1.193

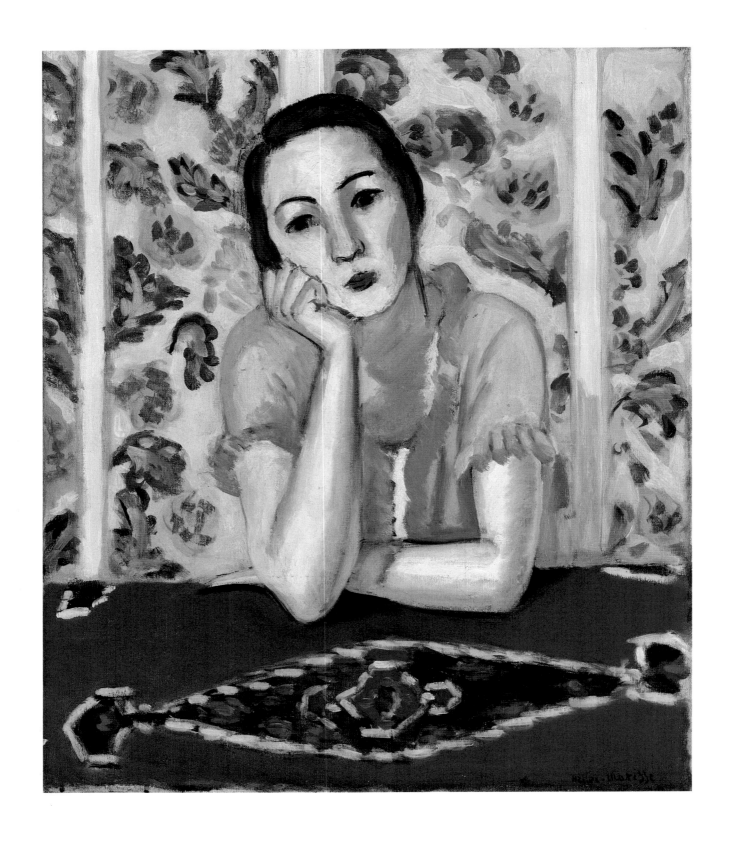

Pl. 152. *La blouse rose,* 1922 or 1923, 55.9 x 46.7 (22 x 18⅜). The Museum of Modern Art, New York, Gift of Mr. and Mrs. Walter Hochschild, 1963

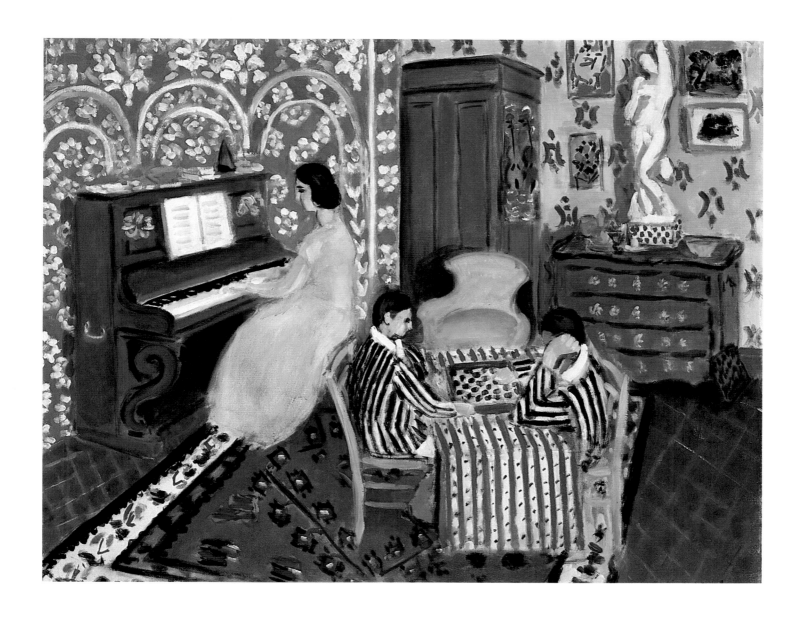

Pl. 153. *Pianiste et joueurs de dames*, early 1924, 74 x 92.1 (29⅛ x 36⅜). National Gallery of Art, Washington, Collection of Mr. and Mrs. Paul Mellon 1985.64.25

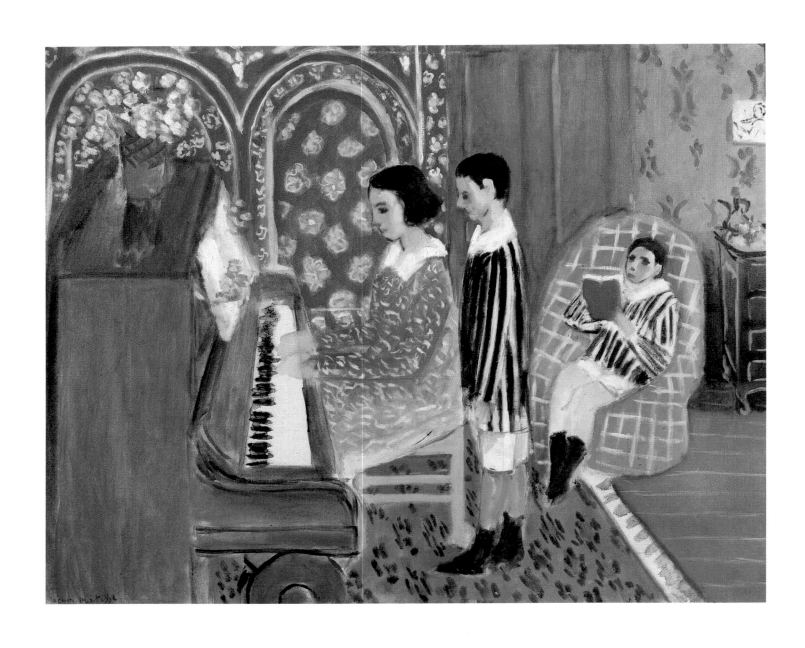

Pl. 154. *La leçon de piano, Henriette et ses frères*, 1923, 65 x 81 (25⅝ x 31⅞). Private collection

Pl. 155. *Petite pianiste, robe bleue, fond rouge,* 1924, 22 x 30 (8⅝ x 11¾). Musée Matisse, Nice

199

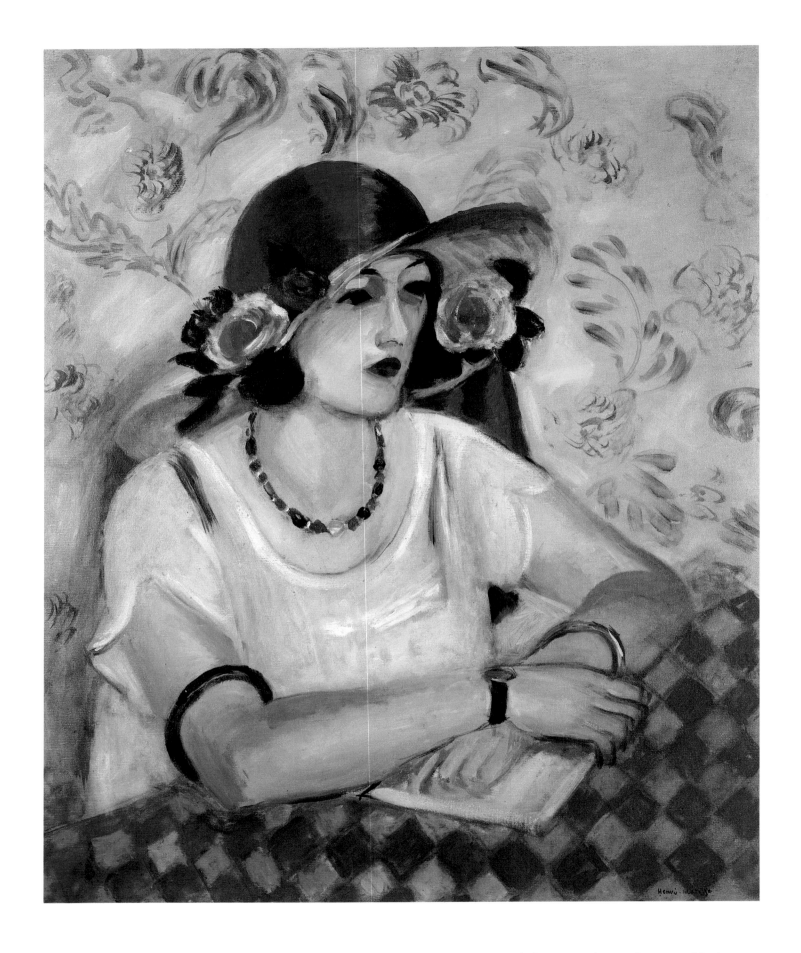

Pl. 156. *La capeline de paille d'Italie*, 1922 or 1923, 73 x 60 (28¾ x 23⅝). Mr. and Mrs. Arnold Saltzman, New York

200

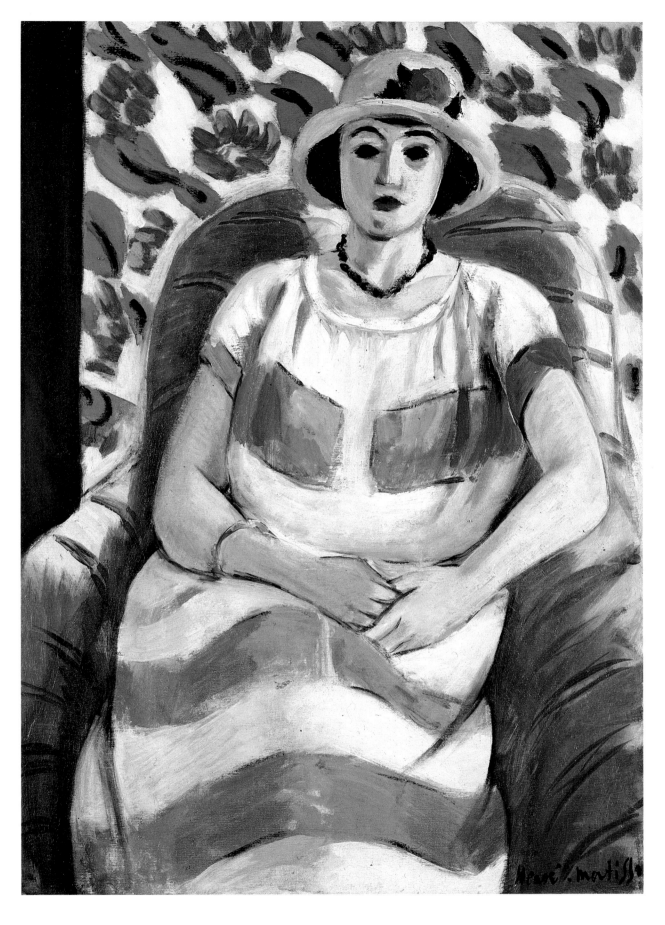

Pl. 157. *Jeune femme en rose*, 1923, 55 x 38 (21⅝ x 15). The Fine Arts Museums of San Francisco,
Memorial Gift from Dr. T. Edward and Tullah Hanley, Bradford, Pennsylvania

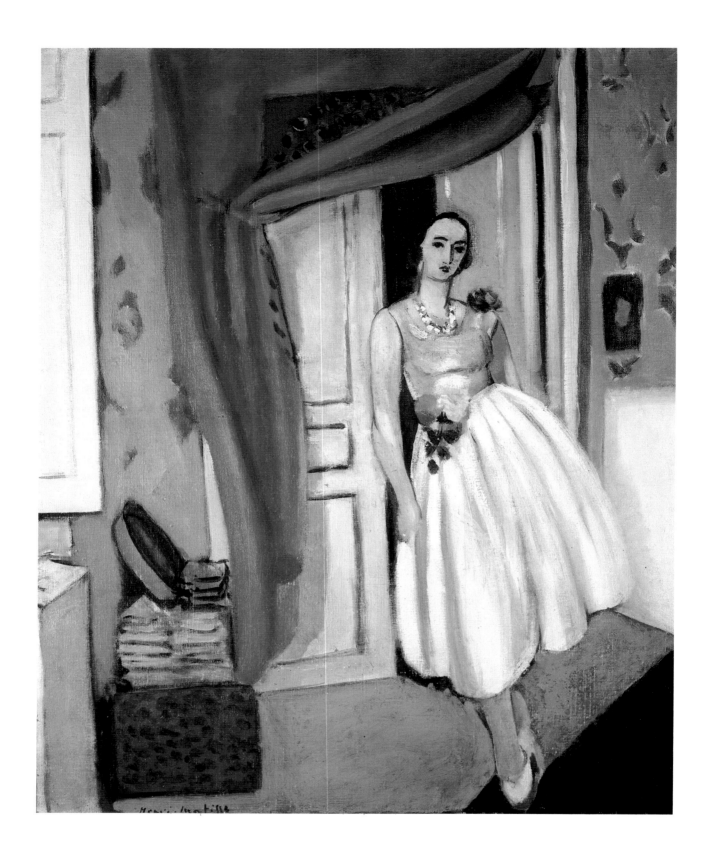

Pl. 158. *Sylphide,* 1926, 45 x 38 (17¾ x 15). Mr. and Mrs. Peter D. Meltzer, New York



202

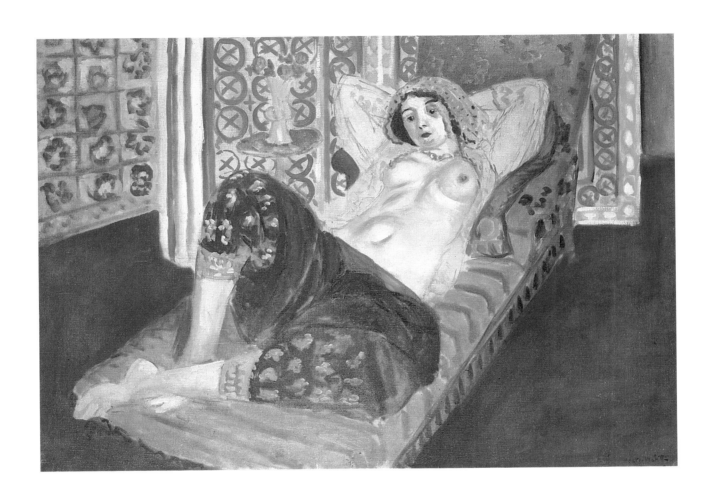

Pl. 159. *Odalisque à la culotte rouge,* 1921, 67 x 84 (26⅜ x 33⅛). Musée National d'Art Moderne/
Centre Georges Pompidou

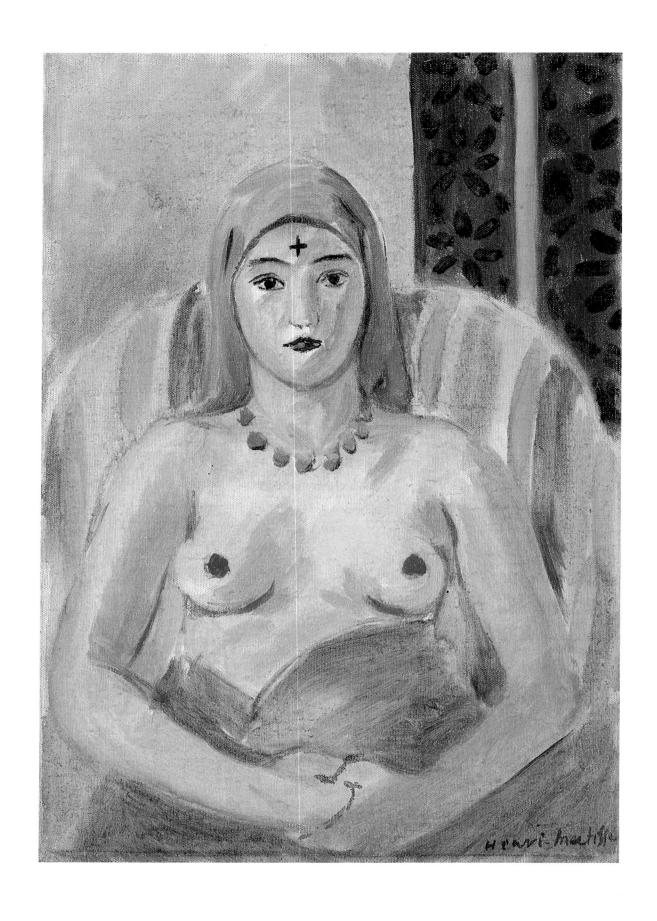

Pl. 160. *Odalisque à mi-corps—le tatouage*, 1923, 35 x 24 (13¾ x 9⁷⁄₁₆). National Gallery of Art, Washington, Chester Dale Collection 1963.10.40

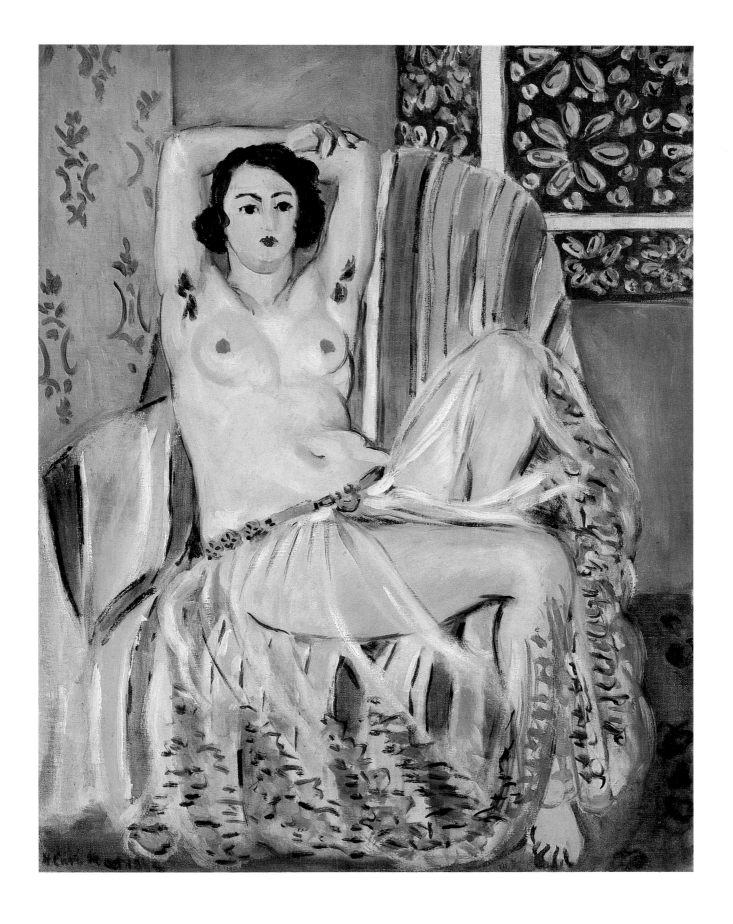

Pl. 161. *Odalisque assise aux bras levés, fauteuil rayé vert*, 1923, 65 x 50 (25⅝ x 19⅝). National Gallery of Art, Washington, Chester Dale Collection 1963.10.167

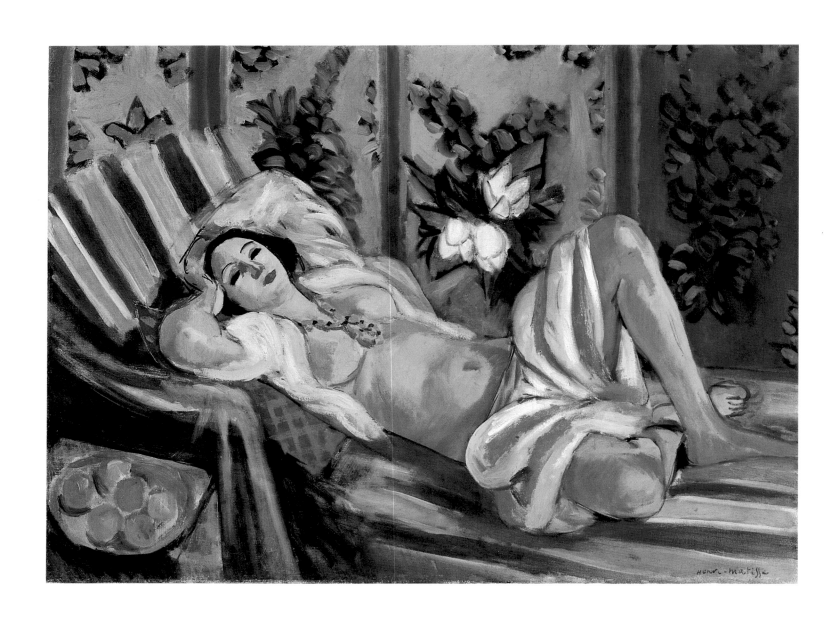

□ Pl. 162. *Odalisque aux magnolias*, 1923, 65 x 81 (25⅝ x 31⅞). Collection David Rockefeller

Pl. 163. (right) *Odalisque debout reflétée dans la glace*, 1923, 81 x 54.3 (31⅞ x 21⅜). The Baltimore Museum of Art: The Cone Collection, formed by Dr. Claribel Cone and Miss Etta Cone of Baltimore, Maryland. BMA 1950.250

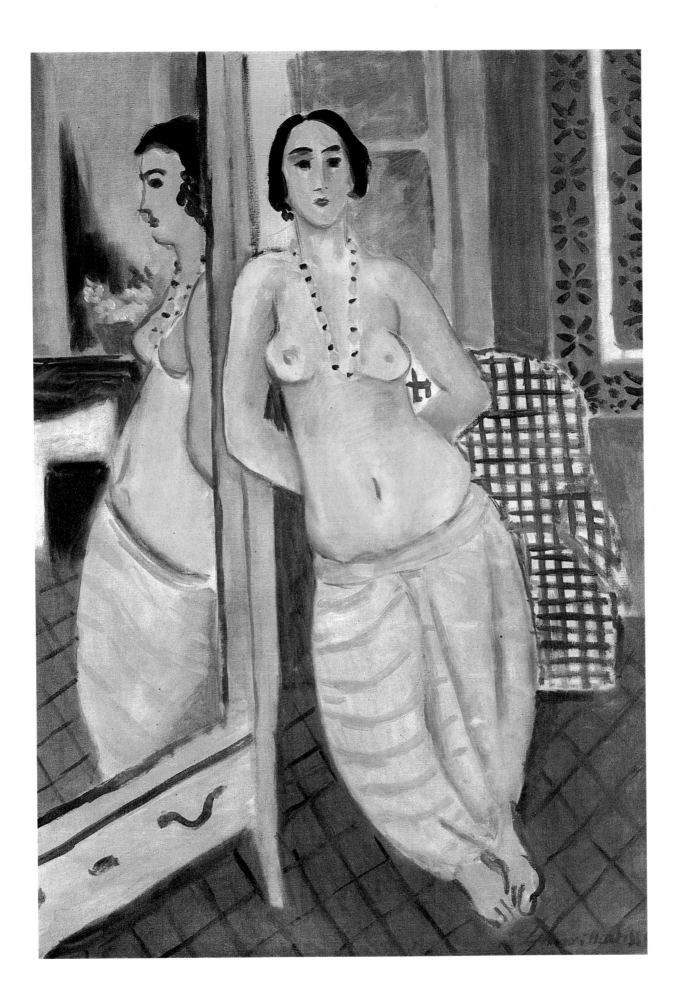

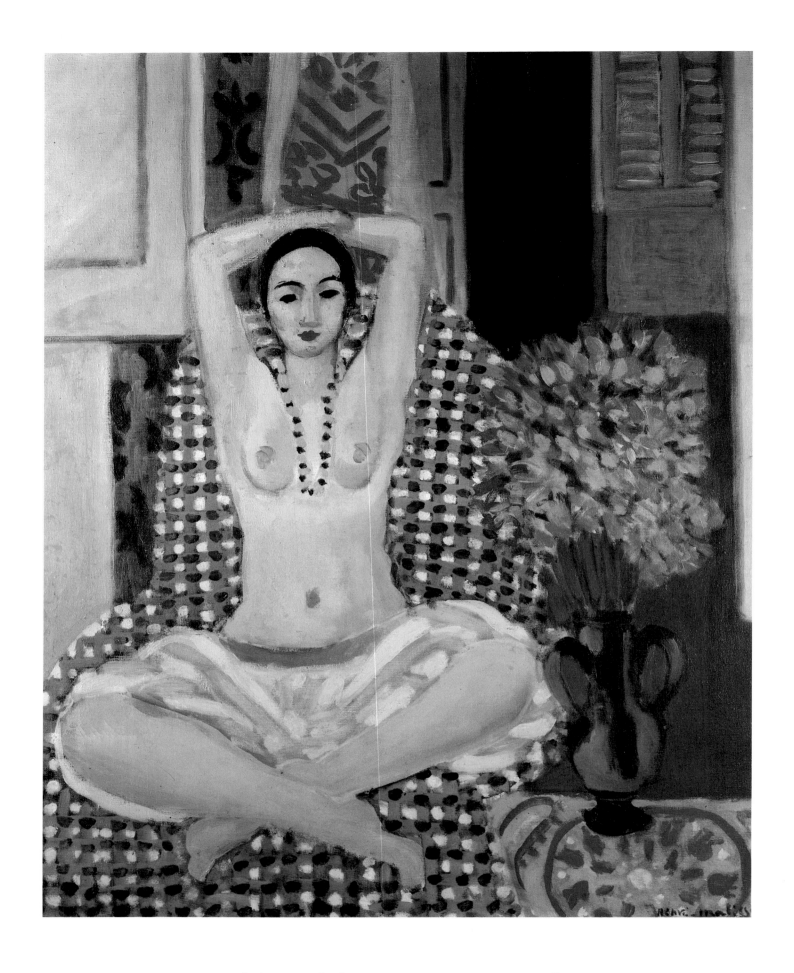

Pl. 164. *La pose hindoue*, 1923, 83 x 60 (32⅝ x 23⅝). Private collection

208

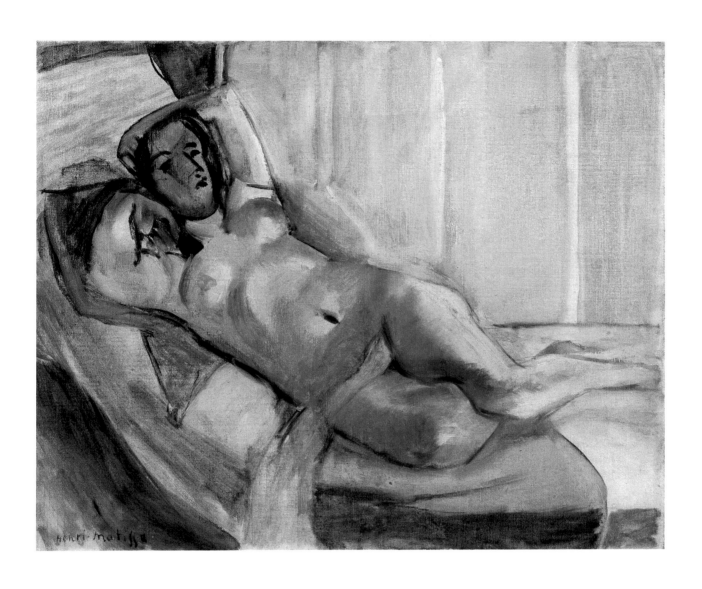

Pl. 165. *Nu allongé sur un sofa*. 1923. 46 x 55 (18⅛ x 21⅝). Private collection

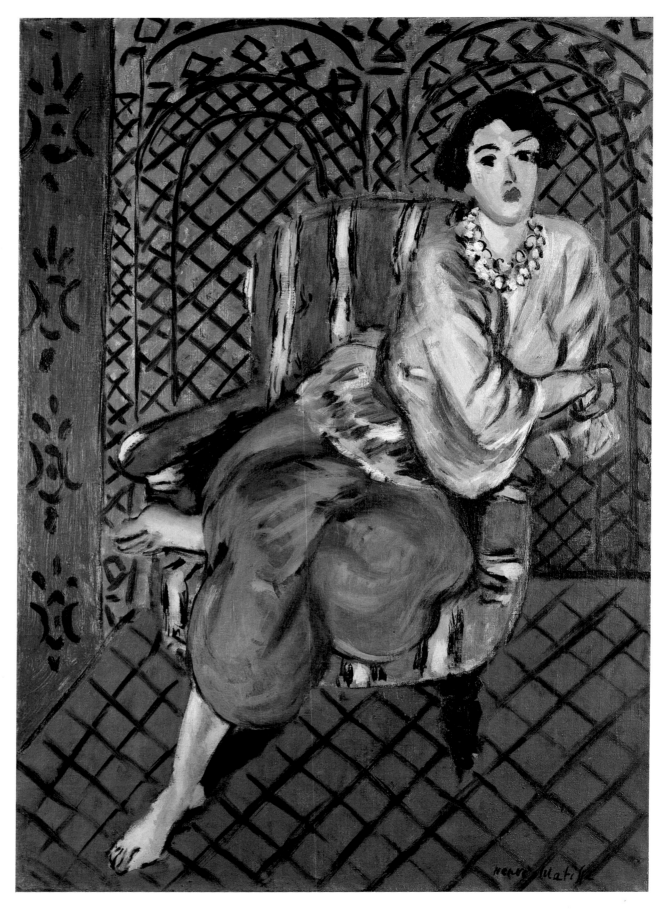

☐ Pl. 166. *Odalisque assise, jambe gauche repliée,* 1926, 65 x 46 (25⅝ x 18⅛). The Baltimore Museum of Art: The Cone Collection, formed by Dr. Claribel Cone and Miss Etta Cone of Baltimore, Maryland. BMA 1950.251

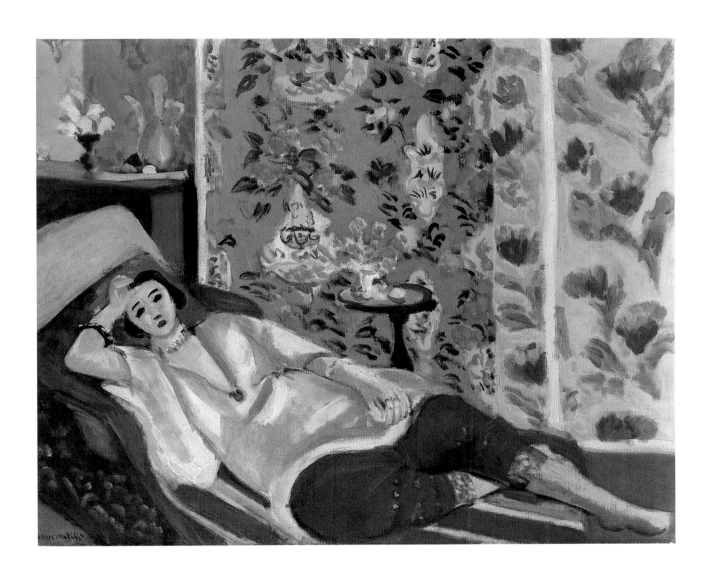

Pl. 167. *Odalisque à la culotte rouge, aiguière, et guéridon*, 1926, 50 x 61 (19⅝ x 24). Paris,
Musée de l'Orangerie, Collection Jean Walter et Paul Guillaume

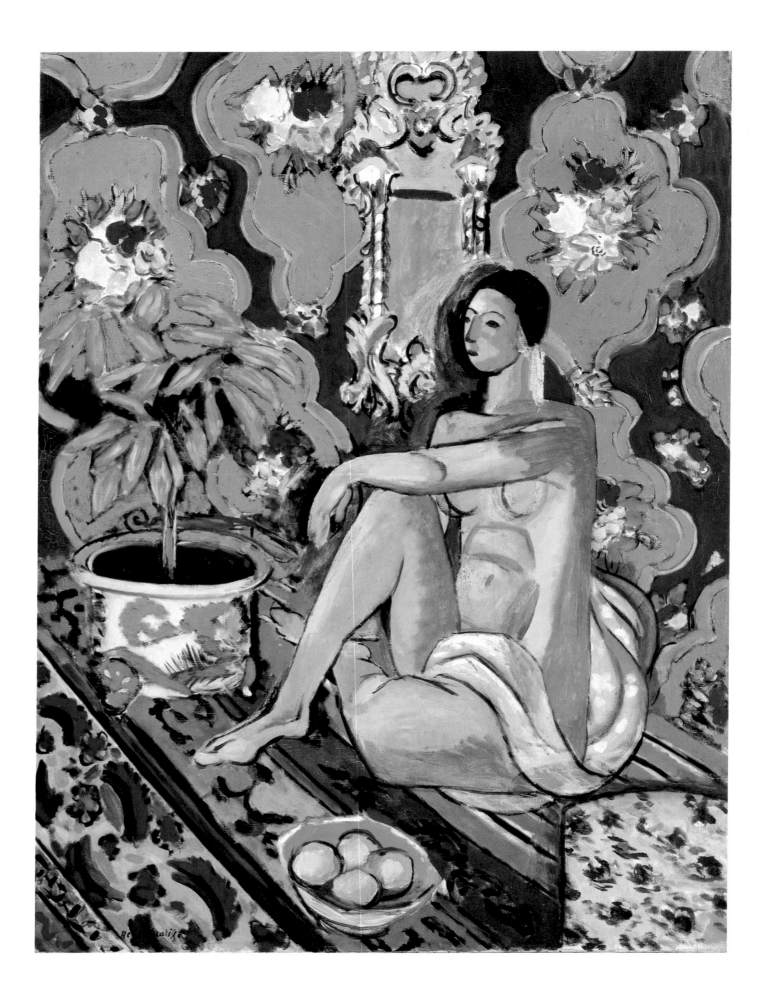

212

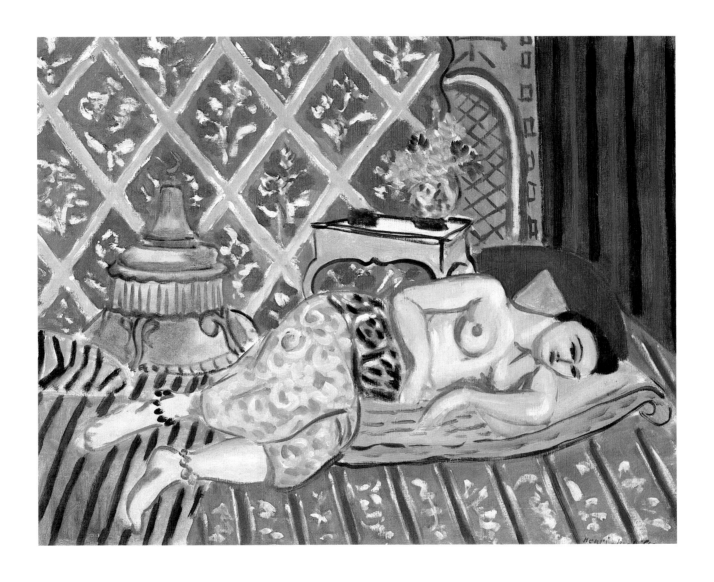

Pl. 168. (left) *Figure décorative sur fond ornemental*, winter 1925–1926, 130 x 98 (51⅛ x 38⅝). Musée National d'Art Moderne/Centre Georges Pompidou

Pl. 169. *Odalisque allongée, culotte verte, ceinture bleue*, 1927, 50 x 60 (19⅝ x 28⅝). Collection of Henry Ford II

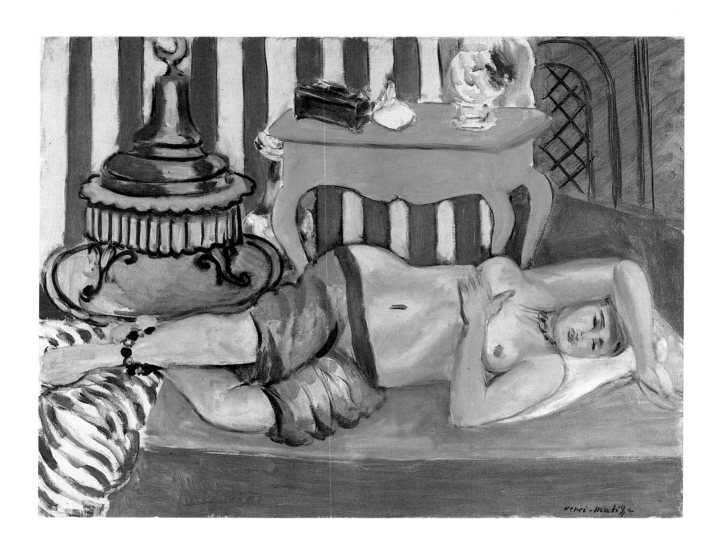

Pl. 170. *Odalisque à la ceinture verte*, 1926–1927, 50.8 x 64.8 (20 x 25½). The Baltimore Museum of Art: The Cone Collection, formed by Dr. Claribel Cone and Miss Etta Cone of Baltimore, Maryland. BMA 1950.253

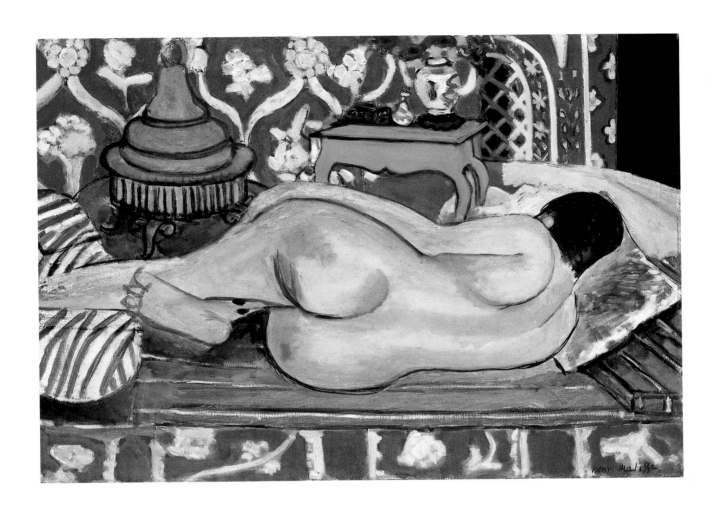

Pl. 171. *Nu couché de dos*, summer 1927, 66 x 92 (26 x 36¼). Gérard Matisse

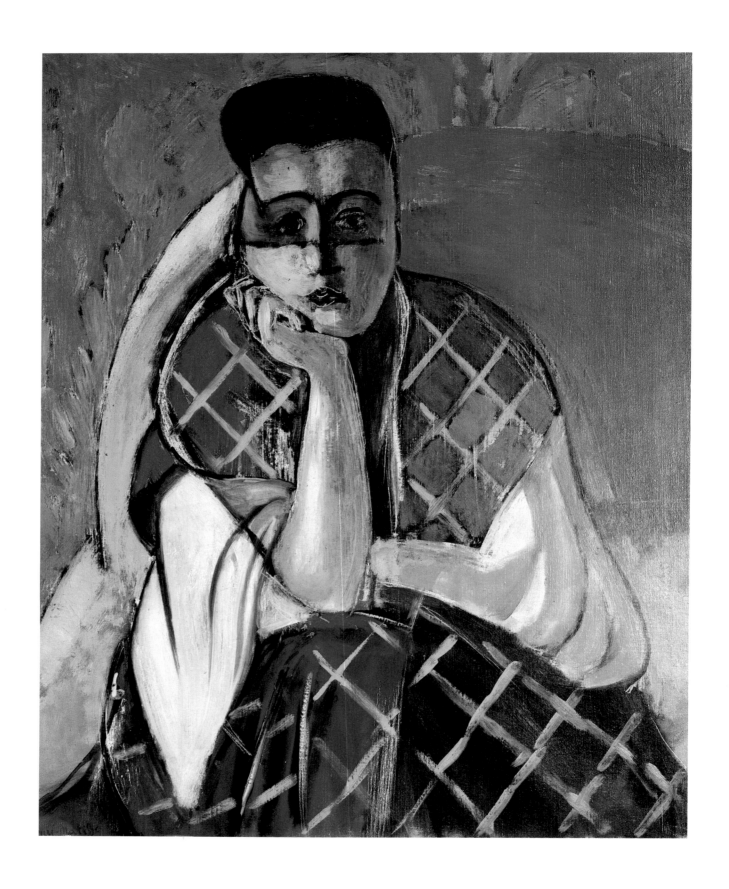

Pl. 172. *La femme à la voilette*, 1927, 61 x 50 (24 x 19⅝). William S. Paley

216

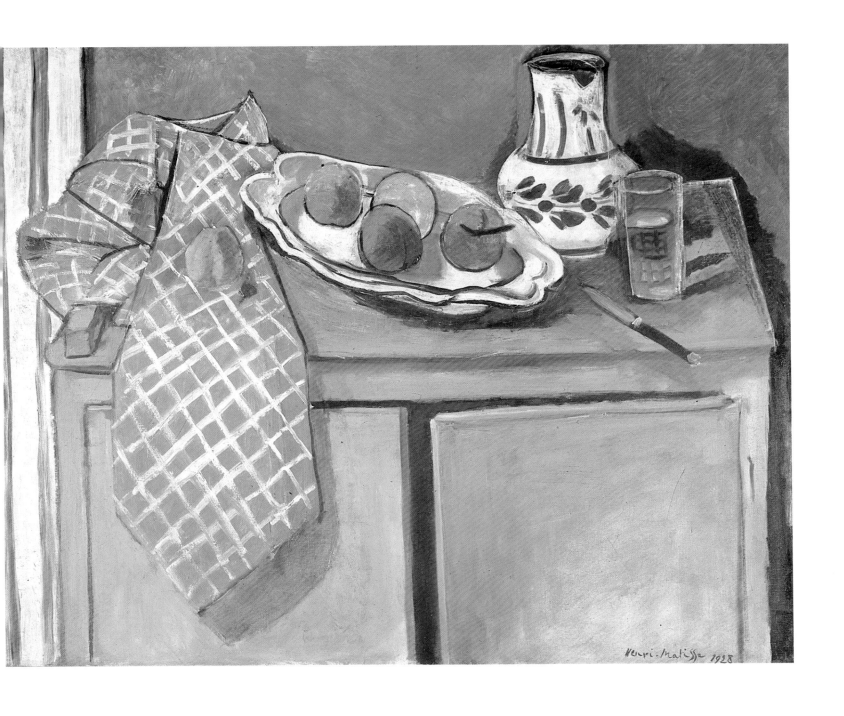

Pl. 173. *Nature morte au buffet vert*, July 1928, 81.5 x 100 (32⅛ x 39⅜). Musée National d'Art Moderne / Centre Georges Pompidou

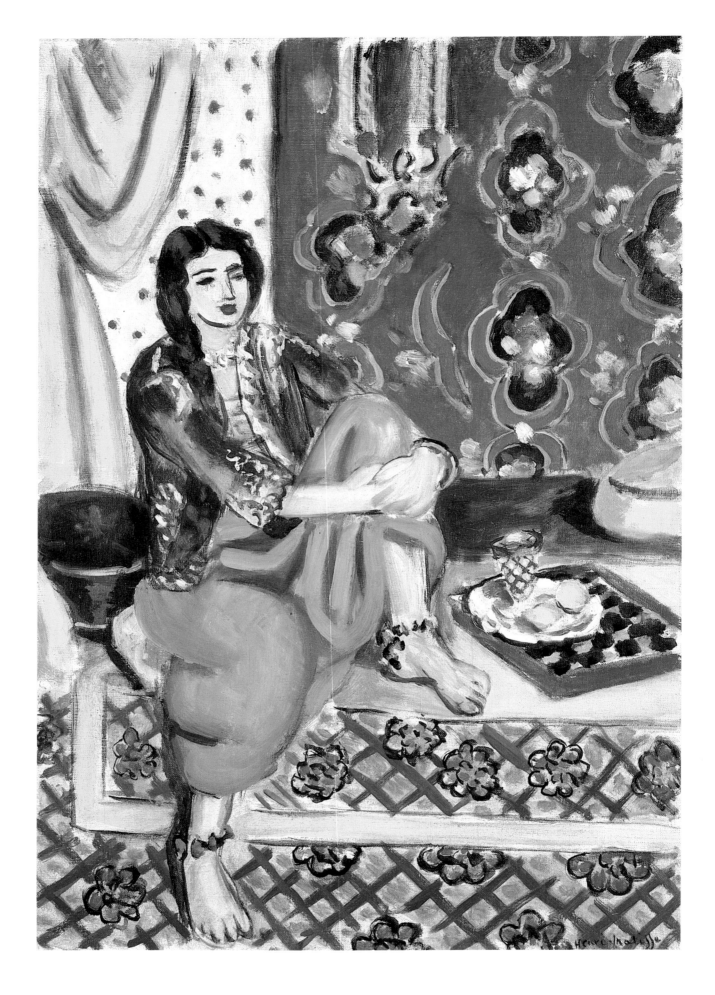

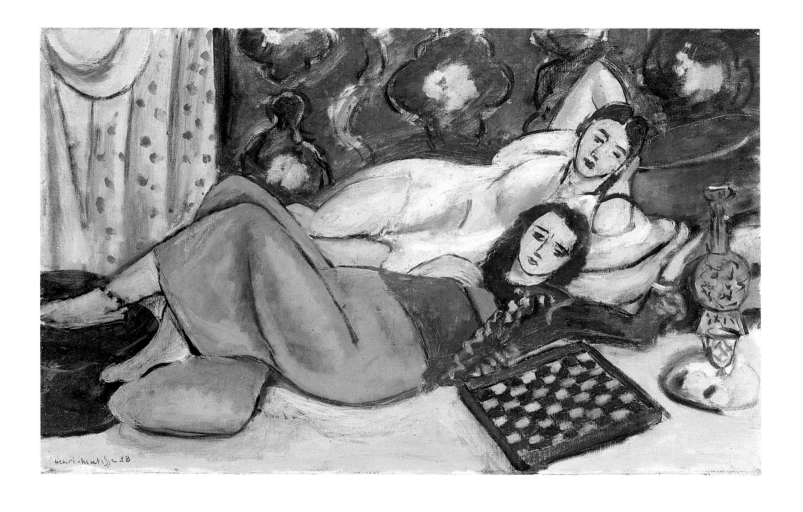

Pl. 174. (left) *Odalisque assise, genou gauche replié, fond ornemental et damier,* 1928, 55 x 37.8 (21⅝ x 14⅞). The Baltimore Museum of Art: The Cone Collection, formed by Dr. Claribel Cone and Miss Etta Cone of Baltimore, Maryland. BMA 1950.255

Pl. 175. *Le repos des modèles, fond ornemental et damier,* 1928, 46.8 x 73.3 (18½ x 28⅞). Philadelphia Museum of Art: Gift of Mrs. Frank A. Elliott

219

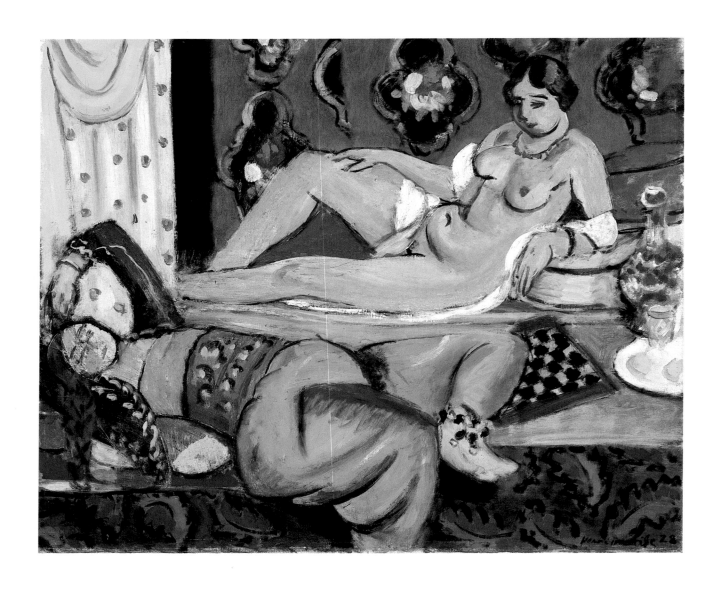

Pl. 176. *Deux odalisques dont l'une dévêtue, fond ornemental et damier,* 1928, 54 x 65 (21¼ x 25⅝). Moderna Museet, Stockholm

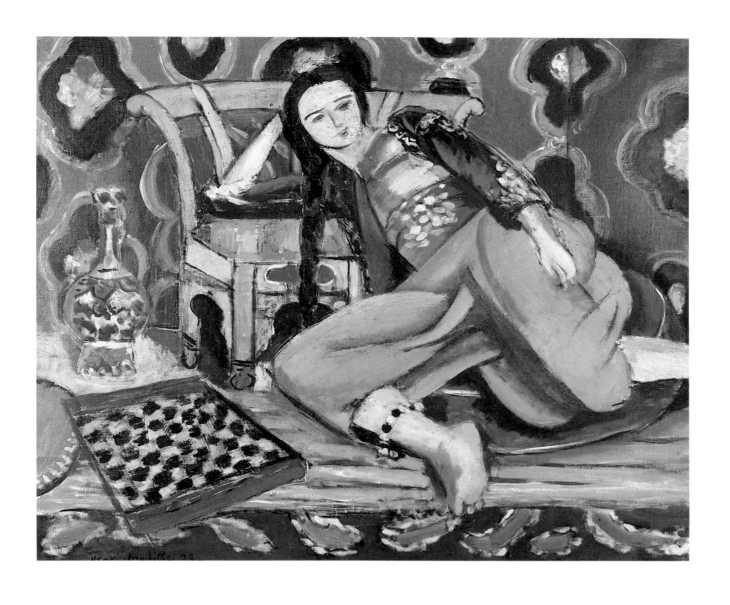

Pl. 177. *Odalisque au fauteuil turc*, March 1928, 60 x 73 (23⅝ x 28¾). Musée d'Art Moderne de la Ville de Paris

221

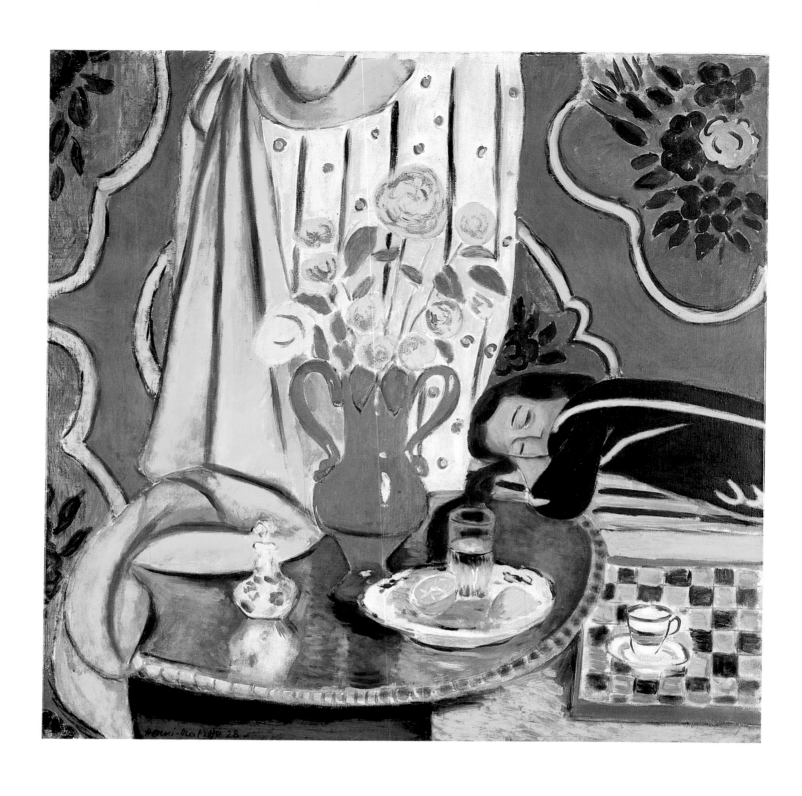

Pl. 178. *Harmonie jaune*, 1928, 88 x 88 (34⅝ x 34⅝). Collection S

222

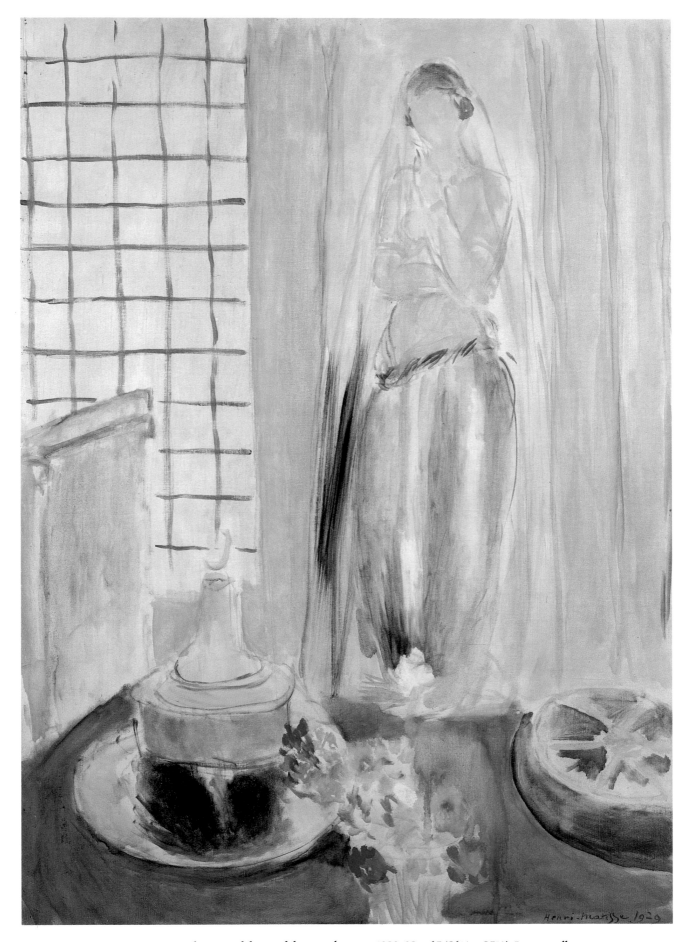

Pl. 179. *Odalisque debout au brasero*, 1929, 92 x 65 (36¼ x 25⅝). Private collection

Pl. 180. *Nature morte au torse de plâtre*, 1928, 59.7 x 48.3 (23½ x 19). William Kelly Simpson

224

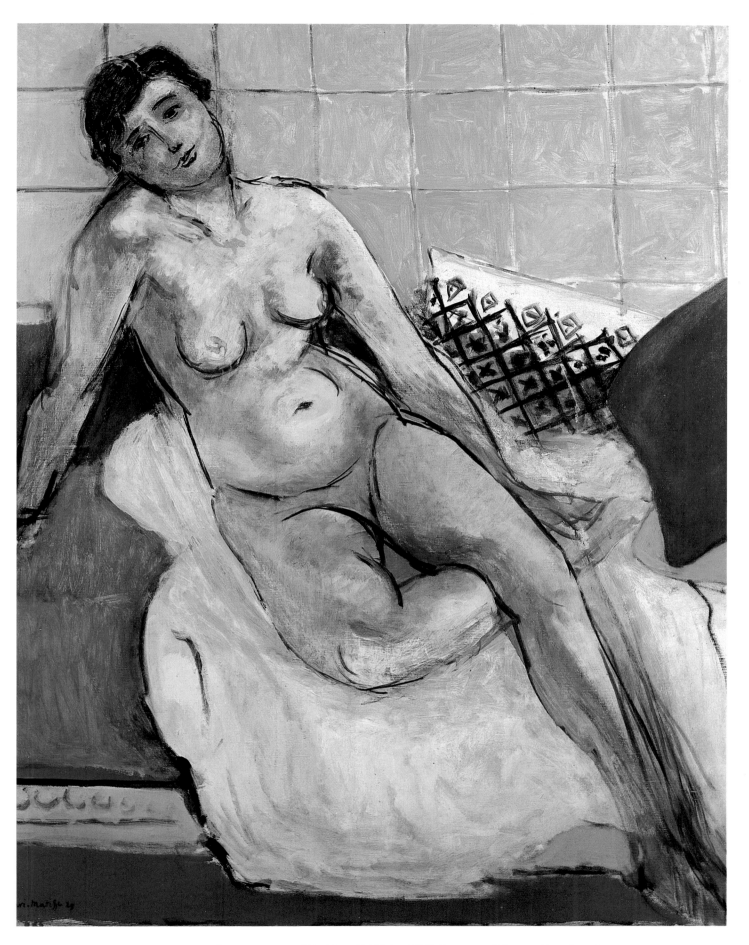

Pl. 181. *Nu gris*, 1929, 102 x 81 (40⅛ x 31⅞). Courtesy of Harmon Fine Arts, Inc.

225

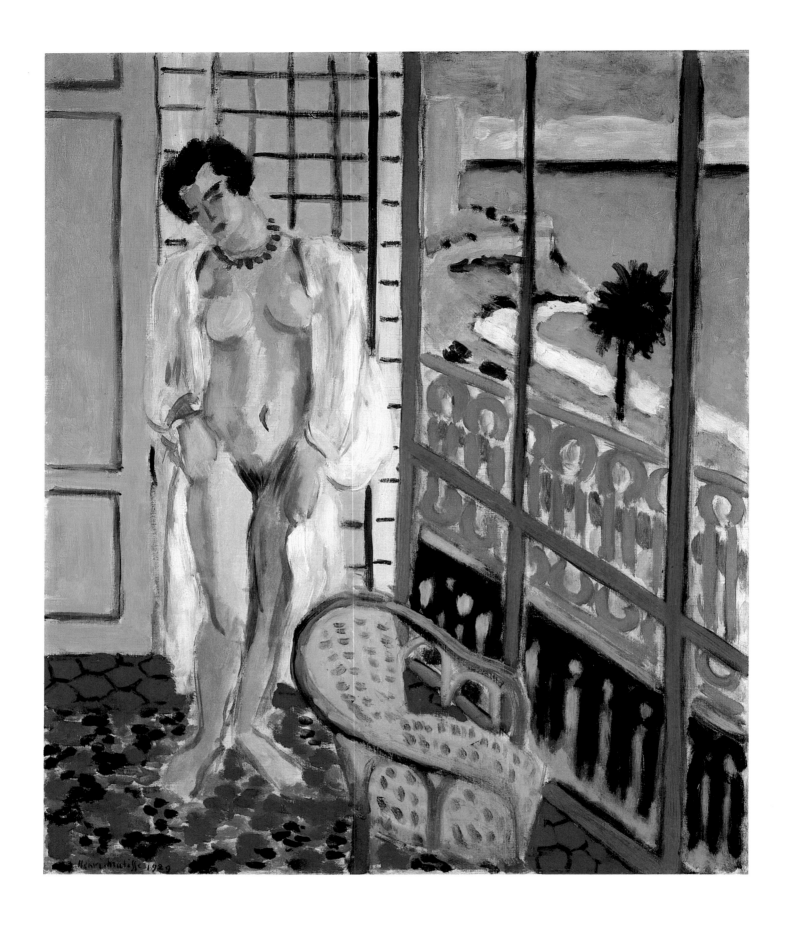

Pl. 182. *Nu nacré*, 1929, 65 x 54 (25⅝ x 21¼). Private collection

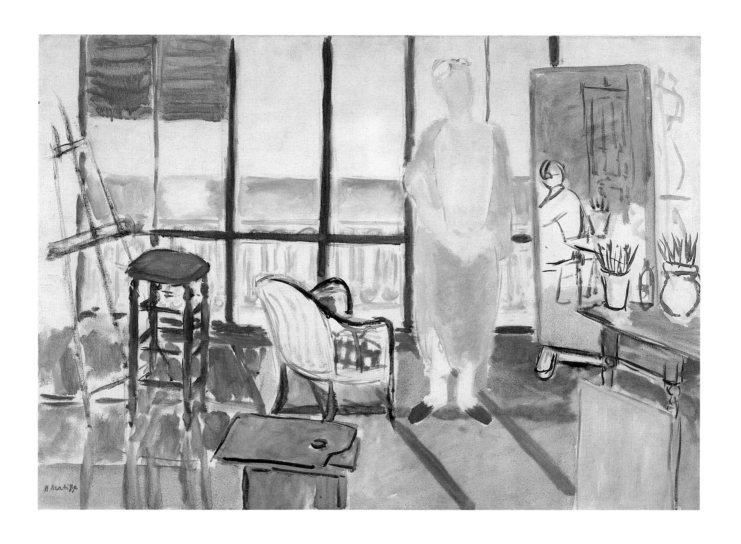

Pl. 183. *Nu dans l'atelier,* 1928, 60 x 82 (23⅝ x 32¼). Fredrik Roos

227

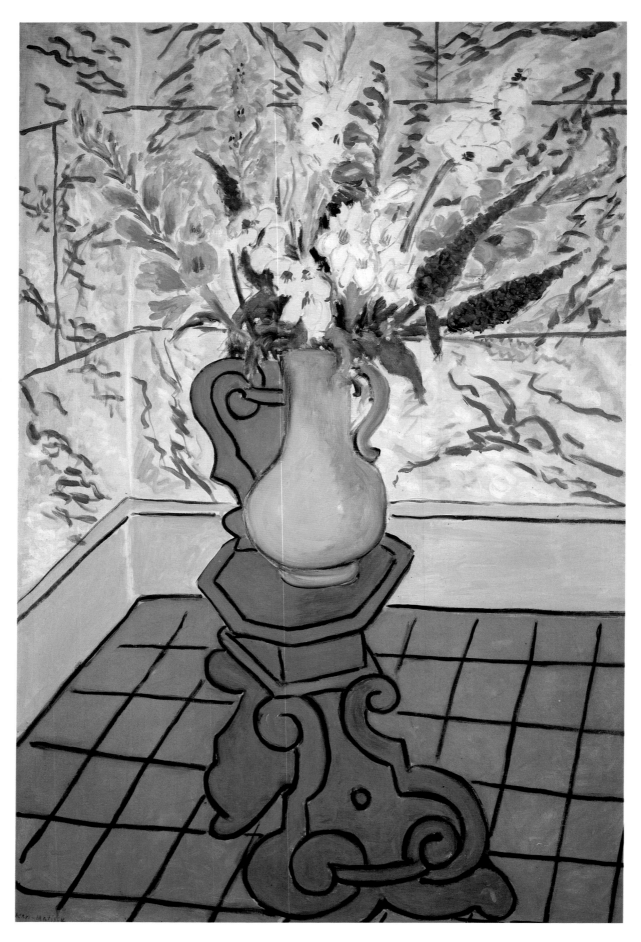

Pl. 184. *Les glaïeuls*. 1928. 154 x 102 (60⅝ x 40⅛). Private collection

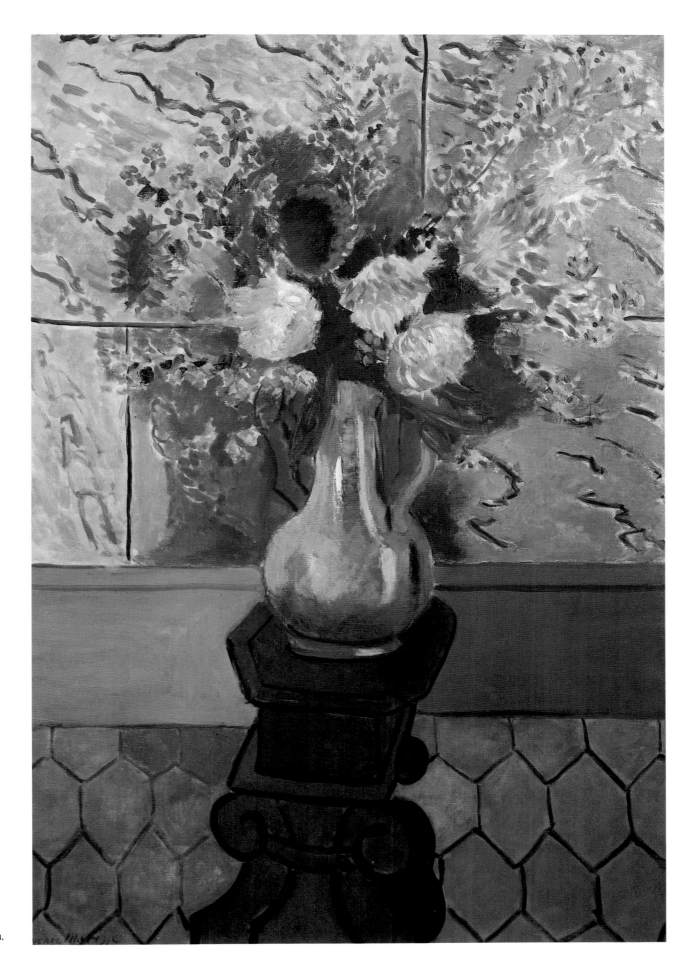

Pl. 185. *Les dahlias*, 1928,
131 x 89 (51⅝ x 35).
From the Mortimer D.
Sackler Family Collection.
Courtesy of Romas
Investments Limited

229

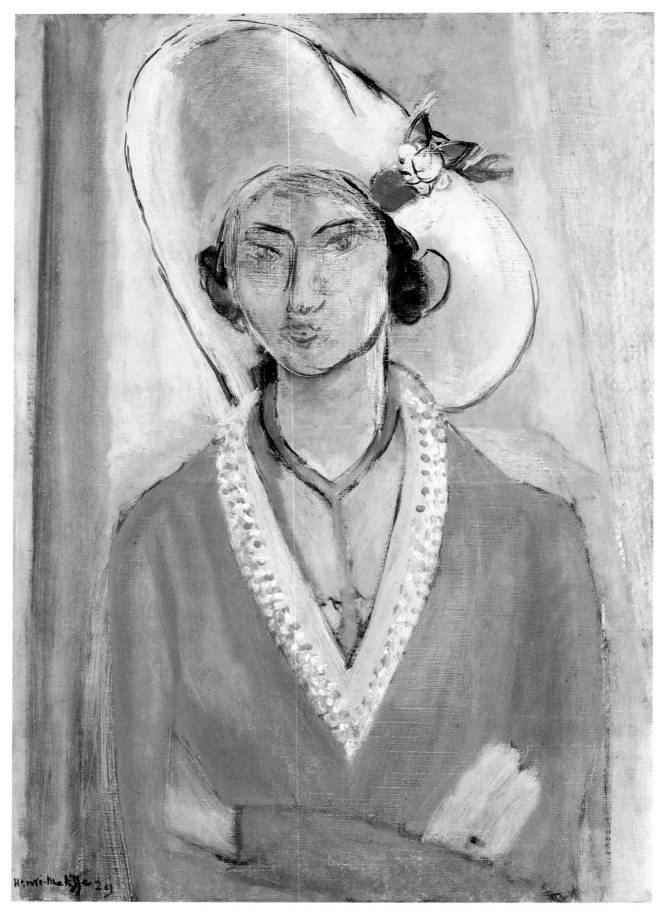

Pl. 186. *Le chapeau jaune*, 1929, 65 x 45 (25⅝ x 17¾). Courtesy of Smith College Museum of Art, Northampton, Massachusetts

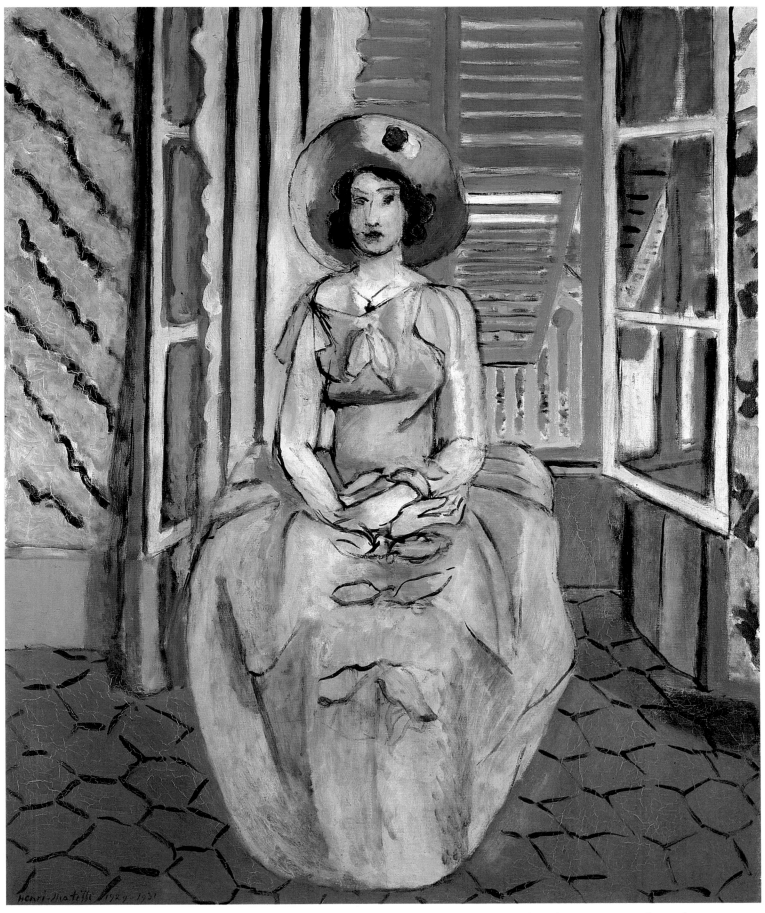

Pl. 187. *La robe tilleul*, 1929–1931, 99.7 x 80.7 (39¼ x 31¾). The Baltimore Museum of Art: The Cone Collection, formed by Dr. Claribel Cone and Miss Etta Cone of Baltimore, Maryland. BMA 1950.256

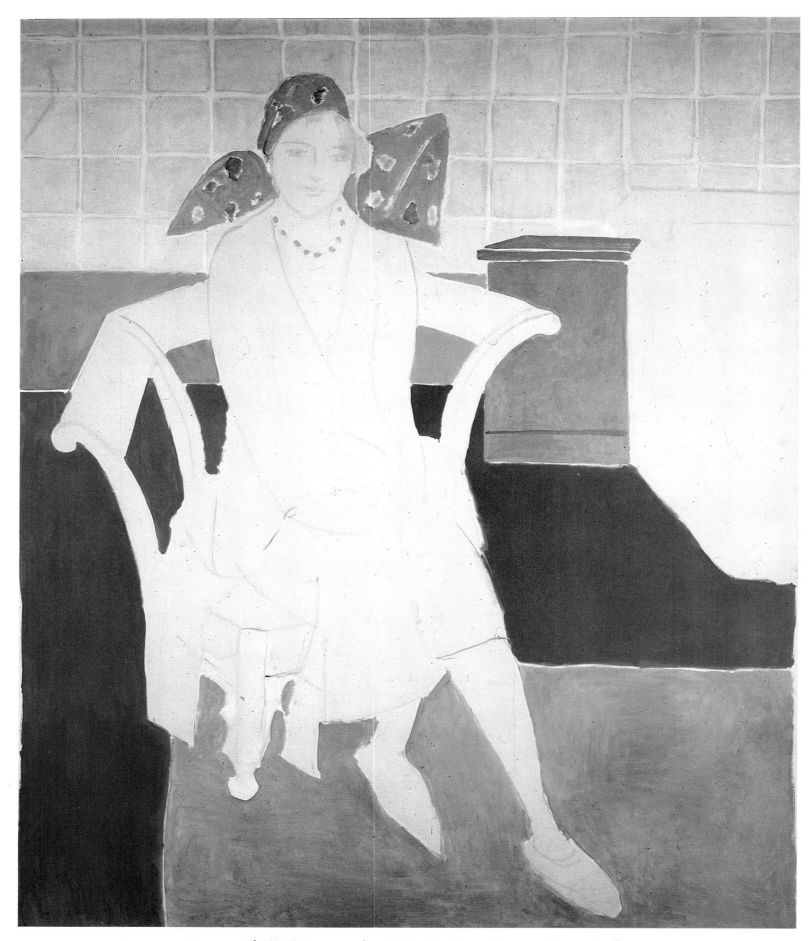

Pl. 188. *Femme au madras*, 1929–1930, 180 x 152 (70⅞ x 59⅞). Private collection

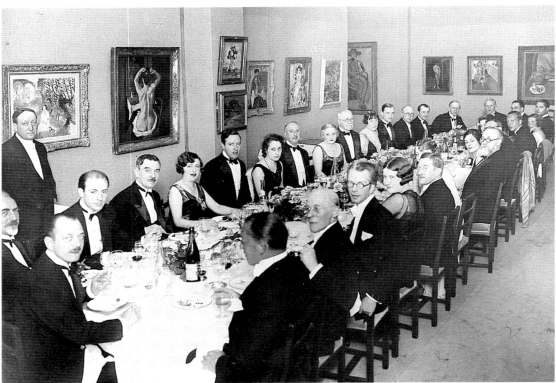

Fig. 1. Banquet for the Matisse retrospective exhibition at the Galerie Georges Petit, Paris, June 1931. (See fig. 52 for identification of the guests.)

Fig. 2. Banquet for the Matisse retrospective exhibition at the Galerie Georges Petit, Paris, June 1931. (See fig. 53 for identification of the guests.)

Collecting Matisses of the 1920s in the 1920s

Margrit Hahnloser-Ingold

In the 1920s modern art achieved a level of acceptance in the major cities of Europe and America that would have been unthinkable before the war. This acceptance was accompanied, and in part caused, by the combined and almost feverish activity of dealers, critics, and collectors of the new art. What had been the adventurous championing of a small, misunderstood avant-garde before the war developed new characteristics in the economic expansion of the postwar decade. This acceptance signaled involvement by the expanding audience for private aesthetic enjoyment and acquisition of cultural products, in a profitable international market, and in a shared national pride in artistic talent.

The international character of the art "network" in the 1920s was evident at a banquet held in Matisse's honor at the time of his retrospective exhibition at the Galerie Georges Petit in Paris in 1931. The invited guests were art dealers, critics, and collectors from France, England, and America. The list of lenders, which stretched from Copenhagen to Glasgow, from Paris to New York, Philadelphia, and Baltimore, illustrated just how broad was the interest in paintings by Matisse throughout the western hemisphere. In the opinion of the organizers, he had been influential in international art for two decades. The exhibition, in a slightly altered version, was also shown at the Kunsthalle Basel and at the newly opened Museum of Modern Art in New York. One fourth of the Matisse retrospective had already been seen at the Galerien Thannhauser in Berlin in 1930.

The popularity of French post-impressionist art (including certain kinds of fauve- and cubist-influenced works) led to the rise of a different class of patrons who required information about the art market in which they had begun to speculate.[1] For the first time the galleries sought to provide collectors practical information about dealers, auctions in Paris, and estimates of real and projected value of objects; modern art became an investment opportunity. "It is on account of [speculation] that so many people buy paintings today; this allows artists to produce with security and well-being, and maintains among them a permanent competition. It is speculation which, always on the lookout for new talent, knows that today there are no longer any unrecognized geniuses."[2] Comparisons of prices from the beginning and the end of the twenties reveal a sharp increase in prices realized in the art market. For example, a medium-size Matisse picture that cost five thousand francs in 1917 was worth thirty to fifty thousand francs in 1928. Certain individual works of art reached the hundred-thousand-franc range at auctions held at the

235

Fig. 3. Installation, Matisse exhibition,
Galerie Georges Petit, Paris, June–July 1931

Fig. 4. Installation, Matisse exhibition,
Galerie Georges Petit, Paris, June–July 1931

Fig. 5. Installation, Matisse exhibition,
Galerie Georges Petit, Paris, June–July 1931

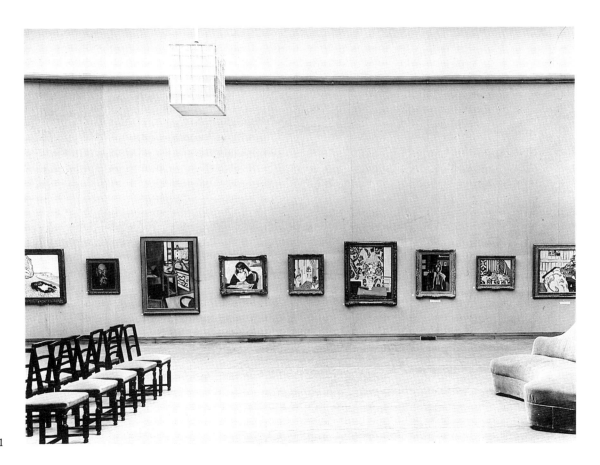

Fig. 6. Installation, Matisse exhibition,
Galerie Georges Petit, Paris, June–July 1931

Hôtel Drouot, the major Parisian auction house; Matisse's *Fête des fleurs*, for instance, from the Soubies collection (pl. 105) sold in 1928 for 121,000 francs. Through sales such as these, Matisse's paintings became some of the most expensive works by a living artist. Not even Picasso attained such a price during the twenties, and equal-size paintings by Modigliani or Utrillo fetched something around ten thousand francs.[3]

Art collecting in the 1920s was varied and, in the case of Matisse, often based on his established reputation. Besides the modest buyers and wealthier "aesthete" collectors of the prewar period, the twenties drew collectors from the ranks of a broader range of

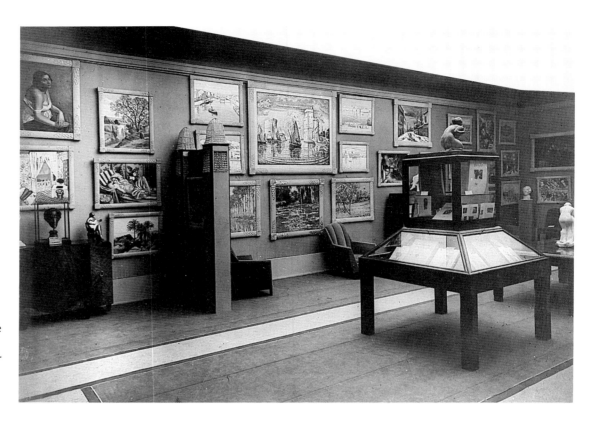

Fig. 7. Installation, Pavilion of the Exposition des Arts Décoratifs, Paris, 1925. At the extreme left are Matisse's *Intérieur à la boite à violon*, 1918/1919 (pl. 171) and *Odalisque aux magnolias*, 1923 (pl. 162). Among the other paintings are works by Derain, Marquet, Vlaminck, and Signac

professions and industry, to include dealers and writers on art. Collectors had diverse reasons for acquiring works of modern art: satisfaction of an aesthetic impulse, the prestige and pleasure in supporting particular artists, and, for some, financial investment. The formation of private collections was in advance of public institutional collecting of contemporary art. Yet thanks to the renown that resulted from this private patronage, institutions and associations dedicated to making acquisitions at the very forefront of avant-garde art would soon be established.

Attempts to reconstruct the private collections of the twenties have been hampered by lack of documentation. We must depend on insufficient exhibition catalogues with their mere mention of titles, on sporadic newspaper reviews, and on verbal reminiscences for information about these early collections.

In three broad groups—French, American, and other European collections—the pattern of acquisition is similar in substantial ways. Early *amateurs*, friends, and former students promoted Matisse's work through personal contacts and through directors of small galleries. Early controversial exhibitions, staged in the prewar period, had exposed Matisse's work to an advanced art community (positively) and to a larger public (often negatively). The dislocations of the war years caused the confiscation and/or sale of many collections, closed certain markets, and greatly expanded others. After 1918 there was a larger art public ready to acquire art. This market partook of the economic fluctuations of the next decade, which was, on the whole, one of prosperity until 1929.

Paris

Those who could not travel to Paris in January and February 1918 to view the major Matisse-Picasso exhibition at the Galerie Paul Guillaume had to wait a long time before again seeing such an important gathering of works of art. Guillaume Apollinaire, who wrote the introduction to the catalogue, was also the exhibition's organizer. His missionary zeal on behalf of the younger generation of artists, especially during the war years, had encouraged a new generation of collectors to take up the banner of contemporary art.

Fig. 8. Paul Guillaume in his office, 1920s

Fig. 9. Amedeo Modigliani, *Paul Guillaume*, c. 1915, oil on canvas mounted on board, 105 x 75 (41⅜ x 29½). Musée de l'Orangerie, Paris

One of those inspired by Apollinaire was the youthful **Paul Guillaume** (1891–1934). Apollinaire also introduced Guillaume to his own artistic friends. Guillaume must have been a combative yet playful individual, a shrewd businessman, as well as a passionate collector. "Paul Guillaume belongs to a generation which, on the eve of the war, took part in the liquidation of a century and precipitated its fall."[4] Appearing nonchalant as Modigliani portrayed him, he was always on the lookout for something new. The motivating force behind his great interest in modern art was his early passionate involvement with avant-garde writers and artists, through whom his interest in African art intensified. He became an early proponent of *art nègre*, and thereby inspired an entire generation of collectors. In 1914 Guillaume established his own art gallery where he exhibited these objects, and soon he was selling them to a wide clientele. Conscious of the growing significance of *art nègre* since the emergence of cubism, astute collectors of this new generation soon began acquiring African art along with modern works. By the early twenties, Guillaume's gallery at 108, faubourg Saint-Honoré became one of the centers of the art trade catering to an international audience. As early as 1914 Guillaume had lent African sculpture to Alfred Stieglitz's New York gallery, 291, for the first tribal art show in an American gallery of contemporary art. Mutual enthusiasm for this art was the basis of Guillaume's friendship with the collector Albert Barnes, who eventually amassed an astounding collection of modern art, now housed in the Barnes Foundation, Merion, Pennsylvania. It was there on 4 April 1926 that Guillaume gave a lecture on artists who constituted the spiritual elite of the contemporary avant-garde. Mentioned was Henri Matisse, an artist whose work Guillaume had come to appreciate in the course of the twenties.[5]

Guillaume was a skillful advocate of this art. In 1917 he, with Apollinaire, published a book called *Album d'art nègre*. This was followed, in 1919, by a *fête nègre* which Guillaume

239

Fig. 10. Galerie Bernheim-Jeune, 83, faubourg Saint-Honoré, Paris, 1925–1926

mounted in the Théatre des Champs-Elysées. The press did not miss the opportunity to identify all of the illustrious guests by name. Apparently Guillaume quickly won over Parisian high society. In 1924, Albert Barnes noted: "His gallery has now become the mecca not only of all the important creators of France, but also of the United States, Japan, England, and of all the continental countries."[6]

Guillaume distributed information about his undertakings and, on 15 March 1918, began publishing the review *Les arts à Paris* (1918–1935). This rare series of twenty-one issues became an important journal of international information about art for an increasingly interested Parisian public. Eleven years later, in 1929, the collector Guillaume exhibited his personal collection in the showrooms of the Galerie Bernheim-Jeune. The

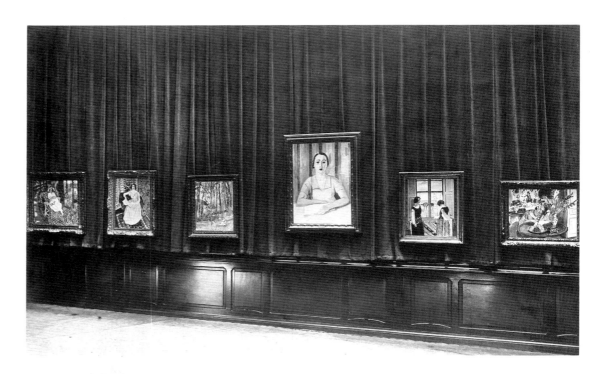

Fig. 11. Installation, Matisse exhibition, Galerie Bernheim-Jeune, Paris, April 1923

Fig. 12. Installation, Matisse exhibition, Galerie Bernheim-Jeune, Paris, April 1923

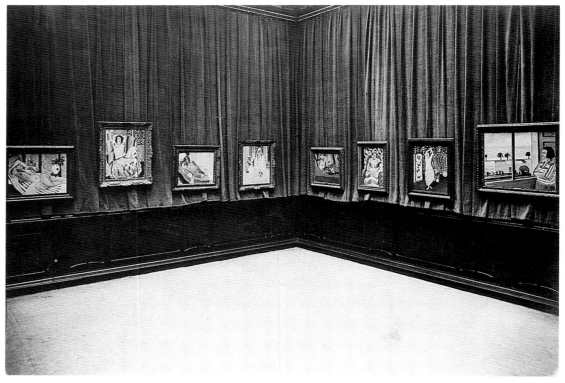

Fig. 13. Gaston Bernheim de Villers and Henri Matisse in the 1930s

lavish catalogue became the model for the documentation of contemporary art in private collections. In addition to pictures by Derain, Picasso, Rousseau, Soutine, and Modigliani, there were seventeen works by Matisse from the years between 1917 and 1929.

The main source of information regarding the market for Matisse's art is the **Galerie Bernheim-Jeune**. Matisse was under contract to the gallery as early as 1909, having agreed to sign a contract with Bernheim-Jeune on the advice of his friend, the critic **Félix Fénéon**, who directed the gallery's contemporary division. In 1917 Matisse renewed his contract, which had lapsed in 1915, and pledged the gallery half his entire artistic production except for works of unusual size. The contract was regularly renewed every three years until 1926. These contracts provided Matisse a certain amount of liberty, as long as he did not sell his share of his art below the prices previously established with his dealer; they also provide the historian with an excellent barometer of the art market.

In May 1919 Fénéon organized Matisse's first one-man show after the war, displaying thirty-six works from the years 1917 to 1919. It was the first time any of his works done in Nice were shown to the general public. On an almost yearly basis until 1926 Matisse had Bernheim-Jeune exhibitions that provided the public with a good overview of his recent output.[7] The pictures sold well and quickly. Although the gallery records are incomplete today, the guest book does provide the names of the clientele. From the Paris art world came Alphonse Kann, Dr Soubies, Jacques Zoubaloff, Henri Canonne, Marcel Kapferer, Charles Vignier, Lucien Demotte, Charles Pacquement; among the international visitors were the English dealers Percy Moore Turner II and Alexander Reid, and the Americans Albert C. Barnes, Claribel Cone, and Samuel A. Lewisohn. Also included were the agents C. W. Kraushaar, Valentine Dudensing, Marius de Zayas, Paul Reinhardt, and many more.

The gallery's financial success allowed it to move from 15, rue Richepanse to the more elegant 83, faubourg Saint-Honoré. At the same time, and under the stimulus of Fénéon, they published books on impressionism and post-impressionism.[8] Furthermore, they printed a valuable newsletter for the novice collector entitled *Le bulletin de la vie artistique*

Fig. 14. Residence of M. and Mme Gaston Bernheim de Villers and M. and Mme Josse Bernheim, 107, avenue Henri Martin, Paris, c. 1920, showing a wall of paintings by Renoir

Fig. 15. Residence of Josse Bernheim, rue Desbordes Salmare, Paris, c. 1925

from 1919 to 1926. It contained information on auctions and exhibitions, as well as reviews of events at home and abroad. The directors of the gallery, Josse Bernheim and Gaston Bernheim de Villers, had magnificent personal collections of modern art, including important examples of Nice-period paintings by Matisse.

An impressive array of instructive art and culture magazines appeared. A partial list includes *L'amour de l'art* (1920–1930), *L'art vivant* (1925–1930), *Bulletin de l'effort moderne* (1924–1927), *Cahiers d'art* (1926–1930), *La vie des lettres et des arts* (1920–1926), and *L'esprit nouveau* (1920–1930). Simultaneously with their appearance, a new generation of critics came to light: men like Waldemar George, Pierre Courthion, Francis Carco, Adolph Basler, Gustave Coquiot, Franz Jourdain, André Salmon, and Maurice Raynal. The first major articles and monographs on Matisse were published; many stressed Matisse's mastery of the art of painting within the French tradition.

The collections of Jacques Doucet and Alphonse Kann can be singled out as a source of inspiration to the new series of connoisseurs who became interested in acquiring art. **Jacques Doucet** (1853–1929) was known best as a great couturier. He was one of France's most extraordinary Maecenases who, like a Renaissance prince, collected artifacts from all periods of history. In 1912 he auctioned off a large number of his antique objects and turned his attention to the creations of modern artists, from the impressionists to Duchamp and Picabia. To form this, his third collection, he astutely sought and followed the suggestions of the most farsighted advisers (André Breton, among many others). In a studio in Neuilly he gathered his newest treasures: "Behind the leaders, the Douanier Rousseau, Seurat, one could see the following represented: Picasso, Matisse, Derain, then the surrealists de Chirico, Miro, Ernst, Picabia, not forgetting Man Ray with his admirable photographs. In short, a whole company of reprobates whose names alone would make people back away in horror, to the great joy of Doucet."[9]

During the war he purchased Matisse's famous painting *Le bocal de poissons rouges* (1915) and, before 1921, the still life *Nature morte, vase de fleurs, citrons, et mortier* (1919, pl. 80). "Doucet seemed to have been interested early on in Matisse, who would prevail

242

Fig. 16. Studio of Jacques Doucet in Neuilly, c. 1920. Matisse's *Nature morte, vase de fleurs, citrons, et mortier,* 1919 (pl. 80) hangs beside his monumental *Still Life with Goldfish Bowl,* 1916, now in The Museum of Modern Art, New York

Fig. 17. Alphonse Kann in his youth

several years later in the studio in Neuilly."[10] He bought graphic images by the artist as early as 1915, and they were eventually integrated into the Bibliothèque littéraire Jacques Doucet in the Bibliothèque Sainte-Génèvieve and the Bibliothèque d'art et d'archéologie (Fondation Doucet) of the University of Paris. In a gesture of thanks for this donation, Matisse likewise deposited a gift of rare graphic states in the Bibliothèque Sainte-Génèvieve in 1930.

Despite the respect that Doucet enjoyed in Paris, his fervor for contemporary art met with incomprehension. Out of politeness, visitors overlooked Picasso's *Les demoiselles d'Avignon* when they came for a visit. His large Rousseau, *La charmeuse de serpent,* was rejected when it was presented to the Louvre as a gift in 1929. Doucet's intention that "After my death, all of my collection will go to the Louvre, and I am the only collector whose authority will cause the Louvre to accept vanguard painting . . ."[11] remained unrealized. Despite his power and influence, Doucet could not run in advance of his age. It would take a further generation, and perhaps the example of the American model, before his achievements would be recognized. Most of his works of art eventually were sold through the dealer Jacques Seligmann during the 1930s.

Alphonse Kann, a contemporary of Matisse with approximately the same lifespan, is hardly remembered today. No documentation of his collection exists, but the provenances of many exceptional works of art contain his name. He was English and came from a large banking family of German origin, some of whose members were also collectors. In the prewar years in Paris he began to collect modern art under the tutelege of Leo and Gertrude Stein and Ambroise Vollard, and owned ten Matisse works before the war. Kann was interested in artifacts from all periods. It is said that as early as 1907 he bought a Bruegel painting at the famous auction of his uncle, Rudolf Kann.[12] By 1913 his villa in Saint Germain-en-Laye was crammed with art objects and pictures by the post-impressionists.

243

Kann's name appears in the files of Bernheim-Jeune: in 1916 he purchased Matisse's *La branche de lierre dans le pot Catalan* (1915), in 1921 *Les Eperlans* (1921), and in 1928 *La femme en blanc.* Further, Kann owned unusual and, in those days, difficult pictures like the remarkable *Le rideau jaune* (1914) and *La table de marbre rose* (1917, pl. 30), as well as the beautiful *Les glaïeuls* (1928, pl. 184). Pierre Loeb tells us: "On the walls, against a background of Gothic tapestries and Coptic fragments, a Matisse was beside a Fayum painting; a Cézanne and a van Gogh were mingled with cubist Picassos; a Klee painting was placed above a display cabinet filled with Cycladic sculptures; Bonnards and Braques, above the display cabinets sheltering archaic Chinese bronzes."[13]

Whenever a new Matisse was welcomed into the collection, Alphonse Kann, as Matisse's daughter Marguerite Duthuit recalled, would invite the artist to come to inspect it. It must have been a gratifying aesthetic experience for Matisse to see his paintings among the creations of other epochs; and, as did his visits to the eighty pictures by Cézanne in the Auguste Pellerin collection, they provided the artist a measure of quality against which he was able to assess his own work.

Collecting for Kann became such an obsession that his collection was constantly in flux: "It seems that he would sell, from time to time, when the buyer was worth it, exchange with the dealers the painting he had had for a long time for others which he preferred, not yet appreciated, but which would make a move one or ten years later. He knew the business better than the experts and his sharp, hard eye judged without error, without failure."[14] It is not surprising that passionate novices bought from him. Among the individuals were the Dane Christian Tetzen-Lund and the American Chester Dale. He provided the impetus for numerous people to begin collections of their own. He lived for art, and was, with his more than a dozen exceptional pictures by Matisse, among the most adventurous, clairvoyant, and judicious pioneer collectors of his age.

The continued acquisitions of Kann during and after the war and the sudden passion for the most difficult contemporary work that Doucet's post-1917 purchases betrayed could not be dismissed. Both men were French and had distinguished histories of collecting art of other periods before they began to purchase modern art. Their example went a long way in vindicating the new painters.

Paul Poiret (1876–1944) was a couturier of the *belle époque* who admired and emulated his mentor, Doucet. Like the latter, he had access to the avant-garde through his profession. Prior to the war Poiret luxuriated in Arabian-nights style, most likely inspired by Russian ballet productions, but he gradually adopted a more contemporary style thanks to close cooperation with painters such as Dufy. Although his artistic sense never attained Jacques Doucet's level of taste or independence, he nevertheless surrounded himself with the creations of Matisse and his circle. The sale of his collection in 1925, necessary due to financial setbacks, reveals the level of acceptance of French modern art by the mid-twenties.

Another new collector was **Henri Canonne**, who owned a large medical supply business and, like Alphonse Kann, had a villa near Saint Germain-en-Laye. Closely associated with Bernheim-Jeune, he bought early works by Matisse from various exhibitions. In 1924 he acquired some of Matisse's major creations, such as *Nature morte, "Les pensées de Pascal"* (1924, pl. 141), *La lecture* (1924), *Le concert* (1923), *Nu couché* (1924), and *Le peintre et son modèle* (1924). In total, Canonne amassed more than twelve paintings directly related to Matisse's Nice period. In 1930 Bernheim-Jeune published a beautiful monograph on Canonne's collection on the occasion of the sale of a selection of works from it. The other focal points of Canonne's collection were important works by Monet, Vuillard, Bonnard, Cross, Derain, Dufy, and Vlaminck.[15]

Dr Jacques Soubies, physician and owner of an exclusive clinic, was a passionate lover of art "who worked from morning until night to buy paintings."[16] In 1920 he is listed in a Bernheim-Jeune exhibition catalogue as the owner of several works by Matisse. The

following year, however, he sold some of them at the Hôtel Drouot. He used the money to purchase new works of art in such quantity that Fénéon, on the occasion of a 1927 exhibition of works by Gaston de Villers, could write: "Dr. Soubies [was] a man of taste since he already was collecting Renoir, Cézanne, Monet, Henri Matisse. . . . He goes to the artist's home . . . expressed the desire to see other works. In a short amount of time he acquired thirty works, as much for himself as for friends who trusted his competence. Since he reorganized his collection, he devoted an entire room to the paintings of Henri Matisse and Gaston de Villers."[17] Soubies was trusted and respected by other collectors. His ever-vigilant eye led him to upgrade his collection numerous times by selling off works in order to buy others he judged to be of higher quality.

In 1928 twenty-three of his Matisses, along with pictures by artists ranging from Toulouse-Lautrec to van Dongen, were put up at auction. The Soubies Collection sale became the talk of the day: it was "the biggest sale of the year of modern paintings. Only one hundred paintings, but of what quality and what choice. . . . Dr. Soubies is well informed. The . . . Henri Matisses, incomparable jewels of this selection, have made, by themselves, close to two million."[18] This Paris sale attracted the international market and set new price levels. Dealers and collectors of considerable renown attended the sale: Bignou, Laroche, Bernheim, Guillaume, de Hawke, McNeill Reid, Canonne, Henri Bernstein, Valentine Gallery, and Baron Fukushima.

The collector, writer, and dramatist **Henri Bernstein** purchased four oils by Matisse from the Soubies auction in 1928, including one of the five versions of *Fête des fleurs* (1921). The auctions at the Hôtel Drouot afforded the truly interested collector the best opportunity to acquire paintings by Matisse, which were scarce between 1926 and 1931; fewer oils by Matisse were exhibited in those years because his production shifted from painting to the making of sculpture and prints.

The names of a few other collectors of importance must be noted: **Baron Fukushima**, **Marcel Kapferer**, **Charles Pacquement**, and **Jacques Zoubaloff**, and the particularly discriminating **Baron Napoléon Gourgaud**. They all lived with pictures by Derain, Dufy, Bonnard, Vuillard, Marie Laurencin, Braque, and de la Fresnaye on their walls, and they too purchased works by Matisse mostly from the 1920s. The extraordinary Gourgaud collection, which also featured cubist works, provides a representative idea of the taste of an aristocrat who increasingly oriented his art interests toward contemporary works.[19]

The collecting of artworks in Paris had seldom before achieved such intensity. The haute bourgeoisie cherished the creations of the impressionists and the post-impressionists, but rarely showed interest in more radical, innovative art. It was a rarer kind of collector and those outside the mainstream who were more likely to take chances with the avant-garde; they were the first to sponsor the surrealists. It was possible for young talent to be discovered early and vigorously championed, as was the case with Kisling, Soutine, and Lipchitz. Artists of the elder generation—Matisse, Picasso, and Derain—were raised to the level of indisputable masters. Beginning in 1925–1926, newly founded journals reported on collections of contemporary art to an eager public. It was in these years that the first associations of art lovers and collectors were established, and that the initial demands were voiced for new exhibition spaces for modern art. Even the art dealers formed their own association.[20] In this rich interrelationship of art and art dealing, private collections played an important part.

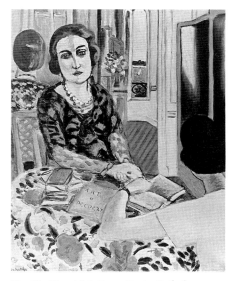

Fig. 18. Henri Matisse, *Portrait de la Baronne Gourgaud*, 1924, oil on canvas, 82 x 66 (32³⁄₁₆ x 26). Musée National d'Art Moderne, Paris

United States

In a young country like the United States, private fortunes built through financial and industrial enterprise often were translated into the desire for cultural expansion. The first American collectors on a grand scale tended to be conservative in their tastes, but catholic in the scope and variety of works acquired. The prestige of these collections was enhanced

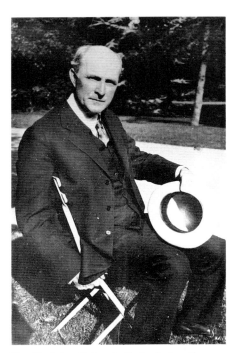

Fig. 19. John Quinn in Paris during the 1920s

when shared; thus, they were often opened to public viewing during the collector's lifetime, were housed in specially built annexes called galleries, and eventually came to enrich America's museums.

The first one-man show of Matisse's paintings in the United States was mounted by the Montross Gallery in New York from 20 January to 27 February 1915. The accompanying catalogue was compiled by Walter Pach, Matisse's friend for several years. The first acquisitions in America were made from this show: John Quinn purchased *Cyclamen pourpre* (1911) and *Hat with Roses (Marguerite)* (1914), and Walter Arensberg, soon to be Marcel Duchamp's major American collector, bought the near-futurist portrait *Yvonne Landsberg* (1914, Philadelphia Museum of Art).

John Quinn (1870–1924) probably was the most unusual pioneering collector of contemporary art in America. "The collection of John Quinn marks an epoch in the history of modern art in America. Mr. Quinn began his great collection roughly in the days when in America to be 'modern' was to be a bold bad martyr. Whatever the number or quality of the pictures and prints which had come into his collection before the Armory Exhibition in New York (February, 1913), the indisputable fact is that Mr. Quinn's affiliation with various artists who dominated the affairs of the Armory Exhibition 'made' him a collector."[21] Quinn, a brilliant lawyer and self-made man, sided with those he patronized, fought the high import taxes on foreign art works, and advised painters on legal matters. The experience of the Armory Show, along with his prewar trips to Europe, formed his sense of art and stirred his passion. In 1921 he lent the Metropolitan Museum of Art twenty-eight works for its first major exhibition of post-impressionist art. There were "seven Redons, six Matisses, four Derains, three Picassos, two Gauguins, and one each by van Gogh, Cézanne, Toulouse-Lautrec, Dufy, Rouault, and Vlaminck."[22] All the works were of the highest quality and substantiated Quinn's opinion that van Gogh and Cézanne were the key to understanding modern French painting. Quinn discovered both masters at the dealer Ambroise Vollard during trips to Paris in 1912 and 1913. His collection of contemporary oils (Matisse, Picasso, Derain, Rouault) was amassed within the ten-year period prior to his untimely death in 1924. "His collection far outstripped the wall space at his command."[23] Henri Pierre Roché, his private agent in Paris, remembered "in 1926, after his death, I spent fifteen days alone in his Central Park apartment, among his collection: 30 Brancusis, 20 Picassos . . . I saw the works, the dates of purchase. I followed his daring course, the opposite of an accumulation, a sort of vital Grand Canyon cut through modern painting."[24]

Quinn knew the Steins, Walter Pach, Marius de Zayas, Joseph Brummer, and many of Matisse's American admirers. Beginning in 1915 he bought major Matisses, often difficult to comprehend, but always key works in the painter's creative production—pictures like the *Nu bleu* (1907), which had been owned by Leo Stein and by Alphonse Kann.[25] He permitted his artist-friends, the proponents of all that was innovative in the age, to advise him. "Mr. Quinn had faith that the modern art he enjoyed so keenly was the true exponent of the genius of its period, even as the great arts of the past were of theirs."[26] Thanks to close contact with the artists, and a bold and sure personal taste, he acquired early masterpieces of lasting significance in a time when even the dreams of less-affluent collectors could be realized. These dreams ignited an entire generation and sparked the acquisitions of Lillie Bliss, Katherine Dreier, Albert Barnes, and the Arensbergs. "Therefore, it is not surprising, that the announcement of a memorial exhibition [and sale] of part of his collection aroused the world of art to such a state of expectancy that collectors and museum directors from all parts of the country came to New York to see the Quinn collection. The public poured into the exhibition and the discriminating literally pounced upon such masterpieces as the self portrait by van Gogh, the portrait of Mme. Cézanne by Cézanne, and others, while envious collectors gazed longingly at the superb Seurat, which Mr. Quinn had bequeathed to the Louvre Museum."[27]

Thanks to the Quinn sale, exceptional Matisse works from his various creative periods

were available in America by 1926. And, the fact that all these pictures were purchased by other American collectors was a clear sign of the nation's aesthetic tastes. These collectors, people like Ferdinand Howald, Earl Horter, Samuel S. White, Etta and Claribel Cone, Samuel A. Marx, and Conger Goodyear, would become significant figures in the history of Matisse's American reception. The admonition Quinn repeatedly gave his fellow art lovers has proven itself through the decades: "I have come to the time in my modest career of collector, when I desire to add only works of first-rate importance and not mere sketches or tentative work. This is a point that every collector, I imagine, arrives at sooner or later."[28]

From his own training as an artist, **Marius de Zayas** (1881–1961) knew prewar Paris, the Steins, and Matisse. Initially he was active in New York in the Stieglitz circle; then, between 1915 and 1919, he worked for the Modern Gallery prior to running his own gallery from 1919 to 1921. Quinn found many of his Matisses through de Zayas, who was an active agent in the transactions of Matisse's art between Paris and New York. De Zayas mounted exhibitions, and was a contributor to the groundbreaking 1920 show *Paintings and Drawings by Representative Modern Masters* at the Pennsylvania Academy of the Fine Arts in Philadelphia.

Walter Pach and **Joseph Brummer** had been guests at Académie Matisse, the influential but short-lived school directed by the artist in Paris between 1908 and 1911.[29] Brummer became involved in tribal art and soon established his own gallery in New York. In 1924 he mounted an important Matisse exhibition, about which the press reported: "The exhibition is a pure joy for anyone who realizes how quintessentially a painter is Henry [*sic*] Matisse."[30]

In December of that year the **Fearon Galleries** showed new works by Matisse which, according to the catalogue, had been selected by the artist himself. It was "the first time that a representative exhibition of Henry Matisse has been arranged for New York." The critics were full of praise: "Both to Matisse and to the New York public in its attitude towards his art much has undoubtedly happened since his debut here, along with many another wild man of that time, in the historic Armory Show ten or more years ago. This really can be referred to as an historic occasion, for it is most decidedly a turning point for American art."[31]

Many factors contributed to this turning point, but one of the more significant was the continuous and tenacious exhibition activity of smaller galleries. Coming to America in December 1924 on the advice of Walter Pach, **Pierre Matisse**, the youngest son of the artist, began organizing exhibitions for the **Valentine Dudensing Gallery** in New York. The critics commented on the Dudensing show: "The existence of a selective mind and the personal taste back of the whole was felt at once, and it was precisely this which rendered the event significant."[32] In 1925 he also showed his father's graphic works at the gallery of **E. Weyhe**.

Pierre Matisse was trained by Audebert Barbazanges in Paris, with whom he had stayed during the war years. According to Pierre, he did not possess any particular artistic talent like the rest of his family. But he quickly learned the art trade and, in New York, organized exhibitions of the highest quality of contemporary art coming from Paris, exhibitions facilitated by his personal connections with his father's colleagues. Yet, in comparison with his own struggles as an artist, Henri Matisse viewed art dealing as too facile, and even Pierre could not always count on his father's support. Regardless, he earned the trust of collectors and their circles of friends. In 1931 he opened his own gallery and, in 1934, staged a large exhibition of his father's art. It contained twenty-four major paintings, some of them from private collections. Pierre Matisse became a notable force in molding New York aesthetic tastes during the 1920s, and was instrumental in introducing the work of other talented Europeans like Miró, Giacometti, Tanguy, and Dubuffet.

Parallel with the exhibition activity of the galleries, museums now began to show contemporary art: in 1921 the Brooklyn Museum exhibited eleven works by Matisse, and

Fig. 20. Henri Matisse, *Walter Pach*, 1914, etching, 16.1 x 6 (6⁵⁄₁₆ x 2³⁄₈)

Fig. 21. *Pierre Matisse,* portrait by Carl van Vechten, 20 May 1933

the Metropolitan Museum of Art showed nine. Many paintings in this show were owned by **Dikran Khan Kelekian**. Kelekian, a Persian, was a collector and dealer in antiquities who lived for a long time in Paris and moved to America c. 1893. He was known as a dealer of Middle Eastern objects for American collectors. Kelekian purchased oils from the venerable Parisian collectors Théodore Duret, Auguste Pellerin, Henri Rouart, Claude Roger-Marx, and Octave Mirbeau. He knew and advised Jacques Doucet and Alphonse Kann, among others. Furthermore, according to Pierre Matisse, Kelekian had good artistic connections, and bought directly from Matisse's studio. Following the war he sought to make his name in the field of contemporary art through a well-organized auction in New York. A catalogue was prepared for the January 1922 event, and the foreword was written by the renowned critic Arsène Alexandre. Contemporary painting was represented in this auction by Picasso, Derain, Vlaminck, Utrillo, and Matisse. The most satisfying outcome of the Kelekian auction was the acquisition of Matisse's major oil, *La fenêtre* (1916), by Dr. W. R. Valentiner for the Detroit Institute of Arts for $2,500. It thereby became the first work by Matisse to enter an American public collection. Yet for Kelekian the sale was a disappointment; many paintings sold for low prices or did not sell at all, and he suffered severe losses which he never recouped. It was the opinion of the press that "there are relatively few Americans of small means who are collecting. We must endeavor to foster a love for art among the middle classes, for they constitute, so to speak, the backbone of our civilization."[33]

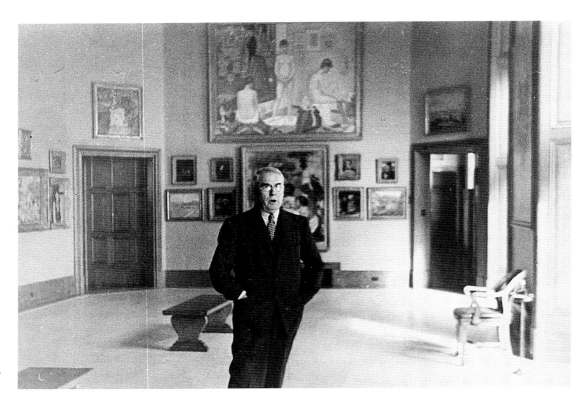

Fig. 22. Albert Barnes in the center gallery of the Barnes Foundation, Merion, Pennsylvania, early 1930s

Dr. Albert C. Barnes (1872–1951) of Philadelphia, a grand collector and rival of John Quinn, purchased works by Cézanne at the Kelekian auction shortly before he established his foundation for modern art in Merion, Pennsylvania, in December 1922. The source of his wealth was an antiseptic, Argyrol, which he collaborated in developing and then successfully marketed. Much has been written about this scholar, physician, self-made man, possessed art lover, and collector, and debate and criticism surround his often unsympathetic reactions and dealings; nevertheless, his accomplishments as a collector are among the most impressive in the history of twentieth-century art, American or European. The magnitude of his collection is astounding: approximately two hundred Renoirs, one

hundred Cézannes, more than sixty Matisses, and forty early Picassos. Unfortunately, no complete list of Barnes' purchases is extant today.[34]

The works in the Barnes Foundation collection initially had to withstand criticism and derision. The attacks began at the time of his first exhibition at the Pennsylvania Academy of the Fine Arts in 1920, but an even larger storm of protest broke out when he displayed his recent Parisian acquisitions there in 1923.[35] Among the works were numerous pieces by Chaim Soutine and Jacques Lipchitz (Barnes being the first to make major acquisitions of the work of the former).

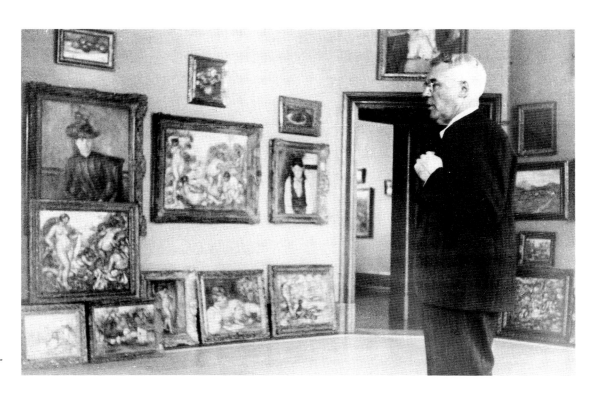

Fig. 23. Albert Barnes in the center gallery of the Barnes Foundation, Merion, Pennsylvania, early 1930s

Barnes had a resilient character and displayed incredible energy in attaining his professional and aesthetic goals; it was his misfortune to have sought public approval in an age unwilling to grant it. To compensate, he began writing scholarly studies on art and developed his own educational methods for the analysis and appreciation of art. Through this two-pronged approach, Barnes sought to unlock and then explicate the formal bases of art to the students in classes at the Barnes Foundation. One of the fruits of his unending investigations was the book *The Art of Henri Matisse*, published in 1933.

Barnes first became interested in art as an amateur painter and through his friendships with American painters, especially William Glackens and Alfred Maurer. According to the ledgers of the Galerie Bernheim-Jeune, Barnes was a regular client after 1912, a time when his aesthetic interest was deepened and intensified by his visits to prewar Paris. There he met the Steins. Tutelage in art appreciation came from Leo Stein; Barnes' first Matisse paintings may have had the same source. Barnes bought no works by Matisse at the Armory Show or the Montross Gallery exhibition in 1915. Matisse affected him only later, probably on his buying trips through Paris after the war.

Barnes' main source for paintings by Matisse was Paul Guillaume. The friendship between this dealer and Barnes was described by the magazine *Les arts à Paris*, and seems to have been most intense between 1923 and 1927. It was in this same magazine in October 1927 that Barnes informed its Parisian readership of his foundation which, at that time, already consisted of one hundred Renoirs, fifty Cézannes, twelve Matisses, and twenty-two Picassos. Barnes probably acquired the majority of his Matisse oils in the years between

Fig. 24. *Vera White*, portrait by Man Ray

Fig. 25. Henri Matisse, *Dr. Claribel Cone*, 1931–1934, charcoal and estompe on paper, 59.1 x 40.6 (23¼ x 16). The Baltimore Museum of Art: The Cone Collection, formed by Dr. Claribel Cone and Miss Etta Cone of Baltimore, Maryland. BMA 1950.12.71

1923 and 1933, the date of his book on Matisse. Later, Barnes frequented the French dealer Etienne Bignou and the Swiss trader Georges Keller, who resided in Paris.[36]

Barnes and Matisse enjoyed a cordial, if sometimes strained relationship. The dramatic events surrounding the large-scale commission of the mural subsequently entitled *La danse* further intensified the relationship between the two men. In February 1932, when it became clear that the mural that Matisse had been working on for a year would have to be redone because of incorrect measurements, Barnes journeyed to Nice to prevent further errors.[37] Then in 1933 Matisse was a guest in Merion while the completed panels were installed. The entire commission fostered new aesthetic insights and gave rise to intense intellectual exchanges among the students at the Barnes Foundation. Thanks to Albert Barnes' interest in Matisse's art, the most extensive collection of that master's work in the world at that time was formed.

Among those in Barnes' circle of fellow collectors was **Samuel S. White III** of Ardmore, Pennsylvania. He was an industrialist who, through study and business trips to Paris beginning in 1904, regularly came into contact with French art. His interest in collecting was strengthened by the career of his wife, the artist Vera White; he also had close acquaintance with the controversies surrounding Dr. Barnes and his foundation. Works by Picasso, Matisse, and Cézanne were among his first important acquisitions. The purchases were arranged by artist colleagues, in particular Jacques Mauny, who was also a journalist. Through his assistance, the Matisse oil *Nature morte, "Histoires Juives"* (1924, pl. 131) is thought to have entered White's collection in 1925.[38] In 1928, when he exhibited his collection for the general public at the Philadelphia Museum of Art, he owned three of the five Matisse paintings that would eventually be his. When Matisse came to Pennsylvania in 1931 on his second trip to America he visited the Whites. The collection, together with its numerous oriental objects and prints, reflected the aesthetic interests of a Francophile collector of the 1920s.

Within the circle of Philadelphia collectors was the painter and illustrator **Earl Horter** (1883–1944). He was a successful commercial artist and, as a painter, was open to new ideas. He was influential in the cultural world and was also in close contact with his French colleague Mauny. Like him, he followed the work of Picasso and Braque, and had an interest in cubism, buying one of Matisse's unusual cubist period paintings, *The Italian Woman* (1915–1916), at the 1926 Quinn estate sale.[39]

The staunchest friendship with Matisse was maintained by **Dr. Claribel Cone** (1864–1929) and **Etta Cone** (1870–1949) of Baltimore. No European collector so completely enjoyed the master's trust; the sisters embodied "the real patrons" for Matisse.[40] Their acquaintance with Matisse had its origins, as for so many early-twentieth-century American collectors of contemporary art, in the circle of Leo and Gertrude Stein in Paris. Their first contact with the artist occurred in 1906 when Etta Cone purchased several drawings. However, their true passion for collecting began in earnest in 1922 when the sisters jointly bought six paintings in addition to sculpture and drawings by Matisse from the Galerie Bernheim-Jeune and from Georges Bernheim in Paris. In the summer of 1923 they acquired eleven more oils, nine of which were recent. New pieces were added almost yearly, in part directly from the artist's studio. At the time of Claribel Cone's death in 1929, a total of twenty-six Matisses graced the walls of their home; no other painter was represented so extensively.

Claribel Cone, trained as a physician, is thought to have been the more audacious patron. It was she who bought the much-maligned *Nu bleu* (1907) at the Quinn auction in 1926. The Cone sisters primarily made their purchases in Europe and, even in later years, Etta persisted in buying art on the continent.[41] In most instances, her choices were guided by Matisse, who always set out a selection of three or four works before she came. He knew and respected her taste and, at the same time, was aware that she was forming a most important collection of his works.

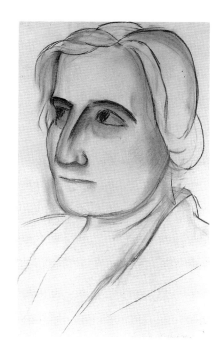

Today, the Cone collection is a precious example in America of a collection formed under the intimate guidance of an artist. It is also rich in graphic materials and first editions of the artist's books, and contains all the working drawings and maquettes for the edition of Mallarmé's *Poésies*, which Matisse illustrated in 1932. In Etta Cone Matisse found a worthy continuation of his American contacts, originally established with the Steins. Sarah and Michael Stein, sister-in-law and brother of Leo and Gertrude Stein, would occasionally purchase a few pictures during the twenties, but they no longer had the means to remain large-scale collectors, as they had been before the war.

Like the Cone sisters, **Duncan Phillips** (1886–1966) also came to Paris for the first time as a student, possibly meeting the Steins at that time. Prior to the war he traveled extensively throughout Europe. In 1913 he visited the Armory Show in New York and, beginning in 1915, acquired American pictures. Along with John Quinn, he was one of the pioneer collectors of contemporary painting. In 1918 he opened a portion of his home in Washington as a public museum. His encounter with avant-garde French art dates from the years shortly after the war, as was the case with many other American patrons; at this time, he made extensive trips to Paris. In 1924 he bought his first Bonnard painting at the Carnegie international exhibition and, in 1926–1927, three of Matisse's oils of his Nice period through American dealers.[42]

Duncan Phillips was an indefatigable collector and intellectual. Together with his wife, the artist Marjorie Phillips, he hunted after paintings and, through numerous essays, made his enjoyment and conviction public knowledge. Collecting for him was as much a serious commitment to a public cause as a personal passion. "I am trying to emphasize the value of a service which the private collector can render unobtrusively not only to the living artist but to the cause of progressive art. And I am attempting to demonstrate the greater value of a public service of the same kind, but with its added educational function, which makes the experimental public or semi-public museum an actual necessity."[43] Phillips' idea of a museum for the creations of living painters and his establishment of the Phillips Memorial

Fig. 28. The main salon of the Phillips Memorial Gallery as it appeared in the 1920s

Fig. 29. Ferdinand Howald in a room of his collection at the Columbus Gallery of Fine Arts, before 1934

Gallery in 1918 were exceptional and pioneering achievements; they may have strengthened Albert Barnes' resolve to establish his foundation. "The greatest tragedy in the story of art from its beginnings to the present moment is the terrible neglect of the best artist[s] during their brief stay on earth."[44] His sharp, uncorruptible aesthetic sense led him continually to seek the best. While he unconditionally approved of Bonnard and placed him at the top— "Bonnard is, in my opinion, the most distinguished and original painter now living"[45]—he had some reservations about Matisse: "As in the case of Matisse, his facility and popularity are distinct sources of danger in his path to further progress. . . . He is an assured and sophisticated master in the new language of rhythmical simplification and more or less arbitrary pattern."[46]

Ten Matisse pictures passed through his hands as he constantly exchanged one oil for another. The chronology of this exchange neatly reveals the refinement of his taste and the shifts in his sense of quality. Yet, Phillips perpetually ran the risk of misinterpreting the aesthetic value of individual pictures, as in the case of the pivotal *Le Torse de plâtre, bouquet de fleurs* (1919, pl. 26), which he traded away in 1942. Nevertheless, he was enraptured again and again by Matisse, and once wrote his New York dealer, F. Valentine Dudensing: "I am in love with the picture reproduced on page 24 of *Art News* entitled *Composition 1928*. It has a pattern with roses against sky and a coffee cup on a checkerboard. . . . it is just the Matisse I have always wanted."[47]

Duncan Phillips was the first American collector to establish a public museum devoted to contemporary art. Within the decade his pioneering achievement was admirably followed by four institutions in New York: the Societé Anonyme, Katherine Dreier's modern museum, in 1920; the Gallery of Living Art, from the A. E. Gallatin collection, in 1927; the Museum of Modern Art, with the Lillie P. Bliss collection as its nucleus, in 1929; and the Whitney Museum of American Art, founded by Gloria Vanderbilt Whitney, in 1931.

Ferdinand Howald (1846–1934) was a pioneer collector from Columbus, Ohio, who is little known today. Originally from the Swiss town of Wangen an der Aare, he was an engineer in the coal industry. During and after the First World War he made regular visits to every New York gallery in search of art. His acquisitions of modern American art were

inspired by his friendship with the dealer Charles Daniel and his fascination with the Stieglitz circle. Forbes Watson described him as an enthusiastic and adventurous collector. Already in his sixties, Howald bought what appealed to him, "not counting the result either in material advancement or social approach."[48] The varied nature of his huge collection, with works of well-known and lesser-known American and French painters hanging side by side, attests to the spontaneous and highly personal nature of his collecting habits. Figurative and cubist pieces were intermingled, Derain next to Picasso, Pascin next to Juan Gris and Marsden Hartley, and Matisse and Vlaminck next to Preston Dickinson.

Beginning in 1921 Howald started to acquire French art: Degas, Derain, and his initial Matisse. In all likelihood he was inspired to collect his oils by the exhibitions at the Brooklyn Museum and the Metropolitan Museum of Art in 1921.[49] By 1926 five major Matisse pictures were in his possession; all of them were part of his important donation to the Columbus Gallery of Fine Arts. His name appears as one of the backers of the Gallery of Living Art in 1927. For its opening exhibition, he lent, among other works, three Matisses. The nearly eighty-year-old Howald gave away his massive collection; "as he proposes to give away all of his works of art, he obviously cares nothing for the material question of a rising [art] market."[50] "Howald was no man to sit at another's feet and he was a hard man to patronize. . . . A generous man who helped out many a poor devil of an artist . . . bought steadily and well up to the crash in the late 1920s."[51]

The opening of the Gallery of Living Art at New York University on 12 December 1927 was the first step in New York's institutional acceptance of contemporary art. Among those backing this undertaking were, in addition to Howald, such pioneer patrons as Walter Pach, Jacques Mauny, and Henry McBride, the critic who was an early enthusiast for modern art. The spokesman was **Albert Eugene Gallatin** (1881–1952). The son of a Geneva family, Gallatin painted as a hobby and collected automobiles as well as works by the cubists Picasso, Braque, Juan Gris, and Léger. "The Gallery of Living Art . . . was founded in order that the public might have an opportunity of studying at least some of the many phases of the newer influences at work in progressive twentieth-century painting, not only in private possession and at dealers, but in a public museum."[52] Gallatin, in the gallery's catalogue, mentioned Chester Dale, Stephen C. Clark, Samuel [A.] Lewisohn, and called special attention to Mrs. Sarah Stein, Miss Cone, John Quinn, Dr. Barnes, and Ferdinand Howald as the first patrons of Matisse. In 1933 he published in the Gallery of Living Art's journal a series of portrait photographs of artists that he had taken in France in 1932. Matisse was photographed in Nice in his home in front of his own pictures; one of those, *Ma chambre au Beau-Rivage* (1917–1918, pl. 47), was bought by Gallatin. However, Matisse was not to be the central focus of Gallatin's cubist-based collection.

Stephen C. Clark (1882–1960) was a lawyer and part owner of the Singer Manufacturing Co., as well as a longtime member of the board and trustee of the Metropolitan Museum of Art and the Museum of Modern Art. Initially he wanted to be a painter before he joined his father's company. Art continued to fascinate him and he was untiring as a collector. Though he was in Paris for the first time in 1912, his period of making acquisitions blossomed during the 1920s. Then Clark filled his New York home with oils by Cézanne, Renoir, van Gogh, Seurat, assorted old masters, and with a large number of pictures by Matisse. Clark ranked with Barnes and Quinn in having a great concentration of Matisse's *niçoises* works. He installed them in a room with decor inspired by the colors, the appointments, and the ambience of the artist's studios in Nice. Henri Matisse dined there on his trip through New York, and must have been amazed to discover such a setting for the Nice-period work. It was designed by Mr. and Mrs. Eugene Speicher and housed approximately fifteen Matisse oils. These pieces were purchased between 1925 and 1934, mostly from American or English dealers.

Two more collectors enlivened the New York art scene and collected French art from the impressionists onward. **Chester Dale** (1883–1962) was a stockbroker who was

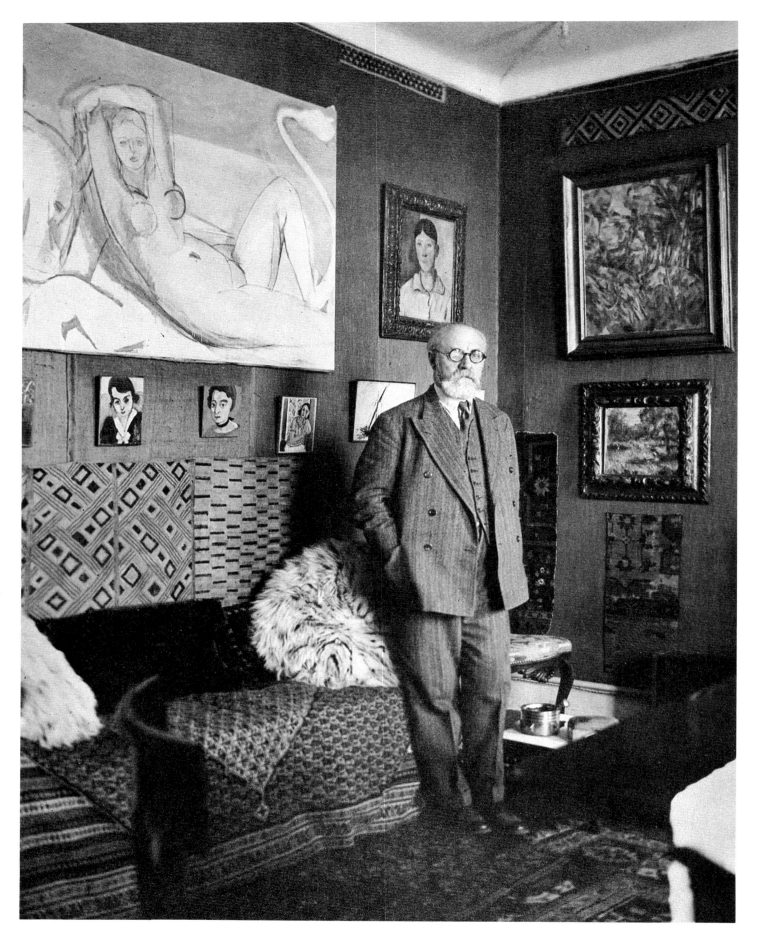

Fig. 30. Henri Matisse, fourth-floor apartment, 1, place Charles-Félix, Nice, 1932, portrait by Albert Eugene Gallatin

Fig. 31. Chester Dale in the 1920s

Fig. 32. Maud Dale in the 1920s

Fig. 33. The Chester Dale house, 20 East 79th Street, New York, showing works by Matisse and Picasso, all now in the National Gallery of Art, Washington

encouraged to collect by his wife, the artist **Maud Dale** (1875–1953). Before the war she had studied art with Théophile Steinlen in Paris. Imaginative, attractive, and posessing a keen memory for forms, she took up the cause of French art in both word and deed. Following a few early tentative purchases, the Dales began buying extensively and earnestly in 1925. "Maud . . . taught me values. . . . I did all the buying"[53] was Chester Dale's motto. Shrewd and well-versed in business matters, he soon mastered the rules of the Paris art market and worked his way into its very midst. In the opinion of John Walker, "his knowledge of the history of art might be minimal, but his knowledge of the world of art [was] prodigious."[54] He bought from auctions at the Hôtel Drouot, made direct acquisitions from private collections, and was part owner of a gallery. In conjunction with his agent, Etienne Bignou, and the Bernheims he administered the Galerie Georges Petit where, in 1931, the great Matisse retrospective and banquet took place. His collection, which encompassed Chardin to Lurcat, with a few older works, contained numerous masterpieces, including Picasso's *Family of Saltimbanques* and Manet's *The Old Musician.* In 1931, Dale's collection was estimated to contain about four hundred art objects, among them eight works by Matisse.[55] In 1962 a large part of the collection was donated to the National Gallery of Art where Chester Dale had been the president of the Board of Trustees between 1955 and 1962.

The Dales were generous lenders, and enjoyed the prestige their artworks bestowed upon them. Maud Dale organized numerous exhibitions, mostly for charity. She responded to sporadic criticisms voiced by Europeans in the following way: "People in Europe have become accustomed of late to point accusing fingers at America and to start rumors about a certain country of war victors who are robbing Europe of its art treasures. But one conveniently forgets that America was a market for European art long before the last war. Mother Europe ought to be proud of her vigorous sons, who have been able to turn their dreams into reality and deeds without ever forgetting the beauty in life itself. Mankind marches forward in this world only as far as his dreams take him, and as long as he can transform them into actuality. Both Americas were dreams once, which have been converted into deeds and reality."[56] The actualized dreams of many American collectors

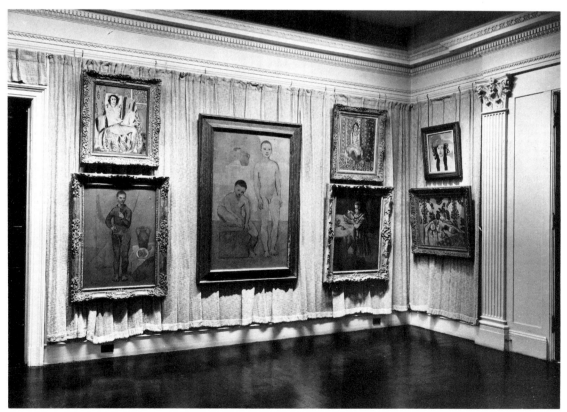

255

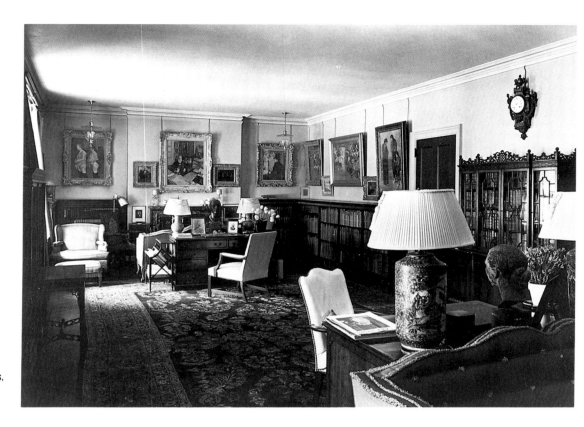

Fig. 34. The Chester Dale house, 20 East 79th Street, New York, showing works by Toulouse-Lautrec, Daumier, Vuillard, Degas, and Picasso, among others, all now in the National Gallery of Art, Washington

Fig. 35. Samuel A. Lewisohn with daughter Betty in Central Park, New York, c. 1933

entered museums as bequests, and they were earlier and stronger expressions of their epoch than their counterparts in Europe.

Samuel A. Lewisohn (1884–1951) was the scion of a banking family with a tradition of collecting. His father, Adolphe Lewisohn, was one of the pioneer patrons of impressionist art, and apparently purchased his first Monet and Renoirs in the 1880s. He soon discovered Manet, Cézanne, and Gauguin. They, in turn, might have prompted his acquisition of Matisse's willful portrait *Lorette en blouse blanche*, which was reproduced in the magazine *The Arts* as early as 1921. Shortly thereafter it was joined by additional works from the same artist.[57]

It is unclear whether father or son bought all the Matisse oils, since Samuel Lewisohn had been collecting since approximately 1912, and purchased a Monticelli picture from the Armory Show in 1913. After 1917 they both resided at 88th Street and Fifth Avenue. On the top floor of the house was a large skylit gallery where the works of art were displayed in rooms specifically constructed for them. Samuel Lewisohn's taste was more modern, his interest more intellectual. "I admit that I am one of those who experience keen pleasure in the presence of the work of art which relies for its appeal purely on esthetic principles. . . . Plastic art is in some respects a sort of visual gymnastics. This is particularly true of modern paintings. Probably what makes modern painting so exciting to many of us is the element of surprise that is given to the eye."[58] His admonition "a picture should be bought for one's personal refreshment for the same reason that one goes to a concert"[59] brought him into line with Matisse's concept of art's mission. The pieces in the Lewisohn collection were of fine quality and dramatic power, and among them were canvases of Rousseau, Rouault, Soutine, and Modigliani as well.

Samuel Lewisohn championed the Museum of Modern Art (founded in 1929), was one of the members of the board of trustees, and later chairman of the acquisitions committee. In the domain of modern art he had definite opinions, and when he wished to learn about contemporary art trends he traveled to Paris and London with his painter-friend Maurice Sterne. He had many contacts among artists and appears to have known Matisse.

There were additional collectors who in the 1920s also turned their attention to French

painters. **Lillie P. Bliss** (1864–1931), the great benefactor of the Museum of Modern Art, purchased in 1927 Matisse's *Intérieur à la boîte à violon* (1918–1919, pl. 71) and in 1929 *Intérieur à Nice, jeune femme en robe verte accoudée à la fenêtre* (1921, pl. 121), from the Paris collection of Marcel Kapferer. Both works were donated to the Museum of Modern Art; however, the latter oil was eventually sold at auction.

A. Conger Goodyear from Buffalo, first president of the Museum of Modern Art, and **Frank W. Crowninshield**, the publisher of *Vanity Fair* and first secretary of the museum, were enthusiastic art lovers, and purchased individual oils and prints by Matisse. **Josef Stransky**, composer and conductor of the New York Philharmonic Society, lived in that city after 1911. He collected at the same time as John Quinn, and devoted himself to the visual arts after 1923. He owned two brilliant Matisse figure pieces, *Le concert* from the Canonne collection in Paris and *Jeune femme en rose* (pl. 157).

Scofield Thayer (1890–1982), publisher and co-owner of *The Dial*, rejected every variant of cubism but, nevertheless, was a distinguished early patron of Bonnard, Chagall, Munch, Picasso, Schiele, and Matisse.[60]

Chicago was a city exceptionally rich in art, thanks to early patrons and their bequests to the Art Institute of Chicago. The intimate connection with art enjoyed by **Helen Birch Bartlett** and her husband, a painter, led them to form a well-chosen collection. It was bequeathed to the Art Institute in 1926. In it were two works by Matisse: the masterpiece *Femme devant un aquarium* (c. 1923, pl. 119) and *Woman on a Rose Divan* (1921).

The San Francisco collector **Harriet Levy** lived in Paris from 1908 onward and, as early as 1912–1913, not only bought her first Matisse oil, but also commissioned the artist to do her portrait. In 1930 Matisse visited her on his way to Tahiti. Along with Sarah Stein and Etta Cone, she was one of Matisse's earliest and most faithful American friends.

Europe (England, Germany, Denmark, and Switzerland)

For various other Americans, the road to Paris was by way of London. **Roger Fry** (1866–1934), who was educated at Cambridge and trained as a painter in Paris during the 1890s, was an intermediary for them. He advised the prodigious American collector Pierpont Morgan; between 1905 and 1910 he was a curator at the Metropolitan Museum of Art in New York. Upon his return to England he, together with the art critic **Clive Bell** (1881–1964), organized the epochmaking *Second Post-impressionist Exhibition* at the Grafton Galleries in London in 1912. Their access to groups of artists led them early to Matisse and Picasso, whom both men championed in word and deed. This support was influential in American art circles, where knowledge of contemporary painting was largely acquired through English periodicals and journals. Roger Fry and Clive Bell were on intimate terms with Matisse and his entire family; each published influential books on their experiences in the art world during the 1930s.[61]

At the end of the war the **Leicester Gallery** in London undertook a series of Matisse exhibitions, apparently in cooperation with Paul Guillaume. René Gimpel noted: "He [Matisse] sold everything. However, the owners of this establishment and also Mr. Turner, of the Independant, tell me that in England they are still on Corot, that the Impressionists have passed through the world without England having suspected their existence, so that nowadays, when one shows a modern French painting to an Englishman, he doesn't understand. These two establishments are forced to sell old paintings to survive."[62]

At the same time, the young lawyer **Montague Shearman** was sent to Paris by the British foreign office to take part in the 1918 peace conference. He was accompanied by the English painter **St. John Hutchinson**, who was familiar with the Parisian art scene. There Shearman discovered modern art and became one of its pioneer collectors in England. In the words of Hutchinson: "I had come to the moderns by a queer route: George Moore and

Fig. 36. Drawing room of Mrs. St. John Hutchinson's residence, Regent's Park, London. The decorations are by Duncan Grant and Vanessa Bell. The Matisse over the fireplace is now in the collection of the Saint Louis Art Museum

the Impressionists. It is true that our imaginations had been fired and our interest awakened by the Post Impressionist exhibition organised by Mr. Roger Fry, but we had no other opportunities of seeing similar pictures, and it was when we were at the Peace Conference at Paris, in 1918, that we first realised Matisse. . . . I well remember Monty Shearman being first bitten by the beauty of the French modern school of paintings. There in Paris, where art did not seem an idiosyncrasy or a pose, where the workman looked into the picture shops and at modern pictures, without splitting his sides with laughter, where the upper classes never looked at them at all, but where the middle classes bought them, because they liked them, and where at that time the big dealers' boom had not commenced, one should see the artists of our renaissance flourishing like flowers in a flower shop. Matisse, Picasso, Braque, Utrillo were literally eye-openers and a delight."[63]

Shearman bought the works of these painters and somewhat later acquired works by Renoir, Toulouse-Lautrec, and Cézanne. He also generously supported English artists, as well as the Contemporary Art Society, whose "honorary secretary" he was. On the advice of Shearman the society purchased Matisse's oil *Liseuse en plein air, ombrelle sur la table* (1921, pl. 126) in 1926 with the intention of giving it to the Tate Gallery. However, since the trustees of the Tate approved the inclusion of the piece only in 1938, Matisse's creations appear to have evoked a certain amount of consternation. This is not all that unusual when one recalls the mistrust encountered by the more than two hundred works of the Davies collection (today in the National Museum of Wales) at about the same time; and this collection comprised pieces by the older generation of French painters. Only after 1923 was the Tate Gallery willing to accept works by Cézanne on a loan basis. Montague Shearman donated six oils to the Contemporary Art Society, among them Matisse's *La liseuse distraite* (1919, pl. 76).

In the first half of the 1920s the collecting impulse in London was strongly oriented toward the nineteenth century or the creations of seventeenth-century Holland. Nevertheless, exceptional individual collections of contemporary works were publicly

displayed. In January 1925 the Burrell Collection (today City of Glasgow) was shown at the Tate Gallery. The first accounts of the Courtauld Collection appeared in periodicals with photographs of oils by Cézanne and Gauguin. Samuel Courtauld began to acquire nineteenth-century French art in the 1920s. The works of Matisse were not included, with one exception, Matisse's *Dancers* from the Reid and Lefevre gallery in 1927. But Courtauld later exchanged it for another painting.

The fortunate union of two perceptive dealers in April 1926, the Scot **Alexander Reid** (1854–1928) and the Briton **Ernest Lefevre** (1869–1932), opened new avenues for the international art market. Both had received training in Paris before the turn of the century, and both knew many artists and dealers. Reid worked at Goupil with Theo van Gogh and befriended Theo's brother Vincent; he used this connection later to mount the first van Gogh exhibition in the rooms of his gallery in Glasgow. Thus a friendly, pro-art climate emerged in this industrial area of Scotland.

The flourishing art market nurtured the appearance of additional galleries in London: **French Gallery** (revived in 1924), **Redfern Gallery** (1924), and **Mayor Gallery** (1925–1926). These galleries operated without great financial reserves. The youthful Fred Hoyland Mayor opened a gallery of avant-garde painting in London in January 1925, partly through the backing of the Kahnweiler and Rosenberg gallery in Paris. Mayor was premature, for he found little support among the English art-buying public and had to close his gallery after two years of operation. In 1933 Mayor staged shows and entered the public arena for a second time; by then, even older, well established galleries, such as **M. Knoedler and Co.** or **Arthur Tooth and Sons**, started to deal in avant-garde works.

In June 1927 the first large-scale Matisse show in London was held at the Reid and Lefevre gallery. It consisted of nineteen paintings, six pastels, and several drawings. The gallery's contact with the French avant-garde was **Etienne Bignou**, who worked for the firm during the years 1922 to 1927. Although he took over the Gallerie Georges Petit in Paris in 1929 and later had his own gallery in New York, Bignou always maintained close business contact with the Lefevre Gallery. The list of those making purchases at the 1927 exhibition reveals a growing circle of lenders and collectors.[64]

Documents regarding the accomplishments of English collectors are scarce. One patron in the Scottish group was **Mrs. E. A. Workman**. Her acquisitions were made with revenues from the shipping business. During the war Mrs. Workman bought works by van Gogh from Alexander Reid; shortly after the hostilities ended, she purchased her first oils by Matisse, including *La fenêtre fermée* (1918–1919, pl. 70). In 1928 she lent many exceptional pictures to *A Century of French Painting* in New York, an exhibition organized by Maud Dale and Etienne Bignou to raise money for charity. In the financial crash of 1929, Mrs. Workman was forced to sell a number of her artworks, many of which found their way into American collections. **Royan Middleton** from Dundee was a printer and publisher of art cards. He seems to have collected from early in his career. He had an unfailing eye for quality and owned at least five Matisse paintings in addition to pieces by Bonnard, Vuillard, Cézanne, van Gogh, Modigliani, and Utrillo.[65] The owner of the Gargoyle Club, the **Hon. David Tennant**, displayed Matisse pictures there. These pieces were acquired early thanks to his friendship with the artist Augustus John and to the help of Matthew S. Prichard, a friend of Matisse. Paintings like *The Red Studio* (1911, The Museum of Modern Art) and the *L'atelier du quai Saint-Michel* (1916, pl. 1) graced the walls of the club. The stockbroker **Frank Stoop**, a native of Holland, is best known today for his bequest to the Tate Gallery. In 1912 he acquired a 1905 Picasso drawing at a show in Amsterdam. A frequent visitor to Vollard's gallery in Paris, after the war he collected contemporary artworks by Braque, Rousseau, Modigliani, and Picasso. He bought the important Matisse oil *Pond at Trivaux* (1917) from the Leicester Gallery in 1926. Three years later, in 1929, his collection was lauded for its exemplary quality: "So his collection is small but choice, chosen in response to some inner impulse. He has collected works of art and not reputation. Some of them were

acquired before fashion had made the painters seem desirable."[66] Several other individuals belonged to the circle of collectors who surrounded themselves with French art. **Lord Ivor Spencer Churchill** and **Lord Berners** preferred Matisse's Nice landscapes, and were partial to impressionist works. The **Duchess of Roxburghe** bought several Matisse oils during the 1920s.

Germany, Switzerland, and Scandinavia succumbed early to the aesthetic emanations radiating from Paris. The cultural impetus from Russia was halted after World War I by the revolution; nevertheless it did exert a certain retroactive influence upon the northern countries and Germany. In the history of the reception of Matisse and his stylistic followers, initial exposure to French ideas in northern European nations came via Germany. In part this is true also for the German-speaking portion of Switzerland. Julius Meier-Graefe and the circle of people around Wilhelm Uhde were particularly important in introducing these ideas to German-speaking patrons. For Matisse, the painter **Hans Purrmann** (1880–1966) was especially important. Born in Speyer, Purrmann resided in Paris after 1905 and was one of Matisse's students and most loyal friends. He championed French art his entire life; organized the first Matisse exhibition in Berlin before the war; secured pictures for museums and individual patrons; and acquired for himself major pieces by his teacher, such as *Goldfish and Sculpture* (1911, The Museum of Modern Art), and the notable *Intérieur à Nice* (1918, pl. 48). He published articles in German and Swiss journals about Matisse, observations on the art market, and forewords to catalogues of his painter friends.[67] In turn, Matisse supplied his friend with the latest art news, even during World War I when their countries were in conflict.

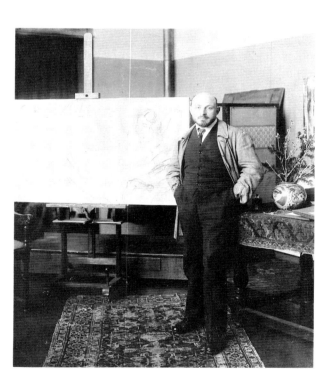

Fig. 37. The artist Hans Purrmann in his Berlin studio during the 1920s

One of Matisse's most important prewar German collectors, Karl Osthaus, founder of the Folkwang Museum in Hagen, had been introduced to the artist by Purrmann. Between 1907 and 1908, Osthaus bought three oils from Matisse: *Les asphodèles* (1907), *La berge* (1907), and *Baigneuses à la tortue* (1908). Later purchases included the ceramic triptych of a nymph and satyr in 1908, which he installed in his home, and the beautiful *La fenêtre bleue* of 1911.

Many pictures by Matisse passed through Purrmann's hands. On the occasion of the first Matisse retrospective in Berlin after the war in the **Galerien Thannhauser**

Fig. 38. Installation, Matisse retrospective exhibition, Gallerien Thannhauser, Berlin, February–March 1930

Fig. 39. Installation, Matisse retrospective exhibition, Gallerien Thannhauser, Berlin, February–March 1930

Fig. 40. Installation, Matisse retrospective exhibition, Gallerien Thannhauser, Berlin, February–March 1930

Fig. 41. Installation, Matisse retrospective exhibition, Gallerien Thannhauser, Berlin, February–March 1930

(15 February–19 March 1930), Purrmann wrote: "Here is a master who stands before us in the purity of French art, adorned with the seductive charm of a highly refined painterly style. . . . His art no longer bespeaks revolution. Indeed, on the contrary, today one perceives a sense of order allowing us to discern in them a model of harmony and balance."[68] Purrmann preferred the experimental works of Matisse, as did many other German collectors whose connoisseurship of the avant-garde had been schooled by the creations of German expressionism. But such paintings were scarce in the market of the late 1920s, and were difficult to obtain even for exhibitions.

Siegfried Rosengart (1884–1985), the nephew of Heinrich Thannhauser, worked in his uncle's gallery in Munich after 1919 and eventually took over the branch office in Lucerne. It was he who organized the Galerien Thannhauser retrospective of Matisse in Berlin. Rosengart easily gained access to Matisse because he was a relative of the Cone sisters of Baltimore. Throughout the decade of the 1920s, the clientele of the Thannhauser gallery was international in character, since many American, French, and Swiss collectors began their acquisitions of French art in Germany. Rosengart said, "In the beginning we handled first and foremost French impressionism and the Old Masters. Yet, we carried as well pictures by Picasso, Matisse, and other artists."[69]

In January 1926 one of Germany's main prewar proponents of French art, Paul Cassirer, died. He was succeeded by **Alfred Flechtheim** (1878–1937), the son of a corn merchant, who had rebuilt Cassirer's stable of artists in the 1920s following the disruptions of the war. Flechtheim continued the goal established in 1913 when Cassirer's gallery initially opened in Düsseldorf, to further the cause of the French and German avant-garde and African art. In the years after 1922 branches of Galerie Flechtheim were opened in Berlin, Vienna, Cologne, and Frankfurt. This scattered network of galleries was held together by so-called gallery letters and, after 1921–1922, by an informative pamphlet, *Der Querschnitt*, much like Paul Guillaume's *Les arts à Paris*. This organ contained news on art as well as on fashion and society gossip. In 1926 it was reported in Paris: "Mister Flechtheim at his main gallery in Düsseldorf, as well as at those in Berlin, Cologne, Frankfurt, and Vienna, directs the choice of German *amateurs* with . . . a sure authority."[70]

Despite the well-organized art trade existing in Germany after the war, there was no significant concentration of collectors for the art of Matisse. To be sure, a few scattered individuals come to mind, like **Berthold Nothmann** in Düsseldorf, **Alfred Tietz** in Cologne, **Dr. Karl Bett** in Berlin, or **Baron van der Heydt**. At the international exhibition staged in Dresden (June–September 1926) a dozen Matisse pictures were shown, among them *Fête des fleurs* from the Flechtheim collection and three works from the Tetzen-Lund collection, Copenhagen. In Germany the zeitgeist seems largely to have passed by Matisse in the 1920s. Other influences—the Bauhaus, expressive realism, Russian constructivism, or abstract painting—exerted a stronger attraction.

Although Matisse's works in the 1926 Dresden show were limited to a specific period within the artist's creative evolution, they were unfairly considered to typify Matisse's aesthetic output as a whole; more inclusive shows of the master's art were staged only later. Persistent and noticeable gaps exist even today in Matisse's works in German museums. This is, of course, due in part to the disappearance of "degenerate" modern art during the confiscations of the Nazi period.

Before World War I Matisse had represented a new aesthetic impulse in Germany and he had been considered one of art's regenerators, yet following the war his works found little responsive echo and did not spark any new developments. Even though his ideals remained alive in the minds of artists, they were overshadowed by the impact of indigenous expressionist art. The Nice pictures were viewed as beautiful, ethereal fairy tales.

In Scandinavia these dream images were more welcome. During the war modernism was spread widely by Matisse's students. For example, the Norweigan artist **Walter Halvorsen** began to organize exhibitions during the war,[71] and stressed through numerous

articles the significance of his teacher's aesthetic legacy for the northern avant-garde. He was a central and active figure in the dissemination of French art and, much like Hans Purrmann, he too had direct access to Matisse. Later Halvorsen switched professions and became a dealer, unlike Purrmann, who remained a painter.

A unique and dynamic series of exhibitions of the works of local artists trained in Paris fostered a new aesthetic climate in Denmark. "It was not until after the outbreak of war, in 1915, that the 'modern' movement in Denmark really became active. Copenhagen then become the great art center of Scandinavia, to which artists flocked, for lack of opportunity to visit the belligerent countries in the south."[72] This state of affairs favored a new, intensive collecting activity carried on in close contact with local painters. During the international hostilities **Wilhelm Hansen** managed to put together his important collection of impressionists, from Delacroix to Degas. Scattered throughout the collection were individual post-impressionist pieces, such as Matisse's *Fleurs et fruits* (1909). He opened his home, Ordrupgaard (now the Ordrupgaardsamlingen, Copenhagen), along with its skylit gallery, to the general public. Through a consortium that included the patron **Hermann Heilbuth** and the dealers **Wilnkel** and **Magnussen**, Hansen's acquisition of art was put on a professional footing: entire estates were purchased and direct acquisitions made from other major private collectors such as Auguste Pellerin and Alphonse Kann.

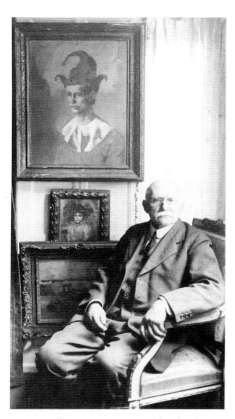

Fig. 42. Christian Tetzen-Lund in his home, Palaegade 6, Copenhagen, c. 1920

In Denmark the most important step toward contemporary art was undertaken by **Christian Tetzen-Lund** (1852–1936), a corn merchant and businessman. It was said of his collection: "Here, like pearl upon pearl, hang works by the young masters Matisse, Derain, Picasso, Henri Rousseau."[73] Among his Matisse oils were such key images as *Joie de vivre* (1906) and *Les trois soeurs* (1916–1917, fig. 3, p. 17), today in the Barnes Foundation. Lennart Gottlieb, relying upon lists of purchases, has concluded that all Tetzen-Lund's French art was bought between 1916 and 1920. These dates parallel both the general art boom and the first large exhibition of modern art in Denmark since 1914.[74] Walter Halvorsen was instrumental in building this collection also. As did Hansen, Tetzen-Lund opened his house to the public. In 1920 approximately twenty Matisse oils of exceptional quality hung in his home. Most of them came from part of the recovered Sarah and Michael Stein collection that had been seized in Germany during the war; Tetzen-Lund, with the Norwegian collector **Trygve Sagen**, had bought them from the Steins after the war. Tetzen-Lund intended to ship his collection to America, but was prevented from doing so for reasons still undefined. The dissolution of the collection in 1924–1925 was welcome news to the picture-hungry international world. Directly and through Parisian middlemen Albert Barnes acquired several important artworks from this collection.[75]

Of special interest for Matisse was the September 1924 one-man show of his art held at the Ny Carlsberg Glyptotek. It contained ninety-one objects, and was the first large-scale Matisse show staged outside Paris. It was Copenhagen's first exhibition by the Society of French Art dedicated to a living painter.

Just how difficult and controversial the public donation of contemporary art was in those days is demonstrated by the case of **Johannes Rump** (1861–1932). Even though he made his intention known in 1923, the Danish state only accepted his promised bequest in 1928. In the collection were approximately 140 pieces of avant-garde French art; among them were sixteen oils by Matisse (including *Intérieur au violon*, 1918, pl. 50), some of which originally had been in the Tetzen-Lund collection. A Paris publication reported: "Mr. Rump, a Danish engineer, made a gift to the State of his collection of modern French art which as of now is part of the Copenhagen museum. The gift is magnificent. In addition, Mr. Rump has taken on all of the installation costs, which was done in a specially built room, and he has allocated an important sum to the museum, destined for future purchases of modern French works of art."[76] Rump's bequest concept (donation of paintings and a financial endowment for additional purchases) was an early step toward a policy of active state support for modern art.

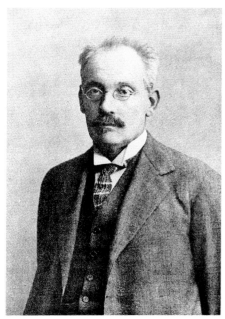

Fig. 43. Johannes Rump in the 1920s

Collecting in Denmark may well have been inspired by the examples of the Russian patrons Shchukin and Morosov, as well as by Germans such as Osthaus. This impetus was nourished by the flood of printed information emanating from Germany, the exceptional prewar exhibitions, and the news from Matisse's students returning from Paris.

As in Denmark, peace in Switzerland encouraged the reception of avant-garde French and German art there. A trend begun earlier burgeoned with the exhibitions of impressionist and post-impressionist art held in Basel and Zurich. Although there had been no proficient Swiss artist at the Académie Matisse who could have proselytized within the indigenous artistic community, a not dissimilar role was played by the painter **Carl Montag** from Winterthur even though, unlike Halvorsen or Purmann, he did not have direct contact with Matisse.[77] Through Montag's efforts the Winterthur art association staged a comprehensive show of French painting in November 1916, which, the following January, was taken over in slightly modified form by the Kunsthalle Basel. Included among the exhibited oils were three Matisse canvases from the collection of Bernheim-Jeune. Nobody bought them, and the works were eventually sent to the Galerie Vallotton in Lausanne.

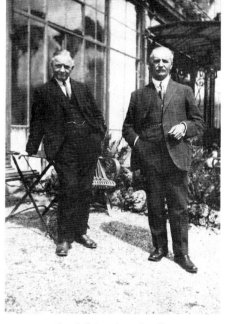

Fig. 44. Félix (left) and Paul Vallotton in Lausanne

Paul Vallotton, the brother of the artist Félix Vallotton, had been active as an art dealer since 1913. His gallery, like the Galerie Tanner in Zurich, was for many years a branch of the Bernheim-Jeune dealership in Paris. The first Swiss purchases of contemporary art were made by clients of the Vallotton and Tanner galleries, thanks to the galleries' close contacts with Paris. This international cooperation, together with increasing numbers of exhibitions of French art in the Kunsthaus Zürich, the Kunsthalle Basel, and the Musée d'Art et d'Histoire in Geneva, made trips to Paris less necessary. These events also encouraged the evolution of a public newly interested in art, and created the preconditions for the emergence of Swiss patrons of French art. The renown of the Galerie Vallotton spread across national borders following the war. The Cone sisters from Baltimore made acquisitions there, as did other dealers from adjoining countries—Paul Guillaume, César de Hawke, Alfred Flechtheim, and others who were buying works on commission.[78]

Collectors who bought art before the war in Paris from Vollard, Durand-Ruel, and Bernheim-Jeune or, in Germany, from Thannhauser or Cassirer, now browsed through the Swiss galleries. One of these was **Josef Müller** (1887–1977) from Solothurn. As an engineering student in Zurich, he surrounded himself with contemporary painting, for example the work of Cuno Amiet and Hodler. Beginning in 1910 he traveled frequently to Paris and came to America from 1912 to 1914. While in this country Müller visited the Armory Show and the pioneering collection of Arthur Jerome Eddy in Chicago. His friendship with Swiss artists and his personal fascination with art and painting led him to consider becoming an artist for a period of time, renting a studio in Geneva. At the same

Fig. 45. Josef Müller at the Marché aux puces, Paris, during the 1930s

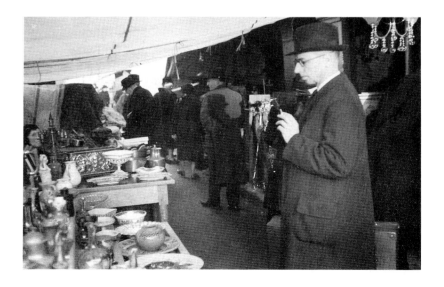

Fig. 46. Collection and studio of Josef Müller in Paris during the 1920s and 1930s

time he was constantly searching for paintings and objects. This search frequently took Müller to the Galerie Vallotton, where in August 1917 he purchased two extraordinary Matisse oils, *Fatma la mulatresse* (1912) and *Nôtre Dame de Paris* (1914). In 1920–1921, he bought *Nu au peigne espanol, assis près de la fenêtre* (1919, pl. 86) and, before 1925, *Nu au bracelet* (1914) and *Mlle Matisse au manteau écossais* (1918, pl. 53). In addition, he also acquired a small portrait by Matisse entitled *Margot* (1906). Between 1925–1926 and the outbreak of World War II he lived in Paris in a rented studio on the boulevard Montparnasse. It was quickly filled with a dramatic collection of modern art and African and Oceanic objects. His love of primitive art made him a knowledgeable early convert to cubism. Like someone possessed, he unearthed uncommon works in small galleries, the Hôtel Drouot, and at flea markets. As prices steadily increased in Paris, Müller's passion for collecting repeatedly strained his finances. For years he tried to acquire Matisse's picture *La chaise aux pêches* (1919, pl. 25); he first had seen the piece in the gallery of Paul Guillaume. The oil was in the collection of Georges Bénard until 1933 and, in 1934, was exhibited in Pierre Matisse's show in New York. Finally, thanks to the sinking prices of art late in the depression, he was able to purchase it for his own collection.

Müller sent crateloads of his paintings to special exhibitions such as the Zurich *Internationale Kunstausstellung* in 1925. The show, lauded in the international press as a great success because of the sale of nearly 100,000 tickets at three Swiss francs each, contained thirty-six works by Matisse, mostly graphics or oils that were not for sale. Dr. Wartmann, another collector in Zurich, asked Müller to intercede for him with various artists, but Müller replied: "Unfortunately, I cannot be of any assistance for your exhibition . . . since I have as yet not personally met with either Matisse, or with Derain and Picasso."[79] These were the age's most sought after artists, but Josef Müller then stood at the beginning of his artistic career and was unable to make such introductions. The experience of amassing numerous objects, however, laid the groundwork for his later career as a curator of the Kunstmuseum in Solothurn during and after World War II. He collected practically up to

Fig. 47. Collection and studio of Josef
Müller in Paris during the 1920s and 1930s

the end of his life, and his passion was an inspiration to his entire family, notably his sister **Gertrud Dübi-Müller**. She was an invaluable partner who, besides being a painter and a photographer, formed her own exquisite collection. She also oversaw her brother's collection and frequently helped him when he needed additional acquisition funds. Waldemar George, during an art tour through Switzerland, expressed the following opinion: "Madame Dubi-Müller's collection is more than a surprise; it is a revelation. Who would expect to find at Solothurn, that little Catholic village that nestles in the shadows of a baroque cathedral, a collection that is one of the most daring, the most original, that it has ever been my lot to visit? Between Cézanne's early *Boy in a Blue Smock* and *The Beggar in a Plaid* (a work of the Aix-en-Provence painter's old age), we find Georges Rouault's *Judges*, a picture of Matisse's Moroccan period, a pink Picasso, Gris, La Fresnaye and Léger."[80]

Arthur and Hedy Hahnloser from Winterthur had the luck, thanks to their friendship with Félix Vallotton, to be associated with Rouault, Bonnard, and the circle of people around Matisse. While they had been encouraged to collect avant-garde French art ever since 1906 through Vallotton and his associates, the Hahnlosers first met Matisse only after the war. They purchased three of the four Matisse paintings shown at the opening exhibition of the Bernheim-Jeune branch in Zurich in 1919.[81] These acquisitions before the start of the international art boom were fortunate for them, since the rapid rise in prices by the 1930s made further large-scale acquisitions impossible for the couple. The majority of their nabi and fauve pictures came into their possession before 1920, and reached their ultimate number by 1930. After 1922 they spent the winter months in Cannes and maintained active contact with artists. This contact could not facilitate the acquisition of additional Matisse pictures, but did help them assemble examples of his graphic art and deepened the friendship between the families. The Hahnlosers also frequented the Galerie Vallotton in Lausanne, as did the Cone sisters of Baltimore, and bought the rest of their Matisses there during the 1920s.

267

Fig. 48. Residence of Josef Müller, Solothurn, c. 1970(?). Among works by Degas, Bonnard, and pieces of tribal art are Matisse's *Mlle Matisse en manteau écossais*, 1918 (pl. 52), *Nu au peigne espagnol, assise prés de la fenêtre*, 1919 (pl. 86), and *Nu gris au bracelet*, 1915

Fig. 49. Gertrud Dübi-Müller and her husband, Otto Dübi, in their Solothurn residence, before a wall hung with paintings by the Swiss artist, Ferdinand Hodler

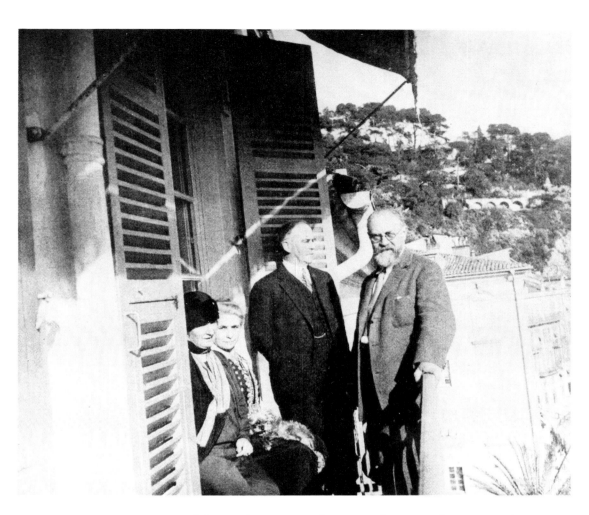

Fig. 50. Hedy Hahnloser, Amélie Matisse, Arthur Hahnloser, and Henri Matisse on the balcony of 1, place Charles-Félix, Nice, 1928/1929

In 1930 Matisse returned from a long-awaited trip to Tahiti very disappointed, according to Hedy Hahnloser. She recalled: "In the New World, in America, Matisse enjoyed himself much more. He returned from New York and Philadelphia in the best of spirits, and with an increased appetite for work. The recognition afforded him there pleased him no end."[82] This experience was a very significant factor in the artist's life and work. From America, he received the commission for the Barnes Foundation mural, a work that renewed his interest in decoration, color, and a more abstract approach to the figure.

Whenever individual, passionate collectors in Switzerland found their way to modern art, it was by way of friendship with local artists. **Willy Russ-Young**, a young chocolate manufacturer in Neuchâtel, was just such an eager collector who built an exhibition space specially for his art treasures: "My gallery, known from afar, received visits from numerous artists and art amateurs; probably several hundred. It would be difficult for me to remember them all."[83] His friendship with the art critic Dr. Johannes Widmer and with the Vallottons led him to Matisse. In Lausanne between 1919 and 1922, Willy Russ-Young acquired four works; they were Nice landscapes and interiors. The collecting activity of Russ-Young inspired the **Dubied** family, Neuchâtel industrialists, and they also began collecting works of art, purchasing four canvases by Matisse from the Galerie Vallotton in 1926. In Geneva the **Galerie Moos** was another source of contemporary art.

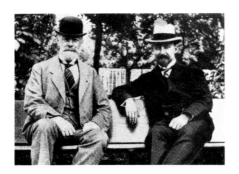

Fig. 51. Willy Russ-Young (right) with
Ferdinand Hodler, before 1918

In the German-speaking half of Switzerland beginning in 1920, an active dialogue about international avant-garde art was underway in the museums of Zurich, Basel, and Winterthur. It was supported by such galeries as Tanner, Wolfensberg, Corray, Aktuarius, and others. Throughout Switzerland, new amateurs such as Hans Mettler of St. Gallen and Richard Doetsch-Benziger of Basel began to collect.

Collectors of Matisse's work in the twenties were speculating in an open and active market. The artist's current works were immediately available through his dealer, Bernheim-Jeune, or from the artist himself. A number of collections containing earlier works by Matisse became available at auction in the 1920s (the Aubry, Poiret, Soubies, Noréro, Zoubaloff, Canonne, Pacquement, Quinn, and Tetzen-Lund collections), so that the full range of Matisse's easel paintings, sculpture, and graphic works were in circulation at some time during the decade.

European collectors depended on the network of galleries, auctions, critical and cultural journals, art books, and catalogues to keep apprised of the latest developments in contemporary art. French museums were slow to acquire works or assume an educational function with respect to the public. The exception to this was the Musée de Peinture et de Sculpture at Grenoble (repository of the Agutte-Sembat Collection, so rich in Matisse paintings), which pursued an aggressively modern acquisition policy. In America, however, where cultural institutions were relatively few and the public less informed, many collectors saw their activity as a missionary endeavor and founded private museums or foundations, or bequeathed their collections to public institutions. A number of such museums, founded to propagate modern art, were initiated by private collectors in the twenties, such as the Gallery of Living Art, the Museum of Modern Art, the Whitney Museum of Modern Art, the Barnes Foundation, and the Phillips Collection. Since Matisse attracted early and active American *amateurs*, museums in the United States are particularly rich in important Matisse works.

In all cases, collectors of modern art played an especially important role in the 1920s, between the heroic, pre-World-War-I period of innovation and the economically and politically dark decade of the 1930s. They supported the artists, made modernism more widely understood and accepted, and frequently allowed larger audiences to enjoy their collections through exhibitions and donations.

Collecting avant-garde art in this decade was new, adventurous, and without any well-established guidelines. Collecting and dealing were in flux, and many artists fulfilled the function of dealer as well. Many passionate collectors realized only later the public importance of their private endeavor. Henry McBride, the American art critic, wrote in 1931: "The public had begun to grow up. Partly, too, the major Matisses had begun to come to America. . . . These young people had matured into connoisseurs and collectors. Matisse was more their man than ever. He had not only justified their taste, he had justified the age they lived in."[84]

Translated by Christopher With

Fig. 52 (from left to right): 1. Jean Bernheim, 2. Bibi Dudensing, 3. Georges Keller, 4. Maud Dale, 5. Henri Matisse, 6. Suzanne Bernheim de Villers, 7. Chester Dale, 8. Thérèse Boney, 9. Duncan MacDonald, 10. Valentine Dudensing, 11. Etienne Bignou

Fig. 53 (from left to right): 12. Etienne Bignou, 13. Pierre Matisse, 14. Geneviève Bernheim, 15. Marguerite Duthuit, 16. Gaston Bernheim de Villers, 17. Mme Bignou, 18. Henry McBride, 19. M. de la Chapelle, 20. McNeill Reid

Notes

I wish to express my gratitude to Dominique Fourcade. He has provided me the use of his peerless library on Matisse. Dominique Fourcade and Jack Cowart have made numerous suggestions that have benefited this essay in uncountable ways. I thank also the staff at the Bibliothèque des Conservateurs, Centre Georges Pompidou, under the direction of Daniel Abbadie, as well as the curatorial and archival staffs at the Tate Gallery, London; the Philadelphia Museum of Art; the Museum of Modern Art, New York; the Baltimore Museum of Art; and Sotheby's, London.

1. This art became so popular in the postwar period that "how-to" manuals on collecting soon appeared on the market. Some examples are Donath 1925 and Fage 1930.
2. Fage 1930, 5.
3. All this is clearly revealed in a valuable and extensive work, Gee 1981, 163–168.
4. George 1929, 8. In 1977, part of the collection was donated to the French state and hangs in the Musée de l'Orangerie, Paris. I am grateful for information given me by M. Michel Hoog, director of the museum. See also Hoog 1984.
5. "There were Derain, Picasso, Matisse, Frank Haviland, André Lhote, Bakst, the painter of the Russian ballet, Pascin, Marcoussis, Braque, Léger, the sweet Fauconnet, Delaunay, the friend of Henri Rousseau. I name them without classification and simply for their common interest in the new discovery. There was Eric Satie, and later on there was Stravinsky. There was Diaghileff and Larionow and Gontcharowa. There were architects, the well-known Perret brothers who have since constructed the Champs-Elysées Theatre in Paris. . . . There was Jeanneret, the architect . . . there was Jacques Lipchitz, Brancusi, there were poets like Jean Cocteau, Blaise Cendrars, Fernand Divoise, Leonard Pieux, Jacques Dyssord, the later Drieu La Rochelle, André Breton, and still later the group of men who speak, write and act so vehemently under the folds of the flag of the Surrealists." Paul Guillaume, "The Discovery and Appreciation of Primitive Negro Sculpture," Les arts à Paris, no. 12 (May 1926), 13.
6. Alfred C. Barnes, "The Temple," Les arts à Paris, no. 10 (November 1924), 12. "The Temple" is the term Barnes used to describe Guillaume's gallery in Paris.
7. Important shows were: 2–16 May 1919; 15 October–6 November 1920; 23 February–15 March 1922; 16–30 April 1923, apparently without catalogue; 6 March–2 May 1924. For many ideas and much documentation concerning the Bernheim family, I am especially grateful to Michel Dauberville and Guy-Patrice Dauberville, who run the family business today.
8. Two large volumes appeared in 1919: L'art moderne and Quelques aspects de l'art d'autrefois, with illustrations of their own collection. Matisse was represented by L'espagnole (1911). Valuable volumes on the prints and drawings of Matisse followed later.
9. Joubin 1930, 76.
10. Chapon 1984, 123.
11. Chapon 1984, 283.
12. Wilhelm Bode, director of the Pinakothek in Berlin, documented Rudolf Kann's collection in a large album of photo engravings in order to "make lesser-known galleries accessible to art historians and larger circles of individuals through a richly illustrated work." There were masterpieces by Rembrandt, Frans Hals, Rubens, Gainsborough, Watteau, and others, in the "most significant private collection in France." Bode 1900, foreword, n.p.
13. Loeb 1946, 5.
14. Loeb 1946, 65. I am also very grateful to Mme Hélène Bokanowski, who gave me valuable information about her uncle, Alphonse Kann.
15. For more, see Alexandre 1930; and Alexandre 1930a, 85–108.
16. Bernheim de Villers 1940, 139. Gaston de Villers was the name under which the dealer Gaston Bernheim painted works that were Matissian in style.
17. Félix Fénéon, foreword to Exposition Gaston de Villers [exh. cat., Galerie Bernheim-Jeune] (Paris, 1927).
18. Fage 1930, 218. A picture by Cézanne, Le jeune homme au petit chapeau, acquired at the auction by Chester Dale, went for 360,000 francs. Matisse's Anémones fetched more than 150,000 francs, and his La robe jaune reached 230,000 francs. Both Matisse pictures were bought by Baron Fukushima, a Japanese collector living in Paris. Archives Rosengart, Lucerne, is the source of this information.
19. In 1927 Marcel Noréro sold Jeune femme au bouquet to Baron Fukushima. The Russian musician and composer Jacques Zoubaloff, who donated an assortment of oils to the Louvre, auctioned his Matisse works, among others, in 1927. In 1929 and again in 1935 he sold additional pieces of art. Marcel Kapferer was very close to Vuillard and one of the friends of Jos Hessel and Bernheim-Jeune. He chiefly purchased his Matisse paintings around 1924. Two of them are today in the Barnes Foundation in Merion. Intérieur à Nice, jeune femme en robe verte accoudée à la fenêtre (1921, pl. 121) was bought by Lillie P. Bliss. The sales were made mostly through English dealers.

Regarding the Charles Pacquement collection, Jacques Mauny wrote: "There are four Matisses in this collection: a large pink still life with pineapples [Nature morte (ananas, compotier, fruits, vase d'anémones), 1925, pl. 133], a nude [Nu au fauteuil, c. 1923], a southern landscape [Rochers de la vallée du Loup, 1925, pl. 67], the Chinese Box, which belongs to the enchanting series of girls with flowers and fruit." Mauny 1928, 14. Pacquement was a lawyer. As a student he is supposed to have purchased works by Daumier and Toulouse-Lautrec. In the circle of those interested in art he occupied a leading position as president of the Amis du

Luxembourg, and was a member of the Conseil Supérieur des Beaux-Arts. In the spring of 1924 Pacquement organized an exhibition in which all professional aspects of French society were represented among the fifteen collectors invited. In 1932, most of his collection also was sold at auction, including the four oils by Matisse. The "Chinese Box" [*Le coffret chinois*] is today in the Barnes Foundation.

Baron Napoléon Gourgaud was married to Eva Gebhart, whose father was an American banker. She had been in Paris since 1892, and commissioned Matisse to do her portrait in Nice in 1924. Together with many other oils of very high quality, she gave this not very successful painting to the Musée National d'Art Moderne in Paris.

When the circumstances permitted, writers, critics, and musicians revealed a great interest in collecting. Among such individuals were the writer Francis Carco (1886–1958), the art writer Félix Fénéon (1882–1971), Charles Vildrac, and the actor and dramatist Sacha Guitry (1885–1957).

20. In 1925 they founded the Syndicat des éditeurs d'art et négociants en tableaux modernes. Josse Bernheim-Jeune was president, Paul Rosenberg vice president, and Etienne Bignou secretary. All important dealers were members.

21. Watson 1926, 5. The *International Exhibition of Modern Art* was held at the 69th Regiment Armory in New York in February 1913.

22. Lynes 1973, 42.

23. Watson 1926, 6.

24. Roché 1959, 34–41.

25. The pictures were *Nu bleu* (1907), *La musique, esquisse* (1907), *Cyclamen pourpre* (1911), *Hat with Roses* (1914), *Still Life with Fruit* (1915), *Italian Woman (L'italienne)* (1915), *Nature morte d'après de Heem* (1915), *Apples (Les pommes sur la table, sur fond noir et jaune*, 1916), *Seated Nude (Nu assise*, 1917), *Girl with Flowers (Jeune femme aux fleurs*, 1919), *The Artist and His Model (Le peintre et son modèle, intérieur d'atelier*, 1919, pl. 81), *Etretat (Grande falaise, le congre*, 1920, pl. 110), and *The White Slave (L'esclave blanche*, c. 1923).

26. Pach 1926, 6.

27. Watson 1926a. The Seurat in question was *Le cirque*. The press extensively covered the exhibition, as well as the auctions in Paris (28 October 1926) and in New York (February 1927). In Paris only two Matisses were sold, *Le chapeau aux roses* (1914) and *Nu bleu* (1907). The latter oil was bought by Michael Stein for the Cone sisters in Baltimore.

28. Letter from John Quinn to Marcel Duchamp, 28 May 1920. In Zilczer 1978, 45.

29. Barr 1951, 116–118 and 550–552.

30. Exhibition review, *The Arts* (March 1924), 169.

31. Exhibition review, *The Arts* (December 1924), 330.

32. "Exhibition of Modern French Paintings at the Dudensing Galleries," *The Arts* (June 1925), 341. Pierre Matisse provided me with many invaluable ideas and documents; he made the whole era come alive.

33. *The Arts* (January 1922), 247.

34. This information was kindly supplied to me by Mrs. Violette de Mazia, the longtime assistant of Albert Barnes, and the director of education and vice president of the Barnes Foundation.

35. Albert Barnes in Philadelphia 1923. Of the 75 pictures, 5 were by Matisse: (no. 17) *Oriental*, (no. 19) *Joy of Life*, (No. 21) *Flower Piece*, (no. 44) *Composition*, and (no. 61) *Nude*. Barnes commented: "This exhibition of contemporary European art is made up of paintings and statuary shown at the Gallery of Paul Guillaume in Paris during January and February of this year. The extraordinary interest it created among artists and the public became a matter of international news which was made known to Philadelphians on two occasions through special cablegrams to our local papers."

36. Frequently Barnes acquired Matisse pictures at second or third hand. Some of these oils were: *Jeune fille en noir au balcon* (1920) and *Le repos du modèle* (c. 1919) from the Soubies collection in Paris, 1928; also *La plage à Etretat* (1920) from the Zoubaloff collection in Paris, 1927. In addition, works were bought from the Oskar Moll collection, from Christian Tetzen-Lund in Denmark, and from the English dealers Reid and Lefevre.

37. Letters in the Barnes Foundation archive attest to the laborious progress of this decorative commission. On 12 June 1932 Barnes wrote to Merion from Juan-les-Pins to check the exact measurements one last time. Arthur Hahnloser, the Swiss collector who regularly sojourned in Cannes after 1922, frequently entertained the American visitor, not only to give Matisse time to work, but also to resolve any language difficulties that might arise between him and the artist.

38. From the Quinn estate in 1926 came the small but powerful *Seated Nude, Back Turned* (1917) and, later, from the Bignou Gallery in New York *Le petit déjeuner* (1920, pl. 94), the *Head of a Woman* (1917) and, finally, in 1942, the late work *Odalisque jaune* (1937). For more on the collection see Gardiner 1968.

39. In addition, Earl Horter owned an oil study for Marcel Duchamp's *Nude Descending a Staircase*. In 1934 he showed his collection at the Philadelphia Museum of Art and at the Arts Club in Chicago.

40. See Richardson 1985, 117.

41. The sisters' preferred dealers during the 1920s and the 1930s were the Paul Vallotton gallery in Lausanne and Siegfried Rosengart in Lucerne. Etta Cone acquired a wide range of art, from Ingres to Modigliani, often buying in accordance with current aesthetic trends.

42. They were *Seated Woman (Girl in a Chair)*, *Path at Nice*, and *Anemones*. Two of them soon were exchanged for a more important piece, *Anémones au miroir noir* (1919, pl. 79).

43. Phillips 1931, 11.

44. Phillips 1931, 12.

45. Phillips 1931, 17.

46. Phillips 1927, 72.

47. Duncan Phillips to Valentine Dudensing, 16 December 1929, archives of the Phillips Collection, Washington.

48. Watson 1925, 70.

49. From the French dealer Georges Bernheim came *Femme dans une intérieur*; from the Fearon Galleries in December, 1924, *Lorette à la veste rouge* (1916 or 1917, pl. 13) and *Roses* (1923); and, from the Quinn estate, *Grande falaise, le congre* (1920, pl. 110).

50. Watson 1925, 70.

51. Mahonri Sharp Young in London 1973, n.p.

52. A. E. Gallatin, *Gallery of Living Art*, New York University, 1933.

53. Walker 1974, 162.

54. Walker 1974, 175.

55. Among them were: *Odalisque à mi-corps—le tatouage* (1923, pl. 160, acquired in 1928 from the Jean Laroche collection, Paris); *Le bord du Loup*, l'allée du pins (fig. 53, p. 44, acquired from the Soubies collection, Paris, in 1928), both now in the National Gallery of Art; and *Interior at Etretat* (1920, purchased in 1930 from the Canonne collection, Paris). From the dealer Bignou, individual paintings came into their collection, works like *Nature morte aux pommes sur nappe rose* (1924, pl. 130). Also, they owned a version of the *Chapeau à plumes* (1919, pl. 92), *Odalisque assise aux bras levées, fauteuil rayé vert* (1923, pl. 161), *Le Pot de geranium* (1912), and the pastel *Woman with Exotic Plant* (1924), all in the National Gallery of Art. *La villa bleue, Nice* (c. 1918), formerly Chester Dale collection, was recently sold, lot 36, Sotheby's London, 3 December 1985. I am deeply grateful to Mrs. Ellen Hirschland for these references. Over the years, she has amassed a great deal of material regarding Maud and Chester Dale.

56. Dale 1931b, 244.

57. They were: in 1928, the painterly and expressive oil *Nu au fauteuil* (1920), as well as *The Pink Tablecloth* (1925, also titled *La nappe rose, citrons et anémones*, pl. 134), and *Les mouettes* (1920).

58. Lewisohn 1931, 186.

59. Lewisohn 1948, 266.

60. His *Gold Fish Still Life* and two small Nice landscapes were purchased at the Leicester Gallery, London. By 1924 they were in his collection together with the spectacular oil *Nasturtiums and The Dance II*, today in the Metropolitan Museum of Art, Dial Bequest. I am indebted to Sabine Rewald for this information.

61. Fry 1932; Fry 1935; Bell 1931.

62. Gimpel 1963, letter dated 3 January 1920, 182.

63. St. John Hutchinson in London 1940a, 2.

64. Some of the sellers were: Oskar Moll and Alfred Flechtheim from Germany and Paul Guillaume, Bernheim-Jeune, and Marcel Kapferer from Paris. Among the buyers were: Kraushaar, Knoedler (Henschel), Mrs. Workman, and McInnes. Others making purchases there were the Americans Stephen Clark, Eugene Gallatin, Samuel White, Alfred Barnes, and Duncan Phillips, as well as the Englishmen Samuel Courtauld and Sir Ivor Spencer Churchill.

 The following provenances best illustrate the frequent exchange of individual oils: *Intérieur à Nice, jeune femme en robe verte accoudée à la fenêtre* (1921, pl. 121), from the Marcel Kapferer collection in Paris, was sold to Mrs. Workman in London in 1927; shortly thereafter it went (via Bignou) to Valentine Dudensing in New York where, in 1929, Lillie P. Bliss found it. One of the three large panels of *The Three Sisters Triptych* (1917, fig. 3, p. 17) came to Lefevre in London from the Alphonse Kann collection in Paris; then, it returned to Paris to Paul Guillaume, where it was discovered by Albert Barnes.

 I am indebted for many insights to Desmond Corcoran, director and chairman of the Lefevre Gallery. Information also has been excerpted from Cooper 1976; and from the foreword by Ronald Pickvance to *A Man of Influence, Alex Reid 1854–1928* [exh. cat., The Scottish Arts Council] (1967). I also thank Ronald Pickvance as well as Juliet Wilson Bareau for material, and Michel Strauss, director of impressionist and modern art at Sotheby's, London for the use of his excellent library.

65. The five Matisse paintings were: *Anémones* (1918), *Antibes* (1925), *La toque de goura* (1918, pl. 38), *Nu au fauteuil* (1922), and *La leçon de piano* (1923, pl. 154, from the Kapferer collection in Paris).

66. Manson 1929, 127.

67. The most extensive book on Hans Purrmann is Göpel 1961. I wish to thank personally Mrs. Heidi Vollmoeller and Dr. Robert Purrmann for supplementary information and documentation.

68. Hans Purrmann in Berlin 1930, 8.

69. This material was contained in an article on Siegfried Rosengart in the magazine supplement to the *Luzerner Neueste Nachrichten* (Saturday, 7 April 1984). Personal remembrances from Siegfried Rosengart, conveyed to me shortly before his death, deepened my appreciation and knowledge of the period.

70. *Le bulletin de la vie artistique*, Paris (January 1926), 15.

71. One of the first significant exhibitions was *Den Franske utstilling: Kunstnerforbundet*, in Oslo in 1916.

72. Marit Werenskiold, *The Concept of Expressionism* (Oslo-Bergen-Stavanger-Tromso, 1984), 146.

73. *Der Cicerone* (2 December 1920), 875.

74. Gottlieb 1984, 18–49. I read this article in a translation by Peter Schield.

75. According to the list drawn up by Lennart Gottlieb, Barnes purchased the following seven oils: *La joie de vivre* (1905–1906), *Nature morte bleue* (1907), *Femme au madras rouge* (1907/1908), *Le Riffain* (1913), *La villa*

bleue, Nice (1917), one panel of the *Three Sisters* triptych (1917), *Damen pa divanen. Portraet of Mme Matisse [sic]* (1918).

76. "La Peinture Française à Copenhague, La Collection Rump," *L'amour de l'art* 5 (May, 1929), 161.

77. See Lukas Gloor, *Von Böcklin zu Cézanne; die Rezeption des französischen Impressionismus in der deutschen Schweiz* (Bern, Frankfurt, New York, in press).

78. The heirs of the Galerie Vallotton, as well as Marina Ducrey, supplied me with this additional information.

79. Letter dated 22 June 1925, and addressed to Dr. Wartmann. It is on deposit in the archives of the Kunsthaus, Zurich. The daughter of the collector, Mrs. Monique Barbier-Müller, and Dr. Ubald Kottmann provided me with many helpful hints and documentation.

80. Waldemar George, "Art in Switzerland," *Formes*, no. 15 (May 1932), 225. Apparently through the Galerie Vallotton, Mrs. Gertrude Dübi acquired in 1919 Matisse's *Odalisque* (or *Tête de Laurette à la tasse de café*, 1917).

In 1931, W. Barth, conservator in Basel, wrote the following note to her regarding a planned Matisse exhibition: "Please send us everything that you deem appropriate, the two small Matisses of your brother's, as well as your *Odalisque with Notre Dame*, and the now very feminine Moroccan. We will insure *Notre Dame, Odalisque, Fatmah, Nu au bracelet,* and *Mädchen auf Balkon* [*Mlle Matisse en manteau écossais* (1918, pl. 52)]."

81. They were *Lorette assise, bergère rose* (1917, pl. 6), *Odalisque beige* (1919), and *Paysage d'oliviers* (1918, pl. 59). In the same year, they purchased three additional paintings from Paul Vallotton in Lausanne. They were *Les pêches ou le pot d'étain* (1917, a variant of the one in the Cone Collection), *Nu au fauteuil* (1918), and a floral picture. The collection was soon expanded with the addition of *Intérieur au cahier noir* (1918, pl. 72) and *La blouse bulgare* (1920). Later *La table noire* (1919, pl. 29), from the property of Emil Hahnloser, was added to the collection.

82. Unpublished notes by Hedy Hahnloser, archives of the Hahnloser Collection, Winterthur, Switzerland.

83. Russ 1945, 93.

84. *Creative Arts* (December 1931), 463.

Catalogue

Compiled by Dominique Fourcade, Jack Cowart, and Marla Price

This Catalogue presents the most extensive verified documentation available for the paintings in this exhibition. Particular emphasis has been given to establishing titles that conform with the Archives Matisse catalogue raisonné project. Our systematic survey of the dated Galerie Bernheim-Jeune photographic archives has yielded new or more precise dates for certain works. These records establish a terminus ante quem, that is, the latest date by which a work could have been completed. We have attempted to record the distinguished provenances of Matisse's paintings, and their broad exposure in both exhibitions and far-ranging publications, thus setting a firm foundation for subsequent interpretive studies.

Explanation of categories and terminology

Title and date

The title is given first in French, with date, followed below with a version in English. Matisse worked in suites, or large groups of related motifs. Titles used during the artist's lifetime often varied, and they either described or alluded to the portrayed elements. Therefore, in close collaboration with Wanda de Guébriant of the Archives Matisse, we have established descriptive French titles that sufficiently distinguish works one from another by focusing on the elements that are specific to each. The titles presented in this Catalogue are expected to figure in the eventual Matisse catalogue raisonné under preparation by the Archives. If a work is dated "season" it means the approximate period (September through May or June) when Matisse would have been residing in Nice.

Location

Each work is located by its site and/or probable place of execution. During these years Matisse lived in various hotel rooms, and later, apartments; he also traveled, had several studios, and still maintained permanent residences in Paris. Almost every painting contains visual evidence of its site, an added confirmation of its date and relationship to the artist's developing oeuvre during these early years in Nice, 1916–1930.

Model

Whenever possible we have identified the sitter, despite the fact that the paintings are rarely portraits in the strict sense. Regardless, each model had distinct features or attitudes of interest to Matisse. These can often be seen in the works and they, too, provide a cross-check for dating, since we know when particular models were present during these years.

Medium and support

Unless otherwise noted, the works are oil on canvas.

Measurements

Height precedes width, given first in centimeters and then, within parentheses, in inches.

Signature

Location is indicated and inscription transcribed verbatim. Matisse often signed his paintings in a subtle, carefully chosen color and location relating to the palette and composition of the piece.

Bernheim-Jeune Photograph

The Galerie Bernheim-Jeune, Paris, photographed Matisse's current production in his Nice studio approximately every six months. While under exclusive contract to the gallery during most of the early years in Nice, Matisse retained the right to keep a certain number of paintings. It is possible that these paintings were not photographed on this schedule. Others escaped photography until later; for example, some works were photographed on an ad hoc schedule when they were sent to Paris for shipment, as was often the case with the Cone sisters' purchases. Finally, a limited number of paintings from these early years were never documented by Bernheim-Jeune.

But to a large degree, the documents so generously made available to us by the Galerie Bernheim-Jeune represent a substantial cataloguing of the many works painted by Matisse. These precious photographic

documents establish, therefore, an irrefutable time line concerning the creation of these individual paintings. The date of the photographic session is the effective terminus ante quem. In addition, Mme Henri Matisse established a duplicate set of these references and they are now in the Archives Matisse. In a number of instances the Archives Matisse has graciously confirmed Bernheim-Jeune photography dates for us.

Provenance
Galleries, collectors, and auctions or other sales are listed chronologically, from the earliest to the most recent. Dates of acquisition are given within parentheses following the owner's name, unless otherwise noted. One cannot always assume that these listings are contiguous, given the number of times works of art have changed hands in the last half century and the imprecisions caused by private collectors who have effectively maintained their anonymity.

Exhibitions
Public exhibitions of museums and galleries as well as auction houses are listed chronologically from the earliest to the most recent. If a catalogue or checklist was issued, the number given the work in the exhibition is recorded as well as its illustration, if it was reproduced. The short-form notation used in these entries refers to a complete list of Exhibitions that follows this Catalogue.

Literature
Major monographs, critical studies, and articles are listed chronologically from the earliest to the most recent. The short-form notation used in these entries refers to the Select Bibliography.

Cat. no. 1, pl. 43

Cat. no. 2, pl. 42

Cat. no. 3, pl. 44

1

Deux bateaux bord à bord dans le port de Marseilles, 1915/1916
Two Ships Side by Side in the Port of Marseilles

Oil on panel
8.9 x 14 (3½ x 5½)
Signed lower left: *H. Matisse*

Private collection

Provenance
Estate of the artist
Private collection (by descent)

2

Quatre bateaux bord à bord dans le port de Marseilles, 1915/1916
Four Ships Side by Side in the Port of Marseilles

Oil on panel
15.9 x 21.6 (6¼ x 8½)
Signed lower right: *H Matisse*

Private collection

Provenance
Estate of the artist
Private collection (by descent)

3

Café des Ponchettes, sous la tente, 1916(?)
Café des Ponchettes, Under the Awning

Nice, quai des Etats-Unis
Oil on board
9 x 14 (3½ x 5½)
Signed lower left: *H. Matisse*

Private collection

Provenance
Estate of the artist
Private collection (by descent)

4

L'atelier du quai Saint-Michel, 1916
The Studio, quai Saint-Michel

Paris
Model: Lorette
146 x 116 (57½ x 45¾)
Unsigned

The Phillips Collection, Washington

Provenance
Private collection, London
Gargoyle Club, London (David Tennant)
Lord Clark, London
Pierre Matisse Gallery, New York (1940)

Exhibitions
Basel 1931, no. 37
Paris 1931a, no. 36
New York 1931, no. 35, ill.
New York 1940b
New York 1941, no. 12
Washington 1941, no. 7
Philadelphia 1948, no. 34, ill.
Philadelphia 1950b, no. 96, ill.
Chapel Hill 1951
New York 1951a, no. 44
New York 1961, no. 50, ill.
Los Angeles 1966, no. 41, ill. color p. 73
London 1968, no. 58, ill. color p. 29
Paris 1970b, no. 134, ill.
San Francisco 1981, p. 82, ill. color p. 83
New York 1983b, no. 66
Tokyo 1983, no. 54, p. 199, ill. color p. 104
Washington 1986, color pl. 2, p. 20

Literature
Vildrac 1921, p. 217, ill.
Fels 1929, ill. pl. 9
McBride 1931a, ill. p. 464
Zervos 1931b, ill. facing p. 24
Barnes 1933, ill. pl. 49
Mushakojo 1939, ill. p. 39, fig. 72
Cheney 1941, ill. p. 357

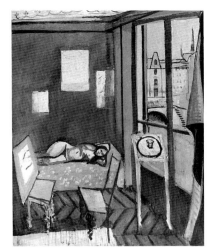

Cat. no. 4, pl. 1

Swane 1944, ill. fig. 23
Hess 1948, ill. p. 19
Wilenski 1949, pp. 258–259, ill. pl. 74
Barr 1951, pp. 171, 177, 181, 191, 262, ill. p. 410
Phillips 1952, p. 68, ill. pl. 138
Diehl 1954, p. 66
Lassaigne 1959, ill. color p. 88
Kreisberg 1964, ill. color p. 8
Leymarie 1966, p. 14
Brill 1967, p. 36, color pl. 21
Guichard-Meili 1967, ill. p. 83
Okamoto 1968, color pl. 49
Phillips 1970, pp. 178, 272, ill. p. 247
Luzi 1971, ill. no. 200, color pl. XXXIV
Flam 1973b, ill. fig. 29
Jacobus 1973, p. 38, ill. pl. 30
Clark 1974, pp. 194–195
Minemura 1976, color pl. 18
Gowing 1979a, p. 132, ill. fig. 166
Green 1981, p. 82, ill. color p. 83
Schneider 1982, ill. no. 200, color pl. XXXIV
Schneider 1984, pp. 82, 438, ill. color p. 425
Watkins 1984, p. 138, color pl. 122

Remarks
The reclining Lorette in this painting is the subject of the large and beautiful *Lorette allongée sur lit rose* (pl. 2) in the Niarchos Collection. A third canvas, in the Norton Simon Collection, shows the same Lorette reclining on the patterned red bed but wrapped in a transparent shawl (pl. 3).

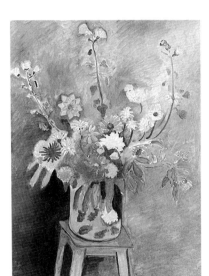

Cat. no. 5, pl. 21

5

Bouquet de fleurs mélangées, 1916 or 1917
Bouquet of Mixed Flowers

Issy-les-Moulineaux
139.7 x 102.87 (55 x 40½)
Signed lower right: *Henri-Matisse*

San Diego Museum of Art: Gift of Annetta Salz Wertheimer

Provenance
Josse Hessel, Paris (in 1928)
M. Knoedler and Company, New York
Annetta Salz Wertheimer (to 1934)

Exhibitions
San Diego 1935, no. 641, ill. p. LV
San Diego 1936, no. 141, ill.
Los Angeles 1937, no. 142, ill. p. 36
San Francisco 1940a, no. 685, ill. p. 89
Philadelphia 1948, no. 39, ill.
Pasadena 1949
Pomona 1950, ill.
Santa Barbara 1951
New York 1954b, no. 40
Colorado Springs 1956
Milwaukee 1956
Atlanta 1959, no. 48
Philadelphia 1963, ill. p. 159
New York 1973, no. 12, ill.
Fort Worth 1984, no. 32, ill.

Literature
Faure 1920, ill. pl. 23
Mushakojo 1939, ill. p. 56, fig. 108

Barr 1951, p. 559
Fairbanks Marcus 1954, color pl. 31
Beach 1960, p. 48, ill. p. 51
Skinner 1964, p. 39, ill.
Hagberg 1966, pp. 86–87, ill.
Petersen 1968, ill. color
Brezzo 1982, p. 483, color pl. 11, p. 487
Mezzatesta 1984, pp. 106–107, ill. p. 106

6

Marguerite au ruban de velours noir, 1916
Marguerite with Black Velvet Ribbon

Issy-les-Moulineaux
Oil on panel
18 x 17 (7⅛ x 6¾)
Signed lower right: *H Matisse*

Private collection

Provenance
Estate of the artist
Private collection (by descent)

Exhibitions
Los Angeles 1966, no. 40, ill. color p. 78
New York 1966a, no. 31, ill. p. 31
London 1968, no. 63, ill. p. 99
Paris 1970b, no. 143, ill. p. 212

Literature
Gallatin 1940, ill.
Matisse 1954, color pl. 121
Selz 1964, ill. color p. 43
Luzi 1971, ill. no. 221
Schneider 1982, ill. no. 221
Schneider 1984, p. 490

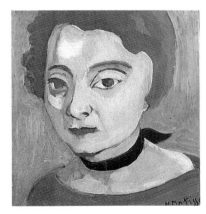

Cat. no. 6, pl. 36

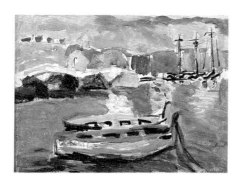

Cat. no. 7, pl. 41

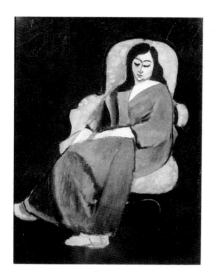

Cat. no. 8, pl. 5

7

Deux barques dans le port de Marseilles, 1917
Two Boats in the Port of Marseilles

Oil on panel
27 x 34.9 (10⅝ x 13¾)
Signed lower right: *H. Matisse*

Private collection

Provenance
Estate of the artist
Private collection (by descent)

Exhibitions
Tokyo 1951, no. 4, ill.

8

Lorette sur fond noir, robe verte, season
1916–1917
Lorette, Black Background, Green Dress

Paris
Model: Lorette
73 x 55 (28¾ x 21⅝)
Signed and dated lower left: *H. Matisse 16*

Private collection

Provenance
Estate of the artist
Pierre Matisse, New York

Exhibitions
New York 1931a, no. 34, ill.
New York 1941, no. 11
Lucerne 1949, no. 48, ill. pl. VI
New York 1951a, no. 46
Los Angeles 1952
Paris 1955a
Paris 1956, no. 44, ill. pl. XX
Los Angeles 1966, no. 43, ill. p. 75
New York 1966a, no. 30, ill. color p. 36
London 1968, no. 62, ill. p. 98
Paris 1970b, no. 132, ill. p. 202
Copenhagen 1970, no. 40, ill.

Literature
Fry 1935, ill. pl. 30
Mushakojo 1939, ill. p. 44, fig. 80
Barr 1951, p. 191, ill. p. 412
Diehl 1954, p. 69
Selz 1964, ill. color p. 40
Guichard-Meili 1967, p. 89, ill. 77
Sutton 1970, color pl. VI, p. 359
Aragon 1971, 2, p. 98, pl. XV
Luzi 1971, ill. no. 218, color pl. XXXV
Watkins 1977, color pl. 24
Mannering 1982, ill. color p. 54
Schneider 1982, ill. no. 218, color pl. XXXV
Schneider 1984, p. 437, ill. color p. 428
Watkins 1984, p. 138, color pl. 123
Fourcade 1986, ill.

Remarks
This painting is the subject depicted by the artist in
the important painting *Le peintre et son modèle*
(pl. 4), in the Musée Nationale d'Art Moderne. The
large *Lorette assise, bergère rose* (pl. 6) shows Lorette

in the same green robe and pink armchair but in a
different pose.

9

Lorette assise, bergère rose, 1917
Lorette Seated, Pink Armchair

Paris
100 x 73 (39⅜ x 28¾)
Signed lower right: *Henri-Matisse*
Bernheim-Jeune photograph December 1917

Dr. and Mrs. Paul Hahnloser, Fribourg

Provenance
Tanner Gallery, Zurich
Arthur and Hedy Hahnloser, Winterthur (1919)
Hans R. Hahnloser, Bern

Exhibitions
Basel 1931, no. 39
Winterthur 1937, no. 85
Lucerne 1940, no. 68, ill.
Winterthur 1949, no. 142
Bern 1953, no. 86, ill.
Vienna 1955
Paris 1970b, no. 146, ill. p. 216
Winterthur 1973, no. 158
Zurich 1982, no. 52, ill. color

Literature
Sembat 1920, ill. p. 29
Zervos 1931b, ill.
Courthion 1934, ill. pl. XXVII
Mushakojo 1939, ill. p. 18, fig. 29
Courthion 1942, ill. color p. 63
Diehl 1954, p. 69
Guichard-Meili 1967, p. 88, ill. color 76
Aragon 1971, 2, p. 103
Luzi 1971, ill. no. 234
Schneider 1982, ill. no. 234
Noël 1983, color pl. 33
Schneider 1984, ill. color p. 492

Remarks
See Remarks, cat. no. 8.

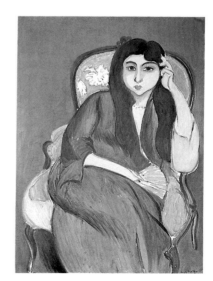

Cat. no. 9, pl. 6

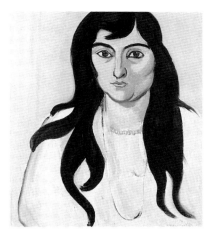

Cat. no. 10, pl. 7

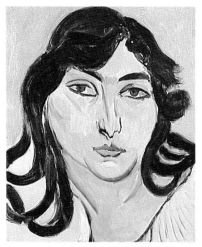

Cat. no. 11, pl. 8

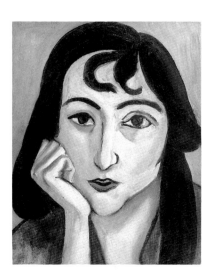

Cat. no. 12, pl. 9

10

La femme au collier d'ambre, 1917
Woman with Amber Necklace

Paris or Issy-les-Moulineaux
Model: Lorette
45.5 x 36.5 (17⅞ x 14⅜)
Signed lower right: *Henri-Matisse*
Bernheim-Jeune photograph August 1917

Private collection

Provenance
Zborowsky, Paris (1920)
Lindquist, Stockholm
Theodore Ahrenberg, Stockholm
Nyman and Schultz, Stockholm (1965)

Exhibitions
Stockholm 1954b, no. 47, ill.
Paris 1956, no. 43
Zurich 1959, no. 73, ill.
Stockholm 1984, no. 26, ill.
Humlebaek 1985, no. 33

Literature
Grünewald 1944, ill. p. 47
Grünewald 1964, ill. facing p. 32
Guichard-Meili 1967, ill. p. 89, no. 78
Luzi 1971, ill. no. 220
Schneider 1982, ill. no. 220

11

Tête de Lorette aux longues boucles,
1916–1917
Head of Lorette with Long Locks of Hair

Paris or Issy-les-Moulineaux
Oil on cradled panel
35 x 27 (13¾ x 10⅝)
Signed upper right in the paint: *Henri-Matisse*

Norton Gallery and School of Art, West Palm Beach,
Florida

Provenance
Thannhauser, New York
Harry Lackritz, Chicago
Ralph H. and Elisabeth Calhoun Norton

Exhibitions
Denver 1954, no. 40
Miami 1959
Chicago 1960, no. 33
Miami 1963
Palm Beach 1965

Literature
Giedon 1948, p. 112, ill. pl. 64
Barr 1951, pp. 191–192
Norton Gallery 1958, p. 20
Flam 1973a, ill. color cover
Norton Gallery 1979, no. 255, ill. p. 109
Schneider 1984, ill. p. 482

12

Tête de Lorette aux deux mèches, 1917
Head of Lorette with Two Locks of Hair

Paris or Issy-les-Moulineaux
Oil on panel
34.9 x 26.4 (13¾ x 10⅜)
Signed upper left: *Henri-Matisse*

Mr. and Mrs. William R. Acquavella, New York

Provenance
Paul Guillaume, Paris
Brandon Davis, London
Valentine Dudensing, New York
Mr. and Mrs. Morton R. Goldsmith, Scarsdale, New
York
Morton R. Goldsmith Trust, New York
Private collection, New York

Literature
Escholier 1960, pl. 13 and dust jacket

13

Tête de Lorette, 1916–1917
Head of Lorette

Paris or Issy-les-Moulineaux
Oil on panel
22 x 15 (8⅝ x 5⅞)
Stamped lower left: *HM*

Private collection

Provenance
Estate of the artist
Private collection (by descent)

Literature
Escholier 1937b, ill. color following p. 58
Mushakojo 1939, ill. color
Duthuit 1956a, vol. III, ill. pl. CLXXII
Schneider 1984, ill. color p. 481

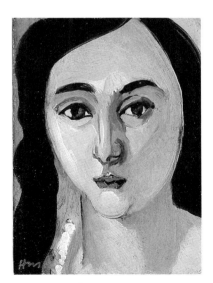

Cat. no. 13, pl. 10

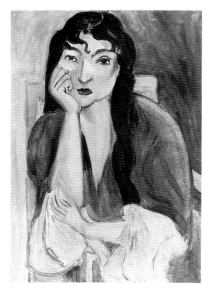

Cat. no. 14, pl. 11

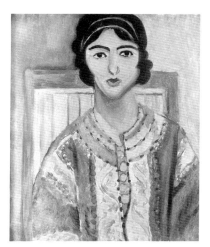

Cat. no. 15, pl. 13

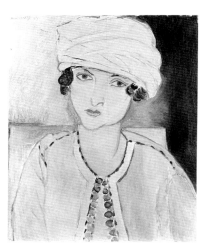

Cat. no. 16, pl. 14

14

La méditation, Lorette, 1916–1917
The Meditation, Lorette

Paris or Issy-les-Moulineaux
49.5 x 34.3 (19½ x 13½)
Signed upper left: *Henri Matisse*

The Museum of Fine Arts, Houston, Gift of Miss Ima
Hogg

Provenance
Galerie Paul Guillaume, Paris
Miss Ima Hogg, Houston (to 1948)

Literature
Les Arts à Paris, (January 1929), ill. p. 25
Schneider 1984, ill. p. 482

15

Lorette à la veste rouge, season 1916–1917
Lorette in a Red Jacket

Oil on panel
46.4 x 36.2 (18¼ x 14¼)
Signed upper right in the paint:
Henri-Matisse

Columbus Museum of Art, Ohio: Gift of Ferdinand
Howald

Provenance
Fearon Galleries, New York
Ferdinand Howald, New York (1922 to 1931)

Exhibitions
Columbus 1969, no. 19
New York 1970b
London 1973, no. 34, ill.
Dublin 1973, no. 34, ill.
Cardiff 1973, no. 34, ill.
Fort Worth 1984, no. 34, ill.

Literature
Mezzatesta 1984, pp. 108–109, ill. p. 108
Schneider 1984, ill. p. 161 color

16

Lorette au turban, veste jaune, 1917
Lorette with Turban, Yellow Jacket

Paris or Issy-les-Moulineaux
Oil on cradled panel
61.3 x 49.5 (24⅛ x 19½)
Signed and dated upper left: *Henri-Matisse 1917*

National Gallery of Art, Washington, Chester Dale
Collection 1963.10.39

Provenance
Thannhauser, Paris
Durand-Ruel, Paris and Paul Rosenberg et Cie, Paris
(jointly, before 1941)
Paul Rosenberg and Co., New York (1950)
Chester Dale, New York (15 October 1952)

Exhibitions
New York 1952
On extended loan to The Metropolitan Museum of
Art, New York, 1954

Literature
Dale 1965, p. 46, ill.

17

Femme au turban, 1917
The White Turban (Lorette)

Paris or Issy-les-Moulineaux
Model: Lorette
81.3 x 65.4 (32 x 25¾)
Signed upper right in the paint: *Henri-Matisse*
Bernheim-Jeune photograph May 1917

The Baltimore Museum of Art: The Cone Collection,
formed by Dr. Claribel Cone and Miss Etta Cone of
Baltimore, Maryland. BMA 1950.229

Provenance
Galerie Bernheim-Jeune (22 May 1917)
Claribel or Etta Cone, Baltimore (11 July 1922)

Exhibitions
Baltimore 1925, no. 65
Baltimore 1930, no. 29, ill. p. 9
Baltimore 1949, no. 34
Baltimore 1950
New York 1979b
Los Angeles 1985

Literature
Boas 1934, ill.
Diehl 1954, p. 70
Vogue 1955, ill. color p. 135
Rosenthal 1967, no. 41, ill. p. 30
Luzi 1971, ill. no. 223
Schneider 1982, ill. no. 223
Richardson 1985, pp. 38, 104, 170, 197, ill. color p. 105

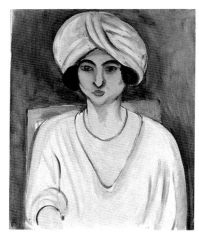

Cat. no. 17, pl. 15

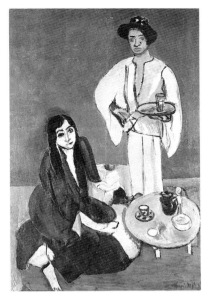

Cat. no. 18, pl. 16

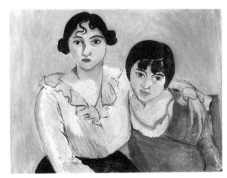

Cat. no. 19, pl. 17

18

Déjeuner oriental, 1917
"Oriental" Lunch

Issy-les-Moulineaux
Models: Lorette (seated) and Aïcha
100.65 x 65.41 (39⅝ x 25¾)
Signed lower right: *Henri Matisse*
Bernheim-Jeune photograph March 1919

Detroit Institute of Arts, Bequest of Robert H. Tannahill

Provenance
Christian Tetzen-Lund
Stephen C. Clark, New York
Museum of Modern Art, New York (1948)
Carstairs Gallery
Robert Hudson Tannahill (1949)

Exhibitions
New York 1934a, no. 109, ill.
Philadelphia 1948, no. 44, ill.
Detroit 1949, no. 21
Detroit 1970, ill. p. 46

Literature
Hoppe 1931, ill. p. 204
Zervos 1931a, ill. p. 293, fig. 61
Zervos 1931b, ill. p. 73, fig. 61
Art News Dec. 2, 1932, cover ill.
Kawashima 1936, ill. pl. 10
Johansson 1941, ill. p. 149
Frankfurter 1948, ill. color opp. p. 22
Barr 1951, p. 192, ill. p. 415
Diehl 1954, p. 70
Cummings 1970, p. 27, ill. p. 46
Luzi 1971, ill. no. 236
Schneider 1982, ill. no. 236

19

Les deux soeurs, 1917
The Two Sisters

Paris or Issy-les-Moulineaux
Models: Lorette and her sister
61 x 74 (24 x 29⅛)
Signed upper right in the paint: *Henri Matisse*
Bernheim-Jeune photograph April 1917

The William D. Lippitt Memorial Collection, Denver Art Museum

Provenance
Galerie Bernheim-Jeune, Paris
Mancini (15 May 1918)
Sam Salz, New York
Helen Dill
M. Knoedler and Co., New York (to Denver Art Museum by exchange, 1950)

Exhibitions
New York 1936b, no. 4
Buffalo 1944, no. 44, ill.

Literature
Mushakojo 1939, ill. p. 50, fig. 93
Barr 1951, pp. 192, 203, 263, ill. p. 417
Diehl 1954, p. 70
Matisse 1954, ill. color p. 113

Luzi 1971, ill. no. 242
Schneider 1982, ill. no. 242

20

Aïcha et Lorette, 1917
Aïcha and Lorette

Issy-les-Moulineaux
Models: Aïcha (on left) and Lorette
38 x 46 (15 x 18⅛)
Signed lower left: *H. Matisse*

Private collection

Provenance
Estate of the artist
Private collection (by descent)

Exhibitions
Los Angeles 1966, no. 42, ill. p. 71
London 1968, no. 64, ill. p. 100
Paris 1970b, no. 149, ill. p. 216

Literature
Schneider 1970, ill. color facing p. 90
Aragon 1971, 2, p. 98
Luzi 1971, ill. no. 243
Schneider 1982, ill. no. 243

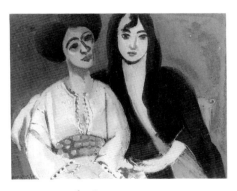

Cat. no. 20, pl. 18

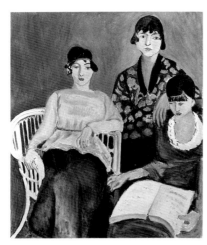

Cat. no. 21, pl. 19

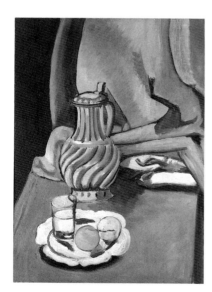

Cat. no. 22, pl. 23

21

Les trois soeurs, 1917
The Three Sisters

Issy-les-Moulineaux
Models: Lorette, seated at left, and her two sisters or Lorette, her sister, and a third model
92 x 73 (36¼ x 28¾)
Signed lower right: *Henri-Matisse*
Bernheim-Jeune photograph May 1917

Paris, Musée de l'Orangerie, Collection Jean Walter et Paul Guillaume

Provenance
Galerie Bernheim-Jeune, Paris
Auguste Pellerin, Paris
Hôtel Drouot, Paris, 7 May 1926, lot 66
Paul Guillaume, Paris
Mme. Jean Walter, Paris

Exhibitions
Paris 1926a, no. 66, ill.
Paris 1929, ill. p. 61
Paris 1935, no. 424
New York 1936b
Paris 1937, no. 21
Paris 1945, no. 158, ill.
Paris 1946b, no. 55, ill.
Philadelphia 1948, no. 29, ill.
Paris 1966, no. 53, ill.
Rome 1978, no. 12, ill. color
Paris 1979, ill. color p. 165
Moscow 1981
Zurich 1982, no. 53, ill. color
Paris 1983, ill. p. 50

Literature
Sembat 1920, ill. p. 61
Les Arts à Paris 1927, ill. p. 23
Tériade 1927, ill. p. 28
Ternovets 1928, ill. p. 69
George 1929, pp. 68, 70, ill. p. 61
Neugass 1929a, ill. p. 21
Sarraut 1930, ill. facing p. 40
Cassou 1933, ill. p. 108
Huyghe 1935, ill. p. 108, fig. 123
Escholier 1937b, ill. p. 39
Cassou 1939, color pl. 6
Lassaigne 1947, ill. color 63
Barr 1951, p. 192
Diehl 1954, pp. 69–70, ill. pl. 80
Escholier 1956, p. 181
Aragon 1971, 2, p. 103, color pl. XVI
Luzi 1971, ill. no. 225
Lassaigne 1981, ill. color
Schneider 1982, ill. no. 225
Hoog 1984, no. 50, pp. 116–119, ill. color p. 117
Schneider 1984, pp. 436, 440

22

Le pot d'étain, 1917
The Pewter Jug

Paris or Issy-les-Moulineaux
81.3 x 65.4 (32 x 25¾)
Signed lower left: *Henri-Matisse*

The Baltimore Museum of Art: The Cone Collection, formed by Dr. Claribel Cone and Miss Etta Cone of Baltimore, Maryland. BMA 1950.230

Provenance
Georges Bernheim, Paris
Claribel Cone, Baltimore (24 July 1922)

Exhibitions
Baltimore 1925, no. 68
Baltimore 1930, no. 27
Paris 1931, no. 48
Basel 1931, no. 45, ill.
New York 1931, no. 44
Baltimore 1941
Philadelphia 1948, no. 30
Baltimore 1949, no. 32, ill. p. 17
Baltimore 1950
New York 1951a, no. 42
Richmond 1953
New York 1955a
Los Angeles 1966, no. 46, ill. p. 76
New York 1966a, no. 36, ill. p. 40
New York 1979b
Los Angeles 1985

Literature
McBride 1930, ill. pl. 47
Einstein 1931, ill. p. 238
Zervos 1931a, fig. 67, p. 299
Zervos 1931b, ill. fig. 67, p. 78
Boas 1934, ill.
Barr 1951, p. 194, ill. p. 409
Rosenthal 1955, ill. p. 61
Vogue 1955, ill. color p. 135
Lassaigne 1959, ill. color p. 91
Selz 1964, ill. color p. 42
Rosenthal 1967, no. 42, ill. pp. 11, 43
Aragon 1971, 2, p. 239, color pl. XXXVI
Luzi 1971, ill. no. 238
Russell 1969, ill. color p. 85
Schneider 1982, ill. no. 238
Richardson 1985, p. 170, ill. color p. 162

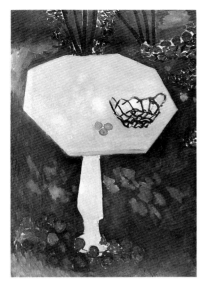

Cat. no. 23, pl. 30

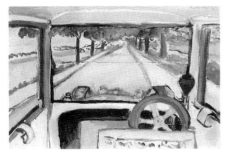

Cat. no. 24, pl. 39

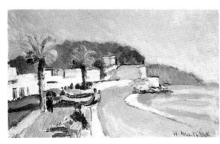

Cat. no. 25, pl. 45

23

La table de marbre rose, spring or autumn 1917
The Rose Marble Table

Issy-les Moulineaux
146 x 97 (57½ x 38¼)
Signed lower right: *Henri Matisse*

Collection, The Museum of Modern Art, New York.
Mrs. Simon Guggenheim Fund

Provenance
Alphonse Kann, Paris
Mme Bokanowski, Paris (by descent)
Galerie Beyeler, Basel

Exhibitions
Paris 1931, no. 39
Basel 1956, no. 28, ill. color
New York 1956
Washington 1963
New York 1966a, no. 39, ill. p. 40
New York 1978a, ill. color p. 117
New York 1980
Atlanta 1982

Literature
Zervos 1931a, ill. p. 290, fig. 58
Zervos 1931b, ill. p. 70, fig. 58
Mushakojo 1939, ill. p. 52, fig. 98
Barr 1951, p. 194, ill. p. 407
Diehl 1954, pp. 68, 141, color pl. 78
Diehl 1970, no. 28, ill. color
Luzi 1971, ill. no. 240
Greenberg 1973, ill.
Elderfield 1978a, pp. 116–118, 213, ill. color p. 117
Schneider 1982, ill. no. 240
Fourcade 1983, ill.
Schneider 1984, pp. 397, 399
Wilkin 1985

24

Route de Villacoublay, 1917
The Road to Villacoublay

38 x 55 (15 x 21⅝)
Signed upper right: *Henri-Matisse*
Bernheim-Jeune Photograph October 1917

The Cleveland Museum of Art, Bequest of Lucia
McCurdy McBride, In memory of John Harris
McBride II

Provenance
Galerie Bernheim-Jeune, Paris (from the artist, 7
October 1917)
Hébrard, Paris (31 October 1917)
Etienne Bignou, Paris
Mrs. R. A. Workman, London
Alex Reid and Lefevre, London and Glasgow
Kraushaar Galleries, New York (late 1920s)
Mrs. Malcolm McBride, Cleveland (1944)

Exhibitions
Glasgow 1924
New York 1929a, no. 16, ill.
New York 1931a, no. 40, ill.
Providence 1931
Boston 1938
Cleveland 1938

Paris 1970b, p. 314
Cleveland 1973
Los Angeles 1984, ill. p. 75

Literature
Grautoff 1921, ill.
Schacht 1922, ill. p. 77
Goodrich 1929a, pp. 53–54
Goodrich 1929b, p. 118
Mushakojo 1939, ill. p. 52, fig. 97
Barr 1951, pp. 183, 194, ill. p. 418
Escholier 1960, ill. fig. 26
Gottlieb 1964, p. 398, ill. fig. 9
Aragon 1971, 1, p. 166, color pl. XX
Luzi 1971, ill. no. 250
Ooka 1972, color pl. 56
Cleveland 1973, no. 253, p. 113, ill. p. 87
Carpi 1975, p. 10, ill. color
Saisselin and Wrolstad 1978, p. 249, ill.
Schneider 1982, ill. no. 250
Schneider 1984, pp. 414, 422, 438

25

Promenade des Anglais, Nice, 1915/1917

Oil on board
9 x 14 (3½ x 5½)
Signed lower right: *H. Matisse*

Mrs. Heinz Berggruen

Provenance
Paul Kantor, Los Angeles (c. 1965)

26

Oliviers, jardin de Renoir à Cagnes, 1917
Olive Trees, Renoir's Garden at Cagnes

Cagnes-sur-Mer
38 x 46 (15 x 18⅛)
Signed and dated lower left: *H Matisse 17*

Private collection

Provenance
Estate of the artist
Private collection (by descent)

Exhibition
Paris 1978, no. 10, ill.

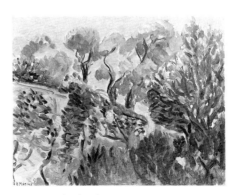

Cat. no. 26, pl. 56

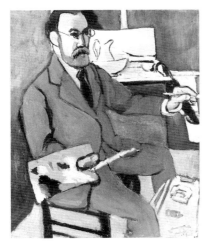

Cat. no. 27, pl. 46

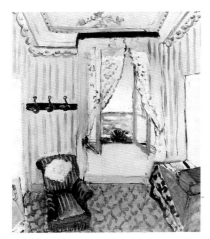

Cat. no. 28, pl. 47

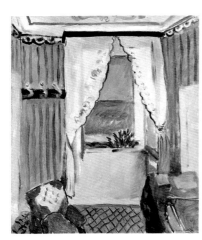

Cat. no. 29, pl. 48

27

Autoportrait, January 1918
Self-Portrait

Nice, Hôtel Beau-Rivage
65 x 54 (25⅝ x 21¼)
Signed lower right: *Henri-Matisse*

Musée Matisse, Le Cateau

Provenance
Estate of the artist
Jean Matisse, Pontoise (bequest to Musée Matisse, 1978)

Exhibitions
Copenhagen 1924, no. 56, ill.
New York 1951a, no. 48
Los Angeles 1952
Liège 1958, no. 29, ill.
Aix-en-Provence 1960, no. 16
Albi 1961, no. 7, ill. pl. 1
Los Angeles 1966, no. 50, ill. color p. 80
London 1968, no. 76, ill. p. 111
Paris 1970b, no. 155, ill. p. 218
Paris 1980, no. 255, ill.
Stockholm 1984, no. 33
Humlebaek 1985, no. 40, ill.

Literature
Faure 1920, ill. pl. 27
Kawashima 1936, ill. pl. 11
Besson 1939, pp. 39–44, ill. p. 38
Mushakojo 1939, ill. p. 56, fig. 107
Fels 1950, ill. p. 163
Barr 1951, p. 26, 205, ill. p. 422
Greenberg 1953, ill. frontispiece
Besson 1954, ill. pl. 38
Escholier 1956a, p. 115
Diehl 1954, p. 74
Matisse 1954, ill. color p. 115
Astrom 1955, ill. frontispiece
Huyghe 1955, ill. frontispiece
Lübecker 1955, ill. frontispiece
Ferrier 1961, color pl. 9
Vaughan 1965, ill. color p. 26
Luzi 1971, ill. no. 279, color pl. XLVI
Watkins 1977, color pl. 28
Mannering 1982, ill. color p. 57
Schneider 1982, ill. no. 279, color pl. XLVI
Szymusiak 1982, pp. 39–40, ill. color on cover
Schneider 1984, p. 153 note 58, 519, ill. p. 518
Watkins 1984, p. 151, color pl. 131

Remarks
A photograph taken by George Besson in January 1918 shows this painting, unfinished, with the artist in his room at the Hôtel Beau-Rivage; see fig. 8, p. 19.

28

Ma chambre au Beau-Rivage, late 1917–early 1918
My Room at the Beau-Rivage

Nice, Hôtel Beau-Rivage
73.7 x 60.6 (29 x 23⅞)
Signed lower right: *Henri Matisse*
Bernheim-Jeune photograph May 1918

Philadelphia Musem of Art: The A. E. Gallatin Collection

Provenance
Galerie Bernheim-Jeune, Paris (from the artist, 22 March 1918)
Bois-Lurette
Galerie Bernheim-Jeune, Paris (1921)
L'Art Moderne (from Bernheim-Jeune, 29 April 1927)
Valentine Dudensing, New York
Alex Reid and Lefevre, London
A. E. Gallatin, New York (by 1933)

Exhibition
Philadelphia 1954, no. 115, ill. p. 112

Literature
Gallatin 1933, no. 81, ill.
Gallatin 1940, no. 83, ill.
Barr 1951, pp. 196 n. 5, 558
Escholier 1956a, p. 115
Luzi 1971, ill. no. 247
Schneider 1982, ill. no. 247
Watkins 1984, p. 150, ill. pl. 134

Remarks
This and *Intérieur à Nice* (cat. no. 29) depict almost identical views of the same hotel room, and belong to the first group of paintings done by Matisse in Nice.

29

Intérieur à Nice, January 1918
Interior, Nice

Nice, Hôtel Beau-Rivage
65.5 x 54.5 (25¾ x 21½)
Signed lower right: *Henri-Matisse*
Bernheim-Jeune photograph April 1918

Private collection

Provenance
Galerie Bernheim-Jeune, Paris (from the artist, 18 March 1918)
Galerie Paul Vallotton, Lausanne (sold 31 October 1918)
Hans Purrmann
Rudolf Vollmöller, Zurich

Exhibitions
Paris 1931
Basel 1931, no. 42
Lucerne 1949, no. 52, ill. pl. VIII

Literature
Barr 1951, pp. 195, 196, 204–205, ill. p. 420
Diehl 1954, p. 74
Luzi 1971, ill. no. 246
Schneider 1982, ill. no. 246

Remarks
See remarks, cat. no. 28.

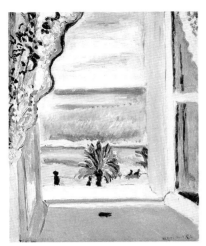

Cat. no. 30, pl. 49

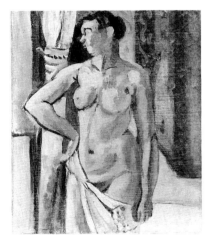

Cat. no. 31, pl. 51

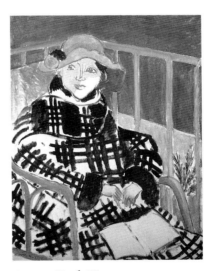

Cat. no. 32, pl. 55

30

La fenêtre ouverte, early 1918
The Open Window

Nice, Hôtel Beau-Rivage
42 x 33 (16½ x 13)
Signed lower right: *Henri-Matisse*
Bernheim-Jeune photograph May 1918

Private collection

Provenance
Marcel Kapferer, Paris
Etienne Bignou, Paris
Valentine Dudensing, New York
Mr. and Mrs. David M. Levy, New York
E. and A. Silberman Galleries, Inc., New York
Albert J. Dreitzer
Sotheby's, New York, 13 November 1985, lot 22

Exhibitions
Paris 1930b
New York 1985b, no. 22, ill. color

Literature
Brattskoven 1930, ill. p. 241
Zervos 1930, ill. p. 255
Scheiwiller 1947, ill. pl. XXIII

31

Nu debout de face, devant une fenêtre, tête tournée vers la droite, 1918
Standing Nude Front View, Before a Window, Head Turned to the Right

Nice, Hôtel Beau-Rivage
Oil on cardboard
41 x 33 (16⅛ x 13)
Signed upper right: *Henri Matisse*

Private collection, Paris

Provenance
Docteur Jacques Soubies, Paris
Hôtel Drouot, Paris, 14 June 1928, lot 56
Private collection, Paris

Exhibitions
Paris 1928a, no. 56, ill.
Lucerne 1949, no. 74

Not in exhibition

32

La baie de Nice, Easter 1918
The Bay of Nice

Nice, 105 quai des Etats-Unis
90 x 71 (35⅜ x 28)
Signed lower left: *Henri-Matisse*

Private collection

Provenance
Michael and Sarah Stein, Paris, and later, San Francisco
Private collection, San Francisco

Exhibitions
San Francisco 1936, no. 20, ill.
San Francisco 1952, no. 22
Paris 1970b, no. 153, ill. p. 219

Literature
Diehl 1954, pp. 76, 155
Luzi 1971, ill. no. 254
Schneider 1982, ill. no. 254

33

Mlle Matisse en manteau écossais, Easter 1918
Miss Matisse in Scotch Plaid Coat

Nice, 105, quai des Etats-Unis
Daughter Marguerite
95 x 75 (37⅜ x 29½)
Signed lower left: *Henri-Matisse*

Collection of Henry Ford II

Provenance
Galerie Bernheim-Jeune, Paris
Gaston Bernheim de Villers, Paris
Walter Taylor, London (to 1939)
Christie's, London, 3 March 1939, lot 156
Stanley William Sykes, Cambridge
Henry T. Mudd, Los Angeles
M. Knoedler and Co., New York (to present owner 6 February 1960)

Exhibitions
London 1926, p. 5
London 1928, no. 57
London 1936a, no. 26
London 1939, no. 156
On loan to the Fitzwilliam Museum, Cambridge, 1944–1955

Literature
Vanderpyl 1920, pp. 100–106, ill. pl. II, p. 104
Earp 1926, p. 65

Cat. no. 33, pl. 52

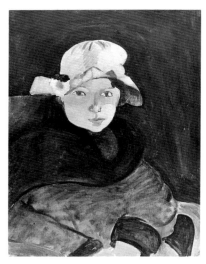

Cat. no. 34, pl. 54

34

Portrait de Mlle Matisse, Easter 1918
Portrait of Miss Matisse

Nice, 105, quai des Etats-Unis
72.5 x 52.5 (28½ x 20⅝)
Signed upper right: *Henri-Matisse*

Ohara Museum of Art, Kurashiki, Japan

Provenance
Torajiro Kojima (from the artist, 25 November, 1920)
Magosaburo Ohara

Exhibitions
Kurashiki, 1921, no. 18
Kurashiki, 1922, no. 29
Kyoto 1927, no. 32
Tokyo 1928, no. 41
Philadelphia 1948, no. 37
Osaka 1949
Tokyo 1951, no. 43
Osaka 1953, no. 24
Tokyo 1954, no. 25
Nagoya 1960, no. 26
Tokyo 1981, no. 44, ill. color p. 68

Literature
Kawashima 1936, ill. color
Yomiuri 1951, color pl. 49
Matisse 1954, color pl. 123
Ogawa 1966, color pl. 18
Watanabe 1973, color pl. 46

Remarks
Receipt in the archives of the Ohara Museum: "19 Quai
Saint-Michel/Reçu de Monsieur Torajiro Kojima la
somme de dix mille francs pour une toile de Henri
Matisse 'Portrait de Mademoiselle Matisse' 1918, Paris
le 25 nov 1920/MHMatisse"

Cat. no. 35, pl. 58

35

Paysage du midi, 1918
Landscape of the Midi

Oil on board
33 x 41 (13 x 16⅛)
Signed lower left: *Henri-Matisse*

Columbus Museum of Art, Ohio: Gift of Ferdinand
Howald

Provenance
Gustav Bollag, Zurich
Daniel Gallery, New York (1921)
Ferdinand Howald, New York (from Daniel, 1 May
1921 to 1931)

Exhibitions
New York 1921a, no. 149
Columbus 1931, no. 154
Dayton 1945, no. 13
Dayton 1949
Cincinnati 1951, no. 14, ill. p. 8
Delaware 1959
Youngstown 1969, no. 24
New York 1970a, no. F-17

Literature
Barr 1951, p. 558
Eglinton 1924, p. 376, ill. p. 377

Remarks
Inscription on reverse: "Mont Alban (Nice)"

36

Paysage d'oliviers, 1918
Landscape with Olive Trees

Nice
33 x 41 (13 x 16⅛)
Signed lower left: *Henri-Matisse*
Bernheim-Jeune photograph May 1918

Private collection

Provenance
Galerie Bernheim-Jeune, Paris (from the artist, 26 April
1918)
Galerie Paul Vallotton, Lausanne (31 December 1919)
Arthur and Hedy Hahnloser, Winterthur
Hans R. Hahnloser, Bern

Exhibitions
Nice 1950, no. 11
Winterthur 1973, no. 166

Cat. no. 36, pl. 59

Cat. no. 37, pl. 60

Cat. no. 38, pl. 62

Cat. no. 39, pl. 63

37

Les eucalyptus, Mont Alban, spring 1918
[between 14 May and 1 June]
Eucalyptus, Mont Alban

Nice
32.7 x 40.8 (12⅞ x 16¹⁄₁₆)
Signed lower left: *Henri-Matisse*
Bernheim-Jeune photograph March 1919

The Baltimore Museum of Art: The Cone Collection,
formed by Dr. Claribel Cone and Miss Etta Cone of
Baltimore, Maryland. BMA 1950.231

Provenance
Galerie Bernheim-Jeune, Paris
Private collection, Germany
G. and L. Bollag, Zurich, April 1925, lot 139, ill. pl. 50
Cone Collection, Baltimore (acquired between 1925
and 1934)

Exhibitions
Zurich 1925a, no. 139, ill. pl. 50
Baltimore 1930, no. 37(?)
Baltimore 1949, no. 33
Baltimore 1950
New York 1979b

Literature
Faure 1920, ill. pl. 29
Grautoff 1921, ill. pl. 3
Schacht 1922, ill. p. 76
Boas 1934, ill.
Mushakojo 1939, ill. p. 59, fig. 114
Rosenthal 1967, no. 43, ill. p. 11
Luzi 1971, ill. no. 253
Schneider 1982, ill. no. 253
Richardson 1985, p. 197

38

Chemin entre les murs, 1918
Road between the Walls

Nice
33 x 41 (13 x 16⅛)
Signed lower left: *Henri-Matisse*

Private collection

Provenance
Galerie Bernheim-Jeune, Paris (July 1918)
Private collection, Oslo (A. F. Klaveness?)
Private collection, London
Sotheby's, London, 31 March 1982, lot 84
Leslie Waddington, London

Exhibition
London 1982b, no. 84, ill. color

39

L'automne à Cagnes, 1918
Autumn at Cagnes

33 x 41 (13 x 16⅛)
Signed lower right: *Henri-Matisse*
Bernheim-Jeune photograph January 1919

Private collection

Provenance
Estate of the artist(?)

Exhibition
Paris 1919a, no. 23, ill.

Literature
Diehl 1954, p. 74

40

Le jardin du Château, 1918
The Château Garden

Nice
Oil on cardboard
33 x 41 (13 x 16⅛)
Signed lower left: *Henri Matisse*
Bernheim-Jeune photograph July 1918

Kunstmuseum Bern

Provenance
Eugène Blot, Paris
Hôtel Drouot, Paris, 2 June 1933, lot 77
Private collection

Exhibitions
Paris 1933a, no. 77, ill. pl. XX
New York 1940c, no. 4
New York 1944d, no. 11
New York 1948c, no. 8
Biel 1953, no. 71
Moutier 1956, no. 50
Humlebaek 1985, no. 45

Literature
Faure 1920, ill. pl. 31
Mushakojo 1939, ill. p. 59, fig. 114
Kuthy 1983, no. 1051, ill. p. 283
Stockholm 1984 (not in exhibition)

Cat. no. 40, pl. 64

Cat. no. 41, pl. 65

41

Grand paysage, Mont Alban, 1918
Large Landscape, Mont Alban

Nice
73 x 92 (28¾ x 36¼)
Signed lower left: *Henri-Matisse*
Bernheim-Jeune photograph September 1918

Alexina Duchamp

Provenance
Galerie Bernheim-Jeune, Paris (from the artist,
9 September 1918)
Galerie Paul Vallotton, Lausanne (31 December 1918)
Mary Callery
Pierre Matisse, New York
Mrs. Pierre Matisse, later Mrs. Marcel Duchamp

Exhibitions
Paris 1919a, no. 19
New York 1940a
New York 1943b, no. 10
New York 1944c, no. 3
New York 1951a, no. 49
London 1968, no. 77, ill. p. 106
On loan to Philadelphia Museum of Art, 1969
Paris 1970b, no. 157, ill. p. 222
Sydney 1975, p. 94, ill. p. 95

Literature
Courthion 1934, ill. pl. XXX
Fry 1935, ill. pl. 32
Mushakojo 1939, ill. p. 47, fig. 85
Barr 1951, pp. 183, 205, ill. p. 420
Greenberg 1953, color pl. 24
Diehl 1954, p. 74
Astrom 1955, color pl. 24
Huyghe 1955, color pl. 24
Lübecker 1955, color pl. 24
Alpatov 1969, color pl. 22
Luzi 1971, ill. no. 271, color pl. XLVII
Schneider 1982, ill. no. 271, color pl. XLVII

Cat. no. 42, pl. 24

42

Nature morte, pêches et verre, 1916 or 1918
Still Life, Peaches and Glass

Issy-les-Moulineaux
22.5 x 27.7 (8⅞ x 10⅞)
Signed lower left: *Henri-Matisse*
Bernheim-Jeune photograph October 1925

Collection Martha Baer

Provenance
Collection Parent, Paris
Galerie Bernheim-Jeune, Paris (from Parent 1925)
Carstairs Gallery, New York (1926)
M. Knoedler and Co., New York (1927)
Mrs. M. Frick
Sacha Guitry, Paris
Galerie Pétridès, Paris
Stephen Hahn, New York

Exhibitions
Paris 1931, no. 41
New York 1927c

Literature
Barnes 1933, pp. 44, 47, 51, 52, 54, 92, 126, 127, 143,
194, 207, 208, 210, 221
Guitry 1954, p. 131, ill.

Remarks
The Maurice Wertheim Collection, Fogg Art Museum,
and The Barnes Foundation, Merion, have paintings of
a similar setting. All are close-up views of the
foreground still life arrangements found in the Cone
Collection and Hahnloser Collection paintings entitled
Le pot d'étain. See cat. no. 22.

43

**Petit portrait de Marguerite, toque de
fourrure,** 1918
Small Portrait of Marguerite, Fur Hat

Issy-les-Moulineaux
23.8 x 18.8 (9⅜ x 7⅞)
Signed upper left: *Henri-Matisse*

Private collection

Provenance
Estate of the artist
Private collection (by descent)

Exhibition
Paris 1983

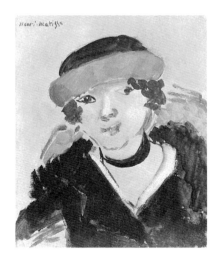

Cat. no. 43, pl. 33

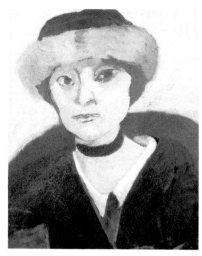

Cat. no. 44, pl. 34

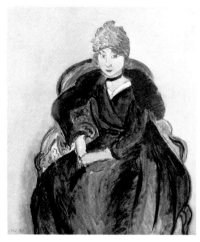

Cat. no. 45, pl. 37

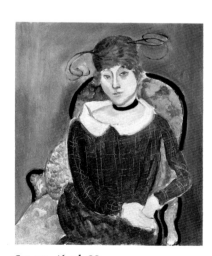

Cat. no. 46, pl. 38

44

Marguerite à la toque de fourrure, late 1918
Marguerite with Fur Hat

Issy-les-Moulineaux
Oil on panel
41 x 33 (16⅛ x 13)
Signed lower left: *Henri Matisse*
Bernheim-Jeune photograph December 1918

Private collection

Provenance
Estate of the artist

Exhibitions
Los Angeles 1966, no. 48, ill. color p. 79
New York 1966a, no. 38, ill. p. 38

Literature
Barr 1951, pp. 42, 194, ill. p. 418
Diehl 1954, pp. 15, 69
Escholier 1956a, p. 174
Luzi 1971, ill. no. 276
Schneider 1982, ill. no. 276

45

Marguerite à la toque bleue, 1918
Marguerite with Blue Hat

Issy-les-Moulineaux
81 x 75 (31⅞ x 29½)
Signed lower left: *H. Matisse*

Private collection

Provenance
Estate of the artist
Private collection (by descent)

46

La toque de goura, 1918
The Ostrich Feather Hat

Paris or Issy-les-Moulineaux
Daughter Marguerite
46 x 38 (18⅛ x 15)
Unsigned (see Remarks)
Bernheim-Jeune photograph December 1918

Wadsworth Atheneum, Hartford, The Ella Gallup
Sumner and Mary Catlin Sumner Collection

Provenance
Galerie Bernheim-Jeune, Paris (from the artist,
18 November 1918)
Montague Shearman (2 October 1919)
Paul Guillaume, Paris
Brandon Davis
Arthur Tooth and Sons, London
Private Collection, Scotland (1932)
Richard L. Feigen and Co., New York (to 1969)

Exhibitions
Paris 1919a, no. 21, ill.
London 1919, no. 16
London 1965, no. 10

Literature
Faure 1920, pl. 24

Einstein 1926, ill. 190
Einstein 1931, ill. p. 243
La chronique des arts 1970, ill. p. 91, fig. 401

Remarks
The object file of the Wadsworth Atheneum indicates
that Matisse did not sign this painting at the time of
its execution. According to Mme Duthuit, the
signature was added later, not by Matisse. In its
present state, the signature has been painted out.

47

La fenêtre fermée, season 1918–1919
The Closed Window

Nice, Hôtel Méditerranée
54 x 44.4 (21¼ x 17½)
Signed lower left: *Henri-Matisse*
Bernheim-Jeune photograph March 1919

Virginia Museum of Fine Arts, Collection of Mr. and
Mrs. Paul Mellon

Provenance
Galerie Bernheim-Jeune, Paris
Collection Emile B., Paris (1923)
Mrs. R. A. Workman, London
Alex Reid and Lefevre, London
M. Knoedler and Co., New York (by 1928)
Stephen C. Clark, New York
Durand-Ruel, Inc., New York (to 1948)
Mr. and Mrs. Paul Mellon, Upperville, Virginia

Exhibitions
Paris 1919a, no. 28, ill.
Glasgow 1924, ill.
London 1926
New York 1928d, no. 44, ill.
New York 1948a, ill. pl. XVIII

Literature
McBride 1930, ill. pl. 36
Near 1985, p. 114, ill. color p. 115

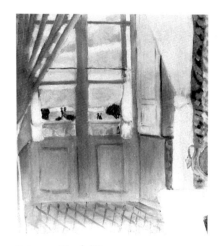

Cat. no. 47, pl. 70

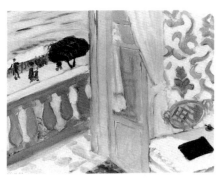

Cat. no. 48, pl. 72

48

Intérieur au cahier noir, December 1918
Interior with Black Notebook

Nice, Hôtel Méditerranée
Oil on cardboard
23.5 x 42 (9¼ x 16½)
Signed lower left: *Henri-Matisse*

Private collection, Switzerland

Provenance
Crès, Zurich
Arthur and Hedy Hahnloser, Winterthur
Lisa Jäggli-Hahnloser, Winterthur

Exhibitions
Paris 1931, no. 43
Basel 1931, no. 47
Winterthur 1937, no. 84
Lucerne 1940, no. 70
Winterthur 1973, no. 159, ill. pl. 42
Zurich 1982, no. 62, ill. color
Stockholm 1984, no. 35, ill. color
Humlebaek 1985, no. 42, ill. color p. 36

Literature
Zervos 1931a, ill. p. 302, fig. 70
Zervos 1931b, ill. p. 82, fig. 70
Barnes 1933, pp. 36, 48, 62, 66, 102, 103, 104, 112, 115, 145, 148, 195, 208, ill. p. 283
Diehl 1954, p. 75
Hahnloser 1956, ill. p. 23
Luzi 1971, ill. no. 270
Schneider 1982, ill. no. 270
Schneider 1984, ill. p. 83 color

New York 1954c
Cambridge 1955
Paris 1956, no. 52
Pittsburgh 1963
New York 1978a, pp. 118–120, 213–214, ill. color p. 119
New York 1979c
Basel 1980, no. 11, ill. color
Madrid 1980, no. 23, ill. color
Tokyo 1981, no. 45, ill. color p. 69
Zurich 1982, no. 61, ill. color

Literature
Sembat 1920, ill. p. 59
McBride 1930, pl. 37
Mushakojo 1939, ill. p. 49, fig. 91
Barr 1951, pp. 205, 558, ill. p. 423
Diehl 1954, p. 75
Escholier 1960, pl. 20
Alpatov 1973, pl. 29
Luzi 1971, ill. no. 292
Elderfield 1978a, pp. 118–120, 213–214, ill. color p. 119
Gowing 1979b, color pl. 5
Schneider 1982, ill. no. 292
Hoog 1984, ill. p. 122
Schneider 1984, p. 451

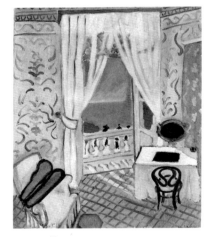

Cat. no. 49, pl. 71

49

Intérieur à la boîte à violon, winter 1918–1919
Interior with Violin Case

Nice, Hôtel Méditerranée
73 x 60 (28¾ x 23⅝)
Signed lower right: *Henri-Matisse*
Bernheim-Jeune photograph March 1919

The Museum of Modern Art, New York, Lillie P. Bliss Collection, 1934

Provenance
Galerie Bernheim-Jeune, Paris
Etienne Bignou, Paris
Alex Reid and Lefevre, London
Kraushaar Galleries, New York (1927)
Lillie P. Bliss, New York

Exhibitions
Paris 1919a, no. 36, ill.
Paris 1925b
New York 1927b, no. 11, ill.
London 1927, no. 9
New York 1931c, no. 95, ill.
Andover 1931, no. 73
Indianapolis 1932, no. 69, ill.
New York 1934a, no. 110
New York 1934b, no. 44, ill.
St. Louis 1935
Toledo 1938
Albany 1944
Philadelphia 1948, no. 47, ill.

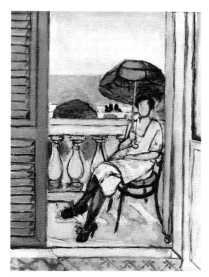

Cat. no. 50, pl. 73

50

Femme au balcon à l'ombrelle verte, de face, 1919

Woman on a Balcony, Green Umbrella, Front View

Nice, Hôtel Méditerranée
Model: Antoinette
66.5 x 47 (26⅛ x 18½)
Signed lower left: *Henri-Matisse*

Private Asset Management Group, Inc., New York

Provenance
Galerie Durand-Ruel, Paris
Paul Rosenberg et Cie., Paris
Dr. Silvan Kocher, Solothurn
Private collection, Switzerland
Christie's, New York, 16 May 1984, lot 44

Exhibitions
Paris 1931, no. 53
Paris 1959, no. 89
Lausanne 1964, no. 288, ill.
Paris 1967, no. 195, ill.
London 1968, no. 87, ill. p. 117
Paris 1970b, no. 163, ill. p. 224
Tokyo 1974, no. 49
Osaka 1974, no. 49, ill.
London 1978, no. 4, ill. color
Basel 1980, no. 16, ill. color
Tokyo 1981, no. 49, ill. color p. 72
New York 1984a, no. 44, ill. color p. 105

Literature
Barnes 1933, pp. 62, 90, 93, 112, 134, 195, 209, 439, ill. p. 285
Zervos 1931a, fig. 69, p. 301
Zervos 1931b, ill. p. 81, fig. 69
Kawashima 1936, ill. pl. 12
Escholier 1937b, ill. p. 131
Mushakojo 1939, ill. p. 61, fig. 121
Diehl 1954, p. 75
Ogawa 1966, color pl. 17
Luzi 1971, ill. no. 354, color pl. IL
Orienti 1971, color pl. 20
Gowing 1979a, p. 150, ill. p. 145, no. 129
Schneider 1982, no. 354, color pl. IL
Schneider 1984, pp. 416(n. 50), 453, 513, ill. p. 452

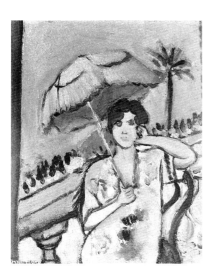

Cat. no. 51, pl. 74

51

Femme au balcon à l'ombrelle rose, de face, mi-corps, 1919

Woman on the Balcony with a Pink Umbrella, Front View, Half-Length

Nice, Hôtel Méditerranée
Model: Antoinette
23 x 19 (9⅟₁₆ x 7½)
Signed lower left: *Henri-Matisse*
Bernheim-Jeune photograph June 1921

Annick and Pierre Berès, Paris

Provenance
Collection Desjardins, Paris (gift of the artist, December 1919)

Literature
Escholier 1937a, ill. color facing p. 37

Remarks
Inscribed on the back: "à Monsieur et Madame Abel Desjardins, souvenir affectueux, Henri Matisse, Décembre 1919"

52

Femme assise au balcon, ombrelle verte, bas violets, 1919

Woman Seated on the Balcony, Green Umbrella, Purple Stockings

Nice, Hôtel Méditerranée
Model: Antoinette
42 x 33 (16½ x 13)
Signed lower right: *Henri-Matisse*
Bernheim-Jeune photograph March 1919

Annick and Pierre Berès, Paris

Provenance
Galerie Bernheim-Jeune, Paris (from the artist, 20 March 1919)
Mancini (23 May 1919)
Georges Renand, Paris

Exhibitions
Lucerne 1949, no. 69
Paris 1958, no. 17

Literature
Marchesseau 1986, ill. color p. 155

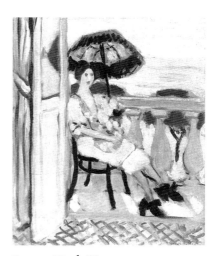

Cat. no. 52, pl. 75

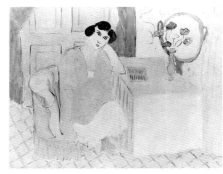

Cat. no. 53, pl. 76

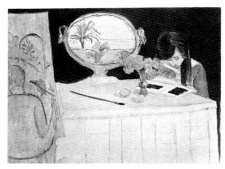

Cat. no. 54, pl. 77

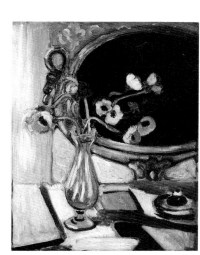

Cat. no. 55, pl. 79

53

La liseuse distraite, 1919
The Distracted Reader

Nice, Hôtel Méditerranée
Model: Antoinette
73.7 x 91.4 (29 x 36)
Signed lower left: *Henri-Matisse*
Bernheim-Jeune photograph March 1919

The Trustees of The Tate Gallery, London

Provenance
Galerie Bernheim-Jeune, Paris (from the artist,
20 March 1919)
Montague Shearman, London (12 June 1919,
bequeathed to The Tate Gallery, 1940)

Exhibitions
Paris 1919a, no. 25
London 1919, no. 21
London 1924, no. 45
London 1940a, no. 11, ill. color
London 1942, no. 76
London 1946, no. 41

Literature
Cassou 1948, ill. color p. 3
San Lazzaro 1949, ill.
Barr 1951, pp. 196–197, 205–206
Bell 1954, ill. color p. 154
Howell 1957, ill. color frontispiece
Escholier 1960, color pl. D
Brown 1968, pp. 63–64
Alley 1981, pp. 497–498, ill.
Mannering 1982, ill. color p. 59
Watkins 1984, p. 154, ill. pl. 138

54

La séance de peinture, 1919
The Painting Session

Nice, Hôtel Méditerranée
The artist and model Antoinette
74 x 93 (29⅛ x 36⅝)
Signed lower left: *Henri-Matisse*
Bernheim-Jeune photograph June 1919

Scottish National Gallery of Modern Art, Edinburgh

Provenance
Galerie Bernheim-Jeune, Paris (from the artist,
23 June 1919)
Galerie Paul Vallotton, Lausanne
R. Bühler, Winterthur (31 December 1919)
Paul Rosenberg, Paris (by 1936)
Confiscated by Marshal Goering in Paris 1940,
recovered by owner 1947
Mrs. Archie Preissmann, New York (1955)
Harry Winston, New York
Christie's, London, 20 May 1960, lot 92
Sir Alexander Maitland Q.C. (through Arthur Tooth,
London, 1960, bequest 1965)

Exhibitions
Stockholm 1931, no. 93, ill.
London 1936b, no. 16
Paris 1938, no. 3
New York 1954a, no. 3, ill.
London 1960, no. 92, ill. color facing p. 39

London 1968, no. 79, ill.
Zurich 1982, no. 63, ill. color

Literature
Eglington 1934, p. 4, ill. p. 6
La Chronique des Arts 1966, no. 311, ill. p. 81
Hall 1966, pp. 261–262
Greenberg 1953, color pl. 21
Huyghe 1955, color pl. 21
Lübecker 1955, color pl. 21
Astrom 1955, color pl 21
Christie's 1960, p. 4, ill. color on cover
Grünewald 1964, ill.
Luzi 1971, ill. no. 285
Schneider 1982, ill. no. 285
Watkins 1984, p. 158, ill. pl. 144

55

Anémones au miroir noir, 1919
Anemones with a Black Mirror

Nice, Hôtel Méditerranée
68 x 52 (26¾ x 20½)
Signed lower left: *Henri Matisse*
Bernheim-Jeune photograph March 1919

Private collection

Provenance
Galerie Bernheim-Jeune, Paris
Pierre Matisse Gallery, New York
Valentine Dudensing, New York
Phillips Memorial Gallery, Washington (1927)
Pierre Matisse Gallery, New York (by exchange,
February 1947)

Exhibitions
Paris 1919a, no. 32, ill.
Washington 1927, ill.
Washington 1928, ill. p. 20
New York 1931a, no. 51, ill.
Buffalo 1944, no. 41
Cambridge 1941
New York 1963, ill. color p. 22
New York 1985a, ill. color p. 39
Paris 1986, p. 38, ill. color p. 39

Literature
Faure 1926, ill. p. 459
Phillips 1931, 2, ill. pl. CXXI
Barr 1951, pp. 205, 207
Vaughan 1965, ill. color p. 28

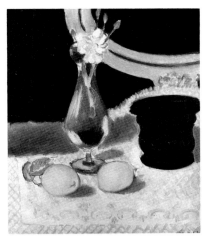

Cat. no. 56, pl. 80

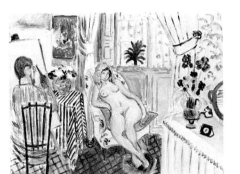

Cat. no. 57, pl. 81

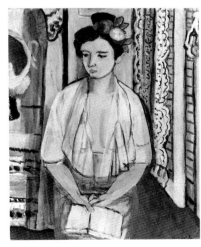

Cat. no. 58, pl. 82

56

Nature morte, vase de fleurs, citrons et mortier, 1919
Still Life, Vase of Flowers, Lemons and Mortar

Nice, Hôtel Méditerranée
46 x 38 (18⅛ x 15)
Signed lower right: *Henri-Matisse*
Bernheim-Jeune photograph July 1919

Mr. and Mrs. James W. Alsdorf, Chicago

Provenance
Jacques Doucet, Paris
Private collection, Paris
Galerie Schmit, Paris
Eugene Thaw, New York

Exhibitions
Paris 1973, no. 35, ill. color p. 51
New York 1977a, ill. color

Literature
Revel 1961, ill. p. 45
Garner 1980, ill. color p. 85
Chapon 1984, p. 210
Baudot 1985, p. 56, ill. color

57

Le peintre et son modèle, intérieur d'atelier, 1919
The Painter and His Model, Studio Interior

Nice, Hôtel Méditerranée
The artist and model Antoinette
60 x 73 (23⅝ x 28¾)
Signed lower right: *Henri-Matisse*

Mr. and Mrs. Donald B. Marron, New York

Provenance
Georges Bernheim, Paris
John Quinn (September 1921)
Dr. and Mrs. Harry Bakwin, New York (1926, from the Quinn sale?)
Dr. Ruth Norris Bakwin
Sotheby's, New York, 13 November 1985, lot 38

Exhibitions
New York 1922, no. 83
New York 1924a, no. 8
New York 1946
New York 1953, no. 1, ill.
Atlanta 1955, no. 45
New York 1962b, no. 45
Los Angeles 1966, no. 80, ill. color p. 35
New York 1967b, no. 26 ill.
Wellesley 1967
London 1968, no. 80, ill. color p. 35
Sydney 1975, no. 69, ill. p. 97
Washington 1978b, no. 52, ill. color p. 124
Wellesley 1978, no. 67, ill., and ill. color on cover
New York 1985c, no. 38, ill. color

Literature
Faure 1923, ill. pl. 14
Watson 1926a, p. 11, ill. p. 70
Barr 1951, p. 205, ill. p. 424
Greenberg 1953, color pl. 20
Diehl 1954, p. 75

Astrom 1955, color pl. 20
Huyghe 1955, color pl. 20
Lübecker 1955, color pl. 20
Guichard-Meili 1967, ill. 85 p. 94
Bowness 1968, color pl. 18
Reid 1968, pp. 495, 502
Russell 1969, p. 110, ill. color p. 111
Aragon 1971, 1, p. 109
Luzi 1971, ill. no. 290
Jacobus 1972, pp. 156–157, color pl. 36
Flam 1973b, ill. fig. 30
Watkins 1977, p. 10, color pl. 31, detail color pl. 15
Elderfield 1978b, p. 19, ill. pl. 17
Gowing 1979a, p. 142, ill. 127 p. 143
Schneider 1982, ill. no. 290
Watkins 1984, p. 149, color pl. 132
Schneider 1984, pp. 510, 511, 513

Remarks
Here dated 1919 by interpreting the imagery, the Archives Matisse is inclined to date this painting April 1921.

58

Liseuse, fleurs dans les cheveux, 1918 or 1919
Reader with Flowers in Her Hair

Nice, Hôtel Méditerranée
Model: a sister of Antoinette
79 x 64 (31⅛ x 25¼)
Signed lower right: *Henri-Matisse*
Bernheim-Jeune photograph June 1920

Stephen Hahn Collection, New York

Provenance
Georges Bernheim, Paris
Docteur Chevalier, Epinal
W. S. Paley, New York
Paul Rosenberg and Co., New York
Pierre Matisse Gallery, New York
Private collection
Acquavella Galleries, New York

Exhibitions
Paris 1920, ill. (but not in checklist)
Paris 1924c
Paris 1937, no. 40
Valenciennes 1937, no. 17
New York 1938a, no. 5
New York 1954a, no. 12, ill.
New York 1973, no. 39, ill. color

Literature
Schwob 1920, ill. p. 193
Vildrac 1921, ill. p. 215
George 1924, ill. p. 54
Zervos 1931a, ill. p. 297, fig. 65
Zervos 1931b, ill. p. 77, fig. 65
Courthion 1934, pl. XXXIV
Chanaux 1980, ill. p. 87

Remarks
See Remarks in entry for *Tête de femme, fleurs dans les cheveux*, cat. no. 59.

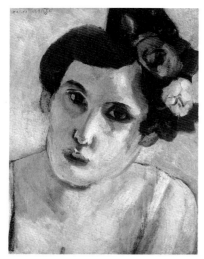

Cat. no. 59, pl. 83

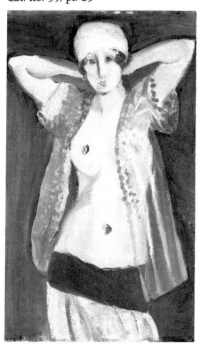

Cat. no. 60, pl. 84

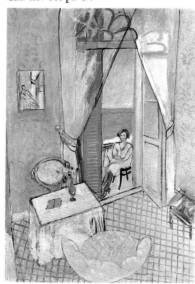

Cat. no. 61, pl. 100

59

Tête de femme, fleurs dans les cheveux, 1918
or 1919
Head of a Woman, Flowers in her Hair

Nice, Hôtel Méditerranée
Model: one of Antoinette's sisters
Oil on board
35 x 27 (13¾ x 10⅝)
Signed upper left: *Henri-Matisse*
Bernheim-Jeune photograph May 1920

Courtesy Galerie Jan Krugier, Geneva

Provenance
Pierre Wertheimer, Paris
Hôtel Drouot, Paris, 17 December 1927, lot 6
McNeill Reid, Glasgow (17 December 1927)
Alex Reid and Lefevre, London
Lefevre Gallery, London
Lawrence Rubin, New York

Exhibitions
Paris 1920, no. 12
Paris 1927a, no. 6, ill.
Paris 1931, no. 49
New York 1931a, no. 43, ill.
Melbourne 1939
Knokke-Le Zoute 1952, no. 25, ill.

Literature
George 1931, ill.
Zervos 1931a, ill. p. 300, fig. 68
Zervos 1931b, ill. p. 80, fig. 68
Scheiwiller 1933, ill. pl. 11
Luzi 1971, ill. no. 278
Schneider 1982, ill. no. 278

Remarks
This painting is a close-up of the head of the same
model in *Liseuse, fleurs dans les cheveux,* cat. no. 58.

60

La blouse transparente, 1919
The Transparent Blouse

Nice, Hôtel Méditerranée
Model: Antoinette
43 x 25 (16⅞ x 9⅞)
Signed lower left: *Henri-Matisse*
Bernheim-Jeune photograph July 1919

Private collection, Switzerland

Provenance
Galerie Bernheim-Jeune, Paris (from the artist June
1919)
Galerie Paul Vallotton, Lausanne or Tanner Gallery,
Zurich (1919)
Arthur and Hedy Hahnloser, Winterthur (31
December 1921)
Mme Lisa Jäggli-Hahnloser, Winterthur

Exhibitions
Basel 1931, no. 53
Winterthur 1937, no. 86
Lucerne 1940, no. 71, ill. pl. 28
Winterthur 1973, no. 164

Literature
Ooka 1972, color pl. 58

61

Grand intérieur, Nice, 1919 or early 1920
Large Interior, Nice

Nice, Hôtel Méditerranée
Model: Antoinette
132.2 x 88.9 (52 x 35)
Signed lower right: *Henri-Matisse*

The Art Institute of Chicago, Gift of Mrs. Gilbert
W. Chapman

Provenance
Georges Menier, Paris
Pierre Matisse, New York
Mr. and Mrs. Charles Goodspeed, Chicago (1936)
Mrs. Gilbert Chapman, Chicago (formerly Mrs. Charles
Goodspeed)

Exhibitions
Paris 1930a, no. 63, ill. fig. 58
Paris 1931, no. 85, ill.
Northampton 1932
Chicago 1933, no. 394
New York 1934c, no. 4
Paris 1937, no. 12, p. 36
Chicago 1938, no. 77
Chicago 1939, no. 9
Philadelphia 1948, no. 54, ill.
New York 1951a, no. 53
Los Angeles 1952, no. 36
New York 1954a, no. 6, ill.
Dallas 1955, no. 21
New Haven 1956, no. 135, ill.
Los Angeles 1966, no. 55, ill.
New York 1966a, no. 42, ill. p. 44
London 1968, no. 88, ill. color p. 40
New York 1973, no. 25, ill. color

Literature
Gauthier 1930, ill. fig. 58, p. 414
Guenne 1930, p. 391
George 1931, ill.
Abbott 1933, ill. p. 15
Barnes 1933, pp. 195, 196, 197, ill. no. 118, p. 307
Morsell 1934, p. 4, ill.
Escholier 1937b, ill. p. 67
Barr 1951, pp. 209, 210, ill. p. 435
Diehl 1954, p. 75
Art Quarterly 1957, ill. p. 326
Lassaigne 1959, ill. color p. 97
Gottlieb 1964, p. 398, ill. fig. 10
Maxon 1970, pp. 121–122, ill. p. 121
Luzi 1971, ill. no. 353
Flam 1973b, ill. fig. 32
Jacobus 1973, p. 158, pl. 37
Gowing 1979a, p. 150, ill. 135, p. 151
Schneider 1982, ill. no. 353
Buettner 1983, ill. p. 129
Hoog 1984, p. 124, ill. p. 125
Schneider 1984, p. 510

Remarks
Previously dated 1921, this work is here redated 1919
because the painting represented on the left wall of
the room, *Femme assise près d'une fenêtre ouverte,*
was sold to Arthur Hahnloser in December of 1919.
Matisse may, of course, have completed this painting
early in 1920.

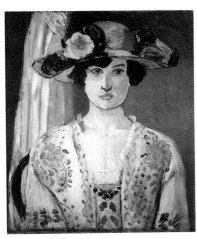

Cat. no. 62, pl. 90

62

Femme au chapeau fleuri, 1919
Woman in a Flowered Hat

Model: Antoinette
58.9 x 49.9 (23⅛ x 19⅝)
Signed lower left: *Henri Matisse*
Bernheim-Jeune photograph October 1927

Mr. and Mrs. Herbert J. Klapper, New York

Provenance
The artist (until 1927)
Justin K. Thannhauser, New York
Marie Harriman Galleries, New York
Sidney Janis Gallery, New York
Lee A. Ault, New York
Christie's, New York, 19 May 1981, lot 348
Acquavella Galleries, New York
Doris Vidor, New York
Acquavella Galleries, New York

Exhibitions
Paris 1920, no. 8(?)
Berlin 1930, no. 45, ill. p. 21
New York 1931a, no. 45, ill.
New York 1932a
New York 1934c
San Francisco 1934, no. 207
San Francisco 1936, no. 19
Los Angeles 1966, no. 54, ill. color p. 81
London 1968, no. 83, ill. p. 114
New York 1968, no. 87, ill. color
New York 1973, no. 20, ill. color
New York 1981a, no. 348, ill. color
New York 1981b, p. 26, ill. color p. 27

Literature
Scheffler 1929–1930, ill. p. 290
Brattskoven 1930, ill. p. 240
Scheiwiller 1933, ill. pl. XII
Courthion 1934, ill. pl. XXIX
Mushakojo 1939, ill. p. 55, fig. 105
Luzi 1971, ill. no. 311
Gowing 1979a, p. 146, ill. no. 130
Schneider 1982, ill. no. 311

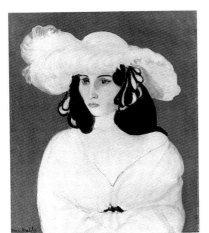

Cat. no. 63, pl. 91

63

Les plumes blanches, 1919
The White Plumes

Nice, Hôtel Méditerranée
Model: Antoinette
Oil on linen
73.03 x 60.33 (28¾ x 23¾)
Signed lower left: *Henri Matisse*
Bernheim-Jeune photograph March 1919

The Minneapolis Institute of Arts, The William Hood Dunwoody Fund

Provenance
Stephen C. Clark, New York
Sam Salz, New York (to 1947)

Exhibitions
New York 1927a
Chicago 1927, no. 7
New York 1930a, no. 54, ill. p. 54

New York 1931a, no. 48
New York 1931e, no. 16, ill.
Chicago 1933, no. 397, ill. pl. LXVIII
New York 1934a, no. 111, ill. pl. 111
New York 1939a, no. 95, ill. in color portfolio
New York 1940a, no. 18
Philadelphia 1948, no. 50, ill. pl. 50
New York 1954a, no. 5, ill.
Paris 1956, no. 56, ill. pl. xxi
New York 1957a
Houston 1958
Cleveland 1966, no. 14, ill. color

Literature
Faure 1920, ill. pl. 32
Sembat 1920, p. 196
Basler 1921, ill. p. 19
Basler 1924a, ill.
Mather 1927, ill. p. 357
McBride 1930, ill. pl. 16
Salinger 1932, ill. p. 9
Craven 1934, ill. p. 170
Lipman 1934, p. 140, ill. p. 135
Fry 1935, ill. pl. 36
Huyghe 1939, ill. pl. 21
Mushakojo 1939, ill. color
Puy 1939, ill. p. 25
Grunewald 1944, ill. p. 64
Hess 1948, ill. p. 19
Minneapolis 1948, pp. 26–31, ill. cover
Barr 1951, pp. 200, 206, 208, ill. p. 427
Greenberg 1953, color pl. 14
Matisse 1954, color pl. 125
Diehl 1954, pp. 75, 77, 155, ill. cover and pl. 85
Astrom 1955, color pl. 14
Huyghe 1955, color pl. 14
Lübecker 1955, color pl. 14
Escholier 1956a, pp. 181–182
Arts 1957, p. 32, ill. p. 35
Ferrier 1961, color pl. 10
Vaughan 1965, ill. color p. 27
Hamilton 1967, ill. p. 443
Leymarie 1967, color pl. 10
Arnason 1968, ill. p. 112
Okamoto 1968, pl. 51
Diehl 1970, color pl. 31
Sachs 1970, no. 170, pp. 322–323, ill. p. 323
Luzi 1971, ill. no. 295
Aragon 1971, 2, p. 103, color pl. XVII
Ooka 1972, color pl. 59
Alpatov 1973, color pl. 31
Minemura 1976, color pl. 22
Gowing 1979a, ill. p. 138 no. 122
Schneider 1982, ill. no. 295
Noël 1983, color pl. 37
Watkins 1984, p. 155, ill. no. 140
Schneider 1984, p. 503

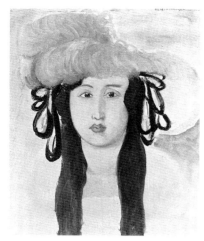

Cat. no. 64, pl. 92

64

Le chapeau à plumes, 1919
The Plumed Hat

Nice, Hôtel Méditerranée
Model: Antoinette
48 x 39 (18⅞ x 15⅜)
Signed upper right: *Henri-Matisse*
Bernheim-Jeune photograph July 1919

National Gallery of Art, Washington, Chester Dale
Collection 1963.10.168

Provenance
Carfax and Patterson, London (1920)
Brandon Davis, South Africa (c. 1920)
Leicester Galleries, London
Kraushaar Galleries, New York
Chester Dale, New York (1 December 1925)

Exhibitions
London 1920
New York 1928a, no. 25
New York 1928b, no. 17
New York 1928c, no. 53
New York 1931b, no. 25
Paris 1931, no. 57
Chicago 1943, no. 36, ill.
Washington 1952
Washington 1960, p. 36, ill.

Literature
Faure 1923, ill. pl. 8
Dale 1929a, no. 72, ill.
Dale 1929b, ill. p. 49
McBride 1930, ill. pl. 17
George 1931, ill.
McBride 1931b, p. 58
Salinger 1932
Dale 1943, ill. p. 51
Minneapolis 1948, ill. p. 27
Dale 1960, p. 38, ill.
Dale 1965, p. 47, ill.
Orienti 1971, p. 36

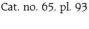

Cat. no. 65, pl. 93

65

Antoinette au chapeau à plumes, debout torse nu, early 1919
Antoinette with the Plumed Hat, Standing, Nude Torso

Nice, Hôtel Méditerranée
66 x 50 (26 x 19⅝)
Signed lower left: *Henri-Matisse*
Bernheim-Jeune photograph July 1919

Mrs. Harold Uris, New York

Provenance
Georges Bernheim, Paris
Galerie Bernheim-Jeune, Paris
Zborowski, Paris (9 May 1922)
Etienne Bignou, Paris
Polk collection, Los Angeles (by 1952)
Dalzell Hatfield Gallery, Los Angeles
M. Knoedler and Co., New York (January 1964)
Mr. Harold Uris, New York (1964)

Exhibitions
Paris 1931, no. 42
New York 1931a, no. 46 ill.
Basel 1931, no. 44
New York 1938b
New York 1939b, no. 9
Beverly Hills 1952, no. 5

Literature
Einstein 1931, ill. p. 246
Art News 1938, ill.
Mushakojo 1939, ill. p. 55, fig. 104
Barr 1951, pp. 206, 246, ill. p. 427
Luzi 1971, ill. no. 298
Schneider 1982, ill. no. 298

66

Maison entre les arbres, 1919
House Among the Trees

Nice
33 x 41 (13 x 16⅛)
Signed lower left: *Henri-Matisse*
Bernheim-Jeune photograph March 1919

Private collection, Paris

Provenance
Monsieur R[iesnan?], Paris
Percy Moore Turner, London
Private collection, Paris

Exhibitions
Paris 1931, no. 64
Lucerne 1949, no. 55
Paris 1956, no. 59

Literature
Basler 1924a, ill.
McBride 1930, ill. pl. 28
Aragon 1946, ill. color
Diehl 1954, pp. 75, 155
Luzi 1971, ill. no. 323
Schneider 1982, ill. no. 323

Not in exhibition

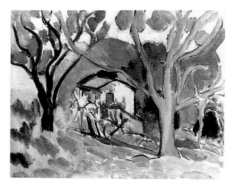

Cat. no. 66, pl. 57

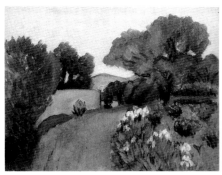

Cat. no. 67, pl. 61

67

Dans la campagne de Nice, jardin aux iris,
1919
In the Nice Countryside, Iris Garden

33 x 41 (13 x 16⅛)
Signed lower left: *Henri-Matisse*
Bernheim-Jeune photograph July 1919

Collection Lois and Georges de Menil

Provenance
Galerie Bernheim-Jeune, Paris (from the artist,
23 June 1919)
Galerie Vildrac, Paris (1920)
Etienne Bignou, Paris
Alex Reid and Lefevre, London
Sir George Sutton, London
Arthur Tooth and Sons, London
M. W. Ritchie, Colorado
Sotheby Parke-Bernet, New York, May 2, 1974, lot 234
Waddington and Tooth, London (1977)

Exhibitions
New York 1974a, no. 234, ill. color
Wellesley 1978, no. 68, ill.

Literature
McBride 1930, ill. pl. 29

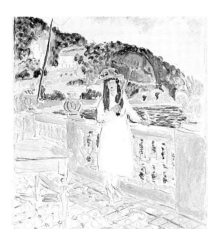

Cat. no. 68, pl. 89

68

Sur la terrasse, jeune fille à l'ombrelle rose,
1919
On The Terrace, Young Woman with Pink
Umbrella

Nice
Model: Antoinette
55.7 x 47.7 (21⅞ x 18¾)
Signed lower right: *Henri-Matisse*
Bernheim-Jeune photograph July 1919

Worcester Art Museum

Provenance
Galerie Bernheim-Jeune, Paris (from the artist, June
1919)
Bourgeois Galleries, New York (sold to Worcester Art
Museum 10 October 1929)

Exhibitions
Cleveland 1938
Amherst 1948
Cambridge 1955, no. 5

Literature
McBride 1930, ill. pl. 33
Barr 1951, p. 559
Cott 1948, p. 90, ill. fig. 129
Rich 1974, pp. 262–263, ill. p. 592

69

Jeunes filles au jardin, summer 1919
Young Girls in the Garden

Issy-les-Moulineaux
Mme Matisse, Daughter Marguerite, and model
Antoinette
54.5 x 65 (21½ x 25⅝)

Signed lower left: *Henri-Matisse*
Bernheim-Jeune photograph May 1921

Musée des Beaux Arts de La Chaux-de-Fonds,
Collection René and Madeleine Junod

Provenance
Georges Moos, Geneva (to May 1944)
M. et Mme René Junod, La Chaux de Fonds (to 1986)

Exhibitions
Paris 1919b, no. 896
Lucerne 1949, no. 71
Nice 1950, no. 17, ill.
Geneva 1954, no. 176
Lausanne 1964, no. 287, ill.
Paris 1967, no. 194, ill.
London 1968, no. 81
Osaka 1974, no. 48, ill.

Literature
Cogniat 1950, ill. fig. 124
Diehl 1954, p. 75

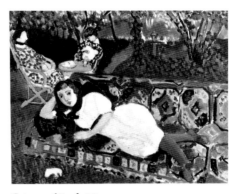

Cat. no. 69, pl. 32

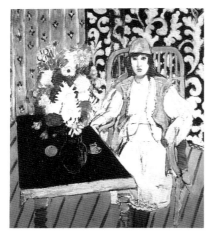

Cat. no. 70, pl. 29

70

La table noire, summer 1919
The Black Table

Issy-les-Moulineaux
Model: Antoinette
102 x 80 (40¼ x 31½)
Signed lower right: *Henri-Matisse*
Bernheim-Jeune photograph September 1919

Private collection, Switzerland

Provenance
Georges Bernheim, Paris
Emil Hahnloser
Arthur and Hedy Hanloser, Winterthur
Hans R. Hahnloser, Bern

Exhibitions
Paris 1919b, no. 893
Basel 1931, no. 79
Zurich 1935, no. 579
Bern 1953, no. 87
Paris 1959, no. 88
Winterthur 1973, no. 165, ill. pl. 40
Zurich 1982, no. 64, ill. color

Literature
Klingsor 1921, ill. pl. XVIII
Zervos 1931b, ill.
Huyghe 1935, ill. p. 110, fig. 127
Mushakojo 1939, ill. p. 70, fig. 143
Courthion 1942, ill. color frontispiece
Wild 1950, color pl. V
Barr 1951, pp. 197, 206, 207, 208, 209, 210, n. 529, ill. p. 430
Diehl 1954, p. 75
Escholier 1960, ill. pl. 29
Guichard-Meili 1967, ill. p. 93, no. 84
Aragon 1971, 2, p. 103, color pl. XIX
Luzi 1971, ill. no. 300
Schneider 1982, ill. no. 300
Schneider 1984, ill. p. 494 color

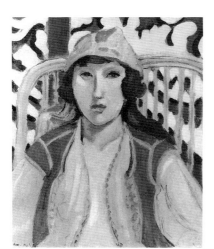

Cat. no. 71, pl. 28

71

Femme vêtue à l'orientale, July 1919
Woman Dressed as an Oriental

Issy-les-Moulineaux
Model: Antoinette
Oil on canvas on cardboard
40.8 x 32.7 (16¹/₁₆ x 12⅞)
Signed lower left: *Henri-Matisse*

Glasgow Art Gallery and Museum

Provenance
George Eumorfopoulos
Sotheby's London, 6 December 1940, lot 30
Alex Reid and Lefevre, London
William McInnes (gift to Glasgow Art Gallery and Museum, 1940)

Exhibitions
London 1940b, no. 30
Glasgow 1943, no. 69
Edinburgh 1944, no. 214
Glasgow 1945, no. 75
Knokke-Le Zoute 1952, no. 21, ill.
Edinburgh 1955, no. 9

London 1962, no. 240, ill.

Literature
Faure 1920, ill. pl. 36
Mushakojo 1939, ill. p. 60, fig. 120
Barr 1951, p. 557
Glasgow 1953, p. 38, ill.
Glasgow 1967, 2, ill. p. 76
Honeyman 1969, pp. 19–20, ill. p. 20
Glasgow 1985, p. 96, ill. color

Remarks
This painting focuses on the head of the model found in the larger composition, *La table noire;* see cat. no. 70.

72

Nu au tapis espagnol, summer 1919
Nude with Spanish Carpet

Issy-les-Moulineaux
Model: Antoinette
65 x 54 (25⅝ x 21¼)
Signed lower left: *H. Matisse*

Private collection

Provenance
Estate of the artist
Private collection (by descent)

Exhibitions
Paris 1931, no. 38
London 1936b, no. 23
Lucerne 1949, no. 83
Paris 1953, no. 129, ill.
Paris 1956, no. 57
Paris 1970b, no. 160, ill. p. 221
Copenhagen 1970, no. 48, ill.
Zurich 1982, no. 59, ill. color
Stockholm 1984, no. 39, ill. color p. 33
Humlebaek 1985, no. 47

Literature
Duthuit 1962, ill. color p. 181
Sutton 1970, ill. no. 10, p. 363
Luzi 1971, ill. no. 302, color pl. XLVIII
Orienti 1971, color pl. 19
Schneider 1982, ill. no. 302, color pl. XLVIII

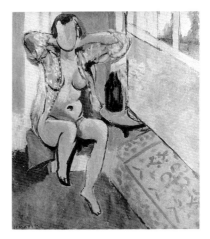

Cat. no. 72, pl. 27

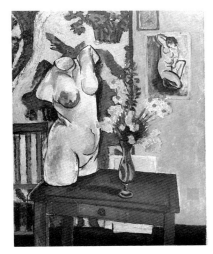

Cat. no. 73, pl. 26

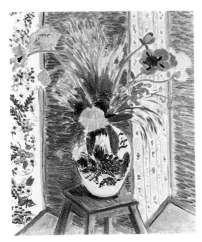

Cat. no. 74, pl. 20

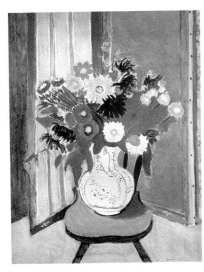

Cat. no. 75, pl. 22

73

Le torse de plâtre, bouquet de fleurs, 1919
Plaster Figure, Bouquet of Flowers

Issy-les-Moulineaux
113 x 87 (44½ x 34¼)
Signed lower right: *H. Matisse*
Bernheim-Jeune photograph September 1919

Museu de Arte de São Paulo

Provenance
Paul Rosenberg, Paris
Phillips Memorial Gallery, Washington (1934)
Paul Rosenberg, Paris (from Phillips Gallery by exchange, 1942)
Leigh B. Block, Chicago
Wildenstein and Co., New York

Exhibitions
Washington 1941, no. 94
New York 1944a, no. 11, ill.
Philadelphia 1948, no. 49, ill.
London 1954, no. 69, ill. pl. XXXVII
New York 1954b, no. 41
New York 1957c, no. 68, ill.
Fort Worth 1984, no. 37, ill. color, cover
Stockholm 1984, no. 37
Humlebaek 1985, no. 44, ill. color p. 34

Literature
Georges-Michel 1944, ill. facing p. 132
Barr 1951, p. 207
Lepore 1966, ill. color
Luzi 1971, ill. no. 307
Watanabe 1973, color pl. 9
Lassaigne 1981, ill. color
Schneider 1982, ill. no. 307
Mezzatesta 1984, pp. 113-114, ill.
Schneider 1984, pp. 441, 524, 536, ill. p. 522 color

74

Les pavots—Feu d'artifice, 1919
Poppies—Fireworks

Issy-les-Moulineaux
100.6 x 81.3 (39⅝ x 32)
Signed lower right: *Henri-Matisse*

Detroit Institute of Arts, Bequest of Robert H. Tannahill

Provenance
Georges Bernheim, Paris
Mr. and Mrs. Edouard Jonas, New York
Mrs. Edouard Jonas, New York
Robert Hudson Tannahill, Detroit (1932)

Exhibitions
London 1930
New York 1931a, no. 47, ill.
Chicago 1933, no. 395
Detroit 1970, ill. color p. 10

Literature
L'Art Vivant 1929, p. 128 ill.
Apollo 1930, ill. color p. 272b
Mushakojo 1939, ill. p. 60, fig. 117
Romm 1947, ill. color facing p. 96
Cassou 1948, p. 16, color pl. 7

Myers 1950, p. 287, ill. fig. 143
Barr 1951, pp. 207, 544
Cummings 1970, pp. 11, 19, 29, ill. color p. 10

75

Bouquet de fleurs—Les marguerites, 1919
Bouquet of Flowers—Daisies

Issy-les-Moulineaux
101.6 x 73.7 (40 x 29)
Signed lower right: *Henri-Matisse*
Bernheim-Jeune photograph September 1919

Private collection, Chicago

Provenance
Galerie Bernheim-Jeune (from the arist, 25 September 1919)
Monteux, Limoges (13 October 1919)
Marianne Fleichenfeld, Zurich (1970)

Exhibitions
New York 1973, ill. color no. 18

Literature
Faure 1920, ill. pl. 35
Mushakojo 1939, ill. p. 60, fig. 119

76

Double portrait de Marguerite sur fond vert,
c. 1919
Double Portrait of Marguerite on a Green Background

32.5 x 41.5 (12¹³⁄₁₆ x 16⅜)
Signed bottom center in the paint: *Henri Matisse;*
lower right: *H. Matisse*

Private collection

Provenance
Estate of the artist
Private collection (by descent)

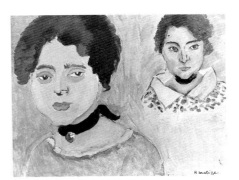

Cat. no. 76, pl. 35

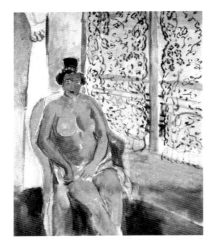

Cat. no. 77, pl. 85

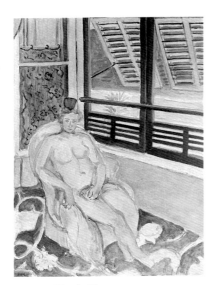

Cat. no. 78, pl. 86

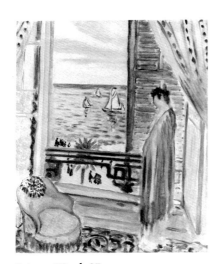

Cat. no. 79, pl. 87

77

Nu au peigne espagnol, assis devant une fenêtre à voilages, season 1919–1920
Nude with Spanish Comb, Seated in Front of a Curtained Window

Nice, Hôtel Méditerranée
Model: Antoinette or her sister
73.2 x 60.4 (28¹³/₁₆ x 23¾)
Signed lower left: *Henri-Matisse*
Bernheim-Jeune photograph June 1920

The Baltimore Museum of Art: The Cone Collection, formed by Dr. Claribel Cone and Miss Etta Cone of Baltimore, Maryland. BMA 1950.237

Provenance
Doctor Soubies, Paris (to 1928)
Hôtel Drouot, Paris, 14 June 1928, lot 69
Bernheim-Jeune, Paris (1928)
Claribel Cone, Baltimore (15 June 1928)

Exhibitions
Paris 1928a, no. 69 ill.
Baltimore 1930
Baltimore 1949, no. 40
Baltimore 1950

Literature
Boas 1934, ill.
Rosenthal 1967, no. 49
Luzi 1971, ill. no. 346
Schneider 1982, ill. no. 346
Richardson 1985, p. 179

78

Nu au peigne espagnol, assis près de la fenêtre, 1919
Nude with Spanish Comb, Seated by the Window

Nice, Hôtel Méditerranée
Model: Antoinette or her sister
92 x 64.5 (36¼ x 25⅜)
Signed lower left: *Henri-Matisse*
Bernheim-Jeune photograph May 1920

Kunstmuseum Solothurn, Josef Müller-Stiftung

Provenance
Josef Müller, Solothurn

Exhibitions
Basel 1931, no. 50
Lucerne 1949, no. 66, ill. pl. IX
Solothurn 1977, no. 34, ill.

Literature
Hauptman 1981, p. 242, no. 224, ill. p. 243

Remarks
A painting of the same setting is in the Cone Collection (cat. no. 77) and another is believed to be in a Japanese private collection; see fig. 22, p. 25.

79

Femme au peigne espagnol, debout devant la fenêtre, 1919
Woman with Spanish Comb, Standing at the Window

Nice, Hôtel Méditerranée
Model: Antoinette, or one of her sisters
73 x 60 (28¾ x 23⅝)
Signed lower right: *Henri-Matisse*
Bernheim-Jeune photograph May 1920

Private collection

Provenance
Charles Vignier, Paris
Art Institute of Chicago, Joseph Winterbotham Collection (1921)
Mr. and Mrs. Josef Rosensaft

Exhibitions
Paris 1920, no. 14, ill.
New York 1973, no. 17, ill. color

Literature
McBride 1930, ill. pl. 33
Joseph 1931, ill. p. 469
Kuh 1947, ill. p. 29
Lewisohn 1948, ill. pl. 46
Luzi 1971, ill. no. 269
Schneider 1982, ill. no. 269

80

Femme assise dans un fauteuil, peignoir entrouvert, 1920
Woman Seated in a Chair, Open Peignoir

Nice, Hôtel Méditerranée
Model: Antoinette or Henriette
45.7 x 30.5 (18 x 12)
Signed lower left: *Henri-Matisse*

Mr. and Mrs. Nathan L. Halpern

Provenance
Gaston Bernheim de Villers, Paris (from the artist)
Sam Salz, New York

Literature
Basler 1924b, ill.

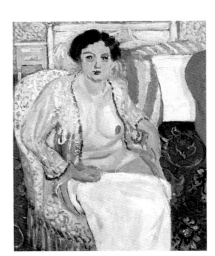

Cat. no. 80, pl. 88

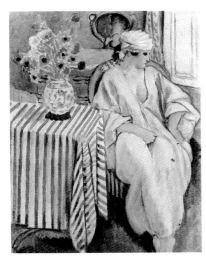

Cat. no. 81, pl. 97

81

La Méditation—Aprés le bain, 1920
The Meditation—After the Bath

Nice, Hôtel Méditerranée
Model: Antoinette or Henriette (see remarks no. 84)
73 x 54 (28¾ x 21¼)
Signed lower left: *Henri-Matisse*
Bernheim-Jeune photograph October 1921

Private collection

Provenance
Gaston Bernheim de Villers, Paris
Mr. and Mrs. Albert D. Lasker, New York
Marlborough Gallery

Exhibitions
Paris 1931, no. 60
New York 1931a, no. 53, ill.
New York 1951a, no. 52, ill. p. 27
London 1968, no. 84, ill. p. 115
Zurich 1971, no. 10, ill. color
London 1978, no. 3, ill. color

Literature
Faure 1923, ill. pl. 9
Huyghe 1939, ill. pl. 25
Mushakojo 1939, ill. p. 63, fig. 127
Grünewald 1944, ill. p. 80
Greenberg 1953, ill. pl. 16 and cover
Diehl 1954, pp. 75, 155
Astrom 1955, ill. pl. 16 and cover
Huyghe 1955, ill. pl. 16 and cover
Lübecker 1955, ill. pl. 16 and cover
Brockway 1957, p. 103, ill. color p. 104
Lassaigne 1959, ill. color p. 98
Luzi 1971, ill. no. 314
Alpatov 1973, color pl. 32
Watanabe 1973, color pl. 49
Gowing 1979a, p. 143, ill. p. 144
Schneider 1982, ill. no. 314
Schneider 1984, p. 513

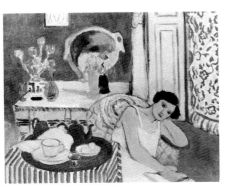

Cat. no. 82, pl. 94

82

Le petit déjeuner, 1920
The Breakfast

Nice, Hôtel Méditerranée
Model: Antoinette
61 x 71 (24 x 28)
Signed lower right: *Henri-Matisse*
Bernheim-Jeune photograph May 1920

Philadelphia Museum of Art: The Samuel S. White,
3rd, and Vera White Collection

Provenance
Galerie Bernheim-Jeune, Paris
Etienne Bignou
Samuel S. White, 3rd, Ardmore, Pennsylvania

Exhibitions
Basel 1931, no. 63
Philadelphia 1947, no. 72, ill.
New York 1947, no. 8
Philadelphia 1948, no. 53, ill.
Philadelphia 1950

Literature
Gardiner 1968, no. 25, ill.
Luzi 1971, ill. no. 342
Schneider 1982, ill. no. 342

83

Le thé du matin, 1920
The Morning Tea

Nice, Hôtel Méditerranée
Model: Antoinette
33 x 56 (13 x 22)
Signed lower right: *Henri-Matisse*
Bernheim-Jeune photograph May 1920

Private collection, Tokyo

Provenance
Galerie-Bernheim Jeune, Paris
Paul Epstein, Paris (30 July 1920)
Georges Lurcy, New York
Parke-Bernet, New York, 7 November 1957, lot 12
Kornfeld, Bern
Galerie Beyeler, Basel
Christie's, New York, 16 May 1977, lot 44
Davlyn Gallery, New York
Galerie Nichido, Tokyo

Exhibitions
Paris 1920, no. 9(?)
New York 1957b, no. 12, ill.
New York 1977b, no. 44, ill. color

Literature
Schwob 1920, ill. p. 192
Grautoff 1921, ill.
Vildrac 1921, ill. p. 218
Schacht 1922, ill. p. 79

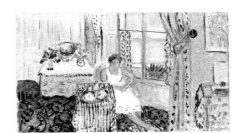

Cat. no. 83, pl. 95

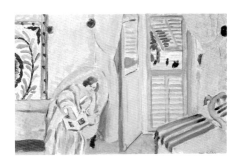

Cat. no. 84, pl. 98

84

Intérieur à Nice, femme assise avec un livre, 1920

Interior, Nice, Seated Woman with a Book

Nice, Hôtel Méditerranée
Model: Antoinette or Henriette (see below)
47 x 66 (18½ x 26)
Signed lower right: *Henri-Matisse*
Bernheim-Jeune photograph June 1921

Philadelphia Museum of Art: Given by Mr. and Mrs. R. Sturgis Ingersoll

Provenance
Laroche, Paris (19 June 1923)
Etienne Bignou, Paris and New York
R. Sturgis Ingersoll, Penllyn (by 1930)

Exhibitions
The Hague 1927
New York 1927b, no. 10, ill.
New York 1931a, no. 50, ill.
Providence 1931
Philadelphia 1933b
Birmingham 1951
Palm Beach 1953

Literature
McBride 1930, ill. pl. 34
Barr 1951, p. 558
Diehl 1954, p. 77

Remarks
It is not clear whether this painting depicts the model Antoinette or the model Henriette. If the latter, the work should be dated late 1920, because Henriette began to model for Matisse in September or October of that year.

85

Femme au divan, 1920

Woman on a Sofa

Nice, Hôtel Méditerranée
Model: Antoinette or Henriette
60 x 73.5 (23⅝ x 29)
Signed lower right: *Henri-Matisse*
Bernheim-Jeune photograph April 1921

Oeffentliche Kunstsammlung, Kunstmuseum Basel

Provenance
Galerie Bernheim-Jeune, Paris (from the artist, 9 April 1921)
Mabzukaka (25 September 1921)
Richard Doetsch-Benziger, Switzerland

Exhibitions
Basel 1956, no. 21, ill.
Paris 1970b, no. 164, ill. p. 164

Literature
Courthion 1937, ill. pl. XXXIX
Courthion 1942, ill. color p. 31
Ferrier 1961, color pl. 11
Luzi 1971, ill. no. 359, color pl. LII
Orienti 1971, color pl. 23
Alpatov 1973, color pl. 34
Muller 1970, ill. color p. 81
Schneider 1982, ill. no. 359, color pl. LII

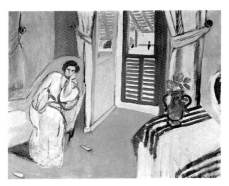

Cat. no. 85, pl. 99

Remarks
See Remarks, cat. no. 84.

86

L'allée des oliviers, 1920

Path Through the Olive Trees

Nice, Rimiez
74 x 60 (29⅛ x 23⅝)
Signed lower right: *Henri-Matisse*
Bernheim-Jeune photograph June 1921

Musée d'Art Moderne de la Ville de Paris

Provenance
Acquired in 1939

Exhibitions
Copenhagen 1924, no. 81
Berlin 1930, no. 36
Basel 1931, no. 66
Amsterdam 1939, no. 68, ill.
Bern 1947, no. 64
Zurich 1947, no. 258
Fribourg-im-Brisgau 1947, ill. pl. 26
Lucerne 1949, no. 73
Nice 1950, no. 15
Knokke-Le Zoute 1952, no. 22, ill.
Paris 1956, no. 54
Paris 1958, no. 13
Nice 1960, no. 86, ill. pl. XIV
Rotterdam 1963, no. 71
Strasbourg 1968, no. 166, ill. pl. 80
Paris 1970b, no. 166, ill. p. 226
Okayama 1974, ill.
Tokyo 1981, no. 48, ill. color p. 73

Literature
Fels 1929, ill. pl. 15
Escholier 1937b, ill. color
Mushakojo 1939, ill. color
Diehl 1954, p. 75
Luzi 1971, ill. no. 324
Schneider 1982, ill. no. 324

Cat. no. 86, pl. 66

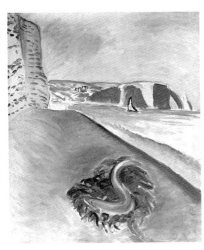

Cat. no. 87, pl. 110

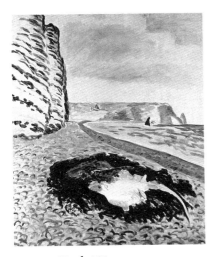

Cat. no. 88, pl. 111

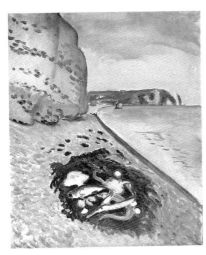

Cat. no. 89, pl. 112

87

Grande falaise, le congre, 1920
Large Cliff, The Eel

Etretat
91 x 72 (35⅞ x 28⅜)
Signed lower left: *Henri Matisse*
Bernheim-Jeune photograph September 1920

Columbus Museum of Art, Ohio: Gift of Ferdinand Howald

Provenance
Galerie Bernheim-Jeune, Paris (from the artist, 8 September 1920)
Marius de Zayas, New York (24 September 1920)
John Quinn, New York
Valentine Dudensing, New York
Ferdinand Howald, New York (1926 to 1931)

Exhibitions
Paris 1920, no. 29, ill.
New York 1921b, no. 70, ill.
Columbus 1969, no. 18, ill.
London 1973, no. 35, ill.
Dublin 1973, no. 35, ill.
Cardiff 1973, no. 35, ill.

Literature
Watson 1926a, p. 11
Barr 1951, p. 209
Zilczer 1978, p. 172
Flam 1973a, n.p.

88

Grande falaise, les deux raies, 1920
Large Cliffs, The Two Rays

Etretat
93 x 73 (36⅝ x 28¾)
Signed lower right: *Henri-Matisse*
Bernheim-Jeune photograph September 1920

Norton Gallery and School of Art, West Palm Beach, Florida

Provenance
Galerie Bernheim-Jeune, Paris (from the artist, November 1920)
L. Marseille, Paris
Lord Ivor Spencer Churchill, London
Harry S. Southam, Ottawa
E. A. Silberman Galleries, Inc., New York (to 1945)
Ralph H. and Elizabeth Calhoun Norton

Exhibitions
Paris 1920, no. 28, ill.
Paris 1931, no. 66, ill.
Basel 1931, no. 55
New York 1931a, no. 54, ill. p. 95
Philadelphia 1948, no. 51, ill.
New York 1951a, no. 34
Palm Beach 1953, no. 21, ill. p. 6
New York 1955b, no. 32, ill. p. 44
Chicago 1960, no. 34
Pittsburgh 1965
New York 1966a, no. 41, ill. p. 43
Sydney 1975, ill. p. 99

Literature
Barnes 1933, pp. 26, 47, 50, 92, 119, 132, ill. p. 297
Mushakojo 1939, ill. p. 61, fig. 122
Barr 1951, pp. 197, 209, 210, 232, ill. p. 433
Dorra 1953, p. 30, ill.
Norton Gallery 1958, p. 20
Escholier 1960, ill. pl. 32
Marchiori 1967a, ill. p. 61
Luzi 1971, ill. no. 333
Flam 1973a, color fig. 2
Norton Gallery 1979, no. 257, p. 111, color pl. 21
Schneider 1982, ill. no. 333
Schneider 1984, p. 504

89

Grande falaise, les poissons, 1920
Large Cliff, Fish

Etretat
93.1 x 73.3 (36⅝ x 29)
Signed lower right: *Henri-Matisse*
Bernheim-Jeune photograph November 1920

The Baltimore Museum of Art: The Cone Collection, formed by Dr. Claribel Cone and Miss Etta Cone of Baltimore, Maryland. BMA 1950.233

Provenance
Georges Bernheim, Paris (from the artist)
Galerie Bernheim-Jeune, Paris (from Georges Bernheim, 6 November 1920)
Claribel and Etta Cone, Baltimore (6 July 1923)

Exhibitions
Baltimore 1925, no. 69
Baltimore 1930, no. 17
Paris 1931, no. 86
Baltimore 1949, no. 37
Baltimore 1950
New York 1979b
Los Angeles 1985

Literature
George 1931, ill.
Boas 1934, ill.
Romm 1937, ill.
Romm 1947, ill.
Vogue 1955, ill. color p. 134
Pollack 1962, ill. p. 172
Rosenthal 1967, no. 45
Luzi 1971, ill. no. 332
Flam 1973a, ref. n.p., fig. 10
Schneider 1982, ill. no. 332
Richardson 1985, p. 173, ill. p. 26, color pl. 174

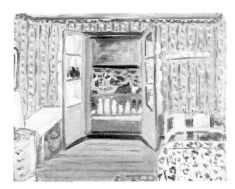

Cat. no. 90, pl. 113

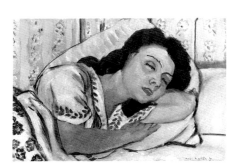

Cat. no. 91, pl. 114

90

Intérieur à Etretat, le 14 Juillet, 1920
Interior, Etretat, 14 July

72.5 x 60 (28½ x 23⅝)
Signed lower left: *Henri-Matisse*
Bernheim-Jeune photograph September 1920

Courtesy of Davlyn Gallery, New York

Provenance

Galerie Bernheim-Jeune, Paris (from the artist,
November 1920)
Oscar Miestchaninoff, Paris (6 November 1920)
Hôtel Drouot, Paris, 17 December 1927, lot 10
Georges Bernheim, Paris (17 December 1927)
Private Collection, Switzerland
Marianne and Walter Fleichenfeld, Zurich
Lefevre Gallery, London

Exhibitions

Paris 1920, no. 49
Paris 1927a, no. 10, ill.
London 1980, no. 12, ill. color
London 1981
Tokyo 1981, no. 51, ill. color
Zurich 1982, no. 67, ill. color
London 1983a, no. 7, ill. color p. 17
New York 1984a, no. 48, ill. color

Literature

Diehl 1954, p. 77

91

Portrait de Marguerite endormie, 1920
Portrait of Marguerite Asleep

Etretat
46 x 65 (18⅛ x 25⅝)
Signed and dated lower right: *Henri-Matisse 19-*
Bernheim-Jeune photograph February 1922

Private collection

Provenance

Estate of the artist
Private collection (by descent)

Exhibitions

Zurich 1925b, no. 300, ill. pl. XXVIII
Lucerne 1949, no. 70
Nice 1950, no. 14
Paris 1956, no. 58
London 1968, no. 86, ill. p. 65

Literature

Faure 1923, ill. pl. 15
Schürer 1925–1926, ill. p. 290
Einstein 1926, ill. pl. II
Zervos 1928, ill. p. 159
Mushakojo 1939, ill. p. 68, fig. 139
Duthuit 1956a, vol. III, ill. pl. CLXXIV
Duthuit 1956b, ill. p. 24
Escholier 1960, ill. pl. 37

92

Les crevettes roses, 1920
Pink Shrimps

Etretat
54 x 73 (21¼ x 28¾)
Bernheim-Jeune photograph September 1920
Signed lower left: *Henri-Matisse*

Everhart Museum, Scranton, Pennsylvania

Provenance

Galerie Bernheim-Jeune, Paris (from the artist, early
November 1920)
Oscar Miestchaninoff, Paris
Hôtel Drouot, Paris, 17 December 1927, lot 8
Jean Aron, Paris (17 December 1927)
Pierre Wertheimer, Paris
Stephen C. Clark, New York
Galerie Durand-Ruel, New York
Mr. and Mrs. David M. Levy, New York (1949)
Adele R. Levy Fund, Inc., New York (Gift to Everhart
Museum 1962)

Exhibitions

Paris 1920, no. 31, ill.
Paris 1927a, no. 8, ill.
New York 1930b, no. 55
Paris 1931, no. 76
Basel 1931, no. 59
New York 1931a, no. 58, ill.
New York 1934a, no. 112, ill.
New York 1961a, ill. p. 26

Literature

McBride 1930, ill. pl. 44
George 1931, ill.
Lipman 1934, p. 143, ill. p. 141
Romm 1937, ill.
Romm 1947, ill.
Barr 1951, p. 229, ill. color p. 228
Diehl 1954, p. 76
Frankfurter 1962, p. 52, ill. p. 30
Luzi 1971, ill. no. 309
Schneider 1982, ill. no. 309

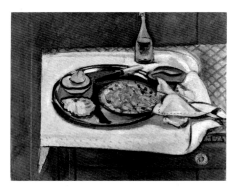

Cat. no. 92, pl. 115

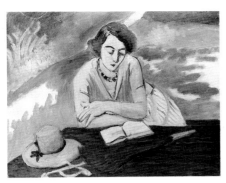

Cat. no. 93, pl. 126

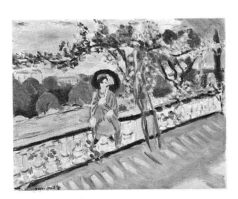

Cat. no. 94, pl. 127

93

Liseuse en plein air, ombrelle sur la table,
October 1921
Reader in the Open Air, Umbrella on a Table

Nice
Model: Henriette
50 x 61 (19⅝ x 24)
Signed lower right: *Henri-Matisse*
Bernheim-Jeune photograph February 1922

The Trustees of The Tate Gallery, London

Provenance
Contemporary Art Society (from the artist, 1926, presented to the Tate Gallery in 1938)

Exhibitions
Paris 1922, no. 17
Copenhagen 1924, no. 69, ill.
London 1926
London 1928, no. 71
London 1935, no. 38

Literature
Vildrac 1922, ill. pl. 11
Faure 1923, ill. pl. 27
Fels 1929, ill. pl. 21
Zervos 1931a, ill. p. 229
Zervos 1931b, ill. p. 9, fig. 1
Barnes 1933, pp. 49, 195, ill. p. 299
Mushakojo 1939, ill. p. 84, fig. 172
Swane 1944, ill. fig. 27
Barr 1951, p. 557
Luzi 1971, ill. no. 322
Alley 1981, p. 498 ill.
Schneider 1982, ill. no. 322
Mannering 1982, ill. color p. 58

Remarks
In a letter to St. John Hutchinson, Matisse said this was among the paintings he had intended to keep: "They are my library and give me information about my work, my direction. . . ." (Alley 1981, p. 498)

94

Sur la terrasse, Parc Liserb, 1921
On the Terrace, Parc Liserb

Nice
Model: Henriette
Oil on canvas on cardboard
37.5 x 45.5 (14¾ x 18)
Signed lower left: *Henri-Matisse*
Bernheim-Jeune photograph April 1921

Musées Royaux des Beaux-Arts de Belgique, Bruxelles
Koninklijke Musea voor Schone Kunsten van België, Brussel

Provenance
Galerie Bernheim-Jeune, Paris (from the artist, 19 April 1921)
La Société de l'Art Vivant (9 January 1922)

Exhibitions
Knokke-Le Zoute 1952, no. 24, ill. p. 28
Tournai 1956, no. 53
Liège 1958, no. 28, ill.
Bruges 1961, no. 64

Literature
Faure 1923, ill. pl. 12
Mushakojo 1939, ill. p. 66, fig. 136
Lejard 1952, color pl. 9
Luzi 1971, ill. no. 426
Schneider 1982, ill. no. 426
Mertens 1984, p. 412 ill.

Remarks
This painting may depict a view from the gardens surrounding the hill of the Château, Nice; see p. 28.

95

La conversation sous les oliviers, 1921
Conversation under the Olive Trees

Nice (probably Rimiez)
Daughter Marguerite and model Henriette
100 x 84 (39⅜ x 33)
Signed
Bernheim-Jeune photograph April 1921

Thyssen-Bornemisza Collection, Lugano, Switzerland

Provenance
Josse Bernheim-Jeune, Paris
A. de Seyssel, Paris
Stephen Hahn, New York

Exhibitions
Paris 1931, no. 88
Basel 1931, no. 64
Paris 1948, no. 60
Paris 1952
Paris 1957b, no. 128, ill. pl. 12
Paris 1958, no. 16, ill.
Paris 1970a
Tokyo 1980, no. 21, ill. color

Literature
Faure 1923, ill. 24
Barnes 1933, pp. 63, 64, 83, 110, 111, 140, 144, 157, ill. p. 315
Mushakojo 1939, ill. p. 79, fig. 159
Ogawa 1966, color pl. 20
Luzi 1971, ill. no. 355
Schneider 1982, ill. no. 355
Pury 1983, ill. color p. 71
Schneider 1984, ill. p. 86

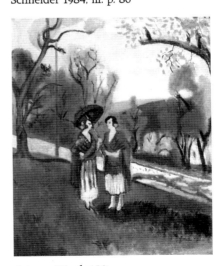

Cat. no. 95, pl. 129

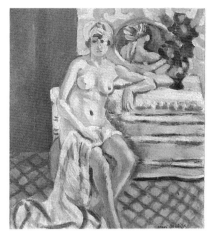

Cat. no. 96, pl. 96

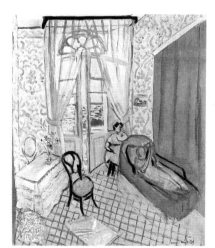

Cat. no. 97, pl. 101

96

Nu assis au turban, reflété dans le miroir, 1921

Seated Nude with Turban, Reflected in a Mirror

Nice, place Charles-Félix
Model: Henriette
38.4 x 34.9 (15⅛ x 13¾)
Signed lower right: *Henri-Matisse*
Bernheim-Jeune photograph April 1921

Sam and Ayala Zacks Collection, Art Gallery of Ontario

Provenance

Galerie Bernheim-Jeune, Paris
Docteur Jacques Soubies, Paris
Hôtel Drouot, Paris, 14 June 1928, lot 53
Henri Canonne, Paris
Ayala and Sam Zacks, Toronto

Exhibitions

Paris 1928a, no. 53, ill.
Toronto 1956, no. 68, ill. pl. 11

Literature

Alexandre 1930a, ill.
Arts 1956, ill. p. 36

Remarks

There is a larger version of this painting in a European private collection. See Luzi 1971, ill. no. 339.

97

Deux femmes dans un intérieur, February 1921

Two Women in an Interior

Nice, Hôtel Méditerranée
Daughter Marguerite on the divan and model Henriette
92 x 73 (36¼ x 28¾)
Signed lower right: *Henri-Matisse*
Bernheim-Jeune photograph May 1921

Paris, Musée de l'Orangerie, Collection Jean Walter et Paul Guillaume

Provenance

Georges Bernheim, Paris
Paul Guillaume, Paris
Mme. Jean Walter, Paris

Exhibitions

Paris 1923a
Paris 1929, p. 76, ill. p. 65
London 1945, no. 29, ill.
Glasgow 1946, no. 24
Brussels 1946, no. 9, ill.
Amsterdam 1946
Paris 1960, no. 74, ill.
Paris 1966, no. 56, ill.
Rome 1978, no. 14, ill. color
Athens 1980, no. 17, ill. color p. 130
Tbilissi 1981, no. 23, ill. color

Literature

Les arts à Paris 1924, ill. p. 13
George 1929, p. 76, ill. p. 65
Mushakojo 1939, ill. p. 73, fig. 148
Luzi 1971, ill. no. 344

Lassaigne 1981, ill. color
Schneider 1982, ill. no. 344
Hoog 1984, no. 52, pp. 122–124, ill. color p. 123

98

Femme à l'ombrelle rouge, assise de profil, 1919 or 1921

Woman with Red Umbrella, Seated in Profile

Nice, Hôtel Méditerranée
Model: Antoinette or Henriette
81 x 65 (31⅞ x 25⅝)
Signed lower left: *Henri-Matisse*
Bernheim-Jeune photograph June 1921

Private collection

Provenance

Galerie Bernheim-Jeune, Paris (from the artist, 14 June 1921)
Monteux, Limoges
Acquavella Galleries, Inc., New York, and Marianne Fleichenfeld, Zurich (jointly, through Philippe Reichenbach, Montreux, 1971)

Exhibitions

New York 1973, no. 22, ill. color

Remarks

If the painting dates from 1919, the model is Antoinette; if 1921, Henriette.

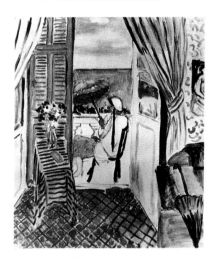

Cat. no. 98, pl. 102

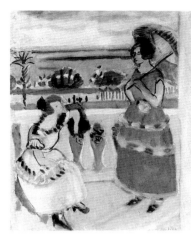

Cat. no. 99, pl. 103

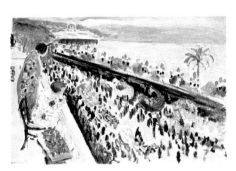

Cat. no. 100, pl. 105

99

Deux femmes sur un balcon, 1921
Two Women on a Balcony

Nice, Hôtel Méditerranée
Daughter Marguerite and model Henriette
69 x 54 (27⅛ x 21¼)
Signed lower right: *Henri-Matisse*
Bernheim-Jeune photograph April 1921

Simon and Marie Jaglom

Provenance
Galerie Bernheim-Jeune, Paris
W. Taylor, Lóndon
Joseph Hessel, Paris
Georges Renand, Paris
Sam Salz, New York
Mr. and Mrs. Adolphe A. Juviler, New York
Parke-Bernet Galleries, New York, October 25, 1961, lot 23

Exhibitions
Paris 1922, no. 36(?)
London 1936, no. 28
Lucerne 1949, no. 77
New York 1951d
New York 1961b, no. 23, ill. color

Literature
Huyghe 1945, pl. 2

100

Fête des fleurs, 1921
Festival of Flowers

Nice, Hôtel Méditerranée
Daughter Marguerite and model Henriette
72.5 x 99 (28½ x 39)
Signed lower left: *Henri-Matisse*
Bernheim-Jeune photograph 21 May 1921

Private collection, Switzerland

Provenance
Georges Bernheim, Paris (from the artist, 1921)
Docteur Jacques Soubies, Paris
Hôtel Drouot, Paris, 14 June 1928, lot 72
Henri Bernstein, Paris (14 June 1928)
M. Knoedler and Co., New York
Joe and Emily Lowe Foundation, New York
Parke-Bernet, New York, 25 February 1970, lot 43
Galerie Beyeler, Basel (1970)
Private collection
Sotheby's, London, 4 December 1974, lot 14

Exhibitions
Paris 1928a, no. 72, ill.
Paris 1947, no. 96
New York 1970a, no. 43, ill. color
Basel 1970, no. 44
London 1974, no. 14, ill. color
Basel 1980, no. 15, ill. color
Zurich 1982, no. 69, ill. color
Tel Aviv 1982

Literature
Lejard 1952, color pl. 6
Diehl 1954, pp. 15, 76, ill. pl. 94
Luzi 1971, ill. no. 385

Schneider 1982, ill. no. 385

Remarks
Five *Fête des fleurs* paintings of comparable format are known to exist: the four in this exhibition (cat. nos. 100, 101, 111, 126) and one in the Kunstmuseum Bern (pl. 107).

101

Fête des fleurs, 1921
Festival of Flowers

Nice, Hôtel Méditerranée
Daughter Marguerite and model Henriette
65 x 101 (25⅝ x 39¾)
Signed lower left: *Henri-Matisse*
Bernheim-Jeune photograph May 1921

Private collection, Zurich

Provenance
Georges Bernheim, Paris
Alfred Flechtheim, Berlin
Jules Furthman, Los Angeles
Jacques Seligman, Paris
Germain Seligman, Paris and New York
Emil G. Bührle, Zurich
Private collection, Zurich
Marlborough Galerie AG, Zurich

Exhibitions
Hamburg 1927, no. 212, ill.
Berlin 1931, no. 47
Zurich 1958, no. 295
Zurich 1971, no. 11, ill. color

Literature
Seligman 1961, ill. pl. 96a

Remarks
See Remarks, cat. no. 100.

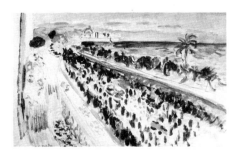

Cat. no. 101, pl. 106

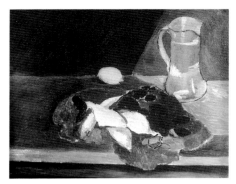

Cat. no. 102, pl. 116

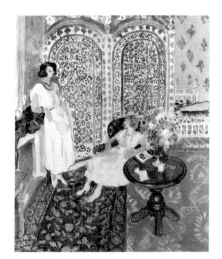

Cat. no. 103, pl. 117

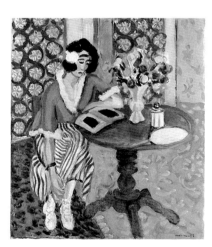

Cat. no. 104, pl. 118

102

Nature morte, poissons et citrons, 1921
Still Life, Fish and Lemons

Etretat
60 x 73 (23⅝ x 28¾)
Signed lower right: *Henri-Matisse*

Private collection

Provenance
Josse Bernheim-Jeune, Paris
Sam Salz, New York

Exhibitions
New York 1966a, no. 43, ill. p. 42
On loan to The Metropolitan Museum, New York

Literature
Barr 1951, p. 229, ill. color p. 228
Greenberg 1953, color pl. 17
Diehl 1954, p. 77
Astrom 1955, color pl. 17
Huyghe 1955, color pl. 17
Lübecker 1955, color pl. 17
Luzi 1971, ill. no. 335
Schneider 1982, ill. no. 335

103

Le paravent mauresque, 1921
The Moorish Screen

Nice, place Charles-Félix
Models: Henriette standing and an occasional model
92 x 74 (36¼ x 29¼)
Signed lower right: *Henri-Matisse*
Bernheim-Jeune photograph February 1922

Philadelphia Museum of Art: Bequest of Lisa Norris
Elkins

Provenance
Galerie Bernheim-Jeune, Paris (or the artist)
Robert Treat Paine II, Boston
M. Knoedler and Co., New York
Lisa Norris Elkins, Philadelphia

Exhibitions
Paris 1922, no. 24, ill.
New York 1931a, no. 59, ill.
Providence 1931
Paris 1936
Boston 1939, no. 75, ill.
Buffalo 1944, no. 43, ill. p. 32
Philadelphia 1947, no. 73
Philadelphia 1948, no. 57, ill.
Miami 1952
Paris 1956, no. 65, ill. pl. XXV
Los Angeles 1966, no. 56, ill. color p. 87
New York 1966a, no. 44, ill. p. 44
London 1968, no. 90, ill. color p. 43
Stockholm 1984, no. 44, ill. color
Humlebaek 1985, no. 54, ill. color p. 41

Literature
Vildrac 1922, ill. pl. 13
Faure 1923, ill. pl. 31
Courthion 1934, ill. pl. XXXV
Mushakojo 1939, ill. p. 75, fig. 152
Cheney 1941, ill. p. 488

Barr 1951, p. 210, ill. p. 437
Diehl 1954, p. 79, color pl. 90
Canaday 1959, ill. p. 416, fig. 500
Brill 1967, p. 37, color pl. 27
Okamoto 1968, color pl. 53
Diehl 1970, no. 32, ill. color
Aragon 1971, 2, p. 110, color pl. XXI
Luzi 1971, ill. no. 345, color pl. LIII
Ooka 1972, color pl. 61
Watanabe 1973, color pl. 47
Flam 1973b, ill. fig. 35
Russell 1974, ill. p. 277
Gowing 1979a, ill. color p. 156
Daval 1980, ill. color p. 47
Mannering 1982, ill. color p. 60
Schneider 1982, ill. no. 345, color pl. LIII
Schneider 1984, pp. 512, 514, ill. color p. 167

104

Liseuse au guéridon (en vert, robe rayée rouge), 1921
Reader at Pedestal Table (in Green Blouse, Red
Striped Dress)

Nice, place Charles-Félix
Model: Henriette
55.5 x 46.5 (21⅞ x 18¼)
Signed lower right: *Henri-Matisse*
Bernheim-Jeune photograph February 1922

Kunstmuseum Bern

Provenance
Josse Bernheim, Paris
Private collection, Switzerland (to 1981)

Exhibitions
Paris 1922, no. 10
Paris 1924b, no. 36
Paris 1931, no. 73
Belgrade 1936, no. 52
New York 1940c, no. 5
New York 1948c, no. 11
Moutier 1956, no. 47
Stockholm 1984, no. 43
Humlebaek 1985, no. 53, ill. color p. 40

Literature
Vildrac 1922, ill. pl. 9
Fry 1924, ill. p. 151
Aragon 1971, 1, p. 88
Kuthy 1983, no. 1052, ill. p. 283
Georgen 1985, p. 66, ill. p. 67

Remarks
The furniture and decorative elements in this painting
are also found in *Le paravent mauresque* (cat. no. 103).
The pattern of the model's red and white striped skirt
can be found in various other paintings as a tablecloth;
see cat. nos. 57, 81, 83.

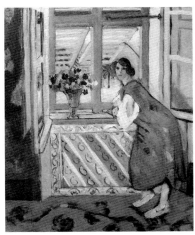

Cat. no. 105, pl. 121

105

Intérieur à Nice, jeune femme en robe verte accoudée à la fenêtre, 1921
Nice Interior, Young Woman in Green Dress Leaning at the Window

Nice, place Charles-Félix
Model: Henriette
65 x 55 (25½ x 21⅝)
Signed lower left: *Henri-Matisse*
Bernheim-Jeune photograph February 1922

Colin Collection

Provenance
Galerie Bernheim-Jeune, Paris (from the artist, 13 February 1922)
Galerie Druet, Paris
Marcel Kapferer, Paris (23 April 1923)
Etienne Bignou, Paris
Valentine Dudensing, New York
Lillie P. Bliss, New York
The Museum of Modern Art, New York (to 1944)
Parke-Bernet, New York, 11 May 1944, lot 83
Mr. and Mrs. Ralph Colin, New York

Exhibitions
Paris 1922, no. 20
Paris 1924c, no. 120
New York 1931c, no. 94, ill.
Andover 1931, no. 72
Indianapolis 1932, no. 68, ill.
New York 1934b, no. 45, ill.
Paris 1937, no. 5
Saratoga Springs 1942, no. 21
New York 1944b, no. 83, ill.
New York 1951c
East Hampton 1952, no. 25
Paris 1956, no. 60, plate 26
New York 1960a, no. 18, ill. color
London 1968, no. 89, ill. p. 118
Paris 1970b, no. 169, ill. p. 229
New York 1973, no. 24, ill. color

Literature
Vildrac 1922, ill. pl. 12
Fry 1924, ill. p. 150
McBride 1930, pl. 35
Goodrich 1930, p. 339 ill.
"Henri Matisse," *Les Chroniques du Jour,* April 1931, pl. 15
Rowe 1931, p. 62, ill. p. 41
Joseph 1931, ill. p. 469
Zervos 1931b, ill. facing p. 80
Cheney 1934, ill. p. 265
Courthion 1934, pl. 37
Kawashima 1936, ill. color
Escholier 1937b, ill. facing p. 73
Barr 1951, p. 210
McBride 1951, ill. p. 36
Diehl 1954, 75
Seckler 1959, ill. color p. 101
Luzi 1971, ill. no. 349, color pl. LV
Gowing 1979a, ill. no. 132, p. 147
Schneider 1982, ill. no. 349, color pl. LV
Schneider 1984, pp. 382 (n. 29), 452, 508, ill. color p. 505
Watkins 1984, p. 159, color pl. 137

106

L'attente, 1921–1922
The Wait

Nice, place Charles-Félix
Models: Antoinette and another woman
61 x 50 (24 x 19⅝)
Signed lower left: *Henri-Matisse*
Bernheim-Jeune photograph October 1922

Collection of the late Lucien Abrams

Provenance
Georges Bernheim, Paris
Louis Vautheret, Lyons
Stephen C. Clark, New York
Marshall Field, Chicago
Lucien Abrams, Old Lyme (1938)

Exhibitions
Paris 1923b
Paris 1931, no. 82
Philadelphia 1948, no. 55, ill.
New York 1964

Literature
Faure 1923, ill. pl. 22
Guenne 1927, ill.
Zervos 1931a, p. 309, ill. fig. 80
Zervos 1931b, ill. p. 89, fig. 80
Kawashima 1936, ill. pl. 16
Escholier 1937b, ill. p. 93
Zervos 1938, ill. p. 169
Cassou 1939, p. 10
Mushakojo 1939, ill. p. 72, fig. 146
Terrasse 1939, ill. pl. 21
Diehl 1954, pp. 77, 155
Escholier 1956a, p. 122
Luzi 1971, ill. no. 395
Schneider 1982, ill. no. 395
Schneider 1984, p. 452

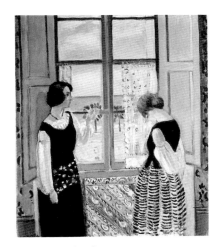

Cat. no. 106 , pl. 122

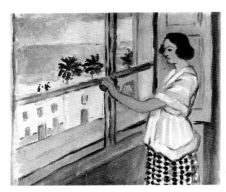

Cat. no. 107, pl. 123

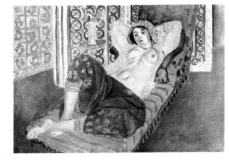

Cat. no. 108, pl. 159

107

Jeune femme à la fenêtre, soleil couchant,
February 1921
Young Woman at the Window, Sunset

Nice, place Charles-Félix
Model: Henriette
52.4 x 60.3 (20 x 25¾)
Signed lower right: *Henri-Matisse*
Bernheim-Jeune photograph March 1922

The Baltimore Museum of Art: The Cone Collection,
formed by Dr. Claribel Cone and Miss Etta Cone of
Baltimore, Maryland. BMA 1950.245

Provenance
Galerie Bernheim-Jeune, Paris (from the artist,
19 February 1922)
Etta (?) Cone, Baltimore (25 June 1923)

Exhibitions
Paris 1922, no. 18
Baltimore 1930, no. 19
Baltimore 1949, no. 48
Baltimore 1950
New York 1979b

Literature
Boas 1934, ill.
Rosenthal 1967, no. 57
Luzi 1971, ill. no. 366
Pollack 1962, ill. p. 172
Schneider 1982, ill. no. 366
Richardson 1985, p. 173, ill. p. 26

108

Odalisque à la culotte rouge, 1921
Odalisque with Red Culotte

Nice, place Charles-Félix
Model: Henriette
67 x 84 (26⅜ x 33⅛)
Signed lower right: *Henri-Matisse*
Bernheim-Jeune photograph March 1922

Musée National d'Art Moderne / Centre Georges
Pompidou

Provenance
Galerie Bernheim-Jeune, Paris
Musée du Luxembourg, Paris (1922)

Exhibitions
Paris 1922, no. 32
Paris 1942
Limoges 1945, no. 26
Beirut 1948
Rio de Janeiro 1949, no. 52, ill.
Santiago 1950, no. 51
Tokyo 1951, no. 43, ill. color
Oostende 1952, no. 32, ill. pl. XIV
Paris 1955b, ill. p. 33
Limoges 1956, no. 17, ill.
Berlin 1946, no. 63
Frankfurt 1956, no. 52
Luxembourg 1956, no. 55
Cardiff 1957, no. 47
London 1957, no. 45
Marseilles 1957, no. 31, ill.
Belgrade 1958, no. 37, ill.

Mexico City, 1962, no. 87
Bombay 1963, no. 186, ill. color
Ghent 1964, no. 183, ill. p. 25
Lisbon 1965, no. 93, ill. color
Los Angeles 1966, no. 58, ill. color p. 88
Cairo 1969, no. 31, ill.
Teheran 1969, no. 10, ill.
Ankara 1969, no. 51
Paris 1971
Munich 1972, no. 394, ill. p. 61
Tokyo 1973, ill. color on cover
Berlin 1977, no. 4115, ill.
London 1984, no. 100, ill. color p. 109

Literature
Fry 1922, p. 237, ill.
Vildrac 1922, ill. pl. 15
Basler 1929, ill. pl. 7
Hintze 1930, ill. p. 26
Huyghe 1930, p. 10
Levinson 1930, pp. 25–27
Barnes 1933, pp. 62, 113, 119, 145, 197, 368, 421,
ill. p. 310
Scheiwiller 1933, ill. pl. XVIII
Romm 1937, p. 23
Huyghe 1935, ill. p. 110, fig. 126
Wilenski 1940, p. 297
Du Colombier 1942, ill. p. 7
Dorival 1946, p. 15
Wild 1950, ill. fig. 44
Barr 1951, pp. 11, 198, 260
Yomiuri 1951, color pl. 55
Bezombes 1953, p. 116, ill. color fig. 341
Rousseau 1953, ill. p. 302
Cassou 1954, p. 111
Diehl 1954, p. 71, 77, 143
Barotte 1954, ill. p. 113
Escholier 1956a, p. 122
Escholier 1956b, p. 712
Lassaigne 1959, p. 72
Dorival 1961a, p. 28, ill. p. 286
Ferrier 1961, color pl. 12
Grunewald 1964, ill.
Vaughan 1965, ill. color p. 27
Jalard 1966, ill. color p. 58
Ogawa 1966, color pl. 23
Muller 1966, ill. no. 66
Marchiori 1967, pp. 64–68, ill. color p. 68
Guichard-Meili 1967, p. 97, ill. color p. 113
Lévêque 1968, color pl. 27
Okamoto 1968, color pl. 60
Russell 1969, ill. color pp. 112–113
Diehl 1970, ill. color no. 34

Jardin des Arts 1970, ill.
Guichard-Meili 1970, ill. color p. 69
Luzi 1971, ill. no. 378
Fermigier 1971, p. 100
Orienti 1971, color pl. 25
Ooka 1972, color pl. 62
Alpatov 1973, color pl. 36
Fourcade 1974, p. 468
Larson 1975, p. 73, ill. p. 72
Monod-Fontaine 1979, p. 48, ill. color p. 49
Muller 1979, ill. color p. 83
Daval 1980, ill. color p. 121
Mannering 1982, ill. color p. 61
Schneider 1982, ill. no. 378
Nöel 1983, color pl. 39
Watkins 1984, pp. 161– 162, ill. pl. 49

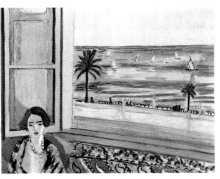

Cat. no. 109, pl. 124

109

Femme assise, le dos tourné vers la fenêtre ouverte, 1921–1923
Seated Woman, Back Turned to the Open Window

Nice, place Charles-Félix
Model: Henriette
73 x 92.1 (28¾ x 36¼)
Signed lower right: *Henri Matisse*

Montreal Museum of Fine Arts / Musée des beaux-arts de Montréal
Purchased 1949 with Tempest Fund

Provenance
Galerie Bernheim-Jeune, Paris
Stephen C. Clark, New York
Durand-Ruel, New York (to 1949)

Exhibitions
New York 1948b, ill. pl. XV
Montreal 1949, no. 20
Ottawa 1949
Toronto 1956
London (Ontario) 1959, no. 13
Ottawa 1962, no. 50, ill. p. 37
Montreal 1965, no. 150
Sarasota 1966, no. 62, ill.
Montreal 1970, no. 107, ill. p. 33
Montreal 1972
Ottawa 1973

Literature
Barr 1951, p. 556
Picher 1956, ill. p. 10
Montreal 1960a, ill. fig. 121
Montreal 1960b, p. 89, no. 1015
Hubbard 1962, p. 88, ill. p. 89
Gottlieb 1964, p. 401, ill. p. 411, fig. 15
Luzi 1971, ill. no. 364
Montreal 1977, ill p. 113, fig. 74
Schneider 1982, ill. no. 364
Callahan 1983, ill. p. 2, fig. 1

110

Intérieur à Nice, la sieste, 1922
Interior, Nice, the Siesta

Nice, place Charles-Félix
Model: Henriette
66 x 54.5 (26 x 21½)
Signed lower left: *Henri-Matisse*
Bernheim-Jeune photograph February 1922

Musée National d'Art Moderne / Centre Georges Pompidou

Provenance
Galerie Bernheim-Jeune, Paris (from the artist 13 February 1922)
Georges Bénard, Paris (with Georges Bernheim, 1 March 1922)
Hôtel Drouot, Paris, 9 June 1933, lot 60
Pommier (9 June 1933)
Frédéric Lung, Algiers
Mrs. Frédéric Lung (to 1961, gift to Musée National d'Art Moderne)

Exhibitions
Paris 1933b, no. 60, ill. p. 65
Albi 1961, no. 17
Caen 1963
Montreal 1963
Strasbourg 1963, no. 90, ill.
Recklinghausen 1967
Madrid 1980, no. 26, ill. color

Literature
Alazard 1951, pp. 68–71, ill. p. 69
Dorival 1961a, p. 38
Dorival 1961c, p. 150, ill. p. 151, fig. 2
Luzi 1971, ill. no. 361
Monod-Fontaine 1979, no. 14, ill. color p. 50
Schneider 1982, ill. no. 361

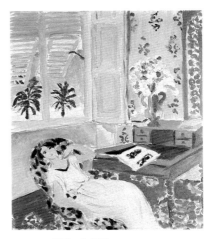

Cat. no. 110, pl. 120

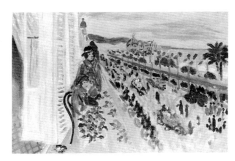

Cat. no. 111, pl. 108

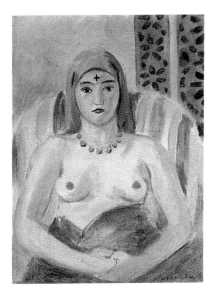

Cat. no. 112, pl. 160

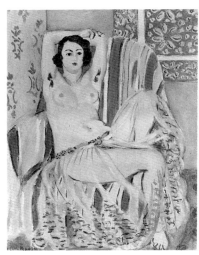

Cat. no. 113, pl. 161

111

Fête des fleurs, 24 February 1922
Festival of Flowers

Nice, Hôtel Méditerranée
Daughter Marguerite and model Henriette
65.8 x 93.1 (25⅞ x 36⅝)
Signed lower right: *Henri-Matisse*
Bernheim-Jeune photograph October 1928

The Baltimore Museum of Art: The Cone Collection, formed by Dr. Claribel Cone and Miss Etta Cone of Baltimore, Maryland. BMA 1950.240

Provenance
Claribel Cone, Baltimore (from the artist, 17 October 1928)

Exhibitions
Baltimore 1930, no. 26
Paris 1931, no. 95
Basel 1931, no. 67
New York 1931a, no. 61, ill.
Baltimore 1949, no. 42
Baltimore 1950
New York 1979b

Literature
Barnes 1933, pp. 92, 196
Boas 1934, ill.
Mushakojo 1939, ill. p. 81, fig. 167
Diehl 1954, pp. 76, 155
Pollack 1962, ill. p. 172
Gottlieb 1964, p. 402, ill. fig. 17
Rosenthal 1967, no. 52
Luzi 1971, ill. no. 384
Schneider 1982, ill. no. 384
Watkins 1984, p. 149, color pl. 133
Richardson 1985, p. 180, ill. color p. 20

Remarks
See Remarks, cat. no. 100.

112

Odalisque à mi-corps—le tatouage, 1923
Odalisque, Half-Length—The Tattoo

Nice, place Charles-Félix
Model: Henriette
35 x 24 (13¾ x 9⁷⁄₁₆)
Signed lower right: *Henri-Matisse*
Bernheim-Jeune photograph February 1923

National Gallery of Art, Washington, Chester Dale Collection 1963.10.40

Provenance
Joseph Hessel, Paris
Georges Bénard, Paris
Galerie Bernheim-Jeune, Paris (14 October 1927)
Jean Laroche, Paris (20 October 1927)
Hôtel Drouot, Paris, 8 December 1928, lot 61
Chester Dale, New York (through Etienne Bignou, 8 December 1928)

Exhibitions
Paris 1928b, no. 61, ill.
Paris 1931, no. 94
Philadelphia 1943

Literature
Faure 1923, ill. pl. 38
Dale 1929a, no. 74, ill.
McBride 1930, ill. pl. 14
McBride 1931b, p. 58
Walker 1965, p. 48 ill.
Luzi 1971, ill. no. 380
Schneider 1982, ill. no. 380

113

Odalisque assise aux bras levés, fauteuil rayé vert, 1923
Odalisque Seated with Arms Raised, Green Striped Chair

Nice, place Charles-Félix
Model: Henriette
65 x 50 (25⅝ x 19⅝)
Signed lower left: *Henri Matisse*

Bernheim-Jeune photograph 1923

National Gallery of Art, Washington, Chester Dale Collection 1963.10.167

Provenance
Galerie Bernheim-Jeune, Paris (from the artist, 1925)
Etienne Bignou, Paris (1928)
Chester Dale, New York (1929)

Exhibitions
Paris 1923b
Lucerne 1929
New York 1930a, no. 60
Paris 1931, no. 103, ill.
Basel 1931, no. 73
New York 1931d, no. 25
Chicago 1943, no. 32, ill.

Literature
Faure 1923, ill. pl. 41
Dale 1929, ill.
McBride 1930, ill. color
Einstein 1931, ill. p. 247
McBride 1931a, p. 58
Barr 1951, p. 211, ill. p. 440
Dale 1960, no. 41, ill. color
Escholier 1960, ill. pl. 33
Dale 1965, ill. p. 51
Bull 1967, color pl. 28
Bowness 1968, color pl. 20
Aragon 1971, 2, p. 110, color pl. XI
Luzi 1971, ill. no. 407
Alpatov 1973, color pl. 33
Schneider 1982, ill. no. 407

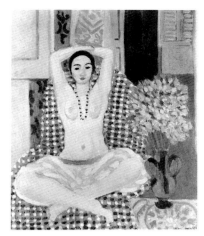

Cat. no. 114, pl. 164

114

La pose hindoue, 1923
The Hindu Pose

Nice, place Charles-Félix
Model: Henriette
83 x 60 (32⅝ x 23⅝)
Signed lower right: *Henri-Matisse*
Bernheim-Jeune photograph October 1923

Private collection

Provenance
Galerie Bernheim-Jeune, Paris
Laroche, Paris
Stephen C. Clark, New York
Valentine Dudensing, New York

Exhibitions
New York 1930a, no. 57, ill.
Paris 1931, no. 98, ill.
New York 1934c
Philadelphia 1948, no. 58, ill.
Paris 1956, no. 71, ill.
New York 1973, no. 29, ill. color

Literature
Guenne 1927, ill.
Fels 1929, ill. pl. 19
Flint 1930, ill. p. 202
McBride 1930, ill. pl. 2
George 1931, ill.
Barnes 1933, pp. 32, 33, 39, 45, 56, 57, 60, 62, 67, 68,
86, 89, 102, 106, 107, 108, 113, 126, 138, 156, 158, 167,
168, 196, 197, ill. p. 325
Courthion 1934, ill. pl. XLVII
Lipman 1934, p. 143
Berthoud 1937, ill. pl. 1
Mushakojo 1939, ill. color
Read 1942, ill. p. 182
Barr 1951, p. 211, ill. p. 441
Diehl 1954, p. 78, ill. pl. 95
Escholier 1956a, p. 122
Lassaigne 1959, ill. color p. 99
Antal 1964, ill. pl. 24
Bowness 1968, color pl. 21
Luzi 1971, ill. no. 408
Watanabe 1973, color pl. 48
Watkins 1977, pp. 10–11, color pl. 32 and dust jacket
Gowing 1979a, ill. p. 155, no. 138
Schneider 1982, ill. no. 408
Schneider 1984, pp. 511, 512, 514
Watkins 1984, p. 162, color pl. 136

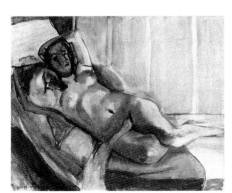

Cat. no. 115, pl. 165

115

Nu allongé sur un sofa, 1923
Reclining Nude on a Sofa

Nice, place Charles-Félix
Model: Henriette
46 x 55 (18⅛ x 21⅝)
Signed lower left: *Henri-Matisse*
Bernheim-Jeune photograph April 1923

Private collection, Switzerland

Provenance
Galerie Bernheim-Jeune, Paris (from the artist,
March 1923)

Roger Perkins (May 1923)

Exhibitions
Paris 1923b
Paris 1985, no. 33, ill. color

Literature
Fry 1924, ill. p. 156
Smery 1927, ill. pl. 20
Escholier 1960, ill. pl. 28

116

Odalisque debout reflétée dans la glace, 1923
Standing Odalisque Reflected in a Mirror

Nice, place Charles-Félix
Model: Henriette
81 x 54.3 (31⅞ x 21⅜)
Signed lower right: *Henri Matisse*
Bernheim-Jeune photograph October 1923

The Baltimore Museum of Art: The Cone Collection,
formed by Dr. Claribel Cone and Miss Etta Cone of
Baltimore, Maryland. BMA 1950.250

Provenance
Etta Cone, Baltimore (from the artist, September 1923)

Exhibitions
Baltimore 1930, no. 18 or no. 39?
Baltimore 1949, no. 54
Baltimore 1950
New York 1979b

Literature
Basler 1924a, ill.
Boas 1934, ill.
Romm 1937, ill.
Romm 1947, ill.
Vogue 1955, ill. color p. 134
Rosenthal 1967, no. 62
Luzi 1971, ill. no. 406
Schneider 1982, ill. no. 406
Richardson 1985, p. 173, ill. color p. 154

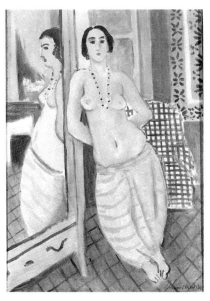

Cat. no. 116, pl. 163

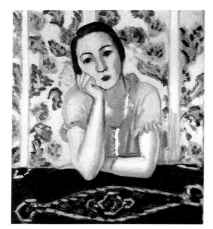

Cat. no. 117, pl. 152

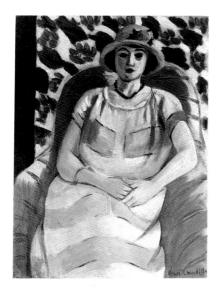

Cat. no. 118, pl. 157

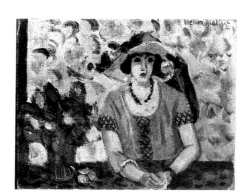

Cat. no. 119, pl. 140

117

La blouse rose, 1922 or 1923
The Pink Blouse

Nice, place Charles-Félix
Model: Henriette
55.9 x 46.7 (22 x 18⅜)
Signed lower right: *Henri-Matisse*
Bernheim-Jeune photograph July 1923

The Museum of Modern Art, New York, Gift of
Mr. and Mrs. Walter Hochschild, 1963

Provenance
Valentine Gallery, New York
Mr. and Mrs. Walter Hochschild, New York
(1929–1963)

Exhibitions
New York 1930c
New York 1931a, no. 52
New York 1932d
New York 1934c, no. 12
New York 1973, no. 34, ill. color
New York 1978a, ill. color p. 123
New York 1985d

Literature
Barnes 1933, pp. 63, 71, 180, ill. p. 333
Fry 1935, ill. pl. 39
Mushakojo 1939, ill. p. 65, fig. 133
Luzi 1971, ill. no. 419
Elderfield 1978a, pp. 122–124, 214, ill. color p. 123
Schneider 1982, ill. no. 419
Schneider 1984, p. 513

118

Jeune femme en rose, 1923
Young Woman in Pink

Nice, place Charles-Félix
Model: Henriette
55 x 38 (21⅝ x 15)
Signed lower right: *Henri-Matisse*
Bernheim-Jeune photograph April 1923

The Fine Arts Museums of San Francisco, Memorial
Gift from Dr. T. Edward and Tullah Hanley, Bradford,
Pennsylvania

Provenance
Galerie Bernheim-Jeune, Paris
Adolphe Lewisohn, New York
Joseph Stransky, New York
Dr. T. Edward and Tullah Hanley

Exhibitions
Paris 1923b
Paris 1931, no. 97
New York 1936a
New York 1967, ill. pl. 34
Columbus 1968, no. 90
Buffalo 1969, no. 173

Literature
Seize Tableaux 1923, ill. pl. 15
Watson 1927, ill. p. 34
Bourgeois 1928, p. 206 ill.
McBride 1930, ill. pl. 18
Dale-Flint 1935, ill.

Escholier 1960, ill. pl. 27
Hattis 1977, p. 311, ill. p. 317

119

La capeline de paille d'Italie, vase de fleurs, 1923
The Italian Straw Hat, Vase of Flowers

Nice, place Charles-Félix
Model: Henriette
13 x 17 (5⅛ x 6¾)
Signed upper right: *Henri Matisse*

Private collection

Provenance
Gift of the artist

Exhibitions
New York 1934c
Bordeaux 1966, no. 105, ill. pl. 63

Remarks
See Remarks, cat. no. 121.

120

La capeline de paille d'Italie, 1922 or 1923
The Italian Straw Hat

Nice, place Charles-Félix
Model: Henriette
73 x 60 (28¾ x 23⅝)
Signed lower right: *Henri Matisse*

Mr. and Mrs. Arnold Saltzman, New York

Provenance
Georges Bernheim, Paris (1923)
Baron and Baroness Gourgaud, Paris
Gourgaud Foundation
Parke–Bernet, New York, 16 March 1960, lot 66
Private collection Los Angeles

Exhibitions
New York 1950b
New York 1960c, no. 66, ill.

Literature
Courthion 1934, ill. pl. XLIII
Diehl 1954, p. 77

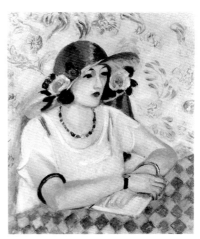

Cat. no. 120, pl. 156

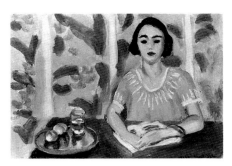

Cat. no. 121, pl. 139

121

Liseuse aux pêches, 1923
Reader with Peaches

Nice, place Charles-Félix
Model: Henriette
12.7 x 17.2 (5 x 6¾)
Signed lower right: *Henri Matisse*

Stephen Hahn Collection, New York

Provenance
Gift of the artist
Private collection (by descent)

Exhibition
New York 1934c

Literature
Schneider 1984, ill. color p. 39

Remarks
This is one of a set of three paintings of identical size and related subjects. Matisse gave one to each of his children. See cat. 119.

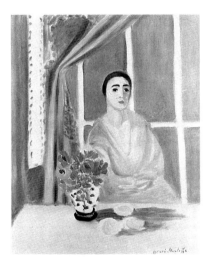

Cat. no. 122, pl. 147

122

Femme assise, sur le fond rouge de l'envers d'un paravent, 1923–1924
Woman seated against the Red Ground of the Back of a Screen

Nice, place Charles-Félix
Model: Henriette
66 x 50.5 (26 x 19⅞)
Signed lower right: *Henri-Matisse*

Worcester Art Museum, Gift of Mrs. R. L. Riley

Provenance
Fearon Galleries, New York
T. Catesby Jones
Louisa Brooke Jones
Private collection, Massachusetts (to 1978)

Literature
Neugass 1929a, ill. p. 17
McBride 1930, ill. pl. 19

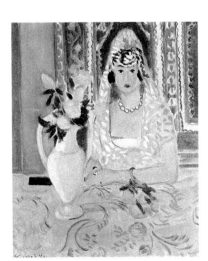

Cat. no. 123, pl. 150

123

L'espagnole aux fleurs, 1923
Spanish Woman with Flowers

Nice, place Charles-Félix
Model: Henriette
61 x 51 (24 x 20⅛)
Signed lower left: *Henri-Matisse*
Bernheim-Jeune photograph April 1923

Private owner represented by Acquavella Galleries

Provenance
Josse Bernheim-Jeune, Paris
Albert D. Lasker, New York
Marlborough Gallery

Exhibitions
Paris 1923b
Copenhagen 1924, no. 79
Paris 1931, no. 99
Zurich 1971, no. 12, ill. color

Literature
Faure 1923, repr. pl. 40
Seize Tableaux 1923, ill. pl. 14
Mushakojo 1939, ill. p. 79, fig. 160
Diehl 1954, p. 78
Brockway 1957, p. 105, ill. color p. 106
Luzi 1971, ill. no. 403
Schneider 1982, ill. no. 403

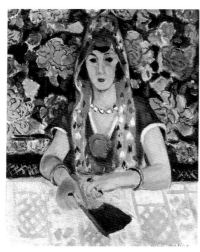

Cat. no. 124, pl. 151

Cat. no. 125, pl. 128

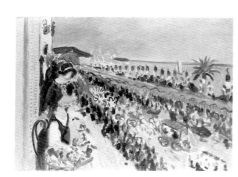

Cat. no. 126, pl. 109

124

Espagnole, harmonie bleue, 1923
Spanish Woman, Harmony Blue

Nice, place Charles-Félix
Model: Henriette
48 x 36 (18⅞ x 14⅛)
Signed lower right: *Henri-Matisse*
Bernheim-Jeune photograph April 1923

Lent by The Metropolitan Museum of Art, Robert
Lehman Collection 1975.1.193

Provenance
Gaston Bernheim de Villers, Paris
Sam Salz(?), New York
Robert Lehman, New York (to 1975)

Exhibitions
Paris 1931, no. 96
Belgrade 1934(?)
New York 1950a, no. 24, ill.
Paris 1957a, no. 71, ill. pl. XLI
Cincinnati 1959, no. 176, ill.
New York 1973, no. 31, ill. color

Literature
Fels 1929, ill. pl. 20
Escholier 1937b, ill. p. 53
Romm 1937, ill.
Mushakojo 1939, ill. p. 83, fig. 171
Romm 1947, ill.
Diehl 1954, p. 78, 155
Antal 1964, ill. pl. 27
Guichard-Meili 1967, p. 99, ill. 90
Marchiori 1967, ill. p. 77
Diehl 1970, ill.
Luzi 1971, ill. no. 404
Schneider 1982, ill. no. 404
Schneider 1984, pp. 513, 514

125

Peintre dans les oliviers, 1923–1924
Painter in the Olive Grove

Model: Henriette
60.3 x 73.4 (23¾ x 28⅞)
Signed lower left: *Henri-Matisse*

The Baltimore Museum of Art: The Cone Collection,
formed by Dr. Claribel Cone and Miss Etta Cone of
Baltimore, Maryland. BMA 1950.249

Provenance
Pierre Matisse
Claribel Cone, Baltimore (6 July 1925)

Exhibitions
Baltimore 1930, no. 31, ill. p. 10
New York 1931, no. 62, ill.
Baltimore 1949, no. 36
Baltimore 1950
London 1968, no. 91, ill. p. 119
New York 1979b
Los Angeles 1985

Literature
Marcel 1924, color pl. XXV
Boas 1934, ill.
Mushakojo 1939, ill. p. 81, fig. 166

Barr 1951, p. 210, ill. p. 438
Rosenthal 1955, ill. p. 63
Vogue 1955, ill. color p. 134
Antal 1964, ill. pl. 23
Guichard-Meili 1967, p. 95, ill. 86
Rosenthal 1967, no. 51, ill. p. 35
Luzi 1971, ill. no. 386
Schneider 1982, ill. no. 386
Watkins 1984, p. 147, ill. pl. 130
Richardson 1985, p. 175, ill. color p. 113

126

Fête des fleurs, 1923
Festival of Flowers

Nice, Hôtel Méditerranée
Daughter Marguerite and model Henriette
67.3 x 95.2 (26½ x 37½)
Signed lower left: *Henri-Matisse*
Bernheim-Jeune photograph May 1923

Cleveland Museum of Art, Mr. and Mrs. William H.
Marlatt Fund

Provenance
Georges Bernheim, Paris
Galerie Bernheim-Jeune, Paris (from Georges Bernheim,
14 April 1923)
Marcel Kapferer, Paris (17 April 1923)
Alex Reid and Lefevre, London and Glasgow
M. Knoedler and Co., New York
Ralph M. Coe, Cleveland (1928)

Exhibitions
Leipzig 1924
Glasgow 1924
New York 1927c
London 1927, no. 10
Cleveland 1929
Chicago 1933, no. 390
Cleveland 1936, no. 327
Los Angeles 1941, no. 24
Philadelphia 1948, no. 59, ill.
Palm Beach 1953, no. 23
New York 1951a, no. 56, ill. p. 27
Cleveland 1956
Kansas City 1961, no. 5, ill. pl. 5

Literature
Faure 1923, ill. 32
Basler 1924a, pl. 24
Basler 1924b, ill. p. 1007
McBride 1930, ill. pl. 25
Watson 1930, p. 333
Mushakojo 1939, ill. p. 68, fig. 140
Francis 1947, pp. 68–70, ill. p. 62
Venturi 1948, color pl. II
Barr 1951, p. 210, ill. p. 438
Diehl 1954, pp. 76, 143
Milliken 1958, ill. 517
Escholier 1960, ill. pl. 25
Luzi 1971, ill. no. 427
Saisselin 1978, ill. p. 248
Schneider 1982, ill. no. 427

Remarks
See Remarks, cat. no. 100.

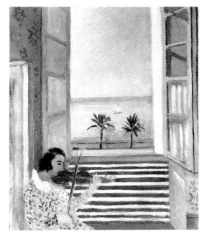

Cat. no. 127, pl. 125

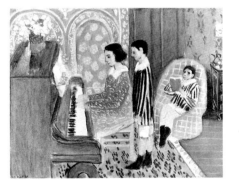

Cat. no. 128, pl. 154

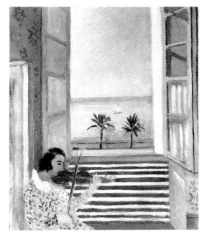

Cat. no. 129, pl. 153

127

Jeune femme jouant du violon devant la fenêtre ouverte, 1923
Young Woman Playing a Violin Before an Open Window

Nice, place Charles-Félix
Model: Henriette
73 x 60.3 (28¾ x 23¾)
Signed lower right: *Henri-Matisse*
Bernheim-Jeune photograph February 1924

Mrs. Leicester Van Leer, New York

Provenance
Galerie Bernheim-Jeune (from the artist, 14 December 1923)
G. Levy (6 March 1924)
Paul Guillaume(?), Paris
Valentine Dudensing, New York
James Thrall Soby (1931)
Marie Harriman Gallery, New York
Maurice Wertheim

Exhibitions
Paris 1924b, no. 24
Chicago 1934, no. 354
San Francisco 1936, no. 25
Cambridge 1946, p. 58, ill. p. 59
New York 1973, no. 28, ill. color

Literature
Bertram 1930, ill. pl. XV
Art News 1936, p. 10, ill.

128

La leçon de piano, Henriette et ses frères, 1923
The Piano Lesson, Henriette and Her Brothers

Nice, place Charles-Félix
65 x 81 (25⅝ x 31⅞)
Signed lower left: *Henri-Matisse*
Bernheim-Jeune photograph February 1924

Private collection

Provenance
Georges Bernheim, Paris
Marcel Kapferer, Paris
Alex Reid & Lefevre, London and Glasgow (1926)
Royan Middleton, Aberdeen, Scotland

Exhibitions
Paris 1924b, no. 30(?)
Paris 1924c
London 1927, no. 12
Glasgow 1927, no. 53
Berlin 1930
Paris 1931, no. 102, ill.
Edinburgh 1954, no. 7
London 1983b, no. 9, ill. color p. 25
Humlebaek 1985, no. 52, ill. color p. 40

Literature
Basler 1924a, ill.
Basler 1924b, ill. p. 1000
McBride 1930, ill. pl. 9
Barnes 1933, pp. 34, 51, 57, 62, 71, 104, 112, 117, 159, 196, ill. p. 320

Scheiwiller 1933, pl. XXIV
Huyghe 1935, ill. fig. 129, p. 111
The Studio, London, February 1939, p. 53
Swane 1944, ill. fig. 31
Scheiwiller 1947, ill. pl. XVIII
Diehl 1954, p. 79, ill. color p. 93
Diehl 1970, ill.
Aragon 1971, 1, p. 134, color pl. XIV
Luzi 1971, ill. no. 401
Schneider 1982, ill. no. 401

129

Pianiste et joueurs de dames, early 1924
Pianist and Checker Players

Nice, place Charles-Félix
Models: Henriette and her brothers
73.7 x 92.1 (29 x 36⅜)
Signed lower right: *Henri-Matisse*
Bernheim-Jeune photograph March 1924

National Gallery of Art, Washington, Collection of Mr. and Mrs. Paul Mellon 1985.64.25

Provenance
Galerie Bernheim-Jeune (from the artist, 21 October 1924)
Sold to G.B. (Georges Bernheim?) (24 October 1924)
Paul Rosenberg, Paris
Stolen by Marshal Goering during World War II, returned to the owner by 1946
Pierre Matisse Gallery, New York
Paul Rosenberg, New York (1965)
Private collection, New York
Mr. and Mrs. Paul Mellon, Upperville, Virginia (until 1985)

Exhibitions
New York 1935
Paris 1937, no. 34
Paris 1946a, no. 53
Los Angeles 1966, no. 59, ill. color p. 86
Sydney 1975, ill. p. 101
Washington 1978a
Washington 1986

Literature
Marcel 1924, ill. pl. XXVII
Warnod 1925, ill. facing p. 144
Eglington 1934, p. 4, ill. p. 5
Art News 1935, ill. p. 12
Barr 1951, pp. 210–211, ill. p. 439
Diehl 1954, pp. 79, 155
Escholier 1960, pl. 35
Luzi 1971, ill. no. 402
Radulescu 1974, color pl. 62
Schneider 1982, ill. no. 402
Schneider 1984, pp. 437, 510, 511, 512, 514, 516, 517, ill. color p. 507

Cat. no. 130, pl. 155

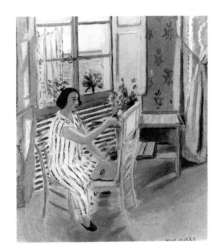

Cat. no. 131, pl. 148

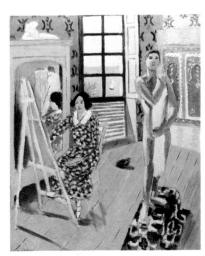

Cat. no. 132, pl. 149

130

Petite pianiste, robe bleue, fond rouge, 1924
Small Pianist, Blue Dress, Red Background

Nice, place Charles-Félix
Model: Henriette
22 x 30 (8⅝ x 11¾)
Signed lower right: *Henri Matisse*

Musée Matisse, Nice

Provenance
Estate of the artist
Mme Henri Matisse (gift to the Musée Matisse by the artist's children in compliance with the verbal bequest of Mme Henri Matisse)

Exhibitions
Paris 1937, no. 54
Knokke-Le Zoute 1952, no. 26, ill. p. 30
Tokyo 1981, no. 67, ill. color p. 91

Literature
Cassou 1939, color pl. 11
Barr 1951, ill. p. 27
Thirion 1967, p. 57

131

La séance du matin, 1924
The Morning Session

Nice, place Charles-Félix
Model: Henriette
74 x 61 (29⅛ x 24)
Signed lower right: *Henri-Matisse*
Bernheim-Jeune photograph July 1925

Private collection

Provenance
Valentine Dudensing, New York
Stephen C. Clark, New York
Mr. and Mrs. Maurice Newton, New York
Frederick M. Peyser, New York
Sotheby's New York, 13 May 1986, lot 42

Exhibitions
Paris 1925, no. 614 or 615
New York 1973, no. 32, ill. color
New York 1986, no. 42, ill. color

Literature
Marcel 1924, color pl. XXIX
George 1925b, ill. p. 353
Basler 1930, ill. p. 27
Lipman 1934, p. 143
Guichard-Meili 1967, ill. 89, p. 98
Luzi 1971, ill. no. 396
Schneider 1982, ill. no. 396
Schneider 1984, pp. 426, 510–511

132

La séance de trois heures, early 1924
The Three O'Clock Session

Nice, place Charles-Félix
Models: Henriette (painting) and her brother
92 x 73 (36¼ x 28¾)
Signed lower left: *Henri-Matisse*

Bernheim-Jeune photograph July 1925

Private collection

Provenance
Stephen C. Clark, New York
Private collection, New York

Exhibitions
Paris 1925, no. 614 or no. 615
Paris 1931, no. 107
Basel 1931, no. 82
New York 1932b
Philadelphia 1948, no. 60, ill.
New York 1954a, no. 10, ill.
New York 1978b, no. 45, ill. color

Literature
Marcel 1924, color pl. XXX
Mauny 1925, ill. p. 287
Fels 1929, ill. pl. 23
George 1931, ill.
Lipman 1934, p. 143
Kawashima 1936, ill. color
Romm 1937, ill.
Mushakojo 1939, ill. p. 88, fig. 185
Romm 1947, ill.
Davidson 1948, ill. fig. 55
Hess 1948, ill. p. 18
Marchiori 1967a, ill. p. 76
Luzi 1971, ill. no. 421
Schneider 1982, ill. no. 421

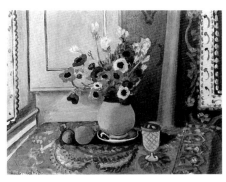

Cat. no. 133, pl. 143

133

Anémones dans un vase de terre, 1924
Anemones in an Earthenware Vase

Nice, place Charles-Félix
73 x 92 (28¾ x 36¼)
Signed lower left: *Henri-Matisse*
Bernheim-Jeune photograph May 1924

Kunstmuseum Bern

Provenance
Gaston Bernheim de Villers, Paris
Galerie Rosengart, Lucerne (to Kunstmuseum Bern, 1945)

Exhibitions
Paris 1924b, no. 3(?)
Copenhagen 1924, no. 89
Paris 1931, no. 109
Bern 1947, ill.
Lucerne 1949, no. 80, ill. pl. X
Nice 1950, no. 21, ill.
Paris 1951, no. 23, ill.
Biel 1953, no. 69, ill. color
Rotterdam 1954, no. 131, ill. p. 65
Moutier 1956, no. 46
Paris 1959, no. 90, ill. pl. 49
Wolfsburg 1961, no. 99
Paris 1964, no. 43, ill.
Los Angeles 1966, no. 61, ill. color p. 8
London 1968, no. 94, ill. p. 122
Zurich 1982, no. 71, ill. color

Literature
Neugass 1929a, ill. p. 13
Luzi 1971, ill. no. 413
Schneider 1982, ill. no. 413
Kuthy 1983, no. 1055, ill. p. 283

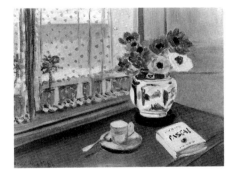

Cat. no. 134, pl. 141

134

Nature morte, "Les pensées de Pascal," 1924
Still Life, "Les Pensées de Pascal"

Nice, place Charles-Félix
50 x 65 (19⅝ x 25⅝)
Signed lower left: *Henri-Matisse*
Bernheim-Jeune photograph May 1924

Private collection

Provenance
Galerie Bernheim-Jeune, Paris
Henri Canonne, Paris (1931?)
Private Collection, Paris
Galerie Schmit, Paris
Lefevre Gallery, London
Perls Gallery, New York

Exhibitions
Paris 1924b, no. 26, ill.
Paris 1931, no. 111, ill.
Paris 1969, no. 82, ill. color
Paris 1982, no. 64, ill. color
London 1982a, ill. color
London 1983a, no. 8, ill. color
Stockholm 1984, no. 48
Humlebaek 1985, no. 58, ill. color p. 63

Literature
Alexandre 1930a, ill.
McBride 1931a, ill. p. 466
Barnes 1933, pp. 44, 47, 86, 109, 112, 127, 144, 169, ill. p. 331
Mushakojo 1939, ill. p. 86, fig. 181
Ozenfant 1968, p. 215
Luzi 1971, ill. no. 412
Schneider 1982, ill. no. 412
Apollo 1983, ill. color on cover

135

Vase de fleurs devant la fenêtre, 1924
Vase of Flowers in Front of the Window

Nice, place Charles-Félix
60 x 73.5 (23⅝ x 29)
Signed lower right: *Henri-Matisse*
Bernheim-Jeune photograph February 1924

Museum of Fine Arts, Boston, Bequest of John T. Spaulding

Provenance
Georges Bernheim, Paris
M. Knoedler and Co., New York (1929)
John T. Spaulding, Boston (1929 to 1948)

Exhibitions
New York 1928d, no. 45, ill.
Cambridge 1929, no. 62
Boston 1931
Cambridge 1949
Denver 1954
Boston 1957
New York 1973, no. 35, ill. color
Framingham 1975

Literature
Edgell 1949, ill. color
Pope 1930, p. 98, ill. color p. 117
Hendy 1931, pp. 109–113, ill. p. 113
Barr 1951, p. 557
Luzi 1971, ill. no. 414
Schneider 1982, ill. no. 414
Murphy 1985, p. 184, ill.

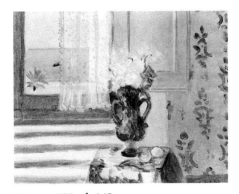

Cat. no. 135, pl. 142

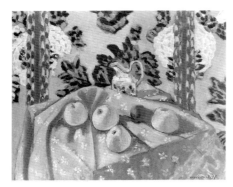

Cat. no. 136, pl. 130

136

Nature morte aux pommes sur nappe rose, 1924
Still Life with Apples on a Pink Tablecloth

Nice, place Charles-Félix
60.4 x 73 (23¾ x 28¾)
Signed lower right: *Henri-Matisse*
Bernheim-Jeune photograph March 1925

National Gallery of Art, Washington, Chester Dale
Collection 1963.10.169

Provenance
Galerie Bernheim-Jeune, Paris (4 February 1925)
Percy Moore Turner, London (6 June 1925)
Mrs. R. A. Workman, London
Alex Reid and Lefevre, Ltd., London (1 May 1928)
Kraushaar Galleries, New York (22 May 1928)
Chester Dale, New York (December 1930)

Exhibitions
London 1928, no. 13
New York 1928c, no. 9, ill.
New York 1930b, no. 13
Pittsburgh 1931, no. 5, ill.
New York 1931a, no. 60A
Chicago 1943, no. 35, ill.
Washington 1952, no. 38, ill.

Literature
Goodrich 1928, p. 371 ill.
McBride 1930, ill. pl. 42
Dale 1931a, ill. p. 35
Dale 1960, p. 40 ill.
Dale 1965, p. 50 ill. color
Luzi 1971, ill. no. 391
Jacobus 1979, p. 160, color pl. 38
Schneider 1982, ill. no. 391

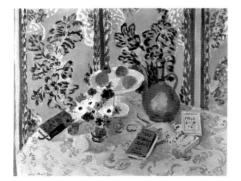

Cat. no. 137, pl. 131

137

Nature morte, "Histoires Juives," 1924
Still Life, "Histoires Juives"

Nice, place Charles-Félix
82 x 101 (32¼ x 39¾)
Signed lower left: *Henri-Matisse*
Bernheim-Jeune photograph May 1924

Philadelphia Museum of Art: The Samuel S. White,
3rd, and Vera White Collection

Provenance
Galerie Bernheim-Jeune, Paris (from the artist, 15 April 1924)
Samuel S. White, 3rd, Ardmore (31 January 1925)

Exhibitions
Paris 1924b, no. 24(?)
Philadelphia 1928
Paris 1931, no. 114, ill.
New York 1931a, no. 65, ill.
Providence 1931
Philadelphia 1933a
Chicago 1933, no. 396, ill. pl. LXVII
San Francisco 1936, no. 26
Boston 1938, no. 34
Philadelphia 1947, no. 75
Philadelphia 1948, no. 63, ill.
Philadelphia 1950a

Philadelphia 1963, ill. p. 160
Philadelphia 1965, no. 18

Literature
Barnes 1933, pp. 26, 32, 34, 36, 56, 57, 67, 87, 92, 93, 103, 108, 119, 134, 146, 156, 167, 196, ill. p. 330
Mushakojo 1939, ill. p. 87, fig. 183
Hess 1948, ill. p. 18
Barr 1951, p. 212
Hamilton 1967, ill. p. 444
Gardiner 1968, no. 26, ill.
Luzi 1971, ill. no. 411
Schneider 1982, ill. no. 411
Schneider 1984, p. 27

138

Liseuse accoudée à une table, devant une tenture relevée, season 1923–1924
Reader Leaning at a Table, Before a Drawn-up Curtain

Nice, place Charles-Félix
60 x 49 (23⅝ x 19¼)
Signed lower left: *Henri-Matisse*
Bernheim-Jeune photograph May 1924

Collection of Henry Ford II

Provenance
Galerie Bernheim-Jeune, Paris
Paul Rosenberg, Paris
Coutot, Paris
Ganowitz, New York
A. Bellanger (1938)
Alex Reid and Lefevre, London
Kraushaar Gallery, New York
Edwin C. Vogel, New York
Sam Salz, New York (to present owner 14 March 1957)

Exhibitions
Paris 1924b, no. 36(?)
Oslo 1938, no. 9, ill.

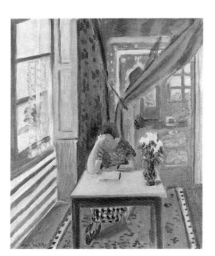

Cat. no. 138, pl. 146

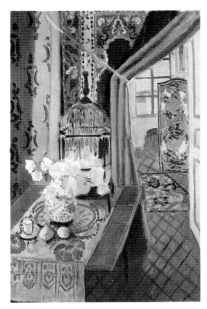

Cat. no. 139, pl. 145

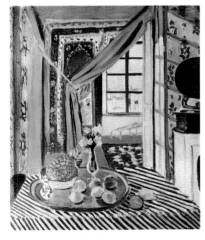

Cat. no. 140, pl. 144

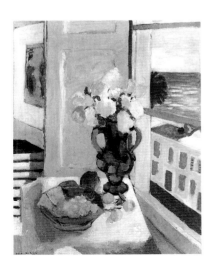

Cat. no. 141, pl. 138

139

Intérieur, fleurs et perruches, 1924
Interior, Flowers and Parrots

Nice, place Charles-Félix
117 x 74 (46⅛ x 29⅛)
Signed lower right: *Henri Matisse*
Bernheim-Jeune photograph May 1924

The Baltimore Museum of Art: The Cone Collection, formed by Dr. Claribel Cone and Miss Etta Cone of Baltimore, Maryland. BMA 1950.252

Provenance
Galerie Bernheim-Jeune, Paris
Pierre Matisse
Etta Cone, Baltimore (6 July 1925)

Exhibitions
Paris 1924b, no. 32, ill.
Baltimore 1930, no. 16(?)
New York 1930a, no. 58, ill.
Chicago 1933, no. 393
Baltimore 1949, no. 56
Baltimore 1950
New York 1951a, no. 57, ill. p. 28
New York 1954a, no. 8, ill.
London 1968, no. 92, ill. p. 120
New York 1979b
Los Angeles 1985

Literature
Boas 1934, ill.
Barr 1951, p. 212
Diehl 1954, p. 78
Rosenthal 1955, ill. p. 62
Vogue 1955, ill. color p. 135
Rosenthal 1967, no. 64, ill. color p. 37
Luzi 1971, ill. no. 417
Schneider 1982, ill. no. 417
Richardson 1985, p. 175, ill. color p. 44

140

Intérior au phonographe, 1924
Interior with Phonograph

Nice, place Charles-Félix
100.5 x 80 (39⅝ x 31½)
Signed lower right: *Henri-Matisse*
Bernheim-Jeune photograph May 1924

Private collection

Provenance
Georges Bernheim, Paris
Stephen C. Clark, New York
Albert D. Lasker, New York
Marlborough Gallery

Exhibitions
Paris 1924b, no. 13, ill.
Philadelphia 1948, no. 61, ill.
New York 1951b
Dallas 1952
San Francisco 1954
New York 1962
Los Angeles 1966, no. 62, ill. p. 90
Paris 1970b, no. 171, ill. p. 230
Zurich 1971, no. 13, ill. color

Literature
Schürer 1925–1926, ill. p. 291
McBride 1930, ill. pl. 38
Courthion 1934, ill. pl. LXIV
Lipman 1934, p. 144, ill. p. 137
Grünewald 1944, ill. p. 88
Barr 1951, ill. p. 442
Diehl 1954, p. 78
Brockway 1957, p. 107, ill. color p. 108
Antal 1964, ill. pl. 19
Luzi 1971, ill. no. 416, color pl. LVIII
Gowing 1979a, p. 146, ill. 131
Selz 1981, ill. color fig. 171
Schneider 1982, ill. no. 416, color pl. LVIII
Buettner 1983, ill. p. 129
Schneider 1984, pp. 414, 438, 452, 511, ill. color p. 509
Watkins 1984, p. 162, ill. pl. 50

141

Les roses safrano devant la fenêtre, 1925
Saffron Roses in Front of the Window

Nice, place Charles Félix
80 x 65 (31½ x 25⅝)
Signed lower left: *Henri-Matisse*
Bernheim-Jeune photograph July 1925

Private collection, Switzerland

Provenance
Galerie Druet, Paris (September 1925)
Mrs. H. Goldet, Paris (December 1925)
Private collection, Paris
Galerie Schmit, Paris

Exhibitions
Paris 1958, no. 19, ill.

Literature
Fels 1929, ill. pl. 28
Fry 1935, ill. pl. 44
Escholier 1937b, ill. p. 103
Romm 1937, ill.
Mushakojo 1939, ill. p. 92, fig. 190
Romm 1947, ill.
Antal 1964, ill. pl. 26
Fry 1970, ill. p. 14
Luzi 1971, ill. no. 430
Paris 1982, ill. color p. 65 (not in exhibition)
Schneider 1982, ill. no. 430

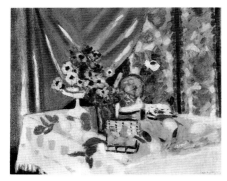

Cat. no. 142, pl. 132

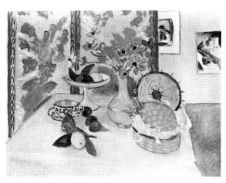

Cat. no. 143, pl. 133

Cat. no. 144, pl. 67

142

Nature morte, nappe rose, vase d'anémones, citrons et ananas, 1925

Still Life, Pink Tablecloth, Vase of Anemones, Lemons, and Pineapple

Nice, place Charles-Félix
80 x 100 (31½ x 39⅜)
Signed and dated lower right: *Henri-Matisse 25*

Private collection

Provenance
Pierre Matisse Gallery, New York
Private collection

Exhibitions
Berlin 1930, no. 67, ill.
New York 1934c
New York 1954a, no. 11, ill. color

Literature
Schneider 1984, ill. color p. 512

143

Nature morte (ananas, compotier, fruits, vase d'anémones), 1925

Still Life (Pineapple, Compote, Fruits, Vase of Anemones)

Nice, place Charles-Félix
81 x 100 (31⅞ x 39⅜)
Signed lower left: *Henri-Matisse*
Bernheim-Jeune photograph April 1925

Philadelphia Museum of Art, The Henry P. McIlhenny Collection In Memory of Frances P. McIlhenny

Provenance
Galerie Bernheim-Jeune, Paris (from the artist, 20 April 1925)
Charles Pacquement, Paris (6 May 1925)
Hôtel Drouot, Paris, 12 December 1932, lot 48
Valentine Dudensing, New York (12 December 1932)
Henry P. McIlhenny, Philadelphia

Exhibitions
Basel 1931, no. 74
Paris 1932, no. 48, ill.
New York 1936b, no. 9
San Francisco 1936
Philadelphia 1947
Philadelphia 1948, no. 64, ill.
San Francisco 1962, no. 28, ill. color
Allentown 1977, p. 94, ill. color p. 95
Pittsburgh 1979
Atlanta 1984, no. 39, ill. color p. 91

Literature
Huyghe 1935, ill. p. 106, fig. 122
Barr 1951, p. 212
Luzi 1971, ill. no. 433
Schneider 1982, ill. no. 433

Remarks
There are two other paintings with this composition: one in the Glasgow Museum of Art, and the major *La nappe rose, citrons et anémones*, see pl. 134.

144

Rochers de la vallée du Loup, 1925
Rocks in the Valley of the Loup

38.5 x 47 (15⅛ x 18½)
Signed lower left: *Henri-Matisse*
Bernheim-Jeune photograph April 1925

Bridgestone Museum of Art, Tokyo

Provenance
Galerie Bernheim-Jeune, Paris (20 April 1925)
Charles Pacquement, Paris (6 May 1925)
Hôtel Drouot, Paris, 12 December 1932, lot 46
Walter Halvorsen(?)

Exhibitions
Paris 1931, no. 119
Basel 1931, no. 89
Paris 1932, no. 46, ill.
Tokyo 1981, no. 69, ill. color p. 93

Literature
Tokyo 1974, ill. color
Tokyo 1977, ill. color

145

Antibes, paysage vu de l'intérieur d'une automobile, 1925
Antibes Landscape from the Interior of an Automobile

37 x 61 (14⅝ x 24)
Signed lower right: *HM*

Mr. and Mrs. Warren Brandt

Provenance
Mme Duthuit, Paris
The Crestart Company, Tulsa (1971–1977)

Exhibition
Tulsa 1972, no. 96

Literature
Schneider 1984, ill. p. 60

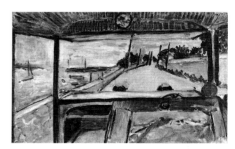

Cat. no. 145, pl. 68

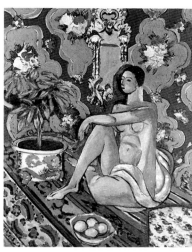

Cat. no. 146, pl. 168

146

Figure décorative sur fond ornemental,
winter 1925–1926
Decorative Figure on an Ornamental Ground

Nice, place Charles-Felix
Model: Henriette
130 x 98 (51⅛ x 38⅝)
Signed lower left: *Henri-Matisse*
Bernheim-Jeune photograph October 1926

Musée National d'Art Moderne/Centre Georges Pompidou

Provenance
Les Musées Nationaux (from the artist, 1938)

Exhibitions
Paris 1926b, no. 2178
New York 1927
Chicago 1927, no. 13
Venice 1928
Berlin 1930, no. 73, ill. pl. 45
Paris 1931, no. 118
Basel 1931, no. 92, ill.
New York 1931a, p. 21, no. 70, ill.
Stockholm 1931, no. 92
Chicago 1933, no. 39
New York 1934c, no. 14
Brussels 1935, no. 630
Paris 1937, no. 33
London 1945, no. 22, ill.
Glasgow 1946, no. 21, ill. pl. 3
Berlin 1946, no. 118, ill.
Konstanz 1946
Innsbruck 1946
Mainz 1946, no. 118, ill.
Baden-Baden 1946, no. 118, ill.
Vienna 1947, no. 94, ill.
Philadelphia 1948, no. 66, ill.
New York 1951a, no. 59, ill. p. 28
London 1957, no. 47
Tokyo 1961, no. 262, ill. color
Cleveland 1966, no. 39, ill. color
Los Angeles 1966, p. 16, no. 66, ill. p. 95
Washington 1968, no. 26, ill.
Paris 1970b, no. 172, ill. p. 229
Copenhagen 1970, no. 52, ill.
La Courneuve 1974
Rome 1978, no. 16, ill. color
Zurich 1982, no. 72, ill. color

Literature
Tériade 1926, p. 110, ill. p. 111
Bouyer 1926, p. 125
Charensol 1926, p. 206, ill. p. 203
Guenne 1926, p. 402
Rey 1926, p. 44
Bulliett 1927, ill. facing p. 81
Jean 1927, p. 56
Watson 1927, ill.
Fels 1929, ill. pl. 31
Neugass 1929a, ill. p. 377
Palmer 1929, ill.
Cahiers d'Art 1930, no. 2, ill. p. 107
McBride 1930, p. 17, ill. pl. 1
Chroniques du Jour 1931, no. 9, ill.
Fry 1931, ill.

McBride 1931a, p. 466
Schapiro 1932, p. 34, ill. frontispiece
Barnes 1933, pp. 32, 70, 72, 102, 104, 156, 159, 185, 196, 208, 209
Bulliett 1933, ill. facing p. 88
Fry 1935, ill. pl. 46
Kawashima 1936, ill. pl. 18
Escholier 1937b, ill. p. 79
Cassou 1939, color pl. 16
Mushakojo 1939, ill. p. 94, fig. 194
Grünewald 1944, ill. p. 96
Swane 1944, ill. fig. 35
Dorival 1946, p. 15
Cassou 1948, color pl. 6
Lewisohn 1948, ill. pl. 139
Myers 1950, p. 287, ill. fig. 44
Raynal 1950, p. 54, ill. color p. 55
Barr 1951, pp. 200, 203, 214, 215, 224, 260, 269, ill. pp. 27, 449
Greenberg 1953, color pl. 23
Rousseau 1953, ill. p. 93
Cassou 1954, p. 112
Diehl 1954, pp. 79, 83, 155, color pl. 99
Huyghe 1955, color pl. 23
Astrom 1955, color pl. 23
Lübecker 1955, color pl. 23
Médicine de France 1955, ill.
Escholier 1956a, p. 166
Hunter 1956, ill. color fig. 19
Neumayer 1956, color pl. 4
Le Jardin des Arts 1957, ill. color on cover
Lassaigne 1959, ill. color p. 103
Escholier 1960, ill. pl. 38
Dorival 1961a, p. 126, ill. p. 290
Selz 1964, ill color p. 49
Antal 1964, ill. pl. 25
Grünewald 1964, ill.
Jedlicka 1965, ill. fig. 13
Lassaigne 1966, color pl. 5
Ogawa 1966, color pl. 27
Brill 1967, p. 37, color pl. 29 and on cover
Leymarie 1967, color pl. XII
Guichard-Meili 1967, pp. 212–214, ill. p. 213
Hamilton 1967, p. 445
Lévêque 1967, ill. color no. 6, p. 21
Marchiori 1967a, p. 64
Marchiori 1967b, ill. color p. 53
Arnason 1968, p. 113, color pl. 39
Lévêque 1968, ill. color p. 31
Bowness 1968, color pl. 25
Okamoto 1968, color pl. 58
Moulin 1968, p. 17
Russell 1969, p. 108, ill. color p. 109
Hoog 1969, p. 539
Cabanne 1970, ill. p. 10
Diehl 1970, ill. color no. 35
Fry 1970, p. 16, ill. p. 17
Jardin des Arts 1970, ill. p. 24
Carlson 1971, p. 110
Luzi 1971, ill. no. 444, color pl. LIX, and dust cover
Elsen 1972, pp. 56, 153, ill. p. 153
Jacobus 1972, pp. 38, 154, 164, ill. color p. 165
Ooka 1972, color pl. 64
Batterberry 1973, ill. color fig. 86
Watanabe 1973, color pl. 10

Bois 1974, pp. 439–440
Garaudy 1974, pp. 237–242, ill. color p. 238
Radulescu 1974, color pl. 52
McBride 1975, p. 267
Maillard 1975, p. 412, ill. color p. 414
Milhaud 1975, pp. 133, 134
Hunter-Jacobus 1976, ill. color p. 217
Minemura 1976, color pl. 26
Gowing 1979a, p. 162, ill. p. 163, no. 149
Monod-Fontaine 1979, pp. 56–61, ill. color p. 56
Lassaigne 1981, ill. color
Schneider 1982, no. 444, color pl. LIX
Nöel 1983, color pl. 41
Monod-Fontaine 1984, p. 35, ill. p. 39
Watkins 1984, p. 164, color pl. 142
Schneider n.d., color pl. V
Schneider 1984, pp. 170, 382(n. 29), 393, 416(n. 32), 513, 532, 534, 536, 539(n. 14), ill. color p. 529

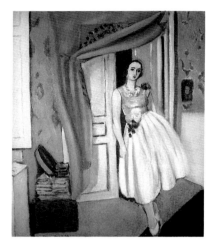

Cat. no. 147, pl. 158

147

Sylphide, 1926

Nice, place Charles Félix

Model: Henriette
45 x 38 (17¾ x 15)
Signed lower left: *Henri Matisse*

Mr. and Mrs. Peter Meltzer, New York

Provenance
Valentine Dudensing, New York
Phillips Collection, Washington (to 1947)
Pierre Matisse, New York

Exhibition
Paris 1928d

Literature
Duthuit 1926, ill.
Charensol 1928, ill. p. 901
Palmer 1929, ill.
Cassou 1939, p. 10

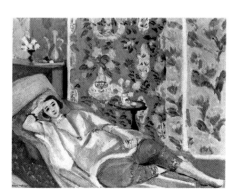

Cat. no. 148, pl. 167

148

Odalisque à la culotte rouge, aiguière et guéridon, 1926

Odalisque in Red Culotte, with Ewer and Round Table

Nice, place Charles-Félix
Model: Henriette
50 x 61 (19⅝ x 24)
Signed lower left: *Henri-Matisse*

Paris, Musée de l'Orangerie, Collection Jean Walter et Paul Guillaume

Provenance
Paul Guillaume, Paris
Mme Paul Guillaume, later Mme Jean Walter, Paris

Exhibitions
Paris 1929
Paris 1931, no. 129
Paris 1946b, no. 56
Paris 1966, no. 61, ill. p. 128
Rome 1978, no. 15, ill. color

Literature
George 1929, ill. p. 9
McBride 1930, ill. pl. 4
Barnes 1933, pp. 82, 87, 89, 108, 126, 144, 156, 164
Lassaigne 1947, ill. color
Luzi 1971, ill. no. 437
Schneider 1982, ill. no. 437
Hoog 1984, p. 136, no. 58, ill. color p. 137

Remarks
A drawing closely related to this painting published in George 1925 (pl. 46) and dated 1923 would suggest a date of c. 1924 for this work.

149

Les citrons au plat d'étain, 1926

Lemons on a Pewter Plate

Nice, place Charles-Félix
43 x 66 (16⅞ x 26)
Signed lower right: *Henri-Matisse*
Bernheim-Jeune photograph October 1926

Mrs. Joanne Toor Cummings

Provenance
Pierre Matisse Gallery (1938)
Lee Ault, New York
Nathan Cummings, New York

Exhibitions
Berlin 1930, no. 56, ill. p. 27
Basel 1931, no. 78
Philadelphia 1948, no. 69, ill.
New York 1951a, no. 60
Los Angeles 1952, no. 38
Los Angeles 1966, no. 65, ill. color p. 94
New York 1966a, no. 47, ill. p. 47
London 1968, no. 100, ill. p. 128
Washington 1970, no. 31, ill. color

Literature
Zervos 1931b, ill. facing p. 96
Barr 1951, p. 215, ill. p. 450
Luzi 1971, ill. no. 449
Watkins 1977, color pl. 34
Schneider 1982, ill. no. 449

Cat. no. 149, pl. 136

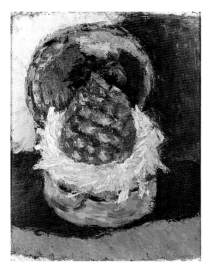

Cat. no. 150, pl. 137

Cat. no. 151, pl. 69

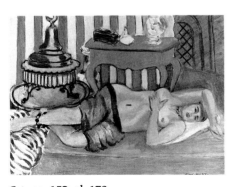

Cat. no. 152, pl. 170

150

Ananas dans un panier, 1926
Pineapple in a Basket

Nice, place Charles-Félix
47 x 38 (18½ x 15)
Bernheim-Jeune photograph October 1926

Mme Jean Matisse

Provenance
Estate of the artist
Jean Matisse, Pontoise

Exhibitions
New York 1938a, no. 1
Paris 1970b, no. 173, ill. p. 230
Madrid 1980, no. 27, ill. color
Tokyo 1981, no. 72, ill. color p. 96

Literature
Luzi 1971, ill. no. 457
Schneider 1982, ill. no. 457

151

Route du Cap d'Antibes—Le grand pin, 1926
Road to Cap d'Antibes—The Large Pine

50 x 61 (19⅝ x 24)
Signed lower right: *Henri-Matisse*

Mme Jean Matisse

Provenance
Estate of the artist
Jean Matisse, Pontoise

Exhibitions
Paris 1937, no. 36
Oslo 1938, no. 12
London 1945, no. 6
Glasgow 1946, no. 6
Brussels 1946, no. 6, ill.
Lucerne 1949, no. 54
Tokyo 1951, no. 50
Albi 1961, no. 19

Literature
Escholier 1937b, ill. p. 75
Cassou 1939, color pl. 13
Yomiuri 1951, color pl. 59
Diehl 1954, p. 79

152

Odalisque à la ceinture verte, 1926–1927
Reclining Odalisque with Green Sash

Nice, place Charles-Félix
Model: Henriette
50.8 x 64.8 (20 x 25½)
Signed lower right: *Henri-Matisse*
Bernheim-Jeune photograph October 1927

The Baltimore Museum of Art: The Cone Collection, formed by Dr. Claribel Cone and Miss Etta Cone of Baltimore, Maryland. BMA 1950.253

Provenance
Galerie Rosengart, Lucerne
Etta Cone, Baltimore (19 August 1937)

Exhibitions
Baltimore 1949, no. 57
Baltimore 1950
New York 1979b

Literature
Gros 1927, ill.
Guichard-Meili 1967, ill. no. 93, p. 101
Rosenthal 1967, no. 65
Luzi 1971, ill. no. 440 and color pl. LXIII
Schneider 1982, ill. no. 440 and color pl. LXIII
Richardson 1985, p. 190

153

Odalisque allongée, culotte verte, ceinture bleue, 1927
Reclining Odalisque, Green Culotte, Blue Belt

Nice, place Charles-Félix
Model: Henriette
50 x 60 (19⅝ x 28⅝)
Signed lower right: *Henri-Matisse*

Collection of Henry Ford II

Provenance
Paul Guillaume, Paris
Valentine Dudensing, New York
Private collection, Switzerland
Carstairs Gallery (to present owner 8 December 1955)

Literature
Gros 1927, ill. p. 272
Uhde 1929, ill. facing p. 26
Seroya 1931, ill. pl. VII

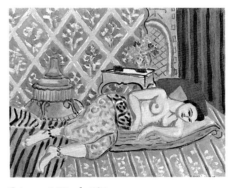

Cat. no. 153, pl. 169

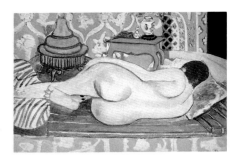

Cat. no. 154, pl. 171

154

Nu couché de dos, summer 1927
Reclining Nude, Seen from the Back

Nice, place Charles-Félix
Model: Henriette
66 x 92 (26 x 36¼)
Signed lower right: *Henri Matisse*
Bernheim-Jeune photograph October 1927

M. Gérard Matisse

Provenance
Estate of the artist
Jean Matisse, Pontoise

Exhibitions
Paris 1927b, no. 1054
Paris 1931, no. 133
Basel 1931, no. 102
New York 1931a, no. 73
Paris 1937, no. 3
Oslo 1938, no. 14(?)
London 1945, no. 8
Glasgow 1946, no. 8
Brussels 1946, no. 8, ill.
Lucerne 1949, no. 86
Nice 1950, no. 26
Philadelphia 1948, no. 70, ill.
Paris 1956, no. 75
Albi 1961, no. 9
Los Angeles 1966, no. 64, ill. color p. 96
New York 1966a, no. 48, ill. p. 47
London 1968, no. 96, ill. p. 124
Rome 1978, no. 18

Literature
Gros 1927, ill.
Fels 1929, ill. pl. 32
Courthion 1934, ill. pl. LIII
Kawashima 1936, ill. pl. 19
Cassou 1939, color pl. 14
Mushakojo 1939, ill. no. 199, p. 98
Hess 1948, ill. p. 18
Diehl 1954, p. 79, ill. pl. 98
Marchiori 1967a, ill. p. 75
Bowness 1968, color pl. 24
Aragon 1971, 1, color pl. LXXIV; 2, p. 110
Luzi 1971, ill. no. 456
Watkins 1977, color pl. 35
Lassaigne 1981, ill. color
Schneider 1982, ill. no. 456
Watkins 1984, color pl. 147

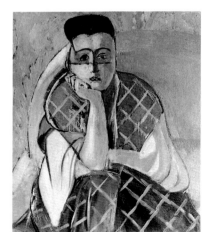

Cat. no. 155, pl. 172

155

La femme à la voilette, 1927
Woman with a Veil

Nice, place Charles-Félix
Model: Henriette
61 x 50 (24 x 19⅝)
Signed lower left: *Henri-Matisse*
Bernheim-Jeune photograph May 1927

William S. Paley, New York

Provenance
From the artist, August 1936

Exhibitions
Paris 1927b
Berlin 1930, no. 71
Paris 1930c
Paris 1931, no. 131
New York 1931a, no. 71, ill.
Basel 1931, no. 104
London 1933, no. 7
New York 1943a, no. 38, ill.
New York 1943b, no. 17
Philadelphia 1948, no. 68
London 1968, no. 98, ill.

Literature
Salmon 1927, ill. p. 276
Fels 1929, ill. pl. 33
Neugass 1929a, ill. p. 372
Joseph 1931, ill. p. 468
Zervos 1931a, ill. fig. 95
Zervos 1931b, ill. fig. 97, p. 95
Fry 1935, p. 8, ill. color
Mushakojo 1939, ill. p. 97, no. 198
Swane 1944, ill. fig. 36
Barr 1951, p. 215, ill. p. 446
Matisse 1954, ill. color p. 129
Aragon 1971, 2, p. 110, color pl. XXIV
Luzi 1971, ill. no. 446
Alpatov 1973, ill. pl. 37
Watkins 1977, p. 11, color pl. 33
Gowing 1979a, ill. color no. 137, p. 153
Schneider 1982, ill. no. 446
Schneider 1984, pp. 39, 42, 528, ill. p. 535 color
Watkins 1984, color pl. 143

Remarks
This is the last painting by Matisse for which Henriette served as the model.

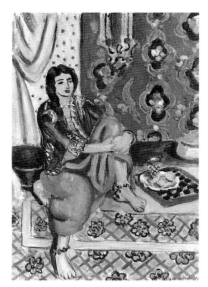

Cat. no. 156, pl. 174

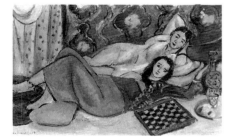

Cat. no. 157, pl. 175

156

Odalisque assise, genou gauche replié, fond ornemental et damier, 1928
Seated Odalisque, Left Knee Bent, with Ornamental Background and Checkerboard

Nice, place Charles-Félix
55 x 37.8 (21⅝ x 14⅞)
Signed lower right: *Henri-Matisse*
Bernheim-Jeune photograph October 1928

The Baltimore Museum of Art: The Cone Collection, formed by Dr. Claribel Cone and Miss Etta Cone of Baltimore, Maryland. BMA 1950.255

Provenance
Claribel or Etta Cone, Baltimore (before 1934)

Exhibitions
Baltimore 1930(?), no. 18 or 39
Baltimore 1949, no. 50
Baltimore 1950
New York 1966b, ill. color
New York 1979b
Los Angeles 1985

Literature
Neugass 1929a, ill. p. 374
Boas 1934, ill.
Kawashima 1936, ill. color
Cone 1950, ill. color p. 38
Barr 1951, p. 215, ill. p. 448
Vogue 1955, ill. color p. 135
Guichard-Meili 1967, ill. color p. 193
Rosenthal 1967, no. 67, ill. pp. 10, 34
Guichard-Meili 1970, pp. 66–68, ill. color p. 67
Luzi 1971, ill. no. 453
Schneider 1982, ill. no. 453
Richardson 1985, ill. pp. 34, 35, ill. color p. 4

157

Le repos des modèles, fond ornemental et damier, 1928
Two Models Resting, Ornamental Ground and Checkerboard

Nice, place Charles-Félix
Model: Hélène and Lily or Zita
46.8 x 73.3 (18½ x 28⅞)
Signed and dated lower left: *Henri-Matisse 28*
Bernheim-Jeune photograph October 1928

Philadelphia Museum of Art: Gift of Mrs. Frank A. Elliott

Provenance
Pierre Matisse Gallery, New York
Cornelius Vanderbilt Whitney, New York (1937)
Mrs. Josiah Marvel, Wilmington (Mrs. C. V. Whitney)
Mrs. Frank Abercrombie Elliott (Mrs. J. Marvel)

Exhibitions
Berlin 1930, no. 79, ill.
Basel 1931, no. 109
Tokyo 1981, no. 74, ill. color

Literature
Fels 1929, ill. pl. 35
Neugass 1929a, ill. p. 375
McBride 1930, ill. pl. 5

Zervos 1931a, ill. fig. 84
Zervos 1931b, ill. p. 91, fig. 84
Courthion 1934, ill. pl. L
Kawashima 1936, ill. pl. 21
Escholier 1937b, ill. p. 119
Mushakojo 1939, ill. p. 100, fig. 202
Slocombe 1939, ill. pl. 32
Georges-Michel 1944, ill.
Antal 1964, ill. pl. 30
Luzi 1971, no. 455 (ill. omitted)

Remarks
This work was painted between 28 January and 7 March 1928.

158

Deux odalisques dont l'une dévêtue, fond ornemental et damier, 1928
Two Odalisques, One Being Nude, Ornamental Ground and Checkerboard

Nice, place Charles-Félix
Models: Zita, dressed, and one of her sisters
54 x 65 (21¼ x 25⅝)
Signed and dated lower right: *Henri Matisse 28*
Bernheim-Jeune photograph October 1928

Moderna Museet, Stockholm

Provenance
Gift of the Society for Promoting the Relations between Swedish and French Art, 1929

Exhibitions
Stockholm 1931, no. 111
Nice 1950, no. 27
Tokyo 1981, no. 75, ill. color
Zurich 1982, no. 73, ill. color
Stockholm 1984, no. 56
Humlebaek 1985, no. 67

Literature
Fels 1929, ill. pl. 36
Mushakojo 1939, ill. fig. 203, p. 101
Grünewald 1944, ill. p. 95
Diehl 1954, p. 83
Antal 1964, ill. pl. 31

Remarks
Begun in the winter of 1927–1928, this painting was finished in July.

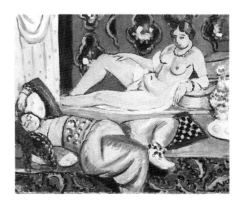

Cat. no. 158, pl. 176

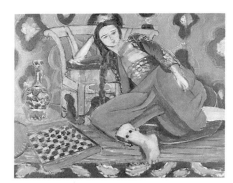

Cat. no. 159, pl. 177

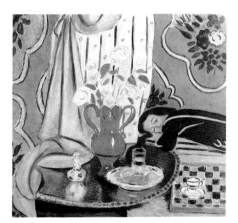

Cat. no. 160, pl. 178

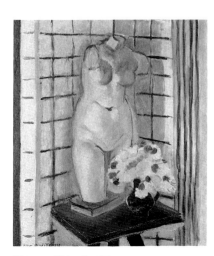

Cat. no. 161, pl. 180

159

Odalisque au fauteuil turc, March 1928
Odalisque with a Turkish Chair

Nice, place Charles-Félix
Model: Zita
60 x 73 (23⅝ x 28¾)
Signed and dated lower left: *Henri Matisse 28*
Bernheim-Jeune photograph October 1928

Musée d'art moderne de la ville de Paris

Provenance
Musée du Petit Palais, Paris (1939)

Exhibitions
Berlin 1930, no. 76, ill.
Paris 1931, no. 134
Basel 1931, no. 107
Amsterdam 1939, no. 74
Buenos Aires 1939, no. 81
Rio de Janeiro 1940
Montevideo 1940
San Francisco 1940b, no. 147, ill. p. 97
Chicago 1941, no. 106, ill. pl. XLIX
Los Angeles 1941, no. 23
Portland 1941
Bern 1947, no. 65
Zurich 1947, no. 259
Lucerne 1949, no. 89, ill. pl. XIII
Venice 1950, no. 37
Hamburg 1951, no. 18, ill.
Rotterdam 1952, no. 88, ill.
Aix-en-Provence 1960, no. 23
Marseilles 1962, no. 76, ill.
Los Angeles 1966, no. 67, ill. p. 92
Paris 1970b, no. 179, ill. p. 233

Literature
Wolfradt 1930, ill. p. 132
Joseph 1931, ill. p. 469
Zervos 1931b, ill. facing p. 96
Escholier 1937b, ill. color
Barnes 1933, pp. 26, 67, 84, 148, 196, 197, ill. p. 341
Genaille 1955, ill. fig. 17
Ogawa 1966, color pl. 26
Guichard-Meili 1967, p. 101, ill. no. 94
Marchiori 1967, ill. p. 78
Guichard-Meili 1970, ill. p. 63
Luzi 1971, ill. no. 452, color pl. LXIV
Gowing 1979a, p. 162, ill. no. 148
Schneider 1982, ill. no. 452, color pl. LXIV

160

Harmonie jaune, 1928
Harmony in Yellow

Nice, place Charles-Félix
Model: Zita
88 x 88 (34⅝ x 34⅝)
Signed and dated lower left: *Henri Matisse 28-*
Bernheim-Jeune photograph October 1928

Collection S

Provenance
Pierre Matisse Gallery, New York (to present owner 1933)

Exhibitions
Berlin 1930
Paris 1931, no. 136
Basel 1931, no. 108
New York 1931a, no. 74, ill.
Chicago 1933, no. 392
New York 1934c, no. 10
Stockholm 1945, no. 59, ill.
Stockholm 1954a, no. 246
Paris 1956, no. 76
Copenhagen 1959, no. 32
Paris 1970b, no. 178, ill. p. 233
Copenhagen 1970, no. 53, ill. color
Basel 1980, no. 18, ill. color
Stockholm 1981, p. 92, ill. color p. 93
Zurich 1982, no. 74, ill. color
Stockholm 1984, no. 55
Lausanne 1985, no. 83, ill. color on cover

Literature
Fels 1929, ill. color p. 20
Neugass 1929a, ill. p. 12
Barnes 1933, pp. 49, 103, 115, 126, 196
Morsell 1934, p. 4
Mushakojo 1939, ill. no. 201, p. 99
Barr 1951, p. 215, ill. p. 451
Diehl 1954, p. 83
Grunewald 1964, ill.
Luzi 1971, ill. no. 460
Schneider 1982, ill. no. 460
Schneider 1984, pp. 35, 36
Humlebaek 1985, no. 66, not exhibited

161

Nature morte au torse de plâtre, 1928
Still Life with Plaster Figure, 1928

Nice, place Charles-Félix
59.7 x 48.3 (23½ x 19)
Signed and dated lower left: *Henri-Matisse 1928*
Bernheim-Jeune photograph October 1928

William Kelly Simpson

Provenance
Galerie Bernheim-Jeune, Paris (November 1930)
Mrs. John D. Rockefeller, New York
Abby Rockefeller Milton
Marylin Milton Simpson

Exhibition
Berlin 1930, no. 78, ill. p. 51

Literature
Neugass 1929a, ill. p. 16
Coronet, July 1938, ill. color p. 14
Diehl 1954, p. 83

Remarks
This painting was begun on 14 June 1928. A similar plaster form on a stand can be seen in the right corner of the false-tiled studio as depicted in *L'atelier,* 1929 (see fig. 39, p. 38 and Schneider 1984, color, p. 61).

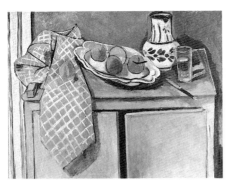

Cat. no. 162, pl. 173

162

Nature morte au buffet vert, July 1928
Still Life on a Green Buffet

Nice, place Charles-Félix
81.5 x 100 (32⅛ x 39⅜)
Signed and dated lower right: *Henri-Matisse 1928*
Bernheim-Jeune photograph October 1928

Musée National d'Art Moderne/Centre Georges
Pompidou

Provenance
L'Association des Amis des Artistes Vivants (from the
artist, 1929)
Musée du Luxembourg, Paris (1929)

Exhibitions
Paris 1928c, no. 1365
Paris 1931, no. 138, ill.
Basel 1931, no. 110
New York 1931a, no. 75, ill.
Paris 1933c, no. 16
The Hague 1936, no. 79
Amsterdam 1939, no. 72, ill.
Limoges 1945, no. 27
Philadelphia 1948, no. 73, ill.
London 1951, no. 42, ill. p. 15
Paris 1951, no. 24, ill.
Amsterdam 1952, no. 59, ill.
Rotterdam 1954, no. 134, ill. pl. 67
Paris 1957b, no. 28
Thonon-les-Bains 1966, no. 7
Moscow 1969, not in catalogue
Okayama 1974, ill.
Stockholm 1984, no. 53, ill. color
Humlebaek 1985, no. 64, ill. color p. 58

Literature
Guenne 1928, p. 871, ill. p. 873
Deutsche Kunst und Decoration 1929, p. 373
Basler 1929, ill. pl. 8
Fels 1929, ill. color p. 27
Neugass 1929a, ill. p. 373
Rey 1929, ill.
Huyghe 1930, p. 7
McBride 1930, p. 20, ill. pl. 46
Zervos 1931b, ill.
Barnes 1933, pp. 49–52, 86, 94, 103, 126, 132, 146, 154,
173, 194, 368, ill. p. 342
Scheiwiller 1933, ill. pl. XXX
Courthion 1934, p. 38
Escholier 1937b, ill. p. 121
Romm 1937, p. 23
Cassou 1939, color pl. 17
Mushakojo 1939, ill. color frontispiece
Wilenski 1940, p. 312
Swane 1944, ill. fig. 37
Dorival 1946, p. 15
Lejard 1948, color pl. 8
Salvini 1949, ill. fig. 46
Soffici 1950, ill. p. 194
Barr 1951, p. 260, ill. p. 450
Lejard 1952, color pl. 10
Cassou 1954, p. 112
Diehl 1954, pp. 83, 143, 155, color pl. 96
Hunter 1956, ill. color fig. 19
Escholier 1960, ill. pl. 36

Dorival 1961a, pp. 40, 128, color pl. 128
Ferrier 1961, color pl. 14
Brill 1967, p. 37, color pl. 30
Marchiori 1967a, p. 97, ill. color p. 96
Lévêque 1967a, ill. color no. 4, p. 25
Lévêque 1968, ill. color p. 34
Okamoto 1968, p. 113, color pl. 61
Diehl 1970, ill. color no. 36
Fermigier 1971, p. 100
Orienti 1971, color pl. 28
Luzi 1971, ill. no. 458
Ooka 1972, color pl. 60
Radulescu 1974, color pl. 23
Monod-Fontaine 1979, p. 63, ill. color p. 62
Muller 1979, ill. color p. 82
Schneider 1982, ill. no. 458
Nöel 1983, color pl. 40

163

Les dahlias, 1928
Dahlias

Nice, place Charles-Félix
131 x 89 (51⅝ x 35)
Signed lower left: *Henri Matisse*

From the Mortimer D. Sackler Family Collection,
Courtesy of Romas Investments Limited

Provenance
Pierre Matisse Gallery, New York
Private collection
Eugene Thaw, New York
Marlborough Gallery, New York

Exhibitions
New York 1938a, no. 7
Chicago 1939, no. 23
New York 1983a, no. 30, ill. color

Literature
Mushakojo 1939, ill. color
Verve 1938, ill. color p. 99
Barr 1951, p. 215
Basel 1980, no. 19, not exhibited

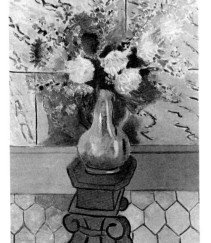

Cat. no. 163, pl. 185

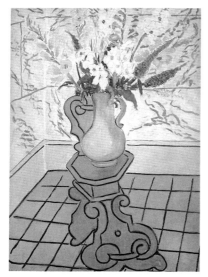

Cat. no. 164, pl. 184

164

Les glaïeuls, 1928
Gladioli

Nice, place Charles-Félix
154 x 102 (60⅝ x 40⅛)
Signed lower left: *Henri-Matisse*
Bernheim-Jeune photograph January 1929

Private collection

Provenance
Joseph Hessel, Paris
Alphonse Kann, Saint Germain-en-Laye
Paul Rosenberg, New York
Walter P. Chrysler, Jr., New York
M. Knoedler and Co., New York
Private collection
Sotheby's, New York, 16 May 1979, lot 265

Exhibitions
Paris 1931, no. 137, ill. p. 49
Paris 1937, no. 23
London 1945, no. 24
Portland 1956, no. 98, ill. p. 141
Dayton 1960, no. 118, ill. p. 126
New York 1962c
Paris 1970b, no. 177, ill. p. 233
New York 1979a, no. 265, ill. color

Literature
Fels 1929, ill. pl. 34
Barnes 1933, pp. 139, 446
Sales 1939, p. 61
Barr 1951, p. 215, ill. p. 452
Diehl 1954, p. 83, 155, ill. pl. 97
Luzi 1971, ill. no. 459
Schneider 1982, ill. no. 459
Schneider 1984, p. 536

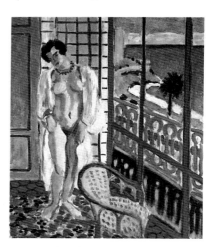

Cat. no. 165, pl. 183

165

Nu dans l'atelier, 1928
Nude in the Studio

Nice, place Charles-Félix
Model: Loulou
60 x 82 (23⅝ x 32¼)
Stamped lower left: *H Matisse*

Fredrik Roos

Provenance
Estate of the artist
Private collection (by descent)
Sotheby's, London, 2 April 1979, lot 58
Davlyn Gallery, New York

Exhibitions
Aix-en-Provence 1960, no. 21, ill.
Paris 1970b, no. 180, ill. p. 235
London 1979, no. 58, ill. color

Literature
Courthion 1970, ill. p. 62
Luzi 1971, ill. no. 461
Schneider 1982, ill. no. 461

Remarks
Another painting depicting more details of this studio
with large window and false-tiled walls is reproduced
in Schneider 1984, p. 61. See also p. 37 and fig. 39.

166

Nu nacré, 1929
Pearly Nude

Nice, place Charles-Félix
Model: Loulou
65 x 54 (25⅝ x 21¼)
Signed and dated lower left: *Henri Matisse 1929*
Bernheim-Jeune photograph October 1929

Private collection

Provenance
Paul Rosenberg
Kraushaar Gallery, New York
H. S. Southam, Ottawa
Vladimir Horowitz, New York
Mrs. Bertram Smith, New York

Exhibition
Philadelphia 1948, no. 71, ill.

Literature
Fels 1929, ill. pl. 40
Kawashima 1936, ill. pl. 22
Mushakojo 1939, ill. p. 103, fig. 206
Barr 1951, p. 215, ill. p. 452
Diehl 1954, pp. 83, 155
Antal 1964, ill. pl. 32
Luzi 1971, ill. no. 463
Schneider 1982, ill. no. 463
Schneider 1984, p. 536

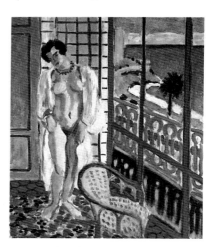

Cat. no. 166, pl. 182

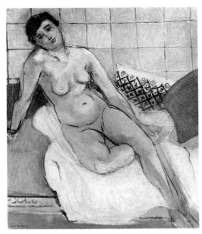

Cat. no. 167, pl. 181

167

Nu gris, 1929
Gray Nude

Nice, place Charles-Félix
Model: Loulou
102 x 81 (40⅛ x 31⅞)
Signed and dated lower left: *Henri-Matisse 29*
Bernheim-Jeune photograph January 1930

Courtesy of Harmon Fine Arts, Inc.

Provenance
Estate of the artist
Marguerite Duthuit, Paris
Galerie Beyeler, Basel
G. David Thompson, Pittsburgh
Galerie Beyeler, Basel
Eugene Thaw, New York

Exhibitions
Berlin 1930, no. 83, ill. p. 55
The Hague 1936, no. 80
New York 1945
Zurich 1960, no. 130, ill. color
Dusseldorf 1960, no. 130, ill. color
The Hague 1961, no. 125, ill. color
New York 1966a, no. 49, ill. p. 46
London 1968, no. 101, ill. p. 129
Saint-Paul 1969, no. 16, ill. color facing p. 37
Zurich 1982, no. 75, ill. color
Fort Worth 1984, no. 47, ill.

Literature
Fels 1929, ill. pl. 38
Scheffler 1929–1930, ill. p. 288
Tériade 1929, ill. p. 289
Zervos 1931b, ill. facing p. 96
Courthion 1934, ill. pl. LV
Mushakojo 1939, ill. p. 103, fig. 205
Barr 1951, p. 215, ill. p. 454
Diehl 1954, p. 83
Guichard-Meili 1967, ill. p. 102, no. 15
Orienti 1971, color pl. 29
Luzi 1971, ill. no. 462
Gowing 1979a, p. 158, ill. no. 145, p. 160
Schneider 1982, ill. no. 462
Mezzatesta 1984, pp. 127–128

168

Odalisque debout au brasero, 1929
Odalisque Standing by the Brazier

Nice, place Charles-Félix
Model: Lisette
92 x 65 (36¼ x 25⅝)
Signed and dated lower right: *Henri-Matisse 1929*

Private collection

Provenance
Estate of the artist
Private collection (by descent)

Literature
Schneider 1984, ill. color p. 515

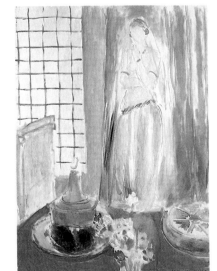

Cat. no. 168, pl. 179

169

Le chapeau jaune, 1929
The Yellow Hat

Nice, place Charles-Félix
Model: Lisette
65 x 45 (25⅝ x 17¾)
Signed and dated lower left: *Henri-Matisse 29*
Bernheim-Jeune photograph January 1930

Courtesy of Smith College Museum of Art,
Northampton, Massachusetts

Provenance
Mrs. Atherton Richards, Honolulu
Herschel Carey Walker, New York (to 1974)
Private collection

Exhibitions
New York 1929b, no. 3
Berlin 1930, no. 82
Paris 1931, no. 141
Basel 1931, no. 111
New York 1931a, no. 78
London 1933, no. 8
Paris 1937, no. 35, ill. p. 39
Oslo 1938, no. 17
New York 1938a, no. 4
New York 1942, no. 5
New York 1943b, no. 19

Literature
Fels 1929, ill. pl. 37
Palmer 1929, ill.
Tériade 1929, p. 286, ill. p. 287
Zervos 1931a, ill. fig. 96
Zervos 1931b, ill. p. 95, fig. 96
Barnes 1933, pp. 72, 157, 179, 182, ill. p. 345
Cassou 1939, color pl. 18
Mushakojo 1939, ill. p. 102, fig. 204
Barr 1951, p. 215, n. 7
Diehl 1954, pp. 83, 155, ill. p. 105
Matisse 1954, ill. color p. 131

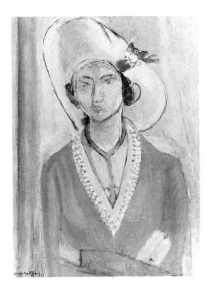

Cat. no. 169, pl. 186

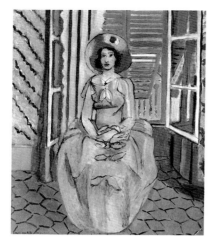

Cat. no. 170, pl. 187

170

La robe tilleul, 1929–1931
The Yellow Dress

Nice, place Charles-Félix, top-floor studio
Model: Lisette
99.7 x 80.7 (39¼ x 31¾)
Signed and dated lower left: *Henri-Matisse*
1929–1931

The Baltimore Museum of Art: The Cone Collection,
formed by Dr. Claribel Cone and Miss Etta Cone of
Baltimore, Maryland, BMA 1950.256

Provenance
Etta Cone, Baltimore (from Mme Duthuit, fall 1932)

Exhibitions
New York 1932c
New York 1933
Paris 1937, no. 4
New York 1939a, no. 96, ill.
Baltimore 1941
Philadelphia 1948, no. 75, ill.
Baltimore 1949, no. 59
Baltimore 1950
New York 1951a, no. 62
New York 1954a, no. 14, ill.
New York 1955a
Los Angeles 1966, no. 68, ill. p. 97
Columbus 1967
London 1968, no. 102, ill. p. 130
Paris 1970b, no. 182, ill. p. 236
New York 1974b
New York 1979b
Tokyo 1981, no. 77, ill. color p. 101
Fort Worth 1984, no. 50, ill.
Los Angeles 1985

Literature
Boas 1934, ill.
Fry 1935, ill. pl. 48
Escholier 1937b, ill. p. 127
Romm 1937, ill.
Mushakojo 1939, p. 104, ill. fig. 207
Greenberg 1953, color pl. 26
Hess 1948, ill. p. 19
Barr 1951, pp. 216, 224, ill. p. 455
Matisse 1954, ill. color p. 133
Huyghe 1955, color pl. 26
Astrom 1955, color pl. 26
Lübecker 1955, color pl. 26
Vogue 1955, ill. color p. 135
La Tourette n.d., ill. pl. XIX
Escholier 1960, ill. pl. 39
Gottlieb 1964, p. 400, ill. fig. 13
Brill 1967, p. 37, color pl. 31
Guichard-Meili 1967, p. 103, ill. no. 96
Romm 1967, ill.
Rosenthal 1967, no. 68, ill. p. 16
Okamoto 1968, color pl. 59
Luzi 1971, ill. no. 465
Flam 1973b, p. 60, ill. fig. 34
Gowing 1979a, p. 59, ill. no. 144
Watkins 1984, p. 169, ill. pl. 155
Schneider 1982, ill. no. 465
Mezzatesta 1984, pp. 132–133, ill.
Schneider 1984, pp. 452, 536, n.3 p. 601, ill.
p. 537 color

Richardson 1985, p. 186, ill. p. 32, ill. color p. 141

171

Femme au madras, 1929–1930
Woman with Madras

Nice, place Charles-Félix
Model: Lisette
180 x 152 (70⅞ x 59⅞)

Private collection

Provenance
Estate of the artist
Private collection (by descent)

Exhibitions
New York 1966a, no. 50, ill. color p. 45
Los Angeles 1966, no. 69, ill. p. 98
London 1968, no. 103, ill. p. 131
Paris 1970b, no. 181, ill. p. 234
Madrid 1980, no. 30, ill. color
Zurich 1982, no. 76, ill. color

Literature
Zervos 1931b, ill. facing p. 9
Verve 1938, ill. color
Barr 1951, p. 216, ill. p. 453
Luzi 1971, ill. no. 464
Flam 1973b, ill. fig. 33
Clay 1975, ill. color p. 227
Schneider 1982, ill. no. 464
Mezzatesta 1984, ill. p. 130
Schneider 1984, ill. p. 371 color

Cat. no. 171, pl. 188

Concordance

Colorplate number	Catalogue number	Colorplate number	Catalogue number	Colorplate number	Catalogue number
1	4	38	46	75	52
2	not in exhibition	39	24	76	53
3	not in exhibition	40	not in exhibition	77	54
4	not in exhibition	41	7	78	not in exhibition
5	8	42	2	79	55
6	9	43	1	80	56
7	10	44	3	81	57
8	11	45	25	82	58
9	12	46	27	83	59
10	13	47	28	84	60
11	14	48	29	85	77
12	not in exhibition	49	30	86	78
13	15	50	not in exhibition	87	79
14	16	51	31	88	80
15	17	52	33	89	68
16	18	53	not in exhibition	90	62
17	19	54	34	91	63
18	20	55	32	92	64
19	21	56	26	93	65
20	74	57	66	94	82
21	5	58	35	95	83
22	75	59	36	96	96
23	22	60	37	97	81
24	42	61	67	98	84
25	not in exhibition	62	38	99	85
26	73	63	39	100	61
27	72	64	40	101	97
28	71	65	41	102	98
29	70	66	86	103	99
30	23	67	144	104	not in exhibition
31	not in exhibition	68	145	105	100
32	69	69	151	106	101
33	43	70	47	107	not in exhibition
34	44	71	49	108	111
35	76	72	48	109	126
36	6	73	50	110	87
37	45	74	51	111	88

Colorplate number	Catalogue number	Colorplate number	Catalogue number
112	89	151	124
113	90	152	117
114	91	153	129
115	92	154	128
116	102	155	130
117	103	156	120
118	104	157	118
119	not in exhibition	158	147
120	110	159	108
121	105	160	112
122	106	161	113
123	107	162	not in exhibition
124	109	163	116
125	127	164	114
126	93	165	115
127	94	166	not in exhibition
128	125	167	148
129	95	168	146
130	136	169	153
131	137	170	152
132	142	171	154
133	143	172	155
134	not in exhibition	173	162
135	not in exhibition	174	156
136	149	175	157
137	150	176	158
138	141	177	159
139	121	178	160
140	119	179	168
141	134	180	161
142	135	181	167
143	133	182	166
144	140	183	165
145	139	184	164
146	138	185	163
147	122	186	169
148	131	187	170
149	132	188	171
150	123		

Exhibitions

Aix-en-Provence 1960
Matisse, Pavillon de Vendôme, 9 July–31 August.

Albany 1944
Beauty and Is It Art?, Albany Institute of History and Art, 1–30 November.

Albi 1961
Exposition Henri Matisse, Musée Toulouse-Lautrec, 11 July–15 September.

Allentown 1977
French Masterpieces of the 19th Century from the Henry P. McIlhenny Collection, Allentown Art Museum, 1 May–18 September.

Amherst 1948
An exhibition at Amherst College, 16–29 May.

Amsterdam 1939
Parijsche Schilders, Stedelijk Museum, 25 February–10 April.

Amsterdam 1946
Exposition Picasso-Matisse.

Amsterdam 1952
Honderd Meesterwerken uit het National Museum voor Moderne Kunst te Parijs, Stedelijk Museum, 18 April–26 May; Brussels, Palais des Beaux Arts, 31 May–14 July.

Andover 1931
The Collection of Miss Lillie P. Bliss, Andover, Mass., Addison Gallery of American Art, 17 October–15 December.

Ankara 1969
See Cairo 1969

Athens 1980
Impressionnistes et Post-Impressionnistes des Musées Français de Manet à Matisse, Musée Alexandre Soutzos.

Atlanta 1955
Painting School of France, Atlanta Art Association Galleries; Birmingham Museum of Art.

Atlanta 1959
Collector's First, Atlanta Art Association, 18 February–1 March.

Atlanta 1982
20th Century Paintings from the Collection of The Museum of Modern Art, High Museum of Art, 13

February–11 April; Seattle Art Museum, 27 April–4 July; San Diego Museum of Art, 23 July–26 September; Kansas City, Nelson Gallery of Art, 21 October 1982–2 January 1983; New Orleans Museum of Art, 4 February–20 March 1983.

Atlanta 1984
The Henry P. McIlhenny Collection: Nineteenth Century French and English Masterpieces, High Museum of Art, 25 May–30 September.

Baden-Baden 1946
Moderne Französische Malerei, Kurhaus, September.

Baltimore 1925
An Exhibition of Modern French Art, Baltimore Museum of Art, 9 January–1 February.

Baltimore 1930
Cone Collection of Modern Paintings and Sculpture, Baltimore Museum of Art, April.

Baltimore 1941
A Century of Baltimore Collecting, Baltimore Museum of Art.

Baltimore 1949
Selections from The Cone Collection, Baltimore Museum of Art, October.

Baltimore 1950
Cone Memorial Exhibition, Baltimore Museum of Art, 13 January–5 March.

Basel 1931
Henri-Matisse, Kunsthalle Basel, 9 August–15 September.

Basel 1956
Maîtres de l'art moderne, Galerie Beyeler, August–October.

Basel 1970
Summer Time, Galerie Beyeler, July–September.

Basel 1980
Matisse, huiles, gouaches découpées, dessins, sculptures, Galerie Beyeler, June–September.

Beirut 1948
An exhibition.

Belgrade 1936
Exposition de la peinture moderne française, Musée du Prince Paul.

Belgrade 1958
Savremeno Francesco Slikarstvo, Belgrade, January;
Zagreb, March.

Berlin 1930
Henri Matisse, Galerien Thannhauser, 15 February–
19 March.

Berlin 1946
Moderne Französische Malerei, Château Impérial,
22 October–6 November.

Berlin 1956
Meisterwerke des Musée National d'Art Moderne,
Akademie der Schonen Kunst, 12 August–2 October.

Berlin 1977
Tendenzen der Zwanziger Jahre, 14 August–
16 October.

Bern 1947
Quelques oeuvres des collections de la Ville de Paris,
Kunstmuseum Bern, 29 March–14 April; La Chaux de
Fonds, Musée des Beaux Arts, 16–24 April; Geneva,
Musée Rath, 26 April–4 May; Kunsthalle Basel,
6–28 May.

Bern 1947
25 Jahre Kunstpflege der Stadt Bern, Kunsthalle Bern.

Bern 1953
Europaische Kunst aus Berner Privatbesitz, Kunsthalle
Bern, 31 July–20 September.

Beverly Hills 1952
*Henri Matisse, Loan Exhibition from Southern
California Museums and Collectors*, Frank Perls
Gallery, 22 May–30 June.

Biel 1953
Meisterwerke des 19. und 20. Jahrhunderts, Stadtische
Galerie Biel, 1953–1954.

Birmingham (Great Britain) 1946
Picasso-Matisse Exhibition.

Birmingham (NY) 1951
Inaugural Exhibition, Birmingham Museum of Art.

Birmingham (NY) 1961
10th Anniversary Exhibition, Birmingham Museum of
Art.

Bombay 1963
*Exhibition of Tapestries and Contemporary French
Decorative Arts*, Bombay, 1 October 1963; New Delhi,
Lalit Kala Akademi; Calcutta; Madras; Hyderabad,
9 April 1964.

Bordeaux 1966
La peinture française, collections americaines, Musée
des Beaux Arts.

Boston 1931
The Collection of John T. Spaulding, Museum of Fine
Arts, May 1931–October 1932.

Boston 1938
Picasso—Matisse, Institute of Modern Art.

Boston 1939
The Sources of Modern Painting, Museum of Fine
Arts, 2 March–9 April.

Boston 1957
Twentieth Anniversary Exhibition, Institute of
Contemporary Art, 9 January–10 February.

Bruges 1961
*Meesterwerken van het Museum voor Moderne Kunst
in Brussel*.

Brussels 1935
Exposition internationale d'art moderne.

Brussels 1946
Exposition Picasso-Matisse, Palais des Beaux Arts,
May.

Buenos Aires 1939
Pintura Francesa, Buenos Aires, 1939; Montevideo and
Rio de Janeiro, 1940.

Buffalo 1944
French Paintings of the Twentieth Century, Buffalo,
Albright Art Gallery, 1–31 December 1944; Cincinnati
Art Museum, 18 January–18 February 1945; Saint
Louis, The City Art Museum, 8 March–17 April 1945;
Washington, French Embassy, n.d.

Buffalo 1969
Works from the Hanley Collection at Canisius College,
Canisius College, 23 November–23 December.

Caen 1963
Exposition Inaugurale, Maison de la Culture.

Cairo 1969
La peinture française du XXe siècle, Cairo, February;
Teheran, 15 March–15 April; Athens, 9 May–6 June;
Ankara, Istanbul.

Cambridge 1929
French Painting of the 19th and 20th Centuries, Fogg
Art Museum, 6 March–6 April.

Cambridge 1946
*French Painting Since 1870, Lent by Maurice
Wertheim, Class of 1906*, Fogg Art Museum, 1 June–
7 September.

Cambridge 1949
Paintings from the Spaulding Collection, Fogg Art
Museum, 1 February–15 September.

Cambridge 1955
Matisse, Busch-Reisinger Museum, 9 May–8 June.

Cardiff 1957
Pictures from the Musée National d'Art Moderne,
National Museum of Wales, 9 March–4 April.

Cardiff 1973
Ferdinand Howald, Avant-Garde Collector, National
Museum of Wales, 28 September–28 October.

Chapel Hill 1951
XXth Century Paintings, Person Hall Art Gallery,
University of North Carolina.

Charlottenlund 1986
*Franske Mesterwaerken Fra Robert Lehman
Collection*, Ordrupgaard Saamlungen, 18 April–
22 June.

Charleston 1980
Matisse, Early Figurative Works, Charleston, West
Virginia, Sunrise Museums, 2 August–18 September.

Chicago 1927
Retrospective Exhibition of Paintings by Henri Matisse, the First Painting 1890 the Latest Painting 1925, The Arts Club of Chicago, 17–27 February.

Chicago 1933
A Century of Progress: Exhibition of Paintings and Sculpture, The Art Institute of Chicago, 1 June–1 November.

Chicago 1938
Loan Exhibition of Modern Paintings and Drawings from Private Collections in Chicago, The Arts Club of Chicago, 2–25 November.

Chicago 1939
Exhibition of Paintings by Henri Matisse, The Arts Club of Chicago, 13 March–18 April.

Chicago 1941
Masterpieces of French Art, Lent by the Museums and Collectors of France, The Art Institute of Chicago, 10 April–20 May.

Chicago 1943
Twentieth Century French Paintings from the Chester Dale Collection, The Art Institute of Chicago.

Chicago 1960
Inaugural Exhibition, The Art Gallery, 18 November–23 December.

Cincinnati 1951
History of an American, Alfred Stieglitz: 291 and After, The Taft Museum, 31 January–18 March.

Cincinnati 1959
The Lehman Collection, Cincinnati Art Museum, 8 May–5 July.

Cleveland 1929
French Art Since 1800, Cleveland Museum of Art.

Cleveland 1936
Cleveland Museum of Art 20th Anniversary Exhibition.

Cleveland 1938
Twenty Oils by Matisse, Cleveland Museum of Art, 10 November–18 December.

Cleveland 1956
The International Language, Cleveland Museum of Art.

Cleveland 1966
Fifty Years of Modern Art, Cleveland Museum of Art.

Cleveland 1973
Year in Review, Cleveland Museum of Art, 27 February–18 March.

Colorado Springs 1956
Garden Clubs of America Exhibition, Colorado Springs Fine Arts Center.

Columbus 1931
Inaugural Exhibition, The Columbus Gallery of Fine Arts, January–February.

Columbus 1967
Selections from The Baltimore Museum of Art Collection, The Columbus Gallery of Fine Arts, 10 November–3 December.

Columbus 1968
Works from the Hanley Collection, The Columbus Gallery of Fine Arts, 7 November–15 December.

Columbus 1969
From the Collection of Ferdinand Howald, The Columbus Gallery of Fine Arts, 10 October–31 December.

Copenhagen 1924
Henri Matisse, Ny Carlsberg Glyptotek, September.

Copenhagen 1959
Grace og Philip Sandbloms Samling, Ny Carlsberg Glyptotek.

Copenhagen 1970
Matisse, Statens Museum for Kunst, 10 October–29 November.

Dallas 1952
Some Businessmen Collect Contemporary Art, Dallas Museum of Art, 6–28 April.

Dallas 1955
Six Centuries of Headdress, Dallas Museum of Fine Arts.

Dayton 1945
The Little Show, Dayton Art Institute, 2–31 March.

Dayton 1949
An exhibition of works by Matisse, Dayton Art Institute, 24 February–16 March.

Dayton 1960
French Paintings 1789–1929 from the Collection of Walter P. Chrysler Jr., Dayton Art Institute, 25 March–22 May.

Delaware 1959
Selections from the Columbus Gallery of Fine Arts, Ohio Wesleyan University, Department of Fine Arts, 13 November–13 December.

Denver 1953
Origins and Trends of Contemporary Art, Denver Art Museum, 11 January–15 February.

Denver 1954
Ten Directions by Ten Artists, The Denver Art Museum, 7 January–14 February.

Detroit 1949
Masterpieces of Paintings from Detroit Private Collections, The Detroit Institute of Arts, 23 April–22 May.

Detroit 1970
A Collector's Treasure: The Tannahill Bequest, The Detroit Institute of Arts, 13 May–13 August.

Dublin 1973
Ferdinand Howald Avant-Garde Collector, The National Gallery of Ireland, 3 August–16 September.

Dusseldorf 1960
Sammlung G. David Thompson, Pittsburgh/USA, Kunstmuseum Dusseldorf, 14 December 1960–29 January 1961.

East Hampton 1952
19th Century Influences in French Painting, Guild Hall, 14 August–8 September.

Edinburgh 1944
A Century of French Art, National Gallery of Scotland.

Edinburgh 1954
An exhibition organized by the Arts Council of Scotland, August–September.

Edinburgh 1955
French Paintings of the 19th and 20th Centuries, Arts Council of Scotland.

Framingham 1975
Inaugural Exhibition, Danforth Museum, 24 May–30 September.

Frankfurt 1956
Ausgewaehlte werke aus dem Musée d'Art Moderne Paris, Stadelsches Kunstinstitut, 20 October–25 November.

Freiburg im Breisgau 1947
Die Meister Franzoscischer Malerei der Gegenwart, 20 October–23 November.

Fort Worth 1984
Henri Matisse Sculptor/Painter, Kimbell Art Museum, 25 May–2 September.

Fort Worth 1986
Modern and Contemporary Masters: Selections from the Los Angeles County Museum of Art, Fort Worth Art Museum, January–16 February, no catalogue.

Geneva 1954
Tresors des collections romandes, Musée Rath.

Geneva 1969
An exhibition and sale of impressionist and modern art, Christie's, 6 November.

Ghent 1964
Figuratie—Defiguratie. DeMenselijke figuur sedert Picasso, Musée des Beaux Arts, July–September.

Glasgow 1924
Exhibition of the Works of Some of the Most Eminent French Painters of Today, The Galleries of Mr. Alex Reid, October.

Glasgow 1927
A Century of French Paintings, McLellan Galleries, May.

Glasgow 1943
Spirit of France, Glasgow Art Gallery and Museum.

Glasgow 1945
The McInnes Collection, Glasgow Art Gallery and Museum.

Glasgow 1946
Picasso-Matisse Exhibition.

The Hague 1936
Hedendaagsche Fransche Kunst, Gementemuseum, 15 February–15 March.

The Hague 1961
Collectie Thompson uit Pittsburgh, Gementemuseum, 17 February–9 April.

Hamburg 1927
Europaische Kunst der Gegenwart, Kunsthalle Hamburg.

Hamburg 1951
Henri Matisse, Gemalde, Skulpturen, Handzeichnungen, Graphik, Hamburg, Dusseldorf, and Munich.

Houston 1958
The Human Image, The Museum of Fine Arts of Houston.

Humlebaek 1985
Henri Matisse, Louisiana Museet, 18 January–14 April.

Indianapolis 1932
Modern Masters from the Collection of Miss Lillie P. Bliss, John Herron Art Institute, 1–31 January.

Innsbruck 1946
Moderne Französische Malerei.

Kansas City 1961
The Logic of Modern Art, Nelson Gallery and Atkins Museum.

Knokke-Le Zoute 1952
Matisse, Grande Salle des Expositions de la Réserve, 12 July–31 August.

Konstanz 1946
Moderne Französische Malerei.

Kurashiki 1921
The First Exhibition of French Contemporary Painting.

Kurashiki 1922
The Second Exhibition of French Contemporary Painting.

Kyoto 1927
Exhibition of Western Paintings, Kyoto National Museum.

La Courneuve 1974
Fête de L'Humanité, September.

Lausanne 1964
Chefs d'oeuvre des collections suisses de Manet à Picasso, Palais de Beaulieu, 1 May–25 October.

Lausanne 1985
De Cézanne à Picasso dans les collections romandes, Fondation de l'Hermitage, 15 June–20 October.

Leipzig 1924
An exhibition at the Galerie Flechtheim.

Liège 1958
Léger—Matisse, Musée d'Art Wallon.

Limoges 1945
Peintures du Musée National d'Art Moderne, Limoges, October–November 1945; Saint-Etienne, December 1945–January 1946; Perpignan, February 1946; Toulouse, March–April 1946; Bordeaux, May–June 1946; Amiens, July–August 1946; Lille, September–October 1946.

Limoges 1956
La peinture française de l'Impressionnisme à nos jours, Musée Municipal, 15 January–15 March.

Lisbon 1965
Un siècle de peinture française, 1850–1950, Fondation Gulbenkian.

London 1919
Exhibition of Pictures by Henri Matisse and Sculpture by Maillol, The Leicester Galleries, November–December.

London 1920
Paintings by Matisse, Carfax and Patterson.

London 1924
The CAS: Loan Exhibition of Modern Foreign Painting, Colnaghi's Galleries, June–July.

London 1926
Opening Exhibition of the Modern Foreign Gallery, National Gallery Millbank, June–October.

London 1927
Exhibition of Works by Henry Matisse, Alex Reid and Lefevre, June.

London 1928
Second Loan Exhibition of Foreign Paintings, M. Knoedler and Co., February.

London 1930
19th Century French Masters, Arthur Tooth and Sons.

London 1933
Henry Matisse, Arthur Tooth and Sons, 22 June–8 July.

London 1935
Silver Jubilee Exhibition of Some of the Works Acquired by the CAS, The Tate Gallery, July–August.

London 1936a
Mr. Walter Taylor's Collection, The Mayor Gallery, September–October.

London 1936b
Exhibition of Masterpieces by Braque, Matisse, Picasso, Rosenberg and Helft, 5–31 October.

London 1939
Modern Paintings and Drawings, the Property of Walter Taylor, Esq., Christie's, 3 March.

London 1940a
The Montague Shearman Collection, The Redfern Gallery, April–May.

London 1940b
The Eumorfopoulos and Harcourt Johnstone Collections, Catalogue of Old and Modern Oil Paintings, etc., Sotheby's 10–12 June (Exhibition and sale of the collection of paintings formed by George Eumorfopoulos).

London 1942
The Tate Gallery's Wartime Acquisitions, National Gallery, April–May.

London 1945
Exhibition of Paintings by Picasso and Matisse, Victoria and Albert Museum, December.

London 1946
Acquisitions of the CAS, The Tate Gallery, September–October.

London 1951
L'Ecole de Paris 1900–1950, Royal Academy of Arts.

London 1954
Masterpieces from the São Paulo Museum of Art, The Tate Gallery, 19 June–15 August.

London 1957
An Exhibition of Paintings from the Musée d'Art Moderne, R.B.A. Galleries, 13 April–18 May.

London 1960
Important Impressionist and Post Impressionist Pictures, Drawings, and Bronzes, Christie's, May 20 (exhibition and sale).

London 1962
Primitives to Picasso, Royal Academy of Arts, winter 1962.

London 1965
XIX and XX Century French Paintings, Lefevre Gallery, 14 October–13 November.

London 1968
Matisse, The Hayward Gallery, 11 July–8 September.

London 1973
Ferdinand Howald, Avant-Garde Collector, Wildenstein and Co., 20 June–21 July.

London 1974
Impressionist and Modern Paintings and Sculpture, Sotheby's, 4 December.

London 1978
Henry Matisse, Marlborough Fine Art, Ltd., June–July.

London 1979
Important Impressionist and Modern Paintings, Sotheby's, 1–2 April (exhibition and sale).

London 1980
Important XIX and XX Century Paintings and Drawings, Lefevre Gallery, 6 November–19 December.

London 1981
Important XIX and XX Century Works of Art, Lefevre Gallery, 1–19 December.

London 1982a
Important XIX and XX Century Works of Art, Lefevre Gallery, 17 November–18 December.

London 1982b
Important Impressionist and Modern Paintings and Sculpture, Sotheby's, 28–31 March (exhibition and sale).

London 1983a
Important XIX and XX Century Works of Art, Lefevre Gallery, 16 June–22 July.

London 1983b
Important XIX and XX Century Works of Art, Lefevre Gallery, 23 November–21 December.

London 1984
The Orientalists: Delacroix to Matisse, London, Royal Academy of Arts, 24 March–27 May; Washington, National Gallery of Art, 1 July–28 October.

London (Ontario) 1959
French Paintings from the Impressionists to the Present, London Public Library and Art Museum, 6 February–13 March.

Los Angeles 1937
Loan Exhibition of International Art, Los Angeles Art Association, October–December.

Los Angeles 1941
From Cézanne to Picasso, Los Angeles County Museum of Art, 15 January–2 March.

Los Angeles 1952
Henri Matisse, Selection from the Museum of Modern Art Retrospective, Municipal Department of Art, 21 July–17 August; Portland, Oregon, Portland Art Museum.

Los Angeles 1966
Henri Matisse, Los Angeles, UCLA Art Galleries, 5 January–27 February; The Art Institute of Chicago, 11 March–24 April; Boston, Museum of Fine Arts, 11 May–26 June.

Los Angeles 1984
Automobile and Culture, The Museum of Contemporary Art, Los Angeles, 21 July 1984– 6 January 1985; Detroit Institute of Arts, 1985.

Los Angeles 1985
Masterpieces from The Cone Collection of The Baltimore Museum of Art, Los Angeles County Museum of Art, 6 October–24 November; Fort Worth, Kimbell Art Museum, 14 December 1985–9 February 1986, no catalogue.

Lucerne 1929
Peintures de l' Ecole Impressionniste et Neo-Impressionniste, February.

Lucerne 1940
Die Hauptwerke der Sammlung Hahnloser, Winterthur, Kunstmuseum.

Lucerne 1949
Henri Matisse, Musée des Beaux Arts, 9 July– 2 October.

Luxembourg 1956
Maîtres de l'art moderne—Peintures et gravures du Musée National d'Art Moderne, Musée de l'Etat, 15 December 1956–13 January 1957.

Madrid 1980
Matisse, oleos, dibujos, gouaches découpées, esculturas y libros, Fundacion Juan March, 14 October– 14 December.

Mainz 1946
Moderne Französische Malerei.

Marseilles 1957
50 Chefs-d'oeuvre contemporains, de Bonnard à N. de Stael, Musée Cantini, 24 June–21 July.

Marseilles 1962
Gustave Moreau et ses élèves, Musée Cantini, 26 June–1 September.

Melbourne 1939
Melbourne Herald Exhibition, October.

Mexico City 1962
Cien años de pintura en Francia, Mexico City, Museo del Palacio de Bellas Artes, October–November; Caracas.

Miami 1952
University of Miami, Lowe Gallery.

Miami 1959
Paintings and Sculpture from the Norton Gallery Collection, Playhouse Gallery, 12–24 January.

Miami 1963
Lowe Art Gallery, 8 February–10 March.

Milwaukee 1956
Still Life Exhibition, Milwaukee Art Institute and Cincinnati Art Museum.

Montevideo 1940
See Buenos Aires 1939

Montreal 1949
Manet to Matisse, The Montreal Museum of Fine Arts, 27 May–26 June.

Montreal 1963
La peinture française contemporaine, Musée des Beaux-arts, 3 October–3 November.

Montreal 1965
J.W. Moricce, The Montreal Museum of Fine Arts, 30 September–31 October; Ottawa, National Gallery of Canada, 12 November–5 December.

Montreal 1970
From Daumier to Rouault, The Montreal Museum of Fine Arts, March.

Montreal 1972
Art of the XXth Century, The Montreal Museum of Fine Arts, 14 January–20 February.

Moscow 1969
Matisse: peinture, sculpture, oeuvre graphique, lettres, Moscow, Pushkin Museum, March–June; Leningrad, Hermitage, September–October.

Moscow 1981
Moscou–Paris, 1900–1930, Pushkin Museum, 3 May–4 October.

Moutier 1956
Peintres français et suisses du XXe siècle, Moutier, France, Ecole Secondaire, September–October.

Munich 1972
World Cultures and Modern Art, Haus der Kunst, 16 June–30 September.

Nagoya 1960
Exhibition of Western Paintings in the Ohara Collection.

New Haven 1956
Pictures Collected by Yale Alumni, Yale University Art Gallery, 8 May–18 June.

New York 1921a
Paintings by Modern French Masters, Brooklyn Museum, February–April.

New York 1921b
Loan Exhibition of Impressionist and Post-Impressionist Paintings, The Metropolitan Museum of Art, 3 May–15 September.

New York 1922
Exhibition of Contemporary French Art, The
Sculptor's Gallery.

New York 1924a
Exhibition of Works by Henri Matisse, Joseph
Brummer, 25 February–22 March.

New York 1924b
An exhibition at the Fearon Galleries.

New York 1927a
*Retrospective Exhibition of Henry Matisse, the First
Painting 1890, the Latest Painting 1926*, Valentine
Dudensing, 3–31 January.

New York 1927b
*Exhibition of Modern French Paintings, Watercolors
and Drawings*, C. W. Kraushaar Galleries,
8–22 October.

New York 1927c
Exhibition of French Art of the Last Fifty Years,
M. Knoedler and Co., 17–29 January.

New York 1928a
*Loan Exhibition of Modern French Art from the
Chester Dale Collection*, Wildenstein and Co., October.

New York 1928b
100 Years of French Portraits, Museum of French Art.

New York 1928c
*Exhibition of Modern French Paintings, Watercolors
and Drawings*, C. W. Kraushaar Galleries,
1–18 October.

New York 1928d
A Century of French Painting, M. Knoedler and Co.,
12 November–8 December.

New York 1929a
*Exhibition of Modern French Paintings, Water Colors
and Drawings*, C. W. Kraushaar Galleries,
5–28 October.

New York 1929b
Henri Matisse, Valentine Gallery, 9 December 1929–
4 January 1930.

New York 1930a
Painting in Paris, The Museum of Modern Art,
19 January–16 February.

New York 1930b
La Nature Morte from Chardin to the Abstract,
Wildenstein and Co.

New York 1930c
Summer Exhibition: Painting and Sculpture, The
Museum of Modern Art, 15 June–28 September.

New York 1931a
Henri Matisse, The Museum of Modern Art,
3 November–6 December.

New York 1931b
Portraits of Women, Romanticism to Surrealism,
Museum of French Art, January.

New York 1931c
*Memorial Exhibition: The Collection of Miss Lizzie
P. Bliss*, The Museum of Modern Art, 17 May–27
September.

New York 1931d
Renoir and His Tradition, Museum of French Art,
November–December.

New York 1931e
Pictures of People 1870–1930, M. Knoedler and Co.,
6–18 April.

New York 1932a
French Paintings, Marie Harriman Galleries.

New York 1932b
Summer Exhibition, Paintings and Sculptures, The
Museum of Modern Art.

New York 1932c
An exhibition at the Art Association.

New York 1932d
An exhibition at the Reinhardt Gallery, January.

New York 1933
International, Rockefeller Center.

New York 1934a
Modern Works of Art, The Museum of Modern Art,
20 November 1934–20 January 1935.

New York 1934b
The Lillie P. Bliss Collection, The Museum of Modern
Art, 14 May–12 September.

New York 1934c
Henri Matisse, Paintings, Pierre Matisse Gallery,
23 January–24 February.

New York 1935
Twelve Paintings by Six French Artists, Durand-Ruel
Galleries.

New York 1936a
The Joseph Stransky Collection, Wildenstein and Co.,
July.

New York 1936b
Twenty Paintings by Henri Matisse, Valentine Gallery,
23 November–19 December.

New York 1938a
*Henri Matisse, Paintings and Drawings of 1918 to
1938*, Pierre Matisse Gallery, 15 November–
10 December.

New York 1938b
*Important Works by French Masters of the XX
Century*, Bignou Gallery, autumn.

New York 1939a
Art in Our Time, The Museum of Modern Art.

New York 1939b
Twentieth Century French Painters and Picasso,
Bignou Gallery, 17 April–13 May.

New York 1940a
*Modern Masters from European and American
Collections*, The Museum of Modern Art.

New York 1940b
Landmarks in Modern Art, Pierre Matisse Gallery,
30 December 1940–25 January 1941.

New York 1940c
*Matisse Modigliani and Utrillo, from a Private Parisian
Collection*, Bignou Gallery.

New York 1941
Masterpieces of Modern Painting and Sculpture, Pierre Matisse Gallery, 5–30 January.

New York 1942
Figure Pieces in Modern Painting, Pierre Matisse Gallery, 20 January–14 February.

New York 1943a
Ancient Chinese and Modern European Paintings, Bignou Gallery, May–June.

New York 1943b
Henri Matisse, Retrospective Exhibition of Paintings 1898–1939, Pierre Matisse Gallery, 9–27 February.

New York 1944a
Manet to Picasso, Still Life, Durand-Ruel Galleries, 8–31 March.

New York 1944b
Notable Modern Paintings and Sculpture . . . , Property of the Museum of Modern Art, Parke-Bernet Galleries, 11 May (exhibition and sale).

New York 1944c
Color and Space in Modern Art Since 1900, Mortimer Brandt, 19 February–18 March.

New York 1944d
Landscapes of France, Bignou Gallery, 14 February–11 March.

New York 1945
11 Nudes by XX Century Artists, Pierre Matisse Gallery, 10–28 April.

New York 1946
Paintings from New York Private Collections, The Museum of Modern Art, summer.

New York 1947
A 20th Century Selection, Paintings and Sculpture, Bignou Gallery, 4–29 March.

New York 1948a
A Selection of Paintings from the Durand-Ruel Galleries (no. 2), Durand-Ruel Galleries.

New York 1948b
A Selection of Paintings from the Durand-Ruel Galleries (no. 3), Durand-Ruel Galleries.

New York 1948c
Henri Matisse, Three Decades, 1900–1930, Bignou Gallery, 27 January–28 February.

New York 1950a
A Collector's Exhibition, M. Knoedler and Co., 6–25 February.

New York 1950b
An exhibition of paintings at The Metropolitan Museum of Art.

New York 1951a
Henri Matisse, New York, The Museum of Modern Art, 13 November 1951–13 January 1952; Cleveland Museum of Art, 5 February–16 March 1952; The Art Institute of Chicago, 1 April–4 May 1952; The San Francisco Museum of Art, 22 May–6 July 1952.

New York 1951b
Impressionist Paintings, M. Knoedler and Co.

New York 1951c
New York Private Collections, The Museum of Modern Art, 26 June–12 September.

New York 1951d
Duchamp to Brancusi, Sidney Janis Gallery.

New York 1952
19th and 20th Century French Paintings, Paul Rosenberg and Co., April.

New York 1953
Collector's Choice, Paul Rosenberg and Co., 17 March–18 April.

New York 1954a
Loan Exhibition of Paintings by Henri Matisse, Paul Rosenberg and Co., 5 April–1 May.

New York 1954b
Magic of Flowers in Paintings, Wildenstein and Co., 13 April–15 May.

New York 1954c
25th Anniversary Exhibition: Paintings, The Museum of Modern Art, 19 October 1954–23 January 1955.

New York 1955a
The Cone Collection, M. Knoedler and Co., January–February.

New York 1955b
An Exhibition of Paintings, E. and A. Silberman Galleries, 12 October–1 November.

New York 1956
Recent European Acquisitions, The Museum of Modern Art, 28 November 1956–20 January 1957.

New York 1957a
Paintings and Sculpture from the Minneapolis Institute of Arts, a Loan Exhibition, M. Knoedler and Co.

New York 1957b
The George Lurcy Collection, French Modern Paintings and Drawings, Parke-Bernet Galleries, 2–7 November (exhibition and sale).

New York 1957c
Paintings from the São Paulo Museum, The Metropolitan Museum of Art, 21 March–5 May.

New York 1960a
The Colin Collection, M. Knoedler and Co., 12 April–14 May.

New York 1960b
Important Impressionist and Post Impressionist Pictures, Drawings, and Bronzes, Christie's, 17–20 May.

New York 1960c
Modern Paintings, Sculptures, Drawings, Collected by the Late Baroness Gourgaud . . . , Parke-Bernet Galleries, 12–16 March (exhibition and sale).

New York 1961a
Masterpieces, a Memorial Exhibition for Adele R. Levy, Wildenstein and Co., 6 April–7 May.

New York 1961b
Modern Paintings and Sculptures from the Collection of Mr. and Mrs. Adolphe A. Juviler, Parke-Bernet Galleries, 21–25 October.

New York 1962a
Modern French Paintings, New York, Wildenstein and Co.; Waltham, Rose Art Museum, Brandeis University.

New York 1962b
Masters of Seven Centuries, Wildenstein and Co., March 1–31.

New York 1962c
An exhibition at Finch College.

New York 1963
Reader's Digest Collection, M. Knoedler and Co., 15 May–8 June.

New York 1964
Important European Paintings from Texas Private Collections, Marlborough-Gerson Gallery, November–December.

New York 1966a
Henri Matisse 64 Paintings, The Museum of Modern Art.

New York 1966b
Gauguin and the Decorative Style, The Solomon R. Guggenheim Museum.

New York 1967a
Selections from the Collection of Dr. and Mrs. T. Edward Hanley, Bradford, Pennsylvania, New York, Gallery of Modern Art, 3 January–12 March; Philadelphia Museum of Art, 6 April–28 May.

New York 1967b
The Bakwin Collection, Wildenstein and Co., 4 October–4 November.

New York 1968
Primitive to Picasso, M. Knoedler and Co., 2–21 December.

New York 1970a
Impressionist and Modern Paintings, Parke-Bernet, 25 February (exhibition and sale).

New York 1970b
The Ferdinand Howald Collection, Wildenstein and Co., 19 May–3 July.

New York 1973
Henri Matisse, Acquavella Galleries, 2 November–1 December.

New York 1974a
Important 19th & 20th Century Paintings and Sculpture, Sotheby Parke Bernet, Inc., 2 May (exhibition and sale).

New York 1974b
Cone Collection, Wildenstein and Co., March–May.

New York 1977a
Twentieth Century Paintings and Sculpture, Matisse to de Kooning, Xavier Fourcade Inc., 29 March–30 April.

New York 1977b
Impressionist and Modern Paintings, Christie's, 10–16 May (exhibition and sale).

New York 1978a
Matisse in the Collection of the Museum of Modern Art, The Museum of Modern Art, 26 October 1978–30 January 1979.

New York 1978b
The Eye of Stieglitz, Hirschl and Adler Gallery, 7 October–2 November.

New York 1979a
Impressionist, Modern and Contemporary Paintings and Sculpture, Sotheby Parke Bernet, Inc., 11–16 May (exhibition and sale).

New York 1979b
Matisse and Master Drawings from the Baltimore Museum of Art, The Solomon R. Guggenheim Museum, 24 August–7 October.

New York 1979c
Art of The Twenties, The Museum of Modern Art, 14 November 1979–22 January 1980.

New York 1980
Modern Masters: European Paintings from The Museum of Modern Art, New York, The Metropolitan Museum of Art, 5 June–12 October.

New York 1981a
Impressionist and Modern Paintings and Sculpture, Christie's, 14–19 May (exhibition and sale).

New York 1981b
XIX and XX Century Master Paintings, Acquavella Galleries, 30 October–30 November.

New York 1983a
Masters of the Nineteenth and Twentieth Centuries, Marlborough Gallery, 7 May–11 June.

New York 1983b
Paintings and Drawings from The Phillips Collection, The IBM Gallery of Science and Art, 8 December 1983–21 January 1984.

New York 1984a
Impressionist and Modern Paintings and Sculpture, Christie's, 11–16 May (exhibition and sale).

New York 1984b
Impressionist and Modern Paintings and Sculpture, Sotheby's, 8–14 November (exhibition and sale).

New York 1985a
Selections from the Reader's Digest Collections, New York, Wildenstein and Co., 10–13 September, 1985; Saint Paul, Detroit, Chicago, Stuttgart, Lausanne, London, Milan, and Paris, 1985–1986.

New York 1985b
The Albert J. Dreitzer Collection, Sotheby's, 9–13 November (exhibition and sale).

New York 1985c
Impressionist and Modern Paintings and Sculpture, Part I, Sotheby's, 9–13 November (exhibition and sale).

New York 1985d
Masterpieces, Sidney Janis Gallery, 14 December 1985–14 January 1986.

New York 1986
*Impressionist and Modern Paintings and Sculpture,
Part I,* Sotheby's 8–13 May.

Nice 1950
Henri Matisse, Galerie des Ponchettes, January–
March.

Nice 1960
Peintures à Nice et sur la Côte d'Azur, 1860–1960,
Palais de la Méditerranée, July–September.

Northampton 1932
Special Exhibition of Three Paintings, Smith College
Museum of Art, winter 1932–1933.

Okayama 1974
Gustave Moreau et ses élèves, Tenmaya Department
Store, February–6 March; Hiroshima, 15–30 March;
Tokyo, Tobu-Nezu, 6–23 April.

Oostende 1952
La femme dans l'art français, Kursaal, 12 July–
31 August.

Osaka 1949
Exhibition of Western Paintings, Osaka Municipal
Museum of Art.

Osaka 1953
*Exhibition of Western Paintings of the Ohara
Collection,* Osaka Municipal Museum of Art.

Osaka 1974
Exposition les fauves, Galeries Seibu Takasuki,
15 November–8 December.

Oslo 1938
Matisse, Picasso, Braque, Laurens, Kunstnernes Hus;
Copenhagen, Statens Museum for Kunst; Stockholm,
Liljevachs Konsthall.

Ottawa 1949
*Forty One Paintings from the Montreal Museum of
Fine Arts Collection,* National Gallery of Canada,
7 October–12 November.

Ottawa 1962
European Paintings in Canadian Collections, National
Gallery of Canada, 9 February–4 March.

Ottawa 1973
Montreal Museum Lends, II, National Gallery of
Canada, 12 April 1973–22 September 1975.

Palm Beach 1953
The Art of Henri Matisse, Society of the Four Arts,
6 February–1 March.

Palm Beach 1965
Feature of the Month, Society of the Four Arts,
February–March.

Paris, 1919a
Oeuvres récentes de Henri-Matisse, Galerie Bernheim-
Jeune, 2–16 May.

Paris 1919b
Salon d'automne, Grand Palais, 1 November–
10 December.

Paris 1920
Exposition Henri-Matisse, Galerie Bernheim-Jeune,
15 October–6 November.

Paris 1922
Exposition Henri-Matisse, Galerie Bernheim-Jeune,
23 February–15 March (complemented by a separate
publication—see Vildrac 1922 in bibliography).

Paris 1923a
*Exposition d'oeuvres d'art des XVIIIe, XIXe, et XXe
siècles,* Chambre Syndicale de la Curiosité et des Beaux
Arts.

Paris 1923b
Exposition Henri-Matisse, Galerie Bernheim-Jeune,
April.

Paris 1924a
Collection Henry Aubry, Hôtel Drouot, 7 April
(exhibition and sale).

Paris 1924b
Exposition Henri-Matisse, Galerie Bernheim-Jeune,
6–20 May.

Paris 1924c
*Première exposition des collectionneurs, organisée au
profit de la Société des Amis du Luxembourg,*
Chambre Syndicale de l'Antiquité et des Beaux Arts.

Paris 1925a
Salon d'automne, Tuileries (Terrasse du bord de l'eau),
26 September–2 November.

Paris 1925b
*Exposition internationale des arts décoratifs et
industriels modernes,* L'Esplanade des Invalides, April.

Paris 1926a
*Tableaux modernes, Aquarelles, Pastels, Gravures . . .
et Dessins,* Paris, Hôtel Drouot, 6–7 May (catalogue of
the exhibition and sale of the Auguste Pellerin
collection).

Paris 1926b
Salon des Tuileries, Palais de Bois.

Paris 1927a
Collection d'un amateur, tableaux modernes, Hôtel
Drouot, 16–17 December (exhibition and sale).

Paris 1927b
Salon d'automne, Grand Palais, 5 November–
18 December.

Paris 1928a
Collection du Docteur Soubies, Hôtel Drouot,
13–14 June (exhibition and sale).

Paris 1928b
*Tableaux modernes provenant de la villa "Sauge
pourprée" à Dauville,* Hôtel Drouot, 7–8 December
(exhibition and sale of the Jean Laroche collection).

Paris 1928c
Salon d'automne, Grand Palais, 4 November–
16 December.

Paris 1928d
L'Ecole de Paris, Salle Pleyel, fall.

Paris 1929
*La Grande Peinture Contemporaine à la Collection Paul
Guillaume,* Galerie Bernheim-Jeune, 25 May–7 June.
(This is both an exhibition catalogue and a book
written by Waldemar George for the occasion.)

Paris 1930a
Exposition de L'Art Vivant, Galerie Pigalle, May.

Paris 1930b
De Delacroix à nos jours, Galerie Georges Petit.

Paris 1930c
An exhibition of sculpture and paintings by Matisse,
Galerie Pierre Loeb, no catalogue.

Paris 1931
*Henri-Matisse, Exposition organisée au profit de
l'Orphelinat des Arts*, Galerie Georges Petit,
16 June–25 July.

Paris 1932
Collection Charles Pacquement, Hôtel Drouot,
10–12 December (exhibition and sale).

Paris 1933a
Collection Eugène Blot, Hôtel Drouot, 1–2 June
(exhibition and sale).

Paris 1933b
Collection G.B. . . . , première vente, Hôtel Drouot,
8–9 June (exhibition and sale of the collection Georges
Bénard).

Paris 1933c
*Tableaux modernes offerts par l'association des Amis
des Artistes Vivants*, Galerie Bernheim-Jeune.

Paris 1935
Hommage du Musée Grenoble à Paul Guillaume, Petit
Palais, February–April (this is an addition to the larger
exhibition and catalogue, *Les chefs d'oeuvre du Musée
de Grenoble*, Petit Palais, February–April).

Paris 1936
Cent ans de théâtre, music-hall et cirque, Galerie
Bernheim-Jeune.

Paris 1937
Les maîtres de l'art indépendant 1895–1937, Petit
Palais, June–October.

Paris 1938
Exposition Henri-Matisse, Paul Rosenberg,
24 October–12 November.

Paris 1942
*Inauguration provisoire du Musée National d'Art
Moderne*, Musée National d'Art Moderne, 7 August.

Paris 1945
Portraits français, Galerie Charpentier.

Paris 1946a
*Les chefs d'oeuvre des collections Françaises retrouvés
en Allemagne par la Commission de Récupération
Artistique*, Orangerie des Tuileries, June–August.

Paris 1946b
Cent chefs d'oeuvre des peintres de l'Ecole de Paris,
Galerie Charpentier.

Paris 1947
Beautés de la Provence, Galerie Charpentier.

Paris 1948
La femme 1800–1930, Galerie Bernheim–Jeune,
April–June, 1948.

Paris 1951
Oeuvres choisies du XXe siècle, Max Kaganovitch,
25 May–20 July.

Paris 1952
Peintres de portraits, Galerie Bernheim–Jeune.

Paris 1953
Figures nues d'école français, Galerie Charpentier.

Paris 1955a
Salon d'automne (Retrospective Henri Matisse), Grand
Palais.

Paris 1955b
Les peintres témoins de leur temps—IV, Le bonheur,
Musée Galliera, 1 March–31 May.

Paris 1956
Henri Matisse, exposition rétrospective, Musée
National d'Art Moderne, 28 July–18 November.

Paris 1957a
Collection Lehman de New York, Musée de
l'Orangerie, summer.

Paris 1957b
Depuis Bonnard, Musée National d'Art Moderne,
23 March.

Paris 1958
Chefs d'oeuvre de Henri Matisse, Galerie Bernheim-
Jeune, May–July.

Paris 1959
*De Géricault à Matisse, chefs d'oeuvre français des
collections suisses*, Petit Palais, March–May.

Paris 1960
*Cent tableaux de collections privées de Bonnard à de
Staël*, Galerie Charpentier.

Paris 1964
Oeuvres choisies de 1900 à nos jours, Galerie Max
Kaganovitch.

Paris 1966
Collection Jean Walter–Paul Guillaume, Orangerie des
Tuileries.

Paris 1967
*Chefs d'oeuvre des collections suisses de Manet à
Picasso*, Orangerie des Tuileries.

Paris 1969
Cent ans de peinture française, Galerie Schmit,
7 May–7 June.

Paris 1970a
Exposition Matisse, Galerie Bernheim-Jeune,
10 February–10 March.

Paris 1970b
Henri Matisse, exposition du centenaire, Grand Palais,
22 April–22 September.

Paris 1971
Delacroix et le fauvisme, Musée Delacroix, May.

Paris 1973
Tableaux de maîtres français 1900–1955, Galerie
Schmit, 16 May–16 June.

Paris 1978
Tableaux des maîtres et des peintres contemporains, Galerie Tamenaga, 18 October–10 November.

Paris 1979
Paris–Moscou 1900–1930, Centre Georges Pompidou.

Paris 1980
Cinq années d'enrichissement du patrimoine national, 1975–1980, donations, dations, acquisitions, Grand Palais, 15 November 1980–2 March 1981.

Paris 1982
Pour mon plaisir, XIXe–XXe siècles, Galerie Schmit, 12 May–22 July.

Paris 1983
Bonjour Monsieur Manet, Centre Georges Pompidou, 8 June–3 October.

Paris 1985
De Corot à Picasso, Galerie Schmit, 10 May–20 July.

Paris 1986
Extraits de la collection du Reader's Digest, Musée Marmottan, 8 April–11 May.

Pasadena 1949
French Painters' Show, Pasadena Art Institute, autumn.

Philadelphia 1923
Exhibition of Contemporary Paintings and Sculpture, The Pennsylvania Academy of the Fine Arts.

Philadelphia 1928
The Inaugural Exhibition, Philadelphia Museum of Art, March, no catalogue.

Philadelphia 1933a
The White Collection, Philadelphia Museum of Art.

Philadelphia 1933b
Ingersoll Collection, Philadelphia Museum of Art.

Philadelphia 1943
Paintings from the Chester Dale Collection, Philadelphia Museum of Art.

Philadelphia 1947
Masterpieces of Philadelphia Private Collections, Philadelphia Museum of Art.

Philadelphia 1948
Henri Matisse, Retrospective Exhibition of Paintings, Drawings and Sculpture, Philadelphia Museum of Art, spring.

Philadelphia 1950a
S. S. White, 3rd, Collection, Philadelphia Museum of Art.

Philadelphia 1950b
Diamond Jubilee Exhibition, Masterpieces of Painting, Philadelphia Museum of Art, 4 November 1950–11 February 1951.

Philadelphia 1954
A. E. Gallatin Collection, Philadelphia Museum of Art.

Philadelphia 1963
A World of Flowers, Philadelphia Museum of Art, 2 May–9 June.

Philadelphia 1965
Peale Club Collectors Show, Peale House Galleries, 23 September–31 October.

Pittsburgh 1931
Exhibition of Twentieth Century Paintings from the Chester Dale Collection, Carnegie Institute, May–June.

Pittsburgh 1963
Works of Art from the Collection of The Museum of Modern Art, Museum of Art, Carnegie Institute, 17 December 1963–February 1964.

Pittsburgh 1965
The Seashore, Paintings of the 19th and 20th Centuries, Museum of Art, Carnegie Institute, 22 October–5 December.

Pittsburgh 1979
French Masterpieces of the 19th Century from the Henry P. McIlhenny Collection, Carnegie Institute, 10 May–1 July.

Pomona 1950
Masters of Art from 1790–1950, Los Angeles County Fair, 15 September–1 October.

Portland 1941
Masterpieces of French Painting, The Portland Art Museum, Oregon.

Portland 1956
Paintings from the Collection of Walter P. Chrysler, Jr., Portland Art Museum; Seattle Art Museum; San Francisco, California Palace of the Legion of Honor; Los Angeles County Museum of Art; The Minneapolis Institute of Arts; City Art Museum of St. Louis; Kansas City, William Rockhill Nelson Gallery of Art; Detroit Institute of Arts; Boston, Museum of Fine Arts.

Providence 1931
Henri Matisse, Rhode Island School of Design.

Recklinghausen 1967
Zauber des Lichtes, Kunsthalle Recklinghausen, 7 June–30 July.

Richmond 1953
The Cone Collection, The Virginia Museum of Fine Arts.

Rio de Janeiro 1949
Exposicion de Pintura Francesa Contemporanea, Rio de Janeiro, October 1949; Caracas, January 1950; Santiago, Museo Nacional de Bellas Artes, May 1950.

Rome 1978
Henri Matisse, Villa Medici, November 1978–January 1979.

Rotterdam 1952
Franse Meesters uit Petit Palais, Museum Boymans van Beuningen.

Rotterdam 1954
Vier Euwen Stilleben in Frankrijk, Museum Boymans van Beuningen, 10 July–20 September.

Rotterdam 1963
Franse landschappen van Cézanne tot heden, Museum Boymans van Beuningen, 4 October–17 November.

Saint Louis 1935
25 Paintings from the Bliss Collection (an exhibition organized by The Museum of Modern Art), City Art Museum, 4 February–4 March; Pittsburgh, Carnegie Institute, 13 March–10 April; Northampton, Smith College Museum of Art, 18 April–19 May.

Saint-Paul 1969
A la rencontre de Matisse, Saint-Paul de Vence, Fondation Maeght.

San Diego 1935
California Pacific International Exposition, Fine Arts Gallery of San Diego, 29 May–11 November.

San Diego 1936
Official Art Exhibition, Fine Arts Gallery of San Diego, 12 February–9 September.

San Francisco 1934
Exhibition of French Painting, from the Fifteenth Century to the Present Day, The California Palace of the Legion of Honor, 8 June–8 July.

San Francisco 1936
Henri-Matisse, The San Francisco Museum of Art, 11 January–24 February.

San Francisco 1940a
Golden Gate International Exposition, May–September.

San Francisco 1940b
The Painting of France since the French Revolution, M. H. de Young Memorial Museum, December 1940–January 1941.

San Francisco 1952
Supplement to the catalogue of the exhibition *Henri Matisse* (New York 1951a), The San Francisco Museum of Art, 22 May–6 July 1952.

San Francisco 1954
Paintings from the Collection of Mrs. Albert D. Lasker, The California Palace of the Legion of Honor, 4 April–17 May

San Francisco 1962
The Collection of Henry P. McIlhenny, The California Palace of the Legion of Honor, 15 June–31 July.

San Francisco 1981
Impressionism and the Modern Vision: Master Paintings from The Phillips Collection, The California Palace of the Legion of Honor, 4 July–1 November 1981; Dallas Museum of Fine Arts, 22 November 1981–16 February 1982; The Minneapolis Institute of Arts, 14 March–30 May 1982; Atlanta, The High Museum of Art, 24 June–16 September 1982; The Oklahoma Arts Center, 15 October 1982–9 January 1983.

Santa Barbara 1951
Santa Barbara Museum of Art, August.

Santiago 1950
See Rio de Janeiro 1949

Sarasota 1966
Masterpieces from Montreal, The John and Mable Ringling Museum of Art, 10 January–13 February 1966; to Buffalo, Rochester, Raleigh, Philadelphia, Columbus, Pittsburgh, to 30 April 1967.

Saratoga Springs 1942
Exhibition of Modern French Paintings, Skidmore College, 8–25 February.

Solothurn 1977
Josef Müller Stiftung, Museum der Stadt, 19 November 1977–8 January 1978.

Stockholm 1931
Fransk Genombrottskonst Fran Nittonhundratalet, March 1931; Oslo, Goteborg, Copenhagen, to June 1931.

Stockholm 1945
Grace og Philip Sandbloms Samling, Stockholm Foreningen for Nutida Konst.

Stockholm 1954a
Cézanne till Picasso, Liljevalchs Konsthall, September.

Stockholm 1954b
Foreign Pictures from Swedish Private Collections, Nationalmuseum, November.

Stockholm 1981
The Grace and Philip Sandblom Collection, Nationalmuseum.

Stockholm 1984
Henri Matisse, Moderna Museet, 3 November 1984–6 January 1985.

Strasbourg 1963
La grande aventure de l'art du XXe siècle, Château des Rohan, June–September.

Strasbourg 1968
L'art en Europe autour de 1918, A l'Ancienne Douane, 8 May–15 September.

Sydney 1975
Modern Masters, Manet to Matisse, Sydney, Art Gallery of New South Wales, 10 April–10 May; Melbourne, National Gallery of Victoria, 28 May–22 June; New York, The Museum of Modern Art, 4 August–1 September.

Tbilissi 1981
Impressionnistes et Post Impressionnistes des Musées Français de Manet à Matisse, Tbilissi, Musée des Beaux Arts de Géorgie; Leningrad, The Hermitage.

Teheran 1969
See Cairo 1969

Tel Aviv 1982
Masters of Modern Art.

Thonon-les-Bains 1966
10 chefs d'oeuvre du Musée National d'Art Moderne, Maison de la Culture, 4–19 June.

Tokyo 1928
Exhibition of Western Paintings, Tokyo Metropolitan Art Museum.

Tokyo 1951
Henri Matisse, National Museum, 3 March–6 June
(complemented by the album *Henri Matisse*, Tokyo, Le
Journal Yomiuri, 1951).

Tokyo 1954
*Exhibition of Western Paintings in the Ohara
Collection.*

Tokyo 1961
Exposition d'art français 1840–1940, Musée National
des Beaux Arts, 3 November 1961–15 January 1962;
Kyoto, Musée Municipal, 25 January–15 March 1962.

Tokyo 1973
*Paris and Japan in the History of Modern Japanese
Art*, Tokyo, The National Museum of Modern Art, 15
September–4 November; Kyoto, The National Museum
of Modern Art, 5 November–31 December.

Tokyo 1974
Exposition Les Fauves, Seibu Museum of Art,
August–September.

Tokyo 1980
Un siècle de paysage de France, 1870–1970, Tokyo,
Grand Magasin Matsuzakaya, 1–13 May; Nagoya,
Grand Magasin Matsuzakaya, 5–10 June.

Tokyo 1981
Matisse, Tokyo, The National Museum of Modern Art,
20 March–17 May; Kyoto, The National Museum of
Modern Art, 26 May–19 July.

Tokyo 1983
*Impressionism and the Modern Vision: Master
Paintings from the Phillips Collection*, Tokyo, The
Nihonbashi Takashimaya Art Galleries, 24 August–
27 September; Nara, Nara Prefectural Museum of Art,
9 October–13 November.

Toledo 1938
Influences in Development of Contemporary Painting,
Toledo Museum of Art, 5 November–11 December.

Toronto 1956
The Ayala and Sam Zacks Collection, The Art Gallery
of Toronto, 11 September–18 October; Ottawa, The
National Gallery of Canada; Winnipeg, The Winnipeg
Art Gallery; Minneapolis, The Walker Art Center;
Vancouver, The Vancouver Art Gallery.

Tournai 1956
Maîtres de l'art contemporain, Musée des Beaux Arts.

Tulsa 1972
Tulsa Collects, Philbrook Art Centre, Inc.,
2–29 October.

Valenciennes 1937
Exposition d'art moderne, Palais des Beaux Arts,
8 April–9 May.

Venice 1928
XVI Biennale di Venezia.

Venice 1950
XXV Biennale di Venezia.

Vienna 1947
Meister der modernen Französischen malerei,
Kunstgewerbemuseum.

Vienna 1955
Europäische Kunstgestern und Heute,
Oesterreichisches Museum für Angewandete Kunst,
6 June–6 July.

Washington 1927
Leaders of French Art Today, Phillips Memorial
Gallery, December 1927–January 1928.

Washington 1928
Tri-Unit Exhibition of Paintings and Sculpture, Phillips
Memorial Gallery, February–May.

Washington 1941
The Functions of Color in Painting, Phillips Memorial
Gallery, 16 February–23 March.

Washington 1952
*Twentieth-Century French Paintings from the Chester
Dale Collection*, National Gallery of Art,
22 November 1952–December 1953.

Washington 1963
*Paintings from The Museum of Modern Art, New
York*, National Gallery of Art, 16 December 1963–
1 March 1964 (extended to 22 March).

Washington 1968
Painting in France, 1900–1967, Washington, National
Gallery of Art; New York, The Metropolitan Museum
of Art; Boston, Museum of Fine Arts; The Art
Institute of Chicago; San Francisco, M. H. de Young
Memorial Museum.

Washington 1970
Selections from the Nathan Cummings Collection,
Washington, National Gallery of Art, 28 June–
11 September 1970; New York, The Metropolitan
Museum of Art, 1 July–7 September 1971.

Washington 1978a
Aspects of Twentieth-Century Art, National Gallery of
Art, 1 June 1978–July 1979.

Washington 1978b
*The Noble Buyer, John Quinn, Patron of the Avant-
Garde*, Hirshhorn Museum and Sculpture Garden,
15 June–4 September.

Washington 1986
*Gifts to the Nation: Selected Acquisitions from the
Collections of Mr. and Mrs. Paul Mellon*, National
Gallery of Art, 20 July–19 October.

Wellesley 1967
*Nineteenth and Twentieth Century Paintings in the
Collection of Doctor and Mrs. Harry Bakwin*, Wellesley
College Art Museum, 1967.

Wellesley 1978
*One Century: Wellesley Families Collect, an
Exhibition Celebrating the Centennial of Wellesley
College*, Wellesley College Art Museum, 15 April–
30 May.

Winterthur 1937
Werke aus der Sammlung Dr. Arthur Hahnloser,
Kunstmuseum, 18 April–30 May.

Winterthur 1949
Winterthurer Privatbesitz II, Kunstmuseum,
28 August–28 November.

Winterthur 1973
Kunstlerfreunde um Arthur und Hedy Hahnloser-Bühler, Kunstmuseum, 23 September–11 November.

Wolfsburg 1961
Franzosische Malerie von Delacroix bis Picasso, Wolkswagenwerke.

Youngstown 1969
Selections from the Ferdinand Howald Collection of The Columbus Gallery of Fine Arts, Butler Institute of American Art, 2–30 March.

Zurich 1925a
Gemälde und Handzeichnungen, G. and L. Bollag, 31 March–3 April (exhibition and sale).

Zurich 1925b
Internationale Kunstausstellung, Kunsthaus Zurich, 8 August–23 September.

Zurich 1935
Sammlung 1919–1935, Kunsthaus Zurich, 26 May–11 August.

Zurich 1947
Petit Palais, Musée de la Ville de Paris, Kunsthaus Zurich, 9 June–31 August.

Zurich 1958
Sammlung Emil G. Bührle, Kunsthaus Zurich, 7 June–30 September.

Zurich 1959
Henri Matisse, Das plastiche Werk, Kunsthaus Zurich, 14 July–12 August.

Zurich 1960
Thompson Collection: aus einer Amerikanischen Privatsammlung, Kunsthaus Zurich, 15 October–27 November.

Zurich 1971
Henri Matisse, Marlborough Galerie, September–October.

Zurich 1982
Henri Matisse, Kunsthaus Zurich, 15 October 1982–16 January 1983; Stadtische Kunsthalle Dusseldorf, 30 January 1983–4 April 1983.

Select Bibliography

This extensive Bibliography is the first to focus on the *niçoise* period of Matisse, 1916–1930. Publications of greatest reference value to these years in the south are marked with a palm tree symbol (🌴). The reader is directed to the following works for other aspects of the artist's career. General references: Alfred Barr, *Matisse, His Art and His Public* (New York, The Museum of Modern Art, 1951); Lawrence Gowing, *Matisse* (London, Thames and Hudson, 1979); and Pierre Schneider, *Matisse* (New York, Rizzoli, 1984). For drawings: Victor I. Carlson, *Matisse as a Draughtsman* (The Baltimore Museum of Art, 1971); Dominique Fourcade and Isabelle Monod-Fontaine, *Henri Matisse, Dessins et Sculptures* (Musée National d'Art Moderne, Paris, 1975); John Elderfield, *The Drawings of Henri-Matisse* (Arts Council of Great Britain, 1984). For sculpture: Albert E. Elsen, *The Sculpture of Henri-Matisse* (New York, Harry N. Abrams, Inc., 1972); Isabelle Monod-Fontaine, *The Sculpture of Henri Matisse* (Arts Council of Great Britian, 1984). For prints: Marguerite Duthuit-Matisse and Claude Duthuit, *Henri Matisse l'Oeuvre Gravé* (catalogue raisonné, privately printed, Paris, 1983). For cut-outs: Jack Cowart, Jack D. Flam, Dominique Fourcade, and John Hallmark Neff, *Henri Matisse Paper Cut-Outs* (The Saint Louis Art Museum and Harry N. Abrams, Inc., 1977). For the artist's writings: Dominique Fourcade, ed., *Henri-Matisse, Ecrits et propos sur l'art* (Paris, Hermann, 1971); and Jack D. Flam, *Matisse on Art* (Phaidon, 1973).

Abbott 1933
A., J. [Jere Abbott]. "Exhibitions." *Bulletin of Smith College Museum of Art* 14 (May 1933): 13–16.

Alazard 1951
Alazard, Jean. "La collection Frédéric Lung," *Etudes d'art*, no. 6, 1951.

Alexandre 1930a
Alexandre, Arsène. *La Collection Canonne.* Paris: Editions Bernheim-Jeune, 1930.

Alexandre 1930b
Alexandre, Arsène. "La Collection Canonne." *La Renaissance* (April 1930): 85–108.

Alley 1981
Alley, Ronald. *Catalogue of the Tate Gallery's Collection of Modern Art Other than Works by British Artists.* London: The Tate Gallery, 1981.

Alpatov 1969
Alpatov, Michale W. *Matisse.* Moscow, 1969.

Alpatov 1973
Alpatov, Michale W. *Henri Matisse.* Dresden: Verlag der Kunst, 1973.

Annuaire 1926
Annuaire de Nice des Alpes Maritimes, Agence Havas, no. 8, 1926.

Antal 1964
Antal, Kampis. *Matisse.* Budapest: Kepzomuveszeti Alap Kiadovallalata, 1964.

Apollo 1983
Cover illustration. *Apollo* 117, no. 252 n.s. (February 1983).

Aragon 1946
Aragon, Louis. *Matisse.* Geneva: Edition d'Art Albert Skira, 1946.

Aragon 1971
Aragon, Louis. *Henri Matisse, roman.* Paris: Gallimard, 1971, 2 vols.

Arnason 1968
Arnason, H. H. *History of Modern Art.* New York: Harry N. Abrams, 1968.

Art News 1935
"The Curtain Rises." *The Art News* 34, no. 1 (5 October 1935): 12.

Art News 1936
"A Premier West Coast Exhibition of Matisse." *The Art News* 34, no. 18 (1 February 1936): 10.

Art News 1938
[D., M.]. "Important Works by French Masters of the XX Century." *The Art News* 36, no. 35 (28 May 1938): 17.

Art Quarterly 1957
"Accessions of American and Canadian Museums April—June 1957." *Art Quarterly* 20, no. 3 (Autumn 1957): 317–327.

Arts 1956
"The Zacks Collection." *Arts* 31, no. 1 (October 1956): 34–41.

Arts 1957
"The Minneapolis Institute of Arts." *Arts* 31, no. 4 (January 1957): 32–37.

Astrom 1955
Astrom, Lars-Eric. *Henri Matisse.* Stockholm: Bonniers, 1955.

Barnes 1933
Barnes, Albert C., and Violette de Mazia. *The Art of Henri Matisse.* Merion: The Barnes Foundation Press, 1933.

Barotte 1954
Barotte, R. "Henri Matisse peintre du bonheur." *Le jardin des arts* 2 (1954).

Barr 1951
Barr, Alfred H., Jr. *Matisse: His Art and His Public.* New York: The Museum of Modern Art, 1951.

Basler 1920
Basler, Adolphe. "Die junge französiche Malerei." *Der Cicerone* 12, no. 20 (October 1920): 748–752.

Basler 1921
Basler, Adolphe. "Henri Matisse." *Jahrbuch der Jungen Kunst* (1921): 16–20; repr. of *Der Cicerone* 13, no. 1 (1 January, 1921): 16–20.

Basler 1924a
Basler, Adolphe. *Henri Matisse.* Leipzig: Verlag von Klinkhardt und Biermann, 1924.

Basler 1924b
Basler, Adolphe. "Henri Matisse." *Der Cicerone* 21 (November 1924): 1000–1009; repr. *Jahrbuch der Jungen Kunst* (1924): 339–349.

Basler 1929
Basler, Adolphe, and Charles Kunstler. *La peinture indépendant en France. Vol. II, de Matisse à Segonzac.* Paris: Les Editions Crès et Cie., 1929.

Basler 1930
Basler, Adolphe. "Das Formproblem der Malerei seit Cézanne." *Kunst und Künstler* 29, no. 1 (October 1930): 25–68.

Batterberry 1973
Batterberry, Michael. *Twentieth Century Art.* New York: McGraw Hill Book Company, 1973.

Baudot 1985
Baudot, François. "Jacques Doucet, Protecteur et mécène des artistes de son temps." *Beaux Arts* 22 (March 1985): 56–63.

Beach 1960
Beach, Warren. *The Fine Arts Gallery of San Diego, California.* San Diego: The Fine Arts Gallery of San Diego, 1960.

Bell 1922
Bell, Clive. "Matisse und Picasso." *Des Kunstblatt* 6 (1922): 430–436.

Bell 1931
Bell, Clive. *An Account of French Paintings.* London: Chatto and Windus, 1931.

Bell 1954
Bell, Clive. "Henri Matisse." *Apollo* 60, no. 358 (December 1954): 151–156.

Bernheim de Villers 1940
Bernheim de Villers, Gaston. *Petites histoires sur des grands artistes.* Paris: Editions Bernheim-Jeune, 1940.

Berthoud 1937
Berthoud, Dorrette. *La peinture française d'aujourd'hui.* Paris: Les Editions d'Art Moderne, 1937.

Bertram 1930
Bertram, Anthony. *Henri Matisse.* New York: The Studio Publications, 1930.

 Besson 1939
Besson, George. "Arrivée de Matisse à Nice." *Le Point* 21 (July 1939): 38–43. Special issue on Matisse.

Besson 1954
Besson, George. *Matisse.* Paris: Les Editions Braun, 1954.

Besson 1985
Besson, George. *Moderne Kunst in Frankreich.* Dresden: VEB Verlag der Kunst, 1985, ed. Pierre Worms.

Bezombes 1953
Bezombes, Roger. *L'exotisme dans l'art et la pensée.* Paris: Elsevier, 1953.

Boas 1934
Boas, George. *The Cone Collection of Baltimore, Maryland, Catalogue of Paintings, Drawings, Sculpture of the Nineteenth and Twentieth Centuries.* Baltimore: Etta Cone, 1934.

Bock 1986
Bock, Catherine C. "*Woman before an Aquarium* and *Woman on a Rose Divan:* Matisse in the Helen Birch Bartlett Memorial Collection." *The Art Institute of Chicago Museum Studies* 12, no. 2 (1986). Forthcoming.

Bode 1900
Bode, Wilhelm. *Gemälde-Sammlung des herrn Rudolf Kann in Paris.* Vienna: Gesellschaft für vervielfältigende Kunst, 1900.

Bois 1974
Bois, Yves-Alain. "Légendes de Matisse." *Critique* 324 (May 1974): 434–466.

Bourgeois 1928
Bourgeois, Stephan. *The Adolph Lewisohn Collection of Modern French Paintings and Sculptures.* New York: E. Weyhe, 1928.

Bouyer 1926
Bouyer, Raymond. "Le IVe Salon des Tuileries au Palais du Bois." *La revue de l'art, Revue de l'art ancien et moderne* 278 (July–August 1926): 121–128.

Bowness 1968
Bowness, Alan. *Matisse et le nu.* Paris: Albin Michel, 1968.

Brattskoven 1930
Brattskoven, Otto. "Nolde und Matisse, zwei Maler als nationale Repräsentanten." *Der Kreis* 4 (April 1930): 213–216.

Braune 1920
Braune, Heinz. "Zu einem Gemälde von Henri Matisse." *Genius* 2 (1920): 197–198.

Brezzo 1982
Brezzo, Steven L. "Aspects of Nineteenth- and Twentieth-Century Art (1850–1950)." *Apollo* 115, no. 244 n.s. (June 1982): 478–487.

Brill 1967
Brill, Frederick. *Matisse.* London: Paul Hamlyn, 1967.

Brockway 1957
Brockway, Wallace, and Alfred Frankfurter. *The Albert D. Lasker Collection, Renoir to Matisse.* New York: Simon and Schuster, 1957.

Brown 1968
Exhibition, The Memoirs of Oliver Brown. London: Evelyn, Adams and Mackay, 1968.

Buettner 1983
Buettner, Stewart. "The 'Mirrored Interiors' of Henri Matisse." *Apollo* (February 1983): 126–129.

Bulliet 1927
Bulliet, C. J. *Apples and Madonnas.* Chicago: Pascal Covici Publisher, 1927.

Bulliet 1933
Bulliet, C. J. *Apples and Madonnas.* New York: Covici, Friede Publishers, 1933.

Cabanne 1970
Cabanne, Pierre. "Matisse: une oeuvre magnifique et une exposition ratée." *Combat* (27 April 1970).

Callahan 1983
Callahan, Maggie. "Matisse in Canadian Collections." *Update* 4/6 (November–December 1983): 2–5.

Canaday 1959
Canaday, John. *Mainstreams of Modern Art.* New York, 1969.

Carco 1924
Carco, Francis. *Le nu dans la peinture Moderne.* Paris: Les Editions G. Gres et Cie., 1924.

Carco 1953
Carco, Francis. *L'ami des peintres.* Paris: Gallimard, 1953.

 Carlson 1971
Carlson, Victor I. *Matisse as a Draughtsman.* Exh. cat., Baltimore Museum of Art, 1971.

Carpi 1975
Carpi, Pinin. *Matisse—Le Finestre del Sole.* Milan: Garzanti Editore, 1975.

Cassarini 1984
Cassarini, Jean. *Matisse à Nice, 1916–1954.* Nice: Union Méditerranéenne pour l'Art Moderne, 1984.

Cassou 1933
Cassou, Jean. "Henri Matisse." *L'amour de l'art* 5 (May 1933): 107–112.

Cassou 1939
Cassou, Jean. *Paintings and Drawings of Matisse.* Paris and New York: Braun et Cie., 1939.

Cassou 1947
Cassou, Jean. *Matisse.* Paris: Les Editions Braun, 1947.

Cassou 1948
Cassou, Jean. *Matisse.* London: Faber and Faber, 1948.

Cassou 1954
Cassou, Jean, Bernard Dorival, and Geneviève Homolle. *Musée National d'Art Moderne, catalogue-guide.* Paris: Editions des Musées Nationaux, 1954.

Chanaux 1980
Chanaux, Adolphe. *Jean-Michel Frank.* Paris: Editions du Regard, 1980.

Chapon 1984
Chapon, François. *Mystères et splendeurs de Jacques Doucet, 1853–1929.* Paris: Jean-Claude Lattès, 1984.

Charensol 1926
Charensol, Georges. "Le Salon des Tuileries." *L'amour de l'art* 6 (June 1926): 206.

Charensol 1928
Charensol, Georges. "Les expositions." *L'art vivant* 94 (15 November 1928): 899–901.

Chavenon 1920
Chavenon, Roland. *Opinions de peintre.* Paris: Georges Cadet, 1920.

Cheney 1934
Cheney, Sheldon. *Expressionism in Art.* New York, 1934.

Cheney 1941
Cheney, Sheldon. *The Story of Modern Art.* New York: The Viking Press, 1941.

Christie's 1960
Christie's Review of the Year 1960. London: Christie, Manson and Woods, Ltd., 1960.

Chroniques du Jour 1931
"Pour ou contre Henri Matisse." *Chroniques du Jour* 9 (1931), special issue on Matisse.

Clair 1970
Clair, Jean. "La tentation de l'orient." *La Nouvelle Revue Française* (1 July, 1970): 65–71.

Clark 1956
Clark, Kenneth. *The Nude, A Study of the Ideal in Art.* London: John Murray, 1956.

Clark 1974
Clark, Kenneth. *Another Part of the Wood.* London: John Murray, 1974.

Clay 1975
Clay, Jean. *De l'impressionnisme à l'art moderne.* Paris: Hachette-Réalités, 1975.

Cleveland 1973
"The Year in Review for 1972." *Cleveland Museum of Art Bulletin* 60, no. 3 (March 1973): 63–115.

Cocteau 1920
Cocteau, Jean. *Carte blanche.* Paris: Aux Editions de la Sirène, 1920.

Cogniat 1950
Cogniat, Raymond. *Orientations de la peinture française de David à Picasso.* Paris: La Diane Française, 1950.

Cone 1950
"Dr. Claribel and Miss Etta, Collectors." *Art News* 48, no. 9 (January 1950): 38–40, 58–59.

Constable 1964
Constable, W. G. *Art Collecting in the United States of America.* London: Thomas Nelson and Sons Ltd., 1964.

Cooper 1976
Cooper, Douglas. *Alex Reid and Lefevre, 1926–1976.* London: Lefevre Gallery, 1976.

Coquiot 1920
Coquiot, Gustave. *Les indépendants 1884–1920.* Paris: Librairie Ollendorf, 1920.

Cott 1948
Cott, Perry B. *Art Through 50 Centuries, from the Collections of the Worcester Art Museum.* Worcester: Worcester Art Museum, 1948.

Courthion 1926
Courthion, Pierre. *Couleurs.* Paris: Editions des Cahiers Libres, 1926.

Courthion 1927
Courthion, Pierre. *Panorama de la peinture française contemporaine.* Paris: Simon Kra, 1927.

Courthion 1934
Courthion, Pierre. *Henri-Matisse.* Paris: Les Editions Rieder, 1934.

Courthion 1942
Courthion, Pierre. *Le visage de Matisse.* Lausanne: Marguerat, 1942.

Courthion 1970
Courthion, Pierre. "La conquête de la lumière." *Hommage à Matisse,* special issue of *XXe Siècle,* Paris 1970.

Cowart 1977
Cowart, Jack, et al. *Henri Matisse Paper Cut-Outs.* Exh. cat., St. Louis Art Museum. New York: 1977.

Craven 1934
Craven, Thomas. *Modern Art.* New York: Simon and Schuster, 1934.

Crespelle 1962
Crespelle, Jean-Paul. *Montparnasse vivant.* Paris: 1962.

Cummings 1970
Cummings, Frederick J., Ellen Sharp, Diane Kirkpatrick, and Willis F. Woods. *The Robert Hudson Tannahill Bequest to the Detroit Institute of Arts.* Detroit: Detroit Institute of Arts, 1970.

Dale 1929a
Before Manet to Modigliani from the Chester Dale Collection. New York: Alfred A. Knopf, 1929.

Dale 1929b
Dale, Maud. "French Art in the Chester Dale Collection." *The Art News* 27, no. 30 (April 1929): 46–50.

Dale 1931a
Dale, Maud. "Twentieth-Century Paintings." *The Carnegie Magazine* 5, no. 2 (May 1931): 35–37.

Dale 1931b
Dale, Maud. "Amerika und Europa." *Kunst und Künstler* 29 (March 1931): 239–244.

Dale 1943
"The Chester Dale Collection." *Bulletin of the Art Institute of Chicago* 37, no. 4 (April–May 1943): 50–51.

Dale 1965
Dale, Maud, and John Walker. *Twentieth Century Paintings and Sculpture of the French Schools in the Chester Dale Collection.* Washington: National Gallery of Art, 1965.

Dale-Flint 1935
Dale, Maud, and Ralph Flint. *French Masters of the XIX and XX Century, The Private Collection of Joseph Stransky, New York.* Special reprint from *Art News Supplement* May 1931 including accessions up to May 1935. New York: Art News, 1935.

Daval 1980
Daval, Jean-Luc. *Journal des avant-gardes, les années vingt–les années trente.* Geneva: Skira, 1980.

Davidson 1948
Davidson, Morris. *An Approach to Modern Painting.* New York: Coward-McCann, 1948.

Denis 1959
Denis, Maurice. *Journal, tome III.* Paris: La Colombe, 1959.

Diehl 1954
Diehl, Gaston. *Henri Matisse.* Paris: Editions Pierre Tisné, 1954.

Diehl 1970
Diehl, Gaston. *Henri Matisse.* Paris: Nouvelles Editions Françaises, 1970.

Donath 1925
Donath, Adolph. *Technik des Kunstsammelns.* Berlin: R. C. Schmidt and Co., 1925.

Dorival 1946
Dorival, Bernard. "Musée d'Art Moderne— Peintures de maîtres contemporains." *Bulletin des Musées de France* 2 (1946): 15–20.

Dorival 1961a
Dorival, Bernard. *L'Ecole de Paris au Musée National d'Art Moderne.* Paris: Editions Aimery Somogy, 1961.

Dorival 1961b
Dorival, Bernard. "La Donation Lung au Musée du Louvre." *La revue du Louvre et des Musées de France* 2 (1961): 143–158.

Du Colombier 1942
Du Colombier, Pierre. "A travers le Musée National d'Art Moderne." *Les beaux arts* 76 (20 August 1942): 6–7.

Duthuit 1926
Duthuit, Georges. "Oeuvres récentes de Henri Matisse." *Cahiers d'art* 7 (1926): 153–161.

Duthuit 1956a
Duthuit, Georges. *Le Musée Inimaginable.* Paris: José Corti, 1956, 3 vols.

Duthuit 1956b
Duthuit, Georges. "The Material and Spiritual Worlds of Henri Matisse." *Art News* 55, no. 6 (October 1956): 22–25, 67.

Duthuit 1961
Duthuit, Georges. *L'image et l'instant.* Paris: José Corti, 1961.

Duthuit 1962
Duthuit, Georges. *Le feu des signes.* Geneva: Skira, 1962.

Duthuit 1974
Duthuit, Georges. *Représentation et présence, premiers écrits et travaux 1923–1952.* Paris: Flammarion, 1974.

Duthuit 1983
Duthuit, Marguerite, and Claude Duthuit. *Henri Matisse, catalogue raisonné de l'oeuvre gravé.* With collaboration of Françoise Garnaud, preface by Jean Guichard-Meili, Paris, 1983.

Earp 1926
Earp, T. W. "Modern French Painting at the Tate Gallery." *Apollo* 4 (July–December 1926): 65.

Edgell 1949
Edgell, George Harold. *French Painters in the Museum of Fine Arts: Corot to Utrillo.* Boston: Museum of Fine Arts, 1949.

Eglington 1934
Eglington, Laurie. "Braque, Matisse and Picasso Exhibited." *The Art News* 32, no. 24 (17 March 1934): 3–4, ills. pp. 5 and 6.

Eglinton 1924
Eglinton, Guy. "Art and Other Things." *International Studio* 79, no. 327 (August 1924): 376–377.

Einstein 1926
Einstein, Carl. *Die Kunst des 20. Jahrhunderts.* Berlin: Propylaen Kunst Geschichte, 1926, vol. 16.

Einstein 1931
Einstein, Carl. *Die Kunst des 20. Jahrhunderts.* Berlin: Im Propylaen Verlag, 1931.

Elderfield 1978a
Elderfield, John. *Matisse in the Collection of the Museum of Modern Art.* New York: The Museum of Modern Art, 1978.

Elderfield 1978b
Elderfield, John. *The Cut-Outs of Henri Matisse.* New York: George Braziller, 1978.

Elderfield 1984
Elderfield, John. *The Drawings of Henri Matisse.*
New York: The Museum of Modern Art, 1984.

Elsen 1972
Elsen, Albert E. *The Sculpture of Henri Matisse.*
New York: Harry N. Abrams, 1972.

Escholier 1937a
Escholier, Raymond. *La peinture française, XXe
siècle.* Paris: Librairie Floury, 1937.

Escholier 1937b
Escholier, Raymond. *Henri Matisse.* Paris: Librairie
Floury, 1937.

Escholier 1956a
Escholier, Raymond. *Matisse, ce vivant.* Paris:
Libraire Arthème Fayard, 1956.

Escholier 1956b
Escholier, Raymond. "Matisse et le Maroc." *Le jardin
des arts* 24 (October 1956): 705–712.

Escholier 1960
Escholier, Raymond. *Matisse from the Life.*
London: Faber and Faber, 1960.

Fage 1930
Fage, André. *Le collectionneur de peintures
modernes.* Paris: Les editions pittoresques, 1930.

Fairbanks Marcus 1954
Fairbanks Marcus, Margaret. *Flower Painting by
the Great Masters.* New York: Harry N. Abrams,
1954.

Faure 1920
Faure, Elie, Jules Romains, Charles Vildrac, and
Léon Werth. *Henri-Matisse.* Paris: Georges Crès &
Cie, 1920.

Faure 1923
Faure, Elie, Jules Romains, Charles Vildrac, and
Léon Werth. *Henri-Matisse.* Paris: Georges Crés &
Cie, 1923.

Faure 1926
Faure, Elie. *Histoire de l'art, l'art moderne.* Paris:
Les Editions Georges Crès, 1926.

Faure 1964
Faure, Elie. *Oeuvres complètes, tome 3, Oeuvres
diverses.* Paris: Jean-Jacques Pauvert Editeur, 1964.

Fels 1925
Fels, Florent. *Propos d'artistes.* Paris: La
Renaissance du livre, 1925.

Fels 1929
Fels, Florent. *Henri-Matisse.* Paris: Editions des
Chroniques du jour, 1929.

Fels 1950
Fels, Florent. *L'art vivant de 1900 à nos jours.*
Geneva: Pierre Cailler, 1950.

Fénéon 1970
Fénéon, Félix. *Oeuvres plus que complètes.* Vol. 1.
Paris: Librairie Droz, 1970.

Fermigier 1971
Fermigier, André. "Matisse et son double." *Revue de
l'art* 12 (1971): 100–107.

Ferrier 1961
Ferrier, Jean Louis. *Matisse 1911–1930.* Paris:
Fernand Hazan, 1961.

Flam 1973a
Flam, Jack D. *Norton Gallery Studies II: The Norton
Matisses.* West Palm Beach: Norton Gallery of Art,
1973.

Flam 1973b
Flam, Jack D. *Matisse on Art.* London: Phaidon, 1973.

Flint 1930
Flint, Ralph. "The Current American Art Season."
Art and Understanding 1 (March 1930): 177–224.

Fourcade 1972
Fourcade, Dominique. *Henri Matisse, Ecrits et
propos sur l'art.* Paris: Hermann, 1972.

Fourcade 1974
Fourcade, Dominique. "Rêver à trois aubergines. . ."
Critiques 324 (May 1974): 467–489.

Fourcade 1975
Fourcade, Dominique. "Je crois qu'en dessin j'ai pu
dire quelque chose." In *Henri Matisse, dessins et
sculpture.* Paris: Musée National d'Art Moderne,
1975.

Fourcade 1976
Fourcade, Dominique. "Autres propos de Henri
Matisse." *Macula* 1 (1976): 92–115.

Fourcade 1983
Fourcade, Dominique. "Matisse et Manet?" In
Bonjour Monsieur Manet. Paris: Musée National
d'Art Moderne, 1983.

Fourcade 1986
Fourcade, Dominique. "Crise du cadre." *Cahiers du
Musée National d'Art Moderne* 17–18 (1986):
68–79.

Francis 1947
Francis, Henry S. "'Fête des fleurs, Nice' by
Matisse." *The Bulletin of the Cleveland Museum of
Art* 34, no. 4 (1947): 68–70, ill. p. 62.

Frankfurter 1948
Frankfurter, Alfred M. "Is He the Greatest?" *Art
News* 47, no. 2 (April 1948): 20–28.

Frankfurter 1962
F., A. M. [Frankfurter, Alfred M.]. "Model Dispersal
of a Great Collection." *Art News* 61, no. 5
(September, 1962): 29–30, 52–53, 55.

Fry 1922
Fry, Roger. "Henri Matisse in the Luxembourg." *The
Burlington Magazine* 230 (May 1922): 237.

Fry 1924
Fry, Roger. "La peinture moderne en France."
L'amour de l'art 5 (May 1924): 141–160.

Fry 1931
Fry, Roger. "Henri Matisse." *Creative Art* 9
(December 1931): 459–462.

Fry 1932
Fry, Roger. *Characteristics of French Art.* London:
Chatto and Windus, 1932.

Fry 1935
Fry, Roger. *Henri-Matisse*. London: A. Zwemmer, 1935.

Fry 1970
Fry, Roger. "Matisse et le renouveau de l'expression plastique." *XXe siècle* (1970): 11–19. Special issue on Matisse.

Fry 1972
The Letters of Roger Fry. ed. Denys Sutton. Vol. 2. New York: Random House, 1972.

Gallatin 1933
Gallatin, A. E. *Gallery of Living Art*. New York: New York University, 1933.

Gallatin 1940
Gallatin, A. E. *Museum of Living Art*. New York: New York University, 1940.

Garaudy 1974
Garaudy, Roger. *60 oeuvres qui annoncèrent le futur*. Geneva: Skira, 1974.

Gardiner 1968
Gardiner, Henry G. *The Samuel S. White, 3rd, and Vera White Collection. Philadelphia Museum of Art Bulletin* 63, nos. 296 and 297 (January–March and April–June 1968): 71–147.

Garner 1980
Garner, Philippe. *Twentieth Century Furniture*. London: Phaidon, 1980.

Gauthier 1930
Gauthier, Maximilien. "Notices bio-bibliographiques des peintres figurant à l'exposition de l'Art Vivant." *L'Art Vivant* 6 no. 130 (15 May 1930): 392–418.

Gee 1981
Gee, Malcolm. *Dealers, Critics and Collectors of Modern Painting, Aspects of the Parisian Art Market between 1910 and 1930*. New York: Garland Publishing Inc., 1981.

Genaille 1955
Genaille, Robert. *La peinture contemporaine*. Paris: Fernand Nathan, 1955.

George 1924
George, Waldemar. "Première exposition de collectionneurs organisée au profit de la Société des Amis du Luxembourg." *L'amour de l'art* 5 (February 1924): 50–55.

George 1925a
George, Waldemar. *Henri Matisse, dessins*. Paris: Editions des Quatre Chemins, 1925.

George 1925b
George, Waldemar. "Le Salon d'Automne." *L'amour de l'art* 6 (September 1925): 351–359.

George 1929
George, Waldemar. *La grande peinture contemporaine à la collection Paul Guillaume*. Paris: Editions des Arts à Paris, 1929.

George 1931
George, Waldemar. "Dualité de Matisse." *Formes* 16 (June 1931): 94–95.

Georgen 1985
Georgen, Theresa. *Französische Interieur-Bilder um 1900*. In *Kunstmuseum Bern*. Braunschweig, 1985.

Georges-Michel 1944
Georges-Michel, Michel. *Les Grandes Epoques de la peinture moderne de Delacroix à nos jours*. New York: Brentano's, 1944.

Giedon 1948
Giedon, Siegfried. *Mechanization Takes Command*. New York, 1948.

Gilot 1965
Gilot, Françoise. *Vivre avec Picasso*. Paris: Calmann–Levy, 1965.

Gimpel 1963
Gimpel, René. *Journal d'un Collectionneur marchand de tableaux*. Paris: Calmann–Lévy, 1963.

Giraudy 1971
Giraudy, Danièle. "Correspondance Henri Matisse–Charles Camoin." *Revue de l'art* 12 (1971): 7–34.

Giraudy 1972
Giraudy, Danièle. *Camoin, sa vie, son oeuvre*. Marseilles: La Savoisienne, 1972.

Glasgow 1953
Catalogue of French Paintings. Glasgow: Art Gallery and Museums Association, 1953.

Golson 1970
Golson, Lucile M. "The Michael Steins of San Francisco: Art Patrons and Collectors." In *Four Americans in Paris*. New York: The Museum of Modern Art, 1970, 35–49.

Goodrich 1928
G., L. [Lloyd Goodrich]. "Exhibitions in New York." *The Arts* 14, no. 5 (November 1928): 267–278.

Goodrich 1929a
Goodrich, Lloyd. "Gallery Gossip." *The Arts* 16, no. 1 (September 1929): 53–54.

Goodrich 1929b
Goodrich, Lloyd. "The Opening Season." *The Arts* 16, no. 2 (October 1929): 114–122.

Goodrich 1930
Goodrich, Lloyd. "In the Galleries." *The Arts* 16, no. 5 (January 1930): 337–344.

Göpel 1961
Göpel, Barbara and Erhard. *Leben und Meinungen des Malers Hans Purrmann*. Wiesbaden: Limes Verlag, 1961.

Gottlieb 1964
Gottlieb, Carla. "The Role of the Window in the Art of Matisse." *Journal of Aesthetics and Art Criticism* 22 (Summer 1964): 393–422.

Gottlieb 1984
Gottlieb, Lennart. "Tetzen-Lunds samling-om dens historie, indhold og betydning." *Kunst og Museum* 19 (1984): 18–49.

Gowing 1966
Gowing, Lawrence. *Henri Matisse 64 Paintings*. New York: The Museum of Modern Art, 1966.

Gowing 1968
Matisse. Introduction by Lawrence Gowing. Exh. cat., The Hayward Gallery. London: 1968, 7–42.

Gowing 1979a
Gowing, Lawrence. *Matisse.* London: Thames and Hudson, 1979.

Gowing 1979b
Gowing, Lawrence. *Matisse—The Harmony of Light.* New York: The Museum of Modern Art, 1979.

Grautoff 1921
Grautoff, Otto. *Die Französische Malerei seit 1914.* Berlin: Mauritius Verlag, 1921.

Green 1981
Green, Eleanor. *Museums Discovered: The Phillips Collection.* New York, 1981.

Greenberg 1953
Greenberg, Clement. *Henri Matisse.* New York: Harry N. Abrams and Pocket Books Inc., 1953.

Greenberg 1961
Greenberg, Clement. *Art and Culture.* Boston: Beacon Press, 1961.

Greenberg 1973
Greenberg, Clement. "Influences of Matisse." In *Henri Matisse.* New York: Acquavella Galleries, 1973.

Gros 1927
Gros, G. J. "Henri Matisse." *Cahiers d'art* 7–8 (1927): 268–274.

Grossman 1930
Grossman, Rudolf. "Matisse and Germany." *Formes* 4 (1930): 4.

Grünewald 1944
Grünewald, Isaac. *Matisse och Expressionismen.* Stockholm: Wahlstrom und Widstrand, 1944.

Grünewald 1964
Grünewald, Isaac. *Matisse och Expressionismen.* Stockholm: Bokforlaget Prisma, 1964.

Guenne 1927
Guenne, Jacques. *Portraits d'artiste.* Paris: Editions Marcel Scheur, 1927.

Guenne 1928
Guenne, Jacques. "Le 25e Salon d'Automne." *L'Art Vivant* (15 November 1928): 869–875.

Guenne 1930
Guenne, Jacques. "L'exposition de l'Art Vivant au Théâtre Pigalle." *L'Art Vivant* 130 (15 May 1930): 385–391.

Guichard-Meili 1967
Guichard-Meili, Jean. *Henri Matisse, son oeuvre, son univers.* Paris: Fernand Hazan Editeur, 1967.

Guichard-Meili 1970
Guichard-Meili, Jean. "Les odalisques." *Hommage à Matisse, XXe siècle,* 1970: 63–69.

Guitry 1954
Guitry, Sacha. *Cent merveilles.* Paris: Raoul Solar, 1954.

Hahnloser 1956
Hahnloser, Hans R. "Werke aus der Sammlung Hahnloser." *Du* 11 (November 1956): 2–55.

Hall 1966
Hall, Douglas. "Matisse's 'La Leçon de Peinture' (Scottish National Gallery of Modern Art)." *The Burlington Magazine* 108, no. 758 (May 1966): 261–262.

Hamilton 1967
Hamilton, George Heard. *Painting and Sculpture in Europe 1880–1940.* Harmondsworth: Penguin Books, 1967.

Harris 1923
Harris, Frank. *Contemporary Portraits, Fourth Series.* New York: Brentano's, 1923.

Hattis 1977
Hattis, Phyllis. *Four Centuries of French Drawings in the Fine Arts Museums of San Francisco.* San Francisco: The Fine Arts Museums of San Francisco, 1977.

Hauptman 1981
Hauptman, William. *Dübi-Müller Stiftung, Josef Müller Stiftung.* Solothurn: Kunstmuseum, 1981.

Heilmaier 1931–1932
Heilmaier, Hans. "Bei Henri Matisse." *Die Kunst und das Schöne Heim* 65 (1931–1932): 206–209.

Hendy 1931
Hendy, Phillip. "The Collection of Mr. John T. Spaulding." *Bulletin of the Museum of Fine Arts* 29, no. 176 (December 1931): 109–113.

Hess 1948
Hess, Thomas B. "Matisse: A Life of Color." *Art News* 47, no. 2 (April 1948): 16–19.

Hintze 1930
Hintze, Bertel. *Modern Konst 1900–Talet.* Stockholm: Lars Hokerbergs Bokforlag, 1930.

Honeyman 1969
Honeyman, T. J. "Les Fauves—Some Personal Reminiscences." *The Scottish Art Review* 12, no. 1 (1969): 17–20.

Hoog 1969
Hoog, Michel. "La peinture et la gravure, Fauvisme et Expressionisme." In *Encyclopedie de la Pléiade, Histoire de l'Art,* tome IV, 526–607.

Hoog 1984
Hoog, Michel, Hélène Guicharnaud, and Colette Giraudon. *Catalogue de la collection Jean Walter et Paul Guillaume.* Paris: Musée de l'Orangerie, 1984.

Hoppe 1931
Hoppe, Ragnar. *Stader och Konstnarer.* Stockholm: Albert Bonniers Forlag, 1931.

Howell 1957
Howell, Arthur R. *The Meaning and Purpose of Art.* London, 1957.

Hubbard 1962
Hubbard, R. H. *European Paintings in Canadian Collections, II, Modern Schools.* Toronto: Oxford University Press, 1962.

Hunter 1956
Hunter, Sam. *Henri Matisse*. New York: The
Metropolitan Museum of Art, 1956.

Hunter-Jacobus 1976
Hunter, Sam, and John Jacobus. *Modern Art, From
Post-Impressionism to the Present*. New York:
Harry N. Abrams, Inc., 1976.

Huyghe 1930
Huyghe, René. "Matisse et la couleur." *Formes* 1
(January 1930): 5–10.

Huyghe 1935
Huyghe, René. *Histoire de l'art contemporain*. Paris:
Librairie Félix Alcan, 1935.

Huyghe 1939
Huyghe, René. *Les contemporains*. Paris: Editions
Pierre Tisné, 1939.

Huyghe 1945
Huyghe, René. *La peinture actuelle*. Paris: Editions
Pierre Tisné, 1945.

Huyghe 1955
Huyghe, René. *Henri Matisse*. Paris: Flammarion,
1954.

Jacobus 1972
Jacobus, John. *Henri Matisse*. New York: Harry N.
Abrams, Inc., 1972.

Jalard 1966
Jalard, Michel-Claude. *Le Post-Impressionnisme*.
Lausanne: Editions Rencontre, 1966.

Jardin des Arts 1970
Le jardin des arts, May 1970, special issue on
Matisse.

Jedlicka 1945
Jedlicka, Gotthard. *Begegnungen Mit Künstler der
Gegenwart*. Zurich: Eugene Rentsch Verlag, 1945.

Jedlicka 1965
Jedlicka, Gotthard. *Henri Matisse: La Coiffure*.
Stuttgart: Philip Reclam, 1965.

Johansson 1941
Johansson, Gotthard. *Kritik*. Stockholm: Albert
Bonniers Forlag, 1941.

Joseph 1931
Joseph, Edouard. *Dictionnaire biographique des
artistes contemporains*. Vol. 2. Paris: Art et Edition,
1931.

Joubin 1930
Joubin, André. "Jacques Doucet 1853–1929." *Gazette
des beaux-arts* (February 1930): 69–82.

Kawashima 1936
Kawashima, R. *Matisse*. Tokyo: Atelier Sha, 1936.

Klingsor 1921
Klingsor, Tristan. *L'Art français depuis vingt ans, la
peinture*. Paris: F. Rieder et Cie, 1921.

Kriesberg 1964
Kriesberg, Irving. *The Visual Experience*. New
York: Pitman Publishing Corporation, 1964.

Kuh 1947
Kuh, Katherine. *The Winterbotham Collection*.
Chicago: The Art Institute of Chicago, 1947.

Kuthy 1983
Kuthy, Sabdor. *Kunstmuseum Bern, Die Gemälde*.
Bern: Kunstmuseum Bern, 1983.

Larson 1974
Larson, Philip. "Matisse and the Exotic." *Arts
Magazine* (May 1975): 72–73.

Lassaigne 1947
Lassaigne, Jacques. *Cent chefs d'oeuvre des peintres
de l'Ecole de Paris*. Paris: Editions de la Galerie
Charpentier, 1947.

Lassaigne 1959
Lassaigne, Jacques. *Matisse*. Geneva: Skira, 1959.

Lassaigne 1981
Lassaigne, Jacques. *A l'école des grands peintres,
Matisse*. Paris: Editions de Vergeures, 1981.

La Tourette n.d.
La Tourette, F. Gilles de. *La peinture française
contemporaine*. Paris: Librairie des Arts Décoratifs, n.d.

Laude 1975
Laude, Jean, et al. *Le Retour à l'Ordre dans les arts
plastiques et l'architecture, 1919–1925*. Saint
Etienne: Université de Saint Etienne, 1975.

Lejard 1948
Lejard, André. *Henri Matisse*. Paris: Fernand
Hazan, 1948.

Lejard 1952
Lejard, André. *Matisse*. Paris: Fernand Hazan, 1952.

Lepore 1966
Lepore, Mario. *I Fauves*. Milan: Arti Grafiche
Ricordi, 1966.

Level 1959
Level, André. *Souvenirs d'un collectionneur*. Paris:
Alain Mazo, 1959.

Lévêque 1967
Lévêque, Jean-Jacques. "Matisse 1." *La galerie des
arts* 44 (May 1967).

Lévêque 1968
Lévêque, Jean-Jacques. *Matisse*. Paris: Club d'Art
Bordas, 1968.

Levinson 1930
Levinson, André. "Les 60 ans de Henri Matisse."
L'Art Vivant (1 January 1930): 24.

Levy 1920
Levy, Rudolf. "Matisse." *Genius* 2 (1920): 186–188.

Lévy 1976
Lévy, Pierre. *Des artistes et un collectionneur*. Paris:
Flammarion, 1976.

Lewisohn 1931
Lewisohn, Samuel A. "Drama in Painting." *Creative
Art* 9 (September 1931): 185–197.

Lewisohn 1948
Lewisohn, Sam A. *Painters and Personality*. New
York: Harpers and Brothers, 1948.

Leymarie 1967
Leymarie, Jean. *Grands peintres—Matisse.* Paris: Hachette, 1967.

Lhote 1933
Lhote, André. *La peinture, le coeur et l'esprit.* Paris: Denöel et Steele, 1933.

Lipman 1934
Lipman, Jean H. "Matisse Paintings in the Stephen C. Clark Collection." *Art in America* 22, no. 4 (October 1934): 134–144.

Lipman 1970
Lipman, Jean, ed. *The Collector in America.* New York: The Viking Press, 1970.

Livingston 1974
Livingston, Jane. "Matisse's 'Tea'." *Los Angeles County Museum of Art Bulletin* (1974): 46–57.

Loeb 1946
Loeb, Pierre. *Voyages à travers la peinture.* Paris, 1946.

Lübecker 1955
Lübecker, Pierre. *Henri Matisse.* Copenhagen: Gyldendal, 1955.

 Luzi 1971
Luzi, Mario, and Massimo Carrà. *L'opera di Matisse, dalla rivolta fauve all'intimismo, 1904–1928.* Milan: Rizzoli Editore, 1971.

Lynes 1973
Lynes, Russell. *Good Old Modern, The Museum of Modern Art.* New York: Atheneum, 1973.

McBride 1930
McBride, Henry. *Matisse.* New York: Alfred A. Knopf, 1930.

McBride 1931a
McBride, Henry. "Matisse in America." *Creative Art* 9 (December 1931): 463–466.

McBride 1931b
McBride, Henry. "The Chester Dale Collection at New-York [sic]." *Formes* 14 (April 1931): 57–58, ills. n.p.

McBride 1951
McBride, Henry. "Rockefeller Whitney Senior Odets Colin." *Art News* 50, no. 4 (June–July–August, 1951): 34–37, 59–60.

McBride 1975
McBride, Henry. *Essays and Criticism.* New York: Atheneum Publishers, 1975.

Maillard 1975
Maillard, Robert. *Dictionnaire Universel de la peinture.* Paris: Dictionnaire Robert, 1975.

Manguin 1980
Manguin, Claude and Lucille. *Henri Manguin, catalogue raisonné de l'oeuvre peint.* Neuchâtel: Ides et Calendes, 1980.

Mannering 1982
Mannering, Douglas. *The Art of Matisse.* New York: Excalibur Books, 1982.

Manson 1929
Manson, J. B. "Mr. Frank Stoop's Modern Pictures." *Apollo* 10 (September 1929): 127–133.

Marcel 1924
Marcel, Philippe. "Henri Matisse." *L'art d'aujourd'hui* I (Summer 1924): 33–46.

Marchesseau 1986
Marchesseau, Daniel. *Diego Giacometti.* Paris: Hermann, 1986.

Marchiori 1967a
Marchiori, Giuseppe. *Matisse.* Paris: La Bibliothèque des Arts, 1967.

Marchiori 1967b
Marchiori, Giuseppe. "Evoluzione di Matisse." *L'arte moderna* X no. 83 (1967): 41–72.

Massine 1968
Massine, Léonide. *My Life in Ballet.* London: MacMillan, 1968.

Masson 1958
Masson, André. *Entretiens avec Georges Charbonnier.* Paris: Julliard, 1958.

Masson 1976
Masson, André. *Le rebelle du Surréalisme.* Paris: Hermann, 1976. Ed. Françoise Will-Levaillant.

Mather 1927
Mather, Frank Jewett, Jr. *Modern Painting, a Study of Tendencies.* New York: Henry Holt and Company, 1927.

Mathiot
Mathiot, Georges. *Dictionnaire des noms des rues.* 2 vols. Ms. Archives Municipales, Nice, unpublished.

 Matisse 1920
Cinquante dessins par Henri Matisse (album édité par les soins de l'artiste). Paris, 1920.

Matisse 1939
Matisse, Henri. "Notes d'un peintre sur son dessin." *Le Point* 21 (July 1939): 8–14.

Matisse 1954
Matisse, Henri. *Portraits.* Monte Carlo: André Sauret, 1954.

Maugham 1962
Maugham, W. Somerset. *Purely for My Pleasure.* London: Heineman, 1962.

Mauny 1925
Mauny, Jacques. "The Autumn Salon." *The Arts* 8, no. 5 (November 1925): 286–288.

Mauny 1928
Mauny, Jacques. "The Charles Pacquement Collection." *The Arts* 13 (January 1928): 5–17.

Maxon 1970
Maxon, John. *The Art Institute of Chicago.* New York: Harry N. Abrams, Inc., 1970.

Meier-Graefe 1923–1924
Meier-Graefe, Julius. "Matisse, das Ende des Impressionismus." *Faust* 2, no. 6 (1923–1924): 1–5.

Meier-Graefe 1927
Meier-Graefe, Julius. *Entwicklungsgeschichte der Modernen Kunst.* Vol. 3, *Matisse und Picasso.* Munich, 1927, 621–636.

Mertens 1984
Mertens, Phil. *Musées Royaux des Beaux Arts de Belgique, catalogue inventaire.* Brussels: Musées Royaux des Beaux-Arts de Belgique, 1984.

Mezzatesta 1984
Mezzatesta, Michael P. *Henri Matisse Sculptor/Painter.* Exh. cat., Kimbell Art Museum, 1984.

Milhau 1975
Milhau, Denis. "Matisse, Picasso et Braque, 1918–1926, y-a-t-il un retour à l'ordre?" *La retour à l'ordre dans les arts plastiques et l'architecture.* Saint-Etienne: University of Saint-Etienne, 1975.

Milliken 1958
Milliken, William H., and William E. Ward. *The Cleveland Museum of Art Handbook.* Cleveland: Cleveland Museum of Art, 1958.

Minemura 1976
Minemura, Toshiaki. *Matisse.* Tokyo: Shincho Art Library, 1976.

Minneapolis 1948
[D., R. S.] "Institute Acquires a Famous Matisse." *The Minneapolis Institute of Fine Arts Bulletin* 37 (7 February 1948): 26–31.

 Monod-Fontaine 1979
Monod-Fontaine, Isabelle. *Matisse, collections du Musée National d'Art Moderne.* Paris: Musée National d'Art Moderne, 1979.

Monod-Fontaine 1984
Monod-Fontaine, Isabelle. *The Sculpture of Henri Matisse.* London: Thames and Hudson, 1984.

Montreal 1960a
The Montreal Museum of Fine Arts, Painting, Sculpture, Decorative Arts. Montreal: The Montreal Museum of Fine Arts, 1960.

Montreal 1960b
Catalogue of Paintings. Montreal: The Montreal Museum of Fine Arts, 1960.

Montreal 1977
Guide. Montreal: The Montreal Museum of Fine Arts, 1977.

Morsell 1934
Morsell, Mary. "Finely Arranged Matisse Exhibit Now on Display." *The Art News* 32, no. 17 (27 January 1934): 3–4.

Moulin 1968
Moulin, Raoul-Jean. *Henri Matisse, dessins.* Paris: Editions Cercle d'Art, 1968.

Muller 1966
Muller, Joseph Emil, and Frank Elgar. *Un siècle de peinture moderne.* Paris: Fernand Hazan, 1966.

Muller 1979
Muller, Joseph Emil, and Frank Elgar. *Cent ans de peinture moderne.* Paris: Fernand Hazan Editeur, 1979.

Murphy 1985
Murphy, Alexandra R. *European Paintings in the Museum of Fine Arts, Boston, An Illustrated Catalogue.* Boston: Museum of Fine Arts, 1985.

Mushakojo 1939
Mushakojo. *Henri Matisse 1890–1939.* Tokyo: Tokamizawa Colour Print Studio, 1939.

Myers 1950
Myers, Bernard S. *Modern Art in the Making.* New York: McGraw Hill and Company, 1950.

Near 1985
Near, Pinkney L. *French Paintings: The Collection of Mr. and Mrs. Paul Mellon in the Virginia Museum of Fine Arts.* Richmond: Virginia Museum of Fine Arts, 1985.

Neugass 1929a
Neugass, Fritz. "Henri-Matisse 1869–1929." *Deutsche Kunst und Decoration* 32, no. 6 (March 1929): 372–380.

Neugass 1929b
Neugass, Fritz. "Henri Matisse." *Die Kunst* 61 no. 1 (October 1929): 12–21.

Neugass 1930
Neugass, Fritz. "Henri Matisse." *L'art et les artistes* 20 n.s. (1930): 235–240.

Neumayer 1956
Neumayer, H. *Fauvismus.* Vienna: Verlag Bruder Rosenbaum, 1956.

Noël 1983
Noël, Bernard. *Matisse.* Paris: Fernand Hazan, 1983.

Norton Gallery 1958
Norton Collection of Painting and Sculpture. West Palm Beach: Norton Gallery of Art, 1958.

Norton Gallery 1979
Catalogue of the Collection, Norton Gallery of Art. West Palm Beach: Norton Gallery of Art, 1970.

Ogawa 1966
Ogawa, Masataka. *Matisse—Rouault.* Tokyo: Kawade Shobo, 1966.

Okamoto 1968
Okamoto, Kenjiro. *Bonnard—Matisse.* Tokyo: Kawade Shobo, 1968.

Ooka 1972
Ooka, Makoto. *Bonnard—Matisse.* Tokyo: Tha Zauho Press, 1972.

Orienti 1971
Orienti, Sandra. *Henri Matisse.* Florence: Sansoni Editore, 1971.

Ozenfant 1968
Ozenfant, Amédée. *Mémoires 1886 – 1962.* Paris: Pierre Seghers, 1968.

Pach 1924
Pach, Walter. *The Masters of Modern Art*. New York: B. W. Huebsch Inc., 1924.

Pach 1926
Pach, Walter. "Foreword." In *Memorial Exhibition of Representative Works Selected from the John Quinn Collection*. Exh. cat., Art Center, New York, 1926.

Pach 1938
Pach, Walter. *Queer Thing, Painting*. New York: Harper and Brothers Publishers, 1938.

Palmer 1929
Palmer, Mildred. *Henri Matisse*. New York: The Arts Portfolio Series, 1929.

Phillips 1927
Phillips, Duncan. *Main Gallery—French and American Paintings of Our Period: A Bulletin of the Phillips Collection*. Washington, 1927.

Phillips 1931
Phillips, Duncan. *The Artist Sees Differently*. New York: E. Weyhe, 1931.

Phillips 1970
Phillips, Marjorie. *Duncan Phillips and His Collection*. Boston: Little, Brown and Company, 1970.

Phillips 1986
Duncan Phillips Centennial Exhibition. Exh. cat., The Phillips Collection, Washington (14 June–31 August 1986).

Picher 1956
Picher, Claude. "Le marché d'art international." *Vie des Arts* IV (September–October 1956): 6–12.

Pleynet 1971
Pleynet, Marcelin. *L'enseignement de la peinture*. Paris: Editions du Seuil, 1971.

Poiret 1930
Poiret, Paul. *En habillant l'époque*. Paris: Bernard Grasset, 1930.

Pollack 1962
Pollack, Barbara. *The Collectors: Dr. Claribel and Miss Etta Cone*. Indianapolis: The Bobbs Merrill Company, 1962.

Pope 1930
Pope, Arthur. "French Paintings in the Collection of John T. Spaulding." *The Art News* 28, no. 3 (26 April 1930): 97–128.

Purrmann 1922
Purrmann, Hans. "Aus der Werkstatt Henri Matisses." *Kunst und Künstler* 20, no. 5 (February 1922): 167–176.

Purrmann 1946
Purrmann, Hans. "Uber Henri Mattisse." *Werk* 33, no. 6 (June 1946): 185–192.

Pury 1983
Pury, Simon de. "Acquis par Thyssen." *Connaissance des Arts* 380 (October 1983): 64–71.

Puy 1939
Puy, Jean. "Souvenirs." *Le Point* 21 (July 1939): 16–33.

Radulescu 1974
Radulescu, Neagu. *Matisse*. Bucharest: Meridiane Bucuresti, 1974.

Ray 1964
Ray, Man. *Autoportrait*. Paris: Robert Laffont, 1964.

Raynal 1950
Raynal, Maurice. *Matisse Munch Rouault*. Geneva: Skira, 1950.

Read 1942
Read, Herbert. "Modern Art and French Decadence." *The Studio* 597 (December 1942): 179–189.

Reid 1968
Reid, B. L. *The Man from New York, John Quinn, and His Friends*. New York: Oxford University Press, 1968.

Revel 1961
Revel, Jean-François. "Jacques Doucet couturier et collectionneur." *L'Oeil* 84 (December 1961): 44–51, 81, 106.

Reverdy 1975
Reverdy, Pierre. *Nord-Sud, Self Defence et autres écrits sur l'art et la poésie (1917–1926)*. Paris: Flammarion, 1975.

Rey 1926
Rey, Robert. "Les Salons." *Art et Décoration* (July 1926): 44.

Rey 1929
Rey, Robert. "Le nouveau Musée du Luxembourg." *L'Art Vivant* (15 March 1929): 245–246, 248–251.

Rich 1974
Rich, Daniel Catton. *European Paintings in the Collection of the Worcester Art Museum*. 2 vols. Worcester: Worcester Art Museum, 1974.

Richardson 1985
Richardson, Brenda. *Dr. Claribel and Miss Etta, The Cone Collection*. Baltimore: The Baltimore Museum of Art, 1985.

Roché 1959
Roché, Henri Pierre. "Adieu, brave petite collection!" *Oeil* 51 (March 1959): 34–41.

Romains n.d.
Romains, Gabrielle. *Séjour et voyage avec Jules Romains*. Paris: Editions La Plume d'Or, n.d.

Romains 1970
Romains, Jules, *Amitiés et rencontres*. Paris: Flammarion, 1970.

Romm 1937
Romm, Alexander. *Henri Matisse*. Leningrad, 1937.

Romm 1947
Romm, Alexander. *Matisse, a Social Critique*. New York: Lear, 1947.

Rosenthal 1955
Rosenthal, Gertrude. *A Picture Book, 200 Objects in*

the *Baltimore Museum of Art*. Baltimore: The Baltimore Museum of Art, 1955.

Rosenthal 1967
Rosenthal, Gertrude. *The Cone Collection*. Baltimore: The Baltimore Museum of Art, 1967.

Rousseau 1953
Rousseau, Madeleine. *Introduction à la connaissance de l'art présent*. Paris: Librairie La Hune, 1953.

Rowe 1931
L., J. [Jeannette Rowe]. "Exhibitions." *International Studio* XCIX no. 409 (June 1931): 62, 66–67, 74.

Russ 1945
Russ, Willy. *Mes souvenirs sur Ferdinand Hodler*. Lausanne, 1945.

Russell 1969
Russell, John. *The World of Matisse*. New York: Time Life Books, 1969.

Russell 1974
Russell, John. *The Meanings of Modern Art*. New York: The Museum of Modern Art, 1974.

Saarinen 1958
Saarinen, Aline B. *The Proud Possessors*. New York: Random House, 1958.

Sachs 1970
Sachs, Samuel, II, and Anthony M. Clark. *Catalogue of European Paintings in the Minneapolis Institute of Arts*. Minneapolis: Institute of Arts, 1970.

Saisselin and Wrolstad 1978
Saisselin, Rémy, and Merald E. Wrolstad. *Handbook of the Cleveland Museum of Art*. Cleveland: Cleveland Museum of Art, 1978.

Salinger 1932
Salinger, Margaretta. "White Plumes with Variations." *Parnassus* 4, no. 7 (December 1932): 9–10.

Salles 1939
Salles, Georges. *Le regard*. Paris: Plon, 1939.

Salmon 1920
Salmon, André. *L'art vivant*. Paris: Editions Grès, 1920.

Salmon 1927
Salmon, André. "Letter from Paris." *Apollo* 6 (December 1927): 275–278.

Salmon 1956
Salmon, André. *Souvenirs san fin*. Vol. 2. Paris: Gallimard, 1956.

Salmon 1961
Salmon, André. *Souvenirs san fin*. Vol. 3. Paris: Gallimard, 1961.

Salvini 1949
Salvini, Roberto. *Guida all'arte moderna*. Florence: L'Arca, 1949.

San Lazzaro 1949
San Lazzaro, G. di. *Painting in France 1895–1949*. London: The Horvill Press, 1949.

Santini 1972
Santini, Pier Carlo. *Les paysagistes du XXe siècle*. Paris: Electa Weber, 1972.

Sarraut 1930
Sarraut, Albert. *Variations sur la peinture contemporaine*. Paris: Editions des Quatre Chemins, 1930.

Scheffler 1929–1930
Scheffler, Karl. "Der Sechzigjährige Henri Matisse in der Galerie Thannhauser, Berlin." *Kunst und Künstler* 28 (1929–1930): 287–290.

Schacht 1922
Schacht, Roland. *Henri Matisse*. Dresden: Rudolf Kaemmerer Verlag, 1922.

Schack 1960
Schack, William. *Art and Agyrol, the Life and Career of Dr. Albert C. Barnes*. New York: Thomas Yoseloff, 1960.

Schapiro 1932
Schapiro, Meyer. "Matisse and Impressionism." *Androcles* 1, no. 1 (February 1932): 21–36.

Scheiwiller 1933
Scheiwiller, Giovanni. *Henri Matisse*. Milan: Libreria Ulrico Hoepli, 1933.

Scheiwiller 1947
Scheiwiller, Giovanni. *Henri Matisse*. Milan: Ulrico Hoepli Editore, 1947.

Schneider n.d.
Schneider, Bruno. *Matisse*. Milan: The Hyperion Press, n.d.

Schneider 1970
Schneider, Pierre. "Galeries Nationales du Grand Palais: Henri Matisse." *La Revue du Louvre et des Musées de France* 20, no. 2 (1970): 87–96.

Schneider 1982
Schneider, Pierre, Massimo Carrà and Xavier Derying. *Tout l'oeuvre peint de Matisse 1904–1928*. Paris: Flammarion, 1982.

 Schneider 1984
Schneider, Pierre. *Matisse*. Paris: Flammarion, 1984.

Schürer 1925–1926
Schürer, Oskar. "Heutige Kunst in Paris." *Die Kunst* 41 (1925–1926): 283–296.

Schwob 1920
Schwob, René. "Henri-Matisse." *L'amour de l'art* 1 (October 1920): 192–195.

Seckler 1959
Seckler, Dorothy Gees. "Preview of 1960." *Art in America* 47 no. 4 (1959): 100–105ff.

 Seize Tableaux 1923
1922–1923, Seize tableaux de Henri-Matisse. Paris: Editions Bernheim-Jeune, 1923.

Seligman 1961
Seligman, Germain. *Merchants of Art, 1880–1960*. New York: Appleton-Century-Crofts, Inc., 1961.

Selz 1964
Selz, Jean. *Henri Matisse*. Paris: Flammarion, 1964.

Selz 1981
Selz, Peter. *Art in Our Time, a Pictorial History.*
New York: Harry N. Abrams, 1961.

Sembat 1920
Sembat, Marcel. "Matisse und Sein Werk." *Genius* 2
(1920): 190–196.

Sembat 1920a
Sembat, Marcel. *Henri Matisse.* Paris: Editions de la
Nouvelle Revue Française, 1920.

Serouya 1931
Serouya, Henri. *Initiation à la peinture
d'aujourd'hui.* Paris: La Renaissance du Livre, 1931.

Shattuck 1968
Shattuck, Roger. *The Banquet Years.* New York:
Vintage, 1968.

Silver 1981
Silver, Kenneth. "Esprit de Corps: The Great War
and French Art, 1914–1925." Ph.D. diss., Yale
University, 1981.

Sitwell 1949
Sitwell, Osbert. *Laughter in the Next Room.*
London: MacMillan and Co., 1949.

Skinner 1964
Skinner, Carl. "Showpiece." *Artforum* 3, no. 2
(November 1964): 39.

Slocombe 1939
Slocombe, George. *Rebels of Art, Manet to Matisse.*
New York: Art and Decoration Book Society, 1939.

Smery 1927
Smery, Volne. *Matisse.* Prague, 1927.

Soby 1957
Soby, James Thrall. *Modern Art and the New Past.*
Norman: University of Alabama Press, 1957.

Soffici 1950
Soffici, Ardengo. *Trenta Artisti Italiani e Stranieri.*
Florence: Vallechi Editore, 1950.

Sutton 1970
Sutton, Denys. "The Mozart of Painting." Apollo 92,
no. 105 n.s. (November 1970): 358–365.

Swane 1944
Swane, Leo. *Henri Matisse.* Stockholm: Norstedts,
1944.

Szymusiak 1982
Szymusiak, Dominique. *Musée Matisse, guide de
visite.* Le Cateau-Cambrésis, 1982.

Tériade 1926
Tériade, E. "Propos sur le Salon des Tuileries."
Cahiers d'Art 5 (1926): 110–111.

Tériade 1927
Tériade, E. "Nos enquêtes: Entretien avec Paul
Guillaume." *Cahiers d'art* 1 (1927).

Tériade 1929
Tériade, E. "L'actualité de Matisse." *Cahiers d'art* 7
(1929): 285–298.

Ternovets 1928
Ternovets, Boris. "La vie artistique à Paris." *Petchat i
Revolioutsia* 1 (1928).

Terrasse 1939
Terrasse, Charles. *La peinture française au XXe
siècle.* Paris: Editions Hyperion, 1939.

Thirion 1967
Thirion, Jacques. "Musées de Nice—
L'enrichissement des collections modernes de 1958
à 1964." *La revue du Louvre et des Musées de
France* 1 (1967): 55–62.

Thornton 1938
Thornton, Alfred. *The Diary of an Art Student of
the Nineties.* London: Isaac Pitmans and Sons,
1938.

Tokyo 1974
Bridgestone Museum of Art Handbook. Tokyo,
1974.

Tokyo 1977
Bridgestone Museum of Art Handbook. Tokyo,
1977.

Uhde 1929
Uhde, W. *Piccasso and the French Tradition.* Paris:
Editions des quatre chemins, and New York: E.
Weyhe, 1929.

Vallotton 1975
Vallotton, Félix. *Journal, tome III, 1914–1921.*
Lausanne: La Bibliothèque des Arts, 1975.

Vaughan 1965
Vaughan, Malcolm. "Matisse, The Brilliant
Designer." In *Reader's Digest Family Treasury of
Great Painters and Great Paintings.* Pleasantville:
The Reader's Digest Association, 1965.

Venturi 1948
Venturi, Lionello. *La peinture contemporaine.*
Milan: Ulrico Hoepli, 1948.

Verdet 1952
Verdet, André. *Entretiens avec Henri Matisse.* Paris:
Prestiges de Matisse, 1952.

Vildrac 1921
Vildrac, Charles. "Henri Matisse." *Das Kunstblatt* 7
(July 1921): 214–219.

Vildrac 1922
Vildrac, Charles. *Nice 1921—Seize reproductions
d'apres les tableaux de Henri-Matisse.* Paris: Les
editions Bernheim-Jeune, 1922.

Vogue 1955
"Matisse: a rare collection record." *Vogue* (1 March
1955): 132–135.

Walker 1965
Walker, John. *Twentieth Century Paintings and
Sculpture of the French School in the Chester Dale
Collection.* Washington: National Gallery of Art,
1965.

Walker 1974
Walker, John. *Self Portrait with Donors.* Boston:
Little Brown and Company, 1974.

Warnod 1925
Warnod, André. *Les berceaux de la jeune peinture.*
Paris: Albin Michel Editeur, 1925.

Watanabe 1973
Watanabe, Junichi. *Matisse.* Tokyo: Chuokoron-Sha,
1973.

Watkins 1977
Watkins, Nicholas. *Matisse.* Oxford: Phaidon, 1977.

Watkins 1984
Watkins, Nicholas. *Matisse.* Oxford: Phaidon, 1984.

Watson 1925
Watson, Forbes. "The Ferdinand Howald
Collection." *The Arts* 8 (August 1925): 65–95.

Watson 1926a
Watson, Forbes. *The John Quinn Collection of
Paintings, Water Colors, Drawings and Sculpture.*
New York: Pigeon Hill Press, 1926.

Watson 1926b
Watson, Forbes. "The John Quinn Collection." *The
Arts* 9 (January 1926): 5–18.

Watson 1927
Watson, Forbes. "Henri Matisse." *The Arts* 11
(January 1927): 29–40.

Watson 1930
W., F. [Forbes Watson]. "Cleveland Museum's
French Exhibition." *The Arts* 16, no. 5 (January
1930): 321–335.

Wild 1950
Wild, Doris. *Moderne Malerei.* Zurich: Buchergilde
Gutenberg, 1950.

Wildenstein 1985
Wildenstein, Daniel. *Claude Monet vie et oeuvre.*
Tome IV, 1899–1926. Lausanne-Paris, 1985.

Wilenski 1947
Wilenski, R. H. *Modern French Painters.* London:
Faber and Faber, 1947.

Wilkin 1985
Wilkin, Karen. "Editorial." *Triangle Forum* 1, no. 1
(August 1985).

Williams 1969
Williams, William Carlos. *Selected Essays.* New
York: New Directions, 1969.

Wolfradt 1930
Wolfradt, Willi. "Henri Matisse zur Ausstellung in
der Galerie Thannhauser, Berlin." *Der Cicerone*
(March 1930): 129–132.

Yomiuri 1951
Henri Matisse. Tokyo: Le Journal Yomiuri, 1951.

Zervos 1928
Zervos, Christian. "Idealisme et naturalisme dans la
peinture moderne—IV, Henri Matisse." *Cahiers d'art*
4 (1928): 158–163.

Zervos 1930
Zervos, Christian. "De Delacroix à nos jours."
Cahiers d'art 5 (1930): 251–258.

Zervos 1931a
Zervos, Christian, Paul Fierens, Pierre Gueguen,
Curt Claser, Will Grohmann, Georges Salles, Roger
Fry, Henry McBride, Karel Asplund, and Giovanni
Scheiwiller. "L'oeuvre de Henri Matisse." *Cahiers
d'art* 5–6 (1931).

Zervos 1931b
Zervos, Christian, Paul Fierens, Pierre Gueguen,
Curt Claser, Will Grohmann, Georges Salles, Roger
Fry, Henry McBride, Karel Asplund, and Giovanni
Scheiwiller. *Matisse.* Paris: Editions cahiers d'art,
1931. (Same authors and texts as Zervos 1931a, but
different pagination and reproductions.)

Zervos 1938
Zervos, Christian. *Histoire de l'art contemporain.*
Paris: Editions cahiers d'art, 1938.

Zilczer 1978
Zilczer, Judith. *The Noble Buyer: John Quinn,
Patron of the Avant-Garde.* Washington: Hirshhorn
Museum and Sculpture Garden, 1978.

Photo credits

Unless otherwise indicated, photographs and transparencies have been supplied by their owners.

Pages 14–45: fig. 1, Pierre Matisse; 2, 3, Copyright © 1986 The Barnes Foundation, Merion, Pennsylvania; 4, Photograph Bernheim-Jeune, Paris; 5, Rostand et Munier, Editions d'art, Nice, courtesy of M. Guillot, Nice; 6, Photograph Bernheim-Jeune, Paris; 7, Courtesy Jean Arnaud, architect, Nice; 8, Photograph by George Besson, courtesy Mme George Besson, Paris; 9, Photograph M. Berard, Nice; 10, 11, Photograph M. Berard, Nice; 12, Photograph Bernheim-Jeune, Paris; 14, Photograph M. Berard, Nice; 15, Copyright © 1986 The Barnes Foundation, Merion, Pennsylvania; 16, Photograph Bernheim-Jeune, Paris; 17, Designed by A. Henriet, extract of L'indicateur de Nice et des Alpes Maritimes, published by Agence Havas, Nice; 18, Edition Giletta, Nice; 19, Copyright © 1986 The Barnes Foundation, Merion, Pennsylvania; 20, Photograph courtesy Kunstmuseum Gothenburg, Sweden; 21, Photograph courtesy Pierre Matisse Gallery, New York; 22, Photograph Bernheim-Jeune, Paris; 23, Photograph by Man Ray, courtesy Archives Matisse, Paris; 24, Library, The Museum of Modern Art, New York, Photo Archives; 25, Photograph courtesy Mr. and Mrs. Pierre Matisse, New York; 26, 27, Photograph M. Berard, Nice; 28, Drafted by Farahnaz Pourbabai, National Gallery of Art, Washington; 29, Library, The Museum of Modern Art, New York, Photo Archives; 30, Hahnloser Archives, Winterthur, Switzerland; 31, Copyright © 1986 The Barnes Foundation, Merion, Pennsylvania; 32, Photograph reproduced from *The Arts* 2 (January 1927), 29; 33, 34, Library, The Museum of Modern Art, New York, Photo Archives; 35, Courtesy Mme Claude Houpert, France; 36, Drafted by Farahnaz Pourbabai, National Gallery of Art, Washington; 37, Courtesy Mme Claude Houpert, France; 38, Library, The Museum of Modern Art, New York, Photo Archives; 39, 40, Photograph Bernheim-Jeune, Paris; 41, Photograph courtesy Marie-Thérèse Pulvenis de Seligny; 42, Courtesy Mme Lydia Delectorskaya, Paris; 43, 44, Photograph by Pierre Matisse; 45, Philadelphia Museum of Art, A. E. Gallatin Collection; 46, Courtesy Mr. and Mrs. Pierre Matisse; 47, Archives Musée Matisse, Le Cateau; 48, Archives Hachette, Paris; 49, Archives Club Nautique de Nice, courtesy M. Icard; 50, Photograph by Peter A. Juley, courtesy Kraushaar Gallery, New York; 51, Courtesy Pierre Matisse Gallery, New York; 52, Courtesy Pierre Matisse; 54, 55, Courtesy Marie-Thérèse Pulvenis de Seligny.

Pages 60–139: plate 3, A. E. Dolinski Photographic, San Gabriel, California; 6, © Musée d'art et d'histoire de Fribourg; 7, Tord Lund, Statens Konstmuseer; 11, A. Mewbourn, Bellaire, Texas; 12, Courtesy Marlborough Fine Art, Ltd; 16, © Founders Society, Detroit Institute of Arts; 27, © SPADEM (VAGA); 29, Gerhard Howald, Bern; 32, Fernand Perret, La Chaux-de-Fonds; 33, 35, Piotr Trawinski, Paris, © SPADEM (VAGA); 38, Joseph Szaszfai; 46, Photo Benitez, Valenciennes; 47, Eric E. Mitchell, Philadelphia Museum of Art; 50, Hans Petersen, Statens Museum for Kunst, Copenhagen; 51, 56, 57, Piotr Trawinski, Paris; 56, © SPADEM (VAGA); 59, Gerhard Howald, Bern; 61, 68, Otto E. Nelson, New York; 69, 74, 75, Piotr Trawinski, Paris; 79, 82, 83, Otto E. Nelson, New York; 84, Foto-Studio H. Humm, Zurich; 86, Schweizerisches Institut für Kunstwissenschaft, Zurich; 87, 88, 93, Otto E. Nelson, New York; 97, Courtesy Marlborough Fine Art, Ltd; 99, Hans Hinz SWB, Allschwil, Switzerland; 103, 104, Otto E. Nelson, New York; 106, Courtesy Marlborough Fine Art, Ltd; 114, Piotr Trawinski, Paris, © SPADEM (VAGA); 116, 121, Otto E. Nelson, New York; 122, Courtesy Marion Koogler McNay Art Museum, San Antonio; 125, 132, Otto E. Nelson, New York; 133, Eric E. Mitchell, Philadelphia Museum of Art; 134, Otto E. Nelson, New York; 137, Piotr Trawinski, Paris; 138, Prudence Cuming Associates, Ltd., London; 139, Otto E. Nelson, New York; 144, Courtesy Marlborough Fine Art, Ltd; 149, Michael M. Fairchild, Cold Spring Harbor, New York; 154, A. C. Cooper, courtesy The Lefevre Gallery, London; 155, Bérard Photographie, Saint-André-de-Nice; 156, 158, Otto E. Nelson, New York; 162, Malcolm Varon Associates, New York; 164, 172, Otto E. Nelson, New York; 176, Tord Lund, Statens Konstmuseer; 178, Jacques Betant, Lausanne; 180, Charles Uht, New York; 182, Nathan Rabin, New York; 184, 185, Otto E. Nelson, New York; 186, Courtesy Smith College Museum of Art, Northampton; 188, Archives Matisse, Paris, © SPADEM (VAGA).